WATSON-GUPTILL PUBLICATIONS / NEW YORK

understanding paintings

themes in art explored and explained

General Editor **Alexander Sturgis**
Consultant Editor **Hollis Clayson**

Understanding Paintings
Themes in art explored and explained

General Editor **Alexander Sturgis**
Consultant Editor **Hollis Clayson**

First published in the United States in 2000
by Watson-Guptill Publications,
a division of BPI Communications, Inc.,
770 Broadway, New York, NY 10003

www.watsonguptill.com

First published in Great Britain in 2000
by Mitchell Beazley, an imprint of
Octopus Publishing Group Ltd,
2–4 Heron Quays, London, E14 4JP

Executive Editors **Mark Fletcher, Alison Starling**
Deputy Art Director **Vivienne Brar**
Managing Editor **Anthea Snow**
Senior Art Editor **Tim Brown**
Editors **Richard Dawes, John Jervis**
Editorial Assistant **Oliver Roberts**
Page Design **Lovelock & Co.**
Picture Research **Jenny Faithfull**
Production **Nancy Roberts**
Index **Hilary Bird**

Contributing Editors

Paul Holberton, Michael Ricketts

ISBN 0-8230-5579-5

Library of Congress Card Number 00-106572

Set in ITC Century and Frutiger
Colour reproduction by Vimnice Printing Press Co. Ltd
Produced by Toppan Printing Co., (HK) Ltd
Printed and bound in China
2 3 4 5 6 7 8 9 / 08 07 06 05 04 03 02 01

General Editor

Alexander Sturgis Ph.D. studied for his doctorate at the Courtauld Institute, London, where he specialized in medieval art history. In 1991 he joined the National Gallery in London, where he worked for a number of years within the Gallery's highly regarded Education Department, and where he currently holds a curatorial post, supporting the Director of the Gallery. In his roles at the Gallery he has lectured to a wide variety of audiences on all aspects of the Gallery's collection, and has written extensively on both the permanent collection and temporary exhibitions. A contributor to both *The Grove Dictionary of Art* (1996) and *The New Oxford Companion to Western Art* (1999), his own publications include *Introducing Rembrandt* (1994), *Magic in Art* (1994), and *Faces* (1999). Alexander Sturgis is also the contributor for **Portraiture**.

Consultant Editor

Hollis Clayson Ph.D. has pursued a distinguished career as an art historian over the past 25 years. Associate Professor of art history at Northwestern University, Illinois, since 1991, she has also held teaching posts at the University of Chicago, the University of Illinois at Chicago, Wichita State University, Schiller College in Strasbourg, and the California Institute of the Arts. She has received many awards in recognition of her outstanding abilities as a teacher, and is the author of numerous articles, reviews, and exhibition catalogue essays as well as longer publications, which most notably include *Painted Love: Prostitution in French Art of the Impressionist Era* (1991). She is a prolific lecturer across North America and in Europe, and has acted as both an advisor and a presenter on radio and television.

Contributors

Rachel Barnes (**The Nude**, **Abstract Painting**) lectures and holds courses at the National Gallery, Tate Britain and Tate Modern, and The Royal Academy in London. A regular contributor to the *Independent* and the *Guardian*, she is the author of several publications, including the series *Artists by Themselves* (1990–3) and *The Pre-Raphaelites and their World* (1998).

Linda Bolton (**Myth and Allegory**, **History Painting**) lectures at Tate Britain, Tate Modern, and the National Gallery in London, and also for the universities of Maryland and Denver. She is the author of three titles in the series *Techniques of the Great Masters*, on *Gauguin* (1986), *Degas* (1987), and *Manet* (1988), and of four titles in the series *Art Revolutions*: *Impressionism, Cubism, Surrealism,* and *Pop Art* (2000).

Michael Douglas-Scott Ph.D. (**Religious Painting**) teaches on both the B.A. History of Art course and the M.A. Renaissance Studies course at Birkbeck College, University of London. A specialist in the Venetian Renaissance and Patronage, he has lectured widely at British universities, at the Victoria and Albert Museum, London, and for the National Art Collections Fund. His written work includes articles for *The Burlington Magazine* and the *Journal of the Warburg and Courtauld Institutes*.

Mari Griffith (**Still Life**) is Assistant Curator of Exhibitions Programs at the National Gallery of Art, Washington DC. Prior to this, she worked for many years as an education officer at the National Gallery in London. She has lectured and broadcast widely, and has taught courses at both the National Gallery, London, and the Philadelphia Museum of Art.

Frances Homan (**Timeline**, **Materials and techniques**, **Genre: Animal Painting** and **Sporting Painting**) lives in San Francisco, USA, where she researches and writes for US galleries, including the Getty Museum and the Museum of Fine Arts, Boston. She was formerly an education officer at London's National Gallery, and has also lectured at the National Portrait Gallery in London, as well as working extensively for the American Council for International Studies.

Rebecca Lyons (**Genre**) studied at the Courtauld Institute, in London, specializing in nineteenth-century art history. Following several years with the American Council for International Studies, both in Boston, USA, and in Europe, she now works as an education officer at the National Gallery in London, where she regularly writes and lectures on the Gallery's collection.

Valerie Mainz Ph.D. (**Landscape**) is a lecturer in the Department of Fine Art at the University of Leeds. A specialist in the art, culture, and society of eighteenth-century France, she has curated exhibitions in Britain and France and has lectured widely, including at the Tate Gallery and the Victoria and Albert Museum in London. Her published work includes *L'Image du Travail et la Révolution française* (1999), and contributions to *The Grove Dictionary of Art* (1996) and the *Dictionary of Women Artists* (1997).

Contents

Introduction

This is a book about painting – or rather Western painting. It contains many of the most famous images produced in Europe and America over the past seven centuries. But although many of the paintings are well known, they are presented here in unfamiliar and stimulating company.

We are used to looking at pictures and reading about them in a particular way. In the major art museums and galleries of the world the paintings on the walls are not hung randomly. Quite how they are arranged varies: different museums have different policies and different curators different priorities, but for the most part you expect to find pictures painted at the same time and in the same place hanging together. Early Italian paintings will be in one part of the museum, seventeenth-century Spanish paintings in other rooms. Some museums emphasize the importance of national school, so that all Italian or all American pictures are grouped together; others stress chronology, placing fifteenth-century pictures near to one another wherever they were painted. There are exceptions, but these are the twin principles by which curators normally arrange the pictures on their walls. The same approach is taken in most published surveys of art, which, depending on their scope, progress from, say, Ancient Egypt, the Middle Ages, or the Renaissance to the present day in a straightforward chronological sequence. Here again the narrative is most often arranged according to geographical "schools" of painting, with chapters on "The Italian Renaissance" or the Dutch "Golden Age," if not on individual great artists. This is certainly not a new way of thinking about painting, indeed it is descended directly from the first book on the history of art, *Lives of the Most Excellent Painters, Sculptors, and Architects*, written in the mid-sixteenth century by the Italian Giorgio Vasari. As the

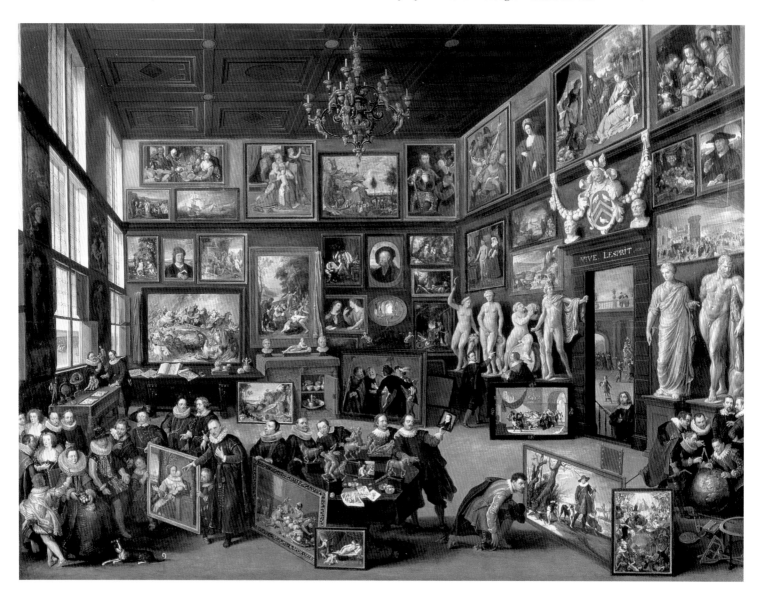

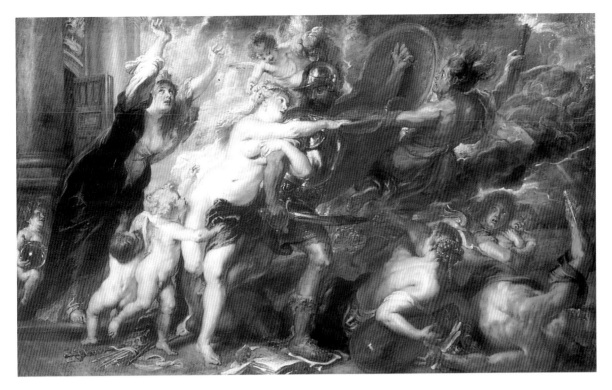

title makes clear, Vasari's approach was biographical, but he also wrote about the history of art in terms of a progression from the crude, flat "Byzantine" painting of the thirteenth century to the triumphs of artists such as Raphael and, more particularly, Michelangelo in the sixteenth. He was also fiercely parochial in his judgements, championing the painters of his native Florence above those from elsewhere in Italy and Europe.

Alternative interpretations

We are so used to being told about pictures in terms of who painted them and as part of a historical progression in which one style of painting develops into the next that it is easy to overlook other ways of explaining art works and alternative ways of writing about and looking at pictures. It is also easy to fail to notice how odd the resulting juxtapositions sometimes are. A fifteenth-century visitor to the Louvre, the National Gallery in London, or the Metropolitan Museum in New York today would be shocked and surprised to find altarpieces from churches hanging next to pictures of the naked gods of the Classical past just because they happened to have been painted at the same time. For such a viewer this would seem to show a disgraceful lack of what in the fifteenth century was termed "decorum" and to miss the point of what paintings were actually for. We might now look at a religious painting by, say, Botticelli, and one of his mythological scenes, as if they were the same kind of thing, but for the artist and his patrons it would have been clear that these pictures fulfilled completely different roles.

Paintings in private collections are organized according to yet other priorities because few collectors worry about presenting a "history of art" when they display their pictures. In the paintings of collections

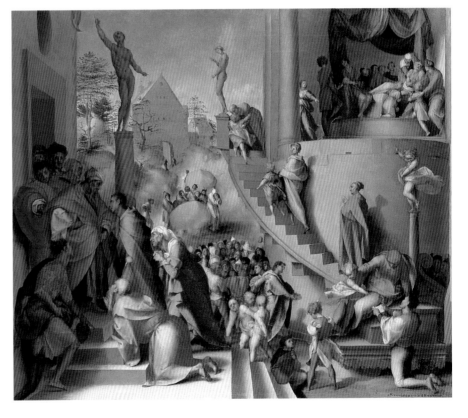

▲ **Essential knowledge**
One of a series of pictures painted to decorate the bedroom of Pierfrancesco Borgherini, this painting shows the story of Joseph. Dressed in gold tunic, lavender cloak, and red hat, Joseph appears four times. On the right he sits on Pharaoh's chariot and on the left he presents his old father, Jacob, to Pharaoh. He appears again on the winding staircase with his two sons, in green, whom he then presents to his dying father for blessing, above. Deciphering this complex painting depends on knowledge of the story it depicts.
Jacopo Carucci Pontormo, *Joseph with Jacob in Egypt*, c.1518.

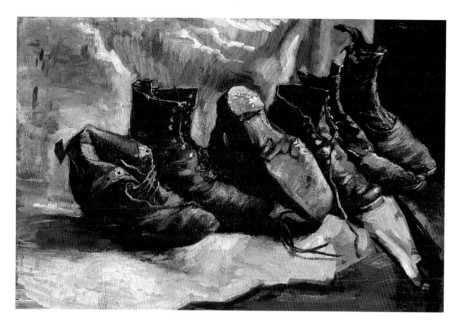

that proliferated in seventeenth-century Antwerp, such as Willem van Haecht's of the collection of Cornelis van der Gheest (see page 6), the emphasis is always on the profusion, wealth, and variety on show rather than any potential order. In van Haecht's picture, made in 1628, paintings of every kind and different periods are hung shoulder to shoulder. By this date pictures were already being collected by connoisseurs such as van der Gheest as the work of great artists and the arrangement of the paintings (though probably not reproducing their actual arrangement in his house) suggests that the religious, political, and commemorative functions for which they were originally painted were no longer considered of primary importance. Today, in our own homes, few of us who have art to hang on our walls would think of hanging pictures along chronological lines. What we choose to put above the mantelpiece or over the bed has nothing to do with when it was made or where, but depends on a variety of other considerations ranging from whether it is the right size to whether it suits the room or, perhaps most importantly, what it shows.

What's in a picture?

This book concentrates on the question of what pictures show. It is organized not by century or country but by subject or genre, and within each section the approach is also thematic. The division of painting into different categories or genres goes back to the seventeenth century. The French Royal Academy – founded in 1648 – famously created a strict hierarchy of subject matter. The highest genre was what was called "history painting," which included religious, literary, mythological, and historical narratives as well as allegory. Then came portraiture, followed by genre (an eighteenth-century term to describe scenes of everyday life), landscape, and finally still life. History painting was seen as the most elevated genre owing to its perceived moral purpose and the demands it made on the imagination and intellect of the painter. In contrast the lower genres were seen as the mere imitation of observable reality.

The idea of judging the worth of a painting by its subject matter seems strange to us today – we don't think less of Vincent van Gogh's still lifes of shoes because of their mundane subject – and the academic hierarchy has not held sway since the later nineteenth century. Indeed since that time one of the recurrent strategies of Modernist artists has been to challenge all such hierarchies of value.

The division of the genres is also not as straightforward as the French Academy would have wished. As

the following sections make clear, landscapes can contain narratives (or narratives can take place in landscapes), portraits can appear to be scenes of everyday life, and so on. But despite the inevitable areas of overlap between the genres, and the difficulty of categorizing some paintings by subject matter at all, approaching paintings by genre rather than by period offers many valuable insights.

In taking this approach in this book there have been two principal aims. The more straightforward of these is to provide a means of answering the most immediate question that often occurs when looking at paintings of the past: what is going on? The sections on Religious Painting and Myth and Allegory, for example, describe many of the most popular subjects and stories painted by artists through the centuries as well as the means by which particular saints, gods, and heroes can be recognized. Other sections explore the use of signs and symbols in their respective type of painting – for example, how music has often been used to symbolize love or harmony in paintings of everyday life, or the rich symbolism of flowers in still lifes. But although we hope that the book will provide a useful guide for the identification of subject matter in painting, perhaps even more valuable is the way in which it shows the richness of the language of painting, demonstrating how in every kind of painting, be it landscape, still life, or portraiture, artists are working within a deep and long tradition which they can exploit or reject to a wide variety of different ends.

Reading pictures

For much art of the past, recognition of its subject matter is often crucial to the understanding and consequent enjoyment of it. Van Gogh's shoes may seem straightforward, but a painting such as Rubens's *The Consequences of War* (see page 7) is for most people on first acquaintance strange, confusing, and consequently off-putting. It shows a world of fleshy women, winged babies, and overblown expression which does not speak clearly to audiences of today. For Rubens, however, writing to his patron about the painting, the subject was "very clear" and indeed it is, once the language that is being used is recognized. The picture is an allegory in which the various figures are intended to personify a variety of abstract ideas. The naked woman is Venus, the goddess of love, here standing for love and harmony itself. She is struggling in vain to restrain Mars, the god of war. He strides forward, trampling on a book and a drawing as other figures – a woman with a lute, an architect with a pair of dividers, and a mother – cower before him. On the left is the wailing and desperate figure of Europe. Once the figures are identified the painting does indeed clarify itself and much of its imagery translates directly into figures of speech. We can still speak of abstract notions as if they were people. We talk of countries or continents being ravaged by war and of war trampling over everything in its wake. Although unfamiliar as a means of expression today (except perhaps in the realm of the political cartoon), pictorial allegory is in some ways imagery at its closest to spoken language.

Understanding allegory depends on both identifying the figures within it and the means of expression, but allegory is certainly not the only kind of painting that has become difficult for the modern viewer to decipher. This is largely because we are now no longer familiar with the body of stories and knowledge that artists working in the sixteenth century, for example, could have been confident their audience would share: most importantly the Bible, the stories of the saints, and the myths of ancient Greece and Rome. Advertisers and film-makers today frequently resort to knowing allusions to a broad range of cultural, historical, and

▼ **Confronting the world**
One of the leading Pop artists of the 1960s, the American Roy Lichtenstein drew on the colourful imagery of comic books and advertisements for his paintings, subverting the divisions between "low" and "high" art. For him commercial art was "usable, forceful, and vital" at a time when he saw the dominant abstract art movements as being "unrealistic, feeding on art," and having "less and less to do with the world."
Roy Lichtenstein, *Whaam!*, 1963.

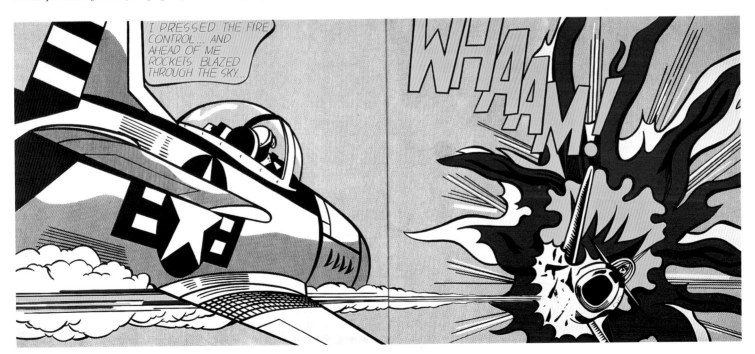

This work by the Belgian painter Magritte is a playful challenge to the idea of illusionism and representation in art. Clearly "this is not a pipe." It is a flat canvas with different colours arranged on it. But the message itself is also "not real." It too is painted illusionistically, complete with screws, and it inhabits the same world of illusion as the image of the pipe above it. We can believe neither words nor image.

René Magritte, *The Betrayal of Images (This is not a Pipe)*, 1953.

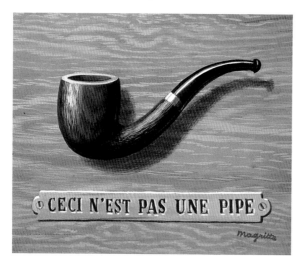

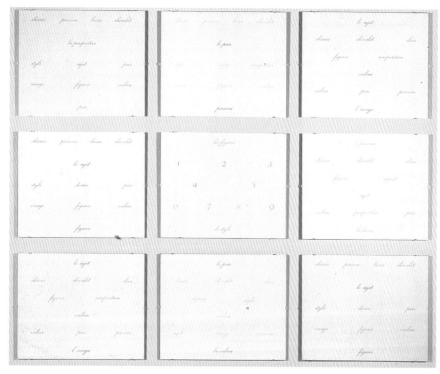

▲ **Elements of painting**

Broodthaers developed many of the ideas of his compatriot Magritte, similarly challenging the very nature and aims of painting. Here, in a work significantly called *Paintings*, he assembles nine canvases on which are painted words which describe elements usually associated with or pictured in paintings, such as figures, composition, perspective, colour, price, value, and so on. Each canvas presents a different arrangement, suggesting the concept of a different painting.

Marcel Broodthaers, *Paintings*, 1973.

Pope Gregory I suggested that pictures should be displayed in churches so that the illiterate "may at least read by seeing on the walls what they are unable to read in books," but paintings of stories cannot communicate their meaning independently. They may remind viewers of stories they have heard and they can make stories more vivid, but without the aid of writing, as in the comic-book images adapted by Pop artist Roy Lichtenstein, paintings cannot tell the whole story. Pontormo's complex painting *Joseph with Jacob in Egypt* (see page 7) would be incomprehensible to someone who knew nothing of the story from the Old Testament.

Hits and misses

The approach taken by this book has a number of consequences for the paintings and artists represented in it. Most of these are positive. As well as covering many of the famous masterpieces of Western art, treating paintings by their subject has allowed for the inclusion of some striking lesser-known paintings by less famous names who might have struggled to be represented in a more conventional chronological history. Some artists inevitably appear more frequently than others and it is certainly revealing that the most featured painter should be Picasso, not only because he turned his hand to nearly every kind of painting but also because, of all twentieth-century artists, he was arguably the one most aware of the tradition in which he worked, constantly challenging and responding to the works of his predecessors. When, in 1946, some of his paintings were hung next to Old Masters in the Louvre he is reported to have exclaimed: "You see, it's the same thing, it's the same thing." This book, for the most part, emphasizes and draws out these elements of continuity, an emphasis that works against the understanding – enshrined in the biographical approach – which sees the meaning of art residing principally or even exclusively in the artist.

But even though Picasso features prominently, his representation is skewed by another self-imposed limitation of the book. This is a book about painting and so ignores his work in ceramic, sculpture, and print. The concentration on painting inevitably means that sculptors of all ages are not included. But arguably this has the greatest repercussions on the representation of modern art owing to the multitude of media, from video to performance, used by artists today. In most contemporary art exhibitions painting will be in a minority and representational painting in a smaller minority still. Even when painting alone is being considered, many of the art movements of the twentieth century present problems for a genre-based study. The term "Modernism" covers a wide range of artistic impulses and strategies. Some of these, such as the picturing of the impact of modernization – as seen in the paintings of modern life by artists such as Manet or the Futurists – can be well encompassed in a subject-based approach. But another aspect of Modernism was an increasing insistence on the separateness of art: a belief

visual knowledge that they can assume the majority of people will understand, but self-evidently this shared body of knowledge has changed beyond measure since the Renaissance. We can be relied on today to recognize Elvis but references to St Nicholas of Bari would need some accompanying explanation (except perhaps in his modern incarnation as Santa Claus).

It is often claimed that every picture tells a story, but experience teaches us that unless we know what story is being told we cannot "read" pictures as easily as we might read a story in a book. Most narrative paintings illustrate existing stories and in order to be understood rely on the viewer's ability to recognize the story. Someone who knew nothing of the Bible, for example, would be more likely to interpret a painting of Adam and Eve as a scene of nudist apple-eaters than to reconstruct the story of the Fall of Man from the book of Genesis. It is true that, in one of the most famous and repeated pronouncements on the use of paintings, in around 600,

that its realm was purely aesthetic, which in turn often led to a preoccupation with form, design, colour, and the flat painted surface at the expense of subject matter. At their most extreme Modernist critics could claim: "The representative element in a work of art may or may not be harmful; always it is irrelevant. For to appreciate a work of art we need bring with us nothing from life, no knowledge of its ideas and affairs, no familiarity with emotions. Art transports us from the world of man's activity to a world of aesthetic exultation." (Clive Bell, *Art*, 1914). Clearly this is an attitude at odds with the arrangement of this book. Nevertheless, it is one that has informed many paintings of the twentieth century which consequently fit uneasily into a subject-based account – for example, Pierre Bonnard's *The Bowl of Milk* (see page 8). The abstract art movements of the twentieth century which stem from this attitude are given their own chapter, which follows more conventionally chronological lines.

If abstract paintings self-evidently deny the importance of conventional subject matter, they are not the only paintings of the twentieth century that have sought to challenge the traditional aims of art, often by deliberately drawing attention to the limits of the painter's medium. For example, perhaps the cleverest, wittiest, and probably the most famous assault on the representational aims of painting was Magritte's *The Betrayal of Images*, an illusionistic depiction of a pipe (complete with shadow) under which is an illusionistically painted sign bearing the words "*ceci n'est pas une pipe*" ("this is not a pipe"). This is a painting about the nature of reality and the very act of

representation. It is a work of art about art and as such is part of another important strand of Modernist painting. The same themes were taken up by Marcel Broodthaers, for example, in the 1970s, but such conceptual games once again evade a subject-based approach to painting.

Having drawn attention to what might slip through the net of a thematically arranged book on painting, it is important to emphasize the strengths and benefits of the approach. Many of these are apparent from even a brief flip through this book. On every page there are interesting and often enlightening juxtapositions. Some of these are familiar comparisons – for example, Cézanne appears next to Poussin (see pages 174–5) and Sargent next to Velázquez (see pages 152–3) – but many are more unexpected, revealing surprising connections or striking contrasts. Van Gogh's paintings of sunflowers, for example, are such famous iconic images that it is easy to think of them in isolation. Seeing one of these studies next to one of the meticulously finished flower paintings of his seventeenth-century predecessor Bosschaert (see pages 226–7) brings home quite how much the later works owe to the tradition of flower painting and – as importantly – what they bring to it.

What this book brings out most clearly and valuably is the way in which different artists have responded to similar themes: how they have drawn on tradition and reacted against it, and the varieties of

▼ **Improving on the past**
The figure of the man in the foreground encircled by snakes is clearly a reference to *The Laocoön*, and other figures in this painting by the Venetian artist Titian have been linked to other Classical statues and reliefs. But while the models were sculptures, this is a painting. Titian's depiction of flesh, his capturing of Bacchus in mid-air, the luminous sky, and the beautiful landscape all seem to advertise how, in producing a painting based on Classical prototypes, he has surpassed his models.
Titian, *Bacchus and Ariadne*, 1522–3.

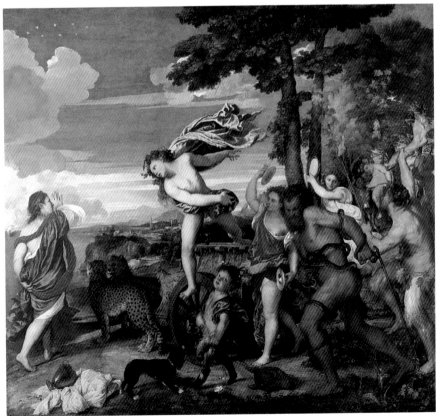

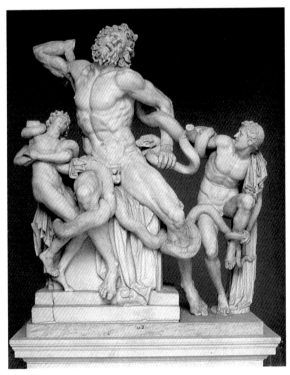

▲ **Classical exemplar**
The Laocoön, discovered in 1506, was bought by Pope Julius II, patron of Michelangelo and Raphael, shortly afterward. It became the most famous Classical statue in Rome and remained so for centuries.
Workshop of Hegesandrus, Athenodorus, and Polydorus of Rhodes, *The Laocoön*, third century BC–first century AD.

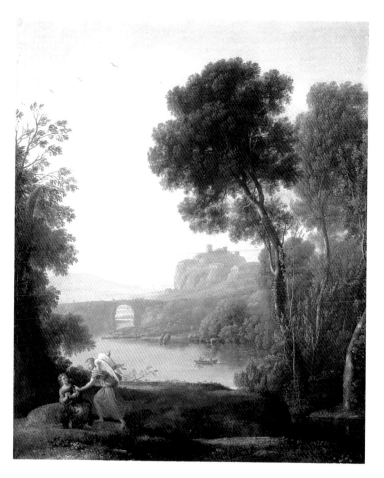

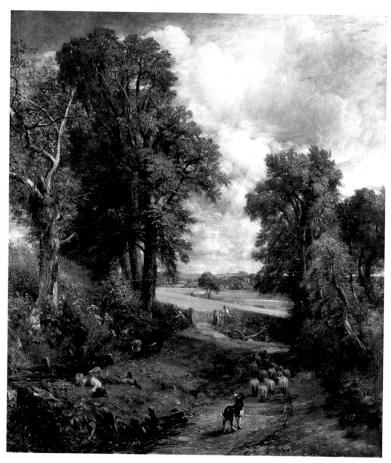

▲ **Light and distance**
The French artist Claude painted
this exquisite small work for an
unknown Parisian patron. It
embodies all that is most
characteristic of him: distant,
light-filled vistas seen between
darker, framing trees. In the
foreground is a scene from a
story in the Bible's book of
Genesis. An angel appears to
Hagar, prophesying the birth of
Ishmael, her son by Abraham,
and telling her to return to the
distant city.
Claude, *Landscape with Hagar
and the Angel*, 1646.

meaning that can be produced as a result. The ways in
which artists respond to the art of the past cover every
possibility from mimicry to outright rejection. Often
artists' dependence on past models is explicit, some-
times it is disguised, but in every instance different
meanings result. The three pairings on these two pages
and the previous page show artists quoting directly
from the art of the past, but in each case the aims and
the effects could scarcely be more different. Titian's
famous painting of *Bacchus and Ariadne* (see page 11)
is one of the most elegant and involved pieces of
"quotation" that one could imagine. It deliberately
invokes Classical precedents in a variety of ways. Its
subject is a Roman myth, showing the moment when
Bacchus meets and falls in love with Ariadne, aban-
doned on the island of Naxos. Details of the represen-
tation derive from a variety of literary sources. But if
the subject depended upon considerable literary erudi-
tion, its depiction demonstrates visual erudition of a
similar level. The bizarre figure in the foreground bat-
tling with snakes depends in part on a description of
Bacchus's retinue by Catullus, but it also quotes the
then recently discovered statue known as *The Laocoön*,
the most famous antique sculpture in Rome. Classical
sources have been suggested for nearly every other fig-
ure, but Bacchus's trailing arm seems to quote a more
recent work. It appears to be based on the arm of God
the Father in Michelangelo's fresco of the Creation of
Adam in the Sistine Chapel, finished ten years earlier.
Such an allusion would not have been lost on Titian's

▲ **Picturesque detail**
Constable spoke of his famous
painting as "having a little more
eye-salve than I usually
condescend to give [the public]."
The statement suggests that the
work's careful finish and
picturesque elements were
deliberately intended to appeal
to that public. Whereas Claude,
in the adjacent painting,
characteristically included a
narrative scene, Constable
scattered anecdotal details,
taken from his sketchbooks,
through his picture. These
include the drinking boy, the
sheepdog, and the donkey.
John Constable, *The Cornfield*,
1826.

patron Alfonso d'Este – we know he had been up on the
scaffolding in 1512 to see Michelangelo at work. Titian's
painting is an extraordinary display of artistic ingenuity
weaving many different elements into a startling whole,
but his use of quotation is of a particular kind and
depends upon, and was no doubt designed to flatter, the
knowledge of his patron. Part of the pleasure that
Alfonso presumably derived from the painting was in his
ability to recognize the wealth of allusions it contained.

Art and nature

In contrast, the English nineteenth-century artist John
Constable has always been praised for his realism and
his intense observation of natural phenomena, such as
clouds, as opposed to his use of the art of the past. This
was a reputation encouraged in part by Constable him-
self. Many of his pronouncements on painting explicitly
criticized artists who looked to art rather than nature
for their models. On one occasion he asserted that
there were two approaches to painting: one was

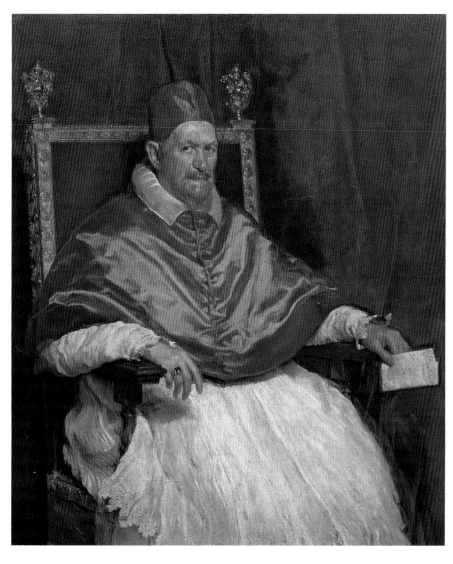

Velázquez's painting of Innocent X
is one of the supreme portraits
of Western art. The Spanish artist
was looking to the past when
he painted it. Its three-quarter
knee-length view of a seated
pope was first used by Raphael
in his portrait of Julius II, painted
early in the sixteenth century, and
was for centuries the standard
way of representing popes.
Diego Velázquez, *Portrait of
Pope Innocent X*, 1650.

"running after pictures and seeking truth at second
hand" while the other aimed for "a pure and unaffected
representation." But although there is no denying
Constable's response to nature his paintings are not
simple records of existing scenes. Those produced for
exhibition were painted not outdoors but in his London
studio and they were careful constructions pieced
together from his many drawings and oil sketches.
Despite his advertised beliefs his compositions also
usually adhere to well-established artistic precedents.
The Cornfield, for example, follows the same composi-
tion (in reverse) as Claude's *Landscape with Hagar
and the Angel*. As it happens, we know that Constable
both knew and admired Claude's painting, which
belonged to his friend Sir George Beaumont. In one
letter he described copying another of Beaumont's
Claudes in terms that reveal a rather different attitude
to what artists could learn from the work of their fore-
bears: "it will be useful to me as long as I live – it
contains almost all that I wish to do in Landscape."

In contrast to Constable's surreptitious but essen-
tial adoption of Claudian compositions, Francis Bacon's
use of Velázquez's famous *Portrait of Pope Innocent X* is
both explicit and provocative. Bacon produced a
number of paintings based on this portrait but claimed
never to have seen the original. Living as he did in a pho-
tographic age, his use of the image was not the equiva-
lent of Titian's erudite quotation, appealing to those in
the know, but a confrontational appropriation of a
much-reproduced icon of Western art. Bacon's painting
depends for its power on the recognition of his source
and its associations, together with the shock of its wilful
distortion. Indeed Velázquez's painting was just one of a
mass of images that Bacon culled – photographs, film
stills, newspaper images – as the raw material of his art.

These are just three examples that suggest ways
in which artists have responded to the art of the past
within the demarcated genre in which they were work-
ing and used the language forged by their predecessors
within that genre for very different ends. This book will
introduce many more. It will explore the different
themes and subjects addressed by painters and the
different ways in which these subjects have been
treated. It will, it is hoped, suggest new ways of looking
at, thinking about, and understanding paintings.

This is one of the first of a series
of popes by the British painter
Bacon that took Velázquez's
famous portrait as their starting
point. The Spaniard's painting
was not the only source for these
works. Here the pope's face and
the architectural background are
based on a photograph of Pope
Pius XII being carried in a form
of sedan chair. In other versions
Bacon gave the pope a screaming
face taken from a still from the
film *Battleship Potemkin* by the
Russian director Eisenstein.
Francis Bacon, *Pope I*, 1951.

Timeline

14th Century

From 14th century Italy's many small city states vie for cultural supremacy, creating a sophisticated court culture and promoting artistic achievement.

1304–74 Life of Petrarch, the earliest great Italian humanist, whose work helped to advance the revival of Classical learning.

c.1307–21 Dante Alighieri writes his epic poem *The Divine Comedy*.

1309–77 Papal court in Avignon, France, attracts many artists, helping to transmit Italian artistic ideas to northern Europe.

1337 The Hundred Years War between England and France begins, weakening England's artistic links with continental Europe.

1347–51 First great epidemic of the Black Death, which kills a quarter of the European population.

1387–1400 Geoffrey Chaucer writes the *Canterbury Tales*.

15th Century

1435 Leon Battista Alberti, Italian architect and art theorist, writes *On Painting*, the first artistic treatise of the Renaissance.

c.1450 Johannes Gutenberg invents movable type in Germany.

1453 The fall of Constantinople to Turkish Ottomans initiates 150 years of intermittent war between the Ottoman Empire and western Europe.

1469–1536 Life of Desiderius Erasmus, greatest humanist scholar of the Northern Renaissance.

1478–92 Lorenzo de Medici, patron of artists such as Botticelli, Leonardo da Vinci, and Michelangelo, rules Florence.

1492 Christopher Columbus sails to the Americas from Spain.

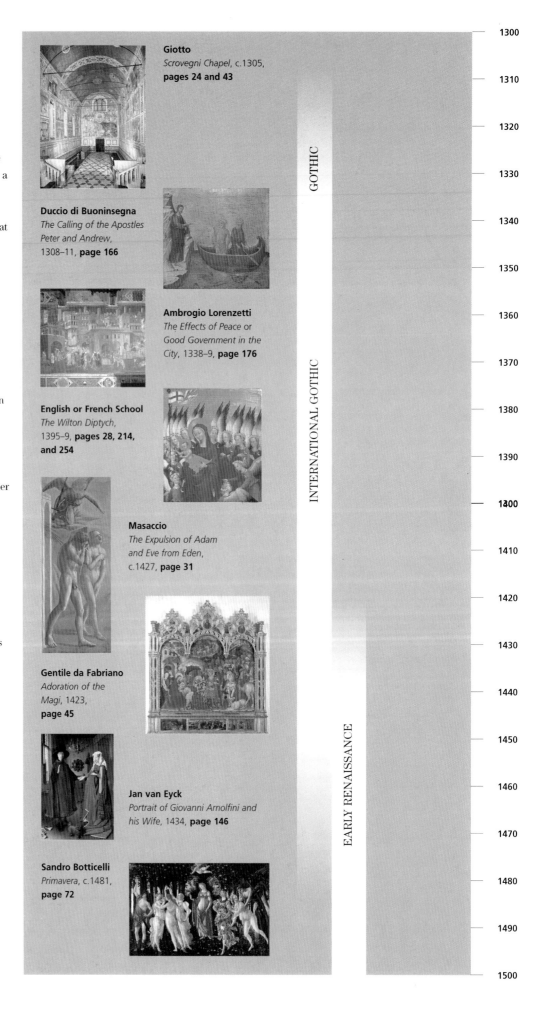

Giotto
Scrovegni Chapel, c.1305, **pages 24 and 43**

Duccio di Buoninsegna
The Calling of the Apostles Peter and Andrew, 1308–11, **page 166**

Ambrogio Lorenzetti
The Effects of Peace or *Good Government in the City*, 1338–9, **page 176**

English or French School
The Wilton Diptych, 1395–9, **pages 28, 214, and 254**

Masaccio
The Expulsion of Adam and Eve from Eden, c.1427, **page 31**

Gentile da Fabriano
Adoration of the Magi, 1423, **page 45**

Jan van Eyck
Portrait of Giovanni Arnolfini and his Wife, 1434, **page 146**

Sandro Botticelli
Primavera, c.1481, **page 72**

GOTHIC

INTERNATIONAL GOTHIC

EARLY RENAISSANCE

1300
1310
1320
1330
1340
1350
1360
1370
1380
1390
1400
1410
1420
1430
1440
1450
1460
1470
1480
1490
1500

HIGH RENAISSANCE	
LATE RENAISSANCE/MANNERISM	

1500

1510

1520

1530

1540

1550

1560

1570

1580

1590

1600

1610

1620

1630

1640

1650

1660

1670

1680

1690

1700

EARLY BAROQUE

HIGH BAROQUE

CLASSICISM

LATE BAROQUE

Michelangelo
Sistine Chapel ceiling, 1508–12, **pages 25, 30, and 255**

Titian
Venus of Urbino, 1538, **page 108**

Hans Holbein the Younger
The Ambassadors, 1533, **page 162**

Jacopo Tintoretto
The Crucifixion, 1565, **page 49**

Peter Paul Rubens
The Judgement of Paris, 1632–5, **pages 76 and 107**

Nicolas Poussin
Et in Arcadia Ego, 1636–9, **page 121**

Rembrandt
Self-portrait with Beret and Turned-Up Collar, 1659(?), **pages 148 and 257**

Diego Velázquez
Las Meninas, 1656, **page 152**

Jan Vermeer
A Young Woman Seated at a Virginal, c.1670, **page 212**

16th Century

1517	Martin Luther's 95 theses launch the German Protestant Reformation. Artists producing religious art are displaced.
1519–22	Ferdinand Magellan sails around the world.
1519–56	Reign of Charles V, King of Spain and Holy Roman Emperor. He commissions Titian, bringing Italian artistic ideas to Spain.
1527	Sack of Rome by German Lutheran troops in the pay of the Holy Roman Emperor creates a pause in artistic production.
From c.1530	Onset of Counter-Reformation, the Catholic Church's movement against Protestantism; its ideas are promoted through the use of religious art and architecture.
1530s	Francis I employs Italian artists at Fontainebleau, drawing Italian Renaissance ideas to France.
1513	Niccolò Machiavelli writes *The Prince*; it is published in 1532.
1550	Giorgio Vasari's *Lives*, the first history of art and biography, is published in Italy.
1564–1616	Life of William Shakespeare.

17th Century

c.1620–80	Gian Lorenzo Bernini transforms the appearance of Rome with Baroque fountains and squares.
1625–49	The court of Charles I, King of England, attracts Peter Paul Rubens and Anthony Van Dyck, who revitalize English art.
1648	The state-supported Royal Academy of Painting and Sculpture is established in France, setting a precedent for academies in Europe and America.
1661–8	Versailles is built for Louis XIV of France and becomes the model for palaces throughout Europe.
1667	The French Academy initiates regular official art exhibitions, or Salons.
1683	The first public museum, the Ashmolean in Oxford, opens.

18th Century

18th century Age of the Grand Tour: travel by northern Europeans, especially to Italy, to complete their education.

1712–78 Life of Jean-Jacques Rousseau, French philosopher, whose writings influenced Romantic painting and literature.

1713–84 Life of Denis Diderot, French encyclopedia editor and first great art critic.

From 1748 Excavations of Pompeii – a great influence on Neoclassicism.

1749–1832 Life of Johann Wolfgang von Goethe, German Romantic philosopher, poet, and writer on aesthetics.

1759 British Museum in London opens.

1768 Royal Academy of Arts established in England, with Joshua Reynolds as president.

1775–83 American War of Independence.

1789–99 French Revolution temporarily abolishes monarchy in France and ends with Napoleon as ruler.

1793 Louvre museum in Paris opens.

19th Century

1821–67 Life of Charles Baudelaire, French poet and literary/art critic, whose writings influenced artists from the Romantics to the Symbolists.

1838 Louis Daguerre exhibits the first photographs in Paris.

1840–1902 Life of Emile Zola, French writer of Realist novels.

1841 Collapsible metal paint tube invented in London by American artist John G. Rand.

1863 Salon des Refusés in Paris exhibits art excluded from the official Academy Salon.

1867 First western exhibition of Japanese art in Paris, which greatly influences Impressionist and Post-Impressionist painters.

1870 Metropolitan Museum of Art in New York opens.

1874–86 Seven Impressionist exhibitions in Paris; first Impressionist exhibition in New York in 1886.

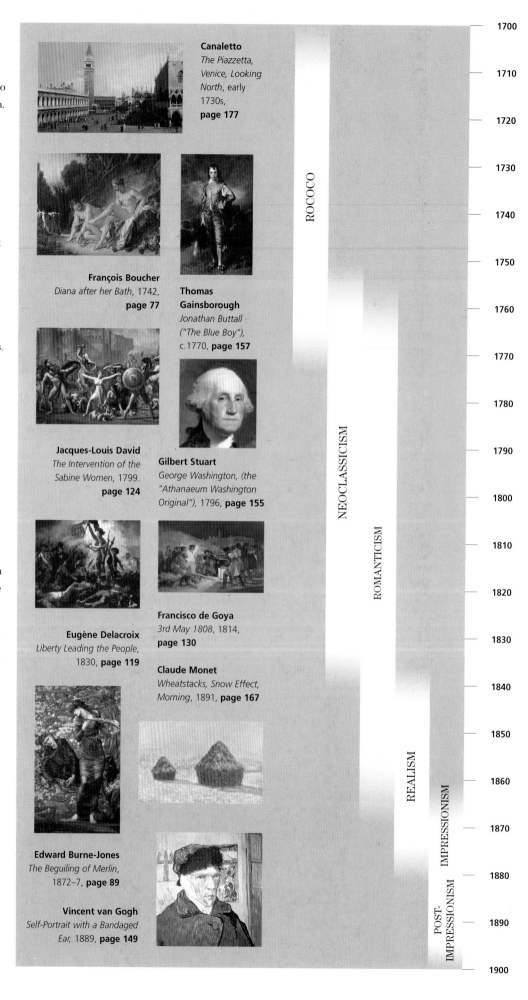

Canaletto
The Piazzetta, Venice, Looking North, early 1730s, **page 177**

François Boucher
Diana after her Bath, 1742, **page 77**

Thomas Gainsborough
Jonathan Buttall ("The Blue Boy"), c.1770, **page 157**

Jacques-Louis David
The Intervention of the Sabine Women, 1799. **page 124**

Gilbert Stuart
George Washington, (the "Athanaeum Washington Original"), 1796, **page 155**

Eugène Delacroix
Liberty Leading the People, 1830, **page 119**

Francisco de Goya
3rd May 1808, 1814, **page 130**

Claude Monet
Wheatstacks, Snow Effect, Morning, 1891, **page 167**

Edward Burne-Jones
The Beguiling of Merlin, 1872–7, **page 89**

Vincent van Gogh
Self-Portrait with a Bandaged Ear, 1889, **page 149**

1700
1710
1720
1730
1740
1750
1760
1770
1780
1790
1800
1810
1820
1830
1840
1850
1860
1870
1880
1890
1900

ROCOCO

NEOCLASSICISM

ROMANTICISM

REALISM

IMPRESSIONISM

POST-IMPRESSIONISM

Timeline (vertical, left axis)

1900
1910
1920
1930
1940
1950
1960
1970
1980
1990
2000

Movements (vertical labels):

SYMBOLISM
FAUVISM
CUBISM & FUTURISM
DADAISM
EXPRESSIONISM
NEO-PLASTICISM
SURREALISM
ABSTRACT EXPRESSIONISM
POP ART
MINIMALISM
NEO-EXPRESSIONISM
NEW DIRECTIONS

Wassily Kandinsky
Painting with the Black Arch, 1912,
page 238

Piet Mondrian
Composition with Grey, Red, Yellow, and Blue, c.1920–6,
page 244

Pablo Picasso
Guernica, 1937,
page 133

Mark Rothko
Light Red over Black, 1957
page 247

Andy Warhol
Mao, 1972, **page 134**

Jean-Michel Basquiat
Pyro, 1984,
page 252

	
1907	First Cubist exhibition in Paris.
1910	Post-Impressionist exhibition in London.
1910	Manifesto of the Futurist painters is published in Italy.
1913	Armory Show in New York exhibits Impressionists, Post-Impressionists, and new artists such as Matisse.
1914–18	First World War.
1916	First Dada manifestation in Zurich.
1917	Russian Revolution overthrows the monarchy and puts Vladimir Ilyich Lenin in power.
1920s	Communist censorship of experimental literature and art in Russia ends the flowering of a Russian avant-garde movement; many artists move to Western Europe and the USA.
1925	First Surrealist exhibition in Paris.
1929	Museum of Modern Art in New York opens.
1937	Adolf Hitler's "Degenerate Art" exhibition in Munich displays modern art, contrasting it with academic, Nazi-approved painting.
1939–45	Second World War; New York becomes an important centre for the modern art movement.
1951	First group exhibition of Abstract Expressionists in New York.
1963	Pop Art exhibition at the Guggenheim in New York.
1980s	Blockbuster shows of Impressionist and Post-Impressionist art in France, England, and the USA.
1987	One of van Gogh's four *Sunflowers* paintings is sold for £25 ($40) million, setting a world record for prices.
1997–9	"Sensation" show of Young British Artists in London and New York creates public and media outrage.

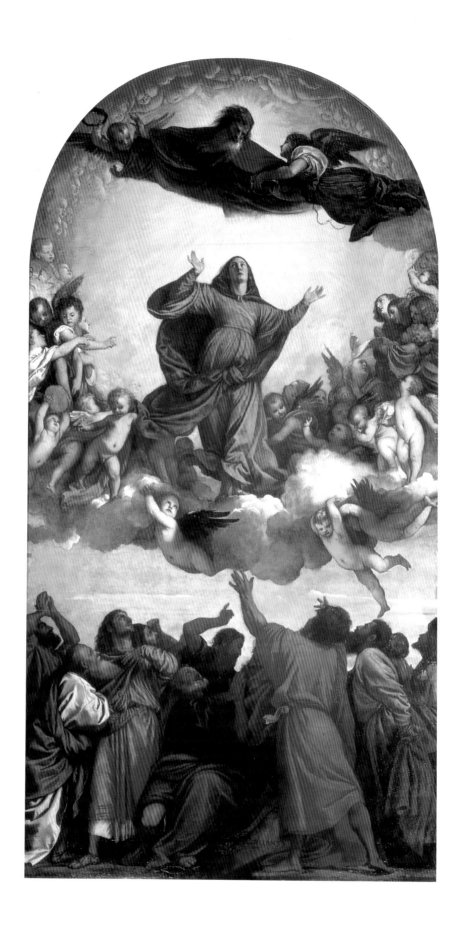

"How depict the invisible? How picture the inconceivable? How give expression to the limitless, the immeasurable, the invisible?"

John of Damascus, *Oratio I*, 726–30 AD

Religious Painting

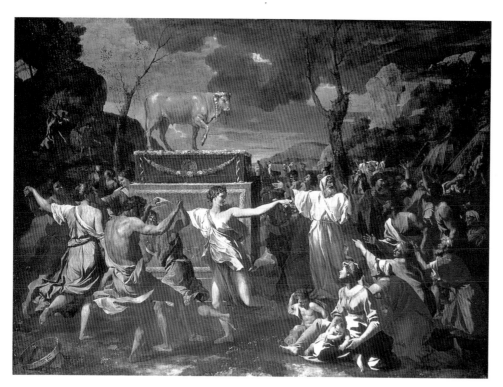

Idolatry
The Israelites dance around an idol of a calf which they worship at the order of its maker, the priest Aaron, the bearded man in white robes. Moses is seen on the left in the background,

returning from Mount Sinai with stone tablets of the Ten Commandments received from God. The second of these bans the making of idolatrous images, and Moses is on the verge of smashing the

tablets in anger. Poussin organized the composition of the foreground as a frieze of figures, based on ancient relief sculpture.
Nicolas Poussin, *The Adoration of the Golden Calf*, c.1634–5.

The visitor to a museum or gallery will find that most of the Western pictures painted before the eighteenth century have religious subjects. From one perspective, this is not unexpected – in many cultures religion and art have strong links. Images have long been used to focus the religious imagination and help worshippers in their dialogue with the numinous and sacred. Since, in pre-modern Europe, the Christian religion was bound up with the fabric of most peoples' lives, framing their understanding of the universe and of their place in the grand narrative of history, it is not surprising to find so many religious paintings on gallery walls.

From another perspective, however, it is surprising. The two religions which share the Old Testament with Christianity, Judaism and Islam, strictly ban images of sacred figures, above all of God. The second of God's Ten Commandments states: "You shall not make a carved image for yourself nor the likeness of anything in the heavens above, or in the earth below, or in the waters under the earth" (Exodus 20:4). This prohibition, at face value, bans all pictorial representation. The prophet Mohammed said that at the Day of Judgement, when the painter stands before God's throne, he will be commanded to put life into his pictures and, when he fails, will be cast down to Hell for laying claim to God's creative function. When Moses returned with the Ten Commandments, he found the Israelites worshipping the Golden Calf. Poussin depicts this in *The Adoration of the Golden Calf*. This was idolatry: investing material objects with divinity. Such worship, though common in the ancient world, was anathema to the monotheism of the Old Testament, whose God is omnipotent, immaterial, invisible, and omnipresent. The acceptance of this prohibition had fundamental consequences for the visual traditions of Islam and Judaism.

Representing the divine

Christians hiding in the catacombs in Rome could only paint symbols of Jesus. After Christianity had been legalized by the Emperor Constantine in 313 AD, however, churches began to be decorated with pictures of Christ. According to Christian belief, God represented himself in human form in Jesus, and this human incarnation of God could be represented, as could his life story. A parallel Byzantine tradition developed in the city of Constantinople, founded by Constantine in the Eastern Mediterranean in 330 AD, which fell to the invading army of the Islamic Ottoman Empire in 1453.

The justification of images developed by the Church was threefold: as lessons in the Christian faith for the illiterate; as visual reminders of the mystery of the Incarnation and the examples of saints; and as a stim-

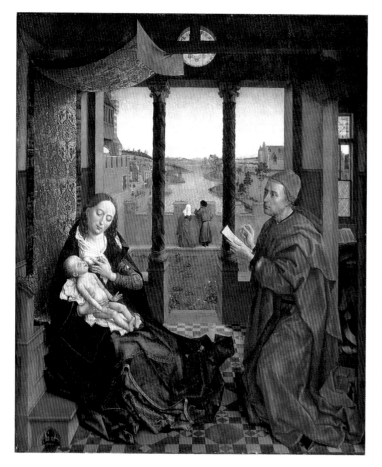

Picturing devotion
St Luke, the patron saint of painters, is shown drawing his vision of Christ and the Virgin Mary under a canopy in a palatial room, overlooking a river. The saint kneels in reverence before

this heavenly apparition and the painting he will make from the drawing will become an object of devotion. All the resources of fifteenth-century Netherlandish oil technique, with its exquisite rendering

of light, have been used by van der Weyden to make the vision experienced by St Luke as palpable as possible to the viewer.
Rogier van der Weyden, *St Luke Painting the Virgin Mary*, c.1435–40.

St Paul, on the way to Damascus to persecute Christians, was thrown from his horse and temporarily blinded by a divine light, which converted him to Christianity. The Italian Mannerist painter Parmigianino has transformed this moment of conversion into a balletic interlacing of elegant curves and artificially elongated limbs and necks. This is an attempt to present the scene not as it might really have looked, but rather as artfully and as gracefully as possible.
Parmigianino, *The Conversion of St Paul*, c.1527–8.

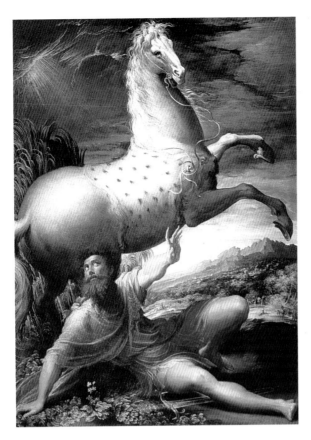

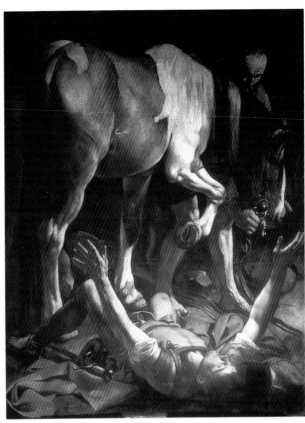

ulus to devotion. Their didactic role was understood by medieval painters: the statutes of the Guild of Sienese Painters from 1355 proclaim: "For we are by the grace of God illustrators for those simple men who cannot read of those things which are brought about by virtue and by virtue of the Holy Faith." Religious images were tied to the Church's teaching, and the same basic subject matter can be found in pictures from different centuries and from the separate theological currents of the Eastern and Western Churches. This system of symbols and images was codified not by written prescription but by convention and iconographic tradition. The ways in which Mary, Jesus, the saints, and even God are imagined today have been established by the work of artists.

The decline of sacred art

The power of images to control the mind and direct behaviour is understood by contemporary advertisers; but where images now sell products they once sold theology, a picture of salvation. However, the potential of images to pervert the mind or to incite idolatry has always caused controversy. Byzantium was split on their use in the eighth century, and iconoclasm was a feature of the Protestant Reformation, resulting in the sixteenth century in the destruction of religious images in parts of Europe.

The declining power of the Church, the secularization of the Western mind, the claims of science and materialism, and competition from other sects and faiths have meant that artists no longer promote, as they once did, the Christian message of salvation. Most of the significant Western art of the past two centuries was produced outside the framework of organized religion, and Modernism has provided a new, abstract language for the communication of religious emotion that does not rely on traditional iconography. Even so, the basic themes and picture types of Christian art continue to exert their hold on painters.

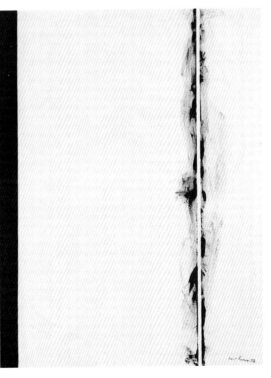

◢ **Modernist vision**
In traditional iconography, the Stations of the Cross were stages of the Passion. This painting from the 1950s abolishes all depiction of the Christian narrative, relying on simple abstract forms, with a jagged vertical "zip" intersecting an open plane, suggesting paths of spiritual energy and the annihilation of matter. Newman was an American Jew, and this title reveals his concern with fundamental themes of suffering and death raised by the Passion. It has been claimed that one source of this kind of Modernism is Old Testament iconoclasm.
Barnett Newman, *The First Station*, 1958.

◢ **Brutal drama**
Caravaggio, who died in 1610 when he was still in his thirties, was a great firebrand in the history of painting, revolutionizing the treatment of familiar religious subjects. Instead of the swanlike horse in Parmigianino's version of the Conversion of St Paul, we see here the rump of an ordinary farm animal, with St Paul sprawling in undignified submission. Despite the brutal naturalism of this painting, with its violent contrast of light and dark, it shares a common iconography with Parmigianino's work, with light as the vehicle of God's grace.
Caravaggio, *The Conversion of St Paul*, 1601.

Sites and functions

In a museum or gallery, it can be difficult for the modern viewer to grasp the variety of places for which religious paintings were made and the range of uses they once served. Not all religious paintings have been removed from their intended locations: wall-paintings and altarpieces, in particular, often remain in situ. Many, however, have been separated from their original sites, and the viewer is confronted with pictures which have lost all ties with the locations and functions envisaged by their original makers, purchasers, or patrons. They have acquired new meanings as works of art, to be valued principally for their aesthetic merits.

Sacred art in the religious setting

Religious paintings were displayed in an enormously diverse range of places. Some were fixed in churches and chapels, often as wall-paintings or as altarpieces above altars. Others adorned the choir screens separating the clergy from the laity. Paintings decorated ceilings, choir shutters, cupboards, and the tabernacles in which the Holy Sacrament was kept. Panels and canvases were hung against church pillars or above doors, and associated buildings such as baptistries had elaborate decorations, sometimes paid for by the individuals buried in them. Paintings were not the only form of visual interest in a church: funerary monuments, church plate, altar furnishings and cloths, the vestments of the priests, and the stained-glass windows and flickering candles (not to mention the liturgy – the Church's rituals – and the theatre of gesture it involved) must have made church the best show in town.

In monasteries, other rooms besides the church were often decorated with paintings, above all the refectory where the brothers ate, which could contain large pictures of meals, such as Leonardo's famous *Last Supper* from the 1490s at Santa Maria delle Grazie in Milan. Monks' cells might also contain small images or wall paintings, for instance those at the Dominican monastery of San Marco in Florence painted by Fra Angelico from the 1440s, while the chapter houses in which meetings were held were often decorated with frescos.

Some images, like painted crucifixes, when not fixed above choir screens or hung from arches in the naves of churches, were carried in procession, as were banners, usually made of cloth and painted on both sides. Other religious images were meant to be seen only occasionally or, in the case of German and Netherlandish altarpieces, were opened and shut according to the liturgical calendar. Murals were even painted on the outside of churches, but most have vanished with age. Temporary altars adorned with altarpieces, which acted as visual aids to sermons, could also be set up in town squares by preachers.

◄ **The High Altar**
The scene depicted in this panel, once part of an altarpiece, is the interior of the abbey church of St Denis near Paris, with Mass being celebrated by St Giles at the High Altar. On the left is the eighth-century Frankish King Charles Martel. The miracle of an angel's appearance at this Mass in Orléans in 719 has been transposed to St Denis as it looked when the panel was painted. The work demonstrates the rich array of visually exciting objects to be seen around the altar, including the gold altarpiece, crucifix, and reliquary, the statues, altar cloth, curtains, and carpet, and the illuminated missal used to read the Mass.
Master of St Giles, *The Mass of St Giles*, c.1500.

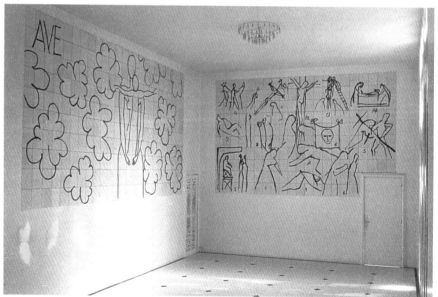

▲ **The modern chapel**
In the late 1940s Matisse designed the Chapel of the Rosary for the Dominican convent at Vence near Cannes, including the priest's vestments, the stained-glass windows, the wall ceramics, and the altar with its furnishings. The coloured light from the windows, with their tree of life motif, falls across the walls and floor, relieving their chasteness. The environment is not cluttered like the interior of St Denis in the work by the Master of St Giles above. The product of the revival of Catholicism in France in the wake of the Second World War, the chapel's purity of form also conformed to the Modernist aesthetic.
Henri Matisse, *The Chapel of the Rosary*, 1947–51.

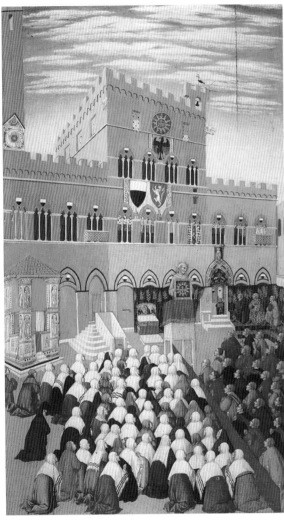

bled, spoken, or answered prayers testifies to the powers ascribed to them and to the deep needs they have met in confirming faith or relieving suffering.

Some paintings were intended for private devotion in the home, especially small paintings of the Virgin and Child. The prayer books of the wealthy were often illuminated with pictures, and many compact images were worn on the person as talismans for use in times of trouble. Paintings with protective shutters on hinges could be carried from place to place and installed for prayer.

In all these cases, the form a painting took was largely shaped by its intended setting and use. Painters adapted their style, and patrons their expectations, to norms sanctioned by tradition and decorum. An altarpiece was a large public image, while the small devotional image was not; a narrative mural was fixed, while a banner was portable, so they have different characteristics. In the art gallery or the virtual museum of photographic or digital reproduction, religious paintings risk losing their distinctive meanings: a danger that the viewer must redress by imaginatively transposing them back to their original sites and functions.

Religious images in the secular world

No secular state existed in Europe before the French Revolution in 1789, and religious images abounded outside churches, in places such as town halls and government buildings. The meeting houses of guilds and lay confraternities (groups of lay people joined together in common worship) were decorated with narrative paintings. Other religious images were placed in shrines around towns or as landmarks in the countryside.

Pictures could become the object of popular devotion, particularly when they were considered to work miracles. These cults had to be regulated carefully by the Church in order to avoid the sin of idolatry, but the number of claims of paintings that have cried,

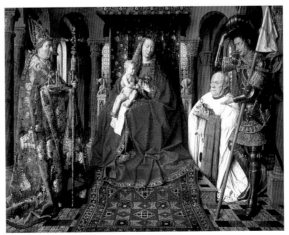

Sacred spaces

In most organized religions, special buildings are designated for worship, whether they be temples, mosques, synagogues, or churches. These buildings are usually separated from the profane world, bringing the worshipper into a closer relationship with the sacred, and are often the location of highly codified rituals conducted by priests, appointed as mediators and expiators of potentially vengeful divine forces. In the ancient Greek temple there was very little space in the interior, which was intended to house in its inner sanctum, or *cella*, a sacred image of a god. In Christianity, however, spacious buildings were needed to accommodate congregations at Mass, attending the central mystery of their faith: the re-enactment at the altar of Christ's saving sacrifice. After the official sanction of Christianity in the Roman Empire by Constantine in 313 AD, Christians therefore adopted not the temple but another building type, the basilica, used by the Romans for justice halls, as the model for their churches.

Some churches needed to be of considerable size: this was especially true of a cathedral, the seat (*cathedra*) of a bishop, or of churches housing famous relics visited by large numbers of pilgrims, but it could also be true of great monastic churches or abbeys. The first major organized monasteries, consisting of men who took the vows of poverty, chastity, and obedience and lived in disciplined communities, were established by St Benedict in the sixth century. The Benedictines were great patrons of the arts, and it was at the Benedictine church of St Denis that the Gothic style of architecture was invented in the 1150s. While some monastic orders, such as the Cistercians, abhorred pictorial art, others, like the preaching orders founded by St Francis and St Dominic, promoted it in their churches as a way of teaching and of encouraging devotion among the growing urban populations of Europe.

Painted interiors

Unlike the sparse decoration of the Roman catacombs, church interiors came to be richly decorated with a wealth of materials used in honour of God. In the early Christian basilicas, scenes from the Bible, representations of Christ and Mary, and images of the saints were all increasingly depicted. These could take the form of mosaics, as at Ravenna in Italy in the sixth century, of

▼ Islamic abstraction
Built from the eighth century on by the Muslim conquerors of Spain, the Great Mosque at Cordoba was preserved as a church after the Christian *riconquista*. The dome over the *mihrab*, the slab marking the direction of Mecca, was erected in 961 by Caliph Al-Hakam, its complex structure decorated with gold mosaics made by Byzantine craftsmen. These contain intricate patterns of stylized vegetation, writing, and abstract patterns, as required by Islam's exclusion of the figurative representation of sacred subject matter. Even so, it strongly suggests a vision of heaven.
Dome of the *Mihrab* at the Great Mosque, Cordoba, 961.

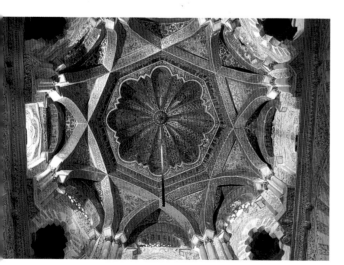

▼ Narrative art
Enrico Scrovegni built this chapel in his palace at Padua for the celebration of mortuary masses for the souls of his father, himself, and his family. The ceiling and walls form a unified decorative and iconographic scheme of nearly forty paintings by the Florentine artist Giotto, spelling out the history of human salvation through the lives of Mary, her mother St Anne, and Christ, with the Last Judgement on the entrance wall. Giotto developed a revolutionary new style of narrative painting here, and these works are often seen as marking the beginning of the Italian Renaissance.
Giotto, *Scrovegni Chapel*, c.1305.

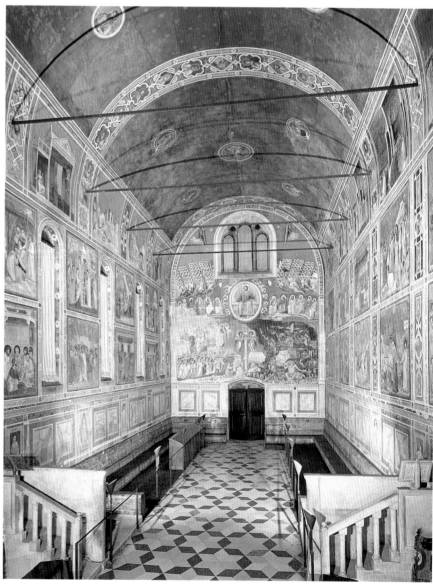

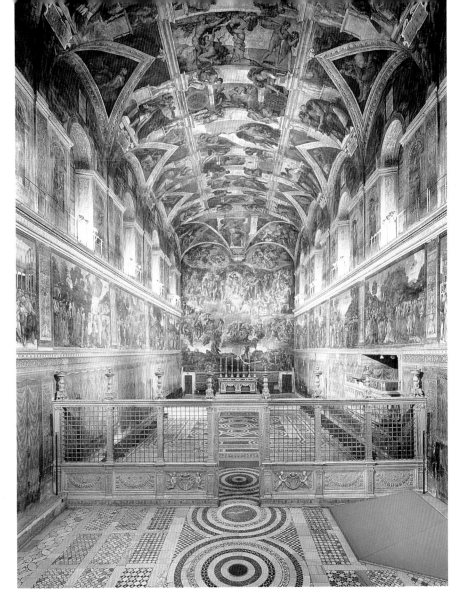

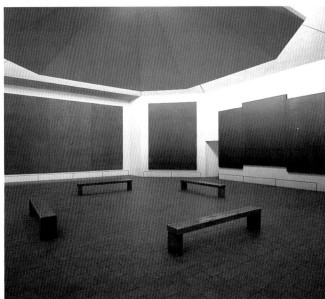

Spiritual resonance
The non-denominational Institute of Religion and Human Development in Houston, Texas, was opened in 1971, complete with a "chapel" decorated with specially commissioned paintings by Mark Rothko. The room has the polygonal form of the early Christian baptistry, and the canvases, arranged like surrogate altarpieces, are called triptychs. But these paintings do not represent the traditional subject matter of Christian art. Their great blocks of amorphous, dark maroons and browns evoke infinite space and deep spiritual energies, equally as open in their appeal to the Zen Buddhist as to the Christian.
Mark Rothko, *Rothko Chapel*, 1971.

stained glass, as at Chartres Cathedral in France in the twelfth and thirteenth centuries, and also of mural painting on walls and vaults. This tradition of fresco painting was particularly strong in Italy from the thirteenth century onward.

While a whole church might contain a single cycle or series of pictures, executed at the same time with a coherent programme, this was generally quite rare as most churches were shared by different users and owners and were decorated at many different times. Coherent cycles were more common in chapels, whether inside a church or elsewhere. From the thirteenth century each chapel had an altarpiece, and many also had wall decorations, both of which were related to the person to whom or mystery to which the altar was dedicated. In the case of Christ, Mary, or a saint, the murals often took the form of scenes from his or her life.

Some chapels formed part of palaces: the Scrovegni Chapel (also known as the Arena Chapel), decorated by Giotto in the fourteenth century, was in the palace of a banker at Padua, while the much larger Sistine Chapel, designed to hold the whole papal court, was in the Vatican Palace in Rome. Most chapels, however, were attached to churches. Some were designed for common use, but many were owned by individuals and families,

Papal authority
The Sistine Chapel is so called because it was built in the Vatican Palace for Pope Sixtus IV. He had its side walls painted in the 1480s by a team of artists who depicted scenes from the life of Moses (left) and Christ (right). Between 1508 and 1512 Michelangelo painted the ceiling for his nephew, Pope Julius II, one of the greatest patrons of the High Renaissance. It was only in 1534–41 that Michelangelo painted his massive *Last Judgement* on the altar wall. The iconography of the whole chapel was designed to stress the connection between the Old and the New Testaments, and to show how the authority of the popes was guaranteed by divine providence.
Michelangelo and others, *Sistine Chapel*, c.1480–1541.

or by lay confraternities. These private chapels, often called chantries, were designed for the commemoration of the souls of those who owned them and, in the case of a family, their ancestors. It was believed that the performance of Masses would reduce the length of time those commemorated would have to spend in Purgatory, where people who were neither good enough to go straight to Heaven nor bad enough to be damned to Hell would be purged (painfully) of their sins. Without this belief, private altars, let alone chapels, would not have come into existence in the late Middle Ages.

Chapels continued to be designed for traditional worship in the modern era – for example, the one for the Dominican nuns at Vence, decorated by Henri Matisse in the late 1940s (see page 22). Perhaps the most moving example of a chapel of the twentieth century is that provided with paintings by the American artist Mark Rothko, not for a church but for the Institute of Religion and Human Development in Houston, Texas. Here the transcendent is not translated through liturgy and ritual, or through the elaborate iconography of the Christian Church, but in simple, resonant forms. The opening of this chapel in 1971 was attended by a Cardinal, a Protestant Bishop, an Orthodox Bishop, a Rabbi, and an Imam.

The altarpiece

In the liturgy of the Catholic Church, the celebration of Mass occupies a central position. At its core is the Eucharist, the ritual re-enactment of Christ's redeeming sacrifice. At the altar the priest consecrates bread and wine which, in Catholic doctrine, in a process known as transubstantiation, become the body and the blood of Christ. From the early thirteenth century it became usual for the priest to stand in front of the altar with his back to the congregation, rather than behind it, which meant that images could be placed at the back of the altar table.

At first these images were low-lying and horizontal, but they soon increased in height, becoming important visual adjuncts to the altar. Church law never required their presence above altars, but they fulfilled valuable functions, providing a visual focus for the congregation, a suitable backdrop for the consecration of the Host, and a signpost of the altar's dedication and the relics it contained. They also performed functions ascribed to all religious images, above all inspiring devotion.

The rise of the altarpiece

Altarpieces became more common in the late Middle Ages, aided by the proliferation of mortuary masses for the souls of individuals and families, by increasing devotion to saints, and by the subsequent growth of side altars in churches, especially those of the preaching orders, the Dominicans and the Franciscans. Lay confraternities whose focus was the altar were formed. Although the clergy might promote the foundation of altars and supervise their decoration, altarpieces were often commissioned by the laity. As a result, they acquired other functions, expressing the devotional orientation of an individual or a group, promoting family or corporate honour, or even enhancing the prestige of an entire city. In this way secular values were blended with religious ones.

In the fourteenth century a type of altarpiece known as the polyptych, made of many parts or panels,

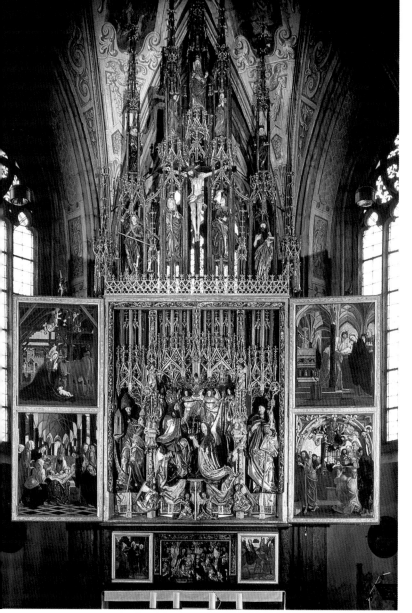

The winged polyptych
Dominating a small Gothic church in the Austrian lake-town of St Wolfgang, this altarpiece by Michael Pacher can be variously configured in accordance with the liturgical calendar. At its centre is a carving of the Coronation of the Virgin, with a Crucifixion among the pinnacles above and, at the bottom, a Last Supper. Shutters, when open, relate the Virgin's life. Closing the first set reveals scenes from Christ's life (below); when the final shutters are closed, scenes from St Wolfgang's life appear. **Michael Pacher**, *St Wolfgang Altarpiece*, 1481.

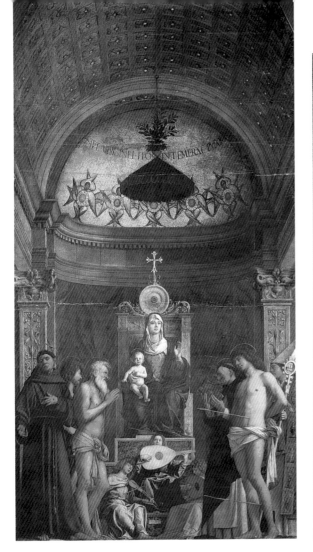

▲ **Unified space**
In this altarpiece, painted by the Italian artist Giovanni Bellini for the Franciscan church of San Giobbe in Venice, the saints are grouped around the throne of the Virgin Mary in a single field, as if occupying a chapel. The saint on the far left is St Francis, and the almost naked old man next to him is Job (to whom the church is dedicated). Mary turns to our right to greet those who enter through the church door, and it is from this source that the fictive light in the picture falls. The gold mosaic in the half-dome refers to the basilica of St Mark in Venice, and to the city's Byzantine roots.
Giovanni Bellini, *Sacra Conversazione*, c.1480.

predominated in Italy. These structures were often multi-tiered, with gabled tops echoing the Gothic architecture around them. Decorated with precious materials such as gold and lapis lazuli, they were works of carpentry and woodcarving as much as of painting. The central and widest panel was often given over to the Virgin and Child, with saints in the other panels. The lowest, horizontal part of the altarpiece, known as the predella, generally featured narrative scenes, which occasionally also appeared in the gables. A few Italian altarpieces were even painted on both front and back.

In the Burgundian Netherlands and Germany in the early fifteenth century a different kind of altarpiece emerged which featured shutters or wings, some examples even boasting two sets. This meant that the altarpiece's configuration could be changed according to the church calendar: it could be shut during periods of contrition like Lent, but opened up in its full glory on feast days. Colour was sometimes reserved for the inside, with monochrome painting on the outside.

Sacred conversations

From the mid-fifteenth century, the polyptych was increasingly viewed as outdated in Italy as painters experimented with spatial depth, overlapping figures, unified light effects, and realistic textures, exploiting the potential of oil as a paint medium. This led to the abandonment of the extensive use of gold in altarpieces

and to the unification of saints around the throne of the Virgin Mary in a single, coherent space. This kind of altarpiece is usually called a *Sacra Conversazione*, or Sacred Conversation. The architecture of the frames of altarpieces became more classical, and the fictive architecture within the picture often linked up with that of the frame to create the illusion of looking through into a sacred space above the altar.

Another important development was the emergence of the narrative altarpiece. Stories from the lives of Mary and Christ were not unusual as the main subjects, but saints were rarely shown in action in the main field. In the sixteenth and seventeenth centuries, however, the saint was increasingly shown performing a miracle or being martyred. During the Reformation in the sixteenth century, altarpieces were viewed by Protestants in northern Europe as incitements to idolatry and image-worship, which led to their wholesale destruction. The Counter-Reformation among Catholics led to saints being hailed as heroic champions of the true faith, and dramatization and physical suffering were increasingly emphasized.

From the sixteenth century, altarpieces also came to be considered as works of art in their own right, and collectors separated them from their altars and removed them from churches. The detachment of altarpieces from their original liturgical functions is enshrined in today's art galleries and museums.

Private devotions

▼ Royal devotion
This painting, made for the English King Richard II at the end of the fourteenth century, could be folded and transported. On the left-hand panel of the diptych, Richard is shown kneeling in the company of his royal predecessors, St Edmund and St Edward the Confessor, and of St John the Baptist, all of whom he venerated. On the right-hand panel, the Virgin Mary stands among angels wearing Richard's emblems, as the infant Christ presents a banner to him. The whole work is executed with such technical excellence and such expense in gold and lapis lazuli that it was clearly highly prized; it is all the more surprising that we know so little about its maker.
English or French School, *The Wilton Diptych*, 1395–9.

The altarpiece was usually a large image displayed above the altar in a church or chapel, and was thus a public statement of the patron's devotion and social status. The private devotional image, however, was normally intended for use in the house or monastic cell, or while travelling, and so was smaller and less formal in character. Such images did not need to provide a backdrop for the solemn celebration of the Mass, nor was it necessary for the liturgy to be interposed between the devotee and the painting, which could therefore be more intimate and personal.

Diversity of purpose

Private devotional images featured on a wide variety of objects with numerous different functions. By far the most common of these was a simple half-length painting of the Virgin and Child. This was often placed high up on the wall of a home, sometimes with a candle or an oil lamp burning before it. Such small-scale images of the Virgin and Child were rarely commissioned, and could be bought at the local market or painter's workshop – the inclusion of a portrait indicates that the work was made for a specific patron at his or her request.

Private chapels in houses were very rare, requiring a special dispensation from the ecclesiastical authorities, and so private altarpieces were generally restricted to the highest reaches of society. Other images were small, portable diptychs or triptychs, with two or three panels on hinges which could be closed for protection during travel, and pieces were often of exquisite workmanship. They might contain a portrait of the donor along with one or more subjects – the Virgin and Child was again the most common image, although dramatic close-ups of the suffering Christ were popular from the fifteenth century onward. Another way in which pictures were used in private devotion was in prayer books, called Books of Hours, which often contained beautiful illuminations next to or surrounding the text – both illustrations and text were generally printed from the late fifteenth century.

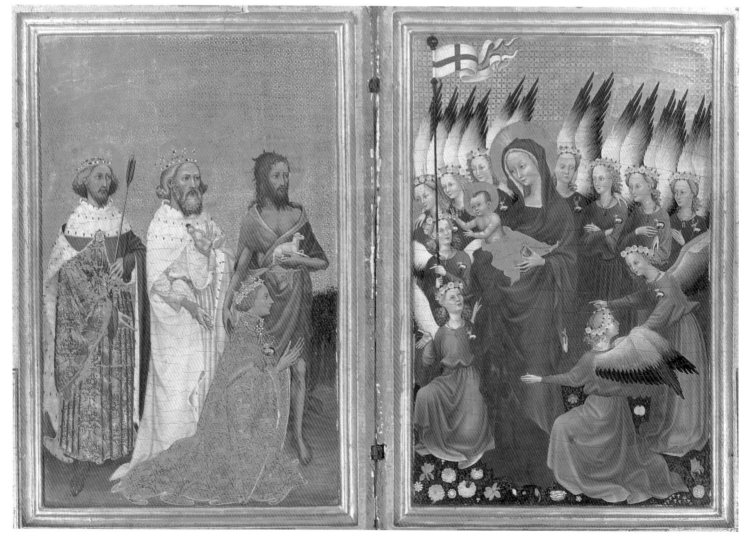

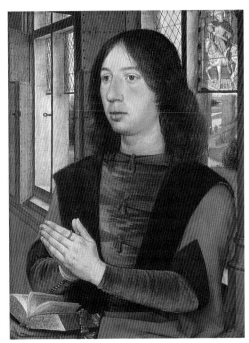

Aristocratic observance
On the left of this diptych are the Virgin and Child, and on the right is the man who commissioned this work for himself, the twenty-three year-old nobleman Maarten van Nieuwenhove of Bruges. The donor and the Virgin are painted as if situated in close proximity in the corner of a single room, with van Nieuwenhove's coat-of-arms in a stained-glass window behind her and St Martin, his name saint, in the window behind him. The Virgin hands to the naked Christ an apple, a symbol of the fallen state of mankind which he will redeem.
Hans Memlinc, *The Van Nieuwenhove Diptych*, 1487.

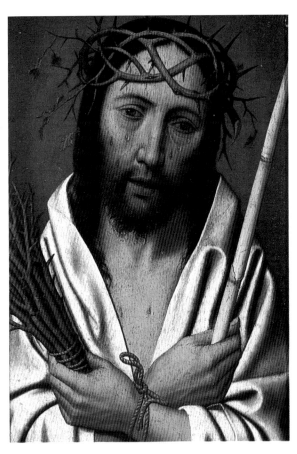

Private religious images performed a variety of overlapping functions. The Virgin and Child placed high up on a wall was unlikely to have been used in regular prayer, whereas the portable diptych was designed for this purpose. Close-ups of Christ were intended to encourage identification with his suffering, while illuminations in Books of Hours accompanied and enlivened the recitation of private prayers. All of these can be considered aids in the creation of an intimate theatre of spirituality for the observance of religion in the domestic sphere. In medieval Europe, privacy was hard to come by even in the wealthiest homes, particularly in an urban environment. In Italy a little room called a *studiolo* afforded its owner the opportunity to surround him or herself with precious objects and books, and it was in this kind of room that religious images might be placed.

Inspiring compassion
Christ, painted half-length in his shroud on a blood-red background, looks directly at us, his head crowned with thorns, blood mingling with his tears, his hands tied, holding in his left the birch with which he was beaten and in his right the reed given to him by Roman soldiers mocking his status as "King of the Jews." This small Netherlandish work was designed to excite compassion and identification with Christ's suffering in an intense face-to-face encounter.
Style of Jan Mostaert, *Christ as the Man of Sorrows*, c.1520s.

Personalized religion

From the thirteenth century onward, the use of private devotional images, both in monasteries and in the secular world of lay religion, was encouraged by the Dominican and Franciscan orders, which recognized the importance of the visual imagination in stimulating piety. Private prayer and meditation were guided by devotional manuals stressing the proximity of the saints and the humanity of Christ. The most famous of these was the *Meditations on the Life of Christ*, written by a Franciscan friar for a nun around 1300, which was translated into almost every European language and widely used by the laity. Such manuals helped to stimulate demand for devotional images, and were sometimes illustrated themselves.

In the Netherlands from the late fourteenth century a religious movement developed called the *Devotio Moderna* which aimed to promote religious observance among the laity, particularly outside the rituals of the organized church. A new kind of spirituality emerged which stressed the interior nature of the religious experience, the imitation of Christ, and the compatibility of holiness with a life led in secular society. This created a demand for private images which could assist in personalizing religion, and in its incorporation into everyday life. Devotees were increasingly invited to imagine themselves in more intimate proximity with Christ, Mary, and the saints, and these heavenly figures were also made less otherworldly. In Netherlandish painting from the 1420s onward Mary is often shown in contemporary domestic settings in rooms overlooking the town square.

Private devotional pictures continue in use to this day, and images of the Virgin Mary or of Christ, now most often a print or reproduction, are still to be found on the walls of houses throughout the Catholic world. These images connect the domestic and everyday with the transcendent and holy. At least as early as the late fifteenth century, pictures made for this purpose were often considered so beautiful that they were collected as works of art in their own right. Even so, their formal beauty and their religious content remain intimately linked.

Creation and Fall

While Christianity, Judaism, and Islam have a shared biblical tradition, and a joint acceptance that there is only one God, they developed very different attitudes about the visual representation of God. All three agreed that God was invisible, immaterial, omnipresent, immeasurable, and eternal, so how could he be depicted in visual form? In Judaism and Islam there was a ban on representations of God, a prohibition also adhered to by many Protestant Christians.

But for those Christians who accepted that God could be represented without impropriety, practical obstacles remained. There is no consistent physical description of God even in the "theophanies" (divine appearances) that occur in the Old Testament, such as Moses's thunderous encounter with God on Mount Sinai. The problem was further exacerbated by the

belief that God had one essence but three persons: God the Father, God the Son, and God the Holy Spirit. The members of the Trinity were co-eternal, existing together outside time, but were supposed to have been active in history at different moments: God the Father during the Creation and throughout the period of the Old Testament, Jesus in the New Testament, and the Holy Spirit acting as an intermediary between God and humankind at certain moments, for example at Christ's Baptism and at the Pentecost, when the Holy Spirit descended on Mary and Christ's disciples.

Picturing God

It was clear that God, in the person of Christ, who was God in human form, could be represented, and the New Testament stated that the Holy Spirit descended in the form of a dove, a manifestation generally adopted by painters. It was less obvious, however, how God the Father, above all in his role as Creator of the Universe, could be depicted. The Book of Genesis told of the Creation of the world in six days, with man at its pinnacle. This is in the account of Creation painted on the Sistine Chapel's ceiling by Michelangelo, which was challenged in the Western world by Darwin's theory of evolution in the nineteenth century, but which Creationists still believe.

In Michelangelo's heroic version of Creation, God is presented as a bearded old man, but how did he acquire this form in Western art? In Genesis, man is described as being made in God's image and likeness, so Michelangelo has represented Adam as a man of absolute beauty, with his life-infusing Creator symmetrical in all but age and garb. But in the earliest representations of the Creation, made between the third and eleventh centuries, God is represented as only a right

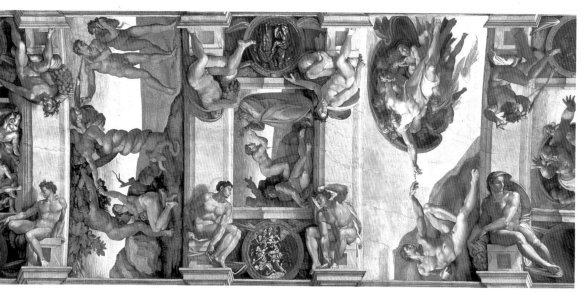

◄ **Genesis**
This is the central portion of the Sistine Chapel's ceiling, with (from right to left) the Creation of Adam, the Creation of Eve, and the Fall. Around the narrative panels are seated male nudes, with circular bronze medallions. By placing Eve's Creation at the centre of the entire ceiling, which covers the Genesis story from the Creation to the Drunkenness of Noah, Michelangelo maximizes Eve's role in the Fall to stress that it will be cancelled out by Mary, the "New Eve." He invented a new heroic style here, combining classical grandeur and biblical narrative.
Michelangelo, *Sistine Chapel ceiling*, 1508–12.

▶ **A vengeful God**
In Blake's idiosyncratic interpretation of the Old Testament, God the Father represents not goodness but unyielding and oppressive justice, which he imposes from his fiery chariot upon an enslaved Adam, who is aged in God's likeness. Blake related God to his own mythological creation, Urizen, who symbolized the tyranny of pure reason. This colour print, finished in pen and watercolour, challenges the orthodox Christian view of the Fall as deserved.
William Blake, *The Punishment of Adam*, 1795–1805

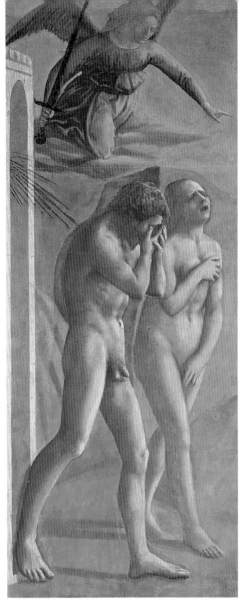

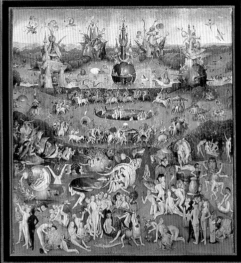

▲ **Triumph of sin**
On the left of this astonishing triptych is the Creation. The central panel seems to show the triumph of lust: a carousel of male riders rotates around bathing women in a fantastical landscape. In the front, naked people are interlaced with huge biomorphic mutations, symbols of transitory gratification and human degradation. The right panel is a terrifying vision of hell, full of nightmarish monsters and surreal torments.
Hieronymus Bosch, *The Garden of Earthly Delights*, c.1490.

Overshadowed by sin

Mankind is placed at the pinnacle of the biblical Creation story, made in the image of God. But this Creation is linked to and modified by the Fall. Adam and Eve, the first man and woman, were placed in the blissful Garden of Eden, but they disobeyed God by eating the fruit of the tree of knowledge. They were expelled for their disobedience, the punishment for this "original sin" being inherited by all their descendants. Men and women owed thereafter a debt of reparation to God, but this debt was unpayable without divine assistance. Men and women became the inhabitants of a fallen world where toil, suffering, sin, and the inevitability of eternal death prevailed. Hence the pessimistic vision in *The Garden of Earthly Delights*, painted by Hieronymus Bosch at the end of the fifteenth century, of a world governed by foily and the futile pursuit of transient pleasures, perverted by the Fall from its original innocence and heading toward infernal damnation. Only God himself, by the sacrifice of someone who was both God and man, could satisfy the debt incurred by mankind at the Fall. For Christians, humanity could thus only be redeemed by Christ's death on the cross, and therefore the whole of Christian history and art are focused on that supreme moment of sacrifice.

▲ **Expulsion from paradise**
One of the mural paintings in a private chapel belonging to the Brancacci family in Santa Maria del Carmine in Florence, this scene by the early fifteenth-century Florentine artist Masaccio shows the moment when Adam and Eve are thrown out of the gate of paradise by an angel. The couple are naked and express absolute despair at their loss, Adam's face buried in his hands, Eve's mouth opened in moaning. Although fallen, they have not lost their human dignity – their bodies are idealized, that of Eve being based on a classical statue. Forms have been simplified and expressions reduced to essentials, renewing the monumental narrative tradition established by Giotto a century earlier (see pages 24–5).
Masaccio, *The Expulsion of Adam and Eve from Eden*, c.1427.

hand emerging from the skies. Between the twelfth and fourteenth centuries, God acquired a face, then a bust, then finally an entire body. God and Jesus, being considered identical as two aspects of one God, initially shared the same face (see pages 40–41). It was only from about 1360 that the familiar notion of God's fatherhood emerged in art, and that he was represented as an old man with long white hair and a flowing beard, an image ultimately derived from classical figures of Jupiter, chief of the pagan gods. Because God was conceived as a ruler, he was dressed up as a figure of power, whether as a pope (with a tiara), an emperor, or a king (crowned), or, as in Michelangelo's version, a senator (with a white toga). This venerable image of God, which still shapes the Western visual tradition, is the creation of art, a purely pictorial fabrication without biblical support.

Angels and devils

The pre-modern world embraced more kinds of being than modern science allows. Not only did medieval bestiaries illustrate mermaids and unicorns, but the world was also thought to be teeming with spirits involved in a cosmic struggle for the possession of individual souls. The main protagonists in this battle between good and evil were angels and devils.

Angelic forms

Angels and devils were believed by Christians to have a common origin: devils are fallen angels, deprived of the vision of God for rebelling against him. This rebellion was led by Lucifer, the "lightbringer" or morning star, who surpassed all other angels in beauty, knowledge, and power, but was defeated and thrown into the abyss with his army. Though not described in the Old Testament, this event was believed to be alluded to by Isaiah: "How you have fallen from heaven, bright morning star" (Isaiah 14:12). It was merged in Christian imagery with St John's vision of the apocalyptic struggle between the Devil and angels led by St Michael at the end of the world (Revelation 12:7–9). Imprisoned at the centre of the earth, the Devil founded his kingdom of Hell where he reigns as Satan, and where the wicked will be tormented for their sins after the Last Judgement.

Angels are mentioned in both Old and New Testaments as spiritual beings and heavenly messengers, as immortal servants and protectors of God, and as his representatives on earth, the heavenly guides of the faithful. Their physical form is not described, although they appeared to various individuals: an angel prevented Abraham from sacrificing Isaac, the angel Gabriel announced to Mary that she was to give birth to Jesus, angels appeared to the shepherds to announce his birth, and another appeared to the Holy Women at Christ's empty tomb. In descriptions of the lives of saints, angels were often recorded as feeding starving hermits or comforting martyrs at the moment of their deaths.

According to Denis the Areopagite, writing in about 500 AD, angels were organized into three hierarchies, each further subdivided into three choirs. The angelic councillors closest to God were the Seraphim, Cherubim, and Thrones – these were usually painted as just the heads of children with four, six, or eight wings, Seraphim as red, Cherubim as blue. The next three choirs were the angelic governors, the Dominions, Virtues, and Powers, and the final three were the angelic ministers, the Principalities, Archangels, and Angels, who were given more human forms. There were thought to be seven Archangels, the most important being Michael, Gabriel, and Raphael.

Since angels possessed celestial beauty yet were immaterial and unseeable, they presented difficulties to artists, who generally depicted them according to contemporary standards of fashion and beauty. The earliest depictions of angels have no wings. These were added only from the fifth century AD since it was believed that angels, as inhabitants of the sky, had to traverse immense distances on their path to and from Heaven. Classical sculptures of winged victories and of "genii" (guardian spirits) were adapted to this new purpose in Christian iconography. As God's servants, angels were visualized in ways that viewers could understand: as courtiers or, especially in the case of St Michael, general of the heavenly armies, as knights in armour.

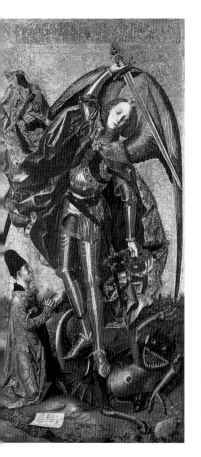

▼ Celestial warrior
The Archangel St Michael stands triumphant over the Devil, as the donor, Antonio Juan, lord of Tous, near Valencia in Spain, kneels before him in prayer holding a book of psalms. This was the central part of a composite altarpiece by the late fifteenth-century Spanish artist Bartolomé Bermejo for the church of San Miguel in Tous. St Michael had been invoked in the reconquest of Spain from the Moors, and here he wields a sword and holds a crystal-domed shield, crushing the chameleon-like Devil at his feet. In his armour is the reflection of the heavenly Jerusalem, which he defends on God's behalf as the general of his celestial army.
Bartolomé Bermejo, *St Michael Triumphant over the Devil*, c.1468.

◄ Rebel angels
The sixteenth-century Antwerp painter Pieter Brueghel was known to his contemporaries as the second Bosch (the famous painter of nightmarish visions of demons and monsters: see page 31, *The Garden of Earthly Delights*). Here the angelic army is pictured in mortal combat with a carnival-like swarm of monstrous demons. Both comic and terrifying, these mutations of fish, reptiles, and disfigured human bodies are the angels who have rebelled against God. St Michael, dressed in armour and with the cross of the Resurrection on his shield, triumphs at the centre, while other angels fight or blow trumpets, anticipating their role at the Last Judgement.
Pieter Brueghel the Elder, *The Fall of the Rebel Angels*, 1562.

Demonic torments
In this section of a multi-panelled altarpiece (see also pages 49 and 52) for the monastery of St Anthony, Isenheim, Grünewald shows the saint harassed by hideous demons in the wilderness. The figure on the left suffers from the skin disease ergotism, known as "St Anthony's Fire," caused by eating contaminated rye. The work's original viewers were from a hospital dedicated to skin diseases attached to the monastery.
Mathis Grünewald, *The Temptation of St Anthony*, c.1515.

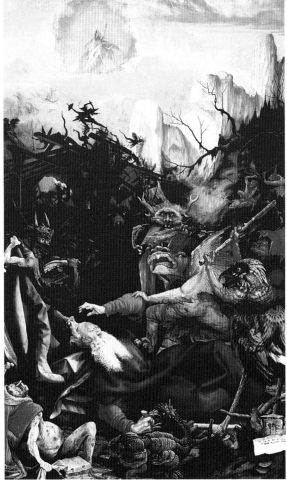

Modern demons
German-born Max Ernst was clearly inspired by Grünewald's painting of the same subject, but transmogrifies the landscape into dead water and "fishbone forests." Although Ernst lived in America from 1941, the setting of this work, painted in the wake of the Second World War for a Hollywood film set, evokes the devastated cities of Europe. St Anthony is inextricably entangled in a dense web of nightmarish creatures, phantasmagoria of the subconscious mind.
Max Ernst, *The Temptation of St Anthony*, 1945.

Depicting the Devil

The Devil has many names, among them Lucifer, Satan, and Beelzebub, and is as old as the world. He is seen by Christians as an invisible yet personal power who directs the forces of evil against God's design and tempts mankind away from goodness, starting with Adam and Eve in the Garden of Eden. Although his bid to tempt Christ failed, he tested the resolve of saints, led sinners to perdition and will torment the damned in Hell.

Lucifer was sometimes represented as beautiful, as in *Satan Smiting Job with Sore Boils* by the English artist William Blake, but more usually he and his demons are disfigured and bestialized, having sacrificed their angelic beauty in disobeying God. Their external form reflected inner ugliness, and painters went to extremes in their depiction, mixing animal and human forms in a manner reminiscent of the pagan satyrs of the Classical world, inventing multiform and multicoloured demons, as in Grünewald's terrifying hybrid monsters.

During the witch crazes of the sixteenth and seventeenth centuries, the socially ostracized, possessors of hidden knowledge, such as midwives, and even the merely eccentric were denounced as witches, who assembled at sabbaths to worship Satan and cast spells. Satan became a form of social control through terror, and images reinforced this fear. In the modern period devils have increasingly migrated to the psyche as demons of the subconscious (as in Ernst's work here), although the rich iconography of the satanic survives to disrupt the outward calm of smalltown America in Hollywood movies.

Lucifer victorious
In the Old Testament, Job was a good and upright man. God tested his faith, allowing Satan to destroy all Job loved, including his children, and to cover his skin with boils. In Blake's visionary religious system, Job undergoes a process of salvation, abandoning the vengeful God of the Old Testament for the new dispensation inaugurated by Christ. Blake's Lucifer is beautiful and glorious in his tormenting triumph.
William Blake, *Satan Smiting Job with Sore Boils*, c.1826.

Heroes and heroines

In Western Christianity, figures from the Old Testament are not venerated in the same way as Christ and his followers. Noah, Moses, Kings Solomon and David, and the prophets Isaiah and Ezekiel do not have altars dedicated to them. It is only those who followed Christ who are considered to be in a state of grace and who were thus considered suitable as the subject of devotional images. Old Testament men and women, no matter how holy, were believed to have been confined to Limbo, a listless place on the outskirts of Hell, until Christ liberated them from their confinement. This is because, in the Christian view, the Old Testament makes sense only in terms of the New that fulfils it. Although prophets occur in altarpieces, they are usually there only because they foretold the advent of the Messiah.

Old Testament subjects generally feature in churches and chapels in one of two ways: as prefigurations of people and events in the New Testament (see pages 36–7) or as part of the history of human salvation. They occur in narrative cycles such as that painted by Giusto de' Menabuoi in the baptistry of Padua Cathedral in the 1370s. Here the events of the Old Testament are included in a programme illustrating the entire history of divine providence, with the Crucifixion

as its climax. Michelangelo painted the ceiling of the Sistine Chapel in Rome between 1508 and 1512 (see page 30) with scenes from Genesis to complement the parallel stories of Moses and Christ painted by others on the side walls in the 1480s. He narrates world history from the Creation and the Fall to Noah and the Flood. He also painted, enthroned beneath the Genesis narratives, colossal prophets and sibyls (female oracles of the ancient Roman world who were claimed by Christians to have foretold the Messiah's coming) and, around the chapel's windows, Christ's ancestors, stressing his lineage in the Old Testament. In the ceiling's four corners he depicted miraculous deliverances of Israel from oppression, presaging the triumph of the Church.

Sex and violence

Outside churches and illustrated Bibles, the range of subjects chosen from the Old Testament in medieval and Renaissance Europe met secular rather than devotional needs. Beyond the stories of the Creation and Exodus, subjects were chosen largely because they were outside traditional Christian iconography, especially those involving sexual encounter and violent action. The Old Testament could also provide good bedside stories,

▼ Fratricide

Adam's two sons, Cain and Abel, followed different paths: Cain became a farmer and Abel became a herdsman. They both offered sacrifices to God at . altars, but while Abel's was accepted by God, Cain's was not and, in a fit of envy, he killed his brother (Genesis 4:2–12). The Flemish painter Rubens, shortly after returning to Antwerp from Italy, where he had seen the work of Michelangelo and Titian, depicts the dramatic moment just before Cain strikes. Every muscle in the bodies of the brothers is strained as the stricken Abel looks up in terror, the smoke of his sacrifice rising to heaven. **Peter Paul Rubens**, *Cain Slaying Abel*, c.1608–9.

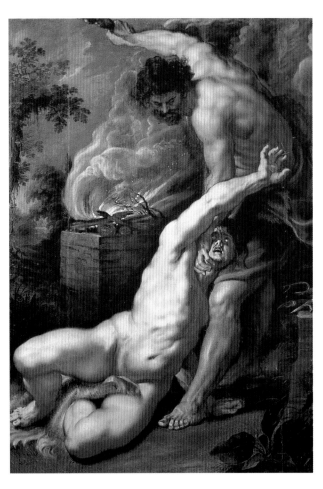

▲ Betrayal

This is the most violent picture ever painted by the Dutch master Rembrandt. The Hebrew warrior Samson revealed to his lover Delilah, who was a Philistine, that his great strength resided in his hair. She cut it off while he was asleep and Philistine soldiers, who could now overcome Samson, blinded him. Rembrandt does not flinch from representing the horrific moment when the struggling Samson's eyes are gouged out with a dagger as armoured soldiers restrain him with chains. Delilah flees from the tent, Samson's hair clutched in her left hand, as darkness closes in on the Old Testament hero. **Rembrandt**, *The Blinding of Samson*, 1636.

as in the tale of Joseph, used to decorate the bridal chamber of the Florentine Pierfrancesco Borgherini around 1518 (see page 7). It could furnish parables of human folly such as the Tower of Babel, built by the descendants of Noah to reach Heaven and painted twice by Pieter Brueghel in Antwerp in the 1560s. Old Testament subjects were used to exemplify the perennial conflict between good and evil, represented by the struggle of Israel against its oppressors. While Old Testament figures could not be invoked as intercessors, they were still exemplary models. In the triumph of the boy David over the giant Goliath, the underdog wins because of the protection of God and his own fortitude.

The power of women

There were also tragic figures, such as the strongman Samson, defeated not in battle but by the deceit of Delilah. The story was painted by many artists, including, in 1610, Rubens, who lived in Catholic Antwerp, and, in 1636, Rembrandt, who lived in Protestant Amsterdam. The moral point about the deleterious effect of the power of women, an important element of the tale, was understood by both sides of the religious divide. In 1639 Rembrandt offered *The Blinding of Samson* to the secretary to the Stadholder of Holland, Constantijn Huygens. About a third of Rembrandt's religious paintings have Old Testament subjects.

Stories of Old Testament women also illustrated men's immoral power over women. In that of Susannah and the Elders two voyeuristic old men try to seduce a bathing woman by blackmailing her. Although this subject offered opportunities to paint erotic female nudes, the moral was clear, as both men were executed. This subject and that of Judith and Holofernes were repeatedly painted

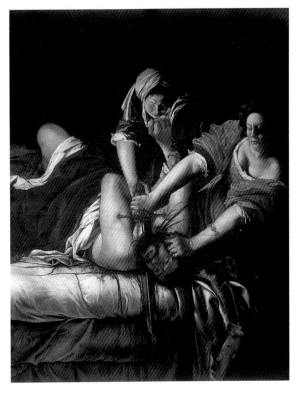

by the Italian Artemisia Gentileschi, after she was raped in 1611, as an assertion of men's abusive power.

In the seventeenth and eighteenth centuries the Old Testament was increasingly mined for subjects for grand "history" paintings. In 1746 Hogarth appropriately painting the Finding of Moses for the Foundling Hospital in London. The English artist and poet William Blake incorporated Old Testament themes into his very personal religious vision in paintings such as *Satan Smiting Job with Sore Boils* (see page 33).

Prefiguration

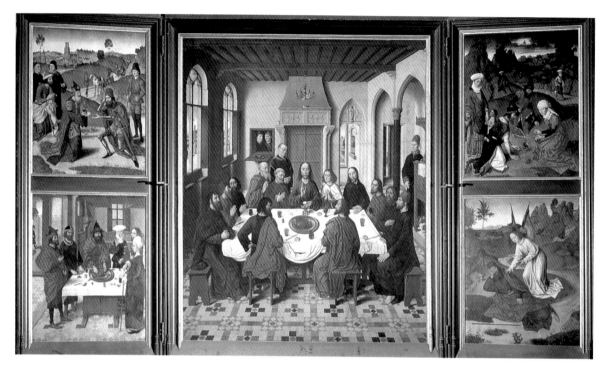

◀ Prefiguring the Eucharist
This winged altarpiece was painted by the fifteenth-century Netherlandish artist Dieric Bouts for a chapel of the Confraternity of the Holy Sacrament at St Pierre in Louvain. The central panel depicts the Last Supper, at which Christ, shown surrounded by his disciples at a table in a light-filled room, established the sacrament of the Eucharist in the bread and wine he offered to them as his body and his blood. Two theologians were appointed by the Confraternity to establish four Old Testament "types" of the Last Supper, to be painted on the wings of this altarpiece. On the left side are, at the top, the meeting of Abraham and Melchizedek (the first offering of bread and wine by a priest), and at the bottom the Passover (the Jewish ritual understood to foreshadow or parallel the Sacrament). On the right side are the gathering of manna (life-saving bread from heaven) at the top and at the bottom Elijah in the desert (who was brought bread and water by an angel).
Dieric Bouts, *The Last Supper*, 1464–8.

While there is a shared biblical tradition linking Islam, Christianity, and Judaism, only Christians accept Jesus as the Messiah foretold by the prophets. The Old Testament is only so called by Christians, because it has been brought into a relationship with the New Testament telling of the life of Christ and of his saving mission for humanity – the era of the Law (the Ten Commandments in the Old Testament) was thus followed by the era of Grace initiated by Jesus. Theologians saw no opposition between the two, but rather continuity, noting that Christ himself said: "Think not that I am come to destroy the law, or the prophets: I am not come to destroy, but to fulfill" (Matthew 5:17). Once the "canon" of authorized books that comprised the Bible had been established, interconnections between New and Old Testaments were made in concordances which linked passages from one to the other.

Typology

Universal history was seen by Christians as a gradual unfolding of God's plan, in which events in the Old Testament did not merely precede those in the New but actually prefigured them. "The New Testament is concealed in the Old, and the New makes plain the Old," wrote St Augustine (354–430). Thus people, events, and even objects in the Old Testament were to be understood not just literally, but allegorically too, as symbolic forerunners of those in the New.

This way of interpreting the Bible is called typology: the Old Testament prefiguration is called the "type," its New Testament fulfilment the "antitype." The method had its authority in Christ, who likened himself to Moses as a lawgiver and to Elijah as a prophet. He also said: "And as Moses lifted up the serpent in the desert, even so must the Son of Man be lifted up, that those who believe in him may not perish but may have everlasting life" (John 3:14–15). The incident referred to here is the plague of fiery snakes sent by God to the people of Israel in the wilderness to punish them for their disobedience. When Moses, at God's instruction, erected a serpent of brass (the Brazen Serpent) on a wooden pole, those who looked at it were cured. This event was presented by Christ himself as the prefiguration of his redeeming sacrifice on the cross, while concordances presented Moses as a "type" of Christ, the lawgiver having led his people out the wilderness, just as Christ would lead the faithful toward salvation.

A distinction between "type" and "antitype" was made by medieval theologians, who saw Moses as a spiritual leader who came face to face with God, and Jesus as the Son of God. The Brazen Serpent resulted in the physical recovery of the Israelites, but Christ was crucified for the spiritual renewal of all mankind – the New Testament thus surpassed the Old. Other Old Testament prefigurations included Abraham's sacrifice of Isaac as a type of the Crucifixion, and the prophet Jonah, who spent three days in the belly of a whale, as a type of the Resurrection. While the relationship of type to antitype was often based on parallelism, it could also be based on opposition: for example, Christ and Mary were presented as the new Adam and Eve because the original sin that resulted in the Fall would be cancelled out by them.

LEX

GRATIA

MYSTERIVM IVSTIFICATIONIS

PECCATVM

AGNVS DEI

HOMO

VICTORIA NOSTRA

MORS

MISER EGO HOMO,
QVIS ME ERIPIET EX
HOC CORPORE MORTI
OB NOXIO / RO. 7

ESAYAS PROPHETA
ECCE VIRGO CONCIPIET ET PARIET FILIVM, ISA. 7.

IOANNES BAPTISTA.
ECCE AGNVS ILLE DEI, QVI TOLLIT PECCATV MVDI. IO. 1

Types and antipes

Painted by Holbein around the time he became court painter to King Henry VIII in England, this symbolic picture illustrates the typological interconnection of the Old and New Testaments. The composition is divided into two by the tree of life, under which sits Man. On the left is the Old Testament, with Adam and Eve at the Fall, and above them Moses receiving the Ten Commandments on Mount Sinai. Behind is the Brazen Serpent (a type of the Crucifixion), and in the foreground lies a corpse. To the left of Man, Isaiah prophesies the Virgin Birth of Christ. and points to Mary on the mountain top. On the right-hand side is the New Testament, with Christ led to his Crucifixion. In the background is the Crucifixion itself. In the foreground the resurrected Christ conquers death in the form of a skeleton, while to the right of Man, St John the Baptist points to Jesus as the Messiah. The New Testament is presented as fulfilling the Old as part of a single history of human salvation, all of which is explained by Latin inscriptions.

Hans Holbein the Younger, *Allegory of the Old and New Testaments*, c.1535.

While this way of thinking may appear remote today, it had considerable popular appeal in the late medieval and early modern period. A book called *Biblia Pauperum* ("The Bible of the Poor") was issued in the fifteenth century in woodblock form, with black-and-white illustrations showing ninety Old Testament types for thirty New Testament scenes. Such books achieved wide circulation among preachers and lay readers, and so their imagery shaped the popular imagination.

In painting, typology is usually found in large cycles like that of the Sistine Chapel, in which a deliberate parallel is made between Christ and Moses on the side walls, painted in the 1480s. It is occasionally also found in altarpieces, like that by Dieric Bouts for the Last Supper, with its four Old Testament types; or in programmatic pictures like Holbein's *Allegory of the Old and New Testaments*, which is a diagram of human salvation linking Old and New Testaments, reflecting Holbein's own Protestant convictions.

Another form of prefiguration is found in paintings drawn from the New Testament alone. Mary has foreknowledge of Christ's tragic destiny, which she does not impede, submitting to its inevitability and the necessity of redemption. This melancholy prescience is present in pictures of the infant Christ, but in Holman Hunt's painting of Christ as a young man it appears dramatically before he leaves home to fulfil his universal mission.

Fulfilling destiny

This picture was begun by the English Pre-Raphaelite painter Holman Hunt during his second trip to the Holy Land in 1869–72. The painter took great pains to ensure that the details were accurate, even starting the work in a carpenter's shop in Bethlehem. Hunt himself explained the work's symbolism – the young Jesus, stretching after a long day's work in Joseph's workshop, unwittingly presages his own crucifixion, which Mary sees as a shadow on the wall. The picture toured Oxford and northern England to great public acclaim.

William Holman Hunt, *The Shadow of Death*, 1870–3.

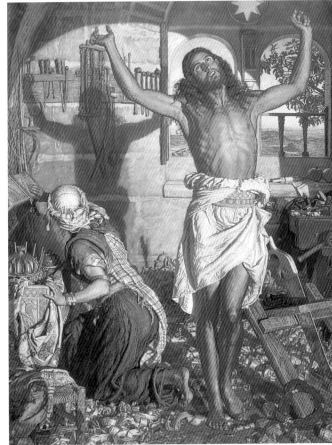

Images of Mary

During the Middle Ages the cult of the Virgin Mary came virtually to eclipse in importance that of Jesus himself in Christian worship. Alongside paintings of the Crucified Christ, the most common religious image of the time was the Virgin and Child, which emphasized in particular Mary's status as the Mother of God. She was seen to be the instrument of the Incarnation, and her status as a virgin lent her special sanctity. Elements of cults of mother goddesses in the ancient world were subsumed in the worship of Mary, and she became the symbol of the Church itself.

Mary's powers as an intercessor on the behalf of sinners made her the object of countless prayers, and most of the images to which miraculous powers were attributed were of the Virgin. She could be domesticated in private devotional images, or presented in celestial majesty in altarpieces and on the walls of public buildings, reigning as the Queen of Heaven. In paintings of the Crucifixion, she became the *mater dolorosa* (suffering mother), and her sorrows were recorded in prayer and in art as the model of compassion. A large variety of different types of image of Mary emerged to meet the diverse religious needs she answered. Protestant reformers considered that devotion to her had become exaggerated at the expense of that due to Christ, and so restricted the proliferation of images of the Virgin in areas of northern Europe from the sixteenth century onward.

Queen of Heaven

This is the main panel of the altarpiece completed by Duccio in 1311 for the high altar of Siena's cathedral. The Virgin Mary was thought by the Sienese to be their protectress, and here she is enthroned in heavenly majesty, with patron saints of the city kneeling before her and other saints and angels behind. Byzantine formality and resplendent gold are blended with a new humanity and softness. The other side of the altar was dedicated to Christ's life; on this side, facing the congregation, Mary reigned.
Duccio di Buoninsegna, *Maestà*, 1311.

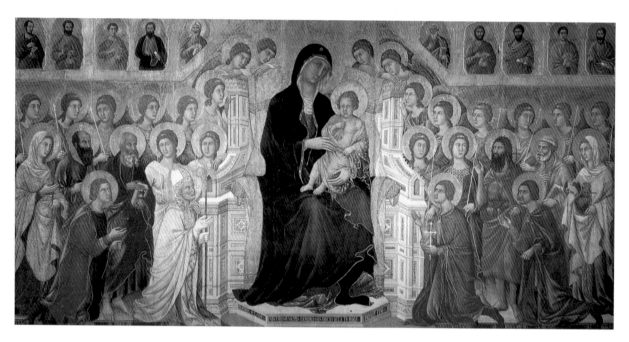

Heavenly vision

Painted for the ceiling of the meeting house in Venice of a lay confraternity devoted to the Virgin, this work by the Italian artist Tiepolo illustrates the moment, in 1251, when the Carmelite English monk St Simon Stock received the scapular from Mary. This piece of cloth, hung from the shoulders by strings, became the symbol of his order, and was claimed to remit periods of punishment in Purgatory. Tiepolo shows the vision as unfolding in the presence of angels in the sky and of souls burning in Purgatory below.
Giambattista Tiepolo, *The Virgin Mary Presents the Scapular to St Simon Stock*, 1749.

Purity

The Immaculate Conception was a doctrine that held that the Virgin was born without the taint of original sin. Promoted by the Franciscans, it was contested by the Dominicans and became a Catholic Church dogma only in 1854. The cult of the Immaculate Conception was especially fervent in Spain, and the Spanish painter Murillo executed over two dozen "Immaculadas" in which the Virgin is usually shown as a girl of about twelve in a white tunic and blue mantle, surrounded by the sun and with the crescent moon at her feet.
Bartolomé Murillo, *The Virgin of the Immaculate Conception*, c.1678.

Divine mercy

This is the central panel of a polyptych commissioned from Piero della Francesca in 1445 by the lay confraternity of Santa Maria della Misericordia in Piero's native town of Borgo San Sepolcro. Under her mantle Mary protects confraternity members, some of whose portraits these may be. They pray together for her intercession on their behalf. On the left is a hooded flagellant, who would chastise himself during processions. In this type of image, Mary is of necessity larger than her supplicants.
Piero della Francesca, *Madonna della Misericordia*, 1445–62.

The milk of kindness

The Virgin Mary suckles the infant Jesus in a well-established type called *Maria Lactans* (Mary nursing), which stresses the tenderness of their relationship. Mary is enthroned under a canopy in a small room, a richly woven carpet at her feet. Christ holds an apple in his left hand, as he will redeem humankind from the Fall. Van Eyck's mastery of oil technique allows him to present subtle differences of texture and light, bringing viewers of this small devotional work into intimate contact with the object of their devotion.
Jan van Eyck, *The Lucca Madonna*, c.1436.

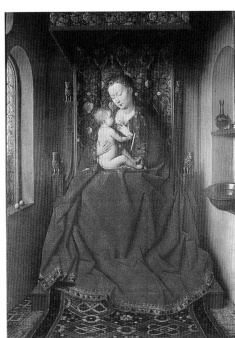

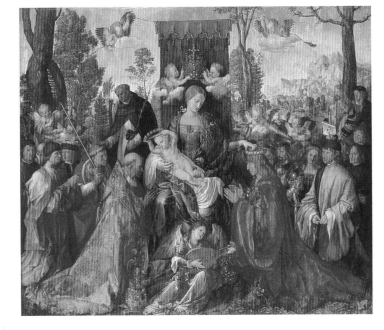

Sorrowful mystery

The dead body of Christ lies arched, stiffened by rigor mortis, over the lap of his grieving mother. To the right Mary Magdalene, holding the jar of oil with which she will anoint Christ's body, wipes tears from her eyes. On the left, St John removes the crown of thorns from Christ's head. This fifteenth-century French painting does not show a narrative scene from the Passion, but a static image – the *Pietà* – removed from any temporal sequence. The unknown priest who commissioned this work, for a church at Villeneuve-lès-Avignon in southern France, is portrayed praying before this scene of naked grief.
Enguerrand Quarton, *The Avignon Pietà*, c.1455.

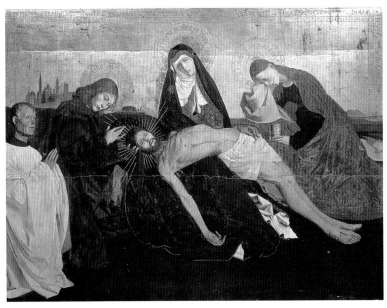

Modern dissension

Max Ernst, a founder of the Surrealist movement in 1924, has portrayed himself with two leading members of the group, André Breton and Paul Eluard. They secretly witness Mary spanking Jesus, whose halo falls to the ground. This deliberately sacrilegious work subverts the notion of prefiguration – the infant Jesus is usually painted sleeping in Mary's lap, anticipating the dead Christ of the *Pietà*. Here Christ's flagellation is prefigured instead, disrupting the harmony traditionally shown between the holy pair.
Max Ernst, *The Blessed Virgin Chastising the Infant Jesus before Three Witnesses*, 1926.

Virgin of the Rosary

Dürer painted this altarpiece for a German confraternity in Venice devoted to the Virgin of the Rosary. The rosary, a string of beads used as an aid in counting prayers to the Virgin, was promoted by Dominicans as a stimulus to devotion. Based on a crude German woodcut of 1476, the work is translated into the format and rich colours of Venetian altarpieces. Mary crowns the German Emperor Maximilian with roses and Christ crowns Pope Julius II, while members of the confraternity look on.
Albrecht Dürer, *The Feast of the Rosary*, 1506.

Images of Christ

How can Christ be represented, who is both God and man? His appearance is not described in the New Testament, yet a standard way of imagining his features has nonetheless emerged. Early Christians showed him only in symbolic form, whether by the fish (the letters that form the Greek word for fish, Ichthus, were used to stand for "Jesus Christ Son of God and Saviour"), by his monogram, or by the Good Shepherd, a beardless young man resembling the Classical god Apollo, with a sheep over his shoulders. Later, the most powerful Christian symbol of all, the cross, triumphed. From the fourth century portraits of Christ were claimed to exist. In the West the most important of these in the medieval and Renaissance periods was the cloth offered by St Veronica to Christ to wipe his face on his way to Calvary. Its existence was first mentioned in the eleventh century, but it was not described as bearing the imprint of Christ's face until the thirteenth century, when the bearded Christ had long since replaced the youthful Roman god.

While the all-powerful, divine Christ dominated the Byzantine East, in the West his features were increasingly individualized and imbued with character so that viewers could identify with his kindness and suffering. This presented painters with the difficult task of retaining Christ's divine status while portraying his humanity and frailty – different types of image were developed to emphasize different aspects of Christ, whether as God, preacher, redeemer, or suffering victim.

▶ Pantokrator

This large twelfth-century mosaic in the apse of the Norman cathedral at Cefalù, Sicily, derives from Byzantine depictions of Christ as all-sovereign God (*Pantokrator* in Greek) which draw on Roman imperial imagery. Christ is shown in majestic frontality, his right hand blessing, his left holding the Gospel. Behind his head is the cruciform halo reserved for Christ alone, with his monogram, IC XC, on either side. Christ's roles as Ruler and Judge are emphasized over his humanity in this hieratic, awe-inspiring image of divine power.
Unknown artist, *Christ Pantokrator*, c.1148.

▶ The Trinity

This is the left-hand panel of a two-part altarpiece commissioned by Edward Bonkil, Provost of the church of the Holy Trinity, Edinburgh, from the fifteenth-century Netherlandish painter Hugo van der Goes. God the Father, enthroned in Heaven, holds in his arms the broken body of his dead son, while the dove, symbol of the Holy Spirit, hovers between them. At the throne's foot is a transparent sphere symbolizing the world. In Christianity, God has one essence but three persons, a mystery here presented as a vision of transcendent suffering.
Hugo van der Goes, *The Trinity*, c.1478–9.

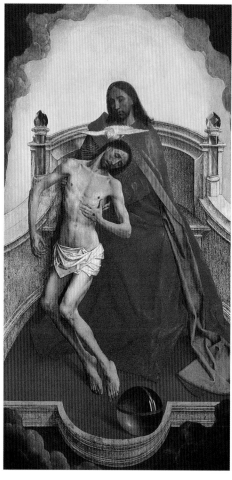

◀ The true likeness

The kerchief (*sudarium*) was given by St Veronica to Christ on his way to Calvary. Housed at St Peter's in Rome, it became an object of devotion as the true portrait of Christ. Other candidates for the true likeness included a cloth called the mandylion in the East, and a linen shroud in which the dead Christ was said to have been wrapped, which still attracts pilgrims to Turin. In this fifteenth-century German work, Veronica holds the relic to encourage prayers to the holy face, which angels adore.
Master of St Veronica, *St Veronica with the Sudarium*, c.1420.

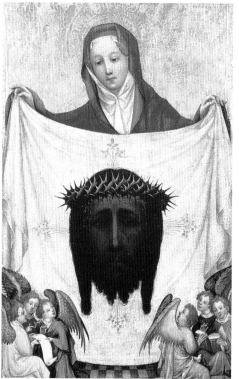

▼ The dual nature

The fifteenth-century Sienese painter Giovanni di Paolo presented Christ twice in this altarpiece. On the left is the tormented Christ on earth, naked and emaciated, holding the cross and crowned with thorns. His skin is chafed from his flogging, and bleeding from the Crucifixion. On the right he is seated in heaven surrounded by angels with trumpets: this is the Christ of the Second Coming, returning as Judge. In the blasted landscape below, the diminutive figures of St Michael and the Devil separate the saved from the damned.
Giovanni di Paolo, *Christ Suffering and Christ Triumphant*, c.1450.

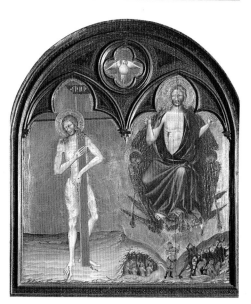

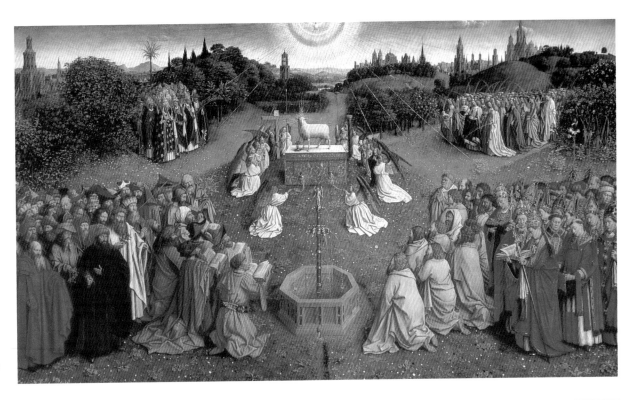

The Lamb of God
Painted for St Bavo in Ghent, this is the central panel of a complex altarpiece. In a meadow on an altar is the "Lamb of God that takes away the sins of the World" (John 1:29), a symbol of Christ as the redemptive sacrifice celebrated in the Mass. The Holy Spirit hovers above, the Fountain of the Water of Life stands in the foreground, with saints and the blessed of the Old Testament on either side, and in the background is the New Jerusalem.
Jan van Eyck,
The Adoration of the Mystic Lamb, 1432.

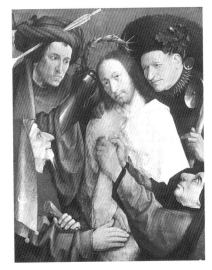

The Man of Sorrows
After his arrest, Christ was mocked by Roman soldiers, who put a crown of thorns on his head. By giving the tormentors sixteenth-century clothes, and symbols which identify them as unbelievers, Bosch satirized his own society and updated Christ's suffering – Christ looks out at the viewer, inculpating us too. This is a static image, not a story, and is intended to encourage reflection on Christ's innocence and the abuse he suffered for mankind's salvation.
Hieronymus Bosch, *The Crowning with Thorns*, 1490–1500.

◀ **Light of the world**
Christ, the bearer of light to a sinful world, holds a lantern and knocks at the closed and overgrown door, symbolic of the obstinately shut mind. This painting, illustrating a text from the New Testament (John 8:12), became the most popular image of Christ in the British Empire, and a version toured Australia, New Zealand, Canada, and South Africa in 1905–7.
William Holman Hunt,
The Light of the World, 1853–6.

▲ **Christ as primitive**
Gauguin based this extraordinary painting of 1889 on a yellow-painted wooden statue in a Breton church near Pont-Aven. He has placed Christ in a field, surrounded by peasant women in local costume. Painted in simple, rhythmic forms and brilliant, garish colours, the work suggests the semi-idolatrous nature of rural image-worship and the artist's rejection of "civilized" society.
Paul Gauguin, *Yellow Christ*, 1889.

The life of Mary

Paintings of the life of Mary appeared very early in Christian art, but this visual tradition was based on an insecure biblical foundation. Mary's birth, death, age, and physical appearance are never mentioned in the four Gospels. In that of St Mark she is mentioned twice, fleetingly, and in that of St John she again appears only twice. Only St Matthew and St Luke relate the infancy of Jesus and involve his mother to a greater degree (see pages 44–5). St Luke tells the story of Christ's conception, birth, infancy, and childhood. In all four Gospels Mary is almost completely absent from Christ's ministry.

The Apocrypha

This meagre biographical information about Mary was insufficient to allow painters satisfactorily to depict scenes from her life. It was, however, greatly fleshed out in the Apocrypha, early writings once associated with the New Testament but rejected from the Bible as uncanonical. These include the Gospels of St James and of Pseudo-Matthew, which give a fuller account of the life of Mary, including her parents, Joachim and Anne, her presentation in the temple as a girl, and the circumstances of her marriage to Joseph. Mary's bodily Assumption into Heaven (see page 53) is likewise not referred to in the Bible. These stories were incorporated into the "Golden Legend" in the thirteenth century and into Franciscan devotional literature such as *Meditations on the Life of Christ*, and so became generally available to the laity. Full of colour and anecdotal detail, entertaining to read, and inviting identification with the human aspects of Mary and Christ, they remained of paramount importance in medieval art and devotion. The reliability of these legends was not really challenged until the Reformation. The Catholic Church eventually bowed to Protestant pressure, and representations in art of the story of Joachim and Anne were forbidden after the Council of Trent in 1563. But much of Christian painting is incomprehensible without some knowledge of these Marian legends.

Scenes from a life

The most common painting of Mary was the image of her with the infant Jesus (see pages 38–9), but narrative scenes from her life were also painted, some independently, others as parts of whole cycles. Scenes of her life and the infancy of Jesus are closely related to her role as vehicle of the Incarnation: it was through Mary

▼ **Holy birth**
Mary's mother, St Anne, sits upright in her bed on the left, receiving refreshments. At the foot of the bed the newly born Mary is swathed by a nursemaid seated next to a rocking crib, while Mary's father, Joachim, returns in the foreground with some food. This domestic scene has been transposed to the side aisle of a grand German cathedral. Angels, holding hands, fly in a ring around the church piers, while another swings incense over Mary. Altdorfer has distorted space and heightened the interplay of light and dark to add to the supernatural aura of this depiction of the holy birth.
Albrecht Altdorfer, *The Birth of the Virgin*, c.1521.

▼ **Initiation**
According to the Apochrypha, as a small child Mary was taken to the Temple in Jerusalem, where, to the astonishment of all, she climbed the fifteen steps up to the High Priest unaided. The Venetian artist Tintoretto painted this picture for the organ shutters of the Venetian church of the Madonna dell'Orto (originally the canvas was divided down the middle and could be opened). As beggars line the Temple's gold-spangled stairs and spectators twist around in amazement, a mother points out Mary's example to her daughter. The drama of light and dark is played around her as, undaunted, she enters upon her religious life.
Jacopo Tintoretto, *The Presentation of the Virgin*, 1556.

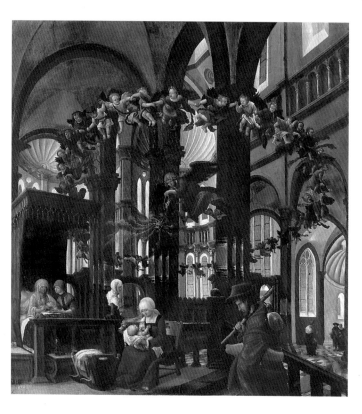

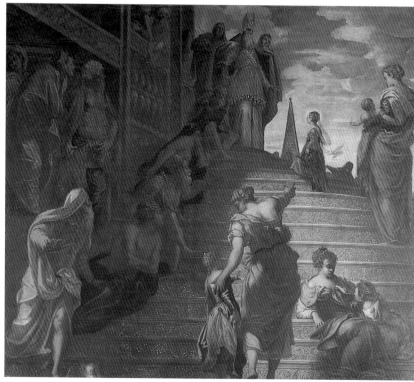

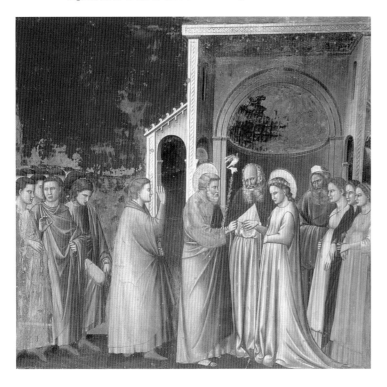

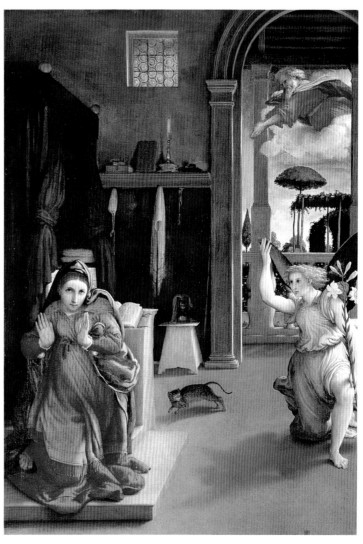

that God was made flesh. The scenes from the life of Mary that were most frequently represented were her Birth, her Presentation at the Temple, her Marriage, the Annunciation and then those scenes associated with the infancy of Jesus (see pages 44–5). Mary is conjoined again with her son at his death (see page 51, Giovanni Bellini, *Dead Christ*) and is present at the descent of the Holy Spirit at Pentecost in the presence of Christ's disciples. The Death of Mary is followed by her Assumption and her Coronation as Queen of Heaven by Jesus (see page 53, Enguerrand Quarton, *The Coronation of the Virgin*); at the Last Judgement she will sit on his right hand, interceding on behalf of sinful humanity (see pages 68–9).

Mary's role in the history of salvation is emphasized in cycles of her life story. One of these is in the Scrovegni Chapel in Padua, painted around 1305 by the Florentine artist and architect Giotto; it is recounted, along with that of Jesus, in some forty rectangular fields painted around the walls and culminating in the Last Judgement over the entrance (see page 24). These start with the time before Mary's birth and tell the apocryphal story of Joachim and Anne, who were childless until rewarded by God with her birth. Anne dedicated her daughter to service in the Presentation at the Temple. When Mary reached puberty the High Priest assembled all the widowers of Israel and Joseph was chosen to marry her. The subsequent stories, also told by Giotto with revolutionary spatial clarity and psychological power, are inextricably linked to the early life of Jesus and have more authority in the canonical Gospels, above all in that of St Luke. Here we find the central event of the Annunciation, when Mary was greeted by Gabriel with the words "Hail, thou that are highly favoured, the Lord is with thee, blessed art thou among women" (1:28) and Christ was conceived in her virgin womb. The Visitation, when Mary embraced the old and pregnant St Elizabeth, the mother of John the Baptist, is likewise to be found in the Gospel of St Luke.

Joyful and sorrowful mysteries

The events of Mary's life were woven into the calendar in great feast days, such as that of the Annunciation on March 25, when the English as well as the Venetian year once began. They were integrated into prayer books in the illustrated Hours of the Virgin, and commemorated in the devotion of the rosary in the fifteen joyful (Annunciation and Childhood of Christ), sorrowful (the Passion), and glorious (Resurrection to Heavenly Coronation) mysteries of the Virgin. Through art and prayer Mary was promoted as an exemplary figure, a model of female conduct. The central episodes of her life, no matter how apocryphal, have been given enduring visual form by painters.

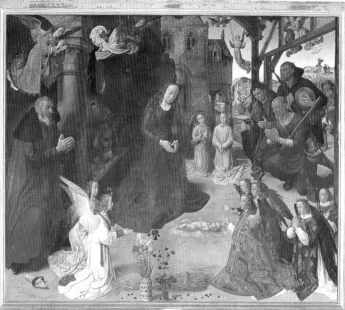

Nativity
By night, Mary kneels in adoration before her own naked baby, who lies in a manger in a common stable. To the left angels also adore the baby and the ass and the ox look on in wonder. Joseph enters on the right. The main source of light is the baby Jesus, glowing with a golden light. In the background on a hill there is another source of light: an incandescent angel announces to the shepherds at their camp the birth of the Messiah. This panel by the Netherlandish artist Geertgen is intimate and was meant for private devotion.
Geertgen tot Sint Jans, *The Nativity*, c.1480–90.

As with the life of the Virgin (see pages 42–3), it is images rather than the written word that shape our mental picture of Christ's infancy and childhood. The story of his early life is inextricably linked with that of Mary. She was the vehicle of the incarnation of God as man. Not only was she a virgin when Christ was conceived, as had been foretold of the Messiah by the Old Testament prophets, but her husband Joseph was descended from King David, making Jesus a rightful King of the Jews.

One of the paradoxes of the Christian story is that so exalted a person should be born in such humble circumstances. Joseph was a carpenter from Nazareth, in Galilee, who went with Mary to Bethlehem for a census ordered by the Romans. Unable to find accommodation, they stayed overnight in a stable, and it was here that Christ was born.

Adoration

The story of Christ's birth is not told by St Mark or St John. St Matthew simply states that he was born in Bethlehem during King Herod's reign. He describes the arrival of astrologers (Magi) from the East, who, guided by a star they saw as the sign of the advent of the Messiah, paid homage to Christ at Bethlehem, presenting gifts of gold, frankincense, and myrrh. St Luke mentions the stable and relates how shepherds were told by an angel about Christ's birth and went to honour him, but he does not refer to the Magi.

The familiar story of Christ's infancy does not therefore appear in coherent form in the Bible. It was elaborated in the Apocrypha (see page 42), and it is here that the ox and the ass make their appearance. For

The Shepherds
This giant winged altarpiece was ordered by a wealthy Florentine businessman, Tommaso Portinari, for his private chapel. He is portrayed as a kneeling donor; his sons are accompanied by male saints on the left shutter and his wife and daughters by female saints on the right shutter. The Christ Child lies on the ground at the centre. Mary, Joseph, and angels kneel before him, as is common in a Nativity, and here the rough-featured shepherds are also in adoration.
Hugo van der Goes, *The Portinari Altarpiece*, 1476.

centuries the most important feast relating to Christ's birth was Epiphany (January 6), when he was worshipped by the Magi. By the third century the Magi were described as kings and it was agreed that there had been three. By the ninth century they were named, and represented three different races: Balthasar, Asian; Gaspar, European; Melchior, African. The earliest known Adoration of the Magi was painted on a wall of the catacomb of St Priscilla in Rome around 200. Here the Magi are wise men, not kings; nor are Joseph, the stable, the ox, or the ass present. In art they did not become kings until the tenth century, with Christ presented as the King of Kings.

In the thirteenth century the focus shifted to Christ's birth. In 1229 St Francis of Assisi constructed the first nativity crib at Greccio in Italy. The Christmas story entered into Franciscan devotional literature, which stressed the need to identify with the innocence and vulnerability of the newborn child, as in *Meditations on the Life of Christ*: "Be a child with the Child Jesus! Do not disdain humble things and such as seem childlike in the contemplation for they yield devotion, increase love, excite fervour, induce compassion, allow purity and simplicity, nurture the vigour of humility and poverty." It

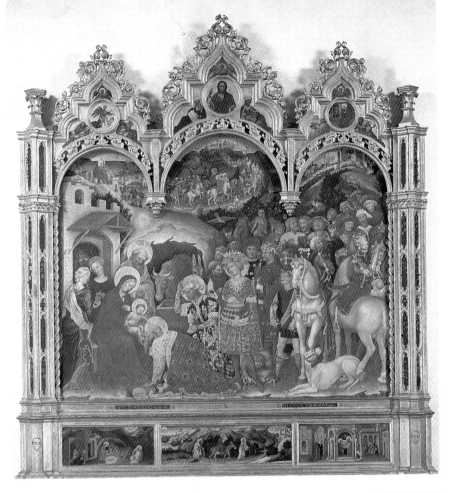

◀ **The Magi**
Painted for the richest man in Florence, Palla Strozzi, this luxuriously decorated altarpiece depicts the three Magi, with their courtly retinues, come to adore Christ. The Magi were revered in their own right and special processions in Florence marked their feast day. Behind Mary stand two midwives, while the ox and the ass are located in front of a cave, as recounted in the Apocrypha. In the predella at the bottom there are three scenes: the Nativity, the Flight into Egypt, and Christ's Presentation in the Temple.
Gentile da Fabriano, *Adoration of the Magi*, 1423.

▼ **Rest**
The Holy Family's Rest on the Flight into Egypt, to escape Herod's persecution, was a common subject in Northern art, offering as it did opportunities to paint landscapes. The German painter Runge was asked to paint this scene for an altarpiece for the Protestant Marienkirche in Greifswald. He used it to express his own pantheistic theology, with the awakening Christ Child at the new dawn symbolically linked to the renewal of nature. The tree on the right sprouts not just heavenly flowers but also sprite-like angels.
Philipp Otto Runge, *The Rest on the Flight into Egypt*, 1805–6.

▲ **The child Jesus**
The press attacked the English painter Millais for showing the Holy Family realistically, in a carpenter's workshop, and as working people. Jesus stands at the centre, his mother kneeling before him. Joseph holds out the left hand of Jesus, who has hurt it with a nail. Far from stressing Christ's mere humanity, this incident prefigures the wounds he will receive on the cross as Saviour of the World, which Mary sorrowfully acknowledges.
John Everett Millais, *Christ in the House of His Parents*, 1850.

was the human side of Christ that now received emphasis. The shepherds who came to adore him just after his birth were poor in the way that St Francis was and the Magi were not. In accordance with a vision of St Bridget of Sweden (d.1373), Mary is sometimes depicted kneeling before Jesus, who lies on the ground. Celebrations shifted from the Feast of the Epiphany to that of Christmas on December 25, which has retained its centrality in the Western Christian calendar.

Both the Adoration of the Shepherds and that of the Magi occurred at the stable, which is often depicted as a building in ruins to symbolize that Christ's birth signalled the advent of a new dispensation as the old one disintegrated. According to the Apocrypha, the birth took place in a cave, and this is sometime represented alongside the stable. Shortly after the birth of Christ Mary and Joseph presented him at the temple of Jerusalem, where he was circumcised.

Alarmed that the Magi honoured a future "King of the Jews," King Herod ordered the murder of all infants of less than three years of age in Bethlehem, a scene depicted in the violent Massacre of the Innocents. Joseph, however, had been warned in a dream by an angel and the Holy Family escaped to Egypt. The Flight into Egypt is depicted either with Mary riding the ass led by Joseph or as a scene of the Holy Family resting on their journey.

Missing years

After this event remarkably little emphasis is placed on Christ's childhood, either in the Bible or in art. Only the Gospel of St Luke tells how the twelve-year-old Jesus left his parents to dispute with teachers in the Temple at Jerusalem, impressing all with his wisdom, depicted in paintings as Christ among the Doctors. The years of adolescence and early manhood are absent, and we do not meet Christ again until he is about thirty years old and on the brink of his world mission.

Fishing for souls

The adult life of Christ opens with his Baptism, which is described in all four Gospels. His cousin John the Baptist had preached repentance in the wilderness, and prophesied the imminent coming of the Messiah. John baptized many people in the River Jordan, saying, "I baptize you with water; but there is one to come who is mightier than I. I am not fit to fasten his shoes" (Luke 3:16). He was referring to Christ, whom he also baptized. This ritual act of symbolic cleansing with water was the moment of Christ's anointing, his rite of passage and initiation. Baptism became, along with the Eucharist, the key sacrament of the Church, without which no salvation was possible, symbolizing rebirth and renewal, washing away the taint of original sin.

The iconography of this event quickly established itself from the third century and may be found in both the Eastern and the Western Churches. John the Baptist, dressed in a camel's hair tunic, stands on the shore baptizing Christ, who is usually on the central axis and standing in the Jordan. Above Christ hovers the Holy Spirit as a dove, in some paintings with the hands of God above it. In such images the Trinity appears and Christ is acknowledged as the Son of God. As angels hold his clothes, he stands naked except for a loincloth and has assumed the perfect male form of the nude gods of Classical art. It is the last time he appears unclothed before the Passion. The Baptism occurs in narrative cycles and also in altarpieces, especially those above altars dedicated to St John. The body of Christ is thus associated with the sacrament of the Eucharist performed at the altar.

Man of action

In paintings of Christ's ministry, he appears as protagonist and man of action rather than as the child of the Nativity or the victim of the Passion. He is recognizable not just by his face but also because he almost always wears a red robe with a blue mantle over it. Christ's first major act, which features in many paintings, was the Calling of the Apostles, the first of whom were fishermen, including Peter and Andrew, to whom he said: "Come with me and I will make you fishers of men" (Mark 1:17). In art the Calling of the Apostles is often conflated with the Miraculous Draught of Fishes, when the first apostles, having failed to catch any fish after working all night on Lake Gennesaret, were told by Christ to lower their nets again. After they made a big catch, he said to them: "From now on you will be catching men" (Luke 4:1–11). This symbolic imagery of fishing for souls was later said by Christ to refer to salvation: those who are caught are saved; those who are not are damned.

Baptism
In a landscape with a palm tree on the left, John the Baptist, wearing a camel's hair tunic and robe and holding a reed cross, baptizes Christ in the River Jordan. Above Christ, the hands of God lower the Holy Spirit. The action of John is very strenuous and this Christ is wiry and angular. One of the two angels kneeling on the left, turning his head toward Christ, represents a different ideal of formal beauty and was, according to Giorgio Vasari (1511–74), painted by Leonardo da Vinci, then a pupil in Verrocchio's workshop in Florence. **Andrea del Verrocchio**, *The Baptism of Christ*, 1470–5.

Miraculous catch
This scene was only one part of a winged altarpiece commissioned by François de Mies for his chapel in St Peter's Cathedral in Geneva. It conflates three events: the Calling of St Peter, the Miraculous Draught of Fishes, and the moment when St Peter tried unsuccessfully to walk on water in imitation of Christ. The German painter Witz has translated the Sea of Galilee to Lake Geneva and the scene is topographically accurate, making it easier for Genevans to imagine the event. The dark mountain above Christ's head is that known as the Mole. **Konrad Witz**, *The Miraculous Draught of Fishes*, 1444.

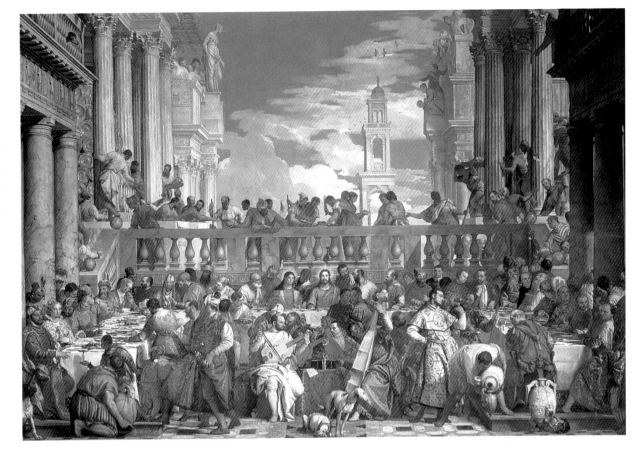

Christ appointed St Peter leader of the Apostles: "You are Peter, the Rock; and on this rock I will build my church, and the power of death shall never conquer it. I will give you the keys of the Kingdom of Heaven" (Matthew 16:18–19). This was taken by the Roman Church as the foundation of its authority, as Peter (whom it claims was the first pope) died in Rome. The Giving of the Keys was depicted twice in the Sistine Chapel, by Perugino in 1481–2 and by Raphael in his tapestry designs of 1515–16.

The first public miracle Christ performed was at a wedding at Cana (John 2:1–10), to which he, his apostles, and his mother were invited. The wine ran out during the feast and Christ changed the Jewish purificatory water, contained in six stone jars, into wine, symbolizing the transition from the Old to the New Covenant. This scene was particularly suitable for paintings in the refectories (eating halls) of monasteries. The Raising of Lazarus is also frequently represented, as an illustration of Christ's power to heal and to conquer death (see pages 58–9).

From Galilee to Jerusalem

In a disjuncture between biblical narrative and the visual tradition, Christ's miracles often occur in art, but his preaching does not. The Sermon on the Mount, his declaration of the new faith, is rarely represented because the content of his sermon could not be pictured: how do you visualize the Lord's Prayer? Another reason why scenes of Christ's preaching do not appear in paintings is that these episodes are not celebrated in the

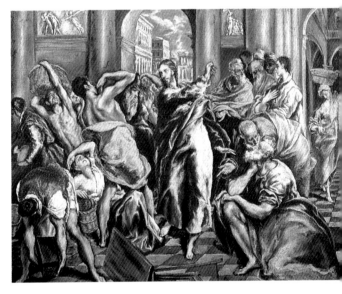

Christian calendar. But Jesus also taught by example and his parables provided powerful images for artists, above all the story of the Prodigal Son, who left his father and squandered his inheritance, only to be forgiven, in the way that Christ forgives those who repent.

Christ's ministry centred around the Sea of Galilee but his move to Jerusalem was a turning point. According to St Luke, after entering the city on a donkey on Palm Sunday he went to the great Temple and, finding it full of money changers, merchants, and animal sellers, evicted them in fury. This revolutionary act challenged Jewish religious authority and contributed directly to his execution.

The Passion

The Passion is the climax of the Christian story, and covers the events immediately leading up to and including the Crucifixion. This was the moment of Christ's redeeming sacrifice, his death for the sake of humanity. It is commemorated at Easter, the critical point in the Christian calendar, and used to be enacted in Passion plays throughout Europe. It has been celebrated in music such as Bach's *St Matthew Passion*, and has provided subject matter for some of the most moving masterpieces of European painting.

Evoking the suffering of Christ

From the early thirteenth century, new devotional currents, largely stimulated by St Francis of Assisi, placed more focus on the human dimension of Jesus, and on identification with his suffering. This emerges in devotional literature of the time, such as the *Little Book on the Meditation of the Passion of Christ*: "It is necessary that when you concentrate on these things in your contemplation, you do so as if you were actually present at the very time when he suffered. And in grieving you should regard yourself as if you had our Lord suffering before your eyes, and that he was present to receive your prayers." The brutality and physical pain undergone by Jesus, his disfigurement, were often graphically evoked. Christ was no longer just a symbol of salvation but engaged the deepest emotions of the worshipper.

Visual images were involved in this enterprise. The crucifix alone could produce extraordinary levels of imaginative identification, as described by the English mystic Mother Julian of Norwich in her *Revelations of Divine Love* of 1373: "After this I saw with my own eyes in the face of the crucifix hanging before me and at which I was ceaselessly gazing something of his Passion. I saw insults and spittle and disfiguring and bruising, and lingering pain more than I know how to describe." Here the entire cycle of Christ's suffering during the Passion is condensed into one image.

In paintings the Passion was also separated into distinct stages. The events that began with the Last Supper and ended in his Crucifixion provided the core, but the scenes chosen varied, and could even be expanded to include the entire narrative from his entry into Jerusalem to his Resurrection. The principal stages were, in chronological order: 1. The Last Supper; 2. Christ Washing his Disciples' Feet; 3. The Agony of Christ in the Garden of Gethsemane; 4. The Arrest of Christ; 5. Christ before the High Priest, Caiaphas; 6. The Mocking of Christ by his Jailers; 7. Christ before the Roman Governor, Pontius Pilate; 8. The Flagellation; 9. The Crowning with Thorns; 10. *Ecce Homo* ("This is the Man" – the words spoken by Pilate on showing Christ to the people of Jerusalem); 11. Christ Carrying the Cross to Calvary; 12. The Crucifixion.

These events are in the New Testament, but were elaborated on in devotional literature and new scenes were incorporated, like the Lamentation over Christ's body, which is not mentioned in the Gospels. In a separate development, Stations of the Cross were devised, corresponding to places on the *Via Crucis* (Way of the Cross) where Christ suffered during the Passion, and which pilgrims to Jerusalem visited – paintings and devotional prayers usually covered fourteen, but sometimes more.

▼ **Interrogation**
In a darkened room at night, lit only by a candle, Christ is questioned after his arrest by the High Priest Caiaphas, who is seated on the left, with the two false witnesses standing behind him. The contrast of light and dark dramatizes the event, focusing our attention on the principal characters. This light also has a symbolic function: Christ, dressed in white, is presented as the Light of the World. The Utrecht painter Honthorst learned to paint such nocturnes while in Rome from c.1610 to 1620, where he painted this picture and saw the work of Caravaggio and his followers.
Gerrit van Honthorst, *Christ before the High Priest*, c.1617.

▲ **Via Crucis**
In this composite image, the Passion cycle, from the Entry into Jerusalem, through the Flagellation at the centre, ending with the Crucifixion at the top, is shown as one continuous narrative. Scenes after Christ's entombment are depicted on the right, outside the city walls. The donors, Tommaso Portinari and his wife, kneel on either side. This Netherlandish work was a miniature of the *Via Crucis*, allowing for a pilgrimage in private prayer.
Hans Memlinc, *The Passion*, c.1480.

Images of Pity

Painters responded in many different ways to the need of worshippers to empathize with Christ, stressing his physical suffering during the Flagellation and Crucifixion, his humiliation in the Mocking and the Crowning with Thorns, his spiritual isolation and despair during the Agony in the Garden and at his dying moments, his rejection by society in the *Ecce Homo*, his humility in the washing of his disciples' feet, and his innocence at his trial. The addition of figures like Mary or St John at Christ's side during the Crucifixion provided role models of appropriate sorrow. A repertoire of gestures was developed to communicate these emotions, some of it with its origins in the formulae used in ancient sculpture to indicate feelings.

A vast amount of visual imagery developed around the subject of the Passion, and with it a grammar of the emotions – a way of organizing and disciplining them – was articulated. Different types of painting were produced for different purposes. These included entire narrative cycles, which taught the Passion story and its place in the history of salvation, for churches, and single scenes from the Passion for altarpieces. There were also images which told no story but were designed for concentrated meditation, especially small devotional paintings for private prayer like the *Imago Pietatis* (Image of Pity, known as the "Man of Sorrows"), in which Christ, sometimes holding or surrounded by the Instruments of the Passion with which he was tortured and executed (the crown of thorns, the scourge, the cross, the nails, the lance that pierced his side, and the sponge of vinegar pressed to his lips among them), is presented frontally, usually half-length, and sometimes upright in his tomb, with his wounds displayed, inviting our pity for his momentous suffering on our behalf.

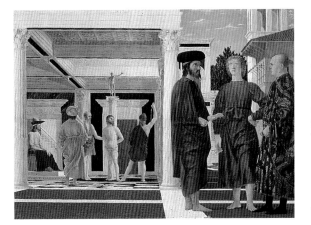

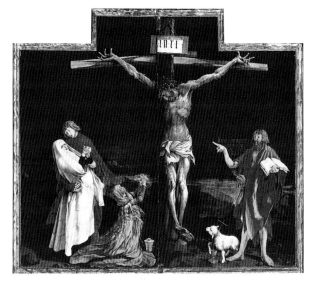

◄ Justice miscarried
In this enigmatic painting by the artist and mathematician Piero della Francesca, Christ is not in the foreground, but, stripped and tied to a column, is under the Classical loggia in the middle distance, being flogged before a seated official. The identity of the three men on the right is uncertain, but they may include Herod and Pilate. An eerie calm and order reign over this act of state violence. **Piero della Francesca**, *The Flagellation*, c.1460.

► Agony
In these closed wings of an altarpiece painted early in the sixteenth century by Grünewald (for other panels see pages 33 and 52, the stress is on the pain of the giant Christ – the arms of the cross are bent by his weight, his body is contorted and his flesh torn – an emphasis appropriate to its original location in an institution for sufferers from skin diseases. On the left are the Virgin and St John, while Mary Magdalene kneels, distraught with grief. On the right John the Baptist points to Christ as the Saviour, the Lamb of God who will take away the sins of the world. **Mathis Grünewald**, *The Crucifixion*, c.1515.

▼ Light in the darkness
This huge canvas by the Venetian artist Tintoretto has at its centre – the axis of the entire composition – the Crucified Christ, with his head bowed. At the foot of the cross Mary has fainted with grief, while to the left the cross of the good thief is lifted with ropes, forming a diagonal pointing at his saviour. Light has been used to dramatize this great panorama, with Christ as its source in the darkness. **Jacopo Tintoretto**, *The Crucifixion*, 1565.

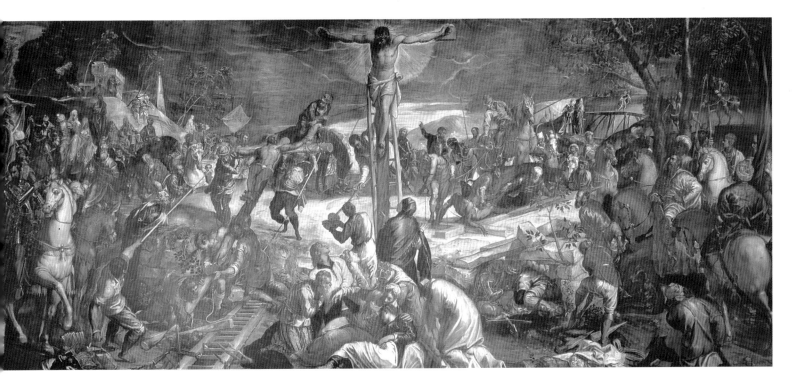

The body of Christ

▼ **The Deposition**

Commissioned by the archers' guild of Louvain for their chapel, this great altarpiece by the fifteenth-century Netherlandish artist Rogier van der Weyden depicts Christ being taken down from the cross. Its shape echoes that of carved altarpieces, and the ten figures are placed in a shallow box, almost like carved figures. But the space they inhabit is too small to contain them all, and this constriction contributes to the heightened emotional atmosphere of the scene. As the dead Christ is lowered by Joseph of Arimathea and Nicodemus on the right, the Virgin Mary faints with grief, and St John the Evangelist, in red on the left, restrains her fall. On the far right St Mary Magdalene is contorted with sorrow, and all participants display dignified sadness. The compositional diagonal of Christ's body is echoed by that of his mother, their hands held near each other.
Rogier van der Weyden, *The Descent from the Cross*, c.1435.

For Christians, Jesus is the Word of God made flesh, the incarnation of God. The duality of his nature as both God and man presents special challenges to artists. Christ's body has many forms in art, emphasizing different aspects of his nature. When he is an infant, both his sacred majesty and his touching childishness can be conveyed. During his baptism, ministry, and miracles, the adult Jesus is presented by artists as the ideal man, the perfect image of his father, but in the Passion his body undergoes pain and disfigurement. After the Crucifixion, Christ's body is represented as dead, a lifeless husk that once contained his divine soul. This physical body is regalvanized and transfigured in the Resurrection, though it still bears the marks of his physical torments: St Thomas, doubting the Resurrection, was invited by Christ to place his fingers in the spear wound in his side. This transfigured body then ascends to Heaven.

In addition to and co-existent with this physical body of Christ there is also an invisible one, made present during the Mass at Communion, uniting all Christians as part of one mystical body. In the Catholic doctrine of transubstantiation, the consecrated bread and wine (the sacraments) are considered to be the Real Presence of Christ – his real body and blood. In this way Christ's abiding spiritual presence in the world is celebrated, and his body remains the focus of worship despite his absence.

Painting the dead Christ

Unlike representations of the punishment and physical suffering of Christ the man during the Passion, paintings of Christ's dead body required less direct empathy with his agony and more with the bereavement of his immediate entourage and their overwhelming sense of loss. Christ's broken body, shattered and disjointed, contorted with pain, stiffened with rigor mortis, is meant to arouse the viewer's own sense of guilt for Christ's judicial murder and to emphasize the apparent finality of death, from which Christ's saving act of sacrifice is the only way out.

Paintings of the dead Christ can occur as continuations of the Passion's narrative scenes – this is how they occur in the Scrovegni Chapel by Giotto (see page 24) and *The Passion* by Memlinc (see page 48). They can also occur as individual images, whether as altarpieces in churches or as smaller devotional paintings for private meditation and prayer. Intermediary figures, often distraught, provide cues as to the appropriate emotional responses, manipulating feelings as tragic actors do. These figures usually include the Virgin Mary, fainting with grief, St John the Evangelist, the three Marys

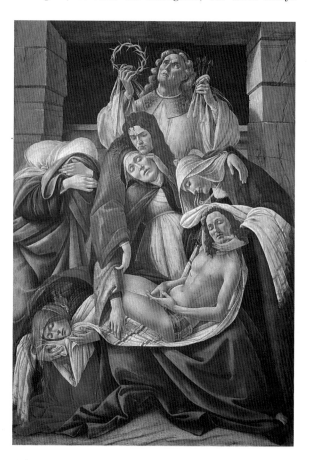

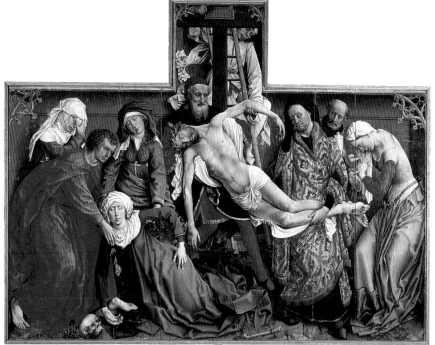

▲ **The Lamentation**
This painting by Botticelli hung on a pillar in Santa Maria Maggiore in Florence. Christ's limp body lies on his fainting mother's lap, wrapped in a shroud, attended by the three Marys. St John sustains the Virgin, while Joseph of Arimathea holds the crown of thorns and the nails with which Christ was crucified. The mood of extreme grief and tension is accentuated by the stark opening to the tomb before which the figures are compressed.
Sandro Botticelli, *Lamentation*, c.1495.

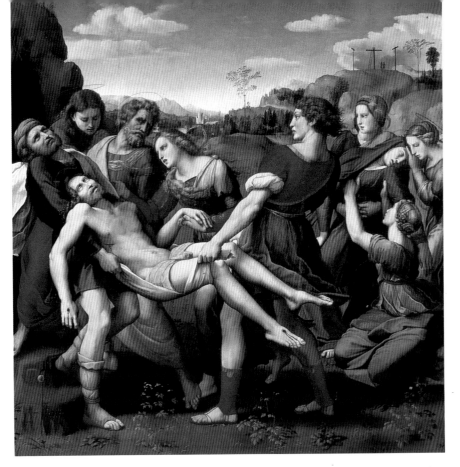

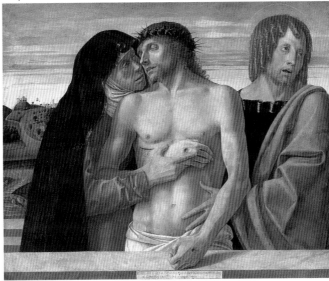

▼ Image of Pity

Although the popular form of the "Image of Pity" simply shows the dead Christ in the tomb, Giovanni Bellini depicts him held upright by his mother and St John the Evangelist. Mary places her cheek close to his and raises his right hand; St John turns away in sorrow. Christ's left hand is placed above an inscription in Latin which reads: "As soon as the eyes swollen let forth their lament Giovanni's work was able to weep." **Giovanni Bellini**, *Dead Christ*, c.1465.

▲ The Entombment

Having begun this work as a Lamentation, Raphael instead created an Entombment with Christ being carried backward into the tomb on the left. Christ's pose is based on an ancient Roman relief – his limp body contrasts with those of his straining supporters. The work was painted for Atalanta Baglione in Perugia, who had lost her young son in a feud, and so identified with Mary's bereavement. **Raphael**, *The Entombment*, 1507.

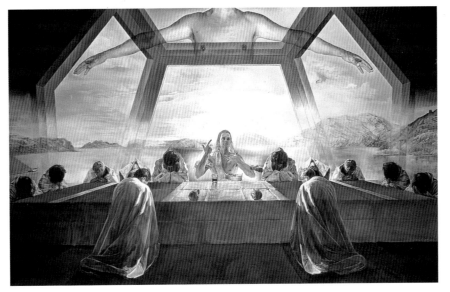

(including Mary Magdalene), St Joseph of Arimathea (who obtained permission from Pilate to bury Jesus), and Nicodemus (a Pharisee who secretly worshipped Christ).

Pictures of the events that followed the death of Christ depict distinct scenes, not all of which are described in the Bible but which nonetheless established themselves in the visual tradition of Christian art. The first type is the Deposition, which shows his detachment and lowering from the cross as described in the Gospels. The next is the Lamentation, when Mary and her companions mourn the dead Christ on the ground. This event is not recorded in the Bible, but a thirteenth-century Italian devotional text, the *Meditations on the Life of Christ*, provided a graphic account of the suffering of those involved. This scene must not be confused with the *Pietà*, which shows the Virgin Mary with her dead son on her lap, which is not described in the Bible and is not meant to be understood as a stage in the narrative. The final stage, and one for which there is biblical authority, is the Entombment, when Christ's body is carried to its resting place in his tomb.

There were also images exclusively designed to aid meditation on Christ's death and on the suffering of Mary and St John. This type of image is called in Latin the *Imago Pietatis* (Image of Pity). It is usually a half-length image of the dead Christ, often upright in a tomb,

sometimes flanked by his mother and St John or held by angels. His arms are folded or limp, and his wounds are apparent. Such images were intended for private devotion and are generally quite small.

All images of Christ emphasize the sacramental nature of his body and its association with the Eucharist, but some stress his invisible presence at Mass more overtly than others. There are images of Christ emerging from a Communion chalice, or with his blood being collected by angels. Paintings of the Last Supper show either the moment when Christ announces that one of his disciples will betray him, or the establishment of the Eucharist, and thus the first Communion of the Apostles, when Christ commanded them: "Take this and eat; this is my body" (Matthew 26:26).

▲ The Eucharist

A beardless Christ presides over a table bearing only bread and wine before which his apostles kneel like priests. Located in an indefinite space, half Modernist penthouse, half northern Spanish coastline, the mystical body of Christ hovers above this unusual Last Supper. When the accusation of vulgarity was raised against this work, Dali replied that he had wanted it to be popular and boasted (wrongly) that it had sold more postcards than the works of Leonardo and Raphael combined. **Salvador Dali**, *The Sacrament of the Last Supper*, 1955.

Triumph over death

The question of death is central to all religions, not just Christianity. "Even in the best of health we should have death before our eyes" and "We will not expect to remain on this earth for ever, but will have one foot in the air," wrote the French Protestant reformer Jean Calvin in the sixteenth century. What happens to us after we die? The Christian answer, whether Catholic or Protestant, is clear: "God loved the world so much that he gave his only son that everyone who has faith in him may not die but have eternal life" (John 3:16).

For Christians, the death of Jesus on the cross was necessary but not final. The pain of the Passion and the desolation of the Crucifixion and its aftermath had to be undergone for the sake of human salvation, as the expiatory sacrifice for the Fall. But the finality of death is abolished, not just because Christ was sacrificed but because he came back to life again. Easter Friday commemorates Christ's death, Easter Sunday his revival three days later. Christ's resurrection was of his body, not his immortal spirit, and it paves the way for the

▼ **Love transfigured**
Mary Magdalene came to Christ's tomb but, finding it empty, began to cry, convinced that his body had been stolen. A man then appeared whom she mistook for a gardener, but who revealed himself to be Jesus. Mary knelt and reached out to touch him, but he recoiled, saying: "Do not touch me ["*Noli me tangere*" in Latin] for I am not yet ascended to my Father . . . to my God and your Lord." Titian set this scene in a pastoral landscape. Christ, holding a hoe, avoids the touch of the woman who loves him, his body now transfigured and beyond the reach of mortals.
Titian, *Noli Me Tangere*, c.1510.

general resurrection for the rest of humanity that must follow at the Last Judgement. This also means that, as a physical event, it could be represented by artists.

The Resurrection

None of the four Gospels describes the Resurrection. It was not witnessed by Christ's followers or even the Roman soldiers who were sent to guard his tomb. Holy women came to the tomb and found it empty. The earliest representations show not Christ but an empty tomb with sleeping soldiers or with the angels who greeted the holy women. In the earliest representations of the resurrected Christ, he is shown with St Thomas, who, doubting the Resurrection, stuck his finger in the wound in Christ's side. From the eleventh century Christ

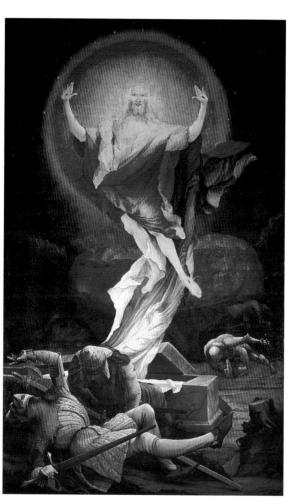

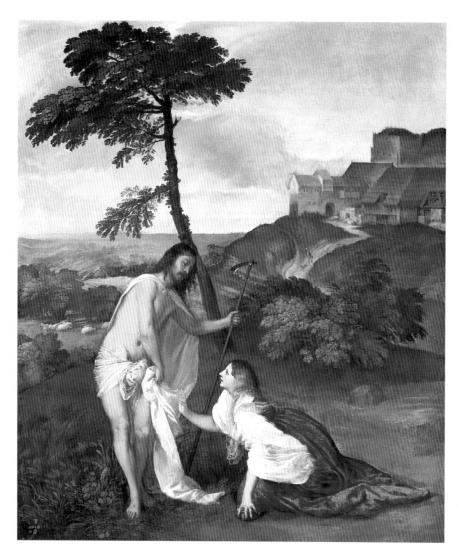

▲ **Glory**
The German artist Grünewald painted this work for a winged altarpiece at Isenheim. In contrast with the outer panels' imagery of overwhelming pain, it presents a picture of incandescent joy. The transfigured Christ has burst from his tomb and radiates energy into the darkness. Soldiers, caught in suspended animation, fall to the ground as Christ assumes the cosmic mantle of the stars, blazing like the sun.
Mathis Grünewald, *The Resurrection*, c.1515.

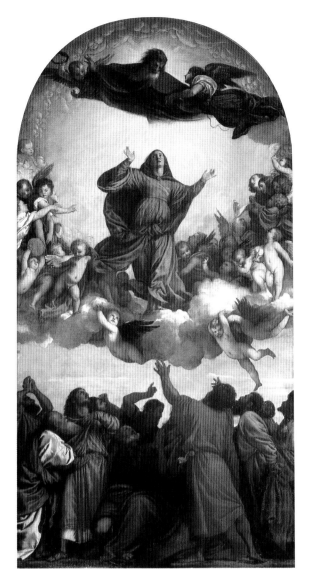

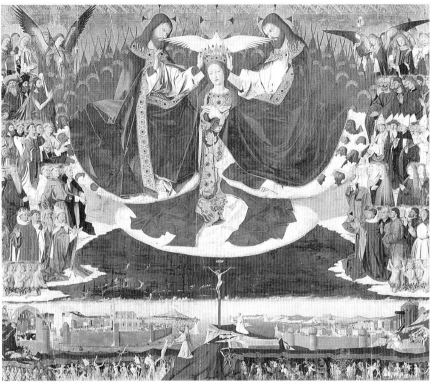

◄ Assumption

Titian painted this work for the altarpiece of the high altar of the principal Franciscan Church in Venice, Santa Maria Gloriosa dei Frari. It has three divisions: the disciples at the bottom, Mary in the middle, and God the Father floating above to receive her.

Mary is propelled up on a cloud by a semicircle of angels against an aureole of golden light, her hands and eyes lifted in ecstasy. The composition is united by the red pyramid of her dress and the robes of two apostles beneath. The figures are over life-size.

Titian, *The Assumption*, 1518.

is shown standing in the tomb; a century later he is shown emerging from it. This was extended to his suspension in mid-air and, from the sixteenth century, to his bursting from the tomb.

In the process of resurrection Christ underwent a change. His body has been transfigured – that is, immortalized. How could painters convey its new status? Duccio, in the scenes on the back of the *Maestà* altarpiece for Siena Cathedral of 1311, simply changed his costume: he used gold leaf along with blue in those scenes representing Christ transfigured. These include the Transfiguration itself, which occurred before Christ's death, in which he appeared to three of his disciples on Mount Tabor between the prophets Moses and Elijah. Where Christ's body is shown partially naked after his death, it is no longer the disfigured body of the Crucifixion and Entombment, but the heroic male nude of the Baptism, but with the five wounds to his flesh.

The first person in the Gospels to see the resurrected Christ was Mary Magdalene on Easter Sunday. This is the much-painted scene in which the risen Christ asks her to refrain from touching him. Christ is also represented after appearing to two of his disciples over supper at Emmaus, near Jerusalem. According to the Apocrypha, it was shortly after this period that Christ descended into Limbo to liberate the just souls of the Old Testament who had lived before his coming, including Adam and Eve, and he is represented in art as bursting open the gates of Hell. The last time he appeared on earth was to ascend to Heaven. The Ascension is much rarer in painting than the Resurrection, as it marks a final disappearance rather than a resurgence, making it more difficult to paint.

The Virgin Mary outlived her son. Her death, described in Acts, was witnessed by the apostles at her bedside. Much more common in art is her Assumption. Described in the Apocrypha but not the Bible, it is the moment when her body and soul were taken up to Heaven. The iconography of this event evolved from her suspension in the sky with the apostles beneath her to a more dynamic presentation of her ascent, as in Titian's version shown here. Her conquest of death is comparable with that of Christ.

Mother and son are reunited for all eternity and a rejuvenated Mary is represented in art being crowned Queen of Heaven by Christ. The Coronation of the Virgin is not based on the Bible but on typological readings of the Old Testament's Psalms and Song of Songs. The subject was especially popular for altarpieces, as it was thought to symbolize the union of Christ with his Church, represented by Mary, enthroned with her son in Heaven and surrounded by angels and adoring saints.

▲ Coronation

This altarpiece was commissioned from the French artist Enguerrand Quarton for the Charterhouse at Villeneuve-lès-Avignon by Jean de Montagnac, a canon there with a devotion to the Trinity. The Virgin Mary is here crowned by the Trinity, not just Christ, who is made to look identical to God the Father. This is because the patron was at that time engaged in negotiations over the nature of the Trinity with the Byzantine Church, which believed that the Holy Spirit issued only from the Father. Montagnac also insisted on the depiction of the heavenly court of angels, apostles, prophets, saints, and the elect, including those infants who died in innocence (left). At the bottom is Christ crucified on Mount Calvary, with Rome on the left and Jerusalem on the right, linked by the sea. Below on the left is Purgatory (with an angel receiving a soul into Heaven) and on the right Hell.

Enguerrand Quarton, *The Coronation of the Virgin*, 1449.

Images of saints

The word "saint" derives from the Latin *sanctus*, meaning holy. The saints were men and women who dedicated their lives to Christ to a heroic degree. The first apostles and the evangelists were recognized as saints by early Christians, as were martyrs who had died for their faith. Some monks were also acclaimed as saints and to them were added exceptional churchmen and teachers, a group called "confessors." At first only the sanction of the local church was required for an individual to be venerated after his or her death. From the tenth century, however, the authority of the Pope was needed and this was only granted after the record of any candidate for sainthood had been scrutinized in a formal process known as "canonization."

Saints were considered to be in a higher state of grace than others, that is more meritorious in God's eyes, and for this reason they occupied a pre-eminent place in Heaven. They were commemorated on their anniversaries, their relics were revered, and they were invoked in prayer as intercessors. In paintings they usually have a halo (a circular disc of light surrounding the head) and are identified either by features of their appearance or by symbols known as "attributes." The legends of their lives and miracles were often depicted, the main source used by painters being the thirteenth-century "Golden Legend." The Protestants abhorred the late-medieval cult of saints, believing that it had degenerated into idolatry.

▶ All saints
This altarpiece was painted for the chapel of a hospice in Nuremberg by the German artist Dürer, who stands, in small scale, at the bottom right. The sky is filled with a vision of heaven, with the Trinity as its centre. At the top is the Holy Spirit, encircled by angels. God supports Christ on the cross. The blessed are in adoration: on the middle tier on the right, the patriarchs, prophets, and kings of the Old Testament; on the left, female saints. Mary kneels on the left, John the Baptist on the right. Beneath are male saints. Among these on the left is the work's bearded donor, Matthäus Landauer.
Albrecht Dürer, *The Adoration of the Trinity*, 1511.

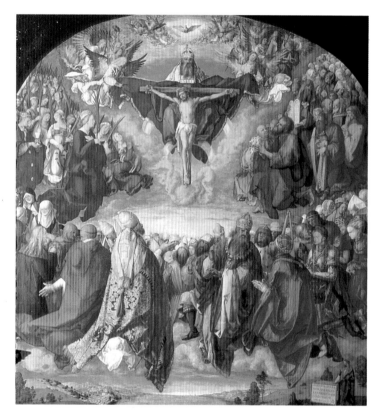

▲ The Evangelists
The four Evangelists who wrote the four books of the New Testament, which relate the life and death of Christ, are sometimes represented not in human form but as symbols: St Matthew as an angel; St Mark as a winged lion; St Luke as a winged ox; and St John as an eagle. The Italian painter Raphael paints a vision of God experienced by the Old Testament prophet Ezekiel. God is surrounded by what Christians interpreted as the symbols of the Evangelists and therefore as prefiguring the New Testament.
Raphael, *The Vision of Ezekiel*, c.1518.

▶ Doctors of theology
The Austrian artist Michael Pacher shows the four founding theologians of the Church enthroned under Gothic canopies, each inspired by the Holy Spirit. Each has an attribute. In the case of St Jerome, on the left, this is the lion he befriended in the desert. He is shown as a cardinal, St Gregory (second from right) as a pope, and St Augustine and St Ambrose as bishops.
Michael Pacher, *The Four Doctors of the Church*, c.1483.

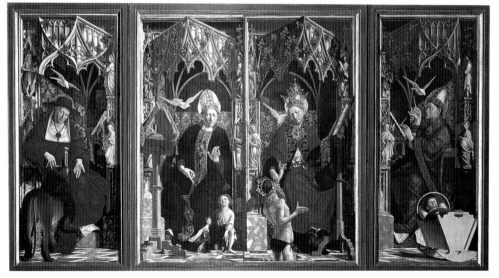

▷ Company of Heaven

Fra ("brother") Angelico painted this altarpiece for the church of a monastery of his Dominican order at Fiesole, near Florence. Mary is crowned by Christ in the court of Heaven. Around the throne, angels play instruments, while on the steps saints kneel, each identified by his or her attribute: for example, St Agnes by her lamb. On the left are Dominican saints dressed in their black and white habits. They include St Dominic, whose life and miracles are pictured in the predella.
Fra Angelico, *The Coronation of the Virgin*, c.1435.

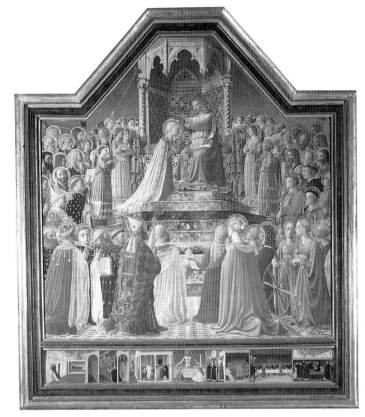

▷ Holy burden

According to legend, St Christopher was a giant who wished to serve the most powerful king in the world. One day he was carrying a child across a ford when the child became extremely heavy. "No wonder," the child explained. "You have been carrying the whole world. I am Jesus Christ, the king you seek." The German artist Dix situates the story on Lake Constance and shows Christ revealing his identity. The story had personal significance for the painter as a symbol of hope. The staff that grew into a tree and the Christ child are both attributes of St Christopher.
Otto Dix, *St Christopher (IV)*, 1939.

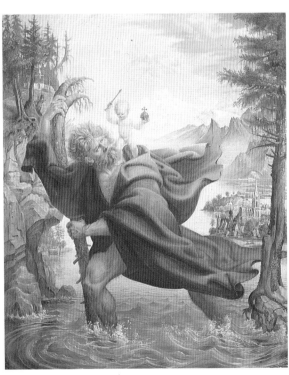

▷ Piety

St Carlo Borromeo (1538–84), a modernizing Archbishop of Milan, was canonized in 1610. Crespi depicts him seated at a table opposite a domestic altar with a crucifix. With only bread and water for supper, this austere figure is moved to tears by his deep reading of the Bible.
Daniele Crespi, *St Carlo Borromeo at Supper*, c.1625.

▲ Angelic healing

The story is taken from the *Book of Tobit* in the Apocrypha. Tobias was sent by his blind father to collect a debt from a distant city. He was escorted by the Archangel Raphael, who told him to catch a fish, gut it, and apply its pulped entrails to his father's eyes. He did so, and cured his sight. Here Raphael holds the ointment and Tobias the fish as they spring arm in arm across the landscape. Both wear fashionable clothes, but Raphael has wings and a halo. He was invoked as a saint before long journeys and as a healer, as was St Christopher.
Attributed to Andrea del Verrocchio, *Tobias and the Angel*, c.1475.

Martyrdom

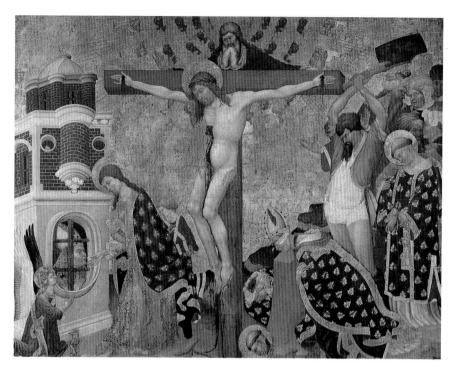

Patron saint
Painted for the Charterhouse at Champmol in Burgundy, by the French artist Henri Bellechose, this gilt altarpiece has the Trinity at its centre. On either side, as part of a continuous narrative, are scenes from the life of St Denis (d.258). On the left St Denis, Bishop of Paris and patron saint of France, having been thrown into prison, is given Holy Communion by Christ in the company of angels. On the other side, the saint is beheaded at the foot of Montmartre (Martyr's Mount) in Paris, along with his companions St Rusticus and St Eleutherius, all three wearing the mantle of Christ.
Henri Bellechose, *Altarpiece of St Denis*, 1416.

Saints have been venerated for different reasons and so feature in paintings in various ways. They could be identified with entire communities – for example, the evangelist St Mark with Venice, and St George as the patron saint of England. Saints also became the protectors of professional groups, like St Luke for artists (see page 20, Rogier van der Weyden, *St Luke Painting the Virgin*). They were made the spiritual heads of chivalric orders, such as the Knights of St John, and of lay confraternities. They were invoked by their namesakes; those with a personal devotion to them; those suffering from afflictions (as were St Sebastian and St Roch by plague victims); or those in danger.

Saints and martyrs

Innumerable images of saints or their symbols (such as the cross of St George, the shell of St James, or the winged lion of St Mark) were made to meet this huge demand. Figures of saints were painted on the walls of churches and public buildings, on either side of Mary in altarpieces, or as central cult figures themselves; their actions were painted as narratives and as examples of heroic conduct. The Reformation in the sixteenth century put an end to this explosion of cult images in the Protestant parts of Europe. Nevertheless images of saints are still widespread in the Catholic world, although the Roman Church has always insisted that saints cannot be worshipped as demigods but only venerated, images of them being devotional aids.

The first people to be called saints were martyrs, those who died for the faith. The early Christians were

Mutiny and martyrdom
This altarpiece was commissioned by King Philip II of Spain, who then rejected it because of its unorthodox treatment of the subject. Around 302 St Maurice and his legion were butchered for refusing to persecute Christians in Gaul. El Greco emphasizes not the martyrdom but the decision to mutiny made by the saint and his officers, on the right. In the middle they are beheaded. Above, angels play music and bear the crowns and palms of martyrdom.
El Greco, *The Martyrdom of St Maurice and the Theban Legion*, 1582.

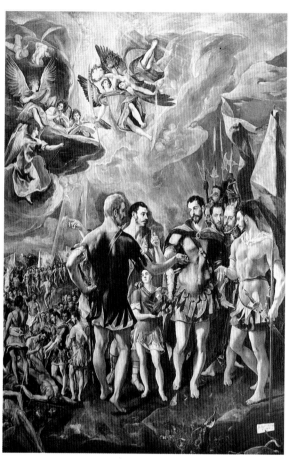

persecuted for refusing to sacrifice to pagan gods and many were executed. Around 200 Tertullian wrote that to be a martyr guaranteed immediate salvation: "Your blood is the key to paradise." Reverence was shown to martyrs at the place where they suffered and were buried and on the anniversary of their martyrdom mass was celebrated. Their deaths were registered in martyrologies and the Christian calendar. The model was Christ in the Passion; St John the Baptist was beheaded (before Christ was crucified), and some of the apostles were martyred, St Peter traditionally being crucified upside down and St Andrew on an X-shaped cross.

In the iconography of saints, martyrs are often represented standing with the instruments or method of their torture as attributes: St Stephen with the stones used to kill him; St Lawrence with the grill on which he

This work is one of a series of the twelve apostles painted by different artists to decorate the church of San Stae in Venice. St James the Greater was the first of Christ's immediate followers to be martyred, on the orders of Herod Agrippa. The Venetian painter Piazzetta depicts the massive, diagonal forms of the henchman and the old saint in blocks of light and dark.
Giovanni Battista Piazzetta, *St James Led to Martyrdom*, c.1722–3.

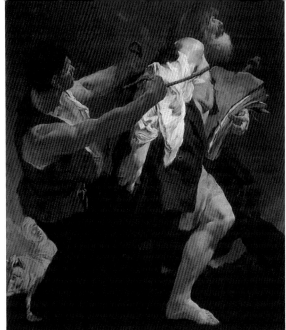

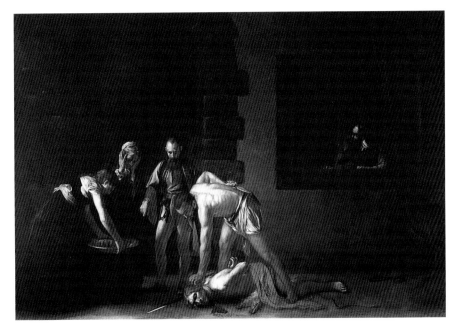

▲ **Darkness at noon**
St John the Baptist has just been executed. His executioner reaches for a knife to finish the job of severing his neck. The jailer points to the plate that will receive the saint's head, held forward by Salome. The jailer's wife clasps her head in horror as prisoners look on from behind bars. In this dark image of brutal death the Italian painter Caravaggio gives over most of the wide canvas to emptiness.
Caravaggio, *The Beheading of St John the Baptist*, 1608.

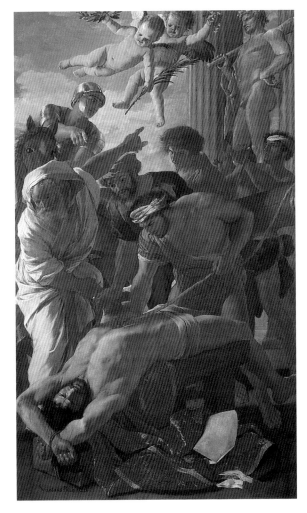

◄ **Torment endured**
St Erasmus, martyred by the Roman Emperor Diocletian around 303, had his intestines torn from his body on a windlass. The Frenchman Poussin painted this altarpiece for an altar in St Peter's in Rome. As a pagan priest points to the idol that St Erasmus has refused to worship, executioners perform their gruesome task, while little angels bear the crown and palm of martyrdom. Counter-Reformatory representations of saints often emphasize agony and ecstasy, but calm nonetheless reigns here.
Nicolas Poussin, *The Martyrdom of St Erasmus*, 1628–9.

was burned to death; St Catherine with the wheel intended to break her; St Bartholomew, who was flayed alive, holding a knife or his own skin. These reminders of physical torture are, however, linked with saints who usually display absolute composure, in a realm beyond pain.

The representation of martyrdom itself could be included in mural cycles of a saint's life – for example, in a martyrium built at the spot of death or burial, or in other chapels or churches dedicated to him or her, and in the predellas of altarpieces. St Sebastian was pictured being shot with arrows as the main field of altarpieces. Especially from the sixteenth century, martyrdom became more common as the main subject of altarpieces. Around 1527 the Venetian painter Titian represented the Dominican preacher St Peter Martyr in an altarpiece (unfortunately burnt in 1857), not in the traditional way, calmly standing with a cleaver buried in his head, but at the moment when he was cut down by robbers in a forest in 1233. As the Reformation grew in strength, the Catholic Church placed new emphasis on the heroic conduct of martyrs and their endurance of extreme pain, often graphically depicted, promoting them as exemplary figures willing to die for the true faith. The false gods to whom they would not sacrifice were now associated with Protestantism or the pagan idols of the New World.

Heroic figures

During the Counter-Reformation of the sixteenth and seventeenth centuries a formula emerged for the pictorial representation of a saint's martyrdom. The saint is shown at the bottom, undergoing torment supervised by a Roman official, and on one side is the idol that he or she has refused to worship. Above, the heavens open to the saint and angels bring down the crown of heavenly victory and the palm of martyrdom. The martyr's bodily suffering is contrasted with the eternal happiness that he or she has won. Such images are an inversion in which pain is transcended, agony sublimated into ecstasy, and death conquered by faith.

Miracles

iracles are considered extraordinary events, the manifestation of the supernatural in human affairs, marvels involving the temporary suspension of the laws of nature. Some are reported in the Old Testament, as when the Red Sea parted to let Moses and the Israelites pass but drowned the Egyptian army that was pursuing them. According to the Gospels, Christ himself performed miracles, considered to be tokens of his divinity. His first miracle was at Cana (see page 47, Veronese, *The Marriage at Cana*), when he turned water into wine. Elsewhere he multiplied five loaves and two fishes to feed a crowd of five thousand; he increased the catch of his disciples in the miraculous draught of fishes; and he walked on water. He also performed miracles of healing, such as restoring sight to a blind man and bringing Lazarus back to life after he had been dead for four days, and he carried out acts of exorcism.

As miracles often involve transformation they can be difficult for painters to represent: how can a static narrative depict the moment of water turning into wine, Lazarus's revival, or the multiplication of loaves and fishes? One solution was to use continuous narrative: the inclusion of two scenes, before and after, in one picture. Another way was to show the astonished reactions of the onlookers or to use light effects to suggest that something supernatural was happening.

Supernatural intervention

Many saints performed miracles, being endowed with supernatural powers by God. Miracles were taken into account in their canonization, as proof of their sanctity. These could be performed during the saint's lifetime or posthumously, when he or she was invoked in prayer by devotees on earth. Long-dead saints are depicted flying

▶ **Rescue at sea**
This work is one of a series of small scenes from the predella of an altarpiece painted for the main altar of a Florentine church dedicated to the fourth-century bishop St Nicholas. The scenes narrate the life and miracles of the saint, and this one depicts a miracle that he performed after his death, when he saved sailors off the Lycian coast from shipwreck. Gentile da Fabriano shows him diving down from the heavens, surrounded by light, as a mermaid swims in the sea. The relics of St Nicholas, who became the patron saint of sailors, were taken to Bari in southern Italy.
Gentile da Fabriano,
St Nicholas of Bari Preventing a Shipwreck, 1425.

▼ **A father's prayer**
This narrative canvas formed part of a series decorating the boardroom of a Venetian lay confraternity that housed a miraculous relic of the cross on which Christ was crucified. It records one of the miracles performed by the relic in 1444. In the main square of Venice the confraternity, in procession on the feast day of St Mark, the city's patron saint, parades the relic in the foreground under a canopy. In the background is the Basilica of St Mark and to the right the Doge emerges from his palace. The miracle is difficult to spot: kneeling to the right of the relic, dressed in red, is Jacopo de Salis, who has just learned that his son in Brescia has fallen and cracked his skull. He prays to the relic and his son recovers.
Gentile Bellini, *Procession in the Square of St Mark*, 1496.

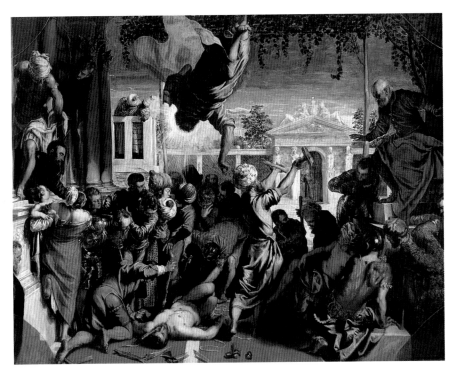

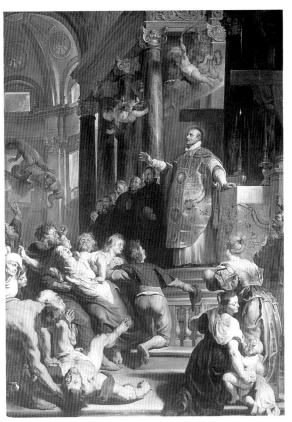

▲ **Heavenly help**
Tintoretto painted this work for the meeting hall of a Venetian confraternity devoted to St Mark. According to the "Golden Legend," the slave of a Provençal master who disobeyed orders and left on a pilgrimage to venerate the relics of St Mark was captured and was about to be punished by having his eyes poked out and his legs broken, when he was miraculously saved by the saint. As the naked slave lies on the ground, the staves and mallets used against him shatter and St Mark plunges from the sky to rescue him. This very large canvas, with figures full of colossal energy, made the Venetian artist's reputation.
Jacopo Tintoretto, *The Miracle of the Slave*, 1548.

down from Heaven to perform miracles, as in the works by Gentile da Fabriano and Tintoretto shown here. Paintings of their miracles could be found in mural cycles in chapels dedicated to them and in the meeting halls of confraternities devoted to their cult, and they often occur in the predellas of Italian altarpieces.

Many painters read about the miracles of saints in the "Golden Legend" (see pages 42–3). Some of its tales are fantastical, such as that of the fourth-century pope St Silvester (d.335), whose miracles, including the saint clasping the jaws of a dragon whose breath asphyxiated people, were painted by Maso di Banco around 1340 on the walls of a chapel at Santa Croce in Florence. In later centuries miracles were increasingly subject to the Church's formal scrutiny; for example, those of Ignatius Loyola (d.1556), painted by Rubens in *The Miracles of St Ignatius Loyola* for the Jesuits as part of their successful campaign to have their founder canonized.

The power of relics

In medieval and early modern devotion, relics of saints were very important and miraculous powers were often ascribed to them. They drew pilgrims to shrines such as those of St Thomas à Becket at Canterbury and St James at Compostela, the route to which was lined with churches. Relics acquired an almost totemic force and were seen as protecting whole communities; they could be a saint's whole body or parts of it, or objects with which he or she had come into contact. They were often the kernel of church-building and decorative projects and occasioned significant paintings, as at the shrine to St Francis at Assisi in the thirteenth century, where murals in the upper church depict his life and miracles.

As both Christ and Mary ascended to Heaven body and all, their relics were harder to come by, but the shroud in which Christ is believed to have been wrapped at his death is venerated in a chapel at Turin; the *sudarium* (see page 40) at St Peter's in Rome gave rise to numerous images; and the cross on which Christ was crucified was venerated in the form of splinters, the legend of its miraculous rediscovery by Emperor Constantine's mother, St Helena, being painted by Piero della Francesca on the walls of the main chapel of San Francesco in Arezzo in the 1450s. Around 1500 Gentile Bellini and others painted canvases recording the recent miracles performed by a fragment of the cross owned by the large Venetian confraternity of San Giovanni Evangelista. Paintings such as the work by Bellini shown here supported the miracles' claim to authenticity through the topographical accuracy of their Venetian setting and the number of eyewitnesses.

The Virgin Mary did not perform any miracles in her lifetime, but she was constantly invoked in prayers and could respond in miraculous ways to them. Votive images of thanksgiving or beseeching were hung at shrines dedicated to her throughout Europe, as at the shrines of saints and their relics. Some images, above all of the Virgin Mary, were believed to work miracles in their own right. The Protestants outlawed as idolatrous the cult of the Virgin Mary, the saints, relics, and images, along with the belief that these could perform miracles.

Solitude

Many saints practised some form of withdrawal from the world, renouncing the pleasures of the flesh, property, family life, and personal ambition in their pursuit of spiritual perfection. This retreat may be represented in images of individuals in a solitary dialogue with God, far away from human society.

The desert

Christ spent forty days and nights in the desert, where he was tempted by the Devil. St John the Baptist is sometimes painted as a young man assuming his solitary vocation in the wilderness, as in Veneziano's *St John the Baptist in the Desert*. According to the "Golden Legend," St Mary Magdalene, a prostitute converted by Christ, retired to the desert for thirty years after his crucifixion. She is depicted as a beautiful young women or, after her long retreat, as a haggard old penitent covered only with her own hair. Georges de la Tour, in *The Penitent Magdalene*, has represented her exchanging her youthful sexuality for saintliness.

Many saints were monks or nuns, and the earliest monks in the third century lived alone as recluses in the deserts of the Middle East. Among these "desert fathers" was St Anthony, whose temptation by devils became a staple of Christian painting (see pages 32–3). The desert was represented by the sixteenth-century German painter Grünewald as a place of demonic terror and harsh torments, but in other paintings the saint is tempted by a beautiful woman.

Despite his vocation to preach to the urban poor, St Francis was also attracted by the idea of retreat for spiritual renewal and in 1224 he withdrew to Italy's Apennine mountains, where he received the stigmata,

the five wounds inflicted on Christ on the cross. Giovanni Bellini's *St Francis in the Desert* varies the traditional iconography of this scene by not including the Seraphim (see pages 32–3) from whom St Francis received the stigmata, or his companion, Brother Leo. But it does communicate the change in attitude toward nature wrought by Franciscan sensibility. St Francis believed the natural world should be praised as God's creation, and the wasteland of the desert fathers flowers in Bellini's picture. This work belonged to a collector in Venice, where it offered a vision of spiritual retreat and of God's presence in nature.

From the fifteenth century onward images of saints in retreat were painted increasingly for the house and the monastic cell. St Jerome, the Church Father who translated the Bible from Hebrew into Latin and who around 374 withdrew to the Syrian desert, is represented as a scholar in his study or as a penitent in the wilderness, as in Gian Girolamo Savoldo's *St Jerome in*

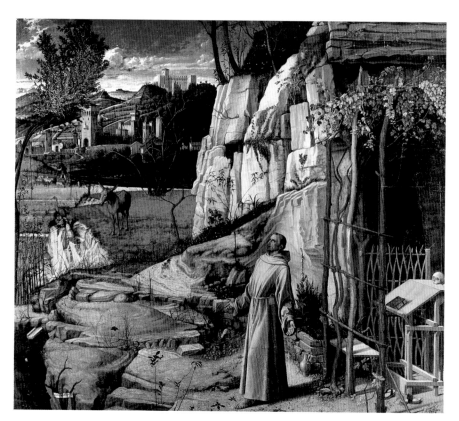

▼ **God in nature**
The Venetian painter Giovanni Bellini depicts St Francis as he emerges from his cave on Mount Alvernia, arms spread in reception of the wounds on his hands, which echo those that Christ received on the cross. The saint's face is turned to a heavenly light source in the top left-hand corner of the picture, a light that unifies the landscape around him. Just outside the city wall, this is no desert forsaken by God, but a countryside that overflows with his presence. In ecstasy, St Francis opens his mouth to sing in praise of the Creator of the world.
Giovanni Bellini, *St Francis in the Desert*, c.1480.

◀ **Renunciation**
Domenico Veneziano depicts St John the Baptist as he strips off his worldly clothes and replaces them with his camel's hair shirt. Naked but for his halo, the saint has the beautiful physique of a Roman god, combining sanctity with athleticism. The landscape is

bleak but for a few shrubs and a copse and a stream curling down from the jagged mountains above. In this wilderness the saint prepares to make the transition from the world of the body to the life of the spirit.
Domenico Veneziano, *St John the Baptist in the Desert*, c.1445.

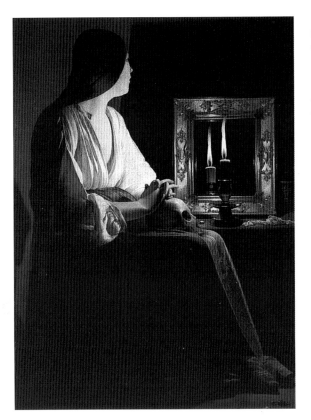

makes the saint dominate the foreground, while in the background the sun sets over blue mountains. A view of Venice – the city to which the Italian painter came from Brescia to work – is visible across the water on the left of the picture.
Gian Girolamo Savoldo, *St Jerome in the Desert,* c.1530.

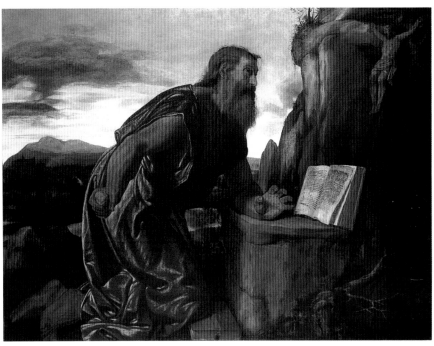

Repentance
Mary Magdalene sits with a skull on her lap, lost in meditation. Her dressing table with her pearl jewelry on it, the former altar of her vanity, has become a still life with a message: a memento mori. The candle's flame, which must die like passing human life, is duplicated in the void of the mirror and Mary turns to it, reflecting on death. Her outer beauty counts for nothing, but in the quietness of the night, in complete stillness, she feels no terror, only inner peace.
Georges de la Tour, *The Penitent Magdalene,* 1638–43.

Mystical isolation
This installation by the American video artist Bill Viola fills a darkened room of the museum where it is displayed. The work combines media, including video, soundtrack, and electric lighting. At the centre of the room is an uninhabited cabin furnished with a desk, a miniature television set, a jug of water, and a glass. This is the room of St John of the Cross, the sixteenth-century mystic and author of *The Dark Night of the Soul.* Against the back wall are the remote mountains of John's isolation, and the soundtrack plays the sound of the wild wind rushing through them. In this work technology transmits the power of the natural landscape in mystical experience.
Bill Viola, *Room for St John of the Cross,* 1983.

the Desert, sometimes with the lion he befriended there. Paintings of St Jerome provided role models for viewers by showing him both as a man engaged in the contemplative life and as a penitent.

The contemplative life
For the lay person, and even for a parish priest or a bishop, it was difficult to emulate the heroic asceticism of the saints. However, some undertook periods of retreat as lay members of orders, as Cosimo de Medici did from the 1440s at the Dominican monastery of San Marco in Florence, whose building and decoration he largely financed. Here Fra Angelico painted devotional pictures for the meditation of the friars in their cells. Cosimo also had a room there.

Meditational exercises were developed for use in retreat, some devised by the Franciscans in the thirteenth century. St Ignatius Loyola (1491–1556) wrote his *Spiritual Exercises* for his first Jesuit companions. Such exercises were important in shaping the religious imagination of both ecclesiastics and laymen. They start with the examination of conscience, in the tradition of medieval manuals for penitents, and move on to meditation and the formation of mental pictures.

In Catholic art of the seventeenth century dramatic extremes came increasingly into play. St Francis becomes an excoriated penitent who in the night undergoes agony in his solitary search for God. Self-denial might be translated into the ultimate goal of all ascetics: mystical union with God, an ecstatic vision of the transcendent reality lying beyond earthly appearances.

The theme of mystical experience in withdrawal still interests artists such as Bill Viola, who does not use a paintbrush but explores modern technology to communicate the spiritual dimension of solitude.

Christianity and the antique

The two most important forces to have shaped Western civilization are Classical antiquity – the legacy of ancient Greece and Rome – and the Christian religion. Harmony has not always existed between them: in early Christianity, the pagan worship of the ancient gods of Olympus was viewed with horror. The temples of ancient Greece and of the Roman Empire were filled with images of pagan divinities, condemned as idols by early Christians. Pope Gregory the Great (c.540–604) said that all these statues in Rome should be thrown into the River Tiber. Although the Emperor Constantine had legalized Christian worship in the Roman Empire in 313 AD, the sensuous art of the ancient world, and above all its celebration of the beauty of the nude human body, was still condemned by medieval Christianity, largely as a result of the distrust of ancient idolatry. The unclothed human body was considered by Christians to be naked and undignified rather than nude and beautiful – nudity was an occasion for shame rather than celebration.

The survival and revival of the antique

Christian artists still needed to find ways of representing Christ, Mary, and the saints, and ancient art provided visual models. The survival of ancient buildings and sculptures throughout Europe after the fall of the Roman Empire ensured its continued vitality as a source, even as Christian art became less representational and realistic. Christ, particularly in the guise of the Good Shepherd, could take on the idealized body of Apollo while losing the pagan connotations. In addition to this survival of ancient motifs in Christian guise, there were also revivals of the antique which aimed at emulating the visual culture of Rome, for example under the Emperor Charlemagne at Aachen around 800 and again during the twelfth century in France.

However, the greatest revival of ancient civilization in the West was the Renaissance, a cultural movement which started in Italy in the fourteenth century, and whose values had spread to much of Europe by the sixteenth century. Florentines led the way in reviving the use of the Classical architectural orders and in looking at ancient statues and reliefs with new attention. From the 1400s, sculptors such as Donatello and architects such as Brunelleschi, with the support of humanist scholars and enlightened patrons, created works that were self-consciously based on the antique. No fifteenth-century painter more exemplified this cult of ancient art than Andrea Mantegna, who from 1460 was court artist to the Gonzaga family at their sophisticated court in Mantua, in the north of Italy. Because no major figurative paintings from ancient times had survived, he looked at Classical sculptures

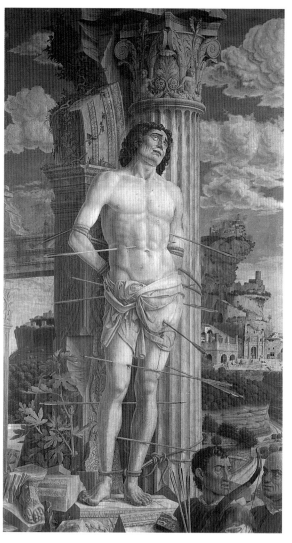

◄ **The cult of the antique**
High above a rocky landscape, the Roman soldier and martyr St Sebastian is tied to a massive corinthian column in the ruins of an ancient building. Naked as a pagan god save for a loin cloth, he looks up to God while his coarse-featured tormentors ignore his agony. He stands on ancient fragments – to the left, the foot of an ancient statue echoes his own, as if Mantegna, the most antiquarian of artists, wished to remind viewers that the dead marble of ancient art could be given flesh in Christian painting.
Andrea Mantegna, *St Sebastian*, c.1480.

▼ **A new synthesis**
This is one of a series of designs made by Raphael for tapestries, woven in Brussels and placed in the Sistine Chapel, Rome, depicting the acts of the Apostles. Here St Paul tears his clothes because the citizens of Lystra are sacrificing a bull to him, believing him a god. Painting in the grand style of the High Renaissance, Raphael has used his knowledge of ancient art and architecture in the depiction of the sacrifice, in the triangular altar, and in the surrounding Classical buildings.
Raphael, *The Sacrifice at Lystra*, 1515–16.

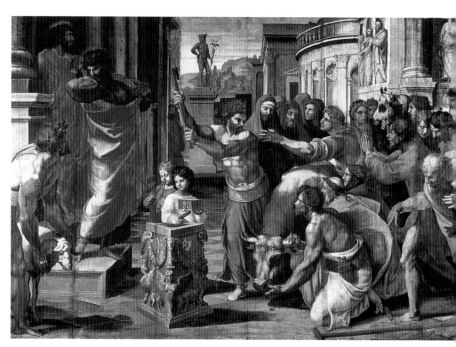

and architectural fragments and incorporated them into his unique style, in which figures appear to be made of stone or bronze.

From around 1500 a new generation of artists created a synthesis between Christian iconography and ancient art, based on an intense study and understanding of Classical works. Rather than quoting from these works, artists such as Michelangelo and Raphael utilized their underlying grammar of form, creating a truly classic style known as the "High Renaissance." Both artists worked in this style for a series of popes in Rome, but it was the rejection of exactly these paganizing values by Luther, who had been to Rome in 1511, that led to the iconoclasm of the Protestant Reformation in northern Europe (see pages 64–5).

The antique after the Renaissance

Interest in antique art persisted despite the impact of religious reform, and Rome remained a centre of attraction to foreigners with a love of the antique. The Frenchman Nicolas Poussin lived in Rome from the 1620s, and his contemporary and fellow countryman the landscape painter Claude spent much of his life there. Academies of art were founded that made the copying of ancient statues part of the educational curriculum of painters, and from the 1750s Rome became the focus of the Neoclassical movement, a new revival of the antique, based on the exact and archaeological study of ancient remains.

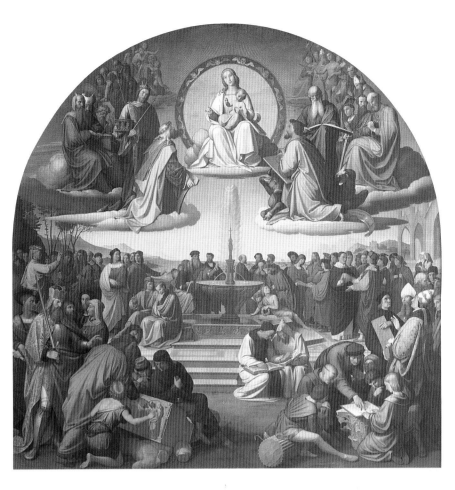

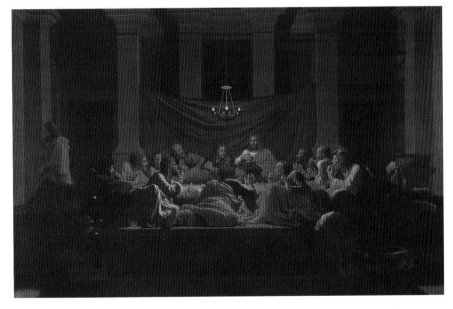

A classical gathering
From a series depicting the sacraments of the Catholic Church painted in Rome by the French artist Nicolas Poussin, this represents the establishment of the Eucharist by Christ at the Last Supper. Seated in a darkened and severely Classical interior lit only by a Roman oil lamp, Christ and his disciples recline on couches in the ancient Roman style rather than upright, as conventionally depicted. Poussin was aware that the Jerusalem of Christ was part of the Roman Empire.
Nicolas Poussin,
The Sacrament of the Holy Eucharist, 1647.

The age of faith
A Brotherhood of St Luke was formed in 1809 by German artists led by Overbeck and Franz Pforr. Known as the Nazarenes, they settled in Rome with the aim of reviving religious painting. Their creed is set out here: a group of artists including Dürer, Memlinc, Fra Angelico, Mantegna and Raphael, presided over by the Virgin, gather together in an ideal assembly. In the background a Gothic cathedral is under construction, a symbol of the new age of faith that will fuel German romantic longings for unification.
Johann Friedrich Overbeck,
The Triumph of Religion in the Arts, 1831.

It is therefore ironic that in 1810 a community of long-bearded German painters newly converted to Catholicism should settle in Rome. Known as the Nazarenes, they re-explored the age-old tension between Christianity and the antique with new conviction, believing that the study of ancient sculpture had corrupted the original simplicity and religious truthfulness of Christian painting. To regenerate religious painting, they felt that art before Raphael's stay in Rome from 1508 should be emulated, and such beliefs were to be adopted by the Pre-Raphaelite Brotherhood established in England in 1848. It is a further irony that Overbeck's composition for the painting *The Triumph of Religion in the Arts*, which shows rejected antique fragments in the foreground, should be based on Raphael's frescos, executed from 1509 for the Stanza della Segnatura in the papal apartments in the Vatican, as these exalt the fundamental unity of the Christian religion and Classical civilization.

Christendom divided

In October 1517 Martin Luther, an Augustinian monk, attached ninety-five theses to the door of the church at Wittenberg Castle, Saxony. In these he attacked the sale by the Church in his native Germany of Indulgences (the reduction of periods of punishment in Purgatory) in return for money to rebuild the Basilica of St Peter in Rome. His condemnation of the abuses of the Renaissance papacy and of the perceived corruption of the entire fabric of late medieval devotional practices, including the worship of saints, was to lead to a total breach between Rome and many parts of Germany. In Lutheranism, some religious images continued to be

produced, and prints were used in an ongoing war of images against Catholicism. As the Reformation spread throughout northern Europe, however, more militant forms of Protestantism, with more restrictive approaches to the use of religious images, arose in Switzerland, France, and Holland, in the Protestant Netherlands. Europe was divided by war in a general crisis which was not settled until the Peace of Westphalia in 1648: whole kingdoms, including England, broke their ties with Rome, splits which last to this day.

The destruction of images

This division of Christendom destroyed the unity of medieval Europe and had vital consequences for religious art. The cult of the Virgin Mary as a figure equally as important as her son was attacked by the reformers, as were devotions to the saints, and demand for their images declined accordingly in Protestant countries. The denial of the Real Presence in the Mass (see page 50) resulted in a decline of elaborate decorations and furnishings for altars and of major altarpieces. In their more extreme forms, and especially in their earlier phases, Protestant movements actually called for the wholesale destruction of religious images as well as banning the production of new ones. Religious paintings were thought to have led to idolatry in popular religion and to have furthered a cult of earthly beauty rather than divine worship. Religious images were destroyed in parts of Germany and Switzerland – Holbein's decision to leave Basel in Switzerland in 1530 was hastened on this account – while in the Netherlands iconoclastic fervour reached a peak with the *Beldersturm* (Storm of Images) of 1566.

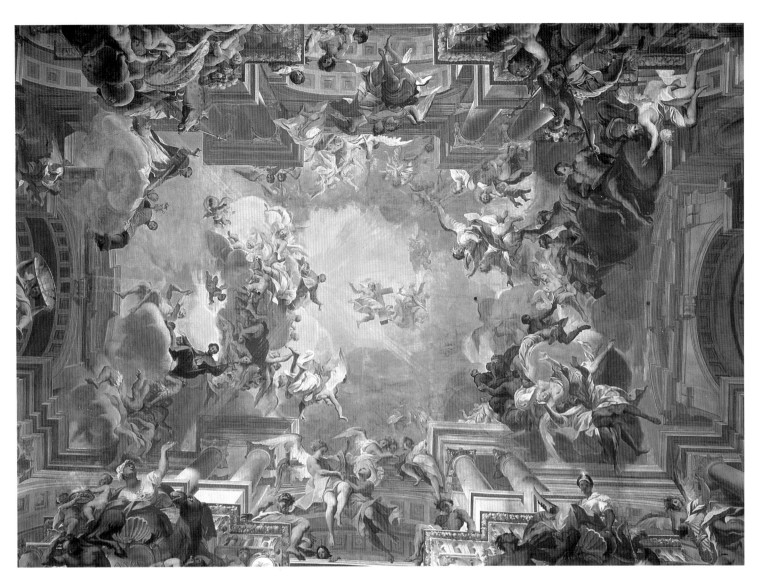

These attacks on religious images led not just to the permanent loss of much medieval and Renaissance art, but also to the purging for good of religious images from many church interiors. Thus in the Protestant Netherlands the whitewashed interiors of churches depicted by Pieter Saenredam can still be seen today, while many of the churches designed by the architect Christopher Wren for London in the wake of the Great Fire of 1666 have similarly stark interiors. In these countries, painters had to find other ways of exercising their skills, which helped to give rise to the importance of genre painting and still life in Holland, and the dominance of portraiture in England.

The Counter-Reformation

In the Catholic world, and above all in Italy, Spain, France, and southern Germany, a counter-offensive was organized by the Church. Known as the Counter-Reformation, this movement for church reform, at once administrative and doctrinal, led to the convocation of the Council of Trent which, in its final session in 1563, defended the existence of religious images against the claims of Protestant iconoclasm. Stricter controls were placed on what paintings could represent, and in 1573 the famous artist Veronese found himself questioned by the Inquisition in Venice about the contents of a Last Supper he had painted. A new religious order, the Jesuits, founded by St Ignatius Loyola in 1534 and recognized by the Pope in 1540, was to become one of the most powerful arms of papal authority. The order began to make use of visual media in its programme of reaffirmation of Catholic dogma.

By the seventeenth century the Catholic world's belief in the efficacy and persuasive power of art was expressed in a style known as the Baroque, which fused together sculpture, painting, and architecture in overwhelming theatrical visions, often on the grandest of scales. Illusionism was employed in paintings to give worshippers the feeling that they were themselves involved in the heavenly rapture or physical torments of saints, and that the ceiling above their heads had been blown away, revealing a celestial realm beyond their own earthbound lives. This style was exported not just across Mediterranean Europe and southern Germany, but also to the Catholic New World, whether Latin America or the Philippines, as part of the Catholic Church's reassertion of its religious authority and of its universal mission of conversion.

Alternative visions

In the West many have held views outside the framework of the Christian Church and have sought distinctive visual forms for them. There were entire non-Christian communities such as the Jews or the Muslims in Spain. Within Christianity there were heretical sects like the Albigensians in Languedoc, persecuted by the newly founded Inquisition from 1233. There have also been individuals who sought union with God in the personal isolation of mystical experience. Some minorities held anti-Christian beliefs, and those suspected of devil worship were victimized as witches, but few invented distinctive pictorial idioms.

The margins of Christianity

In medieval and early modern Europe the borderline between popular religion and deep-rooted paganism was fuzzy, and the distinction between magic and religion unclear. These ambiguities emerged at carnivals, traditional rites, and the widespread idolatrous worship of religious images. At higher levels of society, among a minority of humanist scholars for example, there may have been some scepticism about Christianity. Such views were not legally tolerated: the founder of one Roman academy dedicated to Classical study, Pomponio Leto, was suspected of harbouring pagan views and imprisoned by the Pope in 1468. Even during the Reformation both sides still accepted the Creed, the basic tenets of the Christian religion.

Images in the Catholic world presumed acceptance of Christian iconography and its picture of salvation. The sixteenth and seventeenth centuries witnessed the growth all over Europe of other genres of painting, such as portraiture and landscape, which widened the range of subject matter in paintings. They were not, however, intended to challenge the Christian view of the world, Protestant or Catholic, but coexisted with it.

It was only with the scientific revolution of the seventeenth century and the Enlightenment in the eighteenth century that the hold of the Church and its doctrines began to loosen, and notions began to emerge of indefinite human progress ensured by the perfectibility of man and of nature acting as a machine, governed by discoverable laws. French thinkers even questioned the existence of a personal God and the universal validity of Christianity and attacked superstition in general. During the French Revolution the separation of Church and State was instituted, and the Christian calendar was abolished and temporarily replaced with a new one that

State religion

In June 1794, on the Champ-de-Mars in Paris, a festival in honour of the "Supreme Being" was held at the orders of Robespierre, who was viewed by many as a dictator after his swift rise to power in the wake of the French Revolution of 1789. At the festival, the "God of Liberty, Father of Nature" was honoured at the "Altar to the Nation," and was represented as an ancient hero on a column placed next to a "Tree of Liberty." Hymns were sung eulogizing republican virtue, good citizenship, and the glory of France, and denouncing kingship and tyranny. This occasion, depicted here in a contemporary painting, marked the birth of the religion of the state, which held the state to be the ultimate object of reverence, and in itself the justification for general obedience. Robespierre was himself beheaded the following month.

Attributed to Pierre-Antoine Machy, *Festival of the Supreme Being*, 1794.

Pantheistic visions

This is the smaller of two versions of this work by the German painter Runge. He envisaged a series of the times of day that would decorate a neo-Gothic temple celebrating a pantheisitic religion, to the accompaniment of choral music. Here the dawn in the form of a naked woman – Aurora – greets the newborn child beneath her. A lily grows above her, from which spirits spring in a circle beneath the morning star. This is a mystical vision of spiritual renewal in which light plays a regenerative role, as it often did in Christian iconography.

Philipp Otto Runge, *Spring Morning*, 1808.

Paradise regained

Having lost his Christian faith, the French artist Paul Gauguin sought alternatives in "primitive" cultures. He returned to Tahiti in the French Pacific for the second time in 1897, and painted this picture shortly before a suicide attempt. It is the summation of his ideas on art and religion, starting on the right with birth and ending with the peaceful death of an old woman presided over by a blue idol on the left. Two women to the right reflect on their destiny, while a boy picks fruit in the centre: "simple beings in a virgin nature, which might be the human idea of paradise," as Gauguin wrote of this work.
Paul Gauguin, *Where Do We Come From? Who Are We? Where Are We Going?*, 1897.

Totem

Jackson Pollock explored forms by layering them on top of each other, uncovering new ones in a process of pictorial archaeology in which he, in his own words, "veils the image." At the foundations of this work Pollock unearths a potent hieroglyphic totem, bristling with sacred energy, reminding the viewer of Western civilization's roots in ritual and tribal custom. This is only one of many totemic images derived from the art of North American Indians that Pollock painted between 1937 and 1953.
Jackson Pollock, *Totem Lesson II*, 1945.

ished, especially in German culture in the work of painters such as Caspar David Friedrich and Philipp Otto Runge, where the worship of nature was subsumed into a pantheistic celebration of the presence of the divine in flowers, trees, water, and air.

The nineteenth-century clash between religion and science led to a new critical approach to the Bible and new ways of looking at Christ as man rather than God, especially after Darwin challenged the account of Creation contained in Genesis in *The Origin of Species* (1859). Toward the end of the century, painters such as the Frenchman Paul Gauguin began to look for alternatives to traditional European Christianity – Gauguin himself sought answers to the meaning of life by exploring the religious and artistic traditions of Polynesia.

In the twentieth century extraordinarily few truly innovative paintings were produced either for churches or within the framework of traditional Christian iconography. The German artist Max Beckmann employed canonical formats such as the triptych for his modern subject matter, while Marc Chagall reinterpreted subjects such as the Crucifixion from a Russian-Jewish perspective. After the Second World War painters in America such as Barnett Newman, Mark Rothko, and Jackson Pollock all explored religious themes, but using the new visual language of abstraction (see pages 246–7). Newman worked on the theme of the Passion, but with Jesus as a man abandoned by God, while Rothko's canvases are full of mystical energy, unspecific to one religion. Pollock, like Gauguin and others before him, explored "primitive" religions, such as those of the Mexican and the North American Indians, in his search for the fundamentals of the human psyche. Post-modern artists such as the Englishmen Gilbert & George exploit traditional religious iconography, but with knowing irony, given that Christianity is no longer the only bedrock of Western societies, with their competing values and their growing multi-culturalism.

commenced with the start of the secular revolutionary era rather than the birth of Christ. In the twentieth century, totalitarian regimes, whether Fascist or Marxist, used alternative iconographies of exemplary heroes and mythic achievements to create a religion of the state, glorifying secular power through visual propaganda.

Subjective religions

From the late eighteenth century, artists increasingly turned to new sources of religious inspiration – the visionary English artist William Blake produced images and poetry based on his very personal reading of the Bible and his self-made mythological system, in radical opposition to official doctrines of religion and art. With the emergence of Romanticism, alternative and more subjective representations of religious experience flour-

The Last Judgement

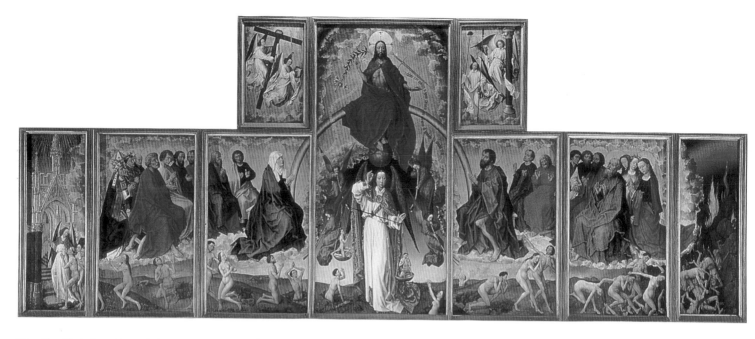

In the Christian view of time, the world has a beginning, the Creation, and an end, the Last Judgement. The latter is not described in the Bible, although in the New Testament's last book, Revelation, St John described in symbolic language the Apocalypse, the violent end of the world, the final triumph of the forces of good over the Antichrist and the forces of evil, the Second Coming of Christ, and the establishment on earth of the Heavenly Jerusalem. This was seen as the era of the four last things: Death, Resurrection, Judgement, and either Heaven or Hell. When exactly the end of the world would occur was a matter of debate, and the first millennium in 1000 AD was one of a number of portentous dates met with trepidation by many Christians.

Establishing an iconography

Although images were painted of the Apocalypse, most depictions of the world's end concentrated on the Last Judgement. Some paintings of Last Judgements were incorporated in altarpieces, but many appeared as large murals, located, as for example in the Scrovegni and Sistine Chapels (see pages 24–5), on the end walls of churches or chapels, or in government halls. In England these paintings were called "Dooms," as they represented Doomsday and the Day of Wrath.

In early Last Judgements, a standard iconography for the scene had not been established – the sixth-century mosaic in the apse of San Apollinare Nuovo at Ravenna, Italy, shows Christ with sheep to his right (symbolizing the saved) and goats to his left (symbolizing the damned). By the ninth century, however, a consistent depiction of the Last Judgement had been formulated in Byzantium and was soon transmitted to the West.

This Last Judgement is a composite image which combines a number of different elements: the Second Coming of Christ, enthroned as Judge and Ruler; the Resurrection of the dead to be judged; the defeat of evil and the final establishment of the Kingdom of God. The composition was usually schematic and symmetrical, with Christ placed high in Heaven at the centre, the blessed arranged on clouds just below him, and Mary to his right and St John the Baptist to his left, both interceding for sinful humanity. Immediately beneath Christ was placed the Archangel St Michael, presiding over the whole occasion as God's general, and holding in his hand not a sword but the scales in which the good and the bad deeds of men and women are to be weighed and their ultimate fate decided. Seven other angels blow trumpets to arouse the dead.

At ground level the dead emerge from their graves, physically reconstituted in their original bodies. The saved move toward the right of Christ (our left) where the gate of Heaven could sometimes be located, and the damned toward his left (our right) and the mouth of Hell. Angels escort the saved to eternal salvation, while devils and demons are usually involved in brutalizing the damned and herding them toward eternal perdition.

Changing interpretations

In the *Last Judgement* painted by Michelangelo from 1536 on the altar wall of the Sistine Chapel in Rome, the whole composition was organized not just symmetrically in horizontal tiers, but also with a general circulatory motion in which the saved are shown rising to Heaven on the right of Christ and the damned, on his left, are shown being dragged downward to Hell. After

▲ **Divine justice**
This multi-panelled altarpiece was commissioned from the fifteenth-century Netherlandish painter Rogier van der Weyden by Nicholas Rolin, Chancellor of the Duke of Burgundy, for the chapel of a hospital for the poor at Beaune. It is here shown open, with Christ enthroned at the top of the tall central panel. To the immediate right of his head (on our left) is the lily of his mercy, on the other side is the sword of his vengeance. He is seated on the rainbow of God's Covenant with mankind. In smaller panels on either side at the top, angels carry the instruments of the Passion, used in his torture and Crucifixion. Beneath him stands St Michael, weighing souls in his scales, surrounded by angels blowing trumpets. In the two panels on either side Mary (on our left) and St John (on our right) intercede for humanity, and the blessed stand on clouds behind them. Below, men and women emerge naked from their graves: the damned are propelled by their own shame to the mouth of Hell in the far right panel, while the saved move toward the gate of Heaven on the far left.
Rogier van der Weyden,
The Last Judgement, 1443–51.

These two frescos, showing the damned (right) and the saved (left), are part of a series of murals depicting the end of the world by the Italian painter Luca Signorelli for a chapel in Orvieto Cathedral, Italy. They were commissioned on the cusp of the half-millennium (1500), when the coming of the Antichrist had been widely prophesied. The damned, completely naked, are tortured by multicoloured devils who, driven from heaven by archangels, fly off with their victims or let them fall to earth, herding them to the mouth of Hell on the left. While the damned writhe and struggle, the saved, strewn with flowers and crowned in glory, assemble in ecstasy to the accompaniment of heavenly music, awaiting their ascent to paradise. Signorelli also used this subject, chosen by the church authorities, to paint the naked human form in a variety of postures and so display his artistry. **Luca Signorelli**, *The Saved* and *The Damned*, 1500–4.

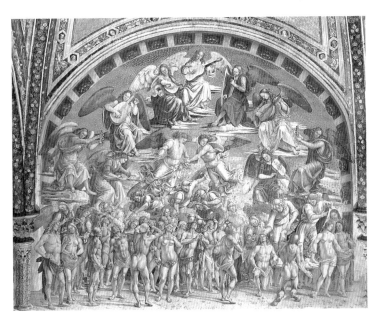
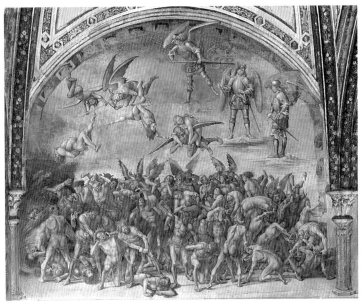

◄ **Village resurrection**
In this very personal vision, the English painter Stanley Spencer places the Resurrection in the graveyard of his local parish church at Cookham. People are naked or clothed, and a beardless, mother-like Christ is enthroned under the church's flowery porch. The artist himself lies on a book-like grave to the right, while others, including his wife, emerge from their graves. Here there is no punishment but only peace and love in a transfigured world, as the dead are transported to Heaven in the boat in the painting's top left-hand corner.
Stanley Spencer, *The Resurrection, Cookham*, 1924–7.

Michelangelo's fresco was unveiled in 1541 it was criticized for the nudity of many of its figures and for its supposed inaccuracies. Among these were the fact that Christ would be enthroned at the Last Judgement, not standing as Michelangelo had shown him; that angels were supposed to have wings; and that he should not have included the pagan figure of Charon (the ferryman who in Classical mythology escorts the damned across the River Styx to Hades, the ancient underworld). Nonetheless, Michelangelo's dramatized vision of the Day of Wrath was followed by the Venetian painter Jacopo Tintoretto in the 1560s and by the Flemish painter Peter Paul Rubens in the seventeenth century.

Representations of the Last Judgement were meant to strike terror into viewers, placing their lives in the context of the theology of the final days: death, resurrection, and judgement. But not all artists have treated resurrection as a terrifying event. In the 1920s the English painter Stanley Spencer located it in his own village of Cookham, describing his vision of it joyfully: "No one is in any hurry. . . . Here and there things slowly move off but in the main they resurrect to such a state of joy that they are content. . . . In life we experience a kind of Resurrection when we arrive at a state of awareness, a state of being in love, and at such times we like to do again what we have done many times in the past, because now we do it anew in Heaven."

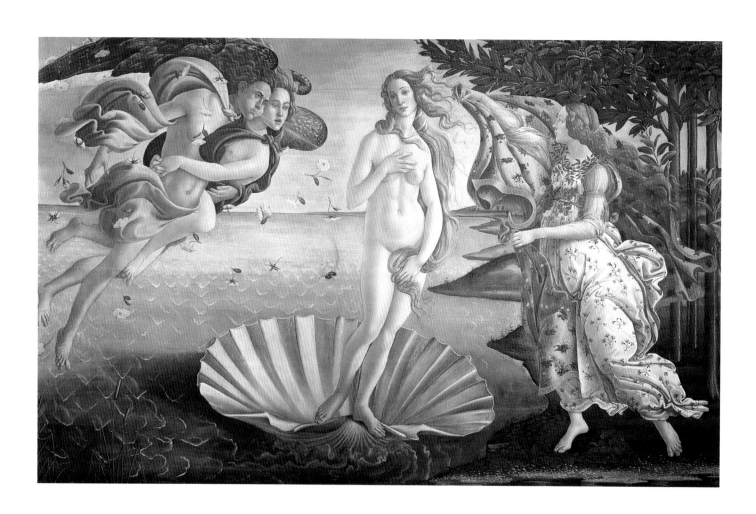

"Fable is art's patrimony, an inexhaustible wellspring of ingenious ideas, joyous images, interesting subjects, allegories and emblems . . . in myth everything is alive, everything breathes the breath of an enchanted world, one in which symbols have bodily form, where matter takes on life."

Chevalier de Jaucourt, *Encyclopédie*, 1751–65

Myth and Allegory

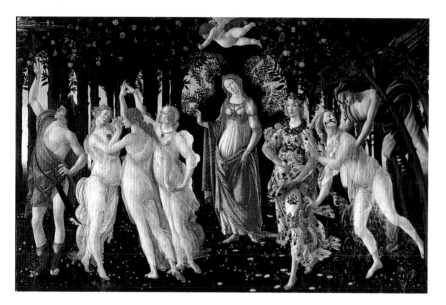

Springtime

This painting, one of the first since antiquity to depict Classical deities on a large scale, may be inspired by Ovid's poetic calendar *The Fasti* and depict the year's cycle. At the touch of Zephyr, the West Wind, the nymph Chloris was transformed into Flora, symbol of Spring, represented by Botticelli as a garlanded woman. Venus and Cupid in the centre, attended by the Three Graces and Mercury on the left, may be composites of descriptions given by a number of Classical texts.
Sandro Botticelli, *Primavera*, c.1481.

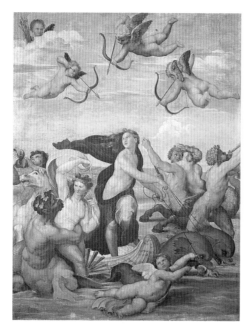

The word "myth" derives from the Greek *mythos*, or story. A myth is a fictional story used to explain fundamental human behaviour or to present a message. Nineteenth-century anthropologists noted that all peoples created their own myths and the Swiss psychoanalyst Jung wrote of mythology as the use of stories to reveal essential truths. From the prehistoric oral tradition to modern films, myth has provided artists with narratives which they have used to illustrate themes such as truth, fear, or desire. They have also used myth allegorically, often to tell of love or expound a patriotic theme.

Classical mythology

The fountainhead of Western culture is ancient Greece, whose myths were established by the time of Homer (ninth century BC) and were elaborated by the ancient Romans more than two thousand years ago. Classical myths persisted through early Christian times and the Middle Ages, to enjoy a full flowering in the Renaissance. Rediscovered works of Greek and Roman literature by Homer, Virgil, Apuleius, and, above all, Ovid told of gods and heroes involved in adventure, love and sexual dalliance, crime and punishment, cruelty and revenge, and these stories inspired artists and their patrons alike for centuries. From 1450 to 1850 Classical mythology was the subject of much painting in European art, and it has remained an important source of imagery and inspiration for painters despite the diversification and expansion of artists' subject matter.

The widespread interest during the Renaissance in the Classical gods of, for example, love, war, wine, and the harvest led to their use as allegorical figures. Many depictions of Mars and Venus express allegorically the desire to see the ability of love to overcome man's warlike instincts. Minerva, goddess of wisdom, is often shown presiding over the arts and civilization, and therefore is used by painters of political allegory to suggest a civilizing presence.

Allegorical images, in which figures represent emotions or other personal qualities, were used from the fifteenth century to celebrate,

Exuberance

Galatea, a nymph of the sea, rides her shell chariot through a crowd of mythological figures where even the harnessed dolphins, among the centaurs and mermen, look mythic. This fresco provided a backdrop to entertainments staged at the villa of Agostino Chigi, a wealthy Roman banker. A comparison with Botticelli's slightly earlier *The Birth of Venus* (see page 106) shows that the gentle and "sweet" painting style of the early Renaissance has been supplanted by the confidence and exuberance of the High Renaissance.
Raphael, *Galatea*, c.1506.

Staged movement

Atalanta, a beautiful, athletic virgin, was reluctant to marry and demanded that her suitors challenge her in a running race in which the penalty for losing was death. Hippomenes, excited by her beauty, decided to compete. He implored the help of Venus, who gave him three golden apples to throw to the ground during the race to distract Atalanta and allow him to overtake her and win. Here the Italian painter Reni depicts the movements of the two competitors almost choreographically.
Guido Reni, *Atalanta and Hippomenes*, 1612.

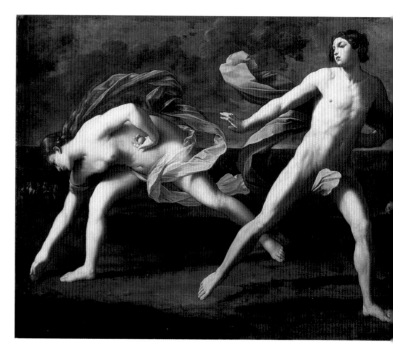

flatter, or warn. For example, they adorned wedding gifts (see page 74, Botticelli, *Venus and Mars*), were represented in paintings given to rulers (see page 99, Bronzino, *An Allegory with Venus and Cupid*), or decorated churches and private and public buildings.

Paintings of myth and allegory served a wide variety of purposes. For the princes of the Renaissance courts they were often a vehicle through which a patron could display his or her learning, commissioning works with carefully contrived iconographical programs, perhaps drawn up by court scholars from a wide variety of Classical texts. Others with less erudite tastes may have sought only the thrill conveyed by the scenes of sexual dalliance and violent action that proliferate in myth and were frequently treated by painters. From the seventeenth century, Church and State developed the use of allegory in huge pictorial schemes celebrating religious and secular achievements. During the eighteenth and early nineteenth centuries the annual exhibitions at venues such as the Salon in Paris and the Royal Academy in London, where large-scale narrative paintings on Classical themes were particularly favoured, provided artists with the opportunity to appeal to the public directly. In post-revolutionary France, scenes from Classical mythology, allegory, and history were commissioned and publicly exhibited to promote notions of patriotism, civic virtue, and moral probity.

Mythologizing the past

During the nineteenth century, which in Europe saw the rise of nationalism and colonial expansion, the canon of myth widened as many people looked back to past glories and mythologized their homeland. Some British artists turned to the tales of King Arthur and the Knights of the Round Table, while in Germany an alternative to the Classical gods was provided by a pantheon of Teutonic gods and legends. Images based on medieval tales extolling chivalry and romance, courtly love, and noble adventure offered an escape from the ugliness of the industrial era.

In the second half of the nineteenth century, painters of the emerging modern movement preferred to represent themselves engaged in the activities of modern life, and in so doing cast aside the subject matter of myth, allegory, and history. However, the twentieth century saw a reinterpretation of myths, often invigorated through Freudian or Jungian interpretation, by painters with a wide diversity of styles, including Picasso, Beckman, Pollock, and Nolan.

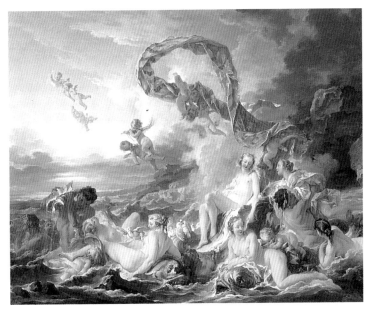

◀ **Rococo fantasy**
The French artist Boucher painted this erotic work simply to delight. A naked Venus reclines on her half-shell chariot, presiding over figures whose hair, decorated with pearls and seaweed, refers to the sea from which the goddess was born. A triton lifts a sea nymph, who presents Venus with a string of pearls on a shell. The frolics continue above, as cupids flit through the air and the silken fabric is lifted by a sea breeze.
François Boucher, *The Triumph of Venus*, 1740.

▶ **A legendary warrior**
Deriving from a fusion of Celtic myth and medieval literature, the mysterious island of Avalon was the final resting place of King Arthur. Legend has it that his sword was forged at Avalon and that he was brought here after his last battle to have his wounds tended by enchantresses. The British painter Burne-Jones evokes the Middle Ages as a lost Golden Age in this dreamlike image of Arthur and his nurses beneath a canopy richly decorated with the exploits of the king and his bold Knights of the Round Table.
Edward Burne-Jones, *King Arthur in Avalon*, 1881–98.

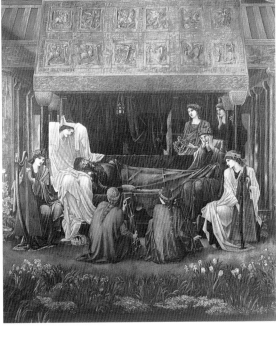

◀ **Abduction**
Europa, the sister of Cadmus, caught the eye of Jupiter, who transformed himself into a snowy bull and abducted her. This act led to the birth of three offspring. Many painters depicted the abduction, usually making the bull's brute force a metaphor for rape. In this deliberately primitive work the Russian artist Serov shows Europa on the animal's back, in an interpretation that focuses less on the brutish aspect of the abduction than on the exotic and magical nature of the myth.
Valentin Alexandrovich Serov, *The Rape of Europa*, 1910.

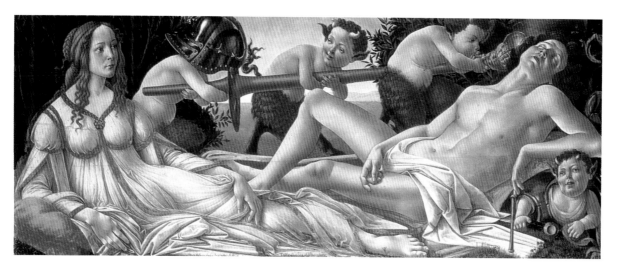

For around a thousand years Rome was a wasteland, a shadow of its former greatness. From AD 500 to 1400 the city which had been the heart of one of the most powerful empires the world had seen became a place of desolation. Sheep and cows grazed in the Roman forum where great orators had addressed a wealthy and élite citizenry. Later visitors to the city looked in wonder at the ruins of once-great buildings, arches, and statues, and lamented the dereliction.

Naturally many attempts were made to resurrect the glories of Rome. The Carolingian Renaissance was an early ninth-century example, but the most important of these rebirths of interest in Classical antiquity is the Renaissance, which began in the early 1400s in Florence and spread throughout Italy during the fifteenth century, and beyond Italy to the rest of Europe in the following century. In medieval and Renaissance Italy the Classical world was almost tangible. Ruins of Imperial greatness were visible not only in Rome but also elsewhere in the peninsula, and later inhabitants looking at the remains of colossal buildings and statuary longed to recreate the beauties, learning, and power of the fallen empire.

A Golden Age recreated

In 1430 the Florentine humanist Poggio Bracciolini wrote an elegiac lament on the ruins of ancient Rome which evokes the nostalgia he and his compatriots felt for ancient Rome as a lost Golden Age: "Not long ago . . . Antonio Lusco and I . . . used to contemplate the desert places of the city with wonder in our hearts as we reflected on the former greatness of the broken buildings and the vast ruins of the ancient city, and again on the truly prodigious and astounding fall of its great empire and the deplorable inconstancy of fortune." These scholars of the Classical world mourned the "ruin of Rome," wept over the decline of "the Capitol that our

▲ **Military prowess**
Mantegna was passionately interested in the Classical world. In his series of nine paintings *The Triumphs of Caesar* this Italian Renaissance painter celebrated Rome at the beginning of its imperial greatness. This one shows Julius Caesar's triumphant entourage bearing the spoils of war. Long trumpets are blown victoriously and banners below them proclaim the emperor's name. King Charles I of England bought the series in 1629 and it became one of his most prized possessions. It was among the few fifteenth-century works still to be seen as a masterpiece during the following century.
Andrea Mantegna, *The Triumphs of Caesar: Vase Bearer and Bearer of Trophies and Bullion*, c.1486–94.

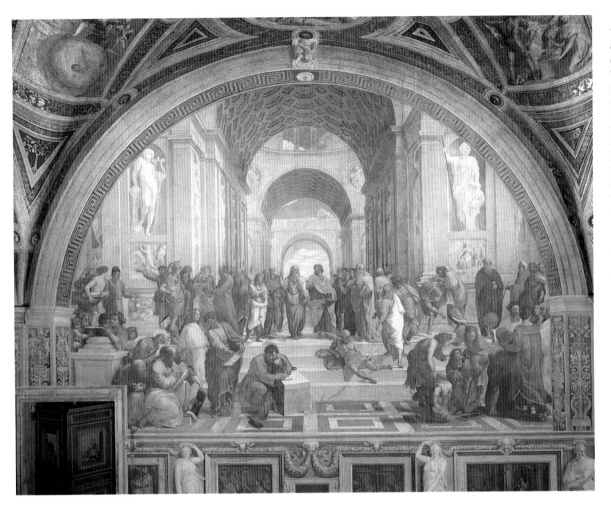

Virgil celebrated," and saw its fall as a disaster greater than any other calamity which had befallen any other city. Rome had ruled the western world from before the birth of Christ until its fall in the early fifth century AD. Imperial Rome had produced great men, rulers, and warriors. It had fostered the arts, administered an effective legal system, and commanded a military discipline which had governed the known world. Moreover, Republican Rome was seen as a model of virtue, a city of morally upright, law-abiding citizens.

In order to recreate this lost grandeur of ancient Rome it was necessary for more to be learned of the life, law, and history of the Classical world. Early humanists sent scribes all over Europe to discover, copy out, and bring back Classical texts. These texts, on architecture, law, history, and Classical mythology, were edited, translated, and published for a clientele of scholars and humanists eager to study different aspects of life in the Classical world. However, the religious climate of the Middle Ages was hostile to many of these secular Classical texts. In the widening world of the fifteenth century the tales of Classical mythology, which many Classical authors dealt with, opened up an exciting new range of subject matter which artists and their patrons embraced with enthusiasm.

In the visual arts patrons and painters looked to the Classical texts to supply information on the sort of paintings the Romans had owned and appreciated.

Almost no paintings from the Classical world survived; the murals at Pompeii and Herculaneum were discovered long after the Renaissance. Artists and patrons of the Renaissance were not able to look at examples of Classical paintings; they could only read about them in Classical texts, and some important works, such as those by Catullus (c.84–c.54 BC) and Philostratus (third century AD), supplied not only stories of Classical mythology but also actual descriptions of picture galleries and images. Such texts furnished patrons with the means of replicating lost Classical galleries. Patrons such as Alfonso d'Este, Duke of Ferrara, and his sister Isabella d'Este, Duchess of Mantua, commissioned artists to reproduce paintings reported in Classical texts.

Birthplace of the Renaissance

This rebirth of the ideals of the Classical world was keenly felt by the artists and thinkers of fifteenth-century Italy, who saw their age as having revived the cultures of Greece and Rome. In 1492 the philosopher Ficino wrote: "This century, like a Golden Age, has restored to light the liberal arts, which were almost extinct: grammar, poetry, rhetoric, painting, sculpture, architecture, music, the ancient singing of songs to the Orphic lyre, and all this in Florence. Achieving what had been honoured among the ancients, but almost forgotten since, the age has joined wisdom with eloquence, and prudence with the military art. . . ."

The gods of Olympus

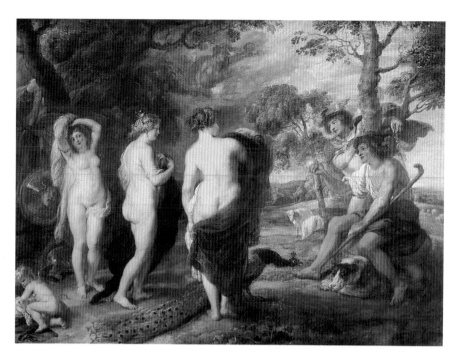

▼ Wrath of the gods
In this fresco, which he executed for the Palazzo del Tè in Mantua, Italy, the building's architect, Giulio Romano, painted a scene of pandemonium in which the gods of antiquity crush the upstart giants. Presiding over the scene from on high is an eagle, symbolizing the regal aspect of Jupiter, god of all the gods. Beneath an angry storm cloud the polymorphous Jupiter, also god of thunder and lightning, is represented in human form, brandishing a thunderbolt.
Giulio Romano, *Jupiter with Thunderbolt*, 1526–35.

The pantheon of the gods of ancient Greece was adopted by ancient Rome and so the Greek gods have Roman counterparts with alternative names but similar characteristics. The titles of Renaissance paintings use the names of the Roman gods because painters of the time took their inspiration from Latin writers describing Roman deities. From the eighteenth century onward a growing interest in Classical Greece was reflected in artists' source material, and there was greater use of Greek deities. In the twentieth century deities from both civilizations appeared in paintings.

Symbolic qualities

Each deity is identified by a symbol, and, like the Christian saints, is recognizable by his or her particular attribute. By far the most frequently depicted deity is Aphrodite or Venus, goddess of love and beauty, because of the importance of her sphere of influence and the opportunity she offered artists to depict an idealized female nude. She is identified in various ways: by the golden apple she wins in the beauty competition painted by, among many others, Rubens in *The Judgement of Paris*; by kissing turtle doves, as in Bronzino's *An Allegory with Venus and Cupid* (see page 99); or by the attendance of the Three Graces or Cupid.

Cupid, the Roman god of love, Eros to the Greeks, is recognizable by his quiver of love darts. He is often shown as an infant with his mother, Venus, as in the painting by Rubens shown here, but can also appear as an adolescent youth. Whichever guise he is in, he is almost always portrayed as naked and winged.

▲ Beauty contest
The Flemish painter Rubens shows Eris, goddess of discord, in the sky, witnessing the trouble she hopes will be caused by the golden apple she has thrown down to earth. Inscribed "to the fairest," this prize is sought keenly by Venus, Minerva, and Juno. Mercury, recognizable by his winged helmet and wand, has taken them to Mount Ida to be judged by Paris in a beauty contest to decide the winner of the apple. Minerva is identifiable by her owl, helmet, and shield; Juno by her peacock. Venus, in the centre, steps forward to claim the prize. She has bribed Paris with the love of the most beautiful woman in the world, Helen of Troy, and from these events will spring the Trojan War.
Peter Paul Rubens, *The Judgement of Paris*, 1632–5.

Artemis or Diana, goddess of chastity, hunting and the moon, provides another opportunity to paint a nubile naked woman. However, she is more psychologically complex than Venus, and her image is often more sexually charged in that the austere chastity she embodies contrasts with her physical desirability.

Juno, wife of Jupiter – the couple were known as Hera and Zeus by the Greeks – is identifiable by the presence of a peacock; the many eyes seen on its tail once belonged to Argus, who was used by Juno to keep watch on her errant husband. Greek Athene or Roman Minerva, goddess of wisdom, protectress of arts and crafts, and presider over peace, is accompanied by an owl, a symbol of wisdom. The Greeks described Athene as springing fully grown from the head of Zeus and wearing full armour: she is represented with helmet, spear, and a shield bearing Medusa's head – a reference to the shield she gave to the gorgon-slaying Perseus. In

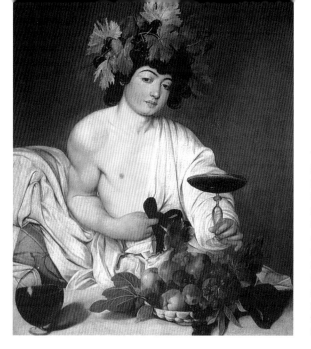

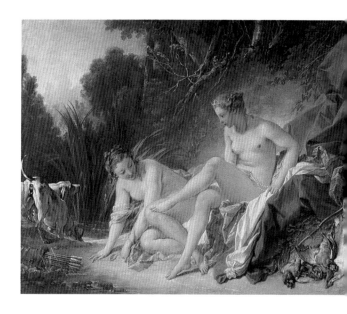

◀ **A contemplative Bacchus**
The Roman god Bacchus (known by the Greeks as Dionysus) is the god of wine. His followers, the Bacchantes, hunt for food at night and celebrate noisily with meat, wine, and music; the adjective "bacchanalian" describes frenzied, drunken revelry. This work by the Italian artist Caravaggio is unusual in depicting Bacchus as a lone and contemplative figure who stares thoughtfully at the viewer.
Caravaggio, *Bacchus*, c.1589.

▲ **Sophistication amid nature**
Diana, goddess of the moon, hunting, and chastity, is identifiable by the crescent moon on her headdress, the quiver of arrows on the left, and the bow and dead game on the right. As she is naked, Boucher could not indicate her divinity, as he would nobility, by the use of costly dress. Instead he includes pearls in her hands and hair, and a swath of silken fabrics on which she sits This sophistication contrasts with the natural setting chosen by the French Rococo painter.
François Boucher, *Diana after her Bath*, 1742.

allegorical works Minerva presides over peace, knowledge, and the arts (see page 102, Rubens, *War and Peace* and Spranger, *Minerva Victorious over Ignorance*.)

Of the male deities, Zeus/Jupiter is frequently depicted as an omnipotent power, identifiable by the eagle that symbolizes and often accompanies him and by the thunderbolt he wields. He can transform himself into other beings and objects (see pages 78–9). Aries or Mars, god of war, is readily identified as a warrior, clad in armour and bearing arms. Hermes or Mercury, the messenger god, is also the god of eloquence, and the conductor of dead souls to Hades. He is recognized by his winged helmet and winged sandals, and bears a caduceus, a winged wand with two serpents twined around it. He is also associated with peace and prosperity, trade and commerce, and is the protector of merchants. Mars and Mercury alike often appear in allegorical works depicting war, peace, or prosperity.

Dionysus or Bacchus is god of wine and also of fertility and frenzied, ecstatic revelry. He may be recognized by the vine leaves that he wears around his head or loins and by his chariot, which is led by leopards. He is accompanied by Silenus, a fat, often naked, old drunk, and also by his followers, the Bacchantes, who

▲ **God of the sea**
Neptune, god of the sea, known as Poseidon by the Greeks, is usually represented as a bearded figure bearing a trident. In this late nineteenth-century painting, the British artist Walter Crane, famous for his illustrations in children's books, offers this traditional image of the god of the sea, with flowing white hair and beard, bearing his trident in his outstretched right hand to command the waves over which he holds dominion. He depicts the waves imaginatively, as Neptune's rearing horses, their white manes forming billowing crests. The undulating line of the horses suggests the shape of a wave that is about to break on the shore.
Walter Crane, *The Horses of Neptune*, 1892.

hunt animals and drink, dance, and sing to excess (see page 80, Titian, *Bacchus and Ariadne*).

In painting, the gods and goddesses of the Classical world represent fundamental elements of life: love and war, food and drink, war and travel. As allegorical figures they symbolize the abstract qualities with which they are traditionally linked, such as love, war, and peace. From the Renaissance onward painters also used them to give a respectable gloss to erotic, cruel, or even comic subject matter.

Continuing inspiration

The myths of the gods of Classical antiquity expressed the emotions, fears, and concerns of the communities with which these deities were associated. Indeed, in contrast to the God of Christianity, they are like humans, only more extravagantly so. Embodying the most extreme passions of humankind, they often become embroiled in human dramas. They have continued to provide inspiration and imagery, not only for painters of the twentieth century and beyond but also in popular culture – in films, advertising, and comic books – and in a wide variety of other spheres, such as the space missions named after Apollo, the sun god.

The loves of Jupiter

Jupiter, as the Romans named the Greek Zeus, king and ruler of the gods of Mount Olympus, is the cosmic seducer. In his *Metamorphoses* the Roman poet Ovid writes of Jupiter's many loves. This compilation of Greek and Roman myths and legends, with its theme of perpetual change, inspired many artists and writers from the Renaissance onward. For centuries art patrons were familiar with Ovid's tales of Jupiter's infidelity. Not only did they recognize the key moment being depicted in any painting inspired by one of his stories but they also knew the frequently unfortunate sequence of events in which that scene played a part – knowledge that added piquancy to their viewing.

From his vantage point in the skies the omnipotent Jupiter spied out the most desirable of female mortals and, exemplifying Ovid's theme of transformation, seduced them by adopting a variety of disguises. He could appear in both male and female human form, take on the appearance of an animal or a bird, and even become a natural phenomenon such as a cloud or a shower of rain. The recipient of his attentions is never aware of his true identity as the god of all gods, and each of his conquests becomes pregnant, usually with disastrous results. Jupiter's exploits allowed artists the opportunity and licence to depict scenes of sexual dalliance that ranged from the playful to the overtly erotic and even brutal.

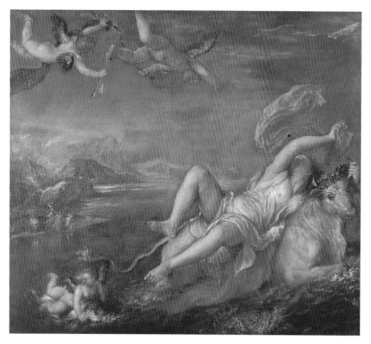

▲ **God of many forms**
To seduce Olympia, Jupiter, here identified by the eagle and thunderbolt, turned himself into a sea monster. The onlooker seen in profile mirrors the action of the viewer, lending a voyeuristic dimension to this work. Other scenes of seduction accompany this fresco in the Hall of Psyche at the Palazzo del Tè in Mantua, the city to which Giulio Romano fled to escape the scandal caused by a series of erotic works he made in Rome. The frescos in Mantua are some of the most sexually explicit scenes of the Renaissance.
Giulio Romano, *Olympia Seduced by Jupiter*, 1528.

◄ **Sensuality**
Taking the the form of a handsome white bull, Jupiter enticed Europa, a princess of Tyre, first into the shallows and then into deeper water. This is one of Titian's seven great mythologies, which he called *poesie*, painted for King Philip II of Spain. The vigour and sensuality of this painting may be interpreted as depicting either the terror and fear of rape or, as suggested by the attendant cupids, a rather alarming prelude to a joyous union.
Titian, *The Rape of Europa*, 1559–62.

▲ **Willing participation**
The seduction of Leda by Jupiter disguised as a swan is the most often painted of Jupiter's conquests – by Raphael, Leonardo da Vinci, and Michelangelo in the sixteenth century and later by Poussin, Rubens, Boucher, Géricault, Cézanne, Delvaux, and Dali. The swan depicted by the Italian artist Correggio combines a sexual urgency with a softness that echoes that of Leda's bare flesh. Leda's compliance suggests a languid lack of intensity, and the work's tenderness, delicacy, and gaiety anticipate the Rococo style of the eighteenth century.
Correggio, *Leda and the Swan*, 1534.

Golden rain

Danaë was held in a tower by her father, Acrisius, King of Argos, who hoped to disprove the prophecy that the son of his daughter would bring about his death. Seeing the captive from above, Jupiter transformed himself into a shower of gold and rained down upon her. Danaë conceived and gave birth to Perseus, who later unwittingly killed Acrisius when throwing a discus. **Titian**, *Danaë Receiving the Shower of Gold*, before 1553.

Ecstasy

Io, daughter of a river god, was lured into a shady wood by Jupiter, who, creating a veil of dark clouds of which he formed a part, ravished her. A close look at the painting reveals the god's face, satyr-like, above Io, while his arm of cloud embraces her like a bear's paw. Correggio's concept is both humorous and erotic, but the intensity of the moment depicted and the suggestion that Io is alone in her pleasure made the painting a byword for pornography in the eighteenth century. **Correggio**, *Jupiter and Io*, c.1530.

Comic eroticism

The flying figure in the pink robe is Jupiter, identifiable by his symbols, the eagle and the scorpion-like thunderbolt. In his arms is the infant Hercules, his son conceived by Alcmena, whom Jupiter seduced by disguising himself as her husband. Jupiter steals Hercules away to drink at the breast of his wife, the goddess Juno, so that the child might gain immortality. The Italian artist Tintoretto paints a scene at once comic and erotic in which Juno awakens and pushes away the suckling child, her milk spilling into the heavens, where its arc forms the Milky Way. This painting was probably one of four such works given to Emperor Rudolf II of Bohemia by the artist. **Jacopo Tintoretto**, *Origin of the Milky Way*, c.1575–80.

Pastoral pursuit

More insidious than any of Jupiter's non-human disguises are those where he appears as a friend or loved one of his prey. Disguised as Diana, the goddess of hunting, he seduces her handmaiden, the nymph Callisto. In this painting Boucher exemplifies the French Rococo style, creating an elegant and light-hearted pastoral idyll that has an erotic charm. Callisto's face registers both surprise at this unexpected attempt at seduction by the chaste goddess and the humble handmaiden's recognition of the impossibility of rejecting the amorous advances of an immortal. **François Boucher**, *Jupiter and Callisto*, 1769.

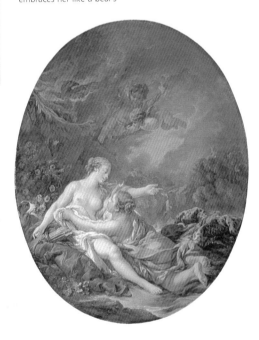

The painter's bible

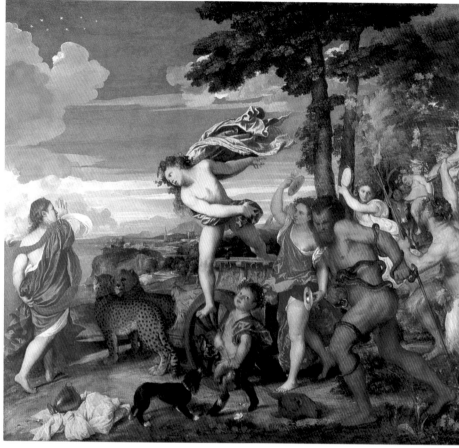

During the Renaissance an appreciation of the literature of Classical Greece and Rome led painters to search it for subject matter. In particular it was the work of Ovid, who wrote in Latin during the first century AD, that furnished the subjects for most paintings based on Classical mythology. The liveliness of Ovid's narratives made his texts immensely popular both during his lifetime and, much later, throughout the Middle Ages and the Renaissance.

Stories of passion and tragedy

Ovid's *Metamorphoses*, a collection of myths and legends in the form of a long poem, was particularly challenging to the teachings of the medieval Church. While telling of passion and tragedy, punishment and salvation, it espouses no clear morality. From the eleventh century Christian scholars had attempted to read Ovid's work as allegory. The most celebrated of these attempts is an early fourteenth-century poem, "Ovid Moralisé," by an anonymous Frenchman, in which characters from the *Metamorphoses* are identified with characters from the New Testament. In this way Actaeon, devoured by his hounds, becomes a symbol of Christ, and Phaeton, who fell to earth when his chariot was broken by one of Jupiter's thunderbolts,

is identified with Lucifer, the rebel angel excluded from heaven. Another moralized Ovid appeared in France in 1340; written by Pierre Bersuire in Latin prose form, this was an important source of inspiration for artists. Ovid was introduced into English literature by Chaucer in the same century, and was Shakespeare's favourite author, supplying him with the source material for many of his plays. In the sixteenth century the *Metamorphoses* was drawn on so frequently by artists that it came to be known as "the painter's bible."

But although Ovid's poem was chief among the Classical sources mined by patrons and painters alike, it was certainly not the only one. The multiple use of Classical texts to provide subject matter for paintings during the Renaissance is demonstrated by the works

commissioned in the early years of the sixteenth century by Alfonso d'Este, Duke of Ferrara for his private gallery. These included Bellini's *Feast of the Gods*, which was based on a legend in Ovid's poetic calendar the *The Fasti*. Bellini originally deviated from the text and the picture had to be altered to make it more faithful. Also in the room were Titian's *Worship of Venus* and *Bacchanal of the Andrians*, which were based not on mythological texts but on literary descriptions of Classical paintings by Philostratus, whose *Imagines* claimed to describe a collection of pictures in third-century Naples. For the scene of Bacchus and Ariadne, Titian was directed to another description of a lost picture, this time by Catullus, which included a reference to a man "girded with writhing snakes," depicted by Titian in the foreground. Other elements came from sources such as Ovid's *Ars Amatoria*. Titian did not read Latin and so presumably the relevant passages were chosen and translated for him by an adviser.

In contrast, Titian's later mythological paintings for Philip II of Spain were taken exclusively from Ovid's *Metamorphoses* (see page 78, *Rape of Europa*). In letters Titian described these as *poesie*, implying their origins in poetry and their comparable aims. Titian's *poesie* exerted an exceptional influence on later interpreters of Ovid, from his younger contemporary Veronese to artists such as Rubens in the seventeenth century.

The repertoire of Classical authors exploited by artists and patrons grew as time passed. In Britain in the eighteenth and nineteenth centuries the education of gentlemen consisted exclusively of the Classics: Greek and Latin language, literature, and history. Texts of antiquity provided narratives and poetry and also the history of the Classical world, which offered examples of government such as the democracy of ancient Athens, the austerity of the Spartans, and the philosophy of the ancient Greeks. Roman texts provided, in addition to narratives, histories in which patriotism and glory became an inspiration for generations of young men who derived from them the Classical attachment to nationhood.

Classical revival

Despite the use of other Classical texts, Ovid retained his pre-eminence and has continued to be mined by a wide variety of painters. Early in the twentieth century the founder of psychoanalysis, Sigmund Freud, became interested in Classical literature and mythology, where he found descriptions of actions that shed light on human behaviour. By the 1920s these sources were providing material for some of the greatest painters of the century. Picasso, for example, produced a body of Classicizing work that included *Nessus and Deianira*, a painting directly inspired by his reading of Ovid.

▼ **Idealized beauty**
An excuse to portray an idealized impression of male and female beauty, this work by the Venetian painter Veronese shows a scene from Ovid's *Metamorphoses*. The story tells of the passion of Venus for the beautiful mortal Adonis. Venus, identified by her infant son, the naked, quiver-bearing Cupid, seems to upbraid him for playing with one of the hounds, which she fears will awaken her lover asleep on her lap. The standing and recumbent hounds present an intimation of the fate of Adonis, who, while hunting, meets a gory death from a wild boar which he disturbs in its lair. **Paolo Veronese**, *Venus and Adonis*, c.1580.

▼ **Fatal pride**
Ignoring the words of his father Daedalus, who had made him a pair of wings, Icarus flew too near the sun. The wax which sealed the feathers melted, the wings loosened, and he fell to earth. The sorrowing sea nymphs singing their lament offer an image of pale, delicate female flesh that contrasts with the darker, masculine body of Icarus. **Herbert Draper**, *The Lament for Icarus*, 1898.

Demigods and heroes

Both demigods and mortal adventurers are the heroes of Classical mythology. Perseus and Hercules, half divine and half human, were the sons of Jupiter by mortal women and so were often aided by the gods. Their feats of courage exemplify virtue rewarded. The Greek king Odysseus, Ulysses to the Romans, was less noble but a more human hero: his later life, as recounted in Homer's *Odyssey*, was characterized by shrewdness and perseverance. Orpheus and Oedipus are examples of men who, unable to escape their destiny, are destroyed by the fates. As suffering mortals they became attractive figures from the Romantic period onward. Orpheus was both supernaturally gifted and very human: he competed with the gods in music, but

was consumed with human sadness for the wife he lost. Classical sculptures of Orpheus carrying a sheep were adopted by the early Christians to portray Christ as the Good Shepherd.

Oedipus epitomizes the man punished by the fates for actions beyond his control. His father Laius, King of Thebes, asked a shepherd to leave the newborn boy to perish, to disprove the prophecy that his son would kill him and commit incest with Laius's wife Jocasta. The shepherd saved the child, who was brought up by the rulers of Corinth and unwittingly fulfilled the prophecy. Revelation of the truth led Jocasta to commit suicide and Oedipus to blind himself. Sigmund Freud used his name to describe a male infant's desire for his mother.

▼ **A political message**
Hercules, Herakles to the Greeks, was hated by Juno as the illegitimate son of her husband, Jupiter. She sent two serpents to kill the infant demigod, but he strangled them in his cradle. Catherine the Great of Russia commissioned Reynolds to paint this political allegory. Hercules, young and strong, stands for Russia, the serpents for Russia's backward-looking nature, which it must destroy to enter the new arena of European politics.
Joshua Reynolds, *The Infant Hercules Strangling the Serpents*, 1786–8.

◄ **Deadly rivalry**
The wedding feast of Perseus and Andromeda was interrupted by the bride's suitor, Phineas, whose claim to her hand led to a fight. The Italian painter Giordano makes diagonal rays of light resemble stage lighting. A curtain is drawn back (top right) as Perseus produces his secret weapon: the head of the snake-haired gorgon Medusa, whose glance turns all who look at her into stone.
Luca Giordano, *Perseus Turning Phineas and his Followers to Stone*, early 1680s.

◄ **Conquering hero**
The Dutch Mannerist painter Goltzius shows Hercules with his lion skin and club, posing triumphantly after killing the fire-spitting giant Cacus. The birth of Hercules' children provoked his jealous step-mother, Juno (Hera to the Greeks), to drive him into a fit of madness in which he murdered the children and his wife. After this dreadful deed, as a penance Hercules was ordered to perform twelve tasks of great difficulty. These, the Labours of Hercules, provided another subject popular with painters.
Hendrik Goltzius, *Hercules and Cacus*, 1613.

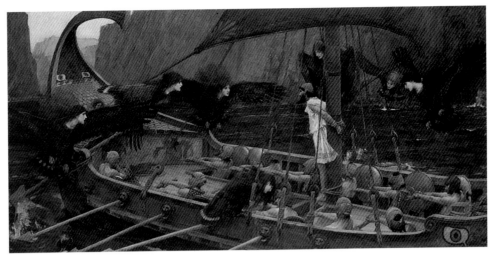

▶ Song of the Sirens
Ulysses was the King of Ithaca who led the Greeks in the Trojan War. His protracted journey home included such episodes as an encounter with the one-eyed Cyclops, the perils of Scylla and Charybdis, and the island of the lotus-eaters, from which he rescued his men. The winged Sirens are mythical figures whose songs fatally lure all who pass their island. Ulysses protected his crew from their deadly charms by blocking their ears with wax, but, wishing to hear the Sirens' song, tied himself to the ship's mast.
John William Waterhouse, *Ulysses and the Sirens*, 1891.

▶ Death of a musician
The story of Orpheus attracted the Frenchman Moreau and other Symbolist painters of the late nineteenth century. Taught to play the lyre by Apollo, Orpheus entranced gods, men, and animals. After the death of his wife, Eurydice, he begged the god of the underworld for permission to rescue her. His request was granted on condition that he neither speak nor look at Eurydice, but on the long journey back to earth he turned to her and she was lost to him for ever. Later, in Thrace, he was torn apart by women in a bacchanalian frenzy.
Gustave Moreau, *The Maiden of Thrace Carrying the Head of Orpheus*, 1865.

▶ Riddle of the Sphinx
The French painter Ingres takes a central incident in the life of Oedipus, the solving of the riddle of the Sphinx: "What animal walks on four feet in the morning, on two at noon, and on all three in the evening?" All those unable to answer it were hurled from a cliff. Oedipus replied: "Man, who crawls on all fours at the start of his life, then walks on two feet, and needs the help of a cane at the end of his life." At this the Sphinx threw herself to her death.
Jean-Auguste-Dominique Ingres, *Oedipus and the Sphinx*, c.1820.

▲ Heroic voyager
In this painting Moreau depicts the Greek hero Jason as an androgynous figure. Behind him stands Medea, who fell in love with him, became his wife, and helped him win the legendary Golden Fleece by giving him a sleeping charm for the dragon that kept constant watch over it. The vanquished dragon can be seen beneath Jason's feet. The son of King Aeson of Thessaly, Jason was dispossessed by his uncle Pelias, who promised to relinquish the throne on condition that Jason return with the Golden Fleece. He set sail in search of it with his crew of fifty Argonauts, who numbered among them the Greek heroes Orpheus and Hercules.
Gustave Moreau, *Jason and Medea*, 1865.

The uses of myth

The spread of Classical literature, much of it concerned with myth, from northern Italy to other countries of Europe from around the end of the fifteenth century provided artists and their patrons with a wide variety of new subjects. Many of these works were dramatic stories, and these offered an exciting alternative to the religious themes that had predominated in painting during the preceding centuries. The specific episodes that artists depicted reflected the taste of either themselves or their patrons.

Esoteric images

Classical mythology also offered the possibility of complex allegorical interpretation and patrons commissioned scholars to devise arcane narratives for this purpose. The integration of myth with personal allegory was used in the fifteenth century by the d'Este court at Ferrara, Italy. Under Borso d'Este the court pursued an interest in the esoteric and arcane, and the painter Francesco del Cossa was commissioned to

decorate the Palazzo Schifanoia with frescoes intended as a show of erudition. The decorative scheme in the Room of the Months, derived from a compilation by scholars, combines Classical myths, astrology, and a suggestion of secret meaning that only the initiated would be able to understand.

As Marie de Medici did later in the cycle of paintings that she commissioned from Rubens (see pages 102–3), the d'Estes had themselves and their circle painted in a cycle of scenes in which the gods of antiquity also played a role. The cycle combines contemporary life in Ferrara with the symbolic and imaginary life of the city, and its complex astrological programme is of great importance in interpreting its scheme. The central horizontal decorative band links the upper and lower levels thematically. It contains the sign of the Zodiac for the relevant month, flanked and crowned by the three figures who each govern ten days of that month. The themes of the cycle may well have been understood by the courtiers, but quite possibly not

▼ **Mannerist horror**
From the story of the Greek hero Cadmus, the artist chooses the horrendous scene in which his followers, who have gone in search of water so that he might make a sacrifice to the gods, are destroyed by the dragon that guards the fountain. Within a triangular composition the artist depicts the creature sinking its claws into one man, whose stricken body traps another. As the muscles of his back show, the trapped man struggles in vain to resist the dragon. Cornelis's contortion of the man's right arm serves to accentuate our sense of his helpless agony as his face is gnawed. Cadmus later exacts revenge by killing the dragon.
Cornelis van Haarlem, *Two Followers of Cadmus Devoured by a Dragon*, 1588.

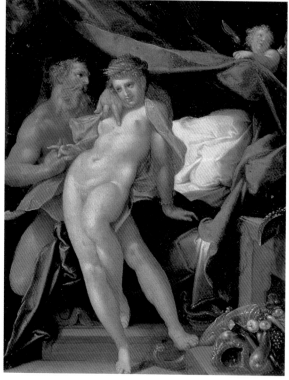

▲ **Eroticism**
Bartholomeus Spranger made a series of paintings for the Emperor Rudolf II, drawn from stories in Ovid's *Metamorphoses*. The stories selected are all highly erotic and one of them inspired this work, in which the enticing Maia thrusts her body toward the viewer while holding Vulcan, god of fire, in thrall. Maia was a nymph whose affair with Zeus led to the birth of Hermes. In very early Roman legend she was a goddess and gave her name to the month of May.
Bartholomeus Spranger, *Vulcan and Maia*, c.1585.

fully by the artists who painted them. Other themes in the cycle illustrate the relationship of Ferrara to its surrounding countryside, almost as a charmed city within a garden, and show the medieval notion of chivalry combined with an interest in Classical antiquity.

Rudolf II, Holy Roman Emperor from 1576, and creator of a great court at Prague, interested himself greatly in the arts and sciences. The effect of his rule was shown allegorically in a painting by Bartholomeus Spranger. The artist's work *Minerva Victorious over Ignorance* (see page 102) shows the flourishing of learning under the aegis of Rudolf. Like the d'Estes and many of the Renaissance princes and scholars, Rudolf was a keen student of astronomy and was also a patron of several well-known astronomers. His commissioning of Spranger to create a fresco cycle that depicted a series of narratives selected from the Roman poet Ovid shows his interest in Classical literature. It also illustrates his taste for the highly charged eroticism that characterizes the work of the Flemish Mannerist painters of the late sixteenth century.

Depicting cruelty

As well as providing themes that offered opportunities for titillation or the display of learning, the Ovidian world presented artists with scenes of cruelty and violence. The story of Cadmus, recounted in Ovid's *Metamorphoses*, was seldom painted, but was used by the Dutch Mannerist Cornelis van Haarlem in *Two Followers of Cadmus*, a work designed expressly to horrify. The painting does not take as its central theme the heroic valour of Cadmus, who later kills the dragon. Instead this scene becomes a background detail, while the depiction of grim carnage fills the foreground of the canvas. Clearly this image answered a taste for horror, for it was widely distributed as a print in the 1590s.

The story of the flaying of Marsyas, painted by several artists, including Titian, Domenichino, and Ribera, is a chilling tale of inhuman cruelty and pride punished. The satyr Marsyas challenges the god of music, Apollo, to a contest in the playing of pipes. Apollo wins, and as victor chooses his prize: the flaying of Marsyas. Ovid's description is horrific: "in spite of his cries the skin was torn off the whole surface of his body: it was all one raw wound. Blood flowed everywhere, his nerves were exposed, unprotected, his veins pulsed with no skin to cover them. It was possible to count his throbbing organs, and the chambers of the lungs, clearly visible within the breast."

The story of Saturn devouring his children is also memorably disturbing. It was a subject from Ovid painted by the Flemish artist Rubens for the Royal Hunting Lodge near Madrid, and inspired Goya to produce, around 1820, a private, non-commissioned painting of the same subject that may be read as a political allegory referring to recent events in Spain.

Mythical beasts and monsters

All mythologies tell of beasts and monsters and most such creatures are a composite of real beings, including humans. The best-known mythical beast is the winged horse Pegasus, which sprang from the blood of the snake-haired gorgon Medusa. Pegasus was ridden by Perseus, who slew the Chimaera, a monster which possessed a lion's head, a goat's body, and a serpent's tail. Another variant of the horse is the unicorn, which, although it dates back to antiquity, is more often associated with medieval heraldry. The unicorn was thought to possess medicinal or magical properties that derived from its single twisted horn. A third variant is the centaur, half man and half horse, which in Classical mythology often symbolizes the baser human passions, such as lust and drunkenness. Also part horse is the hippogriff, which has a horse's body and a griffin's wings and head.

Like the centaur, the satyr is half man, but the lower half is goat. In youth the satyr, or faun, is playful, but in old age symbolizes lust. The Sphinx has a human head, but its body is that of a lion and derives in Egyptian mythology from a combination of the pharaoh and the sun god, Ra. Although the Sphinx appears in Classical texts, it rarely occurred in painting before the Romantic era, when it became an inscrutable femme fatale. This exotic hybrid was popular with Symbolist painters attracted to the unattainable and perverse female. The Minotaur, killed by Theseus, has a man's body and a bull's head.

▶ Winged steed

The British painter Frederic Leighton shows the heroic Perseus mounted on his winged horse Pegasus, hurrying to do battle with the Chimaera, which threatens Andromeda. As Pegasus, his nobility suggested by the lack of saddle and bridle, leaps over rock and water against a dramatic sky, he carries a grisly reminder of his origins: the decapitated head of Medusa, slain by his rider. A length of silken fabric enfolds man and horse like a heroic halo. **Frederic, Lord Leighton**, *Perseus on Pegasus Hastening to the Rescue of Andromeda*, c.1895–6.

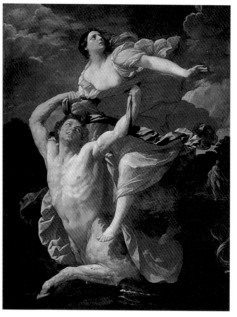

◀ The abductor foiled

In this work by the Italian painter Guido Reni the centaur symbolizes man's lust. Claiming to be the ferryman of the gods, the centaur Nessus offered, for a small fee, to carry the lovely Deianira across the river while her husband, Hercules, swam. Hercules dived into the water, but Nessus galloped off with Deianira in his arms, threw her to the ground, and tried to rape her. Hercules, visible in the background, took up his bow and killed him with a poisoned arrow. **Guido Reni**, *Deianira Abducted by the Centaur Nessus*, 1620.

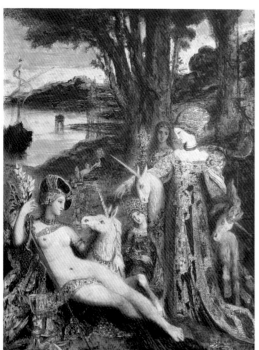

◀ Dream of chivalry

The two principal figures, one clothed and one nude, suggest that this painting is an allegory of love. However, the aim of the French Symbolist artist Gustave Moreau was to paint a mysterious work in which the mythical unicorn and the elegant gothic princess recreated the chivalric imagery of medieval times. In fact, the dreamlike setting combines the courtly world of the High Middle Ages with the exoticism and opulence of Byzantium. **Gustave Moreau**, *The Unicorns*, 1887–8.

▲ Dual nature

Half man and half goat, the satyr or faun was a deity attendant on Dionysus or Bacchus, god of wine and associated with wild orgies. Here the Italian painter Piero di Cosimo portrays not the customary lasciviousness of the mythological satyr but the gentle side of his nature. Having discovered a young woman dead from a wound in her throat, the satyr mourns her tenderly. The scene's poignancy is echoed by the abandoned dogs. **Piero di Cosimo**, *A Satyr Mourning over a Nymph*, c.1495.

▶ Seductress

The sphinxes that adorn the tombs of the pharaohs of ancient Egypt are male, but in the nineteenth century, after European imperial incursions into Africa spawned an interest in a new exotic mythology, the creature's head became that of a beautiful woman. From this time the female sphinx was most often portrayed as a seductive and inscrutable creature. Here the Belgian Symbolist painter Fernand Khnopff paints an image of this feline seductress. Her soft but dangerous body lies close to the young poet's naked chest, which she encircles with her forelegs while stroking his temple with her cheek. **Fernand Khnopff**, *The Caress of the Sphinx*, 1896.

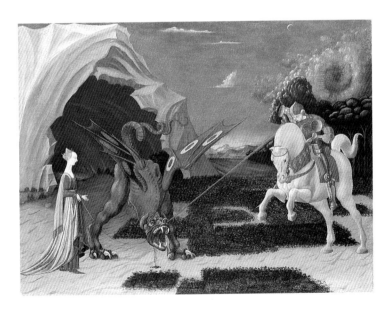

◀ Omnipotence

Picasso identified strongly with the Minotaur and made a series of etchings of himself as the creature, reclining with a beautiful young woman. In his personal interpretation of the myth, Picasso shows the Minotaur as all-powerful, escaping the outstretched hands in a cave and carrying a horse that he seems to have choked. With his defiant left hand he draws attention to the face of a young woman floating above a clenched fist. **Pablo Picasso**, *Minotaur and Dead Mare*, 1936.

▲ Knightly hero

In the well-known legend of St George, the dragon is often seen as a symbol of the non-believer. Artistic interpretations of the story frequently show the saint not killing the dragon but blinding it, and paradoxically showing the creature the light of Christianity. In this work by the Italian painter Uccello, this reading is plausible. Furthermore, the dragon is depicted on a leash held by the princess. This refers to a later part of the story when the captured dragon was led back to the city it had terrorized. **Paolo Uccello**, *St George and the Dragon*, c.1460.

▲ Valiant rescuer

The mount ridden by Ruggiero, hero of *Orlando Furioso*, Ariosto's epic poem of 1532, is a hippogriff, half horse and half griffin. Ruggiero is a variant of Perseus on winged Pegasus, and both heroes rescued a naked and chained maiden. Medieval themes were in vogue in Europe in the nineteenth century and the heraldic quality of the hippogriff made this tale especially popular. The French artist Ingres painted several versions of the subject. **Jean-Auguste-Dominique Ingres**, *Ruggiero Rescuing Angelica*, 1819.

Norse and Arthurian myth

In the late eighteenth and early nineteenth centuries the Romantic movement in literature and art brought a reappraisal of "primitive" humankind. The concept of the "noble savage" described by the French philosopher Rousseau developed the idea that human nature was pure until corrupted by the civilizing effects of society.

Northern myths

By extension the primitive myths of the Celts and Scandinavians, which had not been painted for three centuries, were also seen as attractively uncorrupted. In the late eighteenth century the first major deviation by artists from Classical sources of subject matter was to the legend of the third-century Gaelic bard Ossian (see page 96), with its tales of courageous heroes and courteous deeds. During the following century a keen interest developed in the Norse and Teutonic gods. The Swiss painter Henry Fuseli, whose vivid imagination made him a leading figure of Romanticism, produced in *Thor Battering the Serpent of Midgard in the Boat of Hymir the Giant* one of the earliest paintings derived from Norse mythology. These myths did not simply provide new visual material but were also part of a wider social phenomenon: as hundreds of principalities, kingdoms, and electorates coalesced into the nation state of Germany, a nostalgia developed for what was disappearing. The brothers Jakob and Wilhelm Grimm, philologists, travelled the Germanic lands recording the oral tradition of storytelling and subsequently published *Grimm's Fairy Tales*. These folkloric stories of small kingdoms, kings, queens, princes, and princesses may be seen as an idealization of a world that was dying as the tales were being published. But, like all good myth, they not only reflect aspects of the society that produced

◀ **Norse valour**
Fuseli was born in Switzerland but made his career in England. He depicts Thor, the Norse god of thunder, perched on the edge of a boat attacking a serpent. The giant Hymir recoils at the back of the boat, and at the upper left is the pale figure of the god Odin. This painting may also be read as an allegory in which the humbly born but courageous Thor battles against darkness, represented by the serpent, in front of the aristocratic but less valiant Odin.
Henry Fuseli, *Thor Battering the Serpent of Midgard in the Boat of Hymir the Giant*, c.1790.

▲ **Teutonic epic**
Part of a fresco cycle, this work shows the death of Kriemhild, wife of Siegfried, the hero of the medieval Teutonic epic poem the *Nibelungenlied*. Having killed Siegfried's assassins, Kriemhild herself was murdered by the knight Hildebrand. The artist, with a clarity typical of the Nazarenes, evokes the early Middle Ages in the costumes and in the Romanesque arches and zigzag moulding of the interior architecture.
Julius Schnorr von Carolsfeld, *Kriemhild Being Killed by Hildebrand*, 1849.

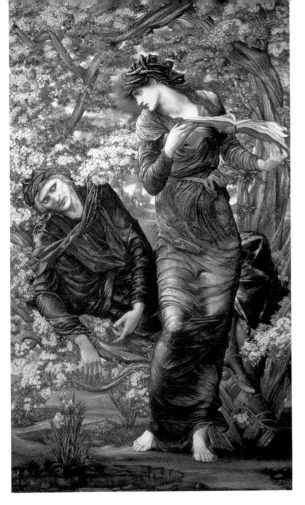

▲ **The magician enchanted**
Legend told how King Pellinore brought to King Arthur's castle a fair damsel named Nimue. The magician Merlin fell in love with her, but later she tricked him and finally imprisoned him under a stone. Burne-Jones painted the subject many times. This version draws upon a medieval French text that tells how Merlin was soothed to sleep by Nimue in a hawthorn bush. It reveals the influence of the Renaissance paintings that the artist saw during his visits to Italy. This is most notable in his treatment of the snake-like coils of Nimue's hair, her elegant stance, and the elaborate drapery folds. Merlin's complete subjugation is suggested by his eyes, hands, and supine position, which make him appear as if drugged by the spell of the enchantress.
Edward Burne-Jones, *The Beguiling of Merlin*, 1872–7.

them but also deal with archetypal characters and common emotions, such as the wicked stepmother or the fear felt by abandoned children. The German people's nostalgia, coupled with a desire to establish a national identity, resulted in a revival of interest in early Teutonic myth. The *Nibelungenlied*, a thirteenth-century epic that narrates the exploits of the hero Siegfried, is a variation on the Icelandic *Völsunga Saga* of similar date. The gods who played a major part in the *Völsunga Saga* appear in the *Nibelungenlied*, this time in minor roles. The legend of the Nibelungs ("children of the mist") was made known throughout the world by Wagner's cycle of four operas *The Ring of the Nibelungs* (1869–76).

Julius Schnorr von Carolsfeld was one of a group of German painters who worked in Rome in the early nineteenth century as a quasi-religious confraternity who called themselves the Nazarenes in emulation of the followers of Christ. Later commissioned to decorate five rooms of the royal palace in Munich, Schnorr von Carolsfeld chose, in a gesture of Teutonic pride, to paint a fresco cycle containing scenes from the Nibelung myth, such as *Kriemhild's Death*.

The Pre-Raphaelites

In the nineteenth century medieval mythology was also influential among artists in England, where, in 1848, a group of young painters formed the Pre-Raphaelite Brotherhood. Revering the medieval world that had flourished before the Italian painter Raphael, they took their subject matter from the Middle Ages and often emulated the more primitive style of medieval art. Like the Nazarenes, they favoured non-Classical subjects, such as Christian or medieval themes. One of their number, Dante Gabriel Rossetti, painted a series of watercolours based on events in the life of Dante, as well as canvases inspired by the legend of King Arthur and the Knights of the Round Table. Although at that time images drawn from Arthurian legend had existed since the Middle Ages, these were small illustrations in books or illuminated manuscripts; after the Renaissance the Arthurian theme was rarely painted until its resurgence in the nineteenth century.

For the Pre-Raphaelite artist Edward Burne-Jones the medieval era was an enchanted world of chivalry, courtly love, and adventure, a world he sought to capture in paintings such as *The Beguiling of Merlin*. At Oxford University he and his friends founded a society dedicated to Sir Galahad, Arthur's purest and noblest knight, and resolved to make a "crusade and holy warfare" against their own era, which they saw as cold, unromantic, and heartless toward the poor. Their reading of the poems of their contemporary Tennyson, such as *Idylls of the King*, and Malory's fifteenth-century prose romance *Le Morte d'Arthur* led them to worship the idea of the knight errant and his spiritual quest for the Holy Grail, the chalice used by Christ at the Last Supper. In a passage that encapsulates the Victorian idealization of the High Middle Ages, Burne-Jones wrote of imagining "the abbey, and long procession of the faithful, banners of the cross, copes and croziers, gay knights and ladies by the river bank, hawking parties and all the pageantry of the golden age."

Women and myth

◄ **Mysterious beauty**
Jupiter gave Pandora a box that she was told not to open. Disobeying him, she released all the ills that have since plagued the earth, shutting the box in time to enclose only Hope. Her gaze does not reveal whether she understands the significance of her action. She seems not to see the wreath of smoke emerging from the box and curling about her malevolently. The model for this painting was Jane Morris, the wife of the artist's protégé William Morris. For Rossetti, who was deeply in love with her, she possessed an enigmatic beauty.
Dante Gabriel Rossetti, *Pandora*, 1869.

With the reflowering, during the Renaissance, of interest in Classical mythology came a profusion of images of nudity. Classical gods were often identified by their nudity and many of the mythological stories told of amorous exploits. Before the fourteenth century nudity in painting was rare and considered a shameful subject. In the Middle Ages Adam and Eve expelled from the Garden of Eden were the most frequently painted nudes, their nakedness itself part of the cause of their shame.

One of the most startling innovations in the paintings of the later fifteenth and sixteenth centuries ompared with those of the previous centuries was the depiction of nudity and a concomitant celebration of the body beautiful. Inspired by Classical sculptures of the idealized nude, painters and patrons alike drew on these

▶ **Echoes of the Fall**
The British painter Collier's depiction of a nubile young woman with a snake coiled erotically around her recalls Lilith's connection with Adam, whose fall from grace was caused by Eve, who was herself ensnared by a serpent. Far from threatening her, the snake, Lilith's expression says, is entirely under her control. The artist was inspired by Keats's description of Lilith in his poem "Lamia" as a serpent who takes on the shape of a beautiful woman, a "palpitating snake . . . of dazzling hue, vermilion-spotted, golden, green and blue."
John Collier, *Lilith*, 1887.

stories for images of female flesh intended to delight the eye. Such works included paintings of goddesses, nymphs, and beautiful mortal women, inspired by mythology, but where no such story was shown, the nude was simply titled "Venus." From the Renaissance onward Venus appears either as part of an allegory in which she represents love, or on her own, contemplating her reflection in a mirror or reclining gracefully on a divan. Her appearance as an idealized figure in art is a

reflection of both changing fashions in female beauty within society and the taste of the individual artist.

Diana, goddess of the hunt and chastity, offers a subtler alternative to the depiction of Venus as an enticing nude, and images of her prefigure the more complex attractions of women portrayed in the Romantic paintings of the late eighteenth and early nineteenth centuries. The athletic prowess and physical appeal that make her a sexually alluring figure are counterpoised by frigidity. Her role as the eternally chaste virgin creates greater psychological tension and a more complex sexuality than is seen in Venus. Minerva, goddess of wisdom and protector of warriors, is traditionally shown as sexually neutral; but there are exceptions, including Spranger's *Minerva Victorious over Ignorance* (see page 102), in which her pneumatic breasts protrude erotically from her armour.

Femme fatale

From the Romantic era to the end of the nineteenth century a vogue prevailed for painting the women of mythology as femmes fatales who ensnare men. The seductive Lilith, who first enters Western art during the Romantic period, is not, however, a character from Classical mythology. In Mesopotamian myth Lilith is described as a nocturnal visitor who consorted with men in sexual dreams, and in the Jewish Talmud she is similarly represented as a succubus who seduces men sleeping alone. She appears in Goethe's poetic drama *Faust* (1808 and 1832) and in the poem "Adam, Lilith and Eve" by the nineteenth-century English poet Robert Browning. Under the name of Lamia, she is the subject of a poem by the English Romantic poet John Keats (1820), in which she is a treacherous and beautiful woman who transforms herself into a serpent. Feared as a demon or a vampire of the night, she is described as "the first Eve," created at the same time as Adam but before Eve, and as such is seen as the first woman.

The esoteric Jewish text the Cabala recommends the wearing of charms against Lilith before intercourse. In more recent times she has become notable in feminist literature as a new archetype for the emancipated woman and a leading figure in contemporary "goddess religion."

In the nineteenth century, English poets such as Tennyson and Swinburne and the painter-poet Dante Gabriel Rossetti made the image of the beautiful but passionless and cruel Belle Dame Sans Merci a frequent subject of their verse. Woman's exotic, sphinx-like

inscrutability appealed to the Romantic wish to be over-powered by a great or sublime emotion. The English artist Burne-Jones painted many images of this destructive and fatally alluring woman (see page 89, *The Beguiling of Merlin*). The European Symbolist painters also focused on the decadent and mysterious aspects of woman. For example, the French artist Gustave Moreau, lost in dreams of Byzantium and the Middle Ages, painted proud queens and unfathomable females who encapsulated this vision of woman as tainted. He described this archetype as "an unthinking creature, mad on mystery and the unknown, smitten with evil in the form of perverse and diabolical seduction."

Decadence

In the twentieth century artists such as the German satirist George Grosz painted women as corrupt and decadent. Grosz was to produce several images of Circe, the enchantress of Homer's *Odyssey*, as a symbol of the decadence of the Weimar Republic of the 1920s, an era of which he later wrote: "A wave of vice, pornography, and prostitution enveloped the whole country."

► **Base creatures**
In Homer's epic poem the *Odyssey* the enchantress Circe lured Odysseus (Ulysses) and his crew to the island of Aeaea and turned them into swine. Here she is used by George Grosz, in one of his most searing indictments of the corruption and decadence of interwar Germany, to satirize venal woman and animal man as stereotypes of the period. Circe, like a prostitute in a Berlin bar, kisses a swinish war profiteer. Bestial man becomes pig-like in manner and intention when ensnared by a debased woman.
George Grosz, *Circe*, 1925.

Freud and mythology

The impact of Sigmund Freud (1856–1939), the father of psychoanalysis, was immense. His work not only influenced the related fields of psychiatry, psychology, criminology, sociology, and anthropology, but also had a profound influence on the cultural life of the twentieth century. His influence has affected writers and painters and inspired a broad base of interest in his work, so that his name has become a term to describe hidden or unconscious motives. Since Freud we have become more aware of the meanings concealed behind both words and images.

The meaning of myth

Freud believed that myths give insight into the human condition. Many Classical myths tell of events that arouse people's deepest fears and desires, such as parricide, infanticide, and incest. Freud analyzed these narratives to find the bearing they had on real people. In particular he examined the stories of Oedipus, Narcissus, and Electra, and gave their names to psychological "complexes." He also investigated literature and art in an attempt to analyze the artist's subconscious as revealed in his or her work. He studied Leonardo's personality through his output, and the

artist's accounts of his dreams, and concluded that these contained evidence of maternal deprivation.

The founder of Surrealism, the French poet André Breton, travelled to Vienna in 1921 to see Freud. In Paris Freud's idea of "free association" was taken up and transformed by Breton and the Surrealists, who encouraged writers to let the unconscious mind freely express disconnected ideas and such associations as might arise. The same approach was also encouraged in painting, where the hand was permitted to roam without the conscious intervention of the brain.

In *The Interpretation of Dreams* (1900) Freud outlined the theory of dreams as disguised wish-fulfilment and a manifestation of repressed sexual desires and energy. His studies of hysteria and infantile sex led him, in *Totem and Taboo* (1913), to propose the theory of what he called the Oedipus complex. This described the infant male's sexual attraction toward his mother and his jealousy of his father. Interestingly, later in life Freud called Anna, his daughter and close companion, Antigone, after the daughter of Oedipus.

The German Surrealist painter Max Ernst incorporated his understanding of Freud's ideas about infant sexuality, fear, and the interpretation of dreams into his

▼ Fatal self-absorption

Here Dali depicts the tale of the beautiful youth Narcissus from Ovid's *Metamorphoses*. Interested only in himself, Narcissus spurned the attentions of every young woman or man. In response Nemesis caused him to fall in love with his own reflection. Unable to tear himself from his own image, he faded away, changing into the flower that is named after him. Dali shows Narcissus alone on a plinth on the right and again in the foreground in the process of transformation. The young man's form is echoed by the bony hand holding an egg from which a narcissus sprouts.
Salvador Dali, *The Metamorphosis of Narcissus*, 1937.

▶ Surreal juxtaposition

Here, as in much of his work, Delvaux uses Classical mythology as his subject matter. His nudes, Classical and sculpturesque, are often placed in an ambiguous setting in which Classical or medieval architecture is juxtaposed with trains, railway lines, or overhead power cables. The dreamlike environment in this picture, with its mixture of industrial, ecclesiastical, and civic architecture, is edged on the right with a curtain, which gives a theatrical setting to Delvaux's modern interpretation of a well-known myth.
Paul Delvaux, *Leda*, 1948.

entranced. Like a figure in her dream, St George epitomizes the powerful male with his phallic lance, which he stabs into a dragon that hints at a vulva. Enforcing the sexual imagery is the red drapery, with its folds that also resemble female genitals.
Giorgio de Chirico, *St George Killing the Dragon*, 1940.

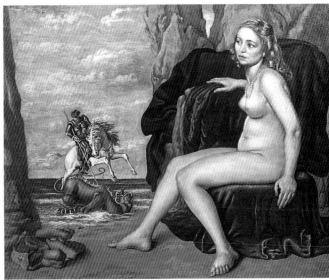

Pietà or *Revolution by Night*. In this painting he inverted the traditional form of the Pietà, in which the body of the dead Christ lies on the lap of his mother, Mary. The work parodies the Pietà to show the live son on his father's lap. Ernst painted this personal reworking of his own relationship with his father in the light of Freud's writings on, in particular, the Oedipal theme.

Freud was revered by the Spanish Surrealist painter Salvador Dali. When they met in 1938 in London, where the psychoanalyst had settled after escaping from the Nazi regime in his native Austria, Dali showed Freud his painting *The Metamorphosis of Narcissus*. Until this time Freud had regarded the Surrealists as fools, but the young artist caused him to change his opinion. "It would indeed be interesting to

▲ **Dream landscape**
As if in a surreal nocturnal stage set, a naked Venus sleeps, arms outstretched, on an ornate divan, while another woman communes with a skeleton. The town square that frames this scene on three sides is entirely Classical in architectural style. Moreover, the correctness of the Doric order of the building on the left and of the frieze of the Ionic temple in the background contrasts with the apparently random action enclosed by the two structures.
Paul Delvaux, *Venus Sleeping*, 1944.

investigate analytically how he came to create that picture," he admitted the next day to the Viennese writer Stefan Zweig, who had introduced the two men.

However, according to Dali, Freud told him: "It is not the unconscious that I seek in your pictures, but the conscious. While in the pictures of the masters – Leonardo or Ingres – that which interests me and which seems mysterious and troubling to me, is precisely the search for the unconscious ideas, of an enigmatic order, hidden in the picture, your mystery is manifested outright. The picture is but a mechanism to reveal it." Freud had written in *Totem and Taboo* that the myth of Narcissus represented a search for sexual gratification in oneself, and the following year he had published a paper entitled "On Narcissism." It is not surprising that the myth of Narcissus struck a chord with Dali, who gave the self-referential title *The Great Masturbator* to one of his paintings.

Dream imagery

The work of the Belgian Surrealist artist Paul Delvaux also both exploits Classical myth and provides fertile ground for Freudian interpretation. His *Leda*, a depiction of the story of Leda and the swan in which the swan's neck is an obvious phallic symbol, treats a myth that had a particular appeal for twentieth-century painters. Here and in many other of his paintings, Delvaux's seemingly arbitrary arrangement of figures and objects in unrelated settings suggests the random-association imagery experienced in dreams – an area of investigation central to Freudian psychoanalysis.

◀ **Imagery of pain**
In this disturbing painting, by the Belgian Surrealist Labisse, Leda is shown with a face swathed in bandages, unable to see, smell, or speak. Her right arm becomes the neck and head of a vicious-looking bird that is not at all the beautiful swan into which Jupiter transformed himself to seduce Leda but an imaginary, quasi-mythical creature. The hardness of the bird's beak, biting her nipple, suggests the brute sexuality of the Classical myth. The ends of Leda's hair have the same prickly quality as the thorny branches of the stylized tree and the bird's crest and beak, adding to the imagery of pain contained in the bandaged face and the assaulted breast.
Félix Labisse, *The Strange Leda*, 1950.

Reinterpreting Classical myth

The use of imagery inspired by the Classical world was challenged in the second half of the nineteenth century by avant-garde artists, who chose to take contemporary life as their theme. The paintings of the first two decades of the new century also contained comparatively little mythology, while abstract art avoided reference to the outside world. When subject matter was recognizable it often celebrated the modern world of the train, plane, and machine, and did not look back to myth and legend.

Modern Classicists

There were exceptions. At the beginning of the century the Austrian artist Gustav Klimt made a number of very imaginative depictions of Classical figures such as Danaë and Athene. These he painted not in the prevailing traditional academic manner but in his own highly idiosyncratic style. Another exception was the Italian metaphysical painter Giorgio de Chirico. A precursor of and inspiration to the Surrealists of the 1920s, he looked to the Classical world for a lyrical alternative to the hard-edged modernism of abstraction. His empty squares edged with Classical colonnades, and his marble torsos and antique heads, are elegiac reworkings of the legacy of ancient Greece.

At the beginning of the 1920s, after a decade of abstraction, there was a "call to order" in which many artists, notably Picasso, returned to a mode of painting

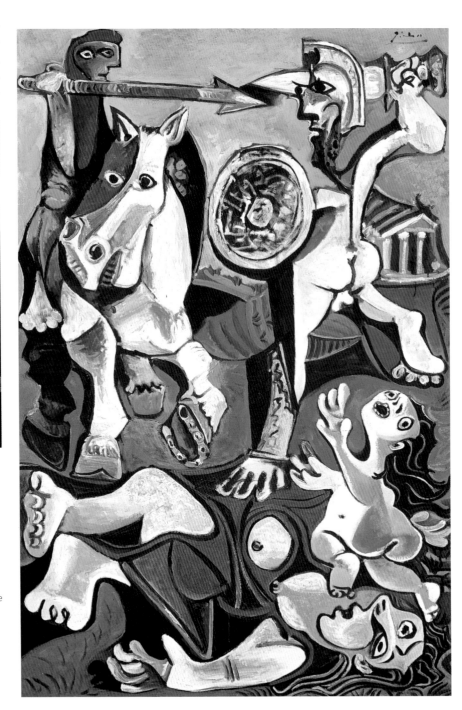

▲ **Rapture**
In this bold composition, in which the dappled left thigh of Danaë occupies a third of the canvas, Klimt painted a highly erotic work. The curled figure of the princess opens her legs to receive a shower of gold, the means used by Jupiter to seduce Danaë. The round gold coins are echoed in the gauzy fabric that forms a decorative pattern on the right. The clench of Danaë's fingers over her breast suggests orgasm.
Gustav Klimt, *Danaë*, c.1907–8.

▶ **Homage to Classicism**
Picasso's return to a more "Classical" ground in the 1920s was emulated by many other European artists, and forty years later his debt to the Classical world was still in evidence. Here he pays homage to the great Classicist David by recreating his chilly Neoclassical masterpiece (see page 124) in a twentieth-century idiom. The work is anything but Classical in style, but it is clearly based on the earlier composition.
Pablo Picasso, *The Intervention of the Sabine Women (after David)*, 1963.

that was more traditional in both style and subject matter. Picasso continued to return to the subject of myth throughout his career, often reworking mythological paintings by masters of previous eras, such as the Neoclassical painters David in *The Intervention of the Sabine Women* and Poussin in *Bacchanal*.

Other artists, including painters as diverse as Grosz, Pollock, Beckmann, and Nolan, similarly reinvented Classical myth for a modern age. No longer using these narratives as a pretext for painting titillating nudes or allegorical themes of patriotism and moral probity, they sought to interpret universally understood stories that are part of the collective consciousness. Many artists, including Picasso, felt that the road to complete abstraction led to mere pattern-making, whereas the reworking of Classical myth lent gravitas to a new style.

Max Beckmann looked to the formats and narratives of both the Classical and Christian traditions for the content of his work. The German painter made a series of triptychs – the essentially Christian format – initially painting religious themes, and followed these with a series of mythological subjects. In the 1930s the Spanish artist Salvador Dali, fiercely rejecting abstraction and seeking to paint his dreams in hallucinatory colour, explored Classical sources, both visual and literary, for imagery.

Primitive influence

The American abstract expressionist Jackson Pollock became interested in Classical myth and Jungian archetypes through reading Freud and Jung. This led him to an eclectic approach to myth in which Native American and South American myths were fused with elements of Greek mythology. Pollock had been profoundly influenced by John Graham's article "Primitive Art and Picasso" in the *Magazine of Art* in 1937. Graham believed in Jung's theory of the "collective unconscious," which he saw as the repository of human psychic heritage. He saw Picasso's paintings as tapping into the unconscious with the same ease as primitive artists, but also saw evidence of conscious thought. Pollock's paintings are usually entirely abstract but are often given titles, such as *Pasiphae*, that allude to myth. Such works were deliberate attempts to embody what Graham had seen in Picasso's work.

The American painter Joe Shannon uses Classical mythology to infuse magic into modern life. His paintings work on an immediate level, striking the viewer as odd, amusing, or surreal, but for those with a knowledge of Classical mythology they are accessible on another level. Most viewers have a residual memory of ancient myths encountered in childhood. Thus the figure with a bull's head in Shannon's *Pink Minotaur Monitor: Night Guests* may recall the story of the Minotaur slain in his maze by Theseus. The use of a mythological subject of this kind offers the possibility of many-layered interpretation.

▲ Epic quest
Max Beckmann investigated the myths of ancient Greece for the subject matter of much of his work. He read Goethe's translation of the account by Philostratus of Jason and the Argonauts' voyage to the Black Sea in search of the Golden Fleece. This episode is depicted in the central panel of this triptych, where Jason and Orpheus are seen embarking on the *Argos* for the kingdom of Colchis. The sea god Glaucus emerges from the waves to prophesy the mission's success. Beckmann's style is as bold as his mythological heroes.
Max Beckmann, *The Argonauts*, 1949–50.

▶ Modern Minotaur
This painting is part of a series featuring the Minotaur that make playful reference to Picasso's Minotaur series. Like those earlier works, they are about art and sex. The crudity of the image echoes the brute force of the Minotaur, whose head is reflected in the TV screen, making a verbal-visual pun that gives the work its title. The fantastic nature of this mythological scene is counterpointed by the girl's straightforward glance at the viewer, and her feet, which are, visually and metaphorically, placed firmly on the ground.
Joe Shannon, *Pink Minotaur Monitor: Night Guests*, 1982.

▲ Turbulent expression
The title of this painting carries echoes of the wooden horse of Troy with which the ancient Greeks defeated the Trojans. Jackson Pollock attached the wooden head of a child's rocking horse, excavated from the rubble beneath a new house, to the finished work. By subordinating the conscious part of the brain to the unconscious and dripping, pouring, and squirting paint onto the canvas, he sought to make "automatic" abstract expressionist paintings.
Jackson Pollock, *Wooden Horse*, 1948

Modern mythology

Toward the end of the eighteenth century the search for the dramatic subject matter that characterizes Romantic painting led to new discoveries and revivals, especially of Celtic and Norse mythology. This appetite for novelty and exoticism is best seen in the phenomenon of Ossian. Little was known about this third-century legendary Gaelic bard and warrior. In emulation of fifteenth-century scholars sent out to the farthest reaches of the known world in search of Classical texts, a Scotsman, James Macpherson, was commissioned by the Faculty of Advocates in Edinburgh to tour the Scottish Highlands in search of material about the legendary hero Fingal, as recounted by his son Ossian.

Macpherson's findings were published in 1762–3 as *Fingal: an Ancient Epic Poem in Six Books*, which was followed by two later volumes. By the 1770s the work was famous all over Europe, for it had received great acclaim and then aroused a storm of controversy about its authenticity. Investigation revealed that it was largely the invention of Macpherson, who used only fifteen genuine pieces of original verse. The rest he had altered or invented to create the epic poem. The work's

evocation of a religion centred on elemental spirits gratified the Romantic elevated expectations of the primitive and it was widely acclaimed as the Nordic equivalent of the Homeric epics. Napoleon read *Fingal* in the Italian translation; it was his favourite poem and he took an illustrated copy on all his campaigns. Ossian was the one of the heroes painted on the ceiling of Napoleon's library at Malmaison, the artist Girodet combining the spurious myth of the ancient bard with a celebration of recent French victories (see page 129, *Ossian Receiving the Shades of French Heroes*).

Reinvention of myth

Few early nineteenth-century works embody so clearly what French Romanticism sought to represent as François-Pascal Gérard's *Ossian Conjures up the Spirits on the Banks of the River Lora*. Gérard seized a literary theme that gave the opportunity for theatrical gesture, dramatic staging, an evocation of night as the harbinger of pain and suffering, hostile nature with treacherous waters, and a castle reduced to a ruin. The Ossian story is an example of the plundering and reinvention of myth. In fact it was because Macpherson's text was thought to adhere too closely to Homer that it was exposed as inauthentic.

Other artists borrowed from European and world mythology to create a synthesis of myths. This can be seen in the work of the French Post-Impressionist Paul Gauguin. In search of an uncorrupted paradise, he travelled to Tahiti, where he became interested in the legends and religious secrets of the islanders. He later wrote on Tahitian lore, relating that his knowledge of the "ancient Maori cult" derived from Tehemana, his thirteen-year-old wife. Tehemana's age and gender would have made it unlikely that she was privy to such religious secrets, but Gauguin was nevertheless struck

▲ Raising the dead
Ossian conjures up the ghosts of the past with his harp. His father, Fingal, King of Morven, is seated on his throne of clouds, spear in hand. Beside the king, Roscrana, his first wife and Ossian's mother, lays her hands and bow on his thigh. The ancient bard in the centre reaching toward the harp is Ullin. On the left Oscar and Malvina embrace, warriors throng about them, and maidens throw flowers and play harps. The tower of Selma appears in the background as a dramatic ruin.
Baron François-Pascal Gérard, *Ossian Conjures up the Spirits on the Banks of the River Lora*, 1801.

▼ Visual poetry
Although the title Gauguin gave this painting echoes Edgar Allan Poe's poem "The Raven," he maintained that the bird perched on the sill was meant to represent not Poe's raven but a bird of the devil keeping watch. Nor was it painted as a direct illustration of Tahitian legend, although this was a subject Gauguin enjoyed, but as a symbolist work that united the poetic, the literary, and the musical. It was intended as a visual poem in which colour suggested particular musical vibrations and sounds. Of an earlier, similar subject the artist wrote: "the general harmony is sombre, sad, sounding to the eye like a death-knell."
Paul Gauguin, *Nevermore*, 1897.

▼ **A modern hero**
In a landscape of yellow, dried scrubland beneath blue sky, Nolan shows the stylized figure of Ned Kelly, armed with a rifle, riding toward the horizon. In his many paintings of the popular hero the artist did not give him a face but alluded to his armour, which was so heavy that he was unable to escape after he was eventually shot and wounded. Despite the intense heat of the Australian outback, Kelly wore a metal helmet with an open eye slit. By painting the outlaw as a bold silhouette and exaggerating the squareness of the helmet and the size of the slit, so that we see an open rectangle within a square, Nolan makes him two-dimensional. This depiction reflects the hallucinatory status that the outlaw had in the minds of many of his fellow Australians.
Sidney Nolan, *Ned Kelly*, 1946.

forcefully by an incident that he related and painted in his *Manao Tupapau: The Spirit of the Dead Keeps Watch* of 1892. Returning home to his hut later than he expected, he found Tehamana lying face down on her bed, eyes wide open. The oil in the lamp had been consumed, and without light she had lain in mortal fear of the spirits of the dead. Gauguin perceived the incident not as a child's anxiety at being alone in the dark but as evidence of "religious fear." It was a theme to which he returned in his *Nevermore*, where he uses the same pose for the female figure but takes his title from the refrain from Edgar Allen Poe's poem "The Raven," in this way combining the myth of the South Seas with Poe's generalized myth-making.

Twentieth-century mythologizing

In the twentieth century the American Abstract Expressionist painter Jackson Pollock looked to both Classical and primitive myth as well as to Jungian archetypes (see page 95) for his subjects. Works such as *Guardians of the Secret*, while hard to interpret with certainty, suggest the influence of all these sources.

The Australian artist Sidney Nolan explored both ancient and modern mythology, but, being of European origin, he identified more readily with the young country's recent mythology than with the ancient legends of its Aborigines. In painting a series of works that included *Ned Kelly*, he examined the relatively recent mythologizing of a wild Irish family who had settled in Australia. At the heart of the Kellys' story was the spirited outlaw Ned, who, having fought against the British colonial overlords, was hanged in 1880 at the age of twenty-five and became a popular hero with almost mythical status.

Painting a message

Myths and fables may contain morals, but there is another type of painting, linked to paintings of myth, that carries a message: the allegorical work. The term "allegory" is derived from Greek and Latin words meaning "speaking otherwise than one seems to speak." An allegory uses one thing to stand for something else. In pictorial allegories, abstract notions and ideas are given visual form.

More often than not, these notions take on human form; they are personified. The Classical gods were often used in paintings to stand for their spheres of influence: Venus and Cupid could represent love, Mars war, Minerva wisdom and peace, and Bacchus wine and hedonism. Other ideas were personified by figures with recognizable or fitting characteristics. One of the most

familiar is Time, shown as an aged, winged man – since "time flies" – carrying his attributes, the scythe and hourglass. Time is a portrayed as a man because the Latin word for time (*tempus*) is masculine, but abstract nouns in Romance languages tend to be feminine and, as a result, so do their personifications.

Vices and virtues

A wide range of ideas, from the seasons to the senses, acquired their own personifications. The virtues and vices were personified from the Middle Ages onward, as were the so-called liberal arts, which included logic and grammar, music and astronomy. The means of representation was not always consistent but, despite this, certain attributes became accepted. Justice, one of the

◀ **Cardinal virtues**
Raphael's fresco, which the Italian painter executed for one of the Papal rooms in the Vatican, Rome, is a lunette depicting three of the cardinal virtues. The central figure of Prudence holds a mirror that enables her to look behind, metaphorically speaking, and learn from experience. The theme of learning from experience is embellished in her headdress, which creates an illusion of an old man in profile and thus suggests an old head on young shoulders. Fortitude, on the left, holds a slender oak, symbol of strength, from which a young cherub plucks an acorn. Temperance, on the right, holds the reins to restrain the young and impetuous infant.
Raphael, *The Cardinal and Theological Virtues (Prudence, Fortitude, and Temperance)*, 1508–11.

◀ **Renaissance interpretation**
Some fifty years after the publication of the treatise *De Pictura*, in which the author, Alberti, commended an ancient allegory to painters, the Italian artist Botticelli made his version of it. Calumny, surrounded by Envy, Treachery, and Deceit, bears a burning torch of resentment and drags an innocent victim by the hair toward a judge who bears the ass's ears of King Midas and who is counselled by Ignorance and Suspicion. The Naked Truth on the far left points upward to the seat of justice. Remorse, clad in dark robes, looks up at Truth while pointing toward the centre of the action.
Sandro Botticelli, *The Calumny of Apelles*, c.1490.

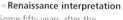

four Cardinal Virtues, was usually shown holding scales and a sword. From the sixteenth century she also appears blindfolded, a sign of her impartiality. In Raphael's painting of the three remaining Cardinal Virtues, Prudence holds a mirror, Temperance holds reins, and Fortitude is identified by the strong oak, although she is more often accompanied by a lion. Prudence can also be shown with snakes, from the biblical injunction "Be ye wise (*prudentes*) as serpents" (Matthew 10:16). With considerable ingenuity, Raphael also depicts his figures accompanied by cherubs representing the three Christian virtues: Faith points heavenward, Hope bears a torch, and Charity shakes acorns from the oak.

Interpretation

Many allegorical figures in paintings are hard to decipher. The Florentine scholar Alberti, in *De Pictura*, his treatise on painting of 1435, advised artists to try to paint a Classical allegory that, according to Lucian, writing in the second century AD, had been painted by Apelles six centuries earlier. The subject was Calumny, and Apelles had depicted an innocent young victim, dragged by Calumny before a judge with ass's ears who is counselled by Ignorance, Suspicion, Envy, Treachery, and Deceipt. Lucian wrote that the tale would end well for the youth if he looked to Repentance and Truth behind him. In *The Calumny of Apelles* Botticelli displayed great fidelity to Alberti's treatise, but while the judge's ass's ears symbolize idiocy and the Naked Truth is a verbal-visual pun, other figures are less easily understood.

Allegories became increasingly complex in the closed circles of Renaissance courts, where they were devised by scholars themselves attracted to mystifica-tion and as a result often became scarcely intelligible outside this narrow world. *An Allegory with Venus and Cupid* by the Italian painter Bronzino contains several figures that we can interpret with certainty and others that we can only guess at. Venus and Cupid, identifiable by the golden apple and quiver respectively, suggest themselves as allegories of love, and Father Time is identifiable by his beard, wings, and hourglass. However, the other figures must be interpreted within the context of a painting that seems to deal with aspects of love. Given the possibilities and complexities of allegorical personifications, it is not surprising that artists resorted to handbooks that suggested suitable attributes and forms. The most famous of these was the *Iconologia* by Cesare Ripa, first published in 1593 and reprinted many times and in many languages since.

Allegory has been used by artists in both the religious and secular spheres. In religious art the allegorical glorification of Catholicism is seen in many ceiling paintings of the late sixteenth century, such as Pozzo's *The Glory of St Ignatius Loyola* (see page 103). Allegory was employed in royal palaces to promote the virtues of particular monarchs (see page 103, Rubens, *Henry IV Receives the Portrait of Marie de Medici*) and in public buildings to honour civic duty and moral probity, as in Ambrogio Lorenzetti's *The Effects of Peace* or *Good Government in the City* (see page 176) or Prud'hon's *Justice and Divine Vengeance Pursuing Crime*.

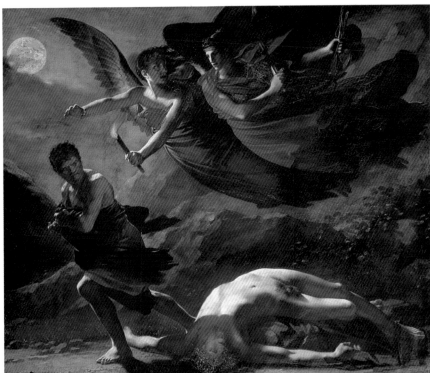

▼ **Crime and punishment**
The French artist Pierre-Paul Prud'hon was unusual in the early nineteenth century in concentrating on allegorical and poetic subjects in preference to painting historical subjects. This dramatic painting was commissioned around 1804 for the courtroom of the Palace of Justice in Paris. The artist shows the assassin (with the face of the Roman Emperor Caracalla) escaping from the scene of the crime into a moonlit night. Above and behind him Justice, bearing a torch of light and righteousness, and Divine Vengeance, with sword and arrows, are poised to strike the miscreant. The realism and pathos of the work made it a sensation at the 1808 Salon, at the close of which Napoleon personally awarded Prud'hon the Legion of Honour.
Pierre-Paul Prud'hon, *Justice and Divine Vengeance Pursuing Crime*, 1808.

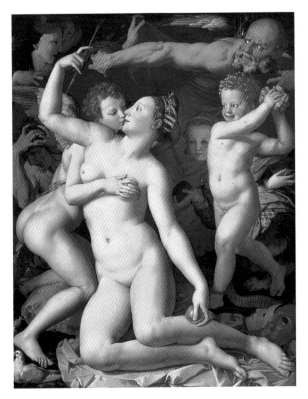

◀ **Complications of love**
In Bronzino's complex allegory Venus, holding her golden apple, takes one of Cupid's arrows. The god and goddess of love kiss and the figures around them also embody aspects of love. Behind the naked boy throwing rose petals is a young woman. She may look beautiful but this allegory of Deception is dangerous, for she holds behind her a thorny spike on the end of a hard, swollen, poisonous-looking ball. At the top right is Father Time, who may be covering or uncovering the scene, apparently in opposition to the figure (perhaps Oblivion) at whom he glares.
Agnolo Bronzino, *An Allegory with Venus and Cupid*, c.1545.

A darker message

Death and the transience of earthly existence has been a theme in Western art since the late thirteenth century, when it originated in poems on the subject of the impartial and equalizing nature of death. The best-known medieval allegory of the passage from this world to the next is The Dance of Death. In such images the hooded figure of Death, holding his symbolic sickle, is shown leading a line of figures by the hand in a macabre dance to the other world.

Rampant death

Untimely death on a grand scale through war and disease was a fact of life in the Middle Ages. In 1348 the Black Death struck northern Italy, killing half the people of Siena and Florence within a few months. The Italian poet Petrarch began writing *The Triumph of Death* in the same year, mourning the loss of his beloved Laura and many of his friends. In Pisa the walls of the burial ground of the Campo Santo near the cathedral are painted with mid-fourteenth-century frescos

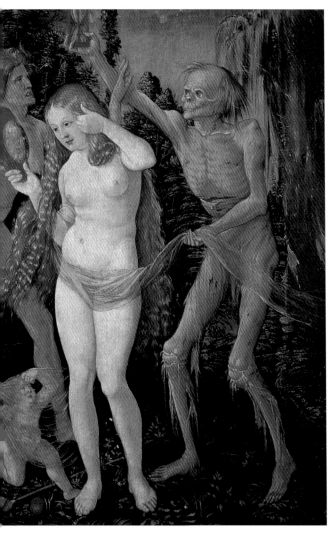

◄ **The Ages of Life**

Grien uses a skeleton holding an hourglass to symbolize death and the passing of time. The infant represents the beginning of life's journey. The prime of life is represented by the naked young woman admiring herself, neither seeing nor heeding Death. The anguished figure on the left is Old Age, reaching out to push the hourglass from Death's hand as if to thwart his grim purpose. **Hans Baldung Grien**, *The Three Ages and Death*, 1509–10.

▲ **Human fragility**

In Rosa's dark allegory, Death as a winged skeleton makes a baby write: "Conception is Sinful, Birth a Punishment, Life Hard Labour, Death Inevitable." These words from a twelfth-century poem are echoed by esoteric symbols. The woman seated on a glass sphere represents the human frailty of the painting's title. Behind her is a bust of Terminus, god of death, and the owl is an omen of death. **Salvator Rosa**, *L'umana fragilità*, c.1656.

showing images of death. Here the theme of the triumph of death and the vanity of life is exemplified by the allegorical painting *The Legend of the Three Living and the Three Dead* by the artist Francesco Traini. A company of knights and ladies on horseback stops before three open coffins in which lie putrefying corpses. The link between the living and the dead is indicated by the hand of the finely dressed woman who points toward the rotting skeletons, and the message is reinforced by the scroll borne by a hermit, on which is written: "Death vanquishes pride and vanity."

The work of the German artist Hans Baldung Grien contains many allegorical images. In his painting *The Three Ages and Death* he depicts the three stages of life and all humanity's ultimate destination, represented by the skeleton. Among the woodcuts of his near-contemporary and fellow countryman Albrecht Dürer are other allegorical reminders of life's brevity, such as *The Knight, Death, and the Devil*.

The personification of Time as a bearded and winged old man emerged in the Middle Ages. He is derived from the figure of Kronos or Saturn in Greek and Roman mythology, the oldest of the Titans and the father of Zeus or Jupiter. To forestall a prophecy that one of his children would depose him, he devoured them. This act, which was interpreted in the late Middle Ages as a symbol of how time eats everything in its path, provided an horrific image that was later used by several artists, most famously Goya. But although derived from Kronos (whose name was very close to the Greek word for time, *chronos*), the winged figure of Father Time, with his familiar attributes of scythe and hourglass, does not appear until the fourteenth century. His character is elusive: he can be destructive, as when shown clipping the wings of Love or wielding his scythe as the "grim reaper," but he can also be benign, protecting or else revealing the future or unveiling his daughter "Truth" in all her naked beauty.

In the allegorical painting *Time Orders Old Age to Destroy Beauty* the subject is the ravages of age, and Father Time is shown directing a withered old hag who reaches out to scratch the rosy face of a young beauty. The Italian painter Pompeo Batoni, who worked in Rome in the eighteenth century and was most famous for his portraits of English gentlemen on the Grand Tour, was particularly proud of this painting, boasting to his patron that the subject was entirely of his "own invention." The work was painted as one of a pair, the other painting containing an allegory warning against Lasciviousness.

Human frailty

In the Calvinist Netherlands of the seventeenth century allegorical meditations on the transience of life were very popular. These took the form of still-life paintings known as vanitas images, from the biblical reference "all is vanity" (see pages 228–9). A similar profound pessimism, along with the artist's interest in alchemy

and witchcraft, is evident in a chilling allegory on the brevity of life painted in that century by the Italian artist Salvator Rosa. In *L'umana fragilità* Rosa integrates his personification of abstract qualities such as frailty and death with symbols of the passing of time to create a *tableau vivant*, or rather a *tableau mourant*.

The truth that no one is exempt from the disfiguring hand of time and that death will eventually claim us all has persisted in allegorical form in painting and literature for centuries. From the Middle Ages, through the dramatizations by Marlowe and Goethe of Faust's pact with the Devil at the expense of his immortal soul, and Oscar Wilde's late-nineteenth-century story *The Picture of Dorian Gray*, right up to the present day, the theme of seeking to escape time and death has also flourished. In modern times meditations on mortality include the silkscreen prints of skulls by the American artist Andy Warhol and the animals preserved in formaldehyde of the British artist Damien Hirst.

▲ **The passing of beauty**
In Batoni's powerful allegory of the transience of life, Time, identified by his hourglass, his advanced age, and his wings, orders the wizened figure of Old Age to destroy youthful Beauty. The harsh truth of the inevitable loss of youthful Beauty is reinforced by the poignancy of Beauty's attempt to recoil from the ravaging hand of Old Age. **Pompeo Batoni**, *Time Orders Old Age to Destroy Beauty*, 1746.

Political allegory

▶ **The triumph of wisdom**
Bartholomeus Spranger travelled from Antwerp to Prague via Italy to work as court painter to Emperor Rudolf II and painted this work to celebrate the flourishing of arts and learning under his imperial patron. Minerva, goddess of wisdom, treads on Ignorance and presides over Bellona, goddess of war, seen lower left, to symbolize the victory of Rudolf's armies over the Turks in several battles between 1593 and 1595. History, on the right, and Learning, seen in the background, are protected by Minerva. Despite her warlike pose, her costume, and the spear she holds, Minerva is painted as a distinctly erotic figure whose bare breasts protrude from her fitted armour, mixing the political message with a sexual one.
Bartholomeus Spranger, *Minerva Victorious over Ignorance: Allegory on Rudolf II*, c.1591.

▲ **Peace and plenty**
The armoured goddess Minerva protects Peace from Mars by pushing the god of war away from the peaceful scene of plenty, toward the Fury Alecto, whose fire-spitting nature symbolizes war's destruction. Naked Peace, in the centre, feeds Plutus, god of wealth. A satyr offers a cornucopia to two girls, one of whom is being crowned by Hymen, god of marriage. The two female figures on the left represent prosperity and the arts. All flourish under Peace.
Peter Paul Rubens, *War and Peace*, 1629–30.

Political allegory uses symbols and the personification of abstract concepts to convey a civic or patriotic message. An early example is the fresco on the theme of "Good and Bad Government," painted for the town hall of Siena in Italy by Ambrogio Lorenzetti in 1338–9 (see page 176, *The Effects of Peace or Good Government in the City*). The work is a simple allegory showing the effects of both kinds of government. The painting allegorizing Good Government shows a panoramic view of the well-governed town and surroundings. The industry in the country and town brings prosperity to both. The city is recognizably Siena, and on the adjacent wall is the personification of Good Government in the form of a noble king flanked by Justice, Prudence, Temperance, and other virtues, including a pensive figure of Peace, clothed in white.

In the following century the d'Este family, the rulers of the dukedom of Ferrara in Italy, commissioned a fresco cycle for the decoration of their palace that celebrated by means of erudite and arcane symbolism the civilizing influence of their court (see pages 84–5).

Much more easily read is the message in the allegory on the achievements of Emperor Rudolf II painted by the Flemish Mannerist artist Bartholomeus Spranger. At the end of the sixteenth century Rudolf transferred the imperial court from Vienna to Prague and in so doing created one of the most magnificent courts of Renaissance Europe. His patronage saw the creation of much highly erotic mythological painting, as well as complex allegories glorifying himself and reflecting his interest and achievements in the arts, learning, science, the occult, and warfare.

Self-aggrandisement

In an even more ambitious programme of self-aggrandisement, Marie de Medici, Queen of France, commissioned from the Flemish painter Rubens twenty-one large canvases depicting scenes from her life as if conducted under the watchful eye and guidance of the Classical gods, with whom she appears on equal terms. Her aim was to be ranked with the immortals.

Rubens's role as both painter and diplomat was put to use in his large allegorical work *War and Peace*. He travelled to England in 1629 as an envoy of Philip IV of Spain to promote peace between the two countries. This painting, a gift to Charles I of England, reflects the stance of the Spanish diplomatic mission by depicting the threat of war to the benefits of peace.

The celebration of single great figures was also seen in the church. Raphael, in his decorative cycle of rooms in the Vatican for Pope Julius II, frescoed the second room in 1511–14 with paintings of historical events that made allegorical references to contemporary

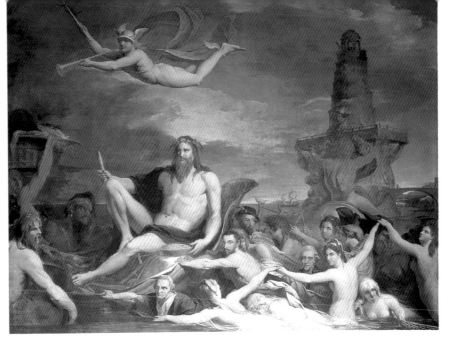

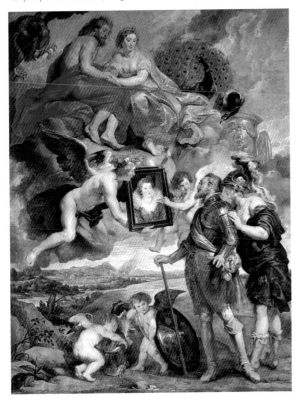

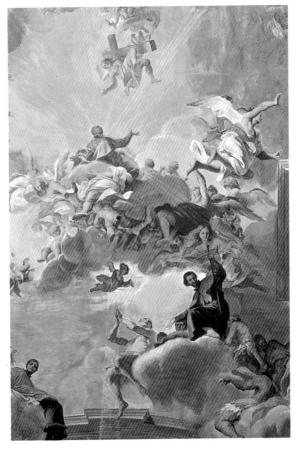

events. Thus his depiction of Pope Leo I, who a thousand years earlier was believed to have miraculously halted the advance of Attila the Hun on Rome, was recognized as a reference to the victory of Pope Julius II over the invading French army. The figure of Leo I was later given the features of Leo X, who succeeded Julius II in 1513. In the next century the glorification of another great religious figure can be seen in *The Glory of St Ignatius Loyola*, a painting that decorates the ceiling of the church of St Ignazio in Rome. This allegory celebrates Loyola's founding of the Society of Jesus, the missionary work of the Jesuits, and his elevation to sainthood.

Commerce

An eighteenth-century personification of the city and hopes for its flourishing is seen in *Commerce* or *The Triumph of the Thames* by James Barry. The Irish history painter elevates London to a great commercial metropolis presided over by the river god himself. Commerce is depicted as the very heart of the capital city, recalling Napoleon's slighting characterization of England as "a nation of shopkeepers."

In post-revolutionary France, a reborn nation consciously modelled on the great cities of ancient Athens and Rome, Napoleon encouraged the painting of allegories that celebrated him and the greatness of his empire. Ingres depicted Napoleon like a modern Jupiter, and in *Ossian Receiving the Shades of French Heroes* (see page 129) another French artist, Girodet, shows Napoleon's fallen generals rising in the afterworld to be greeted by the Gaelic bard Ossian.

In the early twentieth century allegorical imagery served as an instrument of political change in revolutionary Russia. The Bolsheviks painted their trains with abstract images with titles such as *Beat the Whites with a Red Wedge* in order to spread an unambiguous message throughout the country.

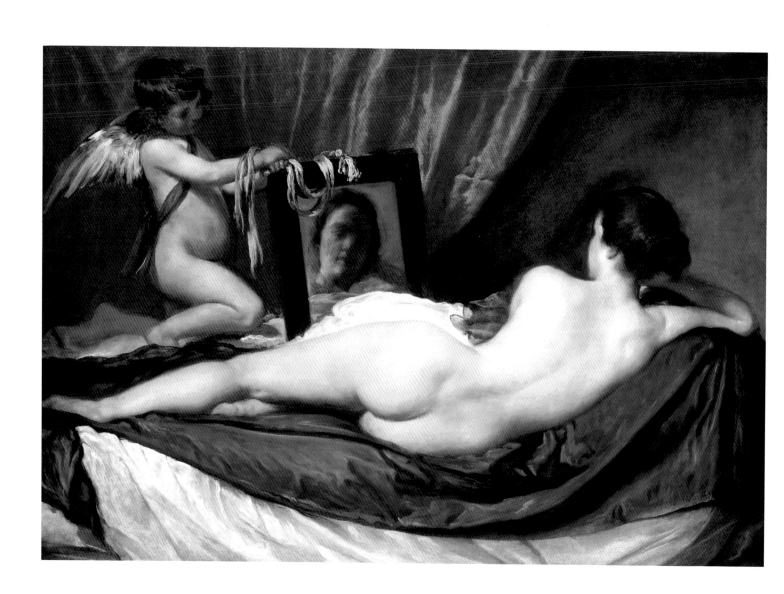

Claude Debussy, *Monsieur Croche, antidilettante*, 1917

The Nude

When this marble
sculpture, illustrating a
scene from Virgil's epic
poem the *Aeneid*, came
to light in 1506 it fired in
many Renaissance artists
an interest in the depiction
of emotion through the
naked human body. The
work was admired for its
cohesive and brilliantly
balanced composition as
well as for the expressive
nature of the bodies and
the faces.
**Workshop of
Hegesandrus,
Athenodorus, and
Polydorus of Rhodes**,
The Laocoön, third century
BC–first century AD.

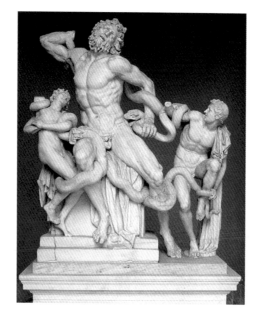

◄ **Stylized Christ**
In this crucifix, cut from
a single plank of poplar,
Jesus is shown on the
cross with the Virgin Mary,
who is supported by two
holy women, on the left.
St John the Evangelist and
the Centurion appear on
the right. Christ's body is
stylized and its anatomy is
reduced to pattern, but
there is great pathos and
majesty in the silhouette.
**Attributed to the Master
of St Francis**, *Crucifix*,
1272–85.

estern art is unusual in its preoccupation with the
naked body. With the exception of India the nude is
of little importance in Eastern cultures, but in the
West the human body has been the essential build-
ing block of art. Consequently mastering it was seen
as the truest test of artistic skill and the vehicle for the widest range of
expression. The nude emerged as a genre in Greece before the fifth
century BC and the idealized Greek nude, perfectly proportioned with
none of the flaws of reality, stands as the source of the Western tradi-
tion. Although ancient Greek philosophers introduced the distinction
between body and soul, the two were seen as linked: the nude could
express both physical beauty and nobility of soul and spirit. In the
Christian era, however, body and soul came to be seen almost as oppo-
sites, and nakedness was more often a sign of shame and humiliation
– the nude became the naked. The naked human figure is virtually invis-
ible in Christian medieval art except in a sinful context, such as scenes
of Adam and Eve and the Last Judgement. From the seventh to the
eleventh centuries even the crucified Christ is usually depicted clothed.

The nude and the model

This attitude toward the naked body as something shameful was
certainly not dispelled by the rediscovery of, and enthusiasm for,
Classical teaching and art in the Renaissance and it persists today.
From the Renaissance, however, the nude once again became a major
artistic theme and since then artists have worked variations on such
enduring motifs as the reclining female nude and the bathing nude. As
importantly, the study of the nude became an indispensable part of an
artist's training from the Renaissance. Writing in fifteenth century
Florence Alberti explained: "Before dressing a man we first draw him
nude, then we enfold him in draperies." Artists such as Leonardo da
Vinci are reputed to have dissected bodies in order to understand their
musculature better, and numerous drawings survive from the
Renaissance of studio assistants posing in their underclothes. When
working in the papal rooms in the Vatican, Raphael first posed his
figures in the nude, in order to understand their real structure, then
clothed them and proceeded to colour in the final picture. This
sequence became enshrined in the academies of art established from
the sixteenth century onward in which study of the nude (almost

► **Gothic influence**
Botticelli's incomparably
beautiful depiction of
Venus, the goddess of
love, as she emerges from
the sea on a shell, does
not slavishly follow the
Greek ideal of beauty and
proportion in the female
nude. Her neck and arms
are unnaturally long, and
her left shoulder slopes
gently. The image of the
two entwined wind gods
is taken from a Classical
source. The picture is
probably an allegory of
spring, with Venus as the
spirit of regeneration,
hence the cloak of flowers
she is about to put on.
Sandro Botticelli, *The
Birth of Venus*, c.1485.

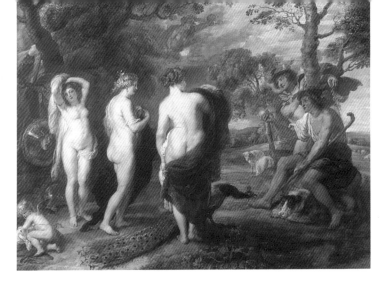

◀ **Divine forms**
This subject, taken from Ovid's *Metamorphoses*, gave full rein to Rubens's talent for painting the female nude. The story allowed him to focus on three nudes, each striking a provocative pose. Paris had the unenviable task of awarding a golden apple to the goddess he believed to be the most beautiful. At this point in the story, which is set in a softly lit Arcadian landscape, Paris has just selected Venus, the central figure in the group.
Peter Paul Rubens, *The Judgement of Paris*, 1632–5.

▼ **Erotic pose**
Louise O'Murphy, or La Morphise, as she was called at the court of King Louis XV of France, became one of the king's mistresses, supposedly at the age of fourteen. Boucher paints a candidly erotic depiction, believed to have been calculated to whet the king's appetite for the young woman. The playful sensuality is characteristic of how Boucher portrayed the female nude.
François Boucher, *Reclining Girl (Portrait of Louise O'Murphy)*, 1752.

exclusively male until the later nineteenth century) became the virtual basis of art training. Students were instructed in drawing from the live model but they were expected to idealize what they saw along Classical lines. Studying the nude also meant studying Classical sculptures and exemplary paintings of the past, Michelangelo setting the standard for the male nude and Titian for the female.

Gender and sexuality

Representations of the nude inevitably reflect attitudes toward gender and sexuality. The Western tradition is patriarchal and most artists and patrons in the period covered by this book were men. Both facts have inevitably affected the ways in which male and female nudes have been represented. The essential difference between the male and female body in art before the late nineteenth century is that men are characteristically shown as active, while women are more frequently passive. There are of course important exceptions to this general rule – the naked suffering Christ is one, the naked female personifications of virtues another – but these are special cases. More typical is the long tradition of showing female nudes asleep or being spied upon, either by figures within the picture or by the viewer. Female nudes also often acknowledge the viewer: Venus's apparent gesture of modesty in Botticelli's *Birth of Venus* (borrowed from Classical sculpture) only makes sense if she is being looked at. In Rubens's *Judgement of Paris* the three goddesses are explicitly on display, presenting themselves to both Paris within the picture and the viewer outside it.

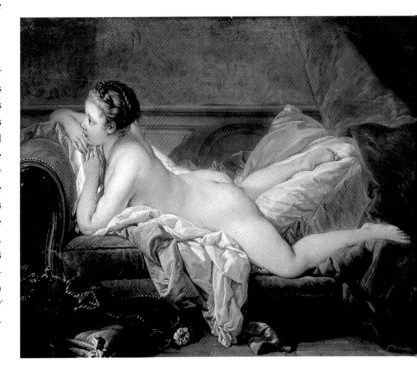

Changing ideals

Depictions of the idealized female nude reveal changing ideas of beauty. In the fifteenth century women are shown with stomachs like pears and breasts like apples. In the seventeenth century, most famously in the work of Rubens, they are heavily built and fleshy while, in the Rococo age, artists such as Boucher and Fragonard favoured a trimmer figure. In the second half of the nineteenth century Realist artists such as Courbet and Degas challenged the tradition of the idealized female nude and instead set out to depict naturalistic bodies in everyday settings. Since then changing attitudes toward sexuality and sexual politics have made the nude one of the most highly charged of all the genres.

◀ **Distortion**
Kirchner painted this work over a period of years while seeking inspiration at a nudist colony near Dresden. The distortion of the figures owes much to the African sculptures that had excited the group of artists known as Die Brücke (The Bridge), to which Kirchner belonged. The man on the far left appears detached from the other bathers, and some believe that this is a self-portrait.
Ernst Ludwig Kirchner, *Bathers at Moritzburg*, 1909–26.

Gods and goddesses

In 1548 the humanist and courtier Annibale Caro wrote to the painter Giorgio Vasari, who was at that period just beginning work on his famous *Lives of the Most Excellent Painters, Sculptors, and Architects*, to ask Vasari to paint him a picture. In his letter Caro perfectly sums up the Renaissance attitude to the nude. He wanted two nudes, which he described to the artist as "the greatest subject of your art." He said he did not mind who they were or what the story was, but he suggested something like Venus and Adonis, because their passion and Adonis's death would make a scene full of feeling. No academic nude for Caro: he wanted something tragic and affecting, and erotically charged.

Attitudes to the nude

Later commentators were far more reticent in their attitude to the nude. Scholars and critics – especially in the nineteenth and twentieth centuries – often sought to deny the obvious sexuality in works such as Titian's *Venus of Urbino*. Her gesture with her hand, for instance, was interpreted as an act of modesty rather than as sexually provocative. A contemporary reference, however, to another nude by Titian makes the viewpoint of the original spectators quite clear; writing to his patron, a courtier enthuses that the work will "put the devil on your back" (arouse lust) and make the *Venus of Urbino* look like a nun. In the male-dominated culture of the period, women's bodies were readily seen as objects to be enjoyed. This enjoyment was not exclusively sexual, however, nor was it always thought of as sinful. Indeed contemplation of a naked woman could

also be regarded as a poetic experience, ennobling the soul, improving the mind, and inspiring music.

Titian's *Venus of Urbino* is not explicitly a representation of Venus (it is also probably not from Urbino). Unusually, Titian's nude is given none of the goddess's usual attributes: there is no figure of Cupid and no golden apple, and the earliest reference we have to the picture talks only of "the nude woman." She does hold roses, a traditional symbol of love, and a dog is curled up at her feet, which has been interpreted as a symbol of faithfulness in love, but there is no agreement as to whether the picture should be read as allegory or fantasy.

The nude and narrative

Paintings of nudes before the nineteenth century are, however, usually clearly identified as gods or goddesses – as in Velázquez's *The Toilet of Venus*, where the figure of Cupid identifies the reclining figure – or are presented in the context of a story. Painters could range among the numerous tales found in Ovid's *Metamorphoses* (most metamorphoses had some kind of sexual motivation) or exploit other rediscovered Classical texts that were ceaselessly being translated. Biblical subjects were also available: the Elders spying upon the bathing Susannah, for example, or King David's lust for Bathsheba. Contemporary familiarity with such subjects made it possible to hint at the situation rather than describe it and in some cases the artist may deliberately have left the identity of his nude ambiguous, as in more than one picture by Rembrandt.

▼ **Body and mind**
Titian's *Venus of Urbino* has been read in very different ways, owing to the fact that it is neither a real-life, naturalistic image, nor an episode from any known story concerning the goddess. It has been interpreted as an allegory of marital fidelity, suggested by the *cassoni*, or marriage chests, in the background, and by the roses and the sleeping dog. Alternatively, Venus might be seen as a kind of vision, a materialization of the spectator's fantasy. The figure's pose derives from a work painted by Titian's contemporary Giorgione in which Venus is shown asleep in the countryside. Here Titian has transposed the figure into a *palazzo* and shown her very much awake.
Titian, *Venus of Urbino*, 1538.

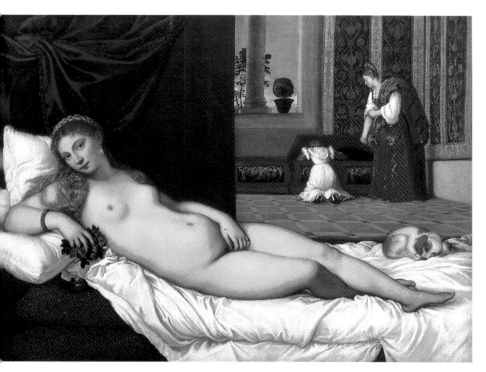

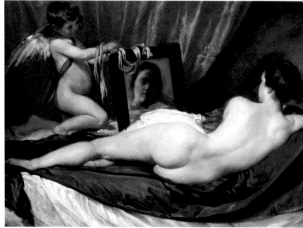

▲ **Flesh tones**
Velázquez probably painted this nude for a client who was fond of both the arts and women. The painter clearly had in mind the great Venetian tradition of nudes, particularly those of Titian and Tintoretto. But despite this, the pearly grey, pink, and cream flesh tones, executed with great subtlety, are peculiar to Velázquez.
Diego Velázquez, *The Toilet of Venus* ("*The Rokeby Venus*"), 1647–51.

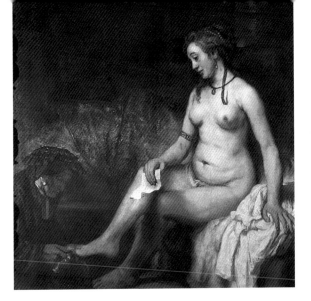

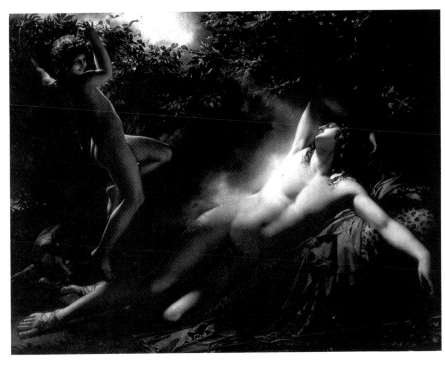

▲ **The erotic male**
The French academic painter
Girodet was a passionate admirer
of ancient literature and Greek
mythology. In this highly erotic
depiction of the male nude, he
reveals his admiration for the
Greek ideal of beauty, learned
from his master, the Neoclassical
painter Jacques-Louis David.
Endymion was a beautiful youth
with whom the goddess Diana,
in her capacity as the moon, fell
in love. It is moonlight that falls
on him in this picture. Endymion
is shown in a pose more usually
associated with women, and
this androgynous beauty is
emphasized.
Girodet, *The Sleep of Endymion*,
1792.

Artists were not entirely free in their representa-
tion of nudes. Where the woman was depicted as an
object of desire, it was usual to introduce some note of
warning. In the story of Susannah viewers were reminded
that the Elders came to a bad end. Some works intro-
duced a note of melancholy, as in Rembrandt's
Bathsheba, which suggests some of the accidents and
evils consequent on adulterous love: in this case, David's
contriving of the death of Bathsheba's husband in order
to obtain her. There was, however, seldom any implicit
criticism of Mars and Venus but instead a cruel joke at
the expense of Vulcan, Venus's unappealing husband.

In Boucher's sensuous depiction of this subject,
typical of the frank hedonism of Rococo nudes, Vulcan is
shown discovering the two lovers. This familiar device of
showing an onlooker emphasizes the act of spying and
looking on the naked body – an act in which those who
look at the painting are inevitably implicated. The same
voyeuristic device is found in the stories of Susannah
and Bathsheba, both spied upon while bathing. Sleeping
or reclining nymphs are often shown being spied upon

▲ **Rococo sensuality**
The French Rococo artist Boucher's
principal patron was a woman,
Madame de Pompadour, the
mistress of King Louis XV, yet the
flagrant eroticism of his nudes
seems intended for male eyes.
Boucher, like other Rococo artists,
often used the voyeuristic device
of showing an amorous couple
caught unaware. The subject is
taken from Ovid's *Metamorphoses*,
but the narrative is less important
than the painter's skill in depicting
the flesh tones of his sensual
Venus. From Venetian painting
onward, Vulcan was often shown
gazing on his wife's genitals.
François Boucher, *Mars and
Venus Surprised by Vulcan*, 1754.

by satyrs, whose eternal fate is to leap upon the naked
nymph only to have her run away – a witty device to
remind viewers that the pleasures depicted are visual
and cannot not be enjoyed in the flesh. The story of
Endymion is unusual in that, in this instance, it is a
sleeping man. But here again it is the act of looking at a
beautiful but unobtainable figure that is emphasized.
Endymion was sent into perpetual sleep by Jupiter in
return for everlasting youth and was visited and admired
nightly by the chaste Goddess Diana. The subject offered
artists the opportunity to depict an idealized, youthful
male nude, but in an unusually passive, vulnerable pose.

The human form

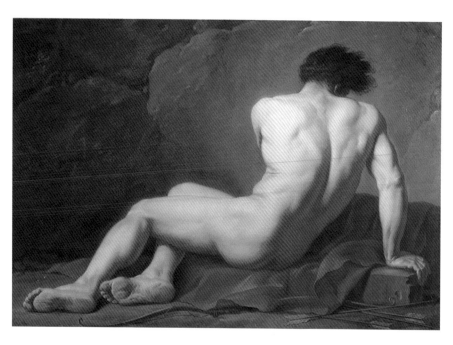

Noble beauty
David was a pupil of the French Rococo artist Boucher but soon rejected his teacher's style in favour of the linear grandeur of Neoclassicism. His careful study of Greek and Roman sculpture showed him how to model the human body and to create a noble, balanced composition. In this work his adulation of Classical splendour is clear.
Jacques-Louis David, *Académie d'Homme dite Patrocle*, c.1777.

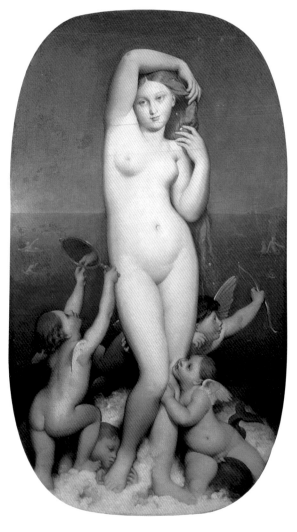

In 1817 the British history painter Benjamin Haydon saw the Elgin Marbles, the Greek sculptures from the Parthenon in Athens that were temporarily located in a shed constructed by Lord Elgin in Park Lane, London. "I felt," he wrote later, "as if a divine truth had blazed inwardly upon my mind." Haydon was not alone in his ecstatic response to the art of Classical Greece and Rome. The arrival of the Elgin Marbles had a huge influence on British artists, inflaming their passion for the antique.

Revival of the nude
The Neoclassical movement had its roots in the previous century. Johann Winkelmann (1717–68), the leading theorist of the movement, who attempted a systematic history of Classical sculpture using stylistic criteria, laid particular emphasis on the importance of ideal beauty, which he looked for in the "noble simplicity and calm grandeur" of the antique. In the academies of art, students were encouraged to spend hours in the life class studying the nude model – often in the pose of a famous Classical sculpture – by candlelight. The painted *Académie*, or life-study, in which the nude model was idealized along Classical lines, became an essential part of an artist's training and practice.

Perhaps the most important artist in the revived academic tradition of painting the nude was Ingres, although it was the female rather than the male nude that was his principal subject. He produced a series of smooth-skinned, sensuous but utterly unreal nudes in the guise of goddesses or eastern odalisques and Turkish bathers. It was largely under Ingres's influence that nude females began to supplement male models in

Sinuous line
Like his master, David, the French artist Ingres admired the heroic style of the antique and believed passionately in the importance of drawing from life. This work, one of the finest of his nudes, reveals his love of line and form. But despite his professed adherence to Classical principles, his female nudes are often highly contorted and hardly Classically correct.
Jean-Auguste-Dominique Ingres, *Venus Anadyomène*, 1848.

the art schools. This was often a contentious issue. When, in the first half of the nineteenth century, in Britain, William Etty played an active role in making the female nude model available to students in the Royal Academy and in art schools up and down the country, there were letters in *The Times* and complaints in Parliament. Even late in the century the Royal Academy strictly controlled the access of male students to the female nude – those under twenty were not admitted unless they were married.

The naturalistic nude
In the 1850s and 1860s the Classical tradition was challenged by Realist artists such as Courbet and Manet.

Courbet's deliberately unidealized nudes shocked the public, as did two highly controversial paintings exhibited by Manet in Paris in 1863 and 1865. His *Le Déjeuner sur l'Herbe* (1863), a reworking of Giorgione/Titian's *Concert Champêtre* (see page 172), took the Parisian art world by storm. In it, Manet depicts an unidealized woman, naked rather than a nude, in the presence of men in modern dress. He created an even greater outrage with *Olympia*, painted that same year but exhibited in 1865, a modern reworking of Titian's *Venus of Urbino* (see page 108). Despite echoes of Titian's painting and the Classical title, Manet's nude is emphatically contemporary and, equally clearly for her original audience, a prostitute. This is a naturalistic nude in a believable if provocative contemporary context. More unexpected and disturbing was the way that Manet's nude confronts her audience – in the place of the langorous and inviting poses of so many academic female nudes, Manet's *Olympia* stares defiantly out of the picture, her neck upright and hand planted firmly on her thigh. This is no come-hither look and her directness is echoed by the aggressive arched back of the kitten at the end of the bed – where Titian had painted a sleeping dog.

Degas, like Manet, explored the subject of the naturalistic nude, but to very different ends, in his extraordinary series of paintings, pastels, and drawings of bathing women. Like Manet's *Olympia* these are contemporary women in believable situations but, in contrast to Manet, Degas's principal interest was in the physicality of the body and his active nudes are shown as self-absorbed and oblivious of the spectator. Degas himself described them as "a human creature preoccupied with herself – a cat who licks herself; hitherto the nude has always been represented in poses which presuppose an audience, but these women of mine are honest simple folk, unconcerned by any other interests than those involved in their physical condition."

Degas's approach was unusual. Renoir did not paint a nude until his fortieth year, but the voluptuous examples he produced, such as *The Bathers*, painted late in his career, are among his best-known works. Although his use of paint was much freer, his nudes share the exuberant voluptuousness of the eighteenth-century Rococo painters and offer a considerable contrast to those of Degas. They have little to do with reality but are creatures of pure fantasy, sexual objects in the Renaissance tradition, even though they are handled in an Impressionistic style.

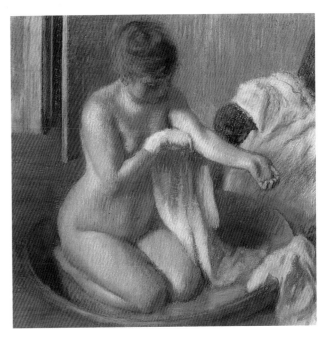

▽ **Breaking with the past**
Manet believed that many conventions in painting, including the depiction of the nude, had become stale and meaningless. In this painting he reworks a famous nude by Titian, but, provocatively, puts her in a modern context. Here, for almost the first time since the Renaissance, a female nude is depicted as a contemporary woman in ordinary surroundings. The fact that she is not a posed, Classical nude and is also clearly a courtesan receiving flowers from a client, shocked the Parisian public.
Édouard Manet, *Olympia*, 1863.

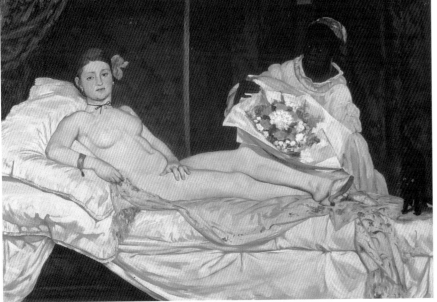

▲ **Domestic study**
This pastel is one of a series which Degas began in the 1880s. He focuses on the female nude in a new way. The figure is not consciously posed and is unaware that she is observed. Degas captures the natural grace as the woman dries herself. Influenced by early photography and Japanese prints, he was interested in adopting unconventional and apparently spontaneous viewpoints.
Edgar Degas, *Woman in a Tub*, c.1883.

▶ **Sunlight on skin**
This late work combines Renoir's interest in Classical art with Impressionist brushwork and a concentration on how sunlight affects flesh tones. Renoir was inspired by the beauty of his models and chose domestic staff whose skin "took the light well" to pose for him.
Pierre Auguste Renoir, *The Bathers*, 1918–19.

The modern male nude

Uncompromising intimacy
Spencer was an original, visionary artist whose work resists easy categorization. In a reference to this imposing double nude, one of two he painted in the winter of 1936–7, he likened himself to an ant crawling over every part of his future wife's body. Spencer's unflinching treatment of both anatomical detail and emotional vulnerability typifies his approach to the nude.
Stanley Spencer, *Self-Portrait with Patricia Preece*, 1937.

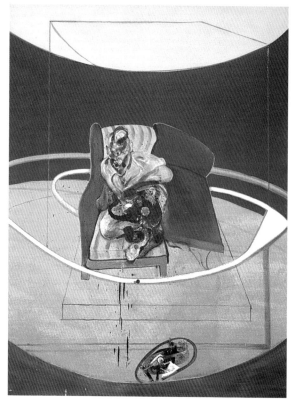

Spiritual pain
Inspired by a photograph of men running taken by the pioneer photographer Eadweard Muybridge, Bacon started to depict the male form. Movement in this painting is, as always, of great interest to him. The distorted pose of his sitter is characteristic of the angst-ridden subjects that the artist painted in his later years, when he manipulated the paint in a highly original way that captured movement and flesh tones, as well as inner unrest.
Francis Bacon, *Study for Portrait on Folding Bed*, 1963.

From the beginning of the twentieth century the avant-garde movements of Cubism, Futurism, and Expressionism approached the human form in radically different ways, distorting and elongating it, and dispensing with the traditional aim of making the nude a thing of beauty. Throughout the century other social and political developments such as the changing role of women in society – which among other things resulted in many more women artists – a growing frankness toward sexuality, and the rise of feminism have all affected how the nude has been depicted and seen.

The modern male nude is seldom the heroic, muscular, active figure of Classical art. In the first decades of the twentieth century, at about the time that Cubism was developing in Paris, a number of German Expressionist painters were distorting line and colour in depictions of the human form to express feeling and mood. Ernst Ludwig Kirchner and other members of the group Die Brücke made a series of paintings of a nudist colony, drawn to the atmosphere of sexual frankness and their subjects' uninhibited postures. The strange distortions of Kirchner's figures (see page 107) reflect, as in the work of the Cubists, the powerful influence of the art of Africa and other cultures then seen as primitive.

Uncompromising depiction

The distortion of the body for expressive ends was a recurrent theme throughout the twentieth century and was given fresh but disturbing impetus by the suffering brought about by, and witnessed during, two world wars. As early as 1914 the Jewish sculptor Jacob Epstein made his famous *Rock Drill*, a bronze sculpture that is half man, half mechanical robot, expressive, as he wrote, "of the terrible Frankenstein's monster we have turned ourselves into."

In the Second World War the horrific images of the tortured, emaciated bodies from the concentration camps inspired the Swiss painter and sculptor Alberto Giacometti to create his famous slender figures, both in bronze and in paint. But his nudes, male and female, also speak of the Existential philosophy of the futility of existence.

In 1945, the year the Second World War ended, Francis Bacon achieved international recognition after exhibiting *Three Figures at the Base of the Crucifixion*. Perhaps more than any artist of the twentieth century, he explored the male nude to express isolation and introspection. His unique way of using paint, which he described as "waiting for the right accident to happen," has an almost visceral effect on viewers, disturbing yet powerfully communicative. Bacon made no attempt to paint the nude descriptively and he never required the

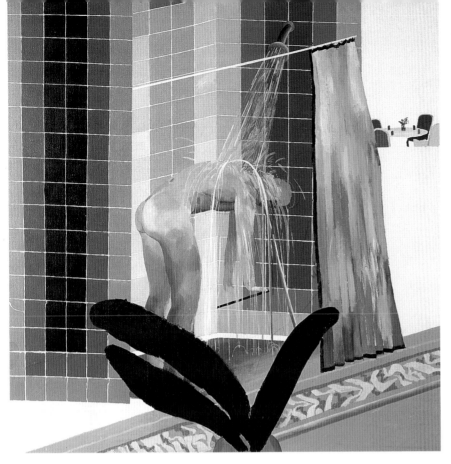

Movement
Hockney painted a series of male nudes while living in Los Angeles in the 1960s. He later wrote that he became fascinated with the challenge of depicting the male nude in action, especially when the subject was surrounded by water. As a homosexual artist, more inspired by male than female beauty, Hockney has added an important chapter to the history of the male nude. In this painting he uses the device of the shower to concentrate on movement. The way parts of the body are obscured in the composition recalls Degas's method of rendering the human form, in which the artist depicts the subject from an angle that prevents a full view.
David Hockney, *Man in Shower in Beverly Hills*, 1964.

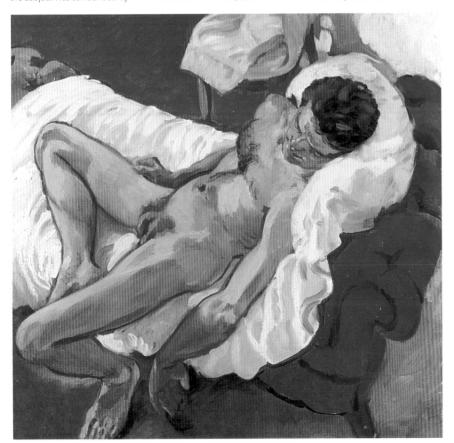

Tenderness
In this composition the unusually high viewpoint and the warm palette of browns, yellows, and reds derive from the artist's admiration of Degas. In her short career – she died at the age of forty-six in 1996 – Fischer painted both male and female nudes, but she brought a particular sensuality and tenderness to her studies of the male body. Here, at the same time as she depicts the physical form of her subject in intimate detail, she conveys the man's vulnerability by showing him asleep in an unguarded position.
Sandra Fischer, *Red Nude*, 1989.

sitter to be present while he worked. His highly original treatment of the nude addressed deeper concerns than his own homosexuality, though this was clearly a factor in his choice of models. While paintings such as *Study for Portrait on Folding Bed* convey something of the sitter's anguish, they also reflect Bacon's own deep pessimism about human life.

If the distortion of the male nude to suggest vulnerability and suffering has been one response to the subject, there have been many others. The eccentric British painter Stanley Spencer approached the subject with a a deliberately frank matter-of-factness. Between 1933 and 1937 he painted seven nude or semi-nude portraits, among which are two double nudes of himself and the woman who was to become his second wife. Particularly striking is the double nude *Self-Portrait with Patricia Preece*, an uncompromisingly realistic depiction of the nude. The starkness of this painting may reflect the couple's problematic relationship.

The bather as subject

Perhaps surprisingly depictions of the male nude as erotic objects are rare in twentieth-century art and have more often been the preserve of male homosexual artists than of women. David Hockney's series of beautiful young men showering or diving into swimming pools, painted in the 1960s in Los Angeles, expresses a sensual delight in observing the active male form. He later wrote of these paintings: "For an artist the interest of showers is obvious; the whole body is always in view and in movement, usually gracefully, as the bather is caressing his own body. There is also a three-hundred-year tradition of the bather as a subject in painting." Hockney's unashamed homosexuality allows him to see himself following in this tradition, even though the bathers he refers to were female.

In contrast few women artists have painted the male nude. It was not until early in the twentieth century that women artists were first allowed limited access to the nude male model in the teaching studio and throughout the century women artists, when painting the nude, tended to focus on their own sex. The "female gaze" – women observing or celebrating male sexuality – is a chapter in the history of the nude yet to be written. Again, there are some exceptions. Sandra Fischer made a series of beautifully observed, descriptive studies – for example, *Red Nude* – combining affection with a gentle, subtle sensuality.

The modern female nude

In the early years of the twentieth century Pablo Picasso and Henri Matisse each invented new ways of depicting the nude. The approaches of the two artists were completely different, yet both were to exert a lasting influence on the way in which modern artists looked at the nude.

Picasso's *Les Demoiselles d'Avignon* is one of the most famous nudes of the twentieth century. Combining a fascination with the formal organization of Cézanne's *Bathers* and a new-found passion for the austerity of the art of Africa and Iberia, Picasso delivered a completely new depiction of the female body. His violent treatment of the subject rejects any notion that the female nude should give pleasure to the viewer.

Painting from experience

It has often been said that Picasso had a love-hate relationship with the nude. He was the most autobiographical of artists and his own life, in particular his lovers and wives, often provided the raw material for his art. The nature of a relationship at a given time indisputably affected the way in which he depicted his subject. Soon after meeting the seventeen-year-old Marie-Thérèse Walter, when he was in his fifties, Picasso celebrated the erotic nature of their relationship in a series of nudes that are full of undulating curves, an expression of both tenderness and frank sexuality.

Much later, when Picasso was in his eighties, he produced a series of distorted nudes of his third wife, Jacqueline Roque. These paintings seem, to some, filled with a rage and bitterness that appears to find relief in torturing the female form.

Matisse had no such plans for his female nudes. His paintings, influenced by both ancient Greek art and the pattern-making of Islamic art, embody a sense of harmony rather than fragmentation. The vivid colours and the expressive freedom of the women in his different versions of *The Dance* are characteristic of the bold palette and uninhibited energy of his painting. Although the use of colour and the freedom of line in *The Dance* was as hostile to academic painting as Picasso's iconoclastic *Les Demoiselles d'Avignon*, its mood could scarcely be more different; it is clearly celebratory. The nude remained a central subject of Matisse's art throughout his long career. In the 1950s, toward the end of his life, Matisse embarked on a series of paper cutouts, some of them nudes. Their simple beauty makes them classics of twentieth-century art.

Challenging convention

When Gwen John followed her brother Augustus to the Slade School of Art in London in the 1890s very few women attended art school and they were certainly not invited to attend the classes in life drawing. Nevertheless, she pursued the subject of the nude in her career, which many critics now hold in higher esteem than that of her brother, who received a great

▼ Afro-European art

Picasso famously repainted the two heads on the right of this composition after wandering into a Parisian gallery showing African art in 1907. He was instantly captivated by the atavism of what he saw, and later wrote: "At last I have discovered what art is about." The two reworked heads clearly show the influence of African masks, but at the same time the geometric forms of all the nude figures, representing prostitutes in a brothel, derive from Cézanne's analytical approach to representing form in his late series of *Bathers*. The amalgamation of these two styles produced an astonishing reinvention of the depiction of the female nude. The work would influence artists for decades.

Pablo Picasso, *Les Demoiselles d'Avignon*, 1907.

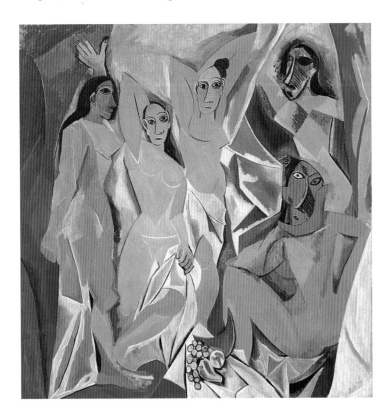

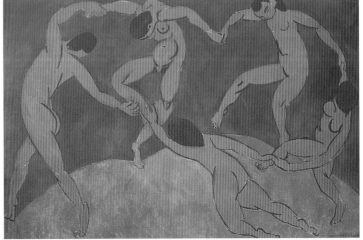

▲ Wild colour

This work reveals the emphasis placed on colour by Matisse and the other Fauvist painters. Pink figures, set against a blue and green background, dance joyously in a circle. They twist and turn with feeling as they lose themselves in the rhythm of the dance. Matisse's work expresses a remarkable intensity of emotion – here, the feeling is one of joy; in other paintings, a profound melancholy is engendered.

Henri Matisse, *The Dance (II)*, 1910.

Isolation
In the early 1990s Lucian Freud began a series of studies of two favourite models: the performer Leigh Bowery and the "Benefit Supervisor." Both sitters had huge, ungainly forms, which Freud clearly found a challenge to paint. Even so, his technical ability to render flesh tones is without parallel in modern art. The obese form of the Benefit Supervisor, seemingly exhausted with her own body's weight, conveys an atmosphere of isolation common in Freud's nudes.
Lucian Freud, *Benefit Supervisor Resting*, 1994.

The unfashionable body
Like Rubens, Jenny Saville loves to explore the sensuality of oil paint to convey flesh tones. She is also influenced by Lucian Freud. This work is one of a series of nude studies in which she specialized during the 1990s. Like much of the artist's work, it highlights the idea of representing women as bodies alone. By depicting obese women Saville also focuses on the idea that food is an issue for women and that the majority of women do not have the fashionable, androgynous bodies represented by models in fashion magazines.
Jenny Saville, *Propped*, 1992.

Objective realism
This painting is one of a pair of pictures of the same model painted in Paris, where Gwen John was living in 1909. John combines objective realism and intimacy, which is rare in the history of the nude, although found in the work of both Stanley Spencer and Lucian Freud. She was known to have an intense dislike of the model, named Fenella Lovell – a hostility that is quite apparent in the way she represents her subject. Nevertheless, when it was first shown the portrait was immediately admired .
Gwen John, *Nude Girl*, 1909–10.

deal more attention in his lifetime. Her passionate affair with the French sculptor Auguste Rodin, for whom she modelled, inspired an interest in the nude. Unlike Rodin's powerfully sensual studies, however, Gwen John's female nudes, such as *Nude Girl*, are quiet and subtle, in many cases emphasizing her subject's introspection. Gwen John is one of the many twentieth-century women artists who have been interested in discovering how to depict the female nude in ways that challenge its passive, erotic presentation in paintings that presupposes a possessive male viewer. John's painting is as much portrait as nude; the girl's gaze is direct and her body is presented in as factual or objective a way as possible.

The same desire to challenge traditional representations of the female form in art and popular culture lies behind the nudes of the contemporary British artist Jenny Saville. In the early 1990s she embarked on a series of nudes of obese women. Saville's works are realistic and unadorned; they are also a deliberate rejection of the contemporary concept of female beauty as represented by young, androgynous-looking women whose boyish bodies belie their sexual maturity.

Psychological studies

Saville's works clearly display the influence, both in subject and in their use of paint, of her older contemporary Lucian Freud. Freud is well aware of his reputation as one of the "great flesh painters" in the tradition of Rubens. His technique of using oil paint to create the illusion of flesh in his nudes – which are as often male as female – is masterly. He has said: "I want the paint to act as flesh." Freud's magnificent nude studies are made carefully and slowly, after many sittings with the subject, whom he almost always knows well. His nudes are not simply sexual beings and his subjects are seldom beautiful young women. Appropriately for the grandchild of the pioneering psychoanalyst Sigmund Freud, his nudes are psychological studies, as concerned with the sitter's character as with his or her body. It is telling that he refers to these paintings not as nudes but as his "nude portraits."

"Historic painting, from its sublime style . . . and the great breadth of imagination to which it is susceptible; from the extensive range of its effects, and the unbounded dominion it gives the painter, occupies the most exalted rank in the various departments of art."

William Cullen Bryant,
Letters of a Traveller, or Notes of Things Seen in Europe and America, 1850

History Painting

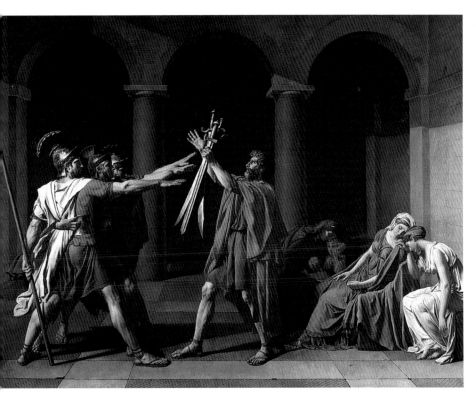

istory painting is not simply the painting of history; the term is wider than that and includes the depiction of events that may or may not have happened, drawn, for example, from Classical mythology or the Bible. It could more accurately be called narrative painting – although it is usually applied only to easel paintings from the Renaissance to the nineteenth century – but the important point is that it is distinct from other kinds of painting that do not tell a story at all, such as portraiture, still life or genre. In much academic theory it has been held in the highest esteem, as if it were the equivalent of epic poetry.

Classical influences

History painting was an invention, or a re-invention, of the Renaissance. When the Florentine humanist Leon Battista Alberti, in his influential treatise *On Painting* (1436), discussed what he expected to find in a painting, he focused on what he called an *istoria*. He took his ideas not only from the great fresco cycles in Italian churches, by painters from Giotto onward, but also from what he had read of Classical painting. In particular he drew on the description of the Calumny of Apelles in the work of Lucian, dating from the second century AD. The painter Apelles was falsely accused at the court of Ptolemy I, King of Egypt, and painted a picture representing his fellow courtiers' treachery. Alberti praised this lost picture above all for its quality of invention and the portrayal of the figures in action. His ideal painting would have several contrasted figures, young and old, male and female, angry and happy, and so on, and it would move the spectator just as Ptolemy was moved by Apelles's painting to pardon him and punish his detractors.

The greatest painters of the High Renaissance consciously took over Alberti's ideals, infusing them with a grandeur derived from Classical sculpture. For later generations, Raphael's frescos in the papal rooms of the Vatican in Rome (see page 75) embodied what history painting should be. The fact that there is no real action in *The School of Athens* (it simply represents Philosophy, in terms of numerous people walking and talking) does not detract from its invention, with crowds of figures of all kinds making noble gestures in striking poses.

Poussin and his followers

During the fifteenth and sixteenth centuries there was little discussion of forms of painting; almost all artists worked on commission and generally painted the subjects they were given with as much display of their art as was permitted or demanded of them. However, by the seventeenth century, more and more artists were able to build careers without relying predominantly on court or religious patronage, and could devise their own subject matter. Nicolas Poussin was a notable example, building up a circle of patrons who would buy the history paintings he invented for them, whether these were mythologies or religious works. Louis XIV's French Academy, founded in 1648 and dominated by Poussin's disciple Charles Lebrun, adopted as a standard of excellence Poussin's carefully deliberated and

▲ Patriotic heroism
The three Horatii brothers swear an oath of allegiance to fight the Curatii brothers to the death in defence of the state. David took the story from the Roman historian Livy. The work celebrates the republican ideals of late eighteenth-century France but ironically it was commissioned by King Louis XVI, who was guillotined in 1793.
Jacques-Louis David, *The Oath of the Horatii*, 1784.

▼ Dramatic conflict
The American artist John Trumbull, inspired by Raphael and Michelangelo, paints as a Classical scene one of the dramatic battles that led to independence for the American colonies. This dramatization of an important conflict in an emergent nation suggests comparison with all that was strongest and noblest in the ancient world of the Greeks and Romans.
John Trumbull, *The Battle of Bunker Hill*, 1786.

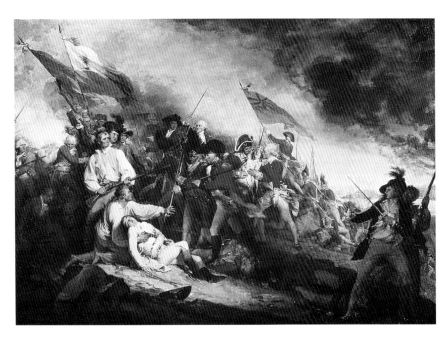

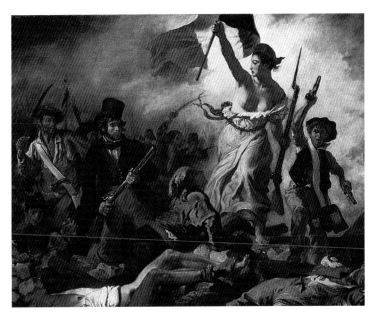

◄ **Freedom fighters**
The French painter
Delacroix documents the
street fighting in Paris
in 1830 and makes his
sympathies clear. Liberty,
in Classical dress, a single
allegorical figure in a
staged scene peopled with
real players, symbolizes a
prized virtue from ancient
days. In a reference to
recent events she wears
the revolutionary cap of
liberty and brandishes a
rifle and the tricolour as
she urges on the popular
struggle for freedom.
Eugène Delacroix, *Liberty*
Leading the People, 1830.

▼ **Self-sacrifice**
Cato the Younger took his
life after an unsuccessful
plot against Caesar in 46 BC.
Guérin's scene of Roman
heroism held great appeal
for revolutionary France.
He created a melodramatic
tableau through the play
of emotional gestures that
sweep from left to right
toward the dying Cato,
who has ripped out his
entrails while resisting the
efforts of his doctor. In
the centre his horrified son
runs toward him, arms
rigid in pain and disbelief.
Pierre-Narcisse Guérin,
The Death of Cato, 1797.

balanced paintings, in which a range of gestures, emotions, and colours was contained in a focused composition. Lebrun also studied Leonardo da Vinci in order to compile a kind of grammar of the passions, represented above all through facial expression.

When painters came to select stories to illustrate they looked chiefly for a moral or an uplifting theme, especially for works that were destined for public display. The greatest Classical example of good conduct was that of Scipio, who conquered not only his enemies but also himself, abstaining, in the episode known as the Continence of Scipio, from taking as his concubine the wife of a defeated captive (see page 125).

The decline of history painting

The eighteenth century saw a decline in the demand for this sort of painting. The French Academy struggled to accommodate Watteau's blatantly frivolous compositions and to honour sufficiently a painter like Chardin, a self-acknowledged specialist in still life and genre. In England, history painting had never been much patronized, Hogarth's rumbustious portrayals of real life being preferred. Joshua Reynolds, president of the new English Royal Academy, founded in 1768, tried to introduce history painting values into portraiture, but other artists, in particular the Americans John Singleton Copley and Benjamin West, more imaginatively extended the form to reportage, representing famous contemporary battles in paintings that were intended to be reproduced as engravings. In France the revolutionary Jacques Louis David brought new life to history subjects by imparting not moral but political messages to them. With the restoration of the French monarchy, despite Delacroix's brilliant attempts to continue the tradition, the life went out of history painting, which, paradoxically, became increasingly valued for its qualities of genre – its details, its costumes, and its exotic settings.

◄ **Timeless contest**
In 1817 Géricault saw the
riderless Barberi horses
race through Rome in
one of the city's
traditional events. A lover
of horses and a keen
observer of modern life,
the French painter was
transfixed by this
spectacle, seeing in it the
fusion of the timeless and
the modern. He stripped
away modern detail and
introduced a Classical
background to create a
universal image of men
and horses engaged in
fierce competition.
Théodore Géricault,
The Race of the Riderless
Horses, 1817–18.

The Classical past

From around 1400, at first in Italy and then in other parts of Europe, ancient Greece and Rome were considered to represent a lost golden age of heroes, conquests, and great thoughts and deeds. Artists and writers looked back to the Classical world for examples of virtue and heroism that would serve as subjects for their work. Poggio Bracciolini, one of the early Renaissance humanists, wrote nostalgically of Rome's fall from greatness, seeking from it inspiration for the present day: "this city is to be mourned over . . . the parent of so many and such great virtues, the mother of so many good arts, the city from which flowed military discipline, purity of morals and life, the decrees of the law, the models of all the virtues, and the knowledge of right living."

Inspiration of the past

Inspired by the writings of scholars such as Poggio, in the fifteenth century Italian artists began to travel to Rome to see what remained of the capital of the once-great Roman Empire. Marvelling at the beauty of the Eternal City's ancient statuary and architecture, they adapted the styles they saw for their own work. Andrea Mantegna, for example, was passionately interested in ancient Rome and sought to capture its glory in works such as his series of nine paintings called *The Triumphs of Caesar* (see page 74).

Very few paintings from ancient Rome survive, and none was known in the Renaissance. However, written descriptions of the paintings, known as *ekphrases*, were collected by humanists, and by the end of the fifteenth century patrons were asking painters to reproduce the works. For example, Botticelli and Mantegna both recreated Lucian's *Calumny of Apelles*; Botticelli's version is shown on page 98. Patrons such as Alphonso d'Este, Duke of Ferrara, commissioned series of works for their private rooms or *studioli*, recreating ancient masterpieces. Titian's *Bacchus and Ariadne* (see page 80), based on a description by Catullus of a figurative embroidery, is one such painting. Alternatively, court humanists were asked to supply appropriate subjects taken from their knowledge of ancient literature.

Adapting the past

In many cases, the story itself provided a clear enough example from which to work. However, humanists and patrons also worked by choosing their theme and then seeking out suitable stories or by adapting mythologies to fit their own ideas. Building on a tradition already established in antiquity, Renaissance artists used Classical figures as personifications of abstract qualities – Venus was used to represent love, for instance, and Mars to represent war – and devised their own tableaux using these protagonists. Although easy to confuse with history painting, many of these works are in fact allegories and not stories; *War and Peace* by Rubens (see page 102) fits into this category. Even when adopting a story from Ovid or another Classical source, artists freely invented the circumstances and emotions.

▼ **Compassion in victory**
The family of the Persian king Darius kneel before Alexander and his companion Hephaestion, who visit them after the defeat of Darius in battle, when Alexander gained control of the entire Persian Empire. The episode is recounted in many histories, including those of Plutarch and Valerius Maximus, who described the potentially disastrous mistake made by Darius's family in mistaking the tall and splendidly attired Hephaestion for Alexander. The former explains that he is not Alexander, while the latter remarks lightly and magnanimously that his companion is like another Alexander. In a show of compassion to the family, Alexander refrained from taking offence, even though the wife of Darius feared for her life. **Paolo Veronese**, *The Family of Darius before Alexander*, c.1565–70.

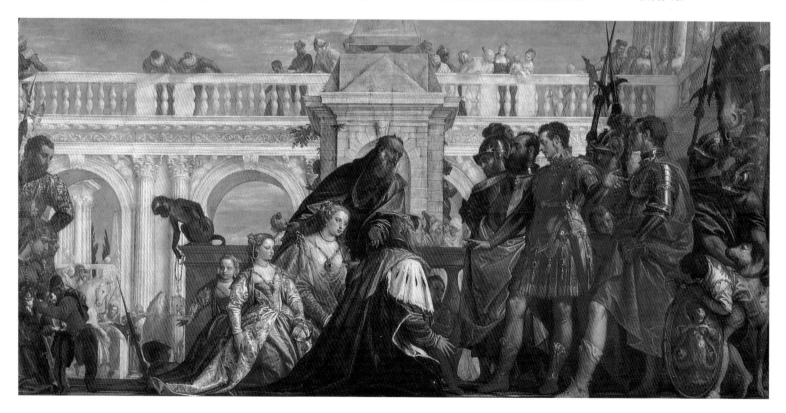

▼ Memento mori
In this enigmatic work Poussin depicts a Classical figure who indicates to three shepherds an inscription on a sarcophagus that reads "Et in Arcadia Ego." "Ego" ("I") is thought to refer to Death, which makes the inscription an allusion to the presence of death in life and a reminder of the omnipresence of mortality even in the loveliest Arcadian idyll. The painter studied Classical literature and philosophy, and based his figures on antique Roman sculpture and those of Raphael.
Nicolas Poussin, *Et in Arcadia Ego*, 1636–9.

In the early Renaissance, Mantegna had been keen to evoke the Classical past by reproducing accurate costume and armour, but by the sixteenth century there was less concern to place the ancients, whether biblical or Classical, in their own contexts and a greater desire to renew their stories entirely in contemporary terms. This is particularly clear in the work of Veronese, who borrows from the pageantry of the doge's audiences to present the confrontation of Alexander with the family of Darius. Veronese displays all the opulence of contemporary Venice, particularly its sumptuous textiles, to evoke a world still grander than the ancient one.

In the seventeenth century Nicolas Poussin, a superlative history painter, evolved a kind of dress and presentation that gave his chosen stories a timeless and universalizing quality. His paintings incorporated archaeological accuracies and occasional direct references to ancient buildings, but created a less specific, perfectly idealized world that the ancients, or his biblical characters, would not have recognized any more easily than Veronese's world. Poussin's contemporary Claude based his settings on the countryside around Rome, but also transformed the old sites and ruins of Rome into grandiose visions that were more inspirational than instructive, as in his *Seaport with the Embarkation of the Queen of Sheba* (see page 122). To some extent, once the setting had been composed and the mood struck, the actual story told did not matter.

Poussin created a style for handling the Classical past that became a point of reference for all subsequent artists. However, the discovery of sites such as Pompeii in the late eighteenth century, and the growth of archaeology, enabled painters to introduce almost topical allusions to recent finds and to rethink Classicism by returning to accurate detail of the ancient world. The nineteenth-century Dutch painter Alma-Tadema created intensely evocative scenes meticulously reconstructed from the evidence of Pompeii and other sites, such as his *The Baths of Caracalla* (see page 210).

▲ Man against nature
Turner sketched a dramatic storm in northern England and later used its effects as the background for this work. The painting draws on an episode in the history of the Punic Wars that tells of the battle of the Carthaginian leader Hannibal and his army against a snowstorm in the European Alps.
Joseph Mallord William Turner, *Snow Storm: Hannibal and his Army Crossing the Alps*, 1812.

Other histories

The search for new subjects began during the Renaissance, prompted by the demands of patrons for representations of appropriate stories with which to decorate their palaces. They wanted scenes featuring contemplative philosophers and theologians to go in their studies; feast scenes in their dining rooms (the Last Supper was popular in monastery refectories, but the Marriage at Cana or the Fall of Manna were also suitable); scenes of battles and pageantry in their state receptions rooms; and, of course, the loves of the gods in their bedrooms. Humanist courtiers were urged to devise "programmes" that would answer the "decorum" of the context wittily and flatteringly. The scope of history painting had expanded so widely by the end of the sixteenth century that the meanings of many pictures still tax the erudition of scholars today.

The process continued into the seventeenth and eighteenth centuries, but by this time the context had become less important and learned artists, or their learned friends, would seek new subjects derived from their own reading. They cast their nets increasingly wide, but it was not until the nineteenth century that history painting began to range freely through the centuries.

Alternative sources of inspiration

From the late eighteenth century onward artists sought to widen their repertoires and explored other mythologies and histories. The saga of the Gaelic bard and warrior Ossian (see page 96), for example, which contained much dramatic narrative and heroism, was an alternative to the Classical pantheon as a source of subjects. Similarly the popular revival of the Arthurian legend in Britain, and of that of the Nibelungs in Germany, provided a rich vein of alternative histories that were seen as dignifying their respective nation's prehistory while at the same time establishing a different tradition from ancient history.

Chronicles of medieval and Renaissance histories provided inspiration for a number of nineteenth-century artists, including the French painter Delaroche. His picture *The Execution of Lady Jane Grey* enjoyed great critical acclaim in the Paris Salon of 1833. The beheading of monarchs, and the sympathy the viewer is invited to feel for the martyr-like figure, may have struck a compassionate, even nostalgic note in post-revolutionary France. Delaroche was greatly esteemed in Paris in the 1830s for creating modern historical subjects, as opposed to Classical historical subjects, by depicting scenes from medieval English history. His *Princes in the Tower* (1830) was a painting of innocent victims, pawns in a political game that led to the subjects' death. Historical texts on English history provided Delaroche with the tragic tale of the two young princes, popularly supposed to have been incarcerated and then murdered by their usurping uncle, King Richard III. He may also have read Shakespeare's history plays for material on the English monarchs.

The nineteenth-century French Classical painter Ingres drew on Giorgio Vasari's *Lives of the Most Excellent Painters, Sculptors, and Architects*, first published in 1550, for subject matter. Vasari's book records the great achievements of contemporary artists such as

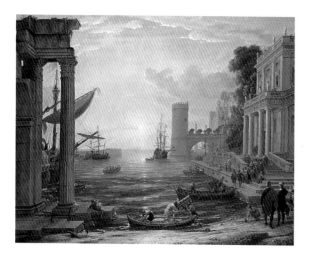

Royal voyage
In Claude's idyllic waterside town the picturesque ruins of a Classical portico on the left are balanced by a fine Classical building on the right. This is the Queen's palace, from which she and her retinue descend to the boats that will transport them to the ships on the horizon, and thence to King Solomon. **Claude**, *Seaport with the Embarkation of the Queen of Sheba*, 1648.

Tribute to a master
The painter-biographer Vasari tells us that La Fornarina was the baker's daughter with whom the Renaissance painter Raphael was in love. In this tribute by the French painter Ingres to the artist he most admired, Raphael is shown seated with his beloved on his knee. She looks out at us, recognizable as the face beneath the headdress that Raphael had painted in 1518. Raphael looks over his shoulder at his painted image of La Fornarina, offering us the three-quarter view of the face he painted in his self-portraits. Among other references to the Renaissance master is the papal chair that appears in Raphael's portrait of Pope Leo X.
Jean-Auguste-Dominique Ingres, *Raphael and La Fornarina*, 1811–12.

◁ Focus of sympathy
Delaroche paints the moment just before the execution of the sixteen-year-old Lady Jane Grey, great-granddaughter of Henry VII. After the death in 1553 of Henry VIII's son, the young Edward VI, Lady Jane Grey became queen for nine days. She was deposed by the supporters of Mary Tudor, elder daughter of Henry VIII, found guilty of treason, and beheaded at the Tower of London in 1554. The pallor of her skin and silken underclothes in the gloom of the tower make her a beacon of light intended to elicit the viewer's sympathy.
Paul Delaroche, *The Execution of Lady Jane Grey*, 1833.

Michelangelo, whose work the author considered to match or even surpass that of the ancients. In tracing the history of Italian painting from Cimabue in the thirteenth century to his own day, Vasari created a fascinating record of a progression toward "perfection." The *Lives* has never been out of print and from its first edition it provided painters, writers, and poets with inspiration. Among these was Ingres, who was moved to depict his hero, Raphael, seated with the object of his love, La Fornarina.

Creating history

The need to establish the history of a nation through literature and painting is seen worldwide, but the histories of late eighteenth-century America and Russia were painted in accordance with the dictates of French history painting. Benjamin West's *The Death of General Wolfe* (1770) (see page 116) illustrates a heroic moment in the early history of colonial America, in the heroic style of European history painting. Artists such as West and John Vanderlyn, who depicted scenes not only of the ancient world but also of their emerging nation, worked within the European tradition, studying and working in Italy, Paris or London and painting according to the "rules" of European history painting.

In the nineteenth century the greatest Russian history painter, Vasily Surikov, depicted scenes of medieval Russia. His works show dramatic incidents as the central focus of vibrant crowd scenes.

◁ Early America
This work by John Vanderlyn was the first American history painting to be exhibited at the Paris Salon. It shows a notorious incident from the Revolutionary War of 1775–83: the colonist Jane McCrea was murdered by Indians, who took her scalp to the British for a reward. Vanderlyn depicts the terrible moment before the atrocity in this dramatic reconstruction in which McCrea is an innocent sacrificial victim overpowered by evil. The artist based the large-scale figures on late-Classical sculpture, deriving the figure on the right from the Roman work known as the Borghese warrior.
John Vanderlyn, *The Murder of Jane McCrea*, 1803–4.

▶ Religious division
An aristocratic opponent of church reform carried out by the czar and Patriarch Nikon in the seventeenth century, Feodosia Morozova was punished as an "Old Believer." Condemned to a horrible death and exposed to shame and abuse as she is driven in chains through Moscow, she nevertheless asserts her intransigence with a sweeping gesture: in an allusion to the cause of her downfall, her two outstretched fingers form the sign of the schism. Surikov was attracted by both the exoticism of the past and the power of religious fanaticism embodied by the heroine of this painting.
Vasily Surikov, *The Execution of Boyarina Pajaritar Morozova*, 1887.

Scenes of virtue

Underpinning history painting was the idea of "example" or exemplary conduct in a difficult situation. In the seventeenth century the Classical world was seen as embodying virtue, stoicism, self-sacrifice, and moral probity, providing material for French dramatists such as Racine and Corneille, as well as for Poussin, the founder of French Classicism in art. The theme of ancient virtue was also influential in France during the eighteenth century, when the nobility of ancient Rome was a guiding principle for the new republic that followed the Revolution.

Virtuous action was not only the province of men. Women and children were also presented in paintings as acting honourably to spouse and parent, friend and stranger. One of the best-known examples of female virtue in the ancient world was that of Lucretia, who, rather than live dishonoured after her rape by Tarquin, King of Rome, took her own life.

Artists could draw on examples illustrating every known virtue. Conjugal fidelity was exemplified by Artemisia, who drank her husband's ashes mixed with wine, thus transforming her body into his grave. Filial piety was the subject of one of the chapters of the nine books of memorable deeds and sayings compiled by the Roman writer Valerius Maximus in AD 30. This contains the story of Cimon and Pero, telling of the respect due to a parent from a child and extolling the virtue of Charity. The Flemish artist Rubens made several paintings of this subject.

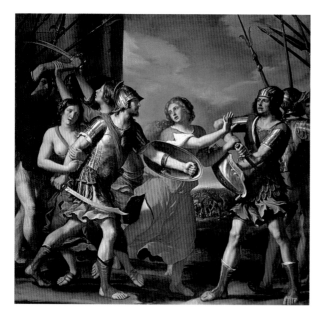

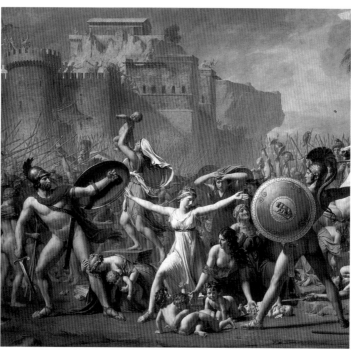

▲ **Champions of peace**
The Italian artist Guercino painted several stirring scenes from ancient history. This work was made for Phélypeaux de la Vrillière, who had been secretary of state to Louis XIII of France, and is a fine example of Classical Baroque. Both style and subject influenced many later works, including David's *The Intervention of the Sabine Women*. Hersilia, wife of Romulus, sweeps onto centre stage to prevent her husband from fighting Tacitus. Her action creates "the peace between the Romans and Sabines" that provided the painting with its subtitle.
Guercino, *Hersilia Separating Romulus from Tacitus*, 1645.

◀ **Greek refinement**
This painting, in which the central figure of Hersilia stretches out her arms to prevent slaughter between fathers and husbands, marks a change in the work of the French painter David. Here he has replaced the harsher style of his earlier Roman canvases, which celebrated republican virtue, with Greek refinement and a message of reconciliation and forgiveness. The Greek theme is also reflected in the nudity of the men and the arrangement of the crowd, which resembles the continuous horizontal band of a Greek frieze.
Jacques-Louis David, *The Intervention of the Sabine Women*, 1799.

▲ **Act of charity**
St Sebastian was condemned to death by the Roman Emperor Diocletian in the third century for refusing to renounce Christianity. Shot with arrows and left to die, he is found and tended by a holy woman, Irene, and her daughters, who nurse him back to health. The image of Sebastian mirrors Christ and his nurses mirror the three sorrowing Marys. The interior and the discarded armour remind the viewer that this is the Classical world, and the French artist Blanchard uses these details to meld the notions of Christian charity and Roman duty.
Jacques Blanchard, *St Sebastian*, 1600–38.

▶ A daughter's love
In this scene, taken by Rubens from Valerius Maximus, Pero visits her imprisoned father Cimon, sentenced to starve to death, and breastfeeds him as if he were an infant. The subject's combination of a titillating and secretive act with the idea of filial devotion led to its being painted in the seventeenth century by many artists in both northern and southern Europe, including the Dutch followers of Caravaggio in Utrecht.
Peter Paul Rubens, *Roman Charity*, 1612.

▶ Final parting
Hector, son of King Priam, and the bravest of the Trojan warriors, played a major role in the Trojan war against the Greeks. This scene by the Russian history painter Lesenko shows him bidding farewell to his wife, Andromache, before returning with Paris to the battlefield after making offerings to the gods. Soon afterward Hector meets his death in battle at the hands of Achilles. The contemporary viewer would have known this and have read into the painting the couple's understanding that this was their last farewell.
Anton Lesenko, *Hector Taking Leave of Andromache*, 1772–3.

▲ Academic study
The English painter Joseph Wright of Derby painted this scene using his trademark dramatic contrast of light and darks. The academy in question is an intimate group of friends meeting to discuss and sketch Classical statuary and, by extension, to gain enlightenment through the study of ancient sculpture. The antique figure of a young, semi-dressed woman is centrally lit and raised on a pedestal. She looks down on the assembled group of admirers, who sketch her beauty and discuss her form. This work related to the topical issue of the foundation of a national academy of art. The Royal Academy was founded in London in 1768 to promote an English school of history painting in the grand manner.
Joseph Wright of Derby, *An Academy by Lamplight*, c.1768–9.

◀ Self-control
This scene, which derives from many sources, including Livy and Plutarch, was painted many times in the seventeenth century. The Roman general Scipio is shown being crowned with the victor's wreath after his defeat of the Carthaginians. But he achieves a further victory by overcoming his own passions. Instead of taking for himself a desirable female captive as the spoils of war, he restores her to her intended husband. Poussin paints the episode in the style of a Classical frieze set against a dramatic backlight of stormcloud and sunburst.
Nicolas Poussin, *The Continence of Scipio*, 1640.

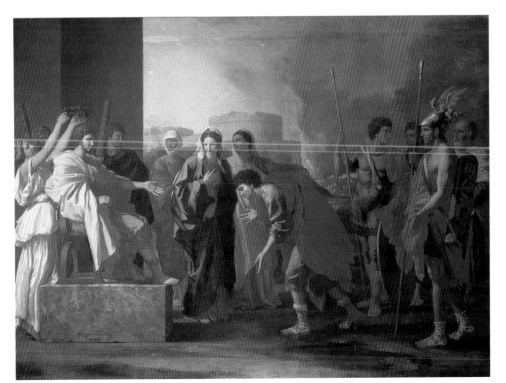

Painting for the public

After the French Revolution of 1789 the founders of the new Republic looked to the antique model of the virtues associated with Classical Greece and Rome. Aristocratic patronage was superseded by civic patronage, with the aim of providing an art for the people, although this was more apparent in theory than in practice. Even so, the eighteenth century saw a shift from aristocratic and church patronage to the public display of art. From the later part of the century the Salon in Paris and the Royal Academy in London staged annual exhibitions in which the work of selected artists was placed on public view.

In these institutions the painters chose and planned the subjects they themselves wished to paint (sometimes in fierce competition with one another), rather than executing commissions. However, this development did not mean the end of aristocratic and church patronage: both continued to exist alongside the new system by which artists submitted their work to a selection committee in the hope that it would be accepted, exhibited, and sold. The annual public exhibitions held in London, Paris, and other European capital cities led not only to a new kind of viewing public that included a large number of middle-class art lovers, but also to the growth of the powerful figure of the critic, the maker and breaker of reputations and creator of taste.

Good history paintings were the focus of most public and critical attention. The French writer Denis Diderot (1713–84) was one of the most influential reviewers of the Salon. He urged artists to abandon the froth of Rococo painting for a more worthwhile style and subject: to "paint as they spoke in Sparta." Artists, he said, should take the ancients as models of sobriety and virtue. The French painter Girodet, a pupil of David, was an artist who looked back to the Classical world in works such as *The Deluge* but also heralded the Romanticism of painters of the following generation, such as his compatriot Delacroix.

Private and public commissions

Popularity and critical acclaim at the Salon or the Academy provided painters with an opportunity for commissioned work, and the success of such work often led to a public commission. Delacroix's reputation as a history painter was already established when he received commissions from the state to supply substantial canvases on historical themes for locations in Paris. The works he painted for the Luxembourg Palace and the Hall of Peace in the Hôtel de Ville mirrored the content and context of earlier examples of political history painting such as that of Ambrogio Lorenzetti, who, in thirteenth-century Italy, painted an allegorical work on the theme of the effects of good and bad government for the town hall in Siena (see page 176).

Many Salon paintings were immense – the French described them as *grandes machines* – and functioned as dramatic, theatrical tableaux that were, in many cases, intended to be read as commentaries on contemporary events. These canvases also served to advertise the talents of the artists in particular fields, such as the depiction of scenes of noble restraint, the wild and dramatic, the imaginative, or the minutely observed.

The Raft of the Medusa, a huge canvas by Géricault, violated the conventions of history painting. The French artist was inspired not by a great national victory or campaign, but by a real event from which morality and virtue were conspicuously absent. An account by two of the survivors of the shipwrecked French vessel *Medusa* was published in 1818 and

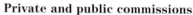

▼ Power and grace
This extraordinary work by the French painter Girodet contains echoes of figures from the Classical world without depicting a particular episode from an ancient text. The artist also creates resonances of the story of the Flood, described in the Old Testament. When the great French Neoclassical painter David saw this work at the Paris Salon of 1806 he expressed his admiration for the way in which his pupil had combined the power of Michelangelo with the grace of Raphael.
Girodet, *The Deluge*, 1806.

inspired Géricault to paint this disaster. While the artist incorporated dead or dying figures in the foreground in order to involve the viewer fully in the survivors' gruesome experience, this powerful and emotional work focuses on the moment of potential rescue and salvation. Géricault treats a contemporary event as a grand episode from ancient history, and indeed the very name of the wrecked ship suggests a Classical approach that is reinforced by the nude and heroically dead figures.

When *The Raft of the Medusa* was shown at the Salon in the summer of 1819 it was seen an explicit criticism of contemporary France and as such attracted adverse and positive criticism alike from those on both the right and the left of the political spectrum. In April 1820 Géricault took the work to London, where it was exhibited in the Egyptian Hall in Piccadilly and attracted more than 50,000 paying visitors.

Entertainment and education

In England in the late eighteenth century commercial exhibition halls, such as London's Egyptian Hall and the Pantheon, allowed the paying public, at this time entirely middle-class, to be both entertained and educated by art. These venues date from the period when the British Museum was founded and anticipate the many other museums and art galleries that opened in the following century. By the end of the nineteenth century it was in the art gallery, rather than the church, castle, palace, or town hall, that most artists would choose to have their work displayed, for it was here that it could most easily be viewed by the public.

▼ **Sex and death**
The source of this painting was a play by the English poet Byron that concludes with the ritual suicide of the Assyrian monarch Sardanapalus. Amid Delacroix's scene of violence and carnality, the eastern potentate, whose face resembles that of the painter, provides a single note of calm. In this exotic and opulent setting the ruler watches with composure an orgy of frenzied killing as his harem is put to death. The impression of confusion and terror is increased by the horses racing in from the left, figures crying out on the right, a naked woman being murdered in the forefront, and a bejewelled nude expiring voluptuously on the silken bed.
Eugène Delacroix, *The Death of Sardanapalus*, 1827.

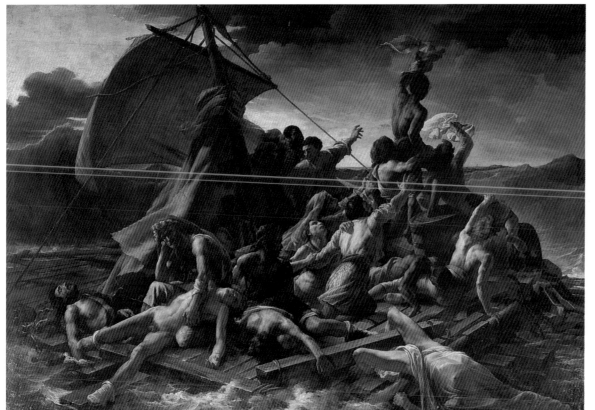

◄ **Prospect of salvation**
In this large work Géricault depicts a contemporary disaster at sea using the scale and format that the public was used to seeing in paintings of ancient history. In the summer of 1816 the French ship *Medusa*, carrying soldiers and settlers to the French colony of Senegal, was wrecked off the coast of Africa. The captain, a nobleman, saved himself in one of the few lifeboats, abandoning his social inferiors to fend for themselves as best they could. The remaining 150 souls built a primitive raft and were adrift for nearly two weeks before being rescued by a sister ship, the *Argus*. Only fifteen people survived to tell of the horrors of the cannibalism and insanity they had witnessed.
Théodore Géricault, *The Raft of the Medusa*, 1819.

Contemporary heroes

For centuries artists were commissioned to commemorate rather than simply record contemporary events, and this requirement led them in most cases to idealize the subject. The absence of any photographic record made this more natural, even though there are examples from Pisanello in the early fifteenth century onward of artists mercilessly depicting the horrors of war and the random operation of justice. Paintings were expected to conform to an antique prototype of heroic valour in which references to ancient heroes or to Christ were readily understood and a comparison with these figures could be made. For this reason many scenes depicting the death of contemporary figures, such as *The Death of Major Peirson, 6th January, 1781*, painted by the American artist John Singleton Copley in 1783, looked back to the ancient world or the Bible and alluded to the deaths of its heroes. Copley's dying British soldier is shown in the familiar pose of the deposed Christ after his removal from the cross.

In *The Death of Marat* by the French painter David, the dead revolutionary resembles the figure of Christ in Michelangelo's *Pietà*. David's interpretation of his subject suggests that Marat is to be regarded as a Christ-like martyr of the Revolution. The austerity, clarity, and serenity of this scene, painted in the year of Marat's death, also seem to associate the work with the weight and dignity of the Classical world.

Elevated status

Painters have traditionally integrated contemporary figures with those of myth and legend in order to enhance the standing of the former. This device was most commonly used in paintings of monarchs and other rulers, as in Rubens's Marie de Medici cycle (see page 103, *Henry IV Receives the Portrait of Marie de Medici*), in which the gods of antiquity play an ennobling role in the earthly life of the French queen. Similarly, the French emperor Napoleon commissioned works in which the symbol of the eagle was painted above him so that he would be associated in the educated viewer's mind with the Roman god Jupiter. He had his fallen marshals depicted in Girodet's work *Ossian Receiving*

▼ **Dramatic licence**
Copley created this dramatic tableau for John Boydell, who had heard the news of the British victory over the French on the Channel Island of Jersey very soon after this event of 1781. A small French army marched on the capital, St Helier, and forced the governor to surrender the island. The British garrison and the Jersey militia spearheaded a counter-attack led by the twenty-three-year-old Major Francis Peirson, who was shot dead by a sniper while positioning his men for the final assault. The sniper was shot dead by Peirson's black servant, Pompey. Copley has heightened the drama by transposing the moment of Peirson's death to the later moment of victory.
John Singleton Copley, *The Death of Major Peirson, 6th January, 1781*, 1783.

the Shades of French Heroes as part of his beloved myth of Ossian (see also page 96), so they were endowed with the valour of this legendary figure.

Géricault's *The Raft of the Medusa* (see page 127) used the heroic form of history painting to depict a scene that was the result of actions that were far from heroic. His painting of the aftermath of a shipwreck that had taken place only three years earlier bears all the hallmarks of classic history painting: the drama of action, the light, the pose, and the triangular composition. Géricault's subversion of the genre of history painting led to a greater individualism among artists, who began to allow themselves greater liberty in their choice of subject matter. It was testimony not only to the painter's daring individualism but also to his financial independence that he was able to create this unprecedented masterpiece. This work preceded Delacroix's *Greece on the Ruins of Missolonghi* of 1826, which turned contemporary events into a heroic political allegory by personifying Greece as a mourning woman.

As the nineteenth century progressed, the concept of the heroic became an outdated model and the very notion of the heroic history painting was called into question. Heroic subject matter, scale, and gesture rarely appeared in the depiction of contemporary events until the fourth decade of the twentieth century, when the notions of tradition, power, duty, and honour were revived for propaganda purposes in art officially sanctioned by Germany's Third Reich and in Soviet art produced between 1930 and 1950.

The "Entartete Kunst" (Degenerate Art) exhibition held by the Nazi government in Munich in 1937 displayed the paintings of proscribed artists. The Third Reich considered these non-naturalistic works to be morally degrading and many were destroyed. The Nazis favoured images of power and heroism and looked to ancient Rome and Greece for examples of excellence in art, sculpture, and architecture. As a result, Neoclassical, idealized, and heroic forms briefly proliferated in twentieth-century German painting.

Elevated status

In the USSR, from the 1930s, the heroism of the ancient world was seen as the model for the construction of the new Communist state. Soviet peasants and workers were the modern heroes, and they were invariably painted as such. Sport was a natural choice of subject matter for artists entrusted by the state with the task of showing post-revolutionary Russia in a heroic light, as it lent itself to the depiction of the perfect body, vigorous action, team spirit, and healthy, happy competition. Painters sought to reflect glory on the Soviet state by idealizing their compatriots' sporting abilities and physical attributes.

▲ The spirit world
Napoleon commissioned this painting from his compatriot Girodet in order to immortalize his marshals, recently fallen in battle. Painted on the ceiling of the emperor's library in the château of Malmaison in France, the work is a fusion of Celtic and Classical mythology. Napoleon's warriors, like players in a pan-mythological setting, stride through a sea of spirits, guided by the wingless Victory, to be greeted by the blind bard Ossian, who sits in Valhalla beneath the eagle of Jupiter and a helmet-bearing Athena.
Girodet, *Ossian Receiving the Shades of French Heroes*, 1802.

History in the making

▲ Miracle worker
Gros shows Napoleon in dress uniform, seemingly as invincible as Christ, touching with his bare hand the sore of a soldier suffering from bubonic plague. The arcaded courtyard of the mosque, converted into a military hospital and filled with naked and semi-clad figures, is reminiscent of biblical scenes that describe Christ healing the sick. The parallel between Napoleon and Christ is emphasized by the emperor's fearlessness and his gesture toward the plague sufferers, which deliberately echoes that of Christ performing a miracle at the Pool of Bethesda.
Antoine-Jean Gros, *Napoleon in the Plague House at Jaffa*, 1804.

▼ Recording history
The news of the execution on June 19, 1867, of Emperor Maximilian of Mexico was received in Paris while the city celebrated the World's Fair. On hearing of the shooting by firing squad of the "marionette emperor," Manet set to work at once to portray this dramatic event. Although he read newspaper reports and worked from photographs of Maximilian and his generals, this painting differs radically from the actual scene of the execution because he used Goya's earlier work *3rd May, 1808* as his inspiration. **Édouard Manet**, *The Execution of Maximilian*, 1867.

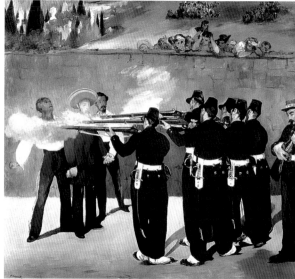

The role of the history painter before the age of photography was to document and to commemorate. For Napoleon, painting was at the service of the French Empire as it had been at the service of the Church in the Middle Ages. *Napoleon in the Plague House at Jaffa*, by the French painter Antoine-Jean Gros, commemorates a particular event but interprets it in heroic style. The emperor, surrounded by the sick, seems almost divine, immune to disease, and able to heal miraculously by his mere presence.

Challenging the genre
In the eighteenth and nineteenth centuries history painting was considered the noblest genre of art and history painters were under pressure to uphold this hierarchy. However, there were methods of painting in a heroic style while not actually depicting a heroic event. John Singleton Copley, a Boston portrait painter who established himself in London, extended the genre in this way and declared: "I have as much as possible employed myself in events that have happened in my own lifetime." His *Brook Watson and the Shark* depicts an event that had taken place in the artist's own lifetime. This work does not show a scene from ancient history, or a Classical hero, or even a well-known modern figure, and does not seek to impart an important moral lesson, as many history paintings do. Instead it shows a life-threatening incident that had happened to a friend of the painter, one that was as terrifying in its way as any gory tale from antiquity.

In the early years of the nineteenth century the Spanish painter Goya recorded events in his country's

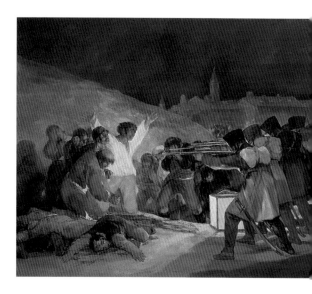

▲ A modern crucifixion
Although painted six years after the event, Goya's work conveys the horrors of the retaliatory execution of hundreds of his compatriots by the occupying French army. He uses the light from a giant lantern to highlight the figure in a white shirt who stands before the firing squad. The man wears an expression of haunting terror. His outstretched arms, reminiscent of the crucified Christ, make this work a modern crucifixion and demonstrate the painter's political sympathies **Francisco de Goya**, *3rd May, 1808*, 1814.

war of liberation against the French army of occupation. He executed his war etchings as an independent observer and for this reason they are free of the restraints that would have been imposed by an official commission. Although made nearly two centuries ago, these works seem radically modern and have something of the cool detachment of the camera. However, Goya had to wait six years, until the restoration of King Ferdinand VII, before he felt free to paint his most dramatic depiction of this troubled period. Painted in 1814, *3rd May, 1808* shows a scene from the execution of hundreds of Spanish insurgents and innocent bystanders by a French firing squad in retaliation for a popular uprising.

Painting after photography

Even after the advent of photography artists chose to continue to document incidents, partly, perhaps, because the camera appeared to record them without interpretation. Painters often used photographs to supply details of background or physiognomy. In 1867 the French artist Manet was fascinated by newspaper accounts of the execution of Emperor Maximilian of Mexico. He began composing the scene before he had seen photographs of the emperor or the firing squad. After reading a report in the newspaper *Le Figaro* that described the firing squad's uniform as similar to that of the French army, he persuaded an influential military friend to dispatch a group of soldiers to pose for him. The finished canvas was seen as a political allegory in which Manet had depicted France as essentially responsible for Maximilian's death, and Manet intended it as a criticism of Napoleon III. The artist painted four canvases of the scene; the huge painting shown here, which Manet regarded as his final version, illustrates the cool matter-of-factness of the composition.

It is typical of Manet's individualism that he chose to make a dramatic contemporary event into a history painting, a genre considered redundant by that time. In his deliberate undermining of the heroic approach to history painting he was also looking back to Goya's *3rd May, 1808*, which he had seen in 1865 and greatly admired. The Impressionist painter Renoir noted the homage, remarking: "This is pure Goya, and yet Manet was never more himself."

In the USSR of the middle decades of the twentieth century Stalin's cult of personality spawned depictions

of Lenin, the new nation's first leader, and later himself, as heroes, presiding over political congresses, concerts, ceremonies, and sports events. The job of the state artist in Soviet Russia was to peddle to the public images, in the form of posters used to decorate the walls of public buildings such as metro stations, of healthy comrades engaged in earnest work or play under the supervision of Father Lenin. Interestingly, Samokhvalov produced his propaganda painting *Kirov at the Sports Day Parade* in 1935, after Stalin had ordered Kirov's assassination.

Official war artists, commissioned to depict scenes ranging from frontline action to the work of the field hospitals, also record events at the request of the state. Forbidden to depict corpses, because this was held to lower morale, some have instead painted allegorical landscapes of a world blasted by bomb and shrapnel, such as Paul Nash's *Totes Meer* (*see* page 133).

Painting as protest

From the nineteenth century painters enjoyed a growing independence from the patronage of the state and other sources and since then they have increasingly adopted anti-establishment stances.

The Italian artist Giuseppe Pellizza da Volpedo made portraits and landscapes but also used the painted canvas as a tool for political campaigning. A political activist who joined his local workers' and peasants' party early in 1890, he depicted striking agricultural workers out of a sympathy with their problems. Outraged at the massacre of workers in Milan in 1898, he began his *The Fourth Estate* as a work in which he spoke, as though for the proletariat itself, against its oppressors. He made three versions of this huge, frieze-like canvas in which the proletariat is ennobled and illustrated as warriors of antiquity. It was both a rallying cry and a protest against the injustice suffered by the working class. The work's purpose, the painter wrote, was to show that "true force lies in the hands of

▼ **Political protest**
This painting, the title of which Pellizza da Volpedo took from his reading about the history of the French Revolution, was to be his manifesto of political intent. He wrote of wanting to paint "a crowd of people, workers of the soil, who are intelligent, strong, robust, united." In this depiction of the marching masses, fronted by a working man and woman, the artist has created proletarian figures who are as heroic as any from Classical antiquity.
Giuseppe Pellizza da Volpedo, *The Fourth Estate*, 1898–1901.

intelligent and good workers who, with the tenacity of their ideals, oblige other men to follow them or to clear the way because retrograde power cannot stop them."

Visually *The Fourth Estate* evokes Delacroix's *Liberty Leading the People* (see page 119) and indeed Pellizza da Volpedo was inspired by the example of revolutionary France with its tenets of equality, liberty, and fraternity. However, the painting was poorly received as political protest when it was exhibited in Turin in 1902. One critic described it as a work that will "leave the spectator cold, as it will the capitalist or the authority toward whom this collective demonstration is directed, indifferent." Although the socialist press made use of the painting, its size and uncompromising political message made it hard to exhibit. It was shown in Rome in 1907 to mainstream critical indifference, and that same year the artist killed himself after the deaths of his youngest child and his wife.

War and its aftermath

In the years following the First World War George Grosz, in works such as *Circe* (see page 91), satirized the corruption of Weimar Germany, using savage caricature to show the war profiteers, corrupt military, and prostitutes who were bleeding the war-ruined country dry. His activities led to prosecution and with the rise of

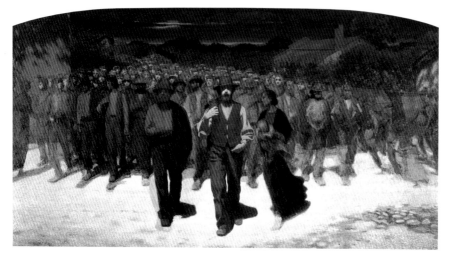

▼ **Pathos of war**
In this chain of figures, wounded and blinded by mustard gas in the First World War, Sargent looked to the antique imagery of the frieze to lend gravitas to the scene. The procession also has religious associations, as does the field hospital on the right in that it is a place of both healing and salvation. In this large canvas – intended to be the central work in a projected Hall of Remembrance – the painter also incorporated imagery of the blind leading the blind and the Dance of Death.
John Singer Sargent, *Gassed*, 1918.

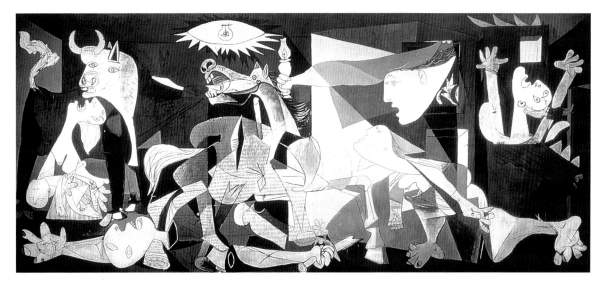

◀ **Destruction of a city**
Picasso executed this large painting, one of his best-known works, very swiftly in his Paris studio in response to the German bombing in April 1937 of Guernica, in the Basque region of northern Spain. A republican anti-fascist, the artist intended the painting to provoke outrage at the dreadful events of the Spanish Civil War of 1936–9. He uses jagged shapes and screaming mouths to evoke the nightmare of war, and the terrified figure with outstretched arms is his reworking of Goya's horrific *3rd May, 1808*.
Pablo Picasso, *Guernica*, 1937.

▼ **Enduring threat**
Nash's inspiration for this work was photographs that he had taken of wrecked German aircraft deposited in a field near Oxford, England. He saw in these shapes a "dead sea," as the German title suggests, of harsh, moonlit metal parts that, even in their wrecked state, appeared to reconstitute themselves and menace the land as they had earlier threatened it from above. Nash was an official War Artist during the Second World War, and, as in his pictures of the First World War, he often used landscapes to express his horror at the destruction wrought by large-scale armed conflict
Paul Nash, *Totes Meer*, 1940–1.

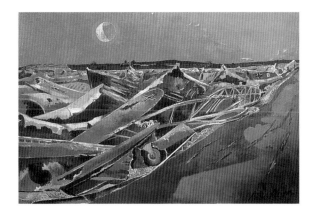

Nazism his work was classified "degenerate." He moved in 1933 to New York, where he dissociated himself from Hitler's Germany by becoming an American citizen.

John Singer Sargent's *Gassed* was not conceived or painted as a protest against war but was commissioned from the American artist by Britain's War Office to commemorate those who had served their country in the First World War. However, the pathos of the work evoked powerful responses, including a questioning of the sentiments of honour, glory, and patriotism for which men were urged to give their lives.

Symbolic landscapes

Paul Nash is the best-known modern British painter of scenes of war. His powerful images of the devastated battlefields of both World Wars, although showing no corpses, convey the damage done not only to the land but also to the bodies of countless combatants. To complete his portrayal of landscapes laid waste by war, he gave his works bitterly ironic titles such as *We Are Making a New World*. The paintings he made during the Second World War, such as *Totes Meer*, speak of a particularly twentieth-century sensibility with their numbed and empty quality, a kind of shell-shocked vacuity.

The imagery of devastation is also the subject of Picasso's *Guernica*, one of the most memorable images of the twentieth century. Painted immediately after the German bombing of the Spanish town of Guernica in 1937, it was the artist's response to this attack on his homeland. The imagery is abstracted but sufficiently readable to suggest an immense and crude shattering. Colour is expunged like a metaphorical banishment of life and hope. *Guernica* was exhibited in the Spanish Pavilion of the Paris World's Fair in the year of its creation. After 1934 Picasso never returned to his native land and stipulated that the work should not return to Spain until General Franco had ceased to be in power. After the dictator's death in 1975 it was transferred to the Prado in Madrid

Fourteen years after *Guernica* Picasso created another work of outraged protest. His much less well-known *Massacre in Korea* uses Classical imagery to suggest the perennial themes of antiquity and war.

▲ **Allegory of war**
In this painting Picasso refers directly to events in the war in Korea, which mirrored those in his native Spain in the late 1930s, when the forces of left and right fought a bloody battle in which countless innocent victims suffered. It shows two groups of naked figures – on the right, soldiers in helmets, bearing arms, and on the left defenceless women and children. The nudity and the sword-bearing figure on the far right are allusions to the Classical world, and as such give the work an allegorical flavour, but the title places it firmly in modern history. Picasso also quotes from the scenes of execution depicted in *3rd May, 1808* by his compatriot Goya, and Manet's *The Execution of Maximilian* (see page 130).
Pablo Picasso, *Massacre in Korea*, 1951.

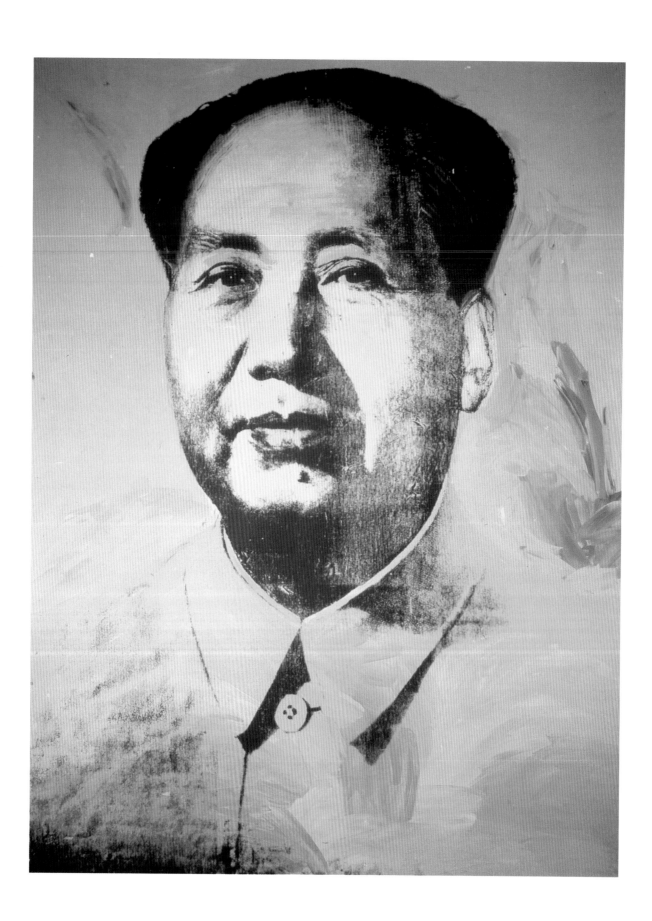

"What is the art of portrait painting?
. . . it is the art of presenting, on the first
glance of an eye, the form of a man by
traits, which it would be impossible to
convey in words."

J. C. Lavater, *Essays in Physiognomy*, 1775–8

Portraiture

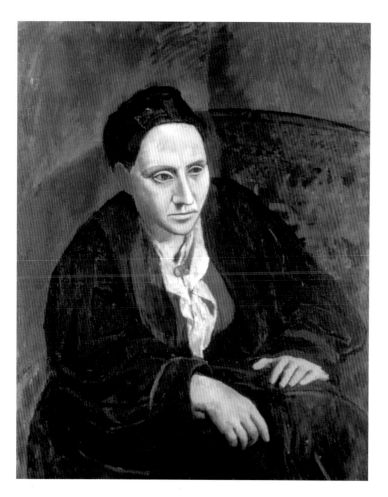

Of all the types of painting discussed in this book, portraits might appear to need the least explanation. After all everyone is used to seeing portraits – even if these are now more often photographs than paintings – and the aims of portraiture certainly seem straightforward. However, defining exactly what a portrait is raises some problems. For example, many paintings have portraits in them but are not portraits themselves: Botticelli's *The Adoration of the Magi*, painted in Florence in the fifteenth century, contains portraits of the artist himself and three generations of his patrons, the powerful Medici family. But even if it is clear why this picture is not classed as a portrait, defining a portrait remains difficult. We might assume that a portrait painting could be described as a likeness of an individual, but even this straightforward definition runs into trouble.

Ignoring resemblance

Not every portrait is a likeness. Early ruler portraits are often more concerned with depicting the office of kingship than the face of a particular king (see page 138, School of Tours, *The Emperor Lothair*). Resemblance may be ignored for other reasons: in the sixteenth century the Italian painter Armenini wrote that "portraits by excellent artists are considered to be painted with better style and greater perfection than others, but more often than not they are less good likenesses." At this time in Italy an "excellent artist" would have been expected to idealize or ennoble a sitter's appearance along Classical lines, adopting the facial types and poses of Greek and Roman sculpture. Ideas of beauty might change, but idealization has often been expected of the artist. Artists have also on occasion altered a sitter's features for other ends. In the early 1900s Picasso gave Gertrude Stein a face inspired by primitive Iberian masks in an attempt to capture not her appearance but her essence.

If some portraits are not likenesses there are also likenesses that are not portraits. Titian's ravishing picture of a wide-eyed beauty known as *La Bella* is sometimes called *Portrait of a Noblewoman*, but this is no lady. The model for the painting – probably a prostitute – posed nude for Titian on other occasions. The painting is probably an accurate likeness of an actual woman but it is not a portrait. What was important for Titian and the duke who commissioned the painting was not the woman's identity but her exceptional beauty and the beauty of the picture.

It is not only paintings of beautiful women that can appear to be portraits without being so. In the seventeenth century there was a huge demand for paintings of characterful heads – often in exotic or historical garb – which were prized as depictions of expression, mood, or particular character types. These works were produced throughout Europe but are perhaps particularly associated with Rembrandt and his school in the northern Netherlands. In Rembrandt's case one can often recognize

▲ **Primitive inspiration**
Picasso struggled with this portrait of the American writer Gertrude Stein for over a year while both were in Paris. After an intensive period of almost daily sittings Picasso left Paris for Spain. On his return he "sat down and out of his head painted the head in without seeing Gertrude Stein again," basing her features on the primitive Iberian sculpture he had seen on his recent travels. When people complained that the picture looked nothing like her he apparently replied, "Never mind, in the end she will look just like it." The artist's prophecy is now fulfilled, for many people with only the vaguest idea of who Gertrude Stein was know her through this painting. She has become her portrait.
Pablo Picasso, *Portrait of Gertrude Stein*, 1906.

▲ **Adoration**
The earliest descriptions of this painting claim that it contains portraits of the Medici family but they do not agree as to which members. However, it is generally accepted that the old king kneeling before Christ is Cosimo de' Medici, the principal founder of the family's fortune and power in fifteenth-century Florence, who died ten years before the picture was painted. Lorenzo "The Magnificent," Cosimo's grandson and Botticelli's most important patron, may be the dark-haired figure with the red stripe on his sleeve who is standing on the right. The figure in yellow on the extreme right and looking out of the picture is probably Botticelli himself.
Sandro Botticelli, *The Adoration of the Magi*, c.1476.

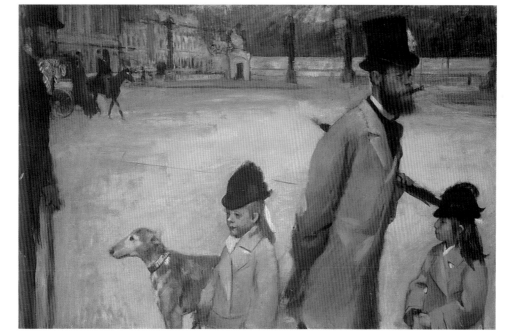

the same model being used from painting to painting, and indeed two of the models he used are traditionally identified as his mother and father. But again, even if these pictures are accurate likenesses of particular people they are not portraits, for, like Titian, Rembrandt was not painting his sitters as themselves. Their identity was entirely unimportant to both him and the people who bought the paintings. In the inventories of Dutch collections paintings of this kind are simply called "tronies," or "heads."

With these anomalies in mind we may prefer a definition of a portrait which does not rely entirely on the idea of likeness. A portrait might be described as an image in which the artist's main concern is to characterize the sitter as an individual. While some portraits restrict themselves to the description of physical appearance, most attempt rather more,

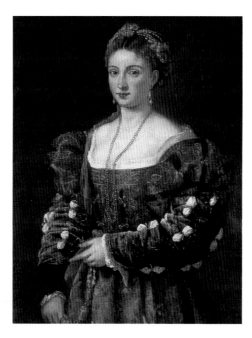

► **Ideal beauty**
The Venetian painter Titian made portraits of this woman more than once, both clothed and naked. This one was commissioned by Francesco Maria della Rovere, the Duke of Urbino, who in May 1636 wrote to one of his agents urging him to persuade Titian to complete his picture showing "that lady wearing the blue garment."
Titian, *Portrait of a Noblewoman (La Bella)*, 1537.

conveying the sitter's status in the world, or characterizing their personality or at least their state of mind at the time of the portrait.

Approved view

But even armed with this definition we find some pictures which refuse to be pigeonholed. This is particularly true in the modern era, when artists, operating in the world of picture dealers and the art market, have been less reliant than their predecessors on accepting portrait commissions in order to survive. For example, Edgar Degas's painting *Place de la Concorde* is both a scene of everyday Parisian life and a remarkably incisive portrait, but what it is not is the kind of portrait that an artist would be inclined to produce to commission. A commissioned portrait – which is to say most of the portraits painted in the period covered by this book – will in nearly every case present an approved view of the sitter. To use a literary analogy, it will be more the "authorized" than the "unofficial" biography. But more importantly it will always give the sitter or sitters the central role in the painting. In a number of paintings from the nineteenth century onward this is no longer the case: in Degas's picture, for example, the Parisian square is as important as any figure in it.

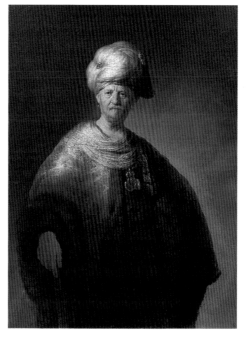

◄ **Faux Oriental**
This is not a painting of an Oriental potentate who strayed into Amsterdam, where Rembrandt painted him. The man's features are clearly European and he was probably a paid model. The way such a picture would have been seen is well conveyed by Rembrandt's friend Jan Livens, writing of a similar painting: "the likeness of a so-called Turkish potentate, done from the head of some Dutchman or other." The Amsterdam merchant who bought this work had himself painted by the artist in the same year.
Rembrandt, *A Man in Oriental Dress: "The Noble Slav,"* 1632.

The origins of portraiture

The wish to commemorate the living and the dead through representation is an ancient one, and even if we restrict our survey to Western civilization we see that portraits were made from its very beginnings. Egyptian portrait statues and reliefs survive from before 3000 BC, and there are many highly individualized portrait heads from ancient Greece and Rome. If we turn to the rare survivals of painted portraits, there are still a number from well before the period encompassed by this book. Some, dating from the first century AD, are preserved on the walls of Pompeii, and a group of painted portraits from second-century Egypt survives.

Early survivals

There is a painting, much damaged and much restored, that may well be the earliest surviving independent painted portrait in the period covered by this book. Dating from the mid-fourteenth century, it shows King John II of France (1319–64) and can be seen below right. But it was certainly not the first portrait to be made. There are a few descriptions of earlier lost portraits, such as two sonnets of 1336 by the Italian poet

Petrarch (1304–74) praising a painting of his beloved Laura by Simone Martini. One poem suggests that this was probably a large-scale miniature painted on parchment rather than a painting on a wooden panel. But Petrarch's revelation that he always carried Laura's likeness perhaps reflects a new demand and use for small private portraits. We do not know in what circumstances John II's portrait was painted, but its small size and the absence of any regalia make it possible that even here the purpose was more private than dynastic.

The term "independent painted portrait" is chosen carefully. Many portraits survive from the medieval West before 1350, but these are either sculpted likenesses or depictions in the pages of manuscripts, or they are features within larger works – such as the portraits of donors that appear in religious paintings. But John II's portrait provides a useful starting point. In contrast to the many earlier medieval survivals, this is no generic type. In the mid-ninth century the Emperor Lothair was shown simply as a man on a throne with imperial guard, crown, and sceptre. In contrast, the painter of John II seemed to wish to create a likeness, even if – as is often

▼ **The earliest survivor**
Despite its importance in the history of portraiture, we do not know who painted this portrait of King John II of France. It has been suggested that the artist may have come from the papal court, at that time relocated from Rome to Avignon, southern France, and its style and technique suggest Italian influence. The absence of any mark of kingship is curious. The most plausible explanation is that the picture was painted before John became king in 1350 and the slightly crooked inscription "John King of France" was added later.
Unknown artist, *Portrait of John II "the Good King" of France*, c.1360.

▶ **Imperial portrait**
The school of artists and scribes attached to the monastery of St Martin in Tours, northern France, was the most prolific of all the ninth-century Carolingian artistic studios. This magnificent full-page illumination opens a book of Gospels dedicated to the Emperor Lothair, who was probably never seen by the artist who depicted him. Although this painting is clearly intended to show the emperor, it is not a portrait in the sense of being a deliberate likeness. Wearing his crown and holding his sceptre, Lothair points with his left hand to the dedicatory poem that appears on the opposite page.
School of Tours, *The Emperor Lothair*, 849–51.

▼ Donor portrait

Those who commissioned religious paintings often asked for their portraits to be included, and these "donor portraits" survive from well before the earliest independent painted portraits. The kneeling figure is Robert of Anjou, King of Naples, who commissioned the Sienese painter Simone Martini to paint this work. Robert is shown in profile and his face is strongly characterized. The features of the seated St Louis, canonized in 1317, are typical of the idealized faces that Simone gave his saints. **Simone Martini**, *Altarpiece of St Louis of Toulouse*, c.1317.

▶ Early mastery

These portraits of an unidentified man and his wife, painted by the fifteenth-century Netherlandish artist Robert Campin, display great skill and subtlety. The contrasts between the older, jowly man and his bright-eyed, smooth-skinned wife are wonderfully observed and recorded. From the evidence of the couple's dress it is clear that they were not especially wealthy nor of elevated status. Even as early as this date, portraiture was not the exclusive preserve of the royal, the noble, or the very rich. **Robert Campin**, *A Man* and *A Woman*, c.1430.

the case – the identification was later reinforced with an inscription. The king is seen in profile, a view much used in early portraiture, particularly in Italy, where nearly all portraits were profiles until about 1500.

The profile

The early popularity of the profile needs some explanation. It can be argued that painting a profile portrait is in some ways less complicated than depicting the face frontally or in three-quarters view because a profile essentially reduces the face to a single outline describing the forehead, nose, lips, and chin. In drawing a profile it is even possible to trace round the subject's shadow, although we do not know if early portraitists did so. It may also be that the profile view was a conventional means of identifying a figure as a portrait, and this seems to be the case in the many religious paintings where donors are shown in profile, in contrast to the saints and holy personages surrounding them, as in Simone Martini's altarpiece. Finally, in painting John II in profile the artist may have been deliberately emulating the profile portraits of emperors that survived on Roman coins. This appeal to Classical precedent was certainly important for the continued popularity of the profile in fifteenth-century Italy.

In common with most early portraits, the king's face is shown against a blank background – here expensively gilded as a mark of the sitter's royal status – and we are given a very restricted view of the sitter which shows only the head and shoulders. In general it was not until the fifteenth century that portraits began to include sitters' hands, but from around 1450 artists extended the view to the waist and beyond.

We can be sure that many portraits from the fourteenth and fifteenth centuries have been lost, but the few survivals show a remarkably rapid development. Within less than one hundred years of John II's portrait, artists in northern Europe, such as Robert Campin and Jan van Eyck (see page 146), were painting sophisticated portraits of a virtuosity scarcely equalled since.

Catching a likeness

◄ **A familiar face**
From 1632 Van Dyck worked as King Charles I of England's "principalle Paynter" on very generous terms, and received a knighthood in the same year. He painted this triple portrait as the model for a bust of Charles to be made by the Italian sculptor Bernini. In doing so he produced a painting that surpassed its purpose by, for example, including his royal patron's hands. When Bernini's bust arrived in England it was admired for "the likenesse and nere resemblance it had to the King's countenance."
Anthony Van Dyck, *Charles I in Three Positions*, 1635–6.

▼ **An unusual view**
Peter Lely came to England from the Netherlands in the early 1640s, around the time of the death of Van Dyck, and was later to become principal painter to Charles I's son, Charles II. This painting is one of his earliest dated English works. Lely's version of Charles has far coarser features than those we are accustomed to in Van Dyck's portraits of the king: his nose is longer and more bulbous, his eyebrows thicker, his forehead narrower, and his lips fuller.
Peter Lely, *Charles I with his Son James Duke of York*, c.1648.

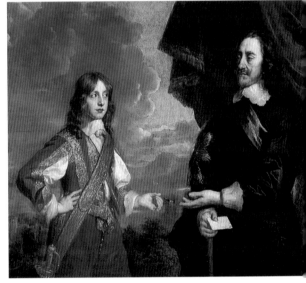

▲ **Exaggeration**
Botticelli has enlarged the sitter's features in proportion to his face and exaggerated them by painting them from slightly different angles. We look straight at the eyes but slightly up at the nose, mouth, and chin. The lips are asymmetrical and the eyes are different in shape. It is because of these distortions that the portrait convinces us that it is a likeness.
Sandro Botticelli, *Portrait of a Young Man*, c.1480–5.

W hen someone has a portrait of themselves painted, it is usually expected to look like them. But this apparently straightforward demand raises all sorts of complications. Personal experience tells us that we can alter our appearance: when we pose for a photograph we may suck in our cheeks or turn our "best side" to the camera; when we look in the mirror most of us instinctively compose our features into a "mirror face" that accords as closely as possible to our image of ourselves. Inevitably this is not how most people see us, and so we may be surprised by photographs that do not look like us.

Interpreting the subject

A camera (if not the photographer) records dispassionately, but painters have always brought their own interpretations to the depiction of a subject. For this reason it is often impossible to say how closely a portrait executed in the past resembles the sitter. Botticelli's *Portrait of a Young Man* is the only record we have of the anonymous youth who posed for the Florentine artist. This is true of many portraits, but there are some figures of the past that we are confident we would recognize. The many paintings of Charles I by his court painter, the Flemish artist Sir Anthony Van Dyck, have made him perhaps the most familiar of all the English monarchs before the age of photography. However, it is

not Charles himself that we know but Van Dyck's version of him, and it can be a shock when we see another artist's interpretation of the same face, as we do in Peter Lely's portrait. We cling to Van Dyck's image as a true likeness because it is familiar, but the artist almost certainly softened and refined the king's features.

The fact that Van Dyck idealized Charles's features does not mean that the king's portraits did not look like him. We have only to think of the wildly different ways in which contemporary cartoonists distil the features of their subjects into instantly recognizable caricatures to realize that there are many ways to construct a likeness. A caricaturist will grotesquely distort notable features of the sitter – for example, Mick Jagger's lips or Prince Charles's ears. Botticelli's young man is not obviously grotesque, but an examination of his features suggests that here too the artist has used distortion, although far more subtly. The subject's

features seem enlarged in proportion to his face and their irregularities have been exaggerated. It is precisely in asymmetries and irregularities that likenesses are caught and the portraitist often slightly overemphasizes these to secure the resemblance.

The portrait painter's quest for likeness is also helped by the fact that we require so few clues to recognize a face. A skilled draughtsman can encapsulate an individual with a few swift strokes of the pen and artists have exploited this fact in a number of different ways. The British eighteenth-century painter Sir Joshua Reynolds believed that his contemporary and rival Thomas Gainsborough exploited our facility for recognizing likenesses by painting his portraits in his characteristically sketchy manner (see page 157). He used fluid and loose brushwork to simplify the face and reduce it to its essentials, just as Botticelli schematized the face in his portrait, albeit in a far more linear manner.

Radical simplification

More extreme examples of simplification and reduction are found in much twentieth-century portraiture, most strikingly in the portraits of Modigliani. The Italian painter devoted himself almost exclusively to portraiture during his short life, and the portrait of his fellow artist Soutine is typical of his stylized, elegant, and elongated figures. While Modigliani has reduced the sitter's face to its bare essentials, there is exactly the same concentration on the irregularities and asymmetries of the features that we saw in Botticelli's painting of more than four centuries earlier.

Although catching a likeness often depends upon distortion, in some cases we find a likeness surviving despite distortion. In the portraits of the twentieth-century British painter Francis Bacon the likenesses of his subjects – who were usually his close friends – are retained even though they have been mauled by the brush. Many of the strokes of paint across the face of Isabel Rawsthorne in his triple portrait of her seem to be deliberately destructive of her features, wilfully erasing or distorting elements of her face. Yet, astonishingly, her physical presence is strongly conveyed. Concentrating only on her appearance, the portrait clearly tells us how her hair was parted and shows us the shape of her nose and lips and the elegant arch of her painted eyebrows. For Bacon, resemblance in portraiture was important, his stated aim being "to distort the thing far beyond appearance but in the distortion to bring it back to a recording of appearance."

◄ **Simplification**
Modigliani's elegant portrait is as much concerned with the rhythms of its design as with creating a likeness. He has emphasized the irregularities of Soutine's appearance. The differences between the eyes – one is higher – and the arches of the eyebrows are exaggerated, as are the asymmetry of the nostrils, the full lips, pointed chin, and long neck. This is a likeness on the very brink of caricature.
Amadeo Modigliani, *Chaim Soutine*, 1917.

▼ **Distortion**
Bacon's triple portrait of Isabel Rawsthorne reminds us of Van Dyck's triple portrait of Charles I, but the format and the sweeping strokes of the brush over the three heads also suggest a face in movement. The paintings seem perfectly to reflect Bacon's claim that he painted his friends as he wouldn't want to paint someone "unless I had seen a lot of them [and] watched their contours."
Francis Bacon, *Three Studies for a Portrait of Isabel Rawsthorne*, 1965.

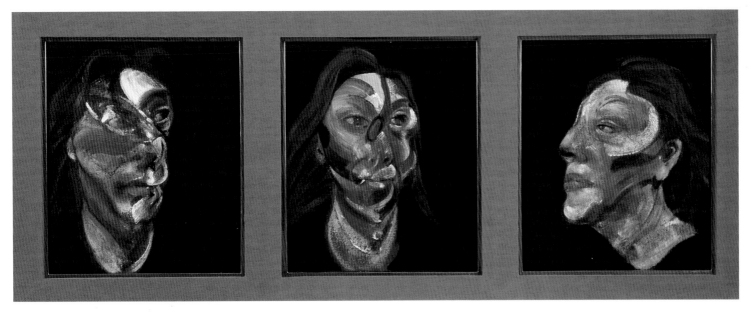

Exploring poses

Even the earliest surviving writings on painting suggest that a portrait should attempt more than simply representing the sitter's outward appearance. A number of ancient Greek and Roman poems on portraiture make it clear that even then an artist was expected to try to paint the subject's "soul" as well. These were rediscovered during the Renaissance, when the problem of how an artist could depict soul or, as we would now say, character, again became a preoccupation of painters. But while portraitists aim to capture more than mere appearance, the means at their disposal are limited. Broadly speaking, they have three areas of manoeuvre, the subjects of this and the following pages: pose, expression, and setting.

Connection

The profile portrait favoured in Italy until about 1500 may have offered some advantages (see page 139) but it provided no opportunity for a psychological connection between the subject and the person looking at the picture. Connection is only possible when the sitter is able to turn toward the viewer, and it is through the relationship between the two that character (and status) is so often conveyed. The three-quarter view was favoured in the Netherlands from the early fifteenth century, but in Italy it was not until the portraits of artists such as Antonello da Messina, Leonardo da Vinci, Sandro Botticelli, and Raphael that sitters turned to address the viewer.

Raphael's portrait of the poet, courtier, and man of letters Baldassare Castiglione is a model of intimate directness. Castiglione is seated – the arm and back of a chair are just visible – and turns his hands, which are gently linked, toward us. But it is not just in the sitter's pose that engagement and intimacy are suggested; it is also in our position in relation to him. We are very close, as if sitting beside him, meeting his gaze eye to eye. Our implied position is often every bit as important as the pose struck by the sitter in suggesting the subject's attitude toward us and by extension the world in which he or she lives; in portraits of rulers for example we invariably find ourselves looking at them from below (see page 156, Hyacinthe Rigaud, *Louis XIV in Royal Costume*).

The gripping portrait of Monsieur Bertin by Ingres owes much to Raphael's picture. We are again faced with a seated figure in sombre clothes turning toward us but, in contrast, we are forced to keep our distance; we have pushed our chairs back to become Bertin's audience rather than his confidant. Ingres uses pose to convey the exceptional power of the sitter's personality in other ways. Everything about Bertin suggests conviction and this quality is conveyed in a straightforward way. There is nothing relaxed here: the subject faces us directly, he leans forward from his chair, his legs are apart, and his great clawlike hands are planted on his knees as he fixes us with his gaze. This is body language that needs no translation.

▼ **Directness**
Bertin was one of the most powerful French newspapermen of his age. According to a much-repeated story, Ingres had so much difficulty arriving at a suitable pose for this portrait that he broke down in tears. One evening, however, he apparently had an epiphany when he saw Bertin adopt this very posture during a heated political discussion. The story may not be true (and versions of it differ) but it is not surprising that legends should have grown up around such a striking and eloquent pose. At the beginning of the twentieth century Picasso was to adapt it in his portrait of Gertrude Stein (*see* page 136).
Jean-Auguste-Dominique Ingres, *Louis-François Bertin*, 1833.

▶ **Intimacy**
The implied intimacy and engagement of the Italian painter Raphael's portrait were celebrated and exploited in a poem written by Castiglione himself in which he imagined his wife writing to him while he was away:

When alone the portrait by Raphael's hand,
Recalls your face and relieves my cares,
I play with it and laugh with it and joke,
I speak to it as though it could reply,
It often seems to me to nod and motion,
To want to say something and speak your words.
Your boy knows and greets his father babbling.

Raphael, *Portrait of Baldassare Castiglione*, 1514–15.

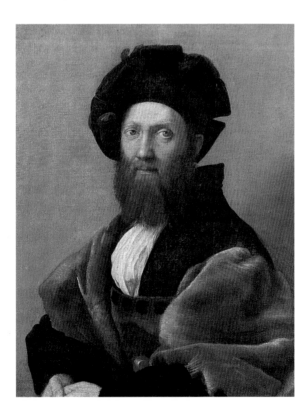

▶ Melancholy

The artist Amelia van Buren was a close friend of the American painter Thomas Eakins, and the connection makes itself felt in this, one of his greatest portraits. Eakins has painted his sitter not as an artist but as a powerfully intelligent woman, apparently captured in a moment of contemplation. There is more than a suggestion of sadness in the picture and Eakins, having taught at the Academy of Fine Arts in Philadelphia, would almost certainly have known that the pose his sitter adopts – her head supported by her hand – was, from the Renaissance onward, seen as the traditional pose of the melancholic.
Thomas Eakins, *Miss Amelia van Buren*, c.1891.

▶ Action

The German artist Otto Dix's portrait of the emancipated journalist Sylvia von Harden shows the monocled intellectual talking animatedly. Her great, bony hands are remarkably eloquent; while her right hand gestures outward, reinforcing her point, her left hand and arm appear defensive. The fact that she appears to be speaking is very unusual in a portrait, but she is not addressing us and we are certainly not seated at her table.
Otto Dix, *Portrait of the Journalist Sylvia von Harden*, 1926.

◀ Display of beauty

"Madame X" was no anonymous model, but Madame Pierre Gautreau, an American married to a Frenchman. A star of the Parisian society pages, she was famed for her beauty and clearly exploited it: the diamond crescent moon in her head-dress, symbol of the Goddess Diana, was her own. The pose she adopts is designed to display her beauty but also evident is the tension of someone on show. The muscles at the back of her neck and of her arm are strained and taut – perhaps betraying a hint of vulnerability beneath the proud aloofness.
John Singer Sargent, *Madame X*, 1883–4.

Once it is expected that the sitter will face the viewer the portrait painter may choose to confound this expectation for a variety of ends. In depicting someone directing their attention elsewhere a portraitist can suggest that the sitter has been caught unaware, whether in repose (above left) or in action (above right), or can imply a deliberate pose of indifference toward the viewer (left). In each case we draw different conclusions as to the sitter's character, although these are based on the assumption that the pose is typical of that person.

The practicalities of posing

In Thomas Eakins's portrait of his former pupil Amelia van Buren the sitter looks away from the viewer, but perhaps surprisingly the effect is one of intimacy rather than distance. We seem placed in the privileged position of witnessing her reverie. The chair she sits in appears in a number of other paintings and portraits by Eakins. This reminds us of another important, if mundane, aspect of the poses adopted in portraits. Usually they must be positions that a sitter can hold for several hours. Eakins has here used the tedium of the sitting in the interest of characterization, but there is a danger for the painter that the boredom of the sitter will make itself felt unintentionally.

The artificiality of posing for an artist can be exploited in other ways. In John Singer Sargent's icily sexy portrait of Madame X, he deliberately returns to the perfect-profile view found in early portraiture, but with an entirely different aim. The proudly aloof Madame X shows us her "best side" in a pose that is contrived, self-conscious, and deliberately distancing. This is a portrait of a poseur.

Expression

When we first meet people we may instinctively take in what they are wearing and how they hold themselves, but it is to the face that we look first for clues as to character and mood. Faces are extremely versatile and subtle communicators and they are, of course, the main subject for the portrait painter.

In portraying a mythological or biblical scene a painter can depict exaggerated facial expression to convey strong emotion, but this is hardly effective in a portrait. Just as dynamic poses are rare in portraits, so are pronounced facial expressions, and for similar reasons. Facial expressions are movements. A smile, for example, is the thing of a moment and if we have to hold one for any length of time it becomes an unnatural grimace. This also affects how we look at those rare portraits with marked and unambiguous facial expressions. At first glance Antonello da Messina's unusual painting of a smiling man might seem natural and lively, but it soon appears inane. It is only relatively recently, in the age of photography, that we have become used to seeing the fleeting expression captured in an instant. As a result, portraits painted during the last hundred years or so are more comfortable with the flash of teeth and with marked facial expressions (see page 143, Otto Dix, *Portrait of the Journalist Sylvia von Harden*).

The smile

Leonardo's *Mona Lisa* is so famous and widely reproduced that it is almost impossible to look at it with a fresh eye; indeed it is difficult to remember that this is after all "just" another portrait. But if we ask why this enigmatic smile has captured the imagination of generations the answer seems to lie in its very lack of definition. Leonardo manages to convey the impression of a fleeting, moving expression, and he does so by literally refusing to fix the edges of the smile. Where Antonello da Messina carefully delineated the lips of his smiling man, Leonardo loses the corners of Mona Lisa's mouth, and the corners of her eyes, in shadow, suggesting at least the possibility of movement. Another device exploited by Leonardo, and one that appears to have been deliberately or instinctively used by many artists, is to give the two halves of a face different expressive qualities, again adding to the illusion of an expression playing across it. In the case of the *Mona Lisa*, the "smile" – the upward turn of the mouth and the shadow around the eyes – is far more pronounced on the right side of the face, as we look at it, than on the left.

The same techniques can be found used to very different effect in Velázquez's mesmerizing portrait of the seventeenth-century Pope Innocent X, although here the corners of the mouth are obscured not by shadow but by the moustache. Where the *Mona Lisa*'s

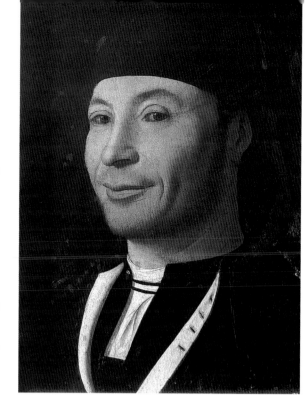

▶ **Capturing expression**
The Sicilian Antonello da Messina is usually credited with bringing the Netherlandish technique of oil painting to Italy. The influence of this style is evident in his portraits, in which he abandoned the traditional profile view of Italian portraiture for the three-quarter view popular in northern Europe, which allowed the portrayal of facial expression. This work is generally regarded as the earliest of his portraits, but it is not the only one which displays a marked facial expression.
Antonello da Messina, *Portrait of a Man*, c.1470.

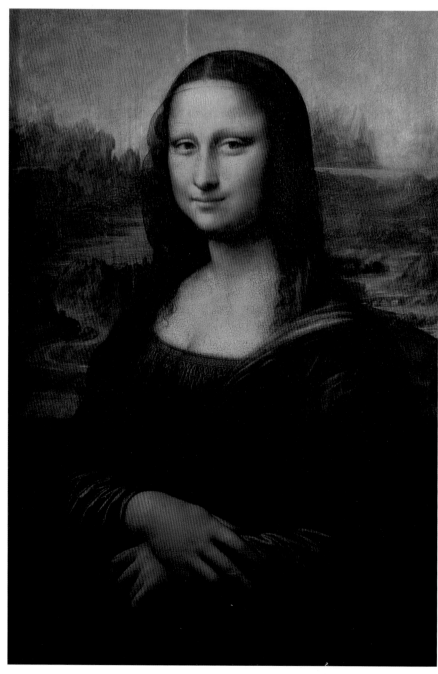

expression suggests serenity, Innocent's is one of penetrating intelligence, an impression reinforced by the strongly illuminated forehead, a common device in the portraits of strong intellects (see page 143, Thomas Eakins, *Miss Amelia van Buren*). But it is in his gaze that much of the power of this portrait lies and it is most naturally to the eyes that we look for illumination as to character.

Windows of the soul

Eyes in themselves tell us very little. Occasionally an artist might make them appear peculiarly bright or dull, but on the whole it is what surrounds the eyes – the brows and lids – and the direction in which the eyes are looking that reveal the most information. The eyes of Innocent X in Velázquez's portrait are set beneath a furrowed forehead and eyebrows that excited comment among his contemporaries: "thick eyebrows bent above the nose [. . .] that revealed his severity and harshness" Eyes can look out from a portrait in various ways. In Ingres's portrait of Monsieur Bertin (see page 142) the sitter stares straight at us, and his gaze is both frank and confrontational. In contrast, Innocent looks out from the corner of his eye in a manner that can be read as disdainful or even shifty. In portraits where the sitter's eyes do not meet ours, again many meanings are possible. In Eakins's painting of Amelia van Buren, the sitter is staring into space in a way that suggests pensiveness. The opposite effect is achieved in Mary Cassatt's *Portrait of Madame J* (see page 147), where the subject's attention seems to have been caught by something "off stage," so that we receive an impression of her liveliness and interest in her surroundings.

In Oscar Kokoschka's portrait of Joseph de Montesquiou-Fezensac the eyes behave in a disturbing way. The painter exploits the asymmetries of the face, as Leonardo did in the *Mona Lisa*. Although the marquis's bulging and red-rimmed right eye stares straight at us, his left eye, smaller and duller, appears to drift away. As a result, we do not know where we stand in relation to this trussed and buck-toothed aristocrat.

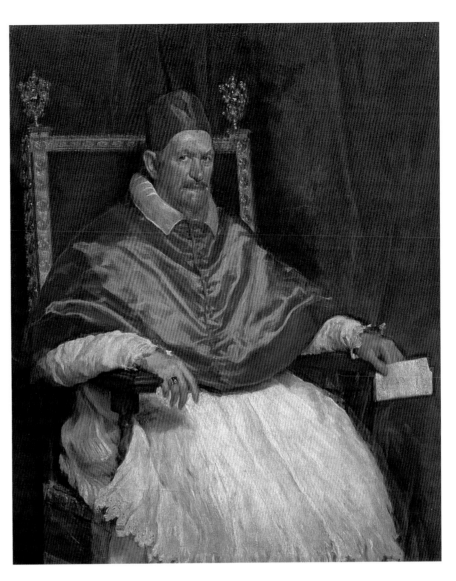

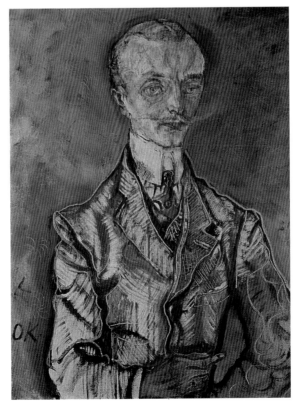

◀ An enduring mystery
This famous woman is probably Mona Lisa, wife of the Florentine Francesco del Giocondo and so known as La Gioconda. The identification rests on the earliest surviving description of what is probably this painting, written about fifty years after it was painted. Even at this early date Mona Lisa's smile was the subject of comment and the account includes the story (which may or may not be true) that Leonardo had musicians keep his sitter amused while he painted her portrait.
Leonardo da Vinci, *Mona Lisa*, c.1503–6.

▶ Degeneracy
Faces can be expressive in more ways than one. In this disturbing portrait the Austrian painter Oskar Kokoschka has exaggerated certain aspects of the face – the bulging cranium and pronounced overbite – to the point of deformity. His purpose seems to have been to characterize the sitter as an inbred aristocrat. Ironically, the subject's most distinguishing feature – his high-domed forehead – would, in the Renaissance, have been seen as a mark of great intelligence.
Oskar Kokoschka, *Joseph de Montesquiou-Fezensac*, 1911.

▲ An arresting gaze
Innocent X was no beauty, but we might hesitate before agreeing with his contemporary who claimed that "his face was the most deformed ever born among men." Velázquez's portrait – all reds, pinks, and whites – was made while the Spanish artist was in Rome. The painter does not disguise the pope's physical shortcomings, but rather makes use of them. It is difficult to drag one's eyes away from the severe and penetrating gaze, the large nose, and the great, lopsided slash of a mouth. In his hand Innocent holds a letter addressed to himself from Velázquez – an elaborate way for an artist to sign a painting.
Diego Velázquez, *Portrait of Pope Innocent X*, 1650.

The use of setting

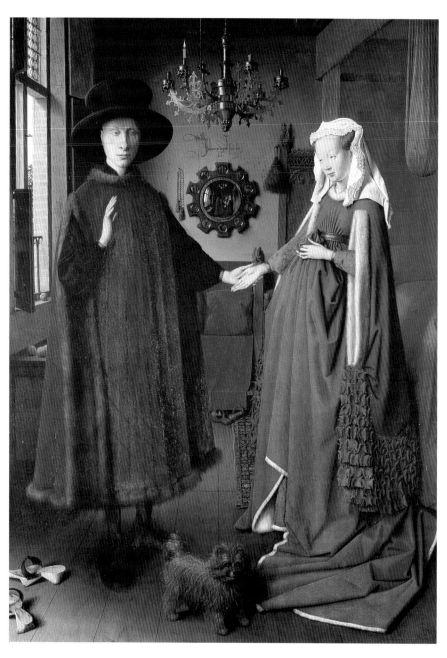

▲ Image in a mirror
Many commentators suggest that this painting records the couple's marriage, arguing that this explains their gestures, the s ingle lighted candle, and other symbolic details. It is more likely that Giovanni's gesture is one of greeting. The scene is reflected in the convex mirror on the back wall, in which we also see two figures entering the room, one of whom may be the artist.
Jan van Eyck, *Portrait of Giovanni Arnolfini and his Wife,* 1434.

The portrait painter need not rely exclusively on the face and figure to convey information about the sitter. Dress, whether official uniform, fashionable garb, or everyday attire, often carries as much information about social standing or professional position as a face. The same is true of the setting and the objects with which a painter surrounds the subject. Given how eloquent settings can be, it seems surprising how often portrait painters have chosen not to exploit them. Portraits frequently show the sitter against either an entirely neutral ground or, as in much seventeenth-century Baroque portraiture, generic and unspecific backdrops of drapes, columns, or landscapes often painted by studio assistants. A portrait with little or no background detail may focus attention on the sitter, but the main reasons for the use of neutral backgrounds are more mundane: they are easier to paint and cheaper to commission.

Possessions

What may be the first portrait to be set in a domestic interior is also one of the most elaborate: the enigmatic picture of the Italian merchant Giovanni Arnolfini and his wife painted by Jan van Eyck in 1434. The setting is probably invented – there is no fireplace, which would have been highly unusual – but the space is certainly intended to stand for the couple's property. Despite the conspicuous bed, this is not a bedroom but a reception room, in which beds were considered an essential part of the furnishings. Almost everything visible can be seen as reflecting the couple's wealth and status. They are both richly dressed; the woman's dress is made from an exorbitant amount of cloth, some of which she has to gather to her waist, leading some observers to believe her pregnant. Similarly luxurious were the brass chandelier; the large, convex mirror; the draped, carved furniture; the oriental carpet; and even the oranges, which were prohibitively expensive in northern Europe at this time.

Where the Arnolfinis had themselves painted in a richly furnished interior, the eighteenth-century English couple Robert and Frances Andrews sought the same statement of wealth by having Gainsborough paint them on their land. The strangely elaborate bench placed incongruously in the middle of a field suggests that here too there has been a degree of invention, but the landscape is a specific one and is as much a portrait as the figures of Andrews and his wife. It shows their property: the Auberies estate in Essex, the two halves of which were united at the couple's marriage.

Possessions are not the only thing that the settings of portraits can indicate: interests, beliefs, accomplishments, and profession are often alluded to. Holbein, painting in the first half of the sixteenth century, was among the first to develop the professional portrait – a figure surrounded with the tools or attributes of his trade. In one of the most elaborate he painted Georg Gisze, a German merchant stationed in London, as if in his office surrounded by objects that identify him and his profession and point to his business acumen, his wealth, and his love of beautiful things. But Holbein's painting is more than a simple record of a merchant at his desk. Inscribed on the wall is the sitter's motto "No joy without sorrow" and beside this warning against earthly pleasure hangs a precarious pair of scales – perhaps intended as a reminder of the scales in which humanity will be weighed at the Last Judgement.

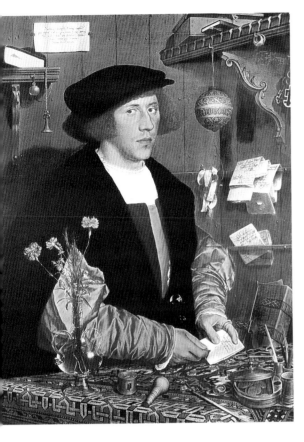

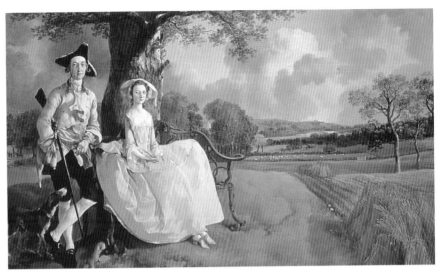

The symbolism of a particular setting or certain objects can add another level of meaning to a picture, although it is often difficult to be certain whether or not the artist intends a symbolic reading. The inclusion of a skull or an equally obvious symbolic object leaves no room for argument (see page 162, David Bailly, *Vanitas Still Life with a Portrait of a Young Painter*). But how can we know if the dog – a common symbol of faithfulness – in the portrait of the Arnolfinis is meant to stand for marital fidelity or if it is simply a much-loved pet? Similarly, the sheaves of corn in Gainsborough's painting of Mr and Mrs Andrews may be an allusion to the hoped-for fecundity of their union, or it could simply record a common summer sight.

Additional elements

In devising settings, portrait painters often have concerns other than the characterization of their sitters. Important among these is composition, but they may also include mere convenience, for most portraits are not painted in the sitter's home, garden, or office. The setting of a portrait may relate to the sitter, or it may record the artist's studio. In Mary Cassatt's portrait of Madame J the framed fan – painted by Degas – hanging in the background belonged to the artist rather than the sitter, and it is certainly more important as an element of the painting's design than as an indicator of the subject's personality. And yet its suggestion of a taste for Japanese art, along with the stylish hat and the striking floral covering of the armchair, reflects the fashionable preferences of the late nineteenth-century Parisian middle class to which Madame J clearly belonged.

Self-portraiture

It is not surprising that, from early in the history of portraiture, painters have turned their attention to themselves. On the most mundane level, painting oneself is convenient. In the words of the French nineteenth-century painter Henri Fantin-Latour (1836–1904), "The model is always ready and offers all sorts of advantages; he is exact, submissive, and one knows him before painting." For the same reason painters used themselves as convenient models to explore facial expressions or lighting effects or generally to perfect their art.

But the reasons for self-portraiture go beyond convenience. Self-promotion has long been an important impulse, and self-portraits allow artists to advertise their skill. Although self-portraits can be private exercises in self-examination and scrutiny, they are in fact more often a means of self-presentation. They also permit a degree of

wish-fulfilment, with the result that painters have often depicted themselves as they wish to be rather than as they are. From the Renaissance until well into the eighteenth century many artists were concerned that their profession be recognized as a liberal art, a noble and learned profession, rather than a mere craft. Self-portraits often proclaim an artist's worldly success or suggest social or intellectual pretensions, but make surprisingly little allusion to the act of painting.

Many fewer self-portraits would have been painted if there were not a market for them. Since the Renaissance, interest in the achievements of the individual has encouraged the collection of portraits of the famous and the great. In a self-portrait by a successful artist a collector has something doubly valuable: a portrait of the painter and an example of the work responsible for the artist's claim to greatness.

▶ Self-reflection
This striking self-portrait was painted by the Italian artist Parmigianino, at the age of twenty-one, to advertise his skill and invention. He has depicted himself as if reflected in a convex mirror (the only kind made at this date). To increase the illusion he painted the picture on a convex surface. The distortion makes his hand larger than his face – perhaps an allusion to the exceptional manual skill with which he produced this painting.
Parmigianino, *Self-Portrait in a Convex Mirror*, 1523–4.

▶ Self-satisfaction
The most famous and successful painter of the seventeenth century, the Flemish Rubens was far from the stereotype of the tortured artist. His self-portraits celebrate either his worldly success or, as seen here, his domestic contentment. This picture shows him with his first wife and was probably painted in their marriage year. The couple link hands, and the honeysuckle around them may be read as a symbol of fruitful love. Rubens paints himself not as an artist but as an elegant gentleman.
Peter Paul Rubens, *Self-Portrait with Isabella Brandt*, 1609.

◀ Self-exaltation
Artists had painted self-portraits before the German Renaissance master Dürer did so, but he was the first to make a habit of self-portrayal. A number of his self-portrait drawings survive and this is the third and last of his magnificent paintings of himself. It is striking in its resemblance to representations of Christ, especially to the "Veronica image," said to have been miraculously imprinted on a cloth belonging to St Veronica. The inscription reads: "Thus I, Albrecht Dürer from Nuremberg, painted myself with indelible colours at the age of 28 years."
Albrecht Dürer, *Self-Portrait at 28*, 1500.

◀ Self-obsession
The seventeenth-century Dutch artist Rembrandt virtually created the self-portrait as an independent genre. Nearly eighty self-portraits – paintings, etchings, and drawings – survive, made throughout his career. Few confront the viewer as directly as this one. The subject is close to the picture plane, and the artist meticulously and mercilessly records the details of his ageing face.
Rembrandt, *Self-Portrait with Beret and Turned-Up Collar*, 1659(?).

Self-promotion

Elisabeth Vigée-Lebrun was one of the most successful women painters of the eighteenth century. In this self-portrait, which contributed to that fame and caused a sensation when exhibited in the Paris Salon in 1783, the French painter has clearly exploited her physical charms. She also holds a palette, a testament to her acknowledged artistry. The picture derives from a famous portrait by Rubens known as "The Straw Hat" – an allusion that was appreciated by the viewers of her day. **Elisabeth Louise Vigée-Lebrun**, *Self-Portrait in a Straw Hat*, c.1782–3.

Self-assertion

The German Expressionist Max Beckmann returned again and again to self-portraiture throughout his career, and this is his most assertive and self-confident image of himself. Elegantly dressed in black tie, his hand on his hip, he seems to be the master of his world. As with Rubens (opposite), Beckmann's success is evidently social as well as artistic. However, such a pose was surprising in the twentieth century, when artists were more often expected to be bohemian non-conformists than socialites. Indeed the painter was criticized at the time by those who saw him as claiming his innate superiority in the portrait. **Max Beckmann**, *Self-Portrait in Tuxedo*, 1927.

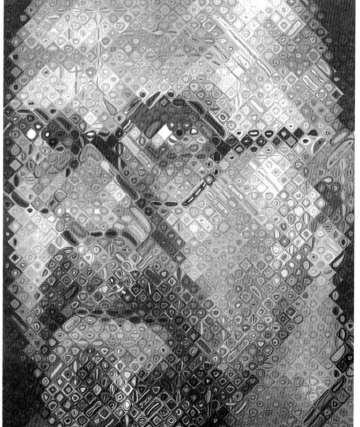

Self-doubt

The Dutch artist van Gogh painted self-portraits throughout his brief ten-year career. This picture dates from the aftermath of the most infamous moment of his life when, in 1888, he cut off part of his right ear after quarrelling with his fellow artist Gauguin. In what was probably one of the first paintings he made after leaving the hospital he makes much of his bandaged wound. Where once artists had aspired to courtly status, van Gogh wears peasant clothes and refers directly to the act of painting by including a blank canvas behind him. **Vincent van Gogh**, *Self-Portrait with a Bandaged Ear*, 1889.

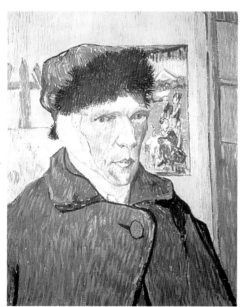

Self-aggrandizement

The American painter Chuck Close has concentrated almost exclusively on the human face, usually on a vast scale. He made his name in the late 1960s with monochrome hyperreal paintings of faces, including his famous *Big Self-Portrait* of 1967–8. In 1988 Close was paralyzed by a blood clot. After recovering the partial use of his arms he developed a manner of painting that, ironically, is freer and more painterly than his earlier techniques. His faces are now made up of mosaics of coloured squares, each filled with squirming multicoloured doughnuts, circles, and figures of eight. **Chuck Close**, *Self-Portrait*, 1997.

Double portraits

E vidence of double portraits survives from the fourteenth century, and although one of the earliest survivals, Jan van Eyck's portrait of Giovanni Arnolfini and his wife (see page 146), is unusual in other ways, it was probably not exceptional in being a full-length double portrait. Nor were early double portraits confined to showing family members: in 1431 Joan of Arc said at her trial that she knew of only one portrait of herself, which showed her kneeling in full armour as she presented a letter to King Charles VII of France.

Marriage

While other kinds of double portrait existed, portraits of married couples have always been the most common. Often these were painted to celebrate the marriage itself, being made at the time or shortly afterward. This is the case in Lorenzo Lotto's charming portrait of Marsilio Cassotti and his bride in which Marsilio is shown in the act of placing the ring on Faustina's finger. Marriage portraits were often painted as pendants – to be hung side by side – but a double portrait provided a greater opportunity to describe a couple's relationship.

Portraits showing two friends together have always been less common than those depicting family ties, but there are examples from the sixteenth century by Raphael and Holbein (see page 162, Hans Holbein, *The Ambassadors*), among others. It is no surprise that Raphael's portraits of friends were of the humanist scholars and poets of his circle, who placed particular emphasis on Platonic ideals, including those of friendship. In the seventeenth century the writers and poets of the court of King Charles I of England also set great store by Platonic friendship – "the sweet union or communion of mind" – and found in the Flemish artist Van Dyck one of its great portrayers. His portrait of Thomas Killigrew and an unknown man is a particularly moving depiction of the consolations and support that friendship can bring. Killigrew, the disconsolate figure on the left, is in mourning for his recently deceased wife. He looks out wearily from the painting, but his friend seems to offer the possibility of recovery. Where Killigrew slumps, the other man is alert; he looks not toward us but to his friend, and he points to a

Friendship in loss
Thomas Killigrew was typical of the young men who peopled the court of King Charles I. A playwright and courtier, he was married to Cecilia Crofts, one of the Queen's ladies-in-waiting, whose death he is shown mourning. A small gold and silver cross engraved with her initials is attached to his sleeve and her wedding ring hangs from a black ribbon at his wrist. His wistful pose contrasts with that of his alert and solicitous companion. **Anthony Van Dyck**, *Thomas Killigrew and an Unidentified Man*, 1638.

The duties of marriage
The Venetian Lorenzo Lotto was one of the most inventive and eccentric portrait painters of the sixteenth century. He revelled in the language of symbols, and although their meaning is often unfathomable, here they seem straightforward. Cupid, the God of Love, hovers above the young couple and holds a yoke above them – a clear reference to the dutiful bond that lies ahead. Sprouting from the yoke and on Cupid's head, laurel branches symbolize virtue. **Lorenzo Lotto**, *Marsilio Cassotti and his Bride Faustina*, 1523.

blank sheet of paper – perhaps a symbol of a life yet to be lived and an indication of hope for the future.

The fascination of double portraits most often lies in the relationships they set up. In painting a single figure, the artist is restricted to playing with the relationship between sitter and viewer, but with a double portrait the options include exploration of the connections and contrasts between the sitters. Some aspects of the relative positions of the sitters in double portraits were in fact formalized. From the Renaissance until the nineteenth century it was customary in portraits of married couples to place the man in the more "honourable" position on the left (on his wife's right) and slightly raised above her, as in Lorenzo Lotto's portrait. This hierarchy of position was also often followed in portraits of siblings or friends, with the elder or the one of higher rank placed on the left.

Contrasts

It is not just in positional relationships that double portraits convey their meaning; many also exploit differences, or indeed similarities, between their sitters to characterize them. The nuances of character are often most effectively conveyed if they have contrasting qualities placed beside them. In the contemporary British painter David Hockney's portrait of his parents the apparently neutral expression and pose of his mother are extraordinarily eloquent when seen against those of her husband hunched over his book. Her face becomes charged with meaning because of what we can now see that she is not doing: she is not looking at a book and she is not looking at her partner. It is also in contrast to Hockney's father that it becomes clearer what she is doing (and he is not): she is facing outward, sitting primly upright, and her feet are planted firmly on the ground. She is also looking at us and, of course, at her son the painter. Hockney's portrait is a model of understatement centred on disconnection, but the relationship between sitters in a double portrait can be far more dynamic. In the double portrait of Heinrich and Otto Benesch by the Austrian painter Egon Schiele the contrasts between the thick-set, red-faced Heinrich, his eye swivelling to confront the viewer, and his pale, thin son Otto are marked. But it is the gesture of the father toward his son that is most intriguing. It seems to embody a certain kind of paternal love: protective yet dominating, the hand reaching out toward the son but with closed rather than open fingers – shielding but also blocking the way.

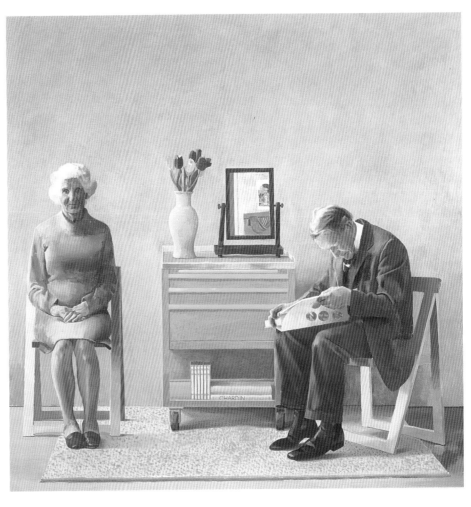

▲ **Three-way relationship**
Hockney has painted many double portraits, and this is the second of his large-scale portraits of his parents. The title makes it clear that the painting is actually as much about how Hockney relates to his parents as how they relate to each other. The stillness of life seems to be one of the themes of the picture. The objects on view, such as the book on the French still-life painter Chardin and the volumes of Proust's novel *Remembrance of Things Past*, also refer as much to the artist's own preoccupations as they do to the sitters themselves.
David Hockney, *My Parents*, 1977.

▶ **Paternal protection**
Heinrich Benesch, a Viennese civil servant, was a supporter of Schiele, whose brief, troubled career included imprisonment for making immoral drawings. His son Otto, seventeen when this portrait was painted, had also become friends with the young painter. Having initially planned to show the father seated, Schiele altered the couple's relationship several times before arriving at the final arrangement. The outstretched arm was one of the last alterations – even at a late stage in the painting Heinrich had both hands in his pockets.
Egon Schiele, *Double Portrait of Heinrich and Otto Benesch*, 1913.

Group portraits

▼ Implied nobility

One of the aims of the Spanish artist Velázquez in painting *Las Meninas* was to stress the nobility of his art. In this group portrait his ingenious composition not only places him in the company of a royal princess but also, by means of the reflection in the mirror, implies the presence of the king and queen themselves. (It would have been unthinkable actually to place himself next to the royal couple.) Throughout the latter part of his career Velázquez campaigned to have himself knighted and succeeded two years after completing this picture. The red cross of the Order of Santiago – the badge of knighthood – was added to the painting afterward.
Diego Velázquez, *Las Meninas*, 1656.

ew group portraits survive from the fourteenth and fifteenth centuries, but there is plenty of evidence that they were being made from the fourteenth century onward. Group portraits are perhaps less likely to survive than others, as they are often large and unwieldy and their owners may be interested in only one or two figures within them, whereas an individual portrait may be treasured by the sitter's descendants.

Royalty and aristocracy

Princes and lords of the courts of Europe were often painted surrounded by their court and servants and engaged in some characteristic activity. In Italy, where painted frescoes frequently served as a cheaper substitute for tapestries, examples of these courtly scenes survive. The decorations of the Palazzo Schifanoia in Ferrara by Francesco del Cossa (see page 194) include portraits of Duke Borso d'Este with his attendants, and frescoes by Mantegna painted in Mantua in 1474 show Marquis Ludovico Gonzaga, together with his family, courtiers, and visitors to the court. From the sixteenth century artists were painting independent family portraits, such as Holbein's famous lost painting of Sir Thomas More and his family, known from preparatory drawings and later copies.

The need for pictorial interest, variety, and characterization often encouraged painters of group portraits to show the subjects within some sort of narrative context. In contrast to single portraits (and even most double portraits) such portraits often show the sitters in action, relating to one another to suggest hierarchies, allegiances, and divisions within the group. Nowhere is this more clearly seen than in the group portraits painted in northern Holland in the seventeenth century. The Dutch invented and developed the large-scale group portrait showing members of a guild, board of directors, or militia company (an armed civilian group which could be called upon in times of popular unrest). The earliest paintings of militia companies were produced in Amsterdam in the early sixteenth century and show ranks of heads and shoulders, occasionally grouped around a table. By the seventeenth century this type of picture had developed into animated scenes of feasting and parading, exemplified by Frans Hals's famous series of paintings of the Haarlem civic guard banquets, which are among the finest group portraits ever painted.

In Rembrandt's *The Nightwatch*, showing a similar company, the excitement and activity of the scene is even greater and threatens to swamp the individuals

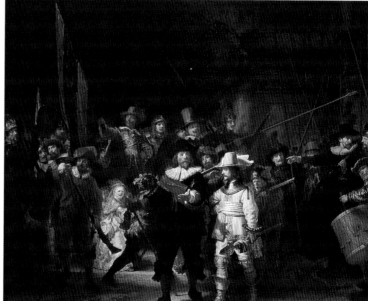

▲ Placement of figures

This painting, which is not a night scene – there are no lanterns – shows the militia company of Frans Banning Cocq, the red-sashed figure, seen with his lieutenant. Sixteen other members paid to have their portraits included. According to one of Rembrandt's pupils: "In the opinion of many he went too far, paying more attention to the overall subject . . . than to the individual portraits he was commissioned to do. However, this painting . . . will outlive all its competitors because it is . . . so ingenious in the varied placement of figures."
Rembrandt, *The Nightwatch*, 1642.

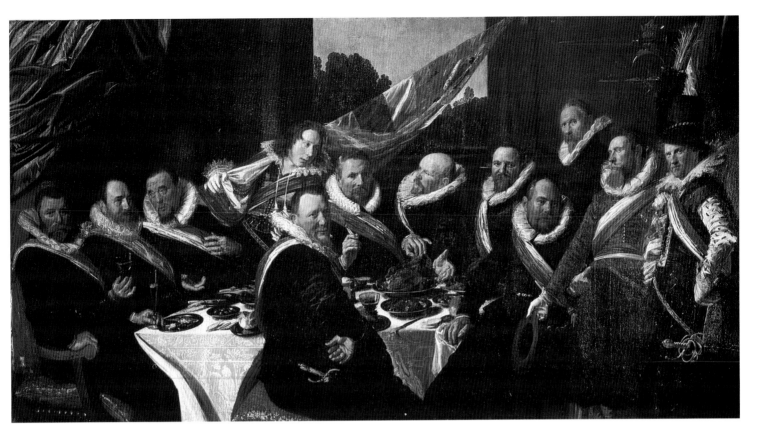

depicted. Indeed the painter was criticized by his contemporaries for sacrificing the requirements of portraiture to the overall conception in this picture. Conflict may well arise between an artist's desire to display his or her invention in a group portrait and the demands of the individual members of a group, each of whom will want to be recognizable, visible, and portrayed to their best advantage. But for many artists, Rembrandt no doubt included, it was in the opportunities for such invention that the appeal of group portraiture lay. In depicting a group in action or within a narrative context the portraitist could show himself equal in imagination and skill to the painter of "histories" – scenes from history, mythology, and the Bible – which from the sixteenth to the early nineteenth century were seen as the noblest and highest form of art.

Masterpiece of illusionism

One of the supreme achievements of Western art is a group portrait. Painted by Velázquez toward the end of his career in 1656, it is known today as *Las Meninas* ("the maids of honour"). This masterpiece of illusionism was described as "the theology of painting" by the Italian artist Luca Giordano when he saw it in the 1690s. The picture is both court scene and portrait and shows a visit of the young Spanish princess, surrounded by her maids, servants, and dwarfs, to Velázquez's studio in the Spanish royal palace. But it is also about the art of painting and the act of looking. Velázquez himself is on the left, apparently at work on a huge canvas. He scrutinizes us as if we were the subject of his painting, but on the rear wall we see in a mirror the dim reflections of King Philip IV and his queen. But if it is the royal couple that Velázquez is painting, then we, as the viewers, have somehow interposed ourselves between them and the scene that we are looking at. On the other hand, when the king and queen stood in front of *Las Meninas*, as they must have done, they would have felt that they were seeing themselves reflected in the mirror within the painting. These and similar conceits abound in this picture, and its influence has been immense. It was copied by, among many others, the American portraitist John Singer Sargent in 1879 and is echoed in the portrait he made three years later of the wealthy Bostonian Edward Darley Boit's daughters.

▲ **Individuals within a group**
Hals's great achievement was to give his group portraits such a natural and lively air that many critics have taken them to be a near-photographic record. In fact this work is a careful construction that both offers animated individual portraits and portrays the hierarchy within this Haarlem civic guard company, of which Hals was a member.
Frans Hals, *Banquet of the Jorisdoelen Officers at Haarlem*, 1616.

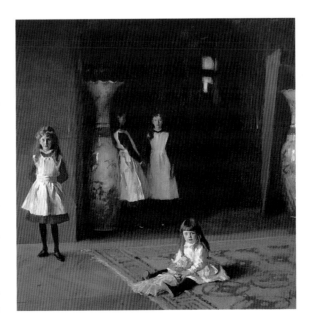

◄ **Growing apart**
Sargent's portrait shows the four daughters of the Darley Boits in their apartment in Paris. The composition owes much to Velázquez's *Las Meninas*. The nearly square format, the vertical strip on the left, the dark recesses of the background opening onto a small patch of light, and the principal focus of a small girl in spreading skirts are found in both pictures. Some critics have seen the painting as evoking a child passing from infancy to adolescence, equating this development with a retreat into darkness and introspection.
John Singer Sargent, *The Daughters of Edward Darley Boit*, 1882.

Ruler portraits

Kings, queens, and princes of the past needed portraits. A portrait let a ruler's subjects know what he or she looked like, and roving ambassadors often carried portraits of those whom they served. Dynastic allegiances with foreign powers caused royal families to be scattered throughout Europe, but portraits allowed relations to see what family members looked like or even what sort of health they were in. Catherine de Medici, Queen of France, wrote in 1548 to her children's governor: "I have received the pictures of my children which you had done for me . . . and see that they are much recovered since I saw them." When royal marriages were being negotiated, portraits of the prospective bride were often commissioned so that the man could gain an idea of what she looked like. Famously, Henry VIII of England had his court painter Hans Holbein paint portraits of two of his prospective wives, Christina of Denmark and Anne of Cleves.

Portraits are seldom neutral likenesses. The image they present is often revealing and for this reason leaders have long recognized the importance of controlling what they show. A ruler's public persona is important and so "official likenesses" were often the source of all subsidiary images. Rulers might also restrict themselves to a single portraitist, as Philip IV of Spain did with Velázquez (see page 163). In the era of mechanical reproduction an official image could be reproduced by the thousand: we cannot now escape Gilbert Stuart's portrait of George Washington, which is perhaps the most reproduced likeness in history – even though his wife felt it did not look like him.

Propaganda

Ruler portraits often do more than merely present an official likeness: they can also be used as propaganda to promote an image that emphasizes such virtues as wisdom, majesty, and military prowess. Ironically, one of the earliest and most imposing royal portraits, a much damaged and restored painting of King Richard II of England, shows a monarch whose authority was far from secure and who was put to death a few years after it was painted.

Richard II's portrait harks back to earlier royal and imperial portraits (see page 138). The portraitists of kings, emperors, and, more recently, presidents have been able to call upon a rich iconography of ruler portraits to suggest continuity or comparisons with great rulers of the past. When the Venetian artist Titian painted his huge portrait of the Holy Roman Emperor Charles V on horseback, in 1548, he was consciously recalling a tradition of imperial equestrian portraiture that went back to the famous statue of the Roman Emperor Marcus Aurelius on the Capitol in Rome.

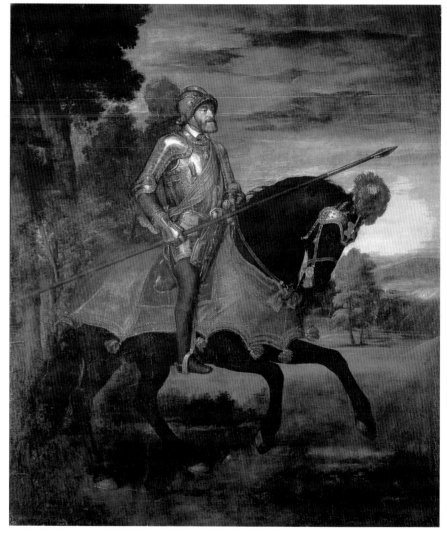

▲ **Imperial power**
In adopting the form of the imperial equestrian portrait Titian clearly wished to suggest that Charles V was reviving the glories of the Roman Empire. The allusions to the Classical past also included the spear, which was not the short weapon carried by Charles but a long one of the type favoured by the Roman emperors. But Charles was also a Catholic Emperor and he appears as a Christian warrior, wearing the armour in which he fought at the Battle of Mühlberg in 1547, his greatest victory over the German Protestant princes.
Titian, *The Emperor Charles V on Horseback at Mühlberg*, 1548.

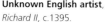

▶ **Royal insignia**
This portrait of King Richard II of England was possibly painted to be placed on the back of the king's pew in Westminster Abbey, London. It is one of three exceptional images of the king that survive from his reign; the other two are the effigy of his tomb, also in Westminster Abbey, and the Wilton Diptych. In all three portraits care was taken to capture the details of his appearance, but this one emphasizes kingship: Richard is surrounded with royal symbols and attributes such as his crown, orb, sceptre, throne, and robes.
Unknown English artist, *Richard II*, c.1395.

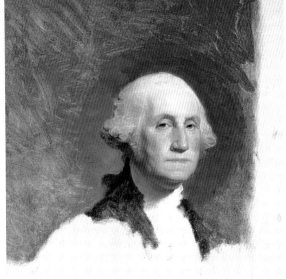

Stuart painted this portrait for Mrs Washington, but kept it in his studio to act as the model for seventy-two of his later likenesses. It became the most repeated of all portraits of the President and its presence on the one-dollar bill makes it the embodiment of Washington in the popular imagination.
Gilbert Stuart, *George Washington (the "Athenaeum Washington Original")*, 1796.

▲ **Idealized image**
This is the original version of the French painter David's portrait of Napoleon, commissioned by King Charles IV of Spain. So successful was the picture that David and his studio were to produce four other versions of it over the next three years. Napoleon is shown calm and masterful on his wild steed as he points the way forward over the Alps. The painting is an elaborate fiction: Napoleon crossed the perilous Mont Saint Bernard on a mule and did not accompany his troops but followed them some days later. The artist was not aiming for historical accuracy, but painted instead an idealized vision of an idealized leader.
Jacques-Louis David, *Bonaparte Crossing the Alps*, 1800–1.

Titian's painting initiated the entire genre of the equestrian ruler portrait in European painting. Two hundred and fifty years later the form was used to dazzling effect and clear propaganda purposes by Jacques-Louis David in his *Bonaparte Crossing the Alps*. Ostensibly David shows Napoleon as a great military leader whose bold decision to cross central Europe's Alps led to victory against the Austrians at Marengo. But as clear as the painting's military import are its imperial associations: Bonaparte's name joins those of Hannibal and Charlemagne (Carolus Magnus) carved on the rocks beneath the horse's feet. Napoleon's horse itself was borrowed from another imperial image, Falconet's statue of the Russian Emperor Peter the Great. Napoleon was not yet emperor, nor even First Consul of France, but the picture was part of his campaign for recognition. David's portrait was painted for Spain's royal palace, where – it is no coincidence – Titian's painting of Charles V also hung.

Informality

Rulers have not always presented themselves in such overbearing ways, nor has every royal portrait been conceived with propagandistic intent. More informal portraits of royal families exist from the eighteenth century as a result of the development of the "conversation piece" (see page 158). This form recalls early group portraits showing princes and their courts hunting and indulging in other pursuits of the nobility. Hunting as a

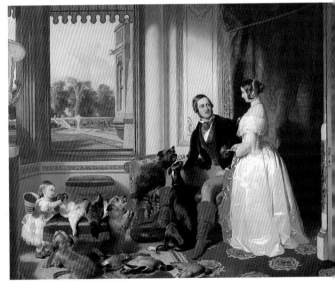

▲ **At home**
Landseer, one of Queen Victoria's favourite artists, came to her court as an animal painter. In this scene, set in the Green Drawing Room at Windsor Castle, he contrasts Prince Albert's outdoor, masculine pursuits with the feminine virtues of the home. The Queen holds a posy and stares lovingly at her daughter, the one-year-old Victoria.
Edwin Landseer, *Windsor Castle in Modern Times*, 1840–5.

pastime for princes appears in Edwin Landseer's *Windsor Castle in Modern Times*, where Prince Albert is surrounded by his favourite dogs, and dead birds are scattered somewhat incongruously about the drawing room. Albert sits while Queen Victoria stands, the only hint as to her more elevated status. Although Victoria certainly exploited the idea of the royal family as a model of domestic virtue, Landseer's painting was not intended for the public's eyes but was hung in the sitting room at Windsor, where, the Queen remarked, it looked "altogether very cheerful and pleasing."

Swagger portraits

One of the main impulses behind the commissioning of portraits has always been ostentation. While many portraits are private statements intended to address a single viewer – for example, an absent friend or a loved one – many more are directed at a larger public, painted to dominate the room and to address a crowd. Few types of portrait proclaim a sitter's grandeur, glamour, and superiority to greater effect than the life-size, full-length "swagger" portrait. As well as seizing the attention, the very scale of such portraits calls for a grand setting: they are for the public rooms of palaces and stately homes, not for the bedroom or study.

The grand full-length was often used to portray royalty and other powerful figures because the main purpose of this portraiture of display was political, to reinforce the status quo. But it is not only royalty who wish to believe themselves exalted. The titled and the moneyed are equally likely to want to present themselves to the best effect even if such images can mislead. In fact swagger portraits may deceive deliberately: contrary to appearances, Gainsborough's famous "Blue Boy" portrays the son of an ironmonger.

Full-length portraits almost inevitably suggest superiority. Once a figure on the "scale of life" is hung upon a wall we are forced to look up at that person and this necessity is often exploited by the artist. It is true that when we look at the faces in each of the portraits on this page we appear to meet them eye to eye, but if we look to the background it is clear that the artist has

▼ **Grandeur**
Rigaud was one of the foremost French painters during the reign of Louis XIV of France. This encapsulation of regal grandeur and majesty in pose, dress, and attributes brought representatives of almost all the ruling houses of Europe to Rigaud's studio to have themselves similarly immortalized. While the painting presents an idealized image of kingship, the swagger of the pose is tempered, if not undermined, by the intense individualization of Louis' features beneath his full-bottomed wig.
Hyacinthe Rigaud, *Louis XIV in Royal Costume*, 1701.

◄ **Passion tamed**
Van Dyck shows Henrietta Maria, queen to Charles I of England, in an informal hunting dress, but alludes to her royal status through the crown on the ledge. The dwarf, Sir Jeffrey Hudson, was served to her in a pie, and became one of her favourites. The monkey may symbolize lust and Henrietta Maria's gesture her control of such passions.
Anthony Van Dyck, *Queen Henrietta Maria with Sir Jeffrey Hudson*, 1633.

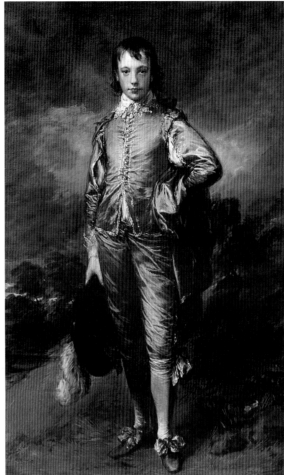

▲ **Elegant movement**
The American portraitist Gilbert
Stuart is most famous as the
portraitist of George Washington
(see page 155), but this is the
painting that made his name.
It was painted in London and
shows the wealthy Scottish
lawyer William Grant. According
to one colourful account Grant
arrived for a sitting one winter's
day complaining that the weather
was much better suited to
skating than to posing for a
portrait. Stuart agreed and their
morning's sport provided the
inspiration for this pose. The
scene is the Serpentine lake in
Kensington Gardens, and the
picture shows Stuart, in his first
full-length portrait, imaginatively
reworking the tradition to depict
action.
Gilbert Stuart, *The Skater,
Portrait of William Grant*, 1782.

placed our eye level well below that of the sitter. We are
at about the level of King Louis XIV's waist in Rigaud's
portrait and just above William Grant's knee as he
skates toward us in Stuart's painting.

Van Dyck

The earliest surviving independent, life-size, full-length
portraits date from the sixteenth century and were
painted by artists such as Lucas Cranach the Elder,
Holbein, Titian, and the Netherlandish portraitist
Anthonis Mor. But it was in the seventeenth century,
with the paintings of Anthony Van Dyck, that the grand
full-length swagger portrait found its greatest master.
Van Dyck adopted and adapted many of the formulas of
his predecessors. The majority of the poses he gave
his sitters derived from such artists as Titian and Mor,
but he managed to imbue them with a languid grace or
elegant dash that was new to portraiture. He also
exploited the glamour of dress to the full, as in his
portrait of Queen Henrietta Maria. His painting of the
texture and sheen of fabrics is often miraculous and
relies on the viewer stepping away from the canvas to
achieve its full effect – itself a way to ensure that view-
ers maintain a respectful distance from his grand sitters.

Van Dyck's influence on European portraiture
was immense. It made itself felt most keenly in
eighteenth-century England, where many portraits were
painted of figures in "Van Dyck" costume and poses, in

an attempt to claim for the sitter the splendour of a
bygone age. Gainsborough's *Jonathan Buttall ("The
Blue Boy")* – in which the artist's virtuoso rendition of
silk is as miraculous as that of his predecessor – is the
most famous example of this trend, although in this
case it seems that the portrait was painted for the
artist's pleasure rather than commissioned.

It was not only in England that Van Dyck's
influence was felt. Rigaud's fantastically grand portrait
of Louis XIV, for example, borrows its pose from Van
Dyck's painting of Charles I as a hunter which is in
the Louvre, with the familiar hand on hip and elbow
thrusting toward us. But while Van Dyck shows Charles
dressed for the hunt, Rigaud exploits every aspect of
his subject's clothing to enhance the majesty and
grandeur of the "Sun King." Swathes of ermine and
cloth embroidered with fleurs-de-lis drape the monarch,
except where they are drawn apart to reveal elegant
royal legs balancing on a pair of red-heeled shoes. The
effect may now seem somewhat ridiculous, but it was
always intended to be theatrical. This sense of "show"
is present in many grand full-lengths, where dress is
often "fancy" and curtains billow or clouds blow
around the sitter. Indeed the wind often blows in
swagger portraits, to add dash and verve. In Gilbert
Stuart's portrait of William Grant, a breeze lifts a corner
of the skater's coat and a lock of his hair, to suggest a
figure both elegant and full of vitality and purpose.

Intimate images

▲ **Family reunion**
Born in Boston, Copley was the leading portraitist in colonial America but moved to England in 1774 to escape the impending Revolution. The portrait shows him – standing at the rear – with his wife Susanna, their children, and his father-in-law, Richard Clarke. Painted to mark the family's reunion in London, it celebrates mutual affection, particularly in the group around Susanna, which may have been based on images of the Madonna and Child seen by Copley in Italy. It was also the painter's intention to announce his arrival in a new marketplace, and the picture was exhibited at the Royal Academy in the year it was painted.
John Singleton Copley, *The Copley Family*, 1776–7.

Full-length portraits in the grand manner are by definition ostentatious, portraying power and importance. Other forms of portraiture exploit the informal and domestic to suggest different virtues. The "conversation piece" emerged in England in the eighteenth century. A fine example is Johann Zoffany's portrait of the Bradshaw family, in which every member is engaged in some form of domestic or recreational activity, giving an impression of an informal group captured in everyday pursuits. But, as so often in the conversation piece, the portrait is altogether more considered than it may at first appear. Thomas Bradshaw is clearly presented as the head of the family, at the apex of the composition and at the top of an insistent diagonal made by the three heads on his right. Even the kite being flown by his son Barrington, on the left, is not entirely carefree in its associations. The artist perhaps suggests that, just as kites can only fly when restrained by their strings, so children will flourish only if they are denied free rein.

Although conversation pieces were domestic in subject and often painted on a domestic scale, many were nevertheless intended as public statements, presenting an ideal of harmonious family life or companionship to the wider world. These intimate virtues could also be celebrated on the grand scale: when the American portraitist John Singleton Copley painted his own family in 1776 he chose a canvas over two metres wide on which to portray an ideal of family love

Public and private

The sense of intimacy generated between a portrait and its viewer is often dictated by scale rather than appearance. A portrait miniature, for example, can only be studied by one person at a time and at close quarters. But not every large-scale portrait is a public image. Whether a portrait is "private" or "public" is often difficult to judge, for what it looks like now is less important than the way in which it was once looked at. Velázquez's late portraits of Philip IV (see page 163) seem to be personal images of an ageing man but were in fact the official and much-reproduced likenesses of one of Europe's most powerful rulers. In contrast, Raphael's portrait of Baldassare Castiglione (see page 142), although one of the most famous and most reproduced portraits of the Renaissance, was apparently used to console the sitter's wife when alone. Nor was it the only portrait to do so; for Leonardo da Vinci, one of the principal goals of the portraitist was to "place the true image of the beloved before the lover, who often kisses it and speaks to it."

Some portraits reflect and explore the relationship between the painter and the sitter rather than that between sitter and viewer. This is clearest in artists'

▲ **The artist's son**
Although Rembrandt painted him on numerous occasions and in many guises, Titus remains a shadowy figure, appearing in documents as a dutiful son working for his father. He appears to have trained as a painter but no paintings survive, and he died while still a young man the year before his father. To learn about Titus we must turn to the portraits, but they are ambiguous and this one is no exception. Titus, familiar from his golden curls, appears younger than the thirteen or fourteen he was when the picture was painted, and Rembrandt may have painted it from memory, perhaps recalling a moment he once witnessed or a familiar attitude.
Rembrandt, *Portrait of Titus at his Desk*, 1655.

◄ **Conversation piece**
Johann Zoffany, a German artist who spent most of his working life in England, is best known for his "conversation pieces" of wealthy and aristocratic English patrons, among them the royal family. He was not the inventor of the conversation piece – artists such as Philip Mercier and William Hogarth preceded him – but he was one of its principal exponents. In its careful construction and meticulous attention to the details of dress, this example is typical of his work. It shows the wealthy and distinguished Thomas Bradshaw, who was to become First Lord of the Admiralty a few years later, with his wife, sister, and children. Bradshaw's eldest son, Robert, on the right, adopts a suitably aristocratic pose with his arm resting on a horse.
Johann Zoffany, *The Bradshaw Family*, 1769.

informal portraits of their own families, uncommissioned works executed for the artist's benefit out of love, rather than to present the sitter to a broader public. Few artists have painted their loved ones with more frequency and intensity than Rembrandt. Although he often used members of his family as models for his paintings of biblical and mythological scenes and characterful heads, at other times he painted and drew them as themselves. He appears to have done so in the beautiful portrait of his son Titus, thumb on chin as he pauses in his writing. But even here the intimacy between sitter and artist may be more apparent than real. Some commentators believe that the picture was less a portrait than a study of melancholy thoughtfulness, intended for sale on the open market as a characterful but anonymous head.

Friends and family

Since the early twentieth century, the importance placed upon subjective experience has led many artists to find subjects in their immediate surroundings and private lives. Contemporary portraits are typically painted because the artist chooses to do so rather than at the request of the sitter. In the twentieth century, more than ever before, painters portrayed friends, as in Modigliani's study of Soutine (see page 141), or on the family, as in David Hockney's portrait of his parents (see page 151). The British painter Lucian Freud – one of the greatest portraitists of the second half of the twentieth century – has explored his relationship with his mother in a string of pictures painted over several years.

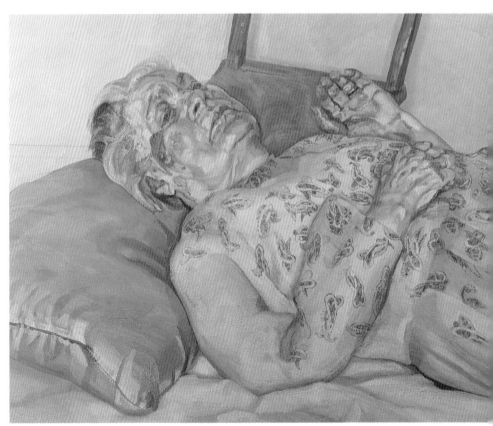

▲ **A mother's image**
Lucian Freud painted his mother Lucie many times in the 1970s after she was widowed. Here, as so often, posed on a bed in his studio, she adopts a pose that almost seems one of blessing; indeed she has been likened in this portrait to "an idol reverently laid flat for packing as a treasured masterpiece." If this was Freud's intention, reverence for his mother is combined with a tender familiarity, apparent in his intense concentration on her blotched and ageing features.
Lucian Freud, *The Painter's Mother Resting III*, 1977.

Abstract portraits

The aims of portraiture and the means by which they were achieved remained remarkably constant until the end of the nineteenth century. Fashions changed, but none appeared that altered either the essentials of portraiture or the assumption that a portrait's principal purpose was to communicate the appearance – however tempered by flattery and idealization – and the personality of the sitter.

In the closing decades of the nineteenth century, however, the priorities of portraiture underwent a dramatic change, due largely to the invention of photography. This new medium had a profound impact on all branches of painting, but it was most keenly felt in portraiture, where many of the roles once filled by the painted portrait were almost instantly usurped by the photograph. Today no one would dream of commissioning a painter if they wanted to discover what someone looked like; we carry photographs, not painted miniatures, of our family and loved ones, and it is through photographs that leaders and celebrities project their images to the public. In fact most people, if called upon to list the great portraitists of the twentieth century, would think of photographers before painters.

Toward abstraction

Portraitists met the challenge presented by photography in many ways. One of the main responses was to play down painting's representational role and emphasize instead its formal, compositional qualities. This approach is encapsulated in the provocative title, *Arrangement in Grey and Black*, that the American painter Whistler gave to his famous portrait of his mother when he exhibited it at the Royal Academy in London in 1871. The title suggested that the interest and importance of the picture lay in the disposition of tones and colours rather than in the sitter. In other words, it was a painting first and a portrait second.

This emphasis on design and pattern became increasingly prevalent toward the end of the nineteenth century and is particularly well illustrated by the Art Nouveau movement. In the portraits by the Viennese artist Gustav Klimt, the sitters are often nearly swamped by the extravagant, almost abstract, designs of their clothes and the background. But while Whistler and Klimt may have claimed that their priorities lay more in formal, abstract qualities than in the desire to portray their sitters, both produced images that were powerful and recognizable likenesses.

The decisive break between portraiture and representation took place in the early years of the twentieth century with the portraits of Matisse and Picasso. Picasso's cubist portrait of one of his dealers, Henry Kahnweiler, clearly does not represent the sitter

▲ **Golden mosaic**
This masterpiece of Klimt's "golden style," influenced by mosaics he had seen in Ravenna, Italy, portrays the wife of the industrialist Ferdinand Bloch-Bauer, one of his main patrons, and is the first of two studies of the sitter. Adele emerges from a plethora of geometric shapes and swirls, some of which contain the letter B for Bloch-Bauer. Although seemingly abstract, these shapes describe the dress, armchair, and cushions, and there is even a glimpse through the window of the green world outside.
Gustav Klimt, *Adele Bloch-Bauer I*, 1907.

▲ **Tonal arrangement**
Whistler's portrait was praised less as an "arrangement of grey and black" than for its "powerful grasp of the Protestant character," while stories about Anna Matilda McNeill's relationship with her son attached themselves to the work. Whistler, however, dismissed the notion of a picture's "dramatic or legendary or local interest."
James Abbott McNeill Whistler, *Arrangement in Grey and Black: Portrait of the Painter's Mother*, 1871.

in a literal way. The aim of Cubism was not to reproduce visual reality but to record a response to an object – whether still life, landscape, or individual – that was developed over time and was both visual, in reflecting different angles of vision, and intellectual. What was important was not the sitter as he appeared to the world but the painter's conception of him. Kahnweiler likened the process to that of poetry, quoting the French nineteenth-century poet Mallarmé, who claimed that his poetic goal was "to describe not the thing itself but the effect it produces." Once photography had freed painters from the obligation to create a likeness, they could abstract the portrait in a variety of ways. For example, throughout his career Picasso adopted different strategies of distortion to communicate his feelings toward his sitters.

A changing balance of power

In order for the artist's subjective response to be considered the most important aspect of a portrait, it was necessary for a change to occur in the circumstances in which portraits were made. In previous centuries the relationship between sitter and artist had been dominated by the sitter: it was the sitter (or the person commissioning the portrait) who dictated how the sitter was represented, and it was the sitter's self-image that the portraitist was employed to convey. But when artists, represented by dealers, began to paint almost exclusively for the open market, portrait commissions gradually became less important to their financial survival. Since the late nineteenth century artists have been increasingly able to choose whom they paint. (Picasso's portraits were almost all of his friends, wives, lovers, and children.) Today when someone commissions a portrait from a leading artist he or she usually does so on the understanding that he or she will submit uncomplainingly to the artist's vision.

Abstraction in portraiture – which results from the imposition of the artist's own personal vision on the sitter – has many sources, but it always depends on the artist being seen as the more powerful partner in the transaction. However, when looking at portraits it is as well to remember how recent such a view is. Today we may remember Mona Lisa only because she was painted by Leonardo, and Mr and Mrs Andrews simply because they had the foresight to ask Gainsborough to portray them, but at the time they would have had no doubt that it was they who were calling the shots.

◢ Shattered image
It is perhaps surprising that in the early stages of Cubism Picasso should have turned to portraiture. Nevertheless, this is one of three great portraits he produced in 1910. It is almost as if he was testing how abstract he could make his images while still retaining a resemblance to the sitter. Here, despite the complex and deliberately confusing construction of the painting, Kahnweiler is still recognizable, Picasso's skill as a caricaturist allowing him to summarize the features he later summed up as "the wave in the hair, an earlobe, and the clasped hands."
Pablo Picasso, *Daniel-Henry Kahnweiler*, 1910.

◢ A personal response
This is one of many portraits Picasso made of Dora Maar, an artist and, in the 1930s and 40s, his mistress. In nearly all of these Maar's face is wildly distorted even if her rounded features and dark arched eyebrows usually make her recognizable. Often, as here, Picasso seems to adopt more than one viewpoint – we see one eye in profile while the other stares straight out at us. But the intention here, in contrast to his angular and fragmented Cubist images, seems to be to impart mood, the soft contours and limpid eyes suggesting tenderness.
Pablo Picasso, *Dora Maar Seated*, 1937.

The passage of time

Portraits have many aims and uses, but their main function has always been commemorative. A portrait preserves a likeness that endures after the sitter is long gone. Indeed a portrait may be painted after the sitter's death. In both Ghirlandaio's *Portrait of an Old Man with a Young Boy* and Hogarth's *The Graham Children* one of the sitters was painted after his death. Portraits are always painted with the future in mind, although the future envisaged by the painter, and the person who commissions such a picture, may be generations hence – or it may be more immediate.

We now rely on photographs to show us what we looked like at different stages in our lives, but for centuries portraits fulfilled this role. Artists often displayed the date of the painting or the ages of the sitters prominently in them, as Holbein did in *The Ambassadors*.

Portraits were also often painted to commemorate particular moments, such as marriage (see page 150, Lorenzo Lotto, *Marsilio Cassotti and his Bride Faustina*) or professional promotion.

The very act of preservation performed by a portrait brings to mind what the picture is not able to preserve. In Oscar Wilde's classic tale it is the portrait of Dorian Gray that ages while the man himself remains unaffected by time and experience, but in real life we know that the opposite is true. Portraits themselves often hint at the relentless passage of time by including symbols of transience and mortality such as skulls and hourglasses. At the same time they remind us of their own ultimate futility. To preserve someone's outward appearance, they suggest, is to preserve nothing but an image: the portrait itself, like the person depicted, will eventually fade and crumble.

▷ Time and mortality

The portrait shows, on the left, Jean de Dinteville, French ambassador to the court of Henry VIII of England, and his friend George de Selve, Bishop of Lavaur. The objects between them point to their learning and accomplishments, but they also suggest the futility of such achievements, the inexorable passing of time, and the sitters' mortality. The object at the bottom of the painting is a skull – the ultimate reminder of death – distorted so that it can be seen correctly only when looked at from the right of the picture.
Hans Holbein the Younger, *The Ambassadors*, 1533.

▷ Vanity

In this work by the little-known Dutch painter David Bailly we see the familiar symbols of life's transience, such as a skull and an extinguished candle. The picture is a self-portrait and shows Bailly as a young artist (identified as such by his mahlstick) holding a picture of himself painted twenty years later.
David Bailly, *Vanitas Still Life with a Portrait of a Young Painter*, 1651.

▽ Generations

The coupling of an old man with a child suggests both the ageing process and the passing of time. Where the two people are related, as they almost certainly are here, we are also reminded of the continuity of families. The ideas of continuity and inheritance may have been central to the purpose of this portrait, for the old man was dead when it was made. The Florentine artist Ghirlandaio recorded the man's nose, disfigured by disease, preserving as accurately as possible the appearance of a now-dead, but – if we believe the evidence of the painting – much-loved relative.
Domenico Ghirlandaio, *Portrait of an Old Man with a Young Boy*, c.1490.

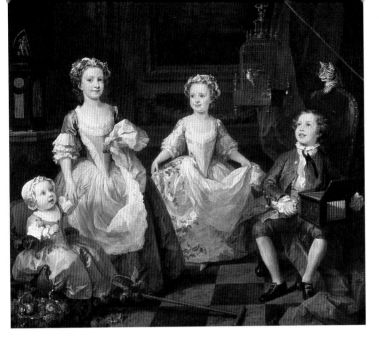

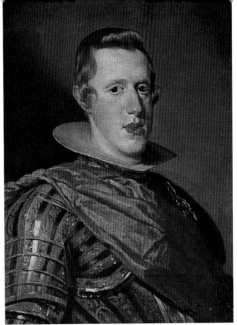

◀ An ageing face
An ageing face
Velázquez's portraits of Philip IV of Spain (1605–65) provide one of the rare instances where we can watch a single figure age over a sustained period through the eyes of a single artist. It is more often possible in self-portraiture, as in the case with Rembrandt (see page 148, *Self-Portrait with Beret and Turned-up Collar*). Velázquez established himself at the Spanish court in 1623 and was to paint the king over the following thirty-four years. The three portraits here show the king as a nineteen-year-old; dressed as a hunter, in his late twenties; and finally at about fifty. They are restrained for royal portraits and concentrate on the sitter's features, which they treat with remarkably little flattery. This was probably on Philip's insistence. He seems to have been particularly concerned about accuracy in royal portraiture, writing in the 1630s: "It is not suitable that portraits be made, sold, and displayed in public which are not well made and like the person represented." This unflinching approach had its drawbacks, however, which it is clear that the king also recognized. A letter from the end of his life states that he did not wish to be painted again, because of his age.
Diego Velázquez, *Philip IV in Armour*, 1624; *Philip IV as a Hunter*, 1632–3; *Philip IV*, 1652–5.

△ Death in infancy
In the bottom-left corner sits a basket of fruit and flowers which, like the fresh-faced children, will wrinkle and wither all too soon. Such messages were all too pertinent when child mortality rates were high, and indeed the baby, Thomas (a boy despite his skirts), died before the picture was completed. In response Hogarth placed a clock above him surmounted by a small figure of Cupid holding a scythe – a symbol of death.
William Hogarth, *The Graham Children*, 1742.

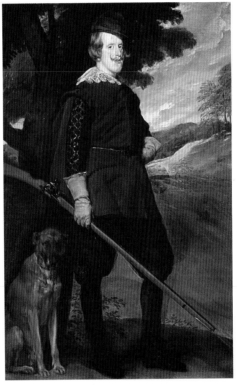

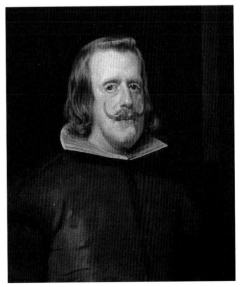

△ Agelessness
The French nineteenth-century painter Ingres deliberately idealized this sitter's features. Her face shows no sign of age. But this generalized vision also reflects the circumstances in which the picture was made. Ingres worked on it for twelve years, during which time the wealthy banker's wife aged from twenty-three to thirty-five. Here she is literally ageless.
Jean-Auguste-Dominique Ingres, *Madame Moitessier*, 1856.

George Inness, "A painter on painting,"
Harper's New Monthly Magazine, 56, February 1878

Landscape

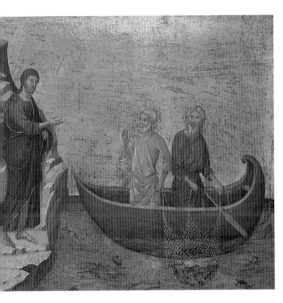

The origins of landscape painting in the post-Classical Western tradition lie in religious imagery. In medieval art certain biblical subjects, such as the Garden of Eden or the Sea of Galilee, demanded at least a cursory landscape setting. In the fifteenth century these settings became increasingly descriptive of the physical world and assumed ever greater significance. In 1521 the German artist Albrecht Dürer noted that the Fleming Joachim Patenier was a good "landscape painter," and around the same time the writer on art Marcantonio Michiel used the word "landscape" of the Venetian artist Giorgione's *The Tempest* (see page 182). Both were referring to the paintings themselves, but "landscape" also means the scene represented. Whether the term describes a painting or the land itself, it always implies a human viewer. Even when no one is present in a landscape painting, the work has been and is to be understood in terms of human existence.

Constructing the world

Landscape paintings reflect attitudes toward the natural world and humankind's place in it. The recording of the material world is never wholly objective or neutral. Until the end of the eighteenth century these works of art were painted in the studio, even if from the fifteenth century artists had sketched out of doors from nature for the purposes of private study. Landscape paintings can honour and celebrate the physical appearance of the natural environment in a variety of ways. In the eighteenth century the awe-inspiring forces of nature were prized as "sublime" (see page 189). By contrast, depictions of cultivated land suggest a more ordered relationship between man and nature. They may demonstrate changes to the countryside made by humans, such as fortifications, buildings, and towns, as well as its division by roads and boundaries. Although paintings of such features may challenge, they more often support claims to ownership of the countryside, reinforcing property rights, and suggest appropriate ways of living on and from the land. In Gainsborough's *The Watering Place*, the view reveals much about a particular estate, but it also conceals a great deal about the processes and social structures that have gone into making such a pleasant rural environment. More recently the scenic view has been used to warn of ecological disaster.

In attempting to depict space and the fleeting effects of light and atmosphere, landscape painters have used certain conventions, including the device of a strong foreground motif to give a sense of recession into space and the framing of views with trees or buildings. Tonal bands of brown to indicate the foreground, then green, and then blue for the distance are often used to create a sense of spacial depth in what is called aerial perspective. Winding features, such as paths and rivers, are also often made to recede, linking the foreground to the background. Many artists have made use of the extensive landscape, where the viewer, adopting an often impossibly high viewpoint, is made to look down onto land that stretches back to a distant horizon beneath cloud-filled skies. This compositional device structured the world views of Patenier (see page 168, *St Jerome in the Desert*), but it was also used

► Understanding nature
The German artist Dürer's
watercolour depicts the
Italian hilltop town of
Arco. Such a recording of
an actual site was a new
phenomenon. In exploring
the physical world's
structure, Dürer shows how
the natural and the man-
made have been combined.
He still, though, omits the
mountains that flank the
town and so makes the
citadel more imposing.
Albrecht Dürer, *View of
the Arco Valley*, 1495.

◄ Land and morality
Ruisdael was the greatest
Dutch landscape painter of
the seventeenth century.
Here massive clouds hang
majestically above his
native Haarlem, with their
lights and darks being
reflected in the land below.
Haarlem was noted for its
linen, a major source of its
prosperity. By depicting
linen being bleached in the
surrounding fields, Ruisdael
shows how the land has
been put to good use. He
may also be suggesting
that moral purity is to be
found there too.
Jacob van Ruisdael,
*View of Haarlem from
the North-west with the
Bleaching Fields in the
Foreground*, c.1670.

▲ Bucolic contentment
As cows slake their thirst in the waters of a gentle stream, Gainsborough shows nature as abundant and calm. The open, freely flowing brushstrokes imitate Rubens's earlier

by Jacob van Ruisdael and, in the late twentieth century, by the Canadian artist Jeff Wall.

Landscape paintings became very popular in the Netherlands in the seventeent century, when the emergence of a new mercantile art-buying public encouraged the development of many kinds of painting and led artists to specialize in certain genres. An explanation of the appeal of landscape views is suggested by Claes. Jansz. Visscher, one of the most important publishers of prints, maps, and topographical views in Amsterdam during the first half of that century. In the text accompanying eleven small etched views of the scenery around Haarlem he noted that they gave a quick look at pleasant places for art lovers with no time to travel. Landscape paintings were an urban commodity, bought to be viewed indoors. They allowed the dramatic effects of storms, rain, and snow to be contemplated in the comfort of the home and gave access to places that might otherwise have remained unknown.

Landscape with a Rainbow (see page 172), which the English painter admired. This glowing view of rustic well-being is essentially nostalgic. At the time when Gainsborough painted this picture,

common land in England was being enclosed and taken away from the rural poor who had used it and depended on it.
Thomas Gainsborough, *The Watering Place*, 1774–7.

(see page 172)

▼ Variations
Monet painted a series of wheatstacks in 1890–91, showing them at different times of the day and in different seasons, lights, and atmospheres. He was interested in capturing the landscape's variability and the sensations that this prompted. There is a long tradition of painting

wheatstacks or grainstacks as symbols of the land's prosperity, and their roof-like shapes also suggest shelter and protection. While this Impressionist painting does not exemplify this tradition, it still depends to some extent upon it.
Claude Monet, *Wheatstacks, Snow Effect, Morning*, 1891.

▲ Cinematic instant
Jeff Wall's image is a conventional landscape in that we look across land to a far horizon below an expanse of sky, the canal recedes, colours merge into a pale distance, and a large tree links foreground to background. But, in a reference to the Japanese artist Hokusai's print *A High Wind in Yeijiri* (c. 1831–3),

sheets of paper blow about, suggesting the randomness of nuclear fallout. The medium of photography gives the incident instantaneity and cinematic coolness. The work both celebrates and subverts the beauty and nostalgia of much traditional landscape painting.
Jeff Wall, *A Sudden Gust of Wind (after Hokusai)*, 1993.

Ideal and sacred places
The landscape painting also permits an environment that has been lost, or even one that has never existed, to be evoked. In such idealized views of nature the town tends to be contrasted with the less tainted surroundings of the natural world. The landscape artist may even seek to imitate divine creative powers, conferring sacred significance on a location so that it may be seen as the material expression of a non-physical, spiritual world, or indeed of God.

God in nature

Certain events in the Bible have subjects that depend on a landscape setting. Since medieval times episodes such as Adam and Eve in the Garden of Eden, the Baptism of Christ in the waters of the Jordan, or the Rest on the Flight into Egypt (see page 45) have been depicted in religious paintings in settings that evoke the untarnished beauties of nature. But the natural world may also be seen as God's creation, suggesting his presence in less explicit ways. In Protestant lands, especially during the seventeenth and nineteenth centuries, depictions of the observed world were often intended to denote the presence of the divine.

In religious paintings of the Renaissance, both north and south of the European Alps, biblical events are usually set in local scenery rather than that of the Middle East. The inclusion of local detail was not accidental, but served to bring the stories into the present and to make the presence of God more immediate. In *The Baptism of Christ* the Flemish painter Gerard David transposed the waters of the Jordan into a green valley bounded by coniferous trees and the verdant flora we associate with mainland Europe. Similarly, the figures wear clothes that would have been familiar to the painting's earliest viewers. God himself appears in the skies, as he usually does when he is depicted as a figure in biblical paintings. Suffused with an ethereal atmosphere, the seemingly infinite expanses above us become as one with the heavens. Mountains, too, reach up to the skies and, by association, heavenward. In *St Jerome in the Desert* by the Flemish landscape specialist Joachim Patenier, it is in the mountains that the hermit seeks spiritual consolation. The artist probably intended this landscape to be viewed symbolically: the steep way to salvation – the rocky, winding path leading to the saint's monastery on the right – contrasts with the distractions of the lush contemporary Flemish landscape stretching away to the left.

Worship of the out-of-doors

Coming to the fore in the early nineteenth century, particularly in America and Germany, where there was a strong Protestant heritage, a related tradition of God in nature shows God not as a physical figure in a landscape but as existing in the beauties of his creation. For these artists the deciphering of nature as a visible sign of the invisible powers and mysteries of the divine becomes a pathway to possible salvation. However, because it is possible to look at almost any landscape as a depiction of God's creation, one cannot always be sure whether this was the artist's intention. In those paintings where we are clearly meant to merge the worship of nature with the worship of God, the landscape painter often makes emphatic use of light. In his painting *Cross in the Mountains* the German artist Caspar David Friedrich silhouettes the figure of Christ on the Cross against an unnaturalistic radiance and in

▼ **Mappa Mundi**
The composition of this landscape allows us to contrast what the penitent has chosen to reject with what he has chosen to accept. Even though St Jerome lived in the Syrian desert in the fourth century, it is the landscape of sixteenth-century Flanders that we see on the left, while on the right Patenier shows a monastery with the late-Gothic architecture of his day. The saint is cut off from both these sights in a crude hut. He kneels before a crucifix, in a pose of devotion and holds a stone with which to chastise himself.
Joachim Patenier, *St Jerome in the Desert*, c.1525.

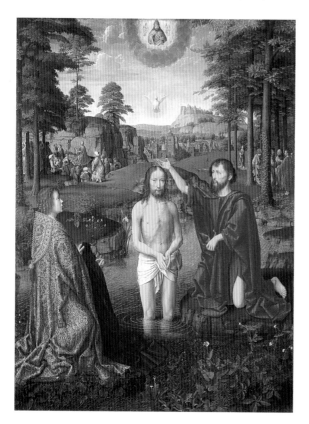

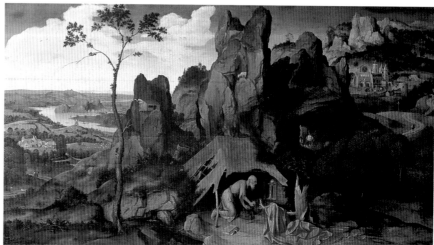

◄ **The blessed**
The Bible tells us that when Christ was baptized the Holy Spirit was seen to descend from Heaven in the form of a dove. Here Christ's grave appearance is matched, above the bird, by the figure of God the Father in Heaven, surrounded by wingless angels, and in the act of blessing. Thus the naturalistic setting below is also being blessed by God. The familiar scenery would have brought the episode to life for worshippers in sixteenth-century Flanders.
Gerard David, *The Baptism of Christ*, c.1502–7.

◀ **Garden of Eden**
This painting by the French artist Nicolas Poussin is one of a series of four that use biblical episodes to depict the four seasons. Spring shows Adam and Eve in early-morning light before the Fall. Eve points to the fruit on the tree of the knowledge of good and evil, but the couple have not yet eaten from it, for they are still in a state of innocence, unselfconsciously naked in their temperate Garden of Eden. God hovers above in the firmament, bestowing his blessing on his earthly paradise.
Nicolas Poussin, *Spring* or *The Earthly Paradise*, c.1660–4.

▲ **Pantheistic meditation**
The golden frame of this painting has the eye of all-seeing God, grains of wheat and grapevines (alluding to the bread and wine of the Eucharist), and an arch with palm leaves, cherubs, and a star. These locate Christ's Passion within a pantheistic vision of the natural world. The rays of the setting sun light the earth from below so that the image of the Crucified Christ also becomes that of the Resurrected Christ.
Caspar David Friedrich, *Cross in the Mountains*, 1808.

the process endows it with visionary, supernatural force. Landscape painters often bathe their views in a golden and benevolent light, as if such scenes were specially blessed by God. Friedrich's paintings of the sandstone mountains of Saxony in Germany, or Thomas Cole's of the banks and hilly plains of the Connecticut River in America, thus lay claim to a special sacredness in their regaining of Paradise after the expulsion of Adam and Eve from the Garden of Eden, as related in the Bible.

In the sixteenth century the most characteristic form of landscape painting was the panoramic vista in which the viewer is presented with a vast array of different types of scenery as if the whole world in all its minute detail were laid out before the eyes. In Patenier's *St Jerome in the Desert*, for example, we are shown mountains, plains, rivers, valleys, cities, towns, hamlets, and farms in what is clearly an amalgamated, synthetic view, assembled by the painter to stand in for all of creation. Viewers of such paintings were probably intended to marvel at the unity and variety of the created world. Later the artist's role in representing this world on panel or canvas could itself come to be seen as imitative of God.

In Cole's panoramic *View from Mount Holyoke, Northampton, Massachusetts, after a Thunderstorm – The Oxbow* the tiny detail of the artist's umbrella links the darker, wilder, and untamed foreground wood with the sunlit and domesticated pastures of the valley and hills below. Cole has included himself as almost sub-merged within the scene. This tiny figure is no anecdotal or decorative detail, but serves to highlight the media-tion of the landscape painter, who is able to recreate for us the splendours of God's original creation.

Topography

The word topography derives from the Greek *topos* (place) and *graphos* (writing). The main aim of a topographical landscape is the portrayal of a place. This role of landscape has always been important, although perhaps it has more often been the province of printmakers than of painters. Painted prospects of country estates were popular in Britain from the seventeenth century, while in the eighteenth century wealthy travellers took home as souvenirs views of popular sites abroad.

A landscape painting can never be an entirely accurate copy of a place, but turning the medium to their advantage, painters often provide more information and sense of place than it would be possible to capture from a single viewpoint. Some sixteenth-century maps included superimposed elevations of architecture

▼ **Cultivated property**
This castle, built between 1600 and 1608 as a country seat for the Flemish Archduke Albert and Infanta Isabella, no longer exists, but the painted prospect still maps out its domain and demonstrates the benign effects of central rule. Ordered lines of cultivation converge on the focal point of the castle. The territory stretches beyond the horizon and also terminates at the foreground palisade and gate that mark out ownership and contribute to the shaping of the land as an ordered and harmonious social division.
Jan Brueghel, *View of the Castle of Mariemont*, 1612.

and other local features to identify parts of the world, and from these there developed the angled, foreshortened painted prospect, which combines the overhead plan with the profile of a frontal elevation. The Flemish court artist Jan Brueghel's *View of the Castle of Mariemont* is an early example of this type of painting, offering as it does a map-like overview. This estate no longer exists but the viewer of the painting is still provided with information as to what might once have been present.

Interpretation

More than 250 years later the French artist Berthe Morisot, in her *View of Paris from the Trocadéro*, painted an extensive city view using similar compositional principles. Both this and Brueghel's painting are organized in broad bands of brown, green, and blue according to well-established formulae for the creation of aerial perspective, and both contain anecdotal detail and touches of colour to enliven and give human interest. But while the two landscapes share certain compositional features, they are radically different in subject matter and aim. In the early view – as in so many paintings of property – rights, duties, and divisions are registered in a geometric and rigidly hierarchical system. We can see how ownership of the estate has entailed its ordered cultivation and how the formal garden in front of the castle gives way to tended fields and woodland that contrast with the common and haphazard peasant farming outside the privileged domain. Morisot, on the other hand, recreates a whole city, stretched out peacefully in silvery sunlight. In doing this she masks the recent devastation of Paris wrought by the Franco-Prussian War and the Communard uprising.

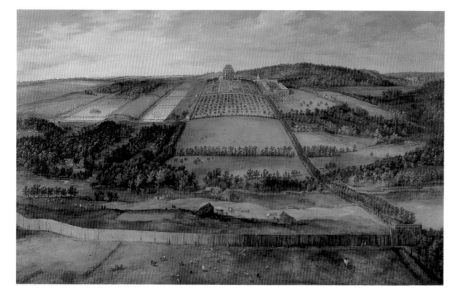

▶ **Foreign views**
In the eighteenth century many artists, including the French painter Claude-Joseph Vernet, congregated in fashionable Naples and painted the famous sight of Vesuvius erupting. In contemplating this painting we, too, can travel in a wide arc from the pleasure craft, the unloading of cargo, and the drawing-in of fishing nets in the bay, round to the Dome of San Giuseppe a Chiaia with the Castel Sant' Elmo above, and then along the peninsula to the mighty volcano.
Claude-Joseph Vernet, *View of Naples with Vesuvius*, 1748.

◀ **Park scenery**
The patrons and owners of Wivenhoe Park, the Slater-Rebows, made Constable alter his initial design for this painting to include the grotto with elms on the left and the deer house on the right. To accommodate these features the painter added wide strips of canvas to left and right. In so doing he enhanced the scene's gentrification, for he also added the pleasant pastimes of, on one side, a fishing boat and, on the other, the Slater-Rebows's daughter driving her donkey cart.
John Constable, *Wivenhoe Park, Essex*, 1816.

▼ **Training ground**
To complete his training in landscape painting, the French artist Corot visited Italy, where he sketched in oil in the open air and directly from nature. This view combines ancient with modern, empty ruin with inhabited dwelling, the made and inanimate with the organic and flourishing. Although the Colosseum lies in ruins, the pink stone of this landmark still evokes the grandeur of ancient Rome.
Jean-Baptiste-Camille Corot, *Study of the Colosseum* or *View from the Farnese Gardens (Noon)*, 1826.

Much favoured in the eighteenth century, the *veduta* (from the Italian word for "view") is another type of topographical landscape painting (see page 177, Canaletto, *The Piazzetta, Venice, Looking North*). The *veduta* offers a view, usually of a famous beauty spot or site, to be taken in at a single glance. It was painted according to a fixed perspective and controlled by wide, left-to-right sweeps. These views were purchased and collected by those on the Grand Tour who travelled to Italy in search of antique and modern culture. In coming to be known as a popular and picturesque beauty spot, a particular location, such as the Bay of Naples with its view of Vesuvius or the Colosseum in Rome viewed from the Farnese Gardens, also came to be recognized as a fine subject for painting and started a tradition of familiar prospects that continues to be followed in picture-postcard views today.

Immediacy

The oil sketch, done in the open air in front of the view being recorded, often possesses an immediacy not found in landscape paintings done in the studio's artificial light. Painting directly from nature did not become common until the end of the eighteenth century, when the direct observation of nature, whether for scientific or educational ends or simply for enjoyment (see pages 182–3), became widespread.

The celebrated English painter John Constable did much out-of-doors oil sketching, capturing in paint the vitality of natural phenomena. But, having sketched directly from nature, he would finish his paintings in his studio, often combining elements drawn from sketches. The apparent realism of his *Wivenhoe Park, Essex*, for example, is deceptive. While Constable has carefully recorded the site's topography, he provides a deliberately contrived vision of the ease of the gentleman's estate. There is no indication that the park's gentle hillocks and copses were created by moving earth and planting trees, and require maintenance. This display again contrasts with Brueghel's depiction of the Castle of Mariemont, where the distinct boundaries clearly reflect a well-defined social hierarchy.

▲ **Placing women**
In this bird's-eye view of Paris landmarks such as the towers of Notre-Dame, the church of St Sulpice, and the gilded dome of Les Invalides are silhouetted on the skyline. Behind a barrier in the green suburb of Paissy, far from the hustle and bustle of the metropolis, Morisot places two women and a girl, perhaps suggesting that the place of the well-to-do and leisured woman, young or old, is not in the heart of the city but in an outlying luxurious residential quarter.
Berthe Morisot, *View of Paris from the Trocadéro*, 1872.

The Golden Age

The idea of the countryside as a delightful and relaxing place of retreat from the cares of the city is an old one and of great importance for landscape painting. During the Italian Renaissance, villas were used as country houses by the wealthy and educated, who also began to enjoy paintings that offered playful and untroubling images of rural leisure and pleasure. This view of the countryside revived attitudes found in the writings of antiquity. Of particular importance was the Latin poetry of Virgil's *Eclogues*, which combine descriptions of the countryside with accounts of the lives and loves of shepherds. Virgil's poems inspired Renaissance equivalents, notably Jacopo Sannazaro's pastoral romance *Arcadia*, published in Venice in 1502, and *The Asolani*, by another Venetian writer, Pietro Bembo. This second work, published in 1505, is a dialogue on sensual love set in an idealized garden retreat of shaded groves and a soothing fountain, based on the one at the Palace of Asolo in northern Italy, where the sophisticated court of the exiled queen of Cyprus, Caterina Cornaro, was to be found. Allied to this poetry, a tradition of painting arose in Venice that evoked visually the sensuous mood and rural delights of the garden retreat. This tradition, exemplified by Giorgione's or Titian's painting *Concert Champêtre*, offers views of figures within scenery that are not intended as faithfully observed reality but provide us with the visual equivalent of pastoral poetry.

The pastoral

The word "pastoral" derives from "pasture" – which sustains grazing animals – and the pastoral tradition in both art and literature deals with benevolent, although essentially secular, feelings about how nature provides humankind with soothing refreshment and delightful restoration. Pastoral landscape paintings fuse certain common elements into a harmonious whole, evoking a "Golden Age." Nature is lush, flourishing, and green and the sky pale blue. Sunlight is temperate and golden, bathing even shaded areas in gentle warmth. Roads, paths, and bridges give easy access, winding rivers and stretches of still water are cool places of refreshment and trees frame, protect, and provide welcome shade. Roads, rivers, and trees also link the foreground space to distant mountains, creating seemingly endless vistas of pleasing harmony. This rich tradition continued into

▶ **Pastoral idyll**

This image, attributed variously to Giorgione and Titian, rejoices in the countryside as a place of uncorrupt pleasure, love, music, and leisure. The lute player is dressed like a fashionable young Venetian patrician of the early sixteenth century and his clothes may be contrasted with the peasant dress and bare feet of his adjacent companion and the nakedness of the two women.
Giorgione or Titian, *Concert Champêtre*, 1508.

◀ **Fullness**

In this idealized view Rubens celebrates the fullness of creation and at the same time invests the land with social and moral purpose. The abundance displayed here may be regarded as partly due to the proper cultivation and harvesting of the land, and partly to the benevolence of God, for the distant rainbow is a visible sign of the covenant between God and humankind (see page 180, Ruisdael, *The Jewish Cemetery*). The land exists, as far as the eye can see, in peaceful harmony with the people and animals it supports, and it reflects nothing of the hard social realities that prevailed in the war-torn Flanders of the early seventeenth century.
Peter Paul Rubens, *Landscape with a Rainbow*, 1636–7.

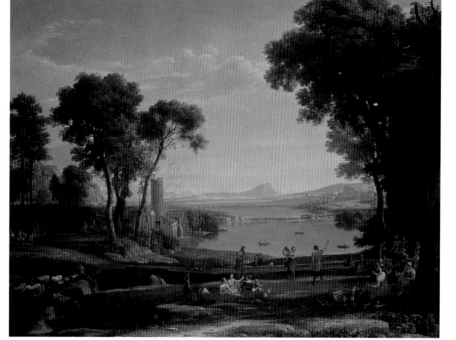

Sunlit bathers

Patches of pure, complementary colour are here juxtaposed to create smooth, flowing line and form. This technique allows the imagery of a seaside bathing scene to break away from naturalistic description, as in the stylized outlines and condensed tonalities of the framing tree. Yet the fresh radiance of this sunlit view still relies on the evocative and sanctioned leitmotifs of the past. Even in the early twentieth century, the pleasures of a distant, golden Arcadia were being evoked.
Henri Matisse, *Luxe, Calme et Volupté*, 1904.

Object of delight

Claude's paintings evoke the landscape of the countryside around Rome in which he travelled and sketched. However, he never produced documentary records of particular locations. This view was constructed according to well-established compositional formulae: it is framed by trees and a stretch of water leads to blue distant hills. The ruined circular temple is based on the ancient Roman temples of Vesta in Rome and Tivoli but is placed here next to a ruined medieval tower and near a watermill.
Claude, *The Mill*, 1648.

the nineteenth and twentieth centuries in the works of the American painter George Inness, such as *The Lackwanna Valley*, and the paintings of the Frenchman Henri Matisse, such as *Luxe, Calme et Volupté*, which is filled with yellow, green, blue, and pink radiance in touches of light, pastel pigment.

Bucolic pleasures

In depicting the natural world as one of unity, harmony, and peace, such works also suggest that the pleasures that they show can be enjoyed by all, irrespective of wealth, status, and occupation. The French artist Claude (born Claude Gellée) specialized in painting Golden Age landscapes and even during his lifetime his works were highly sought after. Although some of his paintings show a range of social types – for example, *The Mill*, where seated and richly dressed spectators of a country dance have been placed beneath the figure of a more rustically clad onlooker – his works, and works of this type by many other artists, were purchased and enjoyed exclusively by the wealthy and not by the peasants they depict. Indeed the inclusion of labouring peasants was regarded as one of the delights proffered by these idyllic views of the countryside.

In a related poetic tradition it was not the lives and loves of shepherds but the agricultural activities of the farmer's year that were celebrated (see pages 184–5). Virgil's *Georgics*, which were imitated in the poetry of sixteenth-century Italy and seventeenth-century Netherlands, gave practical advice on and celebrated the tilling and planting of the land and the rearing of livestock. The landscapes of the Flemish artist Peter Paul Rubens present a famously idealized vision of these rural activities. The most distinguished artist of his day, the highly educated Rubens worked for many major European courts before retiring to his country estate, where he painted some of his largest and finest landscapes. His *Landscape with a Rainbow* depicts a land of plenty where peasants work without breaking sweat, haystacks are piled high, and a plump, barefooted woman with a full pitcher on her head smiles fulsomely as she is propositioned by a man with a pitchfork. In Rubens's hands his native land becomes a haven of rustic peace and plenty.

Integrated progress

Commissioned by the Delaware Lackwanna and Western Railroad Company, this painting depicts a goods train steaming through wide pastures and cultivated fields. It suggests that the progress of civilization depends on technological advance as well as on the ordered settlement and domestication of the land. The tree at the left frames the view, links foreground and background, and is lit from behind in the manner of Claude. This conscious reference to earlier conventions gives authority to the increasing industrialization depicted here. It bathes the scene in golden light, and makes it appear to harmonize with, and be integrated into, its surroundings.
George Inness, *The Lackwanna Valley*, 1856.

Heroic landscapes

Many landscape paintings attempt to show nature not as it is, but consciously transformed and ordered by the artist. In paintings of an imagined Golden Age the countryside is shown as a place of untroubled delight (see pages 172–3), but this is not the only way in which artists have idealized nature. Painters of the "heroic landscape" have tried to impose a logical and austere order on nature, in carefully constructed works that ignore the transitory and accidental. In depicting the underlying structures rather than the details of the three-dimensional world, they intend to elevate us to a nobler and more cerebral plane, free of life's imperfections.

Origins

The heroic landscape had its beginnings in the seventeenth century, most importantly in the landscapes of the French artist Nicolas Poussin, the most famous proponent of the form. The subjects of many of his paintings were taken from the histories of antiquity and, like dramatic tragedy or epic verse, they were intended to prompt reflection on the human predicament. In *Landscape with the Ashes of Phocion*, for example,

Poussin exploited the story of the Athenian general in order to contrast the fickleness of human fate with the indifference of nature to blows of fortune. The gathering of the general's ashes is a ritual that is matched by the dignity of the surroundings in which it is set.

The heroic landscape presents nature not as fleeting movement and passing phenomena but as majestic, aloof, and imperturbable. In this tradition austere formal properties are imposed upon and reconfigure the natural world. Mountains are shown as stable, frontal masses rising up out of surrounding lowlands, to give form and structure to the worlds in which they exist. Buildings and made features such as roads, paths, and stone monuments, whether complete or in ruins, are similarly interlocked within the balanced symmetries that make up these works. In a painting such as *Landscape with the Ashes of Phocion*, clouds do not flit across the sky but are static and mirror the solid, architectonic forms of surrounding trees and hills. A temple in the centre links the two foreground figures with the rocks above the city and then further with the clouds above the rocks.

▲ **Nobility in death**
The subject of this painting is taken from Plutarch's *Lives*, which offers pairs of ethically exemplary figures from Greek and Roman history. Here the Greek general Phocion is paired with the Roman statesman Cato the Younger. Phocion had been unjustly condemned to death and his body cremated. His wife secretly gathered his ashes and took them to Athens, where, after a change of political opinion, they received an honourable burial. Poussin locates the clandestine gathering of the ashes within a landscape of great formal refinement. While the figures in the foreground appear small and insignificant in relation to the grandeur of the setting, the ashes are not left here merely to decay as ashes but are being endowed with noble ideas of purpose and dignity.
Nicolas Poussin, *Landscape with the Ashes of Phocion*, 1648.

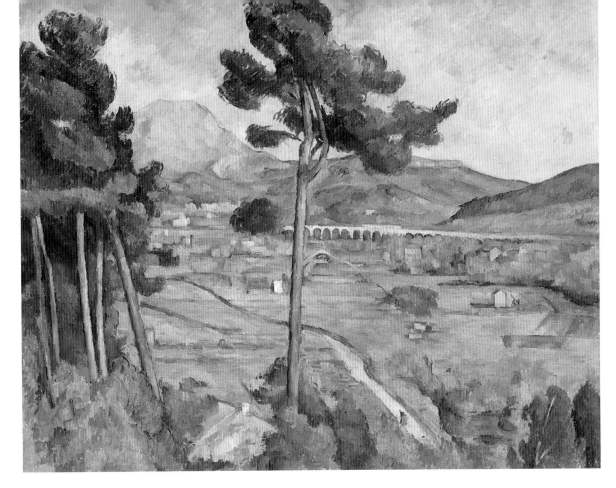

▶ Pattern in nature
Cézanne painted so many views of Mont Sainte-Victoire seen from the south-west of his native town of Aix-en-Provence, where the mountain rises above the valley of the River Arc, that this particular viewpoint has become identified with the artist. In this version, which is one of the painter's most monumental, imposing, grand, and austere, the vertical and horizontal lines of the trees, buildings, and railway bridge are integrated and intersect to create a dynamic surface pattern of interlocking structures, based on three-dimensional geometric forms, with all of nature's imperfections removed.
Paul Cézanne, *Mont Sainte-Victoire*, c. 1882–5.

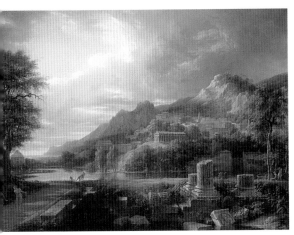

Similar underlying structures can be found in the landscapes of the French painter Paul Cézanne, who is often seen as one of Poussin's spiritual heirs. In one of his many views of Mont Sainte-Victoire the branch of a centrally placed tree echoes the shape of a bend in the road below and also responds to the colour and horizontal forms of a viaduct above. Similarly, the line of the horizon is matched by the contour of the vegetation in the lower foreground.

Ideal beauty

Theorists on painting began to praise the heroic landscape at the end of the seventeenth century, using the works of Poussin as examples. In 1708 the French connoisseur Roger de Piles identified three types of truth in painting: simple truth was a simple and faithful imitation of the expressive movements of nature and

◀ Civic virtue
The citizens of the ancient Sicilian town of Agrigento were famous for their hospitality. In keeping with this tradition, the slave of Gellia, one of the town's prominent citizens, is shown to be offering the generosity of his master's welcome to passing travellers. De Valenciennes combines the demonstration of a model of civic virtue with the depiction of a city of antiquity, known for its ancient monuments and ruins. Agrigento's Temple of Concord, which the painter drew during a visit to Sicily in 1779, is included on the mountain top above the town. The painting was first exhibited at the Paris Salon of 1787, when it was highly praised and compared to the work of Poussin.
Pierre-Henri de Valenciennes, *View of the Ancient Town of Agrigento*, 1787.

objects, ideal truth could never exist but depended on the amalgamation of a range of perfections into one model, and composite truth was composed from a combination of simple and ideal truth to give credible beauty, which often appeared more true than truth itself. De Piles linked the heroic style to composite truth in which objects were taken from what was great and extraordinary in art and nature and then drawn and composed together. Some of this theorizing may be traced back to Classical treatises on rhetoric and to Renaissance and post-Renaissance Italian writings on painting, but it was also developed further by later writers on art.

In 1800 the French landscape painter Pierre-Henri de Valenciennes wrote a treatise on painting, which also made constant reference to Poussin. He considered that his predecessor had been one of the most exceptional proponents of the art of depicting nature not as it was but as it should be. He also suggested how painters should prepare to paint the ideal beauties to be found in nature. First they should read, absorb, and meditate on the verses of the most sublime poets; then they should close their eyes and imagine an ideal nature, although this was something that only painters of genius, such as Poussin, could do. After opening their eyes again, they should look at nature and, in being disappointed with nature as it was – the meanness of the rocks, the depressions of the mountains, the shallowness of the precipices – they should disassociate themselves from these minute truths that held them in chains and aggrandize the mountains and give to precipices the depths of the abyss.

Townscapes

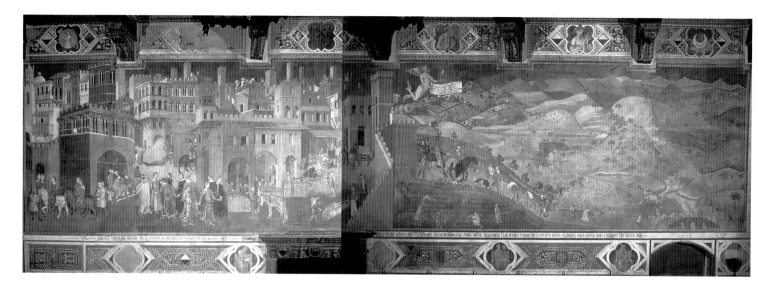

owns and cities had appeared in the backgrounds of religious pictures from the Middle Ages, often including identifiable landmarks (see page 168, David, *The Baptism of Christ*). In the sixteenth century increased travel encouraged the production of printed town "portraits," that is, silhouettes of skylines and bird's-eye views, as well as depictions of individual buildings (see pages 170–1). Paintings that took the town as their main subject first became popular in the Netherlands and Italy during the second half of the seventeenth century. Some townscapes show imaginary views with both actual and invented buildings, but more often they depict specific cities, identified by distinctive buildings, streets, and public squares. Usually

▲ **Social order**
Lorenzetti's view of his subject places the Tuscan city of Siena at the heart of the painting. He depicts the people at different scales: those furthest from the city, on the right side of the fresco, are also the smallest. The scene as a whole represents a benign social order based on efficient government and easy commerce between the city and the countryside.
Ambrogio Lorenzetti, *The Effects of Peace* or *Good Government in the City* (detail of central two-thirds) 1338–40.

celebratory, townscapes were painted both as visual souvenirs for the traveller and to reflect local and civic pride in the particular urban environment and, by extension, in the the social and political structures that maintained it.

Town and country

Images of the town reflect changing attitudes toward the city, which since antiquity has been seen in opposition to the countryside. Positively, the city may be viewed as a sophisticated and civilized place in its relation to the rural scene; more negatively, it may be seen as an artificial environment, subject to rapidly changing fashions.

In one of the earliest townscapes, painted in the fourteenth century, Ambrogio Lorenzetti showed a harmonious relationship between town and country, albeit one in which the country is dependent on the city. He depicts a road linking the walled city of Siena to the countryside and providing access to a site of commercial exchange for peasants who, with their agricultural produce, are on their way to the city. Here the town houses a variety of crafts, a grain and livestock market, a lecture hall, a cobbler, grocery shops, and builders on a scaffold, and these urban occupations contrast with the farming, hawking, and hunting taking place in the countryside.

▲ **Republican grandeur**
Amsterdam's town hall, begun in 1648, was the grandest one of its day. With its classicizing architecture, tall windows, and sculpted decoration, it was a monument to municipal freedom. The artist portrays the majesty of what became the Royal Palace with a brilliant clarity, befitting a great city centre viewed in its best light while doing nothing to hide the pretensions of the burgomasters who governed here. **Jan van der Heyden**, *The Dam with the New Town Hall in Amsterdam*, 1688.

Until the nineteenth century townscapes usually showed streets and squares in bright light and as peaceful and harmonious public spaces. Flat, open areas were bounded by tall, well-positioned buildings and contained well-behaved citizens, as in the work of one of the first Dutch painters to specialize in townscapes, Jan van der Heyden. Many also contained "portraits" of buildings that had symbolic importance in their own right and in the ways they functioned in the running of the city. The scenes of Siena and Amsterdam shown here reveal much about the social order that gave rise to the meeting places depicted. A town hall, library, or clock tower has a useful purpose and serves the community; such buildings may be seen as expensive gestures and showing them off can also serve to extol the principles of civic virtue. A similar vision of an ideal harmonious and sun-drenched city republic was promoted by Canaletto and his followers in their views of Venice. In paintings such as *The Piazzetta, Venice, Looking North* Canaletto shows the people posed with elegant self-consciousness as they congregate, go about their business, and participate in animated, easy exchanges. The architectural beauties of St Mark's Square and the Piazzetta stand for the beauty of Venice as a whole.

Formal values

Seventeenth- and eighteenth-century townscape paintings show off the discipline that can be imposed on the urban environment. The cities they present are usually tamed and unblemished, belying the hustle, bustle, disorder, and dirt of city life. Views were often manipulated, details suppressed, buildings moved, and impossible vantage points assumed. Figures in the city view are rarely in correct proportion to their backgrounds. Those in Jan van der Heyden's *The Dam with the New Town Hall in Amsterdam* are dwarfed by the enclosing architectural setting. Jewel-like and kaleidoscopic, such carefully modelled constructions contain much minute, precise detail. Strong vertical and horizontal lines suggest the rigid boundaries of urban experience. It is

no surprise that townscapes were often referred to as "perspectives" in the seventeenth-century Netherlands.

In the nineteenth century the city was a principal subject of the Impressionists. The cityscapes of artists such as Monet and Camille Pissarro share with their predecessors an often insistently constructed perspective. However, their emphasis is not the well-ordered harmony of earlier townscapes, but the teeming masses of the industrial city. Increasingly the city has been seen as chaotic, alienating, and isolating, a vision suited to the fragmented paintings of the French artists Fernand Léger and Robert Delaunay. Léger evokes these disjunctions in his painting *The City*, but also uses strong, simple segments to remodel and reintegrate the city's components into a coherent whole.

Machine aesthetic
Technology, mechanization, and the modern city are evoked in this fragmented image of Paris. Strong, simple forms, flat, angular, compartmented planes, and pure, unmodulated, saturated colours are juxtaposed and welded together. A lower strut from the Eiffel Tower, a framed, disembodied head and torso, the stencilled letters of billboard art, and roads and stairs are isolated as silhouettes and also fused together, becoming both staccato rhythm and film-like montage.
Fernand Léger, *The City*, 1919.

◀ **Dazzling perspective**
Views of Venice were purchased as souvenirs by those on the Grand Tour who visited the famous and uniquely beautiful city in the eighteenth century. The viewpoint in this painting by a master of the townscape is one with which such travellers would have been familiar – that of the Piazzetta seen on arrival by water from the Mola in fine, clear light. The square has on one side the Doge's Palace and St Mark's and on the other the Library and Mint, and the vista terminates in the clock tower at the entrance to the commercial thoroughfare of the Rialto. In spite of the variety of building styles shown here, at the heart of Venice, the public space of the Piazzetta appears as a masterpiece of harmonious urban design, to be taken in and admired for all its finery at a glance.
Canaletto, *The Piazzetta, Venice, Looking North*, early 1730s.

Seascapes

The Dutch painter Hendrik Vroom created the genre of seascape at the end of the sixteenth century. Before then artists had painted the sea: certain religious subjects, such as the story of Jonah and the Whale, called for shipwrecks and storms; maps were often decorated with pictures of boats, sea monsters and other marine symbols; and aerial views of port towns inevitably included stretches of sea. However, it was Vroom and his seventeenth-century successors in the Netherlands and Britain who established the seascape as a recognized and popular type of painting. That the genre originated in the Netherlands and enjoyed immense and long-lasting popularity in Britain is not entirely surprising. Besides depending on the sea for food, both these nations relied, for their wealth and power, on their command of the oceans, and much Dutch and British seascape painting may be linked to the promotion of national interests and identities.

The elements

Seascapes presented artists with many challenges and opportunities. The vastness of the sea, almost unbounded and unframable, frequently extends to a far-distant horizon, and so requires appropriate compositional strategies. Instead of using one-point perspective, artists often adopt a horizontal, panoramic sweep, with the relief profile of ships, masts, and sails providing structure and a sense of specificity. But it is the sea's changeability and the way it responds to the weather that is often the focus of the marine painter. Wind is an almost tangible presence in many seascapes. It fills sails under cloud-filled skies, but is most evident in the variety of wave imagery that artists exploited. Waves ebb and flow, roll and change direction, and are both ephemeral and endless in their repetition.

In *Dutch Man-of-War and Fishing Boat in a Breeze*, Vroom shows waves propelling the fishing vessel. In contrast, the German painter Emil Nolde, in *The Sea I*, uses their swelling restlessness to suggest the immeasurable voids beneath them and the small boat's seeming lack of movement within their swirling, organic turbulence. Opposite effects were exploited in the popular tradition of becalmed vessels on glassy waters. Marine painters explore the nature of the differing waters that vessels have to negotiate – whether river estuary, rocky coast, sandy beach, or open sea – and some also convey stunning effects of light on water, as in the burnished reflections seen in Joseph Turner's *The Fighting "Téméraire" Tugged to her Last Berth to be Broken Up*.

The sea provides a setting for a range of human activities and it is these that are often the subject of seascapes: from boat building and fishing to pleasurable spectacle and bracing exercise, from travel for commerce and voyages of discovery to battles between opposing fleets. Most seascapes are indeed painted as if from the land and depend upon the contrast between the human environment and the free, untrammelled space of the oceans. In seventeenth-century France Claude developed the popular genre of a view out to sea from an ordered imaginary harbour bathed in sunlight (see page 122, *The Embarkation of the Queen of Sheba*). However, in the beach scenes of Eugène Boudin, the sea is shown only as a narrow strip of water between the beach and the sky. In Boudin's paintings the breezy, windy atmosphere of France's Normandy coast is vividly evoked by human elements – sailing boats, fluttering flags, and the bulging capes and

▶ **Sea power**
Hendrik Vroom was the first painter of the seascape genre and this picture established some of its key features. Ships sail on windswept water across limitless expanses of sea beneath large, cloudy skies. This image claims for the Dutch, who relied on the sea for food, defence, and commercial expansion, a mastery and control beyond that of their own flat land.
Hendrik Vroom, *Dutch Man-of-War and Fishing Boat in a Breeze*, c.1590.

▲ **Journey's end**
The *Téméraire* had helped to win the Battle of Trafalgar for Britain. Thirty-three years later the gunboat was tugged to its last resting place. The masts had in fact been removed but Turner shows it as a majestic ghost ship, masts in place, contrasting with the tug's black funnel and lively stream of smoke. The setting sun is well suited to the subject and the elegaic mood, suggesting the end of the fighting ship's usefulness.
Joseph Mallord William Turner, *The Fighting "Téméraire" Tugged to her Last Berth to be Broken Up*, 1839.

crinolines of the fashionable visitors to the seaside. Even the depiction of a single wave in Gustave Courbet's desolate *The Wave* relies for its structure and sense on the narrow strip of land at the painting's base.

The sea as symbol

The sea is also a rich source of symbolism. Voyages to mysterious and distant lands across treacherous seas were commonly used in paintings as metaphors of the journey of life. In Christian imagery the ship of the Church was steered through the stormy seas by Christ, while in a secular metaphor the ship of State was shown with the wise ruler at its helm. The element of chance in human affairs could also be personified as Fortuna or Tempesta, a nude female figure, standing on a globe and holding between her outstretched hands a billowing sail that propels her across the ocean.

Some of these resonances were exploited in the nineteenth century by Turner in the imagery and title of his *The Fighting "Téméraire" Tugged to her Last Berth to be Broken Up*. The defunct gunship is towed on its final journey to dismemberment, powerless in old age. Another frequently exploited theme was the dramatic vulnerability of those shipwrecked off a storm-ravaged coast or adrift in a small boat on some vast sea; it was used to suggest humanity's insignificance, nature's terrifying power, or fate's vagaries. This subject was popular with painters of the "sublime" in the eighteenth and nineteenth centuries (see page 182, Vernet, *A Storm with a Shipwreck*) and in the twentieth century Emil Nolde used a more personal approach to explore the same theme in paintings such as *The Sea I*.

▼ Drowning in paint
The French artist Gustave Courbet painted this dramatic seascape while he was staying at Etretat on the north Atlantic coast of France. From a low vantage point, the painter focuses on a small section of the sea, making it stand in for the ocean as a natural element of potentially overwhelming power and grandeur. At the point of breaking on the shore, the wave – a full, frontal, dark, bold mass – threatens to burst over and engulf the viewer. Courbet represents the lowering clouds above the sea in such a way that they echo the forms of the water and surf below, and by depicting them in thick dark globs of paint he conveys his intense physical and emotional experience of the brooding, cold climate of Normandy.
Gustave Courbet, *The Wave*, 1870.

▼ Raw energy
Emil Nolde gives to this scene a turbulence that expresses his own strong emotional responses to the endlessly shifting rhythms of the sea. The bold, sweeping brushstrokes fuse the forms and forces of sky and waves, for here nature is experienced as an elemental oneness. The high horizon nearly forces the boat with its passengers beneath the waves, but the glowing amber sail breaks out from this dark, strange world, pushing onward.
Emil Nolde, *The Sea I*, 1912.

▲ Recreation
The nineteenth-century French painter Eugène Boudin specialized in beach scenes and seascapes and influenced the Impressionists, notably Monet. This beach scene, which depicts a fashionable holiday resort on France's Normandy coast, shows the seaside as a site of recreation where sailing boats scud across a distant horizon and elegantly dressed holidaymakers enjoy the spectacle of the flat, coastal setting, sitting, standing or moving about in the fresh air. The groups of modish, anonymous visitors on the shore – the women, children, dog, and rider – are set in characteristic poses and with distinctive gestures. Above the narrow band of sea, the large, open sky is, in contrast, filled with freely floating clouds. Light dabs of paint give an appropriately light, or gently shaded, touch to the breezy, airy spaciousness of the setting.
Eugène Boudin, *The Beach at Trouville*, 1864–5.

The transient world

A macabre dance
Three pyramids diminish in scale and indicate the vastness of their desert setting. The stone sphinx, bizarrely sliced in two, perhaps suggests that the ruins in the foreground are due not to the ravages of time but to human intervention. The strange dance of the women is accompanied by musicians perched above them.

The head from a colossal statue lies in the shadows to the right. Painted the year of Bonaparte's capture of Cairo, the picture is not openly critical of recent events in French history but clearly emphasizes the transience of worldly ambition and power.
Hubert Robert, *Young Girls Dancing Around an Obelisk*, 1798.

The new order
In this work the Dutch painter van Ruisdael has depicted the expensive marble tombs of the Portuguese Jewish community of Amsterdam out of context: before the ruins of a Gothic church and by a flowing stream bridged by a blasted tree. Together with the rainbow, which is mentioned in the Bible as an enduring sign of the covenant promised by God after the Flood, these elements – tombs, ruins, and stream – may imply the promise of passage into the afterlife for the soul of the Christian.
Jacob van Ruisdael, *The Jewish Cemetery*, c.1655–60.

Painters have often used the subject of landscape to suggest the brevity of human life and the futility of human endeavour when measured against the permanence and self-renewing cycles of the natural world. The metaphor of life as a journey through the world – a "walk through the valley of the shadow of death" – is common enough and depictions of landscape may suggest such a reading.

However, landscape paintings are seldom overtly allegorical. A painting like *View of Schroon Mountain*, by the English-born American painter Thomas Cole, with its passing storm, its dead and living trees, and the huge, immovable mountain behind, may well hint at hidden meanings, but we do not need to be able to decode them in order to appreciate the visual beauties of the scenery that the painting depicts. In contrast to the blatant allegorizing of a vanitas still life, for example (see pages 228–9), with landscapes we cannot always be sure whether such a meaning was intended, even if Cole's intense response to nature suggests that such a meaning may be present here.

Humankind and nature

Cole was not alone in his use of living and dead trees to suggest both the cycles of nature and the passing of human life. In landscape imagery, trees have often been made to stand for the human element. More organically alive than rocks and mountains, and more permanent than flowers, they stand upright like humans and, like them, have branching limbs. They are also potentially fragile and vulnerable to the elements. For these reasons they may suggest a variety of human emotions and qualities. For example, in Patenier's *St Jerome in the Desert* (see page 168) a lone tree grows near the hermit's hideaway, mirroring the saint's tenacity and strength in adversity. Blasted trunks, rooted or not, broken stumps, and skeletal branches have all been associated with life's transience, just as new growth reaching to the heavens can express spiritual aspirations.

The living and the dead

In the nineteenth century the German painter Caspar David Friedrich, in *A Walk at Dusk*, endowed a tree with visionary power, setting it against an earthly stone tomb. Nearly two centuries earlier, in his painting of *The Jewish Cemetery*, the Dutch landscape specialist Jacob van Ruisdael juxtaposed living and dead trees among ruins and within a cemetery. This painting has always

◄ **Between life and death**
As day gradually merges into night, an isolated figure contemplates a prehistoric grave. The stones of the tomb have been carefully balanced and behind their horizontal placement the skeletal branches of a tree reach up into the sky. Friedrich depicts a scene in which all is still and peaceful, but we are caught in an intense emotional dialogue with nature and can experience how the threshold between life and death is a crossing between the physical scale of humankind and the infinite expanse of the divine.
Caspar David Friedrich, *A Walk at Dusk*, c. 1830–5.

▼ **The wilderness**
In a poem inspired by his experience on Schroon Mountain, Thomas Cole describes how a lofty peak is the eternal dwelling place of a lone spirit who contentedly sings hymns of gladness and is impervious to tempests, earthquakes, and floods. Similar sentiments imbue the artist's painting of the mountain, where a storm passes over blasted trees but does not touch the majesty of the pyramid-like and, by implication, eternal summit. The wild site is untouched by human hand, but in its confrontation with the powerful, untrammelled forces of nature it may also be seen as reflecting the enduring and weather-beaten qualities of the American people.
Thomas Cole, *View of Schroon Mountain, Essex County, New York, After a Storm*, 1838.

been recognized as carrying an allegorical meaning. One of the earliest descriptions of it describes it as "evidently intended as an allegory of human life." The flow of life is perhaps suggested by the stream that runs through the cemetery, while the painting combines obvious signs of death and transience – dead trees, tombs, and ruins – with those of life and hope – passing clouds, new growth, and the rainbow.

Passing glory

Many artists have included ruins and tombs in their paintings to suggest that even the most monumental works of humankind are ephemeral and perishable. None used such symbols more often than the eighteenth-century French painter Hubert Robert, who became known to contemporaries as "Robert of the Ruins." His paintings inspired the influential philosopher and writer on art Denis Diderot to thoughts about the brevity of human life in an unstoppable, ceaseless world. In his *Young Girls Dancing Around an Obelisk* Robert subverted the most enduring of human monuments – the pyramids – by placing them, in the vastness of the desert, behind other, broken relics from Egypt's distant past. But the picture carries with it more topical and political resonances. It was painted in 1798, the year when Napoleon had taken Cairo in the Battle of the Pyramids. The young girls who dance round the obelisk wear the red, white, and blue of post-revolutionary France, and during the French Revolution, a few years earlier, people had danced round maypoles and trees of liberty. The meaning of Robert's mysterious painting is elusive – probably intentionally – but it is clearly a meditation on the transience of human endeavours in antiquity as well as, we may assume, those of recent times.

Some thirty years later Caspar David Friedrich used another ancient tomb to different ends, but again possibly with reference to contemporary politics. In his painting *A Walk at Dusk* a lone figure contemplates a prehistoric tomb. The man – as in a number of Friedrich's paintings – is dressed in old-fashioned German garb, the costume adopted at this time by those who yearned for the revival of a past when, they imagined, Germany had been great and unified. This imagery suggests that the man is meditating on and seeking strength from a lost homeland. The loneliness of the figure as the light fades perhaps also reflects the painter's own pessimism at a time when political opposition to this form of nostalgic nationalism had rendered it increasingly irrelevant and impotent.

Weather

Landscape painters have responded in a variety of ways to the challenge of depicting weather and its often elusive atmospheric effects. During the Italian Renaissance artists began to use the changeability of the skies as a major expressive resource. In the eighteenth and nineteenth centuries the extreme and uncontrollable forces of nature, such as those of lightning and a sudden storm, were exploited by artists in an attempt to inspire the emotional experience of the "sublime." In the second half of the nineteenth century the Impressionists were concerned with capturing in pigment their perception of the fleeting effects of weather.

Depiction of the weather has long been considered one of the main challenges facing the landscape painter. One of the earliest written accounts of landscape painting, a chapter by the Dutch artist and theorist Karel van Mander in his *The Book on Picturing* of 1604, recommends the painting of hazy atmospheres, with sunbeams filtering through the clouds and shining on towns and mountains, and also the more extreme conditions of thunder and lightning, storms at sea, snow, hail, gloomy weather, and fog. Such effects were a demonstration of the painter's skill in the observation and recording of nature, even if in van Mander's day all landscape painting was still done in the studio. The subject of the painting usually called *The Tempest*, by the Venetian Renaissance painter Giorgione, remains mysterious, but the buildings, caught in startling highlights beneath a flash of lightning, belong to the tradition of depicting weather based on careful observation of its changing effects, later extolled by van Mander.

Working out of doors

In the nineteenth century the fixing in paint of the momentary effects of weather increasingly became the preoccupation of artists who had begun to make their finished paintings out of doors. Sketching out of doors had been part of standard artistic practice from well before that period, and examples survive by artists as diverse as Dürer (see page 166, *View of the Arco Valley*) and Claude. At the beginning of the nineteenth century the English landscape painter John Constable had also painted extensively out of doors, producing, among other things, an extraordinary collection of swiftly painted studies of clouds. But, like those before him, he produced his finished works in the studio; later in the century the Impressionists insisted that a sketch made outside from nature was itself a finished painting. They wished to present more direct visual impressions as equivalents for the impact of the surface sensations offered by the out of doors. Many Impressionists chose

▶ **Flashpoint**
In the 1521 inventory of the art collection of Cardinal Grimani, the Venetian writer on art Marcantonio Michiel gave to this work one of the earliest descriptions of a painting as a landscape by referring to it as "a small landscape [*paesetto*], on canvas, with a thunderstorm, a gypsy, and a soldier." Many other attempts have been made to define what is going on here between the soldier standing on the left and the seated, naked woman suckling a child on the right, but the artist's precise intention remains elusive. Perhaps we should simply be content to admire how Giorgione conveys the brittle atmosphere that usually precedes a storm.
Giorgione, *The Tempest*, c.1505–10.

◀ **Storm at sea**
In this imaginary disaster people strain to hold fast a sailing ship that has been dashed onto a rocky coast by a passing storm. A fishing boat retrieves some of the wrecked vessel's goods and passengers, and a woman, saved and hauled onto the shore by two rescuers, appears to be either in a faint or dead. Crowds descend from the fortified tower to aid the survivors further. The French painter Vernet interprets the storm in relation to the effects it has on people and on the works of humankind. The painting is also a fine example of the taste for the sublime, an artistic and literary impulse that found its most intense expression during the eighteenth century.
Claude-Joseph Vernet, *A Storm with a Shipwreck*, 1754.

Snow cover
Monet captures the appearance of snow that has covered the natural world beneath a uniform blanket. Even the tops of the railings and the gate posts have their own little patches of snow. The momentarily perching magpie has been made to stand out from this scene – not by giving ominous significance to the deadening effects of winter, but as part of the artist's eloquent description of direct visual perception.
Claude Monet, *The Magpie*, c.1869.

Nebulousness
Like most Impressionist works, Sisley's painting of foggy weather is quite small, and this allowed him both to carry the canvas outdoors and to complete the picture quickly. The lack of clear focus conveys the way in which fog dissolves form. A pastel silvery-blue greyness fuses the trees, flowers, a fence, and a woman. The woman gathers flowers in the enclosed seclusion of a garden, her movement echoing the still, twisted branches of the tree behind her.
Alfred Sisley, *The Fog, Voisins*, 1874.

Pure and powerful
This passionate view of the after-effects of a thunderstorm shows the sun bursting through the dark clouds to suffuse the lush, hilly landscape with vital, even ecstatic, energy. The German painter Erich Heckel was a founder member of Die Brücke, a group of artists formed in Dresden in 1905, which aimed to make its art the threshhold of a new spiritual dawn. Simplifying pictorial structure and going back to what they perceived as purer origins, the artists expressed their inner feelings with raw lines, angular planes, and luminous colour.
Erich Heckel, *Landscape in Thunderstorm*, 1959.

to live in northern France, in the countryside around Paris and in Normandy and Brittany. There the fluctuating temperatures and often sharply distinguishable weather patterns gave them ample opportunity to experiment in this trapping of weather on canvas (see page 185, Camille Pissarro, *Woman in an Enclosure, Spring Sun, Eragny Field*). In 1868 a journalist from Le Havre reported that the French painter Claude Monet had been seen painting at an easel out in the snow, half-frozen, wearing several layers of clothing and gloves. The results can be seen in the way that the artist has handled his colours in *The Magpie*, where he shows white, white-yellow, and yellow patches of snow and at the same time fixes on the snow-covered ground the blue shadows cast by the cold, flat light of winter.

The sublime

Extreme effects of weather can also be used to communicate a sense of what, in the eighteenth century, was considered to be sublime. At this time "the sublime" was an aesthetic category that resided not in the observed object but in the observer's response to the object. In the tradition of the first-century literary treatise *On the Sublime*, attributed to Longinus, writers such as Edmund Burke in England and Denis Diderot in France valued the sublime because of the feelings of delightful fear it prompted. By presenting the viewer with scenes in which human life is threatened by the uncontrollable forces of nature – for example when a ship is wrecked in storm-tossed seas, as in Vernet's *A Storm with a Shipwreck* – painters were able to prompt a fearful response in the viewer. Fear could be tinged with delight because not only had the scene been imagined and the artist's life not been put in danger, but also the viewer was safely indoors, far from the kind of perilous scene that inspired the painting.

Elemental force

Storms were particularly popular vehicles for the prompting of such emotions, for they can be seen as the product of nature's elemental force, whose explosive violence can have an overwhelming impact on human life. At the start of the twentieth century, in a painting such as Erich Heckel's *Landscape in Thunderstorm*, the powerful emotion that a storm can inspire was expressed more subjectively than it would have been in the eighteenth century, and may be seen as a pure, purged, and heightened force of nature.

The seasons

For many centuries there has been a tradition in the visual arts of celebrating the changing but eternally recurring annual pattern of the four seasons and the out-of-door activities traditionally associated with them. Linked to the twelve signs of the zodiac, images of the rural labours regarded as characteristic of the various months, such as sowing seeds and harvesting crops, were carved in the stones of medieval cathedrals as symbols of both human life on earth and the cycle of the seasons themselves.

Depictions of the seasons occurred on domestic items such as furniture, wooden plates, and tapestries and served as decorated calendars of Church feast days in manuscripts. The seasons have also long been the subject of series of paintings. Those that depict rather than personify the seasons tend to be straightforward and precise in showing the land, its cultivation, and other activities associated with it. In the nineteenth century increasing urbanization and industrialization caused such cycles to become rarer.

Also long established in painting is the powerful symbolism of the seasons. Spring is seen as a time of birth, flowers, and love; summer as a time of heat, refreshing bathing, ripeness, maturity, and the harvest; autumn as the time of the vine but also of decline; while winter is a time of cold, with snow, ice, and skating, and may symbolize death.

▽ Summer
The seasons often provide the subject of series of four paintings, or of pendant pairs, as shown below by the Dutch artist Jan van Goyen. These works can be circular, as here, oval, or shield-shaped. Van Goyen shows similar scenes at two contrasting seasons, but while the compositions are similar, the activities and tonal qualities are different. The first painting shows the peaceful occupations of summer; all is harmonious and bathed in warm, gentle light.
Jan van Goyen, *Summer*, 1625.

◁ ▷ Working the land
These two paintings are part of a series of Labours of the Month that accompanied the Calendar of a lavish Book of Hours, or prayer book, made for the Duke of Berry in France. June is represented by the work of the harvest: mowing, raking, and staking. October is characterized by sowing. While the burghers of Paris enjoy their leisure, one peasant cultivates the soil on horseback and the other, in ragged leggings, sows seeds.
The Limbourg Brothers, *June* and *October*, from the *Très Riches Heures*, 1410–16.

▽ Winter
In the second painting of Jan van Goyen's pendant pair the artist depicts a wintry scene filled with the typical leisure activities of the Dutch people of the seventeenth century at the time of year when water froze over. Wrapped up in thick clothing as protection against the cold, people walk, skate, or are pulled along in horse-drawn sleds. The trees are bare, smoke rises toward the heavy clouds, and the sky gives off a pale, flat light.
Jan van Goyen, *Winter*, 1625.

▶ Spring light
This painting shows the the French Impressionist Camille Pissarro responding to the theories of colour emerging at the time in France and Germany. The result is a work in which the local colours of objects are modified by the light that falls upon them so that the spring foliage of the trees appears darker on its underside and shadows cast by the sun are flecked with patches of colour.
Camille Pissarro, *Woman in an Enclosure, Spring Sun, Eragny Field*, 1887.

▼ Autumnal labours
The vine and the grape harvest are traditional attributes of autumn, but here the German artist Hackert combines the traditional with a recording of distinctive regional practice. The costume, the vines hanging from willows, the use of long ladders, and the carting away in vats of the must after the grapes have been trampled were all peculiar to the region of Naples.
Jakob Philipp Hackert, *Autumn*, 1784.

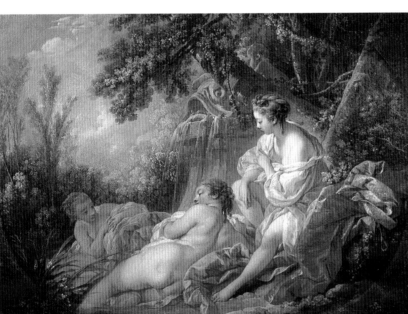

▲ Summer idyll
This is one of the cycle of four canvases on the theme of the seasons that the French artist Boucher painted for Madame de Pompadour, the mistress of King Louis XV of France. Spring and Autumn are pastoral scenes. Winter shows a lady in a fur-trimmed robe seated in a sleigh. The women of Summer enjoy the cooling waters of a river and fountain. Solid though it is, their naked flesh is highly contrived and contrasts with the abundant foliage, the orange, violet, white, green, and gold draperies, and the pastel pink and blue ribbons in the carefully powdered hair.
François Boucher, *Summer*, c.1755.

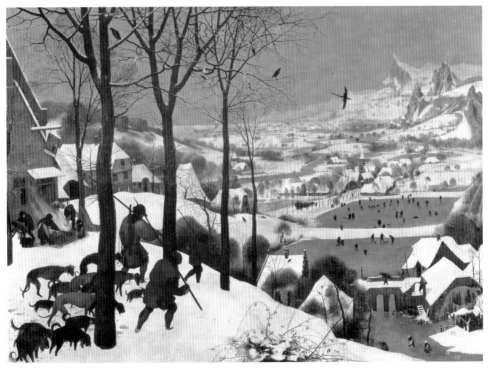

◀ Cosmic detail
The Netherlandish painter Pieter Brueghel uses tall, bare trees to link the hunters in the foreground to the mighty backdrop of a coastal plain and jagged mountain peaks. The scene combines the leisure activity of skating on one side of the composition with the work of cooking a pig on the other side. The warmth of a fire burns against the dull greyness of the pervading cold. The artist structures detail, giving scale and significance to the humblest of rural occupations, to humans, birds, and beasts, and to the made and the natural.
Pieter Brueghel the Elder, *Hunters in the Snow*, 1565.

Times of the day and night

For the artist one of the principal characteristics of any place is the nature of its light, whether it is fiery and intense or pale and diffuse. The depiction of light is especially important for the landscape painter, among whose aims is to capture the way in which the sun or moon illuminates a subject. For example, in Kitty Kielland's *Summer Night*, a landscape of the painter's Norwegian homeland, we are shown in finely modulated tones the distinctive white light of a northern summer's night in which the sun does not set. The light of the night sky gives each reed its own value and refinement and it reflects the green of the land onto the cold, crystalline, and smooth water.

Sunlight changes in intensity, partly in response to changes in cloud cover and other atmospheric conditions, but also as part of a daily cycle. Many artists have been drawn to this variability. In *Agony in the Garden*, one of the earliest and most beautiful depictions of a dawn sky, the Venetian painter Giovanni Bellini shows how the first rays of sunlight at dawn streak through a night sky to strike the undersides of clouds and the buildings on a hilltop above shaded slopes. Bellini's dawn almost certainly has symbolic significance, but later the observation and recording of particular times of day came to be admired for their own sake. This can be seen in the tradition, popular in the seventeenth century and beyond, of creating pairs of paintings that illustrate the contrast between night and day or dawn and dusk. At the head of this tradition, the French painter Claude produced harbour scenes, with departure bathed in the cold blue-green light of morning and arrival and disembarkation bathed in the warm yellow-orange light of the setting sun. But whether the light came from the rising sun or the setting sun, Claude always used it to give focus to his compositions, to unify and harmonize, and to fix in paint the fleeting moments of day passing into night and night passing into day.

Changing light

Later treatises on landscape painting began to recommend the painting of different and distinct times of the day. The French landscape painter and theorist of art Pierre-Henri de Valenciennes (see page 175, *View of the Ancient Town of Agrigento*) noted that sunlight and its

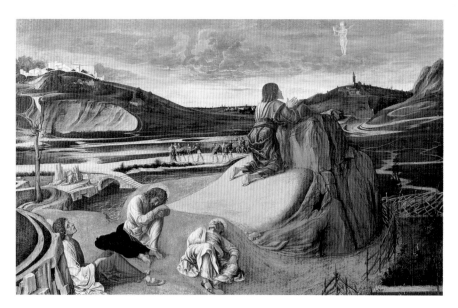

▲ Dawn breaking
Christ prays to God for strength on the Mount of Olives in Bellini's powerful landscape. The painter marks the ending of this vigil in two ways. He shows the impending arrival of soldiers, coming along a path to arrest Christ in the first light of daybreak. This light strikes a hilltop town and the pink undersides of feathery clouds and silhouettes in profile the praying hands and face of Christ. The cherub who appears in the sky belongs to the visionary events of the night that is now ending and is, in contrast to the rest of the scene, illuminated by the silvery light of the moon.
Giovanni Bellini, *Agony in the Garden*, c.1465.

◄ Splendour at sunset
After the death of Julius Caesar in 44 BC, Cleopatra was summoned to Tarsus, on the south coast of modern-day Turkey. The Egyptian queen put on such splendid attire that she immediately captivated Antony, one of the three people who at that time ruled the Roman Empire. Claude has set this moment of captivation on the harbour steps of a landing stage, showing Antony caught in awestruck admiration as he comes to meet Cleopatra. The setting sun illuminates the queen's retinue of women, whose splendour is matched by that of the sailing ships on which the party has travelled.
Claude, *The Landing of Cleopatra at Tarsus*, c.1648.

◄ **Quiet night light**
The northern phenomenon of the white summer night is depicted here with honest, quiet realism by Kitty Kielland. The painter spent her summers with a group of fellow Norwegian artists on a farm near Christiania (now Oslo), where she painted this landscape. The subject has nationalistic implications, but in this painting it receives a subdued and tonal treatment.
Kitty Kielland, *Summer Night*, 1886.

▼ **Blazing moon**
This disturbing nocturnal landscape was painted in the last year of Vincent van Gogh's life and suggests the deep mysteries that lie behind the commonplace. The blazing crescent moon and the smaller, sun-like stars appear as almost visionary presences. The tall cyprus tree in the foreground rises flame-like into the sky, in contrast to the smaller, earthbound church steeple. As if still infused by the energy of the sun, the stars and moon – created out of the stylized dots, dashes, and curving lines of thick, textured paint – flow together in pulsating, undulating rhythms, reflecting the intense experience of the painter.
Vincent van Gogh, *The Starry Night*, 1889.

shadows change constantly because of many factors, including those of the movement of the earth, the amount of moisture in the atmosphere, and the reflections and reflective qualities of a particular site. He proposed to his students that they should paint the same view at different times of the day to observe the differences that light produces on forms, and he recommended four particular times as the most clearly distinctive parts of the cycle: the freshness of morning; the heavy atmosphere and dazzling rays of the noonday sun; the burning horizon of evening; and the calm of night with its soft, silvery moonlight. In the 1880s the French Impressionist painter Monet took this approach to its extreme in his series of paintings of single motifs, such as wheatstacks (see page 167, *Wheatstacks, Snow Effect, Morning*), which he portrayed in a seemingly endless variety of light conditions. Descriptions of Monet at work on these paintings portray him with a stack of canvases by his easel, taking up a new one with each change in the light.

Symbol and metaphor

Light and darkness are also powerful symbolic tools and have been used in landscape, as in other kinds of painting, to imbue a motif with deep, symbolic meaning. In both secular and religious works landscape painters have used the ceaseless passing from night to day to suggest a divine plan or a cosmic system that is eternal and greater than our own limited human existence. In Bellini's painting *Agony in the Garden* the coming of the dawn will bring with it Christ's arrest by the soldiers who, in the middle distance, are being led toward him by his betrayer, Judas. But the rising sun also suggests the themes of the renewal and redemption that Christ's death offers to believers.

In a further symbolic use of light, the sun has frequently been painted as an active, masculine force,

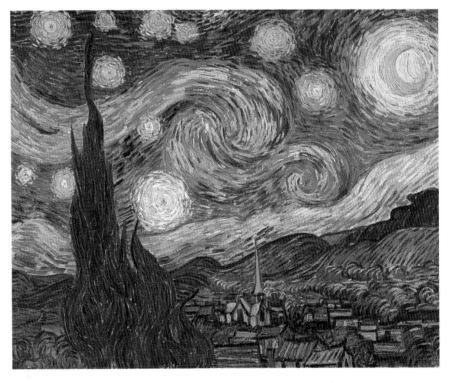

suffusing the natural world with life-giving energy. In contrast, the moon, with its cold, silvery light, has often been seen as more feminine, silent, and subdued, with night perceived as a time of rest, sleep, dreaming, spiritual contemplation (see page 181, Caspar David Friedrich, *A Walk at Dusk*), and even death.

Occasionally such associations are subverted. The sun, for example, may be depicted accurately as scorching and destructive. Similarly, departing from the usual treatment of night as a time of tranquillity, Vincent van Gogh, in his painting *The Starry Night*, depicts with visionary intensity an extraordinarily vibrant, swirling night sky above the strongly illumined Rhône valley of southern France.

Wildness

Much landscape painting presents an ordered view of the world, of idealized places bathed in golden light or of a countryside that bears the marks of habitation. But another strand of landscape painting has concentrated on wilderness and wildness. Remote and inaccessible regions may be seen as savage and dangerous, but they may also be celebrated as uncorrupted or even as sacred sanctuaries untouched by the evils of civilization.

Contrasting sites

Long before the Romantic attitude to nature inspired landscape artists to paint wild regions far from civilization, painters had responded to untamed nature. One Italian commentator of the sixteenth century praised the landscapes of northern artists because "they portray the scenery of their own homeland, which offers most suitable motifs by virtue of its wildness." In the middle of that century Pieter Brueghel drew landscapes in the Alps when he travelled to Italy. In Germany early in the same

century, Albrecht Altdorfer and others in the Danube School painted a number of scenes set in dense, dripping forests peopled by hermits escaping the world or wild men and satyrs untouched by civilization. Forests, like mountains, have long associations with mystery, magic, and danger. Their thick vegetation can hide the strange and unknown or protect the fearful and isolated. But for Altdorfer they may also have suggested an imagined German past of uncorrupted simplicity. His wild men and satyrs formed a stark contrast to the city of Regensburg, where Altdorfer worked, and the princely courts that collected such painted panels. The organic, pagan setting and sylvan simplicity of his *Satyr Family* provide an alternative ideal of a Golden Age to the Classical Arcadia of the Italianate tradition (see pages 172–3).

When the English writer Horace Walpole crossed the Alps in the eighteenth century it was not a northern artist but an Italian whom he called to mind when he wrote: "precipices, mountains, torrents, wolves, rumblings – Salvator Rosa." Others, particularly in England, also held Rosa up as a wild eccentric, admiring his paintings for their savage, desolate beauty and their wild beasts and bandits. Today Rosa's landscapes, such as *The Broken Bridge*, appear to conform more to the settled harmonies of Claude (see page 173, *The Mill*) than to the distortions of some recent landscape painting and there is usually little evidence that they contain wild beasts or that the figures they depict are outlaws.

▼ **Difficult terrain**
In this landscape by the seventeenth-century Italian painter Salvator Rosa travellers on horseback have been abruptly halted on their journey by the rickety state of a broken bridge. One appears to gesture toward another possible crossing place. The terrain across the river that the horsemen intend to enter is more remote, savage, and seemingly inhospitable. Trees near the far side of the bridge are broken and scarred. The path above leads those on foot through a rocky opening formed by craggy overhanging cliffs, whose extraordinary shapes are echoed in the arches of the bridge below.
Salvator Rosa, *The Broken Bridge*, c. 1640.

▲ **Primeval innocence**
Hidden within dark foliage, a satyr family, the male armed with a club, listen and wait anxiously. On the right, a woman in a red dress moves toward the forest as if about to enter it; behind her stands a naked man holding a long stick. The relationship between these two figures is unclear, but their intrusion threatens to disrupt the peace and primitive innocence of the satyr family's haven.
Albrecht Altdorfer, *Satyr Family*, 1507.

▼ Electrifying primitivism
First given the title *Surpris!* (*Surprised!*) when it was exhibited at the Salon des Indépendants of 1891 in Paris, this landscape by the French painter Rousseau depicts a tiger caught, as if electrified, in a tropical storm. The striped creature is both trapped and animated by the diagonal thrusts of the driving rain, the tree's branches, and the giant fronds. The evenly painted surface, distortions of scale, stylized outlines, and richly saturated blocks of colour give this fantasized jungle scene a dense, airless feeling.
Henri Rousseau, *Tiger in a Tropical Storm (Surprised!)*, 1891.

▲ Exotic and remote
Cotopaxi, known for its beauty and symmetry, is the second highest peak in the Ecuadorean Andes. On his second visit there the American painter Frederic Church was struck by the sight of its erupting volcano. Here he captures the effects of the sulphuric eruption as it colours the pale sky with huge clouds of brown smoke. This outpouring contrasts with the waters of a rocky chasm, which erode the land even as it is made. In this way the artist evokes the primordial processes of creation and destruction that take place across vast tracts of geological time.
Frederic Edwin Church, *Cotopaxi*, 1862.

The celebration of nature's violence and grandeur is usually seen as a product of the Romantic era of the late eighteenth and nineteenth centuries, which also saw the development of theories of the sublime. This was often defined in relation to beauty, from which it differed by evoking the more intense emotion of awe. Beauty might be found in the small, familiar, and friendly, but the sublime lay in the vast, the irregular, and the obscure. The period certainly saw a new enthusiasm for awe-inspiring landscapes and a proliferation of paintings of rocky caverns, plummeting waterfalls, erupting volcanoes, and towering cliffs, by artists such as Caspar David Friedrich (see page 169, *Cross in the Mountains*) and Thomas Cole (see page 169, *View from Mount Holyoke, Northampton, Massachusetts, after a Thunderstorm*). Cole's pupil Frederic Church, inspired by the German naturalist von Humboldt's description of the South American tropics as a subject worthy of a painter, found in Ecuador a landscape as wild and remote as possible and painted the erupting volcano *Cotopaxi*.

Primitivism

Wildness has often been associated with a simple way of life, close to nature. The uncontrolled, primeval forces of nature can be allied to powerfully erotic, lustful creative urges, free from social constraint and bursting with energy. This aspect of the wild is present in Altdorfer's satyr family, but it has a long history that continues today. In the early twentieth century it finds expression in the German painter Ernst Ludwig Kirchner's *The Amselfluh* in the figure of the lone cowherd with his horn set within distorted Alpine scenery.

Primitivism may be expressed in other ways. The deliberately naive style of the jungle scenes by Henri Rousseau match form to content. Rousseau painted his tropical jungles without ever leaving Paris and they are fantasies of uncivilized and wild places. In rejecting one-point perspective and naturalistic description he makes the unfamiliar appear more exotic, unexpected, and singular than it might otherwise be.

When analyzing the subject matter of paintings in which wildness is a dominant feature, writers have often attributed wild behaviour to the artist. Often they were wrong, but Kirchner never fully recovered from his traumatic experience serving in an artillery regiment in the First World War, and shot himself in 1938. The anguish of this artist's life, which is also reflected in his death, can, therefore, be associated with the wildness of his work.

▲ Simplification and distortion
Kirchner reduces the mountains and valleys of the Swiss Alps to curving, angular lines and bold, disruptive colours that are disturbing in their departure from empirically observed description. A cowherd blows his horn both in contrast to and in analogy with the strident, aggressive rhythms of his surroundings. Infused with ecstatic, though frightening, distortions, the landscape expresses powerful emotion.
Ernst Ludwig Kirchner, *The Amselfluh*, 1922.

Apocalyptic landscapes

▼ **The world torn apart**
This huge painting is one of three based on the Book of Revelation that John Martin painted at the end of his life. The artist closely follows the Bible's account of God's anger. Below this cosmic upheaval cower the people of the earth, from kings to slaves, who, the Book of Revelation tells us, "hid themselves in the dens and in the rocks of the mountains" attempting to hide from the wrath of God.
John Martin, *The Great Day of His Wrath*, 1851–3.

Although landscape painting has concentrated on the beauties and wonders of the world, painters have also depicted its destruction. The end of the world is described in terrifying detail in the last book of the Bible, known as both the Book of Revelation of St John and the Apocalypse. By extension, the term "apocalyptic" refers to prophecies of prodigious events that will bring about the end of the world and its replacement by another. In landscape painting, these prophecies have found expression in an emphasis on the destruction of the present world rather than the coming of a new world. Nowadays this catastrophe is usually seen as being caused by humans rather than by God.

The destruction of the universe as described in the Apocalypse seems almost beyond representation: ". . . there was a great earthquake; and the sun became black as sackcloth of hair and the moon became as blood; And the stars of heaven fell unto the earth And the heaven departed as a scroll when it is rolled together; and every mountain and island were moved out of their places." Indeed few artists have attempted to paint this particular extraordinary cosmic upheaval. A notable, if eccentric, exception is the nineteenth-century English painter John Martin. His awesome depiction of *The Great Day of His Wrath* follows the description in the Bible closely and is an outstanding example of the Romantic enthusiasm for the terrifying and awe-inspiring in nature.

The apocalypse in religious imagery

Although the moment of destruction has seldom been illustrated in paintings, the Apocalypse has been an extremely rich source of imagery for artists. It forms the basis of much religious imagery, including depictions of the Last Judgement (see pages 68–9), and it underlies such extraordinary scenes as Pieter Brueghel's terrifying *The Triumph of Death*. Here the Netherlandish artist combines the biblical vision of the Triumph of Death riding on his pale horse – seen in the painting's centre – with the northern European tradition of "The Dance of Death," in which a series of scenes showed death carrying off people from every walk and stage of life. In Brueghel's painting the army of death is shown as the great leveller as it overwhelms the land and sea. This consuming comprehensiveness, from which all flee in vain, is a feature of apocalyptic imagery. The panoramic viewpoint of both Brueghel and Martin underlies the universal significance of what they set before us. The theme of death stalking the land further makes the landscape itself horrifying, broken, barren, desolate, and bleak. The terrain is black, grey, brown, or red and devoid of lush, green vegetation.

In the twentieth century two world wars, the fearsome power of nuclear weapons, and, more recently, the degradation of the environment have led to paintings that have suggested that humans are destroying the world. The English painter Paul Nash's *The Menin Road* shows the barren waste of no-man's-land, from

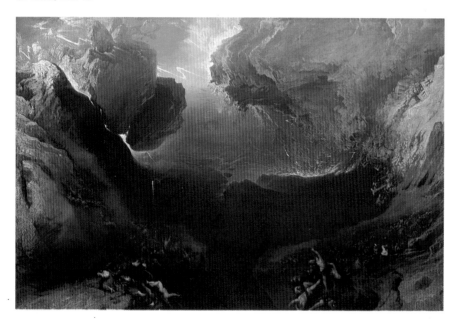

◀ **Multitudes encompassed**
To convey how universal and arbitrary death is, Brueghel combines a high viewpoint with a high horizon so that we have a panoramic view over both land and sea. He includes an encyclopedic compendium of different ways of dying, from passive acceptance to the opposite extreme, exemplified by the figure at the bottom right who futilely draws his sword against the overwhelming army.
Pieter Brueghel the Elder, *The Triumph of Death*, c.1562.

▲ **Painting beyond painting**
In this work, painted in the USA after Max Ernst was forced to leave Europe during the Second World War, the painter scratched through the oil paint to reveal brighter pigments beneath darker, superimposed surface colours. This technique, *grattage*, turns the act of painting into a more automatic process, open to subconscious impulse. It also created strange plants and beings which uncannily suggest the physical and ecological deformities of a post-nuclear era.
Max Ernst, *Europe after the Rain*, 1940–2.

◄ **The waste land**
Commissioned in 1918 by the British Ministry of Information, Paul Nash's bleak painting shows the devastating effects of the First World War. Tiny soldiers move on and are enveloped within land that has been laid waste. There are no dead people but among the pools of water lie an upturned helmet, blocks of concrete, discarded corrugated iron, tangled barbed wire, and an empty box, all of which testify to the destruction perpetrated on the land by modern warfare.
Paul Nash, *The Menin Road*, 1919.

which blasted trees rise in front of a sky lit by search-lights that parody the rays of a setting sun. The strange petrified wasteland of the Swiss Surrealist Max Ernst's *Europe after the Rain* was painted during the Second World War, to which its title makes clear reference. More recently in, for example, the work of the German painter Anselm Kiefer, artists have used apocalyptic imagery to sound warnings about the destruction of the planet. Such works are intended to shock us into awareness of the catastrophic loss that threatens humankind as a result of our past and continuing despoiling of the environment.

▶ **Endings, old and new**
Kiefer's fusion of woodcut, lead, oil emulsion, shellac, and photograph on canvas evokes, on one level, the scorched-earth policies of total war and, on another, the corruption of the soil and the death of forests caused by industry's emission of sulphur dioxide. The work's title also refers, though, to both the pollution of the world's seas and the saving of the Jews during the biblical Exodus and after the Holocaust.
Anselm Kiefer, *The Red Sea*, 1984–5.

Beyond the world

With the exception of Nash's *The Menin Road*, the apocalyptic visions represented here are inventions. However, beyond the imaginary and fantastic visions that they incorporate, they are all intentionally unnaturalistic, for they deal with things that supersede the world that we can see and know with our senses. They suggest nothing less than the transformation of matter into void, and perhaps they succeed in making this black emptiness vivid in more immediate and expressive ways than the written or spoken word can. But what is surprising is that these apocalyptic hallucinations are deeply rooted in both perceived reality and the conventions of landscape painting of the past. The compositions have high horizons, which serve to differentiate land from sky and land from water; they use devices of contrast, comparison, and juxtaposition to exemplify and amplify; and their basic unities and symmetries and their curves and horizontal and vertical lines are all framed within the rectangular and horizontal format of the "landscape" view, which, for centuries, has been the recognized and established format used by artists in the Western world to depict the natural world.

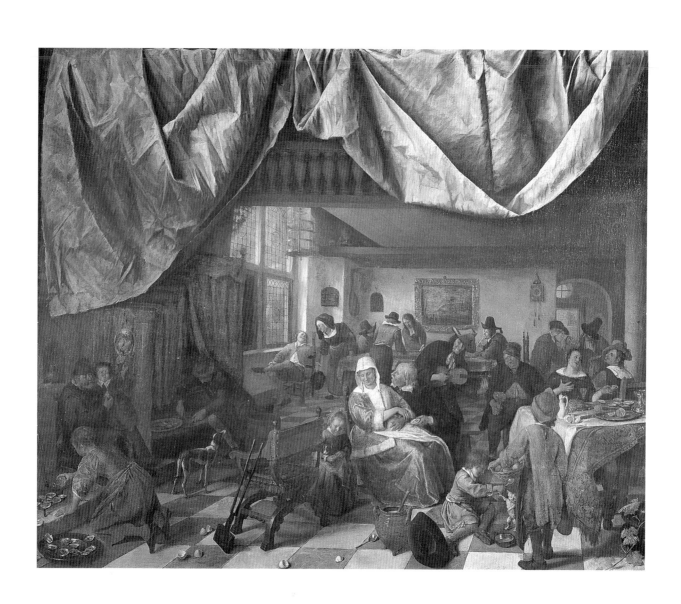

" . . . however much we may love general
beauty, as it is expressed by Classical
poets and artists, we are no less wrong
to neglect particular beauty,
the beauty of circumstance and
the sketch of manners."

Charles Baudelaire, "The Painter of Modern Life," 1863

Genre

► **The months**
This fifteenth-century fresco from the Palazzo Schifanoia in Ferrara, Italy, draws on mythology, astrology, and history. The vineyard workers are carefully observed; the nature of their task reveals which month is depicted. Scenes showing rural labourers were popular in medieval manuscripts, functioning as calendars. Later they provided detail in Renaissance paintings, their labours often imbued with religious significance.
Francesco del Cossa, *The Month of March* (detail), c.1469.

It is a basic human desire to represent one's own reality, and depictions of commonplace activities were popular as a form of decoration at least as early as the sixth century BC. Vases, pots, wall paintings, and sculptures from the ancient Greek and Roman civilizations took as their subjects sport, love, business, and pleasure. This depiction of scenes from everyday life is known as genre painting. The word "genre," which derives from the Latin word *genus*, meaning "kind" or "variety," means different things in different centuries, and it is often used now to refer to a literary or artistic style or type.

With reference to painting, the term was first used to describe those works which dealt with subjects considered to be of lesser importance – ordinary pastimes, animals, landscapes, and still lifes – rather than heroic deeds taken from history and mythology, the lives of saints and prophets, or the portraits of rich clients. By the end of the eighteenth century, however, the use of the word had been refined and was applied in particular to works that depicted familiar or rustic life. During the nineteenth century it was in common usage for paintings that showed scenes of everyday life.

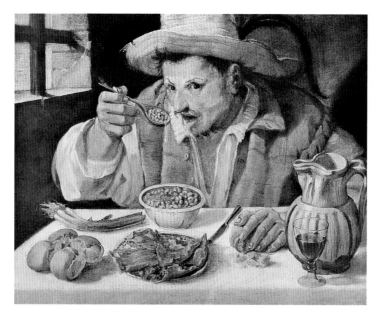

► **Capturing a moment**
The Carracci family founded a school for artists in Bologna, Italy, and were influential in the painting of everyday subjects. In this work by Annibale the foodstuffs are represented with quick brushstrokes in a direct, naturalistic way and the unidealized man is caught mid-action in an almost comical fashion.
Annibale Carracci, *The Bean Eater*, 1580–90.

Classical writers and thinkers argued about the moral value of popular themes in painting, many suggesting that the highest kind of art should represent values and ideals that are beyond the realm of the ordinary. This superior attitude toward painting daily life persisted until the nineteenth century. Pictures of genre subjects remained popular, yet were considered to be less meaningful or of less consequence than paintings of religious or mythological subjects.

The changing nature of genre painting

This exploration of genre painting looks at developments that took place over time and highlights the different themes that have emerged over the centuries. These themes help to reveal changes in attitude toward the painting of everyday life and show how social climates in Europe and America have influenced both the choice of subjects and the relative popularity of the works. Images of food and drink, and of leisure and labour, for example, were as common in the nineteenth century as they had been in the sixteenth century, and they share many characteristics. Yet the reasons they were chosen, the techniques artists employed in painting them, and the public for which they were intended were often quite different.

No matter how important social attitudes and preoccupations are, art is never only about its social context. Some of the works in this chapter were never intended for public viewing, but rather helped artists to practise their skills of observation and imitation. Many show the delight that artists took in harmonious compositions, varieties of texture and the effects of light, and in using subject matter that was familiar and close to hand.

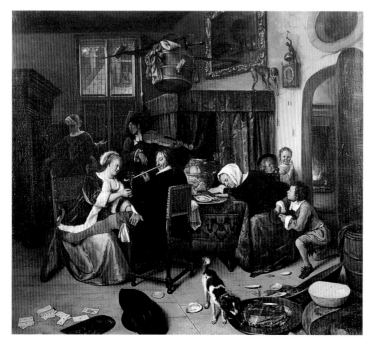

▲ **A morality tale**
Genre painting flourished in the seventeenth-century Netherlands and this work embodies many of its characteristics. It contains moral examples, naturalistic description, and symbolism. Steen's humorous scenes of daily life enabled him to show his skill at painting textures and light.
Jan Steen, *The Dissolute Household*, c.1660.

◄ Physical labour
This peasant, painted by the French artist Millet, is an example of direct observation and realism. In the conservative Parisian art world, subjects such as this created a great outcry, being seen as tokens of advocacy for the rural proletariat and were thus excluded from many state-run art exhibitions. This roughshod and brutish peasant is not viewed with the humour evident in genre works from previous centuries such as Carracci's *The Bean Eater*.
Jean-François Millet, *Man with a Hoe*, 1860–2.

By its very nature, genre painting takes contemporary reality as its subject. These scenes of everyday life can even be used as documentary evidence; in Dutch seventeenth-century genre paintings, for example, we can learn a great deal about costumes and daily practices of the time. However, it is important to remember that even those paintings that most brilliantly observe nature are still representations. It would be a mistake to imagine that real life at the time was exactly how it appears in genre works.

Genre subjects

Many genre paintings explore our sensual experience of the world, especially those that celebrate food or music. It is through our senses that we experience the world around us. Higher ideals and intangible or conceptual subjects were more often explored in history paintings, which showed heroic deeds or lofty aspirations for an ideal world and portrayed characters suffering and sacrificing. Genre painting has always been more rooted in the contemporary world. It can allude to the intangible or to the more "universal" values through the use of signs and symbols or by showing archetypal situations within an everyday setting. Yet it tends to concentrate less on the extremes of human behaviour and more on commonplace experience familiar to both artist and viewer.

▲ Street life
Boccioni was a member of the Italian Futurist group, which loved speed and city life. Here he conjures up an exuberant street festival, contrasting the interior world of the woman on a balcony with the swirl of colour and movement outside. He gives a sense of different kinds of space through intersecting lines and a rush of shapes and colours, creating a dynamic energy that draws the spectator into the whirl of modern life.
Umberto Boccioni, *The Street Enters the House*, 1911.

Experimentation

Finally, many of these genre scenes allow artists freedom to experiment with still-life subjects. Different textures, materials, and surfaces can be explored, a freer style and more spontaneous brushstrokes employed, or the effects of light and shadow playing over familiar objects depicted. History painting often refused to pay attention to the particular or the detail, feeling that it detracted from the intellectual status of the subject. Genre painting, on the other hand, as this chapter so clearly illustrates, delighted in it.

▲ Modern life
The American Pop artist Roy Lichtenstein drew on images from advertising or, as here, comic strips to create art about artificiality rather than reality. Stressing form and colour, he used simple contrasts and print processes taken from comic books. Scenes are stylized and the action is frozen; the ironic tone of the artist means that we often find his striking images of modern life funny rather than emotive. The couple enclosed in their car look as if they have just argued: the feeling of claustrophobia is instantly recognizable.
Roy Lichtenstein, *In the Car*, 1963.

The poor

▼ **Charity**
Sweerts was one of a group of painters from the Netherlands who settled in Rome. Known as the *Bambocciate* (meaning "little dolls") after the nickname of one of their members, they specialized in painting genre scenes for Roman collectors. Although they painted ordinary people, they used geometric compositions and effects of light and shadow to create figures with a solid monumentality. This Roman street scene is taken from a series known as the Seven Acts of Mercy, which shows religious deeds taking place in a contemporary context. **Michiel Sweerts**, *Feeding the Hungry*, 1645–50.

During the sixteenth and seventeenth centuries, genre painting generally depicted scenes of the working routines and leisure pursuits of the very poor. The typical patrons and buyers of these "low-life" subjects were upper or middle class. This pronounced contrast between the themes portrayed in such works and the social status of their owners persisted throughout most of the history of this thread of genre painting.

Paintings of the poor exploited the curiosity of one class about another. Scenes that patrons might shrink from in real life could provide great pleasure in representation. If a painting included humorous peasant types, often as caricatures, it could work as comedy. Aristotle, the Greek philosopher and dramatist, defined comedy as showing us people who are lesser than ourselves. If we can look down on them, then, according to his theory, we can also laugh at them. A comic or ridiculous note in a painting of the poor probably enhanced the viewers' enjoyment by encouraging feelings of moral and social superiority.

Drawing from nature

In Catholic countries such as Italy or Spain, genre painting was an antidote to the grandeur of Renaissance and Baroque church art. Leonardo da Vinci was among the Renaissance masters who urged artists to go into the streets and draw what they saw, and his advice influenced later painters who sketched from life to improve their observational skills and artistic techniques.

▲ **Summer in the fields**
Independent paintings of peasant activities at different times of year marked a departure in Western art because they were painted without religious pretext. Brueghel's pictures take country life, its labours and pleasures, as their main subject. The peasants are shown here in harmony with the seasons, and there is no poverty or hardship. The balance between work and rest, the bright tones, and the peaceful background combine to present a pleasant and ordered vision.
Pieter Brueghel the Elder, *The Harvesters*, 1565.

Annibale Carracci and Caravaggio, the two great innovators of late sixteenth and early seventeenth-century Italy, worked directly from what they observed in the public places around them. Both artists had a variety of motives for depicting everyday life. Some of Carracci's work drew upon the bawdy subjects and erotic humour common in literature at the time, while Caravaggio's genre work may have had moralizing intentions. More importantly, however, they paved the way for a greater naturalism in art.

The genre paintings of Diego Velázquez, the most famous painter in seventeenth-century Spain, allowed him to tackle quintessentially Spanish subjects while

▲ **The virtuous poor**
Louis Le Nain and his brothers helped popularize genre scenes in France. The peasants here may be ragged, but noble overtones are still conveyed. The young girl holds a baby, reminding us of the Madonna and Child, and the beautifully painted yet meagre rations suggest the Eucharist. The fire adds a warm atmosphere, and the music hints at a happy mood despite the humble surroundings.
Louis Le Nain, *Peasant Interior with an Old Flute-Player*, c.1642.

also depicting different textures, materials, and effects of light. His *bodegones* – kitchen or tavern scenes – function as a record of time and place, ennobling the people who inhabited them and showing Spanish produce (see page 202, *The Waterseller of Seville*). Representing the poor as proud national types shifted the emphasis in genre painting away from the purely comic.

Morality in genre painting

Comments on morality were important in genre scenes. The poor were often shown in one of two guises: depraved and foolish or sanitized and deserving. Northern European artists tended more to the former, portraying rough and often rowdy peasants in tavern brawls and brutish quarrels. The scenes were comic, but were also intended as a warning against the dangers of excess and of animal-like behaviour. At whom these warnings might be directed is not clear; the drunk and riotous subjects were certainly not the intended market for these paintings.

A more sentimental image of the poor is typified by the works of the seventeenth-century Spanish artist Murillo and his French contemporary Louis Le Nain. We are shown the needy and deserving poor making the most of humble surroundings and ensuring that, despite their poverty, their prettified children learn the difference between right and wrong. This idealized vision continued into the eighteenth century – Murillo's paintings were particularly popular in Britain, influencing Gainsborough's pictures of rosy-cheeked urchins and sanitized rustic dwellings. In eighteenth-century France, certain strands of philosophical thought suggested that civilization was a corrupting influence, and that the poor were closer to man's "natural" state. Such beliefs influenced aristocrats to play at being poor and may explain the taste for such subjects in art.

Scenes of the poor were often based on Biblical texts. Charity is the virtue most stressed by Christ, and the "blessed poor" or the "meek inheriting the earth" were often illustrated by genre painters. The Roman patrons who commissioned works like Sweerts's *Feeding the Hungry* used them as meditations on the necessity of charity in society, while in Victorian Britain, social realists such as Sir Luke Fildes tried to exploit the power of art to bring about social reform.

The general lack of unrelenting realism should not come as a surprise. The art-buying public would perhaps have preferred to imagine the peasants living and working in the conditions portrayed, reinforcing their sense of social stability. These paintings were intended for enjoyment as well as for meditative or moral purposes – the realities of poverty, hunger, and illness were not generally seen as subjects for aesthetic contemplation.

Virtue

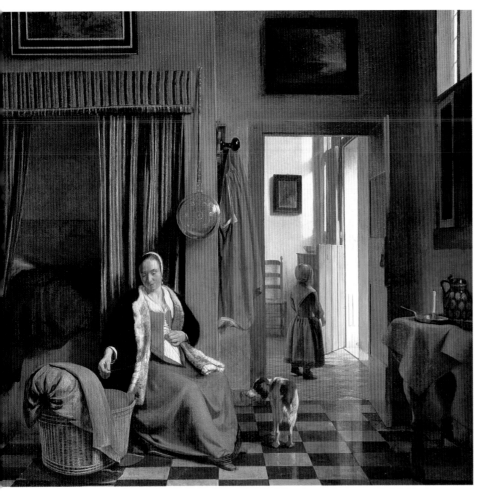

The intimate family unit was rhetorically central to the increasingly middle-class Dutch society of the seventeenth century. Here a mother sits by a cot while the dog – a traditional symbol of fidelity – looks on. The toddler stands in the background, looking through the open door that represents the outside world. De Hooch has reinforced the tender atmosphere by using simple lines and forms, while the elaborate perspective emphasizes the space and solidity of the domestic interior. The subject may be read as an example of "good practice," but the artist is not only concerned with moral qualities. He obviously delighted in the play of light over the interior, reflecting off the pan and the floor tiles to display the quiet beauty of everyday scenes and objects.
Pieter de Hooch, *The Mother*, 1661–3.

▼ **Devotion to work**
The young woman applies herself intently to her needlework, revealing her industry and accomplishment. Although the painting contains few objects, Vermeer, a Dutch contemporary of de Hooch's, has depicted them with as much attention to detail as the lacemaker herself gives to her work. We feel as if she does not know she is being observed and at any moment could look up. The colours are muted and calm, and there are no sharp edges or rough contours – the style of painting emphasizes the tranquillity of the subject.
Jan Vermeer, *The Lacemaker*, c.1669–70.

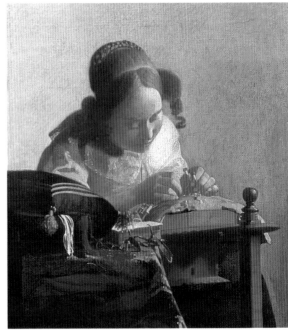

The seventeenth century saw the introduction of a hierarchy of thematic genres in painting that was to endure for two centuries. Biblical and Classical narratives were placed at the top, favoured for their edifying effect. According to much theoretical and philosophical thought at the time, art had a moral purpose. If examples of heroic behaviour or great deeds were depicted, it was thought that the viewing public would be morally elevated, inspired by the scenes of courage, selflessness, and suffering before them. Portraits, landscapes, and genre paintings came much lower. Tied to the real world, they were felt to be less intellectual, more about the depiction of reality than the ideal. Even so, many genre paintings contained didactic messages, often through the depiction of idealized contemporary scenes and of individuals whose behaviour was commendable.

The market for genre paintings

Those who bought and enjoyed genre paintings were not necessarily from the same social groups as those who chose grand history paintings. The decline of the Catholic Spanish nobility and their subsequent ejection by the predominantly Protestant Dutch in the seven-teenth century resulted in a drop in the market for large-scale religious and Classical works. Genre scenes flourished, along with local landscapes and portrait painting. The Dutch, especially the emerging mercantile gentry, took great pride in their own country, and in its people, and wanted to support their own national painting rather than look to the past or to Rome for inspiration.

Except for portrait painters, artists no longer worked solely to commission. They now had to produce works that would appeal to the new market, and the customer would decide whether or not to buy. The size of paintings was also affected: most Dutch genre scenes are small in comparison with history paintings. A contemporary source tells us that "butchers and bakers" and "blacksmithes and cobblers" had paintings in their houses and undoubtedly their tastes and homes would have been different from those of the nobility.

Similarly, genre painting in eighteenth-century France and nineteenth-century England was produced for predominantly middle-class buyers. Most of these new patrons did not know Greek or Latin, and such paintings reflect the world of proverbs and idiomatic speech, of popular theatre and daily tasks.

Virtue in daily life

Placing moral messages in contemporary settings allowed them to be more instantly appreciated by their viewers. The characters depicted are generic types – the mother, the governess, the labourer, the kitchen maid, the innkeeper, and so on. They function not as individuals but as vessels bearing required meanings for specific contexts. Scenes are set in kitchens and taverns, in houses, and school rooms, and on recognizable streets. The use of modest characters and settings made the paintings seem more realistic and also made it more likely that that they would be understood by a broader stratum of society.

Women's domestic abilities were considered extremely important by the middle class, so many moralising genre scenes depict women absorbed in household tasks. These women are shown devoted to duty and caring for their work, the implication being that those looking at the painting should do the same. Often children are learning a lesson or being taught a simple task. Education is a common theme: if children are not educated in the ways of right and wrong, a society might fall into chaos and immorality.

Men were shown labouring in the fields or working in the streets and, like the women, had gentle expressions or smiling faces, indicating a well-ordered society in which all knew their place and were content with their lot. Although an overt religious message in such paintings was rare, their subjects can still be interpreted as having a spiritual tone: in the seventeenth-century Dutch Republic, contentment in labour and industry were essential to the Protestant work ethic. Victorian painters also often chose subjects showing the improvement of society through work, as in Ford Madox Brown's *Work*, and the moral value of labour was much discussed by reformers and critics at the time.

Many genre paintings which depict virtuous examples are also very serene and ordered. Spaces are uncluttered and rooms neatly arranged. The objects depicted are often simple, geometric, and smoothly rounded, balancing the composition and making the paintings easy to understand. As is seen in Ford Madox Brown's *Work*, painters are often concerned with perspective. A convincing depiction of real space and well-calculated perspective made the paintings seem more true to life by contemporary standards. The satisfaction of a well-ordered composition suggests to the viewer a well-ordered world. The harmonious use of colour and the tranquil atmosphere created by gentle lighting and muted colour also helped to suggest how desirable the subjects depicted were.

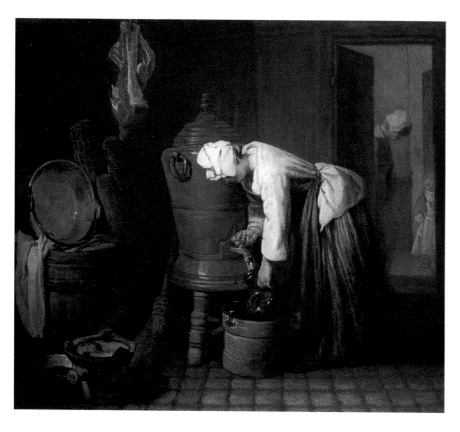

▲ The serving-maid

The French artist Chardin explores various textures and reflections in this painting of a serving-maid drawing water from a copper cistern. The depth created by the open door makes the space more believable. It is unclear how much Chardin intended his work to provide a moral example. Subsequent viewers have certainly seen virtuousness and humility in his observations of daily routine, just as they see the transience of life reflected in his scenes of children playing. Unlike those of the Dutch genre painters, his clients were mainly the aristocracy, who also enjoyed paintings in the extravagant Rococo style.

Jean-Baptiste-Siméon Chardin, *The Cistern,* 1733 or later.

▶ The heroic worker

The significance of the characters in this painting depicting the virtue that comes from industry was explained in a pamphlet by the artist. The hard-working labourers, one clenching a rose between his teeth, depicted as a noble ancient hero, contrast with the idle rich on horses behind. The two gentlemen standing on the right are middle-class intellectuals of the day, Thomas Carlyle and F. D. Maurice. In Brown's vision of society it is these "brainworkers" who maintain a thriving social system. In addition, the frame is decorated with verses from the Bible about the moral significance of hard work.

Ford Madox Brown, *Work,* 1852–65.

Vice

◄ **A fool in love**

This painting shows a lecherous old man behaving in a ridiculous way with a young woman. She distracts him with her charms, and by cupping his chin with one hand, she manages to grab his purse with the other. Unequal couples were a popular theme in sixteenth-century northern European art and literature. The cards and coins on the table allude to gambling, the foolishness of which was also a favourite topic for satire. For the old man's face, Massys has used drawings of a distorted face by Leonardo da Vinci, who also explored grotesque subjects with moral implications.

Quentin Massys, *The Ill-Matched Lovers*, c.1520–5.

▼ **The dangers of drink**

This work takes a comic look at the effects of drunkenness: the mother is slumped by a bowl of burning coals while her children steal her purse, throw roses at a pig, and feed the dinner to a kitten. The serving girl sprawls across the steps, encouraging a parrot to a glass of wine. Parrots symbolized the idea of learning by example (they can only copy what is said to them), making the viewer reflect on the bad examples on display. The beggar's crutch and judicial birch in the hanging basket hint at the family's fate, while the half-eaten loaf resembles a skull, acting as a symbol of vanitas.

Jan Steen, *The Effects of Intemperance*, 1663.

Paintings which convey "wrong" behaviour in order to invite condemnation of their protagonists do so in ways quite different from those used to depict virtuous subjects. They often make use of humour, proverbs, puns, and slang. In most instances these paintings also employ signs and symbols to indicate what has gone awry. Such suggestions can be subtle, inviting the viewer to work out what exactly is improper or wrong. They also avoid potential difficulties. For example, an explicit depiction of the loss of virtue or virginity (a common theme in paintings of this kind) would be too shocking and would fail to provide the moral message considered intrinsic to the status of genre painting as art. If a painting containing the epitome of social evil had nothing to redeem it artistically or intellectually, but instead merely disgusted its viewers, there would be very little pleasure to be gained from looking at it. Alternatively, some viewers might have derived a certain thrill from such vicious examples. Such works can titillate as well as condemn.

Objects of satire

Even in Classical times, foolish behaviour was ridiculed in literature and in the theatre. Satire or satirical comedy presented human folly – and its attendant political, social, and moral problems – in order to make people laugh. At the same time it implicitly warned against such behaviour, its foolishness, and its consequences. Literary satire, such as Erasmus's *In Praise of Folly* (1509), was often used as a source by such artists as Quentin Massys, whose purpose was as much to delight as to instruct their viewers. Love and marriage were particularly common themes. Moral ugliness was often conveyed in paint through physical ugliness, and harsh caricatures were a common way to show people making fools of themselves over love.

In *The World as a Stage (The Life of Man)* (see page 192) the seventeenth-century Dutch painter Jan Steen presents an interior with a curtain draped at the front, perhaps alluding to the tradition of comedy in the theatre. This might suggest realism, reminding us of the great competition between Zeuxis and Parrhasius (see page 224), while also, paradoxically, hinting at artifice and theatricality. More specifically it reminds us that art is representation and should be viewed with some

The end of a family
This is the first in a series of three paintings warning of the effects of adultery. The husband has intercepted a love letter to his wife, now crushed under his foot. She pleads for forgiveness, but her status as a "fallen" woman, literally and figuratively, means that he can cast her out (symbolized by the open door shown in the mirror and the picture of Adam and Eve that hangs to its left). The two children build a house of cards, representing instability, on top of a novel by the author Balzac, suggesting the artist's disapproval of novels with adulterous heroines.
Augustus Leopold Egg, *Past and Present, No.1*, 1858.

Broken eggs
A young girl sits by a basket of broken eggs, symbolizing the loss of her virtue to the man behind. Her mother looks on in dismay and a small boy vainly attempts to patch an egg together, showing the innocence of childhood. A bow and arrow beside the boy remind us of Cupid and the mischief he causes. Despite the contemporary interior and artistic influences, this eighteenth-century French work was made for exhibition and uses Italian costumes with poses and gestures typical of history painting,
Jean-Baptiste Greuze, *The Broken Eggs*, 1756.

A marriage of convenience
The first in a series of six paintings about an ill-matched couple: the two fathers – one with money and one with an aristocratic title – make arrangements while the prospective bridegroom primps before a mirror. His pathetic fiancée sits listlessly behind him, horrified at being married to a vain playboy when she loves the silver-tongued lawyer to her left. The room is cluttered with objects holding wider meaning: the dogs linked at the throat signify the irrevocable bond being sealed; the black spot on the groom's neck indicates syphilis. Hogarth refers to popular expressions and foolish fashions, commenting on follies typical of his own society.
William Hogarth, *Marriage à la Mode: 1, The Marriage Contract*, before 1743.

detachment, as one might view a play. Disorder and disharmony here reign pictorially as well as morally. The scattering of oyster shells in the foreground gives the scene an untidy appearance: the world of those who set a bad example can be a cluttered and chaotic place. The shells also refer to the reputed aphrodisiac powers of shellfish, suggesting sexual immorality, and all the people display a coarse manner, driven by base instincts. Other common symbols for the loss of virginity in such paintings are cracked eggs, dead birds, jugs without lids, spilt liquids, and broken vessels.

A close look at the upstairs balcony in *The World as a Stage* reveals a young boy hiding, blowing bubbles, and a human skull lying next to him. These are vanitas symbols (see pages 228–9), activities or objects that hint at the transience of human life and therefore implicitly at the need for religious belief. Many genre works use objects to suggest life's brevity and fragility – for example, a child building a house of cards, playing with a flimsy shuttlecock, or blowing bubbles.

Reinventing the genre

In the eighteenth century, the English painter Hogarth invented a new theme for his work, the "modern moral subject." He painted several series of such paintings telling tales of improper behaviour and its dire consequences. His paintings are loaded with symbols, leitmotifs, and hints of the bad character of the protagonists. Even though the most horrible events arise, the paintings are still amusing, perhaps because we have little sympathy with the characters, who are all rendered ridiculous in some way. This links back to Aristotle's ideas about comedy – viewers are able to laugh since they do not identify with the subjects.

English artists in the nineteenth century continued Hogarth's theme, perhaps with less humour. They showed scenes of gambling, adultery, and prostitution that were not intended to make the public laugh but were serious attempts to warn about the evils of licentious behaviour. Today they can seem judgemental or sentimental, but they do function as social documents. They tell of a society with a strict moral code and make us aware of the potential pitfalls for anyone stepping outside the accepted codes of behaviour.

Today we are less likely to think of art as having a moral impact. However, in 1997 the "Sensation" exhibition of work from the Saatchi Collection by young British artists caused an outcry. Some works in the exhibition showed children engaged in sexual acts and bodies dismembered by war. One artist, Chris Ofili, depicted the Virgin Mary encrusted with elephant dung and with pornographic photographs worked into her clothing; another, Marcus Harvey, made a portrait of a notorious child-murderer out of the handprints of children. Both works had to be protected by guards, the first in New York, the second in London. Many still respond to paintings on moral grounds.

Food and drink

Eating and drinking are common to everyone across all centuries, cultures, and classes. Very different attitudes and social concerns can be conveyed through representations of these universal necessities. Many paintings depicting people eating and drinking convey a moral message – for example, peasants praying over their meagre rations and teaching their children to do likewise. Conversely, paintings of great banquets and parties can celebrate the pursuit of pleasure with merry indulgence and with little concern for morality.

The five senses were common subjects in painting from medieval times. In painting, all the senses with which we experience the world must be conjured up through the medium of sight alone. This is known as synaesthesia – a sensation of one kind being suggested by experiencing another. Scenes of eating and drinking in paintings often strike a moral note about indulging the senses, cautioning the viewer not to be driven by sensuality. Often artists who painted these moralistic scenes would sharpen their message by creating a powerful sense of reality and of the appeal of such indulgences.

Food and drink can have other symbolic meanings in painting. Bread and wine often refer to the sacrament of the Eucharist; oysters have a sexual connotation in Dutch painting; the bottles and fruits on the bar in Édouard Manet's painting *The Bar at the Folies-Bergères* suggest the importance of consumer goods to an increasingly mercantile society. Finally, foodstuffs and containers provide the opportunity to include still-life elements in genre paintings, allowing artists to enjoy various textures and shapes, and show off their ability to observe and represent.

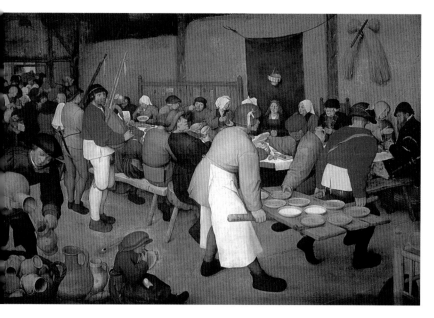

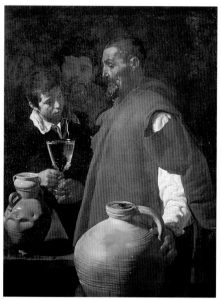

◄ A noble pursuit
The waterseller, a proud and monumental figure, hands a glass to the boy with solemnity. The subject and colours are typically Spanish and represent the dignity of the nation. Velázquez has used the painting to observe surfaces, suggesting the glass of water by white highlights. The water dripping down the side of the carafe is consummately painted, stimulating our senses of taste and touch as well as sight.
Diego Velázquez, *The Waterseller of Seville*, 1623.

▲ A village feast
The empty vessels to be filled by the serving boy on the left strike a comic note, referring to the amount of alcohol consumed by the rosy-cheeked peasants. This Netherlandish painting has a beautifully observed child at the front, blissfully unaware and obviously content. The colour red runs through the composition, suggesting good cheer, and the simple shapes of the costumes and furniture make the scene pleasant to look at, while the plentiful food and drink make it an ideal world for its inhabitants.
Pieter Brueghel the Elder, *The Peasant Wedding*, c.1568–9.

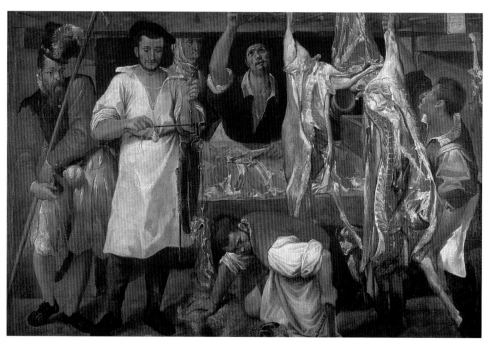

◄ Painting flesh
The most famous genre scene by the sixteenth-century Italian painter Annibale Carracci, this work is as large as a grand history painting. As both Annibale and his brothers advocated drawing from life, it has been suggested that this is an allegory of those aims – the butchers are like the brothers, while the Italian term for the red meat on display is "viva carne," which also means "live flesh." The message of truth to nature gives this immediate and fresh scene a more complex artistic meaning.
Annibale Carracci, *The Butcher's Shop*, early 1580s.

▶ The Five Senses

While in Rome, Ribera, a Spanish artist working in Italy in the seventeenth century, painted a series of the five senses, departing from Renaissance tradition by using working-class models. Ribera was a talented draughtsman, praised for his ability to copy accurately from nature, obvious here in the tactile qualities of the foods on the table. He also used dramatic contrasts of light and dark, suggesting the influence of Caravaggio and his followers.
Jusepe de Ribera, *The Sense of Taste*, c. 1614–15.

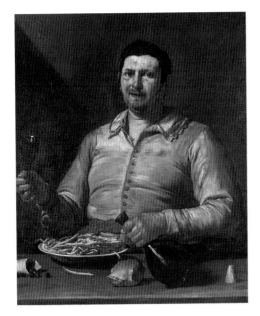

▶ Breaking bread

This painting, unlike many by its Dutch artist, does not show comical or reprehensible behaviour, but rather an intimate scene of peasants praying before a sparse meal. The bread reminds us of the Eucharist, and there is a didactic text on the wall which reinforces the idea of instruction and morality. The key on the wall is perhaps a reference to Heaven – a suggestion that humility, goodness, and prayer are essential to gain entrance there.
Jan Steen, *Grace before Meat*, 1660.

▼ Aristocratic revels

Commissioned by King Louis XV for his own dining-room at the palace of Versailles, this painting by the eighteenth-century French artist Lancret, shows aristocrats feasting in beautiful parkland surroundings. They have obviously been indulging for some time, and the foreground is strewn with broken china. The central figure standing on the table is crowned with vine leaves, a reference to Classical paintings of Bacchus, the god of wine.
Nicolas Lancret, *The Breakfast of Ham*, 1735.

▶ The Folies-Bergères

A densely packed and noisy bar is reflected in the mirror. Drinks are laid out to tempt customers. Are we to imagine the barmaid herself as a commodity? She may or may not be a prostitute, an uncertainty of which viewers would have been aware. The man in the reflection looms closer to her than he could do in reality. Are we seeing a different moment, or her potential "fate"? Her expression reveals little, and the painting plays with these and other ambiguities, highlighting the uncertainty of life in Paris at the time.
Édouard Manet, *The Bar at the Folies-Bergères*, 1881–2.

Leisure

Peasants carousing and dancing to comic effect were a common feature in the genre painting of Northern Europe in the sixteenth and seventeenth centuries (see page 202, Pieter Brueghel the Elder, *The Peasant Wedding*). Scenes showing men and women obviously enjoying themselves are meant to amuse the viewer as well. In eighteenth-century France the representation of lower-class entertainment was not as popular as it was in the Netherlands, even though Dutch genre paintings were collected by aristocratic and middle-class patrons. As the pomp and ceremony of the Baroque style fell from favour, the more light-hearted Rococo style took its place, characterized by works reflecting the gaiety, frivolity, and voluptuousness of the period. Rococo paintings appear spontaneous. Figures are graceful, nature is allowed to run wild, and loose, flowing lines and gay colours abound.

The aristocracy at play

Informal scenes showing the rich at play are closely associated with the Rococo style. Influenced by the pastoral tradition of sixteenth-century Venetian painting, as seen in the work of such artists as Giorgione and Titian, genre painting took the leisured lifestyle of the French aristocracy as its predominant subject. Watteau, Boucher, Lancret, and van Loo based their works on the idylls of a Golden Age, setting them in shady woods or beautiful parks. Couples stroll, sing, and dance in this ideal world, far removed from real life. They often wear theatrical costume – many of the scenes draw on theatre, such as the popular Italian Renaissance comedies, known as the *commedia dell'arte*. The hedonism of court life, particularly under King Louis XV, is captured in paintings of parties, balls, and picnics. Rococo genre scenes were extremely popular with both aristocratic and bourgeois patrons, and were often engraved, making them available to a wider public.

Aristocratic pursuits
Hunting was King Louis XV's favourite sport, and this subject, the *repas de chasse*, was invented especially for him. Fashionable ladies and gentlemen rest after a morning's hunting while servants attend to horses and prepare food. The brushwork, particularly in the foliage, is typically Rococo, with light, feathery strokes and no sharp edges. Van Loo uses strong primary colours for clothes. Engravings of this subject were very popular – aristocracy and bourgeoisie were quick to emulate their ruler's tastes. **Carle van Loo**, *The Rest During the Hunt*, 1737.

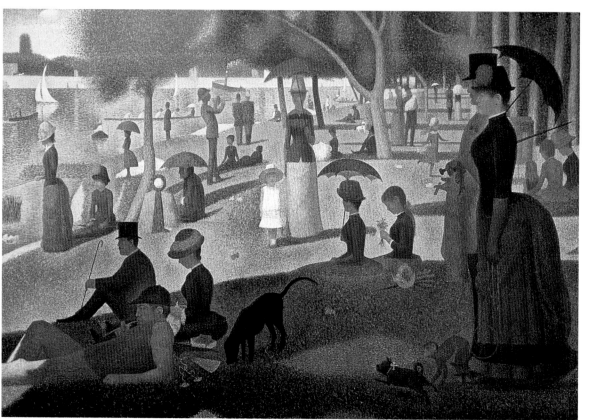

Sunday afternoon
At first sight, this seems to be a harmonious representation of leisure in late nineteenth-century France. Sun falls on people strolling and lazing on the river bank. The atmosphere is calm and still. However, when we look more closely, the work reveals Seurat's concerns about contemporary society. Figures seem stiffly poised and mechanically positioned, and there is no social interaction. Faces are generalized. The minute dots of which the painting is comprised suggest an absence of feeling – technical accuracy, scientific precision, and skilled observation have combined to create a detached mood. Leisure pursuits are said to reveal society's true nature. Seurat presents a troubling glimpse of the new, depersonalized industrial world. **Georges Seurat**, *La Grande Jatte*, 1884–6.

Hockney moved from England to California in 1963, seeking the escapist pleasures of swimming and sunbathing in an almost idyllic world of palm trees, cocktails, and beautiful young men. With its strong colours and geometric forms, the painting appeals to our senses, evoking the ripple of cool water, the heat, the bare skin, and the beauty of the surroundings. The smoothness and brilliance of the acrylic paint reinforce the basic nature of the pleasurable experience. Many of Hockney's swimming-pool scenes were based on snapshots – records of real experiences reproduced on canvas. **David Hockney**, *Portrait of an Artist (Pool with Two Figures)*, 1972.

▶ **Social critique**
The German artist Max Beckmann captures the atmosphere at a rich high-society soirée in Paris. Each party-goer is a caricature, and the thick black outlines give the impression of a spontaneous charcoal-like sketch. Just as this rough style contrasts with the polish and veneer of the party, the grotesque faces contrast with the elegant clothing of the party-goers, who push against each other in the cramped space. Most seem not to notice one another, and certainly no one is paying any attention to the singer in the background. This society is shown as fragmented and hypocritical. **Max Beckmann**, *Paris Society*, 1931 (reworked 1947).

These paintings showed activities in which only a privileged few could hope to participate. The extreme social divisions in France led to growing unrest among the peasants and middle classes, culminating in 1789 with the French Revolution. The Rococo style had already begun to disappear in the latter half of the century and was succeeded by the Neoclassical revival – scenes of heroic deeds from ancient history replaced the frivolous activities of aristocrats at play. Many critics labelled Rococo immoral and degenerate, a "loose" or "careless" style appropriate to a purely pleasure-seeking society.

Escaping everyday life

Scenes of people at leisure can provide delightful subjects for paintings. A party, whether opulent and elegant or basic and rowdy, allows the artist an opportunity to create a dazzling display of costumes, glittering surfaces, and sumptuous settings, or a good, old-fashioned get-together. Such paintings can create a nostalgia for good times remembered, or an Arcadia, an ideal world where life is less complicated and pleasures come unencumbered with moral warnings or unpleasant consequences. Even in the twentieth century, leisure scenes often focus on the sensual pleasures in life, as with David Hockney's paintings of swimming pools.

The bright colours of Impressionist scenes can suggest the gaiety and liveliness of people enjoying their free time; the swirl of line and colour can also convey the hazy atmosphere of crowded, smoky bars or packed open-air restaurants. The rebuilding of the centre of Paris under Baron Haussman in the nineteenth century led to a profusion of social spaces, especially broad boulevards lined with pavement cafés. Impressionist paintings celebrated the new diversions. Scenes of café-concerts, theatres, and operas reflect a world where sensual and visual pleasures dominate. People view the world around them and are themselves observed. In view of the destruction wrought by the Franco-Prussian War and the Commune of 1870–71, many Impressionist works can be read as a record of the rebirth of leisure.

In general, the colours that artists use in paintings of leisure scenes are bright and cheerful. Complementary colours bounce off each other; brilliant hues and strong primary colours are employed. If an artist introduces dark clouds or an overcast sky, or depicts a party where some of the participants seem to be less than happy, there may well be a symbolic meaning. Leisure scenes are usually about an ideal world where the weather is always fine, providing a touch of escapism in a more mundane reality. Any artistic attempt to burst the bubble is usually making a specific and forceful point about society, as can be seen in the works of Seurat and Beckmann.

Rural life

The nineteenth century saw the rise of industrialization, the abolition of slavery, and the modernization of labour. Many post-revolutionary questions about the rights of the individual and social and governmental structures came to the fore. Traditional occupations, which in earlier paintings denoted the labours of the months or provided material for comedy, now took on political and social significance. Changing representations of the rural labourer over the course of the century reflected both this social and political context and the fundamental changes in the subject matter and techniques employed in art.

European transition

Artists living and working in Italy in the nineteenth century, such as the Swiss painter Leopold Robert, were drawn to an idealized image of the peasant, and painted with Italy's Classical and artistic heritage in mind. Although the figures in such works are contemporary peasants, they are overlaid with the beauty, piety, and dignity usually given to religious or mythological subjects. Although realism became increasingly prominent in the late nineteenth century, the idealized image of the Italianate peasant mother and child persisted in the work of artists such as Adolphe William Bouguereau.

In France the image of the peasant had a more political tone. Between 1789 and 1871 France endured four revolutions, and in Paris, in particular, peasants were viewed as a dangerous force with the potential to threaten the social structure. It was infinitely preferable to see paintings of rosy-cheeked peasants working, dancing, and content with their lot than to encounter the large, rough, heavy-shod, and brutish creations of controversial painters such as Millet and Courbet. These realistic images of peasants seemed to threaten the hierarchical structure of art, where biblical and mythological subjects provided moral and intellectual stimulation. By challenging the norms of the traditional art world, the paintings seemed, by extension, to threaten society.

Market forces

The simple faces of Millet's peasants were also perceived as having a quality which was potentially upsetting and, for many who favoured more restrained portrayals, not aesthetically pleasing. In fact, because of the need to sell his work, Millet, himself the son of a peasant, eventually toned down his more graphic depictions of the numbing and harsh labours of the countryside and turned to slightly more idealized scenes of rural life.

Some Realist artists chose to exhibit their work independently rather than in the traditional Salon, aware that their subjects and styles were considered

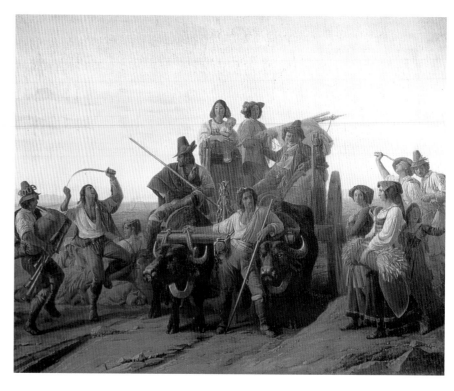

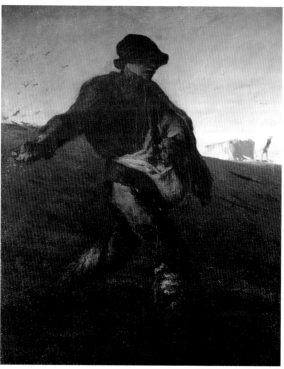

▲ **Timeless labours**
The coarse features of Millet's imposing sower would have signified his low social position to the French public. His clothes are generic, basic, and rough. Yet there is something almost sacred about the man and his work, for the spreading of the gospel is compared by Christ to the act of sowing. The labourer is an essential part of the cyclical processes of the land and of France's agrarian tradition.
Jean-François Millet, *The Sower*, 1850.

▲ **Romantic visions**
Leopold Robert lived in Italy for most of his life, and in this painting draws on both Classical precedents and the work of Old Masters who had painted in Rome. The peasant woman holding her baby at the apex of the central group echoes Raphael's idealized images of the Madonna and child, while the harmony of the figures with their environment, and the composition's balance, remind us of Poussin's carefully constructed scenes. This work was a great success at the French Salon of 1831, presenting an image of industrious, healthy, and contented Italian peasants which complied with current ideas about suitable subjects for painting, and appealed to public taste in France.
Leopold Robert, *Harvesters Arriving in the Pontine Marshes*, 1830.

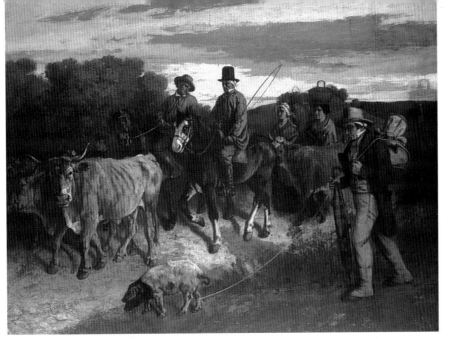

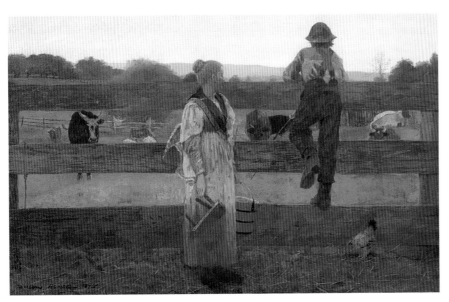

◄ **Country routines**
As in Leopold Robert's work, peasants return from the local fair. Where the characters and setting in the earlier work are idealized, the peasant in the foreground here is realistically heavy-set. The composition is less orchestrated, and the scene seems more real as a result. Such frank depictions of rural realities proved controversial in the conservative art world.
Gustave Courbet, *The Peasants of Flagey Returning from the Fair*, 1850–5.

▼ **Rural devotions**
German artist Wilhelm Leibl is here concerned with Bavarian costumes and with changes in religious experience across generations. The different attitudes of the women at prayer raises issues of education for women and the peasant class, and allows for close observation of faces at different angles, showing the influence of Northern European Renaissance artists such as Hans Holbein.
Wilhelm Leibl, *Three Women in a Church*, 1882.

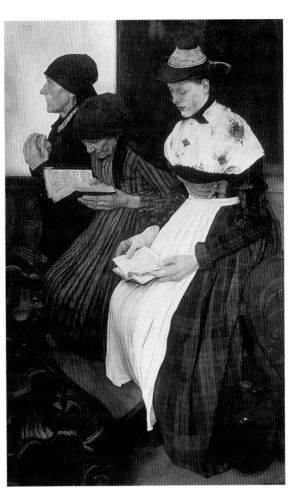

shocking and were likely to be ridiculed. One artist who organised a notorious one-man show in Paris was the "peasant painter" Gustave Courbet. He encouraged a reputation as a Bohemian provincial, shocking the bourgeoisie. Even his technique, with its loose brushwork and lack of finish, seemed to challenge the polish and perfection of more conventional artists.

Courbet and Millet celebrated images of modern life in France – things as they were rather than as people would like them to be. Their observations of the natural world helped prepare the way for Impressionist and Post-Impressionist artists such as Pissarro, van Gogh, and Gauguin. By the time these three were exhibiting in the latter half of the century, the countryside had changed again as industry and railways expanded rapidly, and they, like the Realists, used new artistic techniques and subjects to portray the dramatic transitions.

The American experience
In contrast to French genre paintings, American paintings of different classes and diverse occupations are a record of a socially optimistic period. Genre painting

▲ **Formal experiment**
This painting was one of Homer's "farm pictures" of the 1870s, typically showing tasks from the farming day. Many critics felt that the artist's main aim at that time, especially with this picture, was not simply to represent everyday life but to experiment within traditional formal conventions. The horizontal fence that cuts across the painting's surface in three large sections caused confusion in artistic circles. Some saw its inclusion as innovative, while others thought it was shockingly ugly. Homer uses the fence to provide a background for the figures that makes them stand out, but he also conveys the depth of the scene by referring to the space beyond it.
Winslow Homer, *Milking Time*, 1875.

flourished, celebrating a new world full of opportunities. It is interesting that when the Civil War of 1861–5 presented new subject matter to the artist Winslow Homer (then at the beginning of his long career), he did not focus on the suffering of war. For the most part he observed the military behind the front lines, talking, resting, or amusing themselves. After this period Homer is best known for his paintings of hazy summer days, innocent pastimes, and labours in the countryside. However, he did continue to paint more challenging subjects such as his observations of slaves in the South. The role of the labourer had many connotations, and Homer, like his European counterparts, used the art of the past and references to contemporary events to convey his concerns about this century of dramatic change.

Urban life

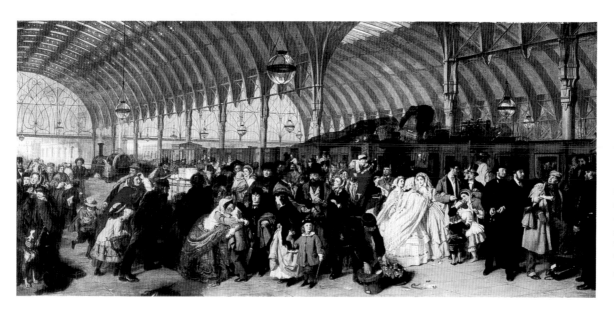

◄ **Catching a train**
This panorama of Victorian society epitomizes the bustle of nineteenth-century urban life. It is crammed with detail, from the impish pickpocketing child to the bride and her upper-class family. Frith himself is in the centre of the painting surrounded by his family. This huge painting is not a realistic observation of everyday life but a carefully constructed social microcosm: Frith was a contemporary of Charles Dickens, and this painting is the pictorial equivalent of the descriptive Victorian novel.
William Powell Frith, *The Railway Station*, 1862.

City life has often promised bright lights, excitement, new pleasures, and future success, yet dangers and potential pitfalls also abound. Artists have tried to convey the impressions and sensations of everyday urban life through a variety of means. They have painted on a large scale, a device employed by many Victorian painters, used loose brushwork or untraditional compositions as the Impressionists did, or employed dramatic and unsettling contrasts of light and dark, as in the work of Munch and Hopper.

The growth of the city

The hubbub of the city was new and exciting in the nineteenth century. Industrialization led to people flocking to the city from the country, assisted by the growth of the railway, an important symbol of change which fascinated such artists as Turner and Monet. In France, cafés, theatres, and watering holes proliferated in the second half of the century. The city became a space for people to see one another and be seen. Paintings of crowds, confusion, and excitement give us a sense of the hustle and bustle of a big city, often represented from a distance, as in Monet's *Boulevard des Capucines*.

In the early twentieth century, the Italian artist Umberto Boccioni found that distinct detail was incapable of expressing the sense of a busy throng and chose a swirl of colour and angular shapes to suggest movement and hubbub (see page 195, *The Street Enters the House*). His works are an assault on our senses, just as the real world might be, and all spaces of the canvas are filled with incident. Compared with the precision of Canaletto's scenes of Venice in the eighteenth century, with their wealth of anecdotal detail, this is a claustrophobic, confusing world. Like the Impressionists,

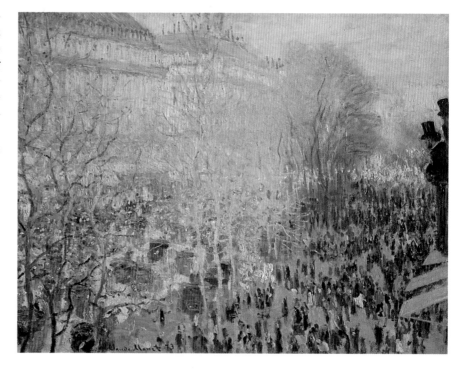

▲ **City life**
Painted from a high vantage point, this elegant Paris boulevard is filled with citizens milling around, observed by those leaning out over a balcony on the right. This wintry scene is painted with a muted and restricted palette. It is impossible to decipher class, and Monet makes no moral comment, presenting the scene before him as a uniformly blurred tableau.
Claude Monet, *Boulevard des Capucines*, 1873.

Boccioni was not concerned with representing city landmarks or precise incident but instead with conveying to the viewer the sometimes thrilling, sometimes disorientating feelings experienced in a crowd.

City life also encouraged different classes to rub shoulders, meeting in crowded stations or on broad boulevards. In a Victorian work like William Powell Frith's *The Railway Station*, classes mingle but remain distinct, their costumes and manners indicating their status. However, in Impressionist works it is sometimes more difficult to discern status, just as it was becoming harder to read society itself. In particular, the figure of the prostitute was often used to embody a new social

unease. Prostitutes dressed for evening entertainment were often difficult to distinguish from gentlewomen; there were now women who worked and lived independently who were not prostitutes. In the city, things were not always as they seemed. The prostitute came to represent the ultimate commodity in an increasingly consumer-driven society. The occupation may have been age-old, but increasing populations and disparities of wealth in cities increased the numbers practising it.

Urban alienation

The crowds and clamour of city life also led artists to create many paintings in which an atmosphere of anxiety, alienation, and loneliness is evoked. The street scenes of the Norwegian painter Edvard Munch convey the anxiety of the individual in a crowd. His figures seem like automatons, following one another down crowded pavements. Compared with village life, society was less tightly knit in cities, which welcomed a constant stream of people seeking their fortune. This transience became a popular theme of nineteenth-century French novels, and artists depicted the perils of the city, often showing pleasures that became tainted through abuse or disenchantment. Alcohol is a key factor in many of these representations – moods can be altered for the better in the chatter and cheer of the café, or for the worse in the depression, addiction, and loneliness of the drinker, as in the painting *Absinthe* by Edgar Degas.

Pictorial poetry

A similar sense of solitude and detachment pervades paintings in urban settings by the twentieth-century American artist Edward Hopper, a despondency not found in his paintings of the countryside. He was seen as a "pictorial poet," the voice of a vast and often bleak America in the first half of the century. His characters do not communicate, remaining isolated from one another in their quintessentially urban surroundings. Service stations, hotels, cinemas, diners, and streets provided him with settings for the everyday situations he observed. Strong colours and unusual angles lend a sense of unease to his urban genre scenes, while dramatic light contrasts and garish colours convey the harsh, modern, electric glare which pervades city life.

Travel and the exotic

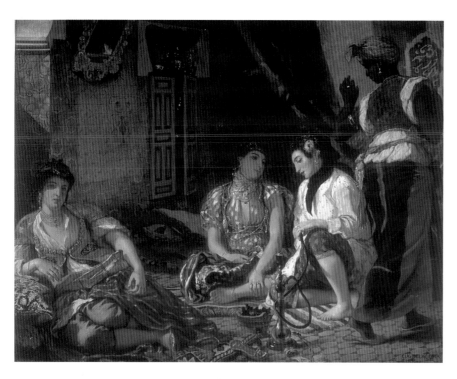

▲ Exotic worlds
The French artist Delacroix had a long-standing interest in Oriental culture and visited Morocco in North Africa in 1832. He was inspired by the people, colours, and architecture he encountered there and kept journals on his travels, recording his appreciation of and wonder at this world reminiscent of Homer and of ancient civilization. This painting is based on drawings he made while in Morocco, and the details of the setting are carefully observed. However, the composition and colouring also reflect the influence of Venetian painters of the sixteenth century such as Giorgione and Titian.
Eugène Delacroix, *Women of Algiers in their Apartment*, 1834.

▼ Ancient pleasures
This Roman bathing scene was carefully researched from new archaeological discoveries, but Alma-Tadema could only imagine the atmosphere. Choosing poses and activities from everyday life for the women in the foreground, he highlights the domestic quality of life in the ancient world. There is also a strong erotic charge – only because the scene was set in ancient Rome was it acceptable to Victorian Britain.
Lawrence Alma-Tadema, *The Baths of Caracalla*, 1899.

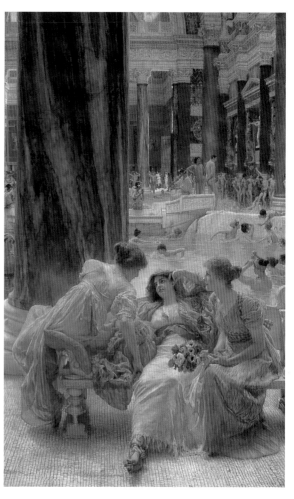

Toward the end of the eighteenth century and throughout the nineteenth century, the depiction of worlds outside the experience of artists and viewers became an increasingly popular subject for genre paintings. Travel, excavation, and military conquests (especially those spearheaded by Napoleon) had made Europe more familiar with and interested in far-flung locales, as had the gathering forces of colonialism. Whether exploring exotic vistas or past civilizations, artists found new ways to depict the inhabitants of these distant worlds, far removed from the day-to-day realities of Western life.

Exploring the past

Historical genre paintings allowed the "high art" of history painting to meet the "low art" of genre work. Most artists considered their calling to be diminished by painting anything too contemporary or everyday, yet they needed to earn a living. Most compromised by painting portraits or smaller genre works for a wider market. These works had less grandiose subjects than the heroic ones depicted in history paintings, but many high-minded artists felt that they were still engaged with history rather than reality. The nineteenth-century French painter Ingres produced many such works with subjects drawn from the everyday life of famous artists of the past such as Raphael, or great poets such as Dante. Owing to their small size these works were also more affordable.

The subjects in all of these genre scenes were distanced from the viewers, as can be seen from the works illustrated here. This distancing was often temporal, as in Ingres's painting *Henri IV of France Playing with his Children*, but it could also be geographical, as in *Women of Algiers in their Apartment* by his fellow Frenchman, contemporary, and rival Delacroix. It could even be both, as in *Baths of Caracalla* by Alma-Tadema, a Dutch artist working in Britain. The distancing effect made it possible for artists to depict scenes which would have been inappropriate within a contemporary context. In the twentieth century, the Mexican painter Diego Rivera showed how he imagined society to be in his country before the arrival of the Spanish. In doing so, he made a political statement about what it had now become. This work was often considered polemical or inflammatory.

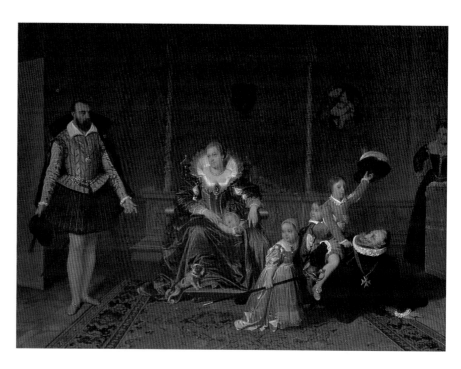

The allure of the exotic

Keyhole views of Turkish baths and luxuriant paintings of recumbent female slaves were extremely popular with collectors, both male and female. The nudity would have been provocative in a contemporary setting, but an Oriental setting allowed artists more freedom from these constraints. Delacroix's work during and after his trip to North Africa in 1832 shows both the erotic and the violent potential of these exotic yet contemporary subjects. The different culture allowed Delacroix to paint the kind of fantasies forbidden in respectable Western society. Interestingly the violence that is often shown is rarely that of the colonial French, but rather that of the local inhabitants, implying that no Westerner would ever behave in such an "uncivilized"

fashion. The intrusion of Western characters into these paintings is solely through their viewership – the scenes themselves remain intact and unspoiled.

The world of the exotic genre painting is charged erotically, and half-naked women and free sexual mores would have appealed to many. Alma-Tadema's work was an attempt to recreate a world where life was thought to be more simple. He distanced himself through both geography and time from his subjects, satisfying both the prurience and the strict morals of his contemporaries. The discovery of Pompeii and Herculaneum in the early nineteenth century had increased knowledge of, and interest in, how the Romans lived. Alma-Tadema was concerned with the accuracy of his scenes, copying tiles, objects, and architecture to construct imaginary settings from all these elements. This Classical authenticity gives his paintings a conviction similar to that of Dutch genre works, which use scrupulously observed everyday objects to create the effect of reality.

Curiosity also lies behind many exotic genre scenes. The world was becoming more navigable; people could travel further and report back about what they had seen. Genre scenes of native peoples in America and Australia functioned as a form of documentary reportage. In the late eighteenth and early nineteenth centuries the American artist George Catlin produced more than 350 scenes of native American Indians and their daily life, making it possible for people to conjure up visions of the New World. American Indians were at times painted sympathetically, their way of life recorded with dignity, although it is also true that some artists treated them as savages. Native Americans appeared as either welcoming or savage; the implication was that either they were happy to see the colonials in their land or they were brutish enough to deserve the crushing outcome of conflict.

Music

Music-making has always been one of the most popular subjects for painting, allowing the artist to extend a work's scope to include hearing as well as sight. Descriptions of art and music share a vocabulary. We speak of colour tones and harmonies and of the composition of a painting, all musical terms. James Abbott McNeill Whistler, a nineteenth-century American artist working in Europe, even entitled several of his landscape works which expressed mood through colour harmonies "Symphony" or "Nocturne."

Music in genre scenes

Depictions of music in genre painting come in many forms, reflecting both artists' concerns and the social contexts in which paintings were made. In Greek mythology, music possessed a magical and redemptive power – Orpheus charmed wild beasts with his lyre. Religious paintings often show angels making heavenly music, suggesting a celestial celebration or heralding a special event. Music engenders harmony between people and is used as a way of showing goodwill and happiness. In the thirteenth-century painting of a Moor and a Christian shown below, music is the medium which allows links to be established between the two cultures, more usually known for making war on one another. Harmony also prevails in Pieter Brueghel's "low life" scenes, in which peasants play music to celebrate special events. Even if circumstances are reduced, as in Le Nain's peasant groups such as *Peasant Interior with an Old Flute-Player* (see page 196), music is still present as a reminder that even the poor can attain happiness in the humblest surroundings. In mythology, stringed instruments were considered more lofty than their wind counterparts, and this distinction can still be seen in genre works – it would be appropriate to show a peasant playing a pipe, but less so to give him a lute.

Music and love

Music lessons were commonly used as the setting for seductions in the novels of the eighteenth and nineteenth centuries, since the young male teacher enjoyed the unusual privilege of spending time alone in the company of young women. Scenes by the seventeenth-century Dutch artist Jan Vermeer of women standing or sitting by musical instruments have been interpreted as containing moral meanings about life and love, but his major concern is the play of different forms and textures against each other. In the world of eighteenth-century French painting, music again reinforces the idea of pleasure and indulgence. The aristocrats in fancy dress shown in Watteau's *The Pleasures of the Ball* delight in their senses, dancing and courting to the sound of elegantly plucked strings.

▼ **Two visions of music**
This painting by the Dutch artist Jan Vermeer shows a young woman poised as if ready to play. A viola da gamba is propped in the foreground, which might suggest that she expects someone to join her. The room is ordered, giving an air of accomplishment and virtue. However, on the wall is a copy of *The Procuress*, a painting by the Utrecht artist Dirck van Baburen. It shows a prostitute in a low-cut dress playing the lute, crammed together with a roguish man offering money and an aged procuress demanding a share. The contrast between Baburen's painting and Vermeer's establishes the theme of profane and ideal love.
Jan Vermeer, *A Young Woman Seated at a Virginal*, c.1670.

▲ **Musical harmony**
This thirteenth-century book illustration shows a vision of harmony between religions at a time when crusades raged across the Holy Land; when the Christian plays, he cannot reach for his sword. The instruments seem to be a kind of lute; the Arab *oud* is the lute's direct ancestor, and is considered the king of instruments in the Muslim tradition. Many Muslim musicians were invited to the court of Alfonso the Wise, for whom this book was made.
Unknown Spanish artist, *A Moor and a Christian Playing Lutes*, c.1221–84.

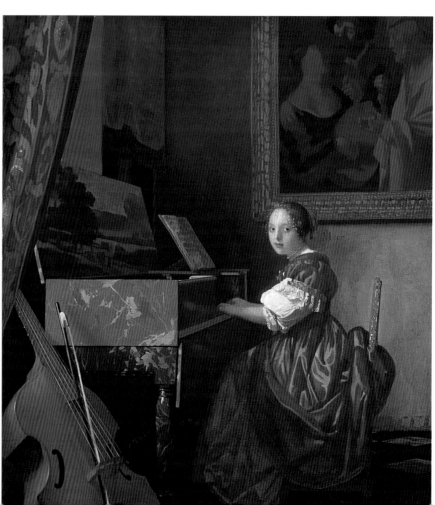

The link between romantic love and music appears everywhere in art, from medieval scenes of ladies, troubadours, and wandering minstrels to depictions of the cancan dancers in nineteenth-century Parisian bars. Orpheus's lyre may have caused peace and harmony around him, but the Classical gods of wine and fertility, Bacchus and Pan, used percussion instrument and pipes to create wild, frenzied rituals, alluding to their base, more sensual natures. The connotations of music as a seducer's tool were often used in seventeenth-century Dutch genre painting and eighteenth-century French Rococo scenes, whose worlds were otherwise far apart.

Music in a modern age

In the second half of the nineteenth century, the contemporary subjects which the Impressionists portrayed were as revolutionary as their techniques. The café-concert was one of the most popular venues for socializing in Paris – customers would enjoy their drinks against a background of singing and playing – and opera and ballet were also popular leisure pursuits. Degas painted many scenes set at the ballet or showing orchestras and singers, trying to recreate the atmosphere by using his Impressionist technique and by cutting into our view as if we were in the audience straining to see from behind other people or objects. In *The Song of the Dog* he ruthlessly exposes how unglamorous the face can look when distorted by the effort of singing.

Expressionists such as the Russian artist Wassily Kandinsky took these scenes a step further in the twentieth century. Instead of recreating the world as it looked and reproducing an impression of it, they tried to paint how music sounded and felt, using colour and shape in a far more abstract way. It is difficult to qualify these works as genre because the recognisable shapes of people and instruments have often disappeared. However, as scenes from everyday life they continue to reflect our experience and as such can be as expressive as the genre works of previous centuries.

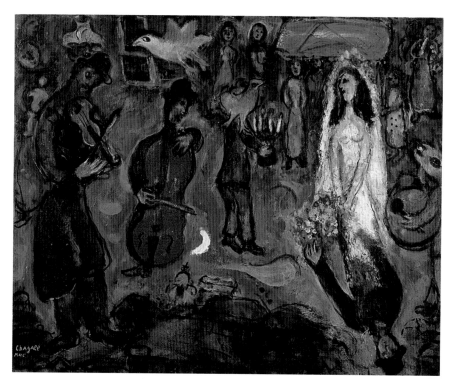

◄ **Parisian night life**
This late nineteenth-century painting communicates the loud and smoky atmosphere of a Parisian café-concert, a form of entertainment thought to be tawdry and vulgar. We presume the singer is entertaining a crowd as they sit, chatting and drinking. Our viewpoint is intimidatingly close – Degas's preoccupation is with conveying the atmosphere of the garishly coloured scene and with the creation of sound. We feel as though the artist is present observing this moment. In fact the singer came to his studio for sittings, and the work took far longer than is apparent.
Edgar Degas, *The Song of the Dog*, c.1876–7.

213

Animal painting

Animals frequently take second place to humans in art. In religious paintings, for instance, they usually form part of the setting for the narrative, such as the ox and ass present when Christ was born. Real and arcadian landscapes often include animals; for example, grazing herds can indicate the wealth of the landowner whose estate is depicted, and John Constable's working farm animals represent a vanishing way of life at the time of the Industrial Revolution.

Animals can, however, have greater prominence, particularly when they are employed symbolically. Christian art is full of symbolic creatures, such as the lamb that represents Christ and the winged lion of St Mark. Renaissance emblem books include many animals that stand for virtues and morals. As a result, in Renaissance and Baroque portraits, the sitter is often accompanied by an animal that suggests his or her character or reinforces social status. Queen Elizabeth I, for example, was depicted with an ermine, representing purity. With a few exceptions, it is not until the eighteenth century, with its interest in natural history, that animals are treated as subjects in themselves, in the work of artists such as George Stubbs. In the nineteenth century Delacroix's lion fights celebrate the beauty and strength of wild animals, while artists such as Landseer invested animals with sentimentality and anthropomorphism. Hockney's paintings of his dogs, however, are true portraits of individuals, who happen to be animals.

▶ Symbolic animals

This graceful white hart, or stag, decorates the exterior of a small folding altarpiece belonging to King Richard II of England (see page 28). The hart was Richard's personal symbol. Figures appearing on the inside panels of the altarpiece wear badges displaying the white hart, and Richard himself sports a cloak embroidered with its image. Here the white hart is a symbol of regal power; it clearly announces the altarpiece's royal ownership. The hart is, however, also beautifully observed, suggesting that the artist may have used the king's own white hart, which he kept in the Forest of Windsor, as a model.
English or French School, *The Wilton Diptych*, 1395–9.

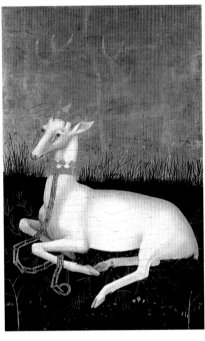

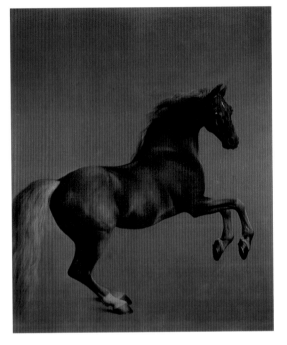

◀ Anatomical accuracy

The eighteenth-century English artist George Stubbs built a highly successful career painting horses and their owners. This life size and remarkably lifelike portrait of a racehorse is one of his masterpieces. It displays his understanding of the anatomy, movement, and psychology of horses, based on rigorous study and observation. Stubbs perfectly captures the muscular energy beneath the animal's glossy coat, the veins standing out on his haunch, the tautness of his leg tendons, and the nervous tension expressed in his eye.
George Stubbs, *Whistlejacket*, 1762.

◀ Agricultural prosperity

This portrayal of rural life in the seventeenth-century Netherlands can be interpreted in several ways. Most obviously it is a virtuoso display of artistic achievement, showing the artist's ability to recreate the forms and textures of the external world; the viewer can almost touch the soft, shaggy coat of the young bull. Potter's work was based on careful observation of nature. The bull's health and strength might also be read as a metaphor for contemporary Dutch prosperity, much of which was based on its agricultural economy.
Paulus Potter, *The Young Bull*, 1647.

Landseer's stag is portrayed with anatomical accuracy and assurance, but it is far from being simply an exercise in recording natural history. This famous image seems to encapsulate the confidence and national pride of Victorian Britain. The stag stands in a romantically grand and misty Scottish landscape. Crowned with majestic antlers and pointedly entitled *Monarch of the Glen*, he is presented as the king of all he surveys. The low viewpoint makes the viewer literally look up to him. This anthropomorphism, or application of human values and sentiments to the animal world, is typical of Landseer, and of Victorian animal painting in general.
Edwin Landseer, *Monarch of the Glen*, 1851.

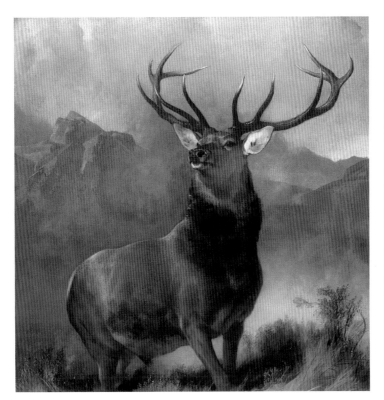

▼ **Nobility in labour**
This enormous painting celebrates the power and beauty of working animals. The magnificent oxen are viewed across an expanse of rich earth, towering above a deliberately low horizon. The arrangement of the oxen in a line across the picture space recalls the composition of a Classical frieze, reinforcing their status as heroic creatures. Rosa Bonheur, one of the most eminent French artists in her day, specialized in paintings based on her meticulous and lifelong study of the animal world.
Rosa Bonheur, *Ploughing in the Nivernais*, 1849.

▼ **Animal portraits**
David Hockney often uses his pet dachshunds as the subjects of his paintings and drawings. Here you can sense the intimacy and trust between the artist and his dog, which creates an informal, affectionate, but unsentimental portrait. There is also a great feeling of spontaneity about the painting, with its unconventional viewpoint, both low down and close up, and its cropped edges, suggesting a snapshot.
David Hockney, *Dog Painting 30*, 1995.

► **Dream creatures**
This picture presents a world far removed from external reality. At this time, the Spanish artist Joan Miró was making what he called "dream paintings," which experimented with ideas originating in his subconscious. Here Miró seems to explore human dreams and desires. The comical, cartoon-like dog barking at the moon may be read as a metaphor for any creature, animal or human, consciously or unconsciously longing for something beautiful, mysterious, and forever beyond reach.
Joan Miró, *Dog Barking at the Moon*, 1926.

ANIMAL PAINTING 215

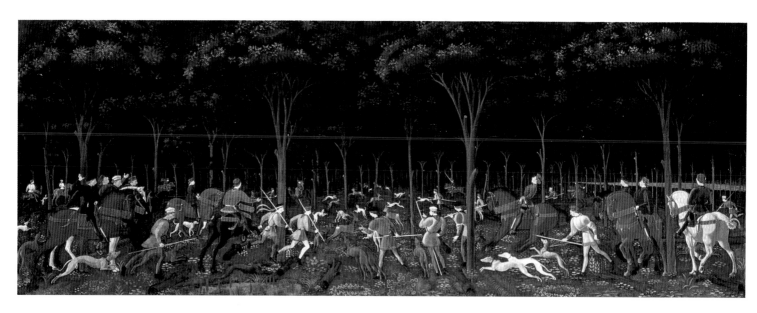

Staged action
Florentine huntsmen and their servants and dogs converge from each side of this scene on the stags in the centre. Instead of portraying the stags' violent death, however, Uccello creates a poetic fairytale-like image of the hunt. Symmetry is everywhere – in the grouping of the huntsmen, the placing of the trees, and the pairing of the hunting dogs and servants. The curving forms of the animals' bodies are played against the straight lines of the trees and lances, forming subtle patterns all over the picture. In the middle, the stags and dogs follow each other in a graceful zigzagging procession into the distance. This is sport as decoration.
Paolo Uccello, *Hunt in the Forest*, c.1460.

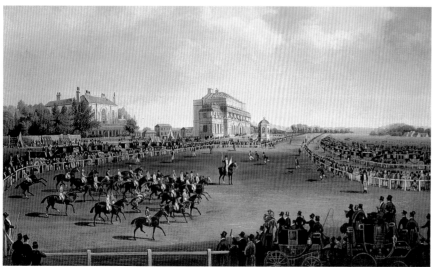

Day at the races
Pollard's scene shows us a horse race about to begin. In the middle the starter is about to lower his arm – the signal for the horses to start. It is a dramatic moment, and the artist has tried to convey this. The waiting racehorses prance impatiently. All around the racecourse the spectators' attention is trained on the start. Pollard's wide-angle view, however, which makes both horses and spectators extremely small, diffuses the tension of the scene. Our eye is encouraged to roam across the racecourse, past the private grandstand and into the distance.
James Pollard, *Doncaster Races, Horses Starting for the St Leger*, 1831

Since Neolithic times, when people decorated the walls of caves with images of the animals by which they were surrounded, and which they often hunted, sporting subjects have featured in the art of most cultures and societies.

The hunting instinct

Up to the nineteenth century the principle sport depicted in painting appears to be hunting. No doubt this is because hunting was the favoured sport of the wealthy, who were also in many cases the people who commissioned works of art. The Renaissance ideal, codified by Baldassare Castiglione (see page 142) was that a gentleman should excel in physical as well as mental pursuits. In The Book of the Courtier, published in 1528, Castiglione speaks of sports that are: "closely related to arms and demand a great deal of manly exertion. Among these it seems to me that hunting is the most important, since in many ways it resembles warfare; moreover, it is the true pastime of great lords, it is a suitable pursuit for a courtier, and we know that it was very popular in the ancient world."

Hunting scenes usually depict the upper levels of society as the huntsmen – as in Uccello's *Hunt in the Forest*, although Brueghel depicted peasants returning from a winter hunt with their dogs in his *Hunters in the Snow* (see page 185). Brueghel's painting is one of a series made for the townhouse of an Antwerp merchant, so it must be seen as an idealized view of rural pursuits, rather than as a realistic picture of country life. Many of Rubens's landscapes, and other Flemish and Dutch seventeenth-century views of the countryside, feature ordinary people hunting. Again, these were paintings made for wealthy city dwellers.

Paintings show the hunting of many different kinds of creatures – most commonly, stags and boars, but also foxes and birds. Rubens, in the seventeenth century, and Delacroix in the nineteenth century, also depicted the hunting of wild lions, which are fantasy paintings, although Delacroix drew on studies of zoo animals.

The hunting portrait was also extremely popular. It presented the sitter as a fully rounded man, who

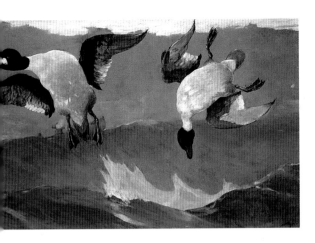

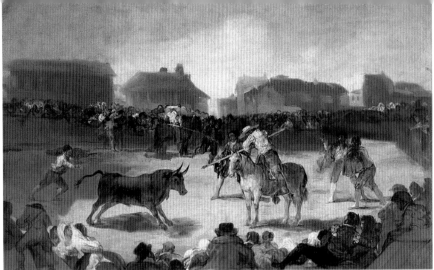

Life and death

American artist Winslow Homer was inspired by the conflict between man and nature. This picture is about shooting – its title alludes to the practice of shooting one duck after another, with separate barrels of a shotgun. The image is full of tension and ambiguity. Has the duck on the right been shot and is therefore plummeting toward the water, or is it flying downward to escape the hunter? Is its mate extending its neck in the throws of death, or twisting away from the next bullet? Homer's reflection on life and death reminds us of the fragility of our own lives. **Winslow Homer**, *Right and Left*, 1909.

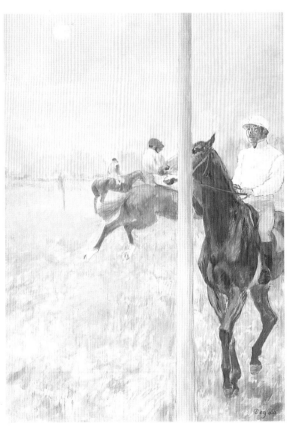

might be a king, statesman, or gentleman in charge of the running of his estate, but who also excelled at physical pursuits, in the manner of the ideal Renaissance man. Velázquez's portrait of King Philip IV of Spain of 1632–3, for instance, (see page 163) shows him standing outside, in hunting dress. His pose is relaxed and he carries a long, elegant gun with nonchalance, indicating that hunting, like every other activity, comes easily to him. That he is king of all the hunting land he surveys is indicated by the low horizon line, above which he towers. The portrait was made for Philip's new hunting lodge outside Madrid, for which Velázquez also painted other members of Philip's family as huntsmen.

Gainsborough's portrait of Mr and Mrs Andrews (see page 147), painted around 1750, underlines the importance of hunting as a gentlemanly accomplishment in eighteenth century England. Mr Andrews, who stands casually with his shotgun, seems to have been hunting on his own, but during the latter half of the eighteenth century, the group hunt became extremely popular. This generated a minor genre of paintings of its own, featuring members of the hunt with their horses and dogs, which continued to flourish throughout the nineteenth century, with the growth of foxhunting as a fashionable sport in Britain.

Popular and elitist sport

With a few exceptions, group hunting scenes shy away from showing the killing of the hunted animal, and hunting portraits tend to show the sitter before or after the chase. Goya's images of the Spanish bullfight, however, are full of drama, tension and violence. The bullfight takes place in an enclosed space, surrounded by rows of transfixed spectators, and offers certain death for the bulls but also possible death for their human opponents in the ring. Goya's extensive painted and etched images of bullfighting are powerful psychological studies of the conflict between men and animals, and his bulls are often given more nobility than the men who surround them. They also exhibit Goya's attraction to what was popular rather than to what was elitist.

In the nineteenth century, horse racing became established as a favourite sport, especially in England, France, and the United States. Racing began as an upper class activity, but evolved into an event attended by people from all levels of society, providing artists with the opportunity to paint scenes combining sporting action with social observation. In France, Degas and Manet enthusiastically took up racing as an exciting new subject, and in particular, as an opportunity to explore movement and speed in painting.

Intense encounter

Goya constructs this scene with a compelling sense of drama. The bullfight takes place in a traditional Spanish village square, around which the crowd marks out a circular arena. In the middle, the mounted picador confronts the bull. The men behind the bull and the picador's horse, all facing the conflict, increase the sharpness of focus on this intense moment, as does the empty area of clear ground around the bull. The bull himself is a figure of great dignity and strength. He and the horse seem to confront each other in an impassive stand-off. **Francisco de Goya**, *Bullfight in a Village*, c.1812–19.

Manipulation of viewpoint

This is one of Degas's many images of horse racing. We see jockeys and their horses in the paddock before a race begins. The horse in the foreground seems nervous and restless. This effect is enhanced by Degas's unusual viewpoint of him, from behind the starting pole, which cuts right through the picture surface, forcing our eye to move around the picture space in a similarly unsettled way. In the middle distance a jockey gallops away. The front of the horse's body is hidden from our view and this, combined with Degas's sketchy brushstrokes, gives a feeling of swift movement. The scene's informality and viewpoint were probably influenced by photography. **Edgar Degas**, *Jockeys before the Race*, c.1869–72.

"Sweeping festoons, braided wreaths of flowers . . . beautiful peaches and apricots, or melons and lemons, and a clear glass of wine on a fully laden table . . . or a music book and vanitas in eternity . . . everything that is contained under the name of still life."

Samuel van Hoogstraten,
Introduction to the noble school of the art of painting, or the visible world, 1678

Still Life

A still life might be simply defined as a painting of inanimate objects and, in some ways, still-life painting is as straightforward as this bald definition suggests. Unlike mythological or religious painting, still life is rooted in the real world, which it often describes with mesmerizing illusionism. This apparent simplicity has often been held against it, and many theorists have seen such paintings as "mere" copies, calling for manual skill but no imagination or intellect. But still life's simplicity is deceptive because the objects depicted are seldom neutral. Many, such as skulls or withered flowers, carry overt symbolical meaning, while others have different connotations – a painting showing a lavish display of luxury objects (see page 223, Willem Kalf, *Still Life with a Late Ming Ginger Jar*) suggests very different aims and concerns from an austere depiction of a cabbage (see page 223, Juan Sánchez Cotán, *Quince, Cabbage, Melon, and Cucumber*).

The depiction of still-life subjects can be traced back to Classical antiquity but the term "still life" was not coined until the mid-seventeenth century. It was only at this period that artists began to produce depictions of flowers, food, and other objects as independent paintings, intended to stand on their own. Given the importance of the Netherlandish painters in this development, it is not surprising that the English term derives from the Dutch "*still-leven*," but this description is not universal: in France and Italy still-life paintings are known as, respectively, "*nature morte*" and "*natura morta*," meaning "dead nature."

Precursors of the still life

Although the modern era of still-life painting dates from the seventeenth century, its precursors can be traced back much further. In ancient Greece artists represented humble, everyday objects in mural decorations, mosaics, and panel paintings. They also painted pictures of food, known as "*xenia*," which was the word for a meal a host offered his guests. Although no still lifes from ancient Greece survive, they were described by several Classical authors, who praised them above all for their realism and ability to deceive the viewer's eye, a characteristic of still life taken up with enthusiasm by many later still-life artists, such as William Harnett.

The Greek tradition of illusionistic still-life painting was continued by the artists of ancient Rome, who also painted food, flowers, and everyday items as decorative details in wall paintings and mosaics, but always, it seems, as part of larger works of art. In the Middle Ages and the Renaissance artists continued to paint still-life objects but not as independent paintings: flowers appear in the margins of medieval manuscripts, for example, and some fifteenth-century church decorations include depictions of still-life objects in painted niches.

At the same time still-life arrangements were also among the subjects of the elaborate marquetry decorations found in some noble private residences. In panel paintings, however, depictions of still-life objects appeared only as details within larger paintings. When artists represented religious scenes within domestic settings they often included objects which both added anecdotal interest and conveyed symbolic meaning. Toward the end of the sixteenth century details of this kind began to appear as subjects in their own right but these

▲ Symbolic detail
In this large Renaissance painting the Virgin Mary is seen receiving the news of her miraculous pregnancy from the angel Gabriel. In the foreground are a gourd and an apple, which are among a number of objects in the picture to have symbolic significance: the apple stands for sin, while the gourd is a symbol of the Resurrection. **Carlo Crivelli**, *The Annunciation with St Emidius*, 1486.

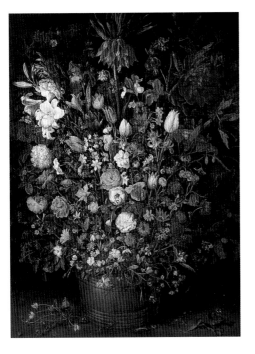

◄ Early flower painting
Flowers were among the earliest still-life subjects and the Flemish painter Jan Brueghel was one of the first artists to specialize in the genre. This painting was owned by Cardinal Federico Borromeo, the Archbishop of Milan, to whom Brueghel wrote explaining that he began the work in spring and finished it in autumn: "I do not believe that a bouquet has ever been created with so many rare plants and with such an abundance of detail. They will look beautiful in winter."
Jan Brueghel, *Large Bouquet of Flowers in a Wooden Tub*, 1606–7.

▶ A new approach
The paintings of the French artist Cézanne broke with many of the conventions of still life. Earlier still-life painters strove to recreate convincingly and accurately the textures and details of objects, but he was more concerned with conveying the solidity of their forms. His bold brushstrokes draw attention to the picture surface and compromise the sense of illusion. Here he also seems to combine several points of view – tabletops slope and floors tip – unsettling the hitherto dominant style of maintaining the illusion of a single vantage point.
Paul Cézanne, *Still Life with Plaster Cupid*, c.1895.

were usually attached to other works; they survive, for example, on the reverse sides and the covers of portraits.

As still life emerged in the seventeenth century it rapidly became an immensely popular type of painting, produced for the most part for the newly developing art market rather than on commission; but from the first it was also looked down on. In 1678 the Dutch artist and writer Samuel van Hoogstraten described the many painters of still life as "the common foot soldiers in the army of art" – even though he painted a number of still lifes himself (see page 231, *Trompe l'Oeil Still Life (Pinboard)*). Still life was regarded simply as an art of imitation, which required good hand-to-eye co-ordination and sophisticated technical skills but no originality of thought. In the hierarchy of genres established by the French Academy of Painting and Sculpture in the 1660s, and adopted by the art academies of eighteenth-century Europe, "history painting" was established as the pinnacle of artistic achievement and still life officially relegated to the lowest of all the categories of painting.

Individual expression

The nineteenth century saw dramatic changes in both the aims and the prestige of still-life painting. The century saw the decline in the power of the art academies and the growth of an independent art market. At the same time many artists were challenging academic doctrine. Increasingly, painting was claimed as a realm of individual expression and creativity which did not have to rely on grand subject matter to achieve its ends. Still life also recommended itself to artists who were exploring new ways of seeing and recording the observable world. The genre's very rootedness in the real world made it appealing to painters such as Cézanne and the Cubists as a vehicle for their artistic experiments.

◄ Informal composition
Anne Valleyer-Coster was one of the most prolific and accomplished still-life painters in France in the eighteenth century. Her intimate depictions show the influence of Chardin (see page 232). Like him, she organized her objects into simple yet carefully staged compositions which have a deliberately informal appearance. During this period still life was seen as the most suitable genre for women artists.
Anne Valleyer-Coster, *Still Life with Ham, Bottles, and Radishes*, 1767.

▶ A lesson from history
Although the objects in this still life are represented realistically, with a detailed and illusionistic treatment of textures, the space they occupy is compressed. Flack includes objects with contrasted connotations: the plate of heavily iced cakes is juxtaposed with the photograph of starving prisoners in a Nazi camp. The candle and clock are traditional vanitas symbols, reminding us of the transience of life; in this painting they refer to the fate of those killed during the Holocaust and the Second World War.
Audrey Flack, *World War II (Vanitas)*, 1976–7.

The independent still life

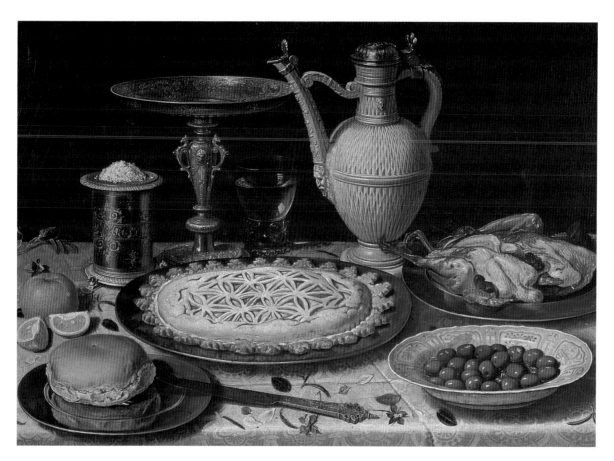

◄ **Banquet**
Like many women artists of the seventeenth century, the Flemish painter Clara Peeters specialized in the still life. Although almost nothing is known about her life or training, her work attests to her versatility within the genre: she painted flower-pieces and game pieces as well as luxurious displays of food. In this painting the wide range of objects depicted demonstrates her skill at representing different textures and visual effects, from the crusty bread and oily olives to the reflections on the shiny silver plates and in the wine. The artist signed her name on the side of the fine knife which she placed prominently at the bottom centre of the painting. **Clara Peeters**, *Still Life with Pie*, 1640.

The seventeenth century was a time of extraordinary importance for still-life painting, from its emergence as a distinct category of painting at the beginning of the century to its acceptance by the French Academy of Painting and Sculpture in the 1660s as an officially recognized, if lowly, genre. As the century proceeded, still lifes became increasingly popular among both the traditional patrons of art, the rulers and princes, and the emerging middle class, who formed a burgeoning new market for art. This was especially true in the Netherlands, where still-life paintings were produced in ever-increasing numbers and developed in various directions.

Secular subjects

The flourishing of the still life in the Dutch Republic coincided with major social and economic change. Having been under Catholic Spanish rule, the northern Netherlands gained a measure of independence in 1609. The powerful Calvinist reformed church of the new republic prohibited the production of religious images. With few commissions coming from churches, Dutch artists concentrated on the domestic and private markets and on secular subject matter in the genres of portraiture, landscape, and still life. While some of these were direct commissions, the seventeenth-century Netherlands saw the emergence of a modern

◄ **Realism**
The Italian artist Caravaggio's realistic and accurate depiction of the fruit basket gives great immediacy to this work. Set against a plain background, the basket seems to project out of the painting into our space. This painting may have been made in emulation of the lost still lifes of Classical antiquity, which, in a similar way, aimed to deceive the viewer's eye through their illusionistic depiction of objects. **Caravaggio**, *Fruit Basket*, c.1596–7.

art market, including both picture dealers and auction houses, which allowed many artists to survive by painting for the open market.

Much of the prosperity of the Dutch Republic was based on its international trading activities, the bounteous results of which were often depicted in still lifes. Sumptuous arrays of precious objects, such as those represented by Willem Kalf, reflect the quality and variety of goods available. Merchants, burghers, and other beneficiaries of the country's new-found affluence could now purchase luxury items, including paintings.

Unlike the princely patrons of the past, who had favoured grand portraits or mythological paintings, the new collectors preferred smaller works based on the real world, which did not require knowledge of learned texts, were more immediate in their appeal, and in their intimate scale were more suitable for modest-sized houses. Still lifes had the added benefit of being able to display expensive objects which were beyond the means of many of those who could afford paintings.

Specialization

The pressures of the open market led artists to specialize in particular types of still life, such as the flower-piece, the vanitas still life, the breakfast-piece (an arrangement of modest foods), or the "pronk" still life (a display of luxury objects). Before about 1650 the term "still life" was not used, and paintings were usually described, as above, according to the objects that were shown.

As in the ancient world, the still-life painter's skill at creating the illusion of reality was one of the features most admired by seventeenth-century viewers. In order to represent objects of varying forms and textures, artists needed mastery and knowledge of sophisticated painting techniques. Visual effects such as the gleam of silver, the transparency of glass, and the juiciness of a lemon, for example, all required different methods of painting, and artists often adapted their technique to suit the subject. While a thick, paste-like paint might be used to render lemon peel, thin glazes were better suited to the representation of smooth silk or porcelain.

Although the largest number and greatest variety of still lifes were produced in the Netherlands, the seventeenth century saw artists throughout Europe turning to the genre. In Italy one of the earliest surviving examples was painted by Caravaggio, and another was painted in Spain by Juan Sánchez Cotán. Unlike the appetizing displays found in Netherlandish still lifes, the foods depicted by these artists were not chosen for their gastronomic or sensory appeal. They are ordinary and familiar fruit and vegetables, displayed in simple settings. Although the two artists were working in different countries, they shared the aim of representing the natural world in a realistic way. The austerity of works such as Cotán's *Quince, Cabbage, Melon, and Cucumber* is often attributed to his association with the strict Carthusian monastic order. His paintings are composed with discipline, restraint, and concentration; he arranged his objects according to strict geometrical rules, and painted them with meticulous accuracy. This intensity of vision and execution makes his banal foodstuffs appear laden with meaning.

Caravaggio's *Fruit Basket* also focuses on ordinary fruit, some of which is old and damaged by insects. These imperfections are typical of the artist's approach to painting, which challenged accepted notions of ideal beauty in favour of an uncompromising realism. Indeed Caravaggio's desire to record the material world as accurately as possible may itself have been his motivation for painting still lifes.

▲ **Aestheticism**
The distinctive appearance of Cotán's still lifes derives from their sparse and measured compositions, which follow a strict geometrical order – the quince, cabbage, melon, and cucumber form a perfect arc. This arresting contrast between the homeliness of the objects and their modest settings, on the one hand, and the eccentricity of the compositions, on the other, is the hallmark of this artist's still lifes.
Juan Sánchez Cotán, *Quince, Cabbage, Melon, and Cucumber*, c.1600.

▼ **Exotic rarities**
Willem Kalf developed a type of still life known as the "pronk" still life, which derives from the Dutch verb *"pronken,"* meaning "to display" or "to show off." His paintings show sumptuous collections of exotic objects and luxury foods, of the kind that were imported into the Dutch Republic during the seventeenth century. The arrangement in this still life includes a jar from China, a carpet from the Middle East, a glass from Venice, and fruit from southern Europe. Kalf's skill at recreating a wide variety of textures can be seen throughout the painting, and his virtuoso technique is particularly evident in the curling lemon rind hanging off the tray.
Willem Kalf, *Still Life with a Late Ming Ginger Jar*, 1669.

Creating an illusion

One of the main goals of still-life painting has always been to deceive the eye and make viewers forget that the picture is an illusion of reality. Since Classical antiquity, the artist's skill at creating illusions has been discussed and admired. In his *Natural History*, the Roman author Pliny (AD 23/24–79) described a contest that took place between two prominent ancient Greek artists of the fifth century BC, Zeuxis and Parrhasius. According to this famous story, Zeuxis painted grapes with such skill, and succeeded in creating such a convincing illusion, that birds flew down from the sky to peck at them. Not wishing to be outdone, Parrhasius responded by painting a curtain that looked so real that it fooled even the discerning eye of his fellow-painter, who tried to draw it to one side to reveal the picture he believed to be hidden underneath. This anecdote was repeated in many later treatises on art, which encouraged painters to emulate the technical accomplishments of the artists of the Classical era.

In order to create illusionistic images, artists had to have knowledge of the rules of perspective, as well as the ability to recreate the appearance of natural light. Still-life painters faced the further challenge of depicting the varied textures and details of their subjects, and they often demonstrated their technical skill and virtuosity by reproducing complicated visual effects, such as the reflective surface of shining metal or the transparency of glass – effects that were very difficult to achieve until the development of oil paint. The most extreme incidents of illusionism, where the flat picture surface is given the appearance of a real, shallow space, are referred to as "trompe l'oeil," which literally means "fools the eye."

▶ Zeuxis's grapes

Espinosa's surviving paintings all depict grapes. With their great accuracy and realism, they rival the legendary illusionism of the grapes painted by Zeuxis. Espinosa gave his fruit strong relief by setting it in a dark, shallow space, and recreated its sheen by using layer upon layer of translucent paint. The fashion for paintings of grapes in Spain in the 1630s may have been influenced by the translation of Pliny's *Natural History* into Spanish around the beginning of the seventeenth century. **Juan de Espinosa**, *Still Life with Grapes*, 1630.

◀ Trompe l'oeil

William Harnett, one of the best-known American still-life painters of the nineteenth century, specialized in trompe l'oeil paintings. His images are painted with such a high degree of illusionism and close attention to detail that they deceive viewers into believing that the painted surface is a real, shallow space. He often depicted objects hanging from wooden walls or, as here, cupboard doors, on which objects are hung from nails or placed on shelves. Harnett's careful depiction of textures, from splintered wood and rusty hinges to the resin-covered violin strings, imbue his paintings with a strong degree of realism and credibility. His success was derived from his ability to create layers of puzzling and deeply satisfying illusionistic effects. **William Harnett**, *Old Models*, 1892.

◀ Parrhasius's curtain

Adriaen van der Spelt's painting reminds us of how Zeuxis was deceived by Parrhasius's accurately painted curtain in Pliny's story. Here, the texture and sheen of the blue silk are skilfully recreated, capturing details such as the horizontal creases and gold-embroidered borders with remarkable accuracy. The tactility of the fabric convinces us that it is real and tempts us to draw it aside to reveal more of the flower-piece that seems to be partly hidden behind it. **Adriaen van der Spelt** and **Frans van Mieris**, *Trompe l'Oeil Still Life with a Flower Garland and a Curtain*, 1658.

Deception

Artists often demonstrated their skill at creating illusions of reality by including in their paintings objects that seem to lie on the surface. In this work by the Dutchman Jan van Huysum, a specialist in flower paintings, the illusionistic fly (see below) tempts us to reach out to brush it away. The artist suggests a distinction between what is clearly a painted image and what might be perceived as a real object by painting prominent shadows which set the fly in strong relief.
Jan van Huysum, *Flowers in a Terracotta Vase*, 1736.

Extended view

The eighteenth-century painter François Desportes was renowned for his lavish "buffet" paintings. This type of still life, which was popular in his native France during that century, depicted sumptuous displays of food and costly receptacles. The silver plates and golden objects in this painting reveal the artist's remarkable ability to represent a wide range of reflective surfaces convincingly, from the smooth, mirror-like plates to the intricate hogs' heads that decorate the tureen. A still life usually shows just one view of the objects depicted, but Desportes used the reflective silver surfaces of the plates to provide a more ample view of the peaches piled up in front of them. A further example of his skill at depicting textures is seen in the rich plumage of the game birds at the bottom right of the picture.
Alexandre-François Desportes, *Silver Tureen with Peaches*, 1733–4.

Light on glass

In this still life Höch explored the complex effects of transparency and reflection. She defined the forms of the decanters by studying the reflection of light on them. There is one legible reflection, a paned window and blue sky, on the long-necked vase at the centre. Like Jan van Eyck and Pieter Claesz, Höch also included an image of herself, reflected in the glass.
Hannah Höch, *Glasses*, 1927.

Reflections

Artists often exploited the reflective quality of shining surfaces to suggest the world beyond the picture frame. They would include details such as the reflection of a window, which give their still lifes an added dimension and identify the source of light. In this painting, Claesz ingeniously included a glass ball that reflects the room in which the objects are displayed. It offers an extensive view of the artist's studio, and like Jan van Eyck's famous mirror (see page 146), it includes a portrait of the artist, standing at his easel.
Pieter Claesz., *Still Life with Glass Sphere*, 1630s.

CREATING AN ILLUSION 225

Flower painting

lowers have been one of still life's most persistent and compelling themes. They are obviously beautiful, and this quality alone has commended them as a subject for painters. But while their beauty is usually short-lived and fleeting, a painting of flowers has the advantage of being able to capture and preserve their ephemeral blooms. In addition, certain flowers carry a rich symbolism, both religious and secular, and artists have exploited them for this purpose as well as for purely visual reasons.

An emerging subject

Like other types of still-life painting, including the depiction of food and precious objects, the "flower-piece" emerged at the end of the sixteenth century. Before that time flowers had appeared as decorations in the illuminated borders of medieval manuscripts and as small, although often symbolically important, details within larger paintings of religious or mythological subjects. A famous painting from the end of the fifteenth century is sometimes claimed to be the earliest known independent flower-piece, but it was never intended to stand on its own. Painted by the fifteenth-century Netherlandish artist Hans Memlinc, this picture of a jug of lilies and irises appears on the reverse of a portrait. The painting of the flowers, which symbolize the Virgin Mary, and the portrait were both originally attached to another image, believed to have shown the Virgin.

About a century after Memlinc painted his work, the flower still life began to develop in earnest, its progress aided by an ever-increasing fascination with flowers themselves. The early seventeenth century brought great advances in the study of botany and horticulture, and numerous new species of flowers were imported into western Europe for the first time. The novelty and rarity of some flowers conferred great value on them and they were often painted alongside other collectables such as shells and jewels. The tulip, for example, first imported from Turkey into Europe in 1554, came to command exorbitant prices, and by the 1630s – the height of "tulip-mania" in the Dutch Republic – some people were trading all their possessions for a single bulb of the right kind. This in turn led to the tulip being used by some artists and moralists as a symbol of foolish and covetous behaviour.

In fact many, if not most, seventeenth-century flower paintings would have been much cheaper than the arrangements they represented. The preciousness of flowers encouraged their botanically exact recording – a characteristic of even the earliest flower paintings, such as those of the Flemish painter Ambrosius Bosschaert. The illusion of reality in these paintings can be misleading, however, as the arrangements of many seventeenth-century flower-pieces could never have existed in life. They are often imaginary, ideal bouquets, assembled over several months, in which flowers of

▼ **Illusionism**
Ambrosius Bosschaert, the founder of a dynasty of artists, specialized in flower painting and enjoyed great fame during his lifetime. Until about 1614 he lived and worked in the Dutch town of Middelburg, at that period home to several renowned botanists. The growth of interest in flowers within academic circles is reflected in Bosschaert's paintings, which render flowers in a precise and accurate way. His bouquets were never painted from life but were assembled from studies of·individual flowers, and this gives his compositions a stylized quality. Each flower has its place and there is almost no overlapping. Here the subject is shown within an open niche that looks out onto a pleasant landscape which, like the flowers, offers an idealized view of nature.
Ambrosius Bosschaert, *Vase with Flowers*, c.1620.

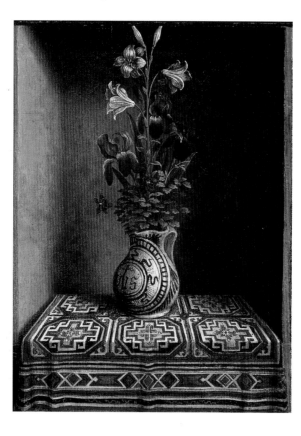

▶ **Floral symbols**
Although credited as the earliest surviving independent flower painting, this image in fact decorates the reverse side of a portrait which was originally attached to a devotional image, probably depicting the Virgin Mary. The lilies and irises stand for the Virgin – the lilies for her purity and the irises for her suffering – and are often present in scenes of the Annunciation (see page 43). They are just two of the many flowers with symbolic significance. For example, the Virgin was also represented by a thornless rose, while roses with their thorns have long been symbols of love, which also contains both pleasure and pain.
Hans Memlinc, *Marian Flower-Piece*, c.1485.

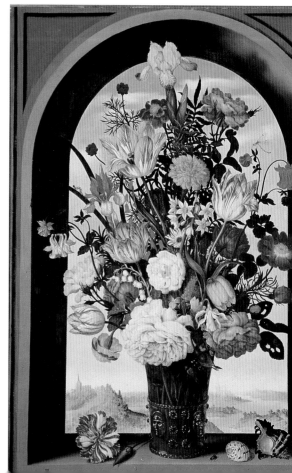

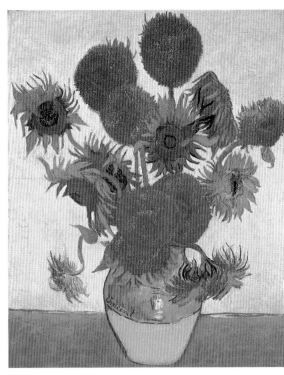

▼ **Personal expression**
Van Gogh wrote: "To get up enough heat to melt those golds, and the tones of those flowers – it's not everyone that can do it. It takes the energy and concentration of a person's whole being." The colour of sunflowers was particularly important for the painter, who developed a personal colour symbolism in which yellow suggested happiness and optimism. In this painting the yellow-dominated palette is intensified by the contrasting blue outline of the vase. The artist was aiming for "the effect of stained-glass windows in a Gothic church."
Vincent van Gogh, *Sunflowers*, 1888.

different seasons were combined in a single image. The decaying effects of time are frozen and the flowers captured for ever at the height of their beauty.

If flower paintings can celebrate flowers at their brief moment of full bloom, this very transience could also be exploited. Flowers, sometimes wilting or shedding petals, became one of many symbols of the brevity of earthly existence found in vanitas images (see pages 228–9). They also often appear in portraits as reminders of mortality (see page 163, William Hogarth, *The Graham Children*). In the late nineteenth century Vincent van Gogh, in his famous series of sun-flower paintings, represented flowers of all ages, and so the full cycle of life. For van Gogh, sunflowers also had personal significance, evoking the warmth and luminosity of Provence, where he settled in 1888.

Decoration and abstraction

Many artists have exploited the symbolism of flowers, but it is their decorative potential that is the most enduring impulse behind their use. Floral motifs have long been the staple of decorators, whether mosaicists of the ancient world or modern wallpaper designers, and painters have often chosen to depict flowers for their abstract, formal qualities. In the twentieth century one artist who explored the decorative potential of painting was the Frenchman Matisse, who used colour in an expressive rather than a purely descriptive way. The chrysanthemum in his *Still Life, Seville II* is the centrepiece of a rhythmic pattern of swirling shapes that echo the flower's leaves and petals. A number of later painters have taken the exploration of pattern and colour to the brink of abstraction. The American painter Georgia O'Keeffe, for example, saw the flower as merely a starting point for her own sensuous vision.

▲ **Expressive colour**
Matisse visited southern Spain in 1910–11, and while he was there he painted two still lifes of flowers with luxuriant Spanish shawls. The rich palette and exotic patterns show both the impact of the Moorish culture on the artist's work and his commitment to the decorative and expressive role of painting.
Henri Matisse, *Still Life, Seville II*, 1910–11.

▶ **Sensuality**
Georgia O'Keeffe wanted people to pause and appreciate the beauty of the natural world. This close-up focuses attention on the lilies and makes a feature of their sensuous shape. Unlike earlier painters, she rarely represented flowers in their entirety, nor within a real, recognizable space. Instead she focused on the sinuous lines and delicate colours of single flower heads, which she enlarged almost beyond recognition. O'Keeffe's flower paintings are often seen as having strong sexual associations, the curves and folds suggesting human anatomy and the soft tones evoking flesh.
Georgia O'Keeffe, *Two Calla Lilies on Pink*, 1928.

Reminders of death

The objects depicted in vanitas still lifes have the purpose of reminding the viewer of the fragility of human life and the brevity of earthly existence. They usually include symbolic reminders of the passage of time, such as skulls, timepieces, or snuffed-out candles, as well as precious items, books, or musical instruments, which warn of the futility of worldly pursuits and possessions. The term "vanitas," Latin for "vanity," derives from · a much-quoted passage in the Old Testament book of Ecclesiastes (1:2): "Vanity of vanities, saith the Preacher, vanity of vanities, all is vanity."

Although the vanitas still life developed in the early seventeenth century, themes such as the transience of life and the futility of worldly things appear in earlier paintings of religious subjects. Many representations of penitent saints such as Jerome or Mary Magdalene show them contemplating a skull as a memento mori, or reminder of death. Skulls also denoted Golgotha ("the place of the skull"), the site of Christ's crucifixion. Their earliest depictions as subjects in their own right appear on the reverse side of paintings, such as that found on the back of the Flemish painter Jan Gossaert's *Carondelet Diptych* (see left).

Painting and morality

From around 1620, artists in the Dutch town of Leyden began to develop the vanitas theme into a distinctive type of still life. Leyden was home to a large university, and its scholarly inhabitants seem to have enjoyed the coded, symbolic language of such paintings. One of the governors of the university was Jacob Cats, a poet and the author of a popular emblem book, which, like the vanitas still life, had strong moralizing intentions and communicated its themes with symbolic images. The town was a stronghold of Calvinism, which, in its condemnation of all things worldly, closely mirrored the themes pursued by its painters.

Harmen Steenwyck's painting *Still Life: An Allegory of the Vanities of Human Life* demonstrates the characteristic traits of the Dutch vanitas still life. A skull, lit by an unrelenting light, forms the centrepiece of a carefully composed arrangement of precious objects: the beautiful shell and fine Japanese sword, both expensive rarities, stand for wealth and worldly possessions; the book symbolizes the knowledge acquired in life; the flute represents the pleasures of the senses. The artist originally painted a portrait bust, now hidden beneath the earthenware pot, as an allusion to worldly glory. These objects are accompanied by a timepiece and a snuffed-out lamp, two more established symbols of the transience of life and its pleasures.

While the vanitas still life conveys its message with clarity, it is often contradicted by the nature of the

Vanity of learning
Following the example of Dutch painters, artists throughout Europe began to paint vanitas still lifes. In this work by an unknown Spanish artist, three books are laid out, waiting to be read. Resting on the largest is an hourglass, inverted and about to start measuring the passage of time. While books may pass from one generation to the next, the knowledge acquired from them is limited to one person's lifetime.
Unknown artist, *Still Life with Books and an Hourglass*, c.1630–40.

painting itself. Beautifully composed and finely painted, it is a worldly object in its own right, designed to bring sensual and aesthetic pleasure to its viewers. The conflict between the display of wealth and the condemnation of it was keenly felt in the Dutch Republic during the seventeenth century. The country's unprecedented prosperity led its Calvinist preachers, like its still-life painters, to warn of the grave moral consequences of pursuing material possessions.

Other vanitas still lifes focus on the futility of learning: for example that painted by an anonymous Spanish artist, in which three books, their corners curling from age and use, are shown with an hourglass, a conventional sign of the passage of time.

The predominant themes of the vanitas continued to be explored by nineteenth-century artists, but the established symbolism and conventions were replaced by a more personal and direct approach. Artists were less concerned with the moral consequences of material wealth and knowledge than with the reality of death and its implication for both the individual and society. The French Romantic painter Théodore Géricault made a series of paintings of disembodied human remains, arranged as if they were still-life objects. Unlike the symbolic skulls of earlier vanitas paintings, these grim studies convey the gradual process of decay with uncompromising directness, and confront us with the physical reality of death.

Modern interpretation

The theme of mortality and the fragility of human life remained a preoccupation of twentieth-century artists, whose paintings often reflect events and circumstances specific to the modern age. In 1939, between the end of the Spanish Civil War and the beginning of the Second World War, Pablo Picasso made a series of still lifes in which he adopted the traditional conventions of the vanitas. While the paintings may have been intended as memorials of his mother, who had died some weeks earlier, they may also have been made in response to the horrors and atrocities of war. In his *Bull's Skull, Fruit, and Pitcher* the jagged skull carries grim connotations, but the colourful fruit and flowering tree sound a note of optimism, suggesting that in the wake of war and death come peace and new life.

A study in mortality
This is a preparatory study for Géricault's large-scale painting *The Raft of the Medusa*, which showed the survivors of a shipwreck who had stayed alive by eating the corpses of their companions. The artist acquired the heads at a morgue and kept them for weeks while he copied them. The exercise of painting from decomposing flesh may have been a way for him to become acquainted with death and cannibalism, as no such heads appeared in the final work.
Théodore Géricault, *The Severed Heads*, c.1818.

Reworking tradition
Picasso saw himself as continuing, and constantly reworking, the European artistic tradition. Here he adopted the conventions of the seventeenth-century vanitas still life, but replaced the human skull with a bull's skull. The starkness of its appearance and the bleakness of its message are softened by the vigorous treatment and the colourful nature of the surrounding objects.
Pablo Picasso, *Bull's Skull, Fruit, and Pitcher*, 1939.

Symbolism and allegory

The objects depicted in still lifes often convey meanings beyond those that are immediately apparent. While a skull or an hourglass in a vanitas painting obviously stands for mortality and transience, the symbolism of other still-life objects is not always as clear. When the still life emerged as an independent genre in the seventeeth century, many of the objects painted by artists still retained the symbolic value they had in earlier religious pictures, so that a painting of a lily or a rose, for example, might represent the Virgin Mary.

During the course of the seventeenth century, the symbolism of objects in still lifes became increasingly varied and complex. In the Dutch Republic, where the genre enjoyed the greatest popularity, artists might exploit the symbolic meanings given to objects in the so-called "emblem books" of the period, which drew a variety of morals from the material world; for example, a tulip could stand for folly, owing to the phenomenal prices people were willing to pay for this highly prized novelty. Still-life painters also began to represent abstract concepts, such as the seasons, the senses, and the arts, all of which had traditionally been depicted using allegorical female figures. While some symbols were based on established conventions, others were devised by the artists: both Samuel van Hoogstraten and Vincent van Gogh depicted objects of personal significance as a means of representing themselves.

In the work of twentieth-century artists the symbols are often harder to define; for example, in Magritte's painting *The One Night Museum* it is the strange combination of objects, rather than the objects themselves, that gives the work its meaning.

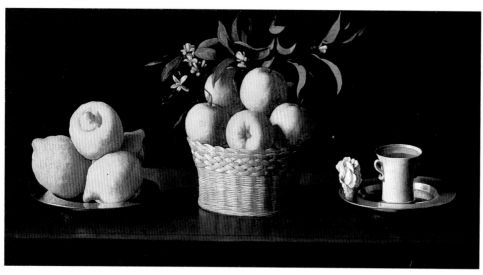

◀ **The Virgin Mary**
Francisco de Zurbarán was the leading religious painter in Seville in the 1630s. His large paintings of saints and biblical subjects often include still-life details that convey symbolic meanings. Some of these were developed into independent still lifes in which the objects depicted were probably intended to retain their religious significance. In this work the items are all related to the Virgin Mary. The cup of water is a symbol of purity, the rose one of her floral attributes, and the oranges and blossom stand for virginity and fertility. The lemons on the left are emblems of faith. The well-ordered composition gives the objects the appearance of offerings on an altar. **Francisco de Zurbarán**, *Still Life with Lemons, Oranges, and a Rose*, 1633.

▶ **The pictorial arts**
In the French painter Chardin's still life, the palette and brushes stand for painting, while the drawings and geometrical instruments stand for architecture. In the centre is a statue of Mercury, messenger of the gods and patron of the arts, sculpted by Chardin's contemporary Jean-Baptiste Pigalle. At the right is the cross of the Order of St Michael, awarded to the sculptor in 1759. Pigalle was the first artist to receive the honour, and by including it Chardin was drawing attention to the improving status of artists during the period. **Jean-Baptiste-Siméon Chardin**, *Still Life with Attributes of the Pictorial Arts*, 1766.

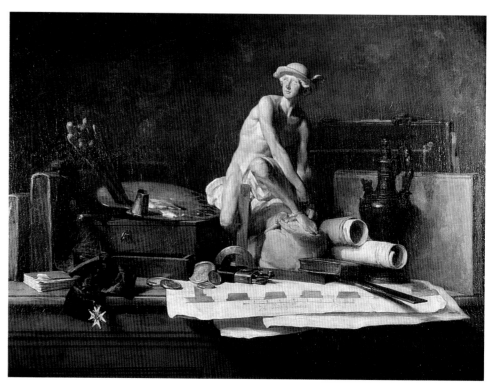

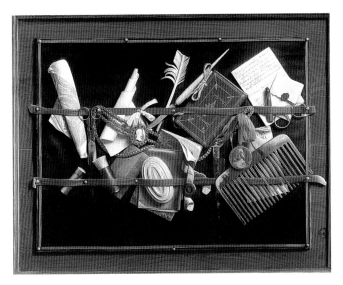

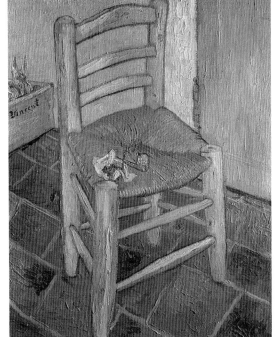

◄ **Emblematic portrait**
The Dutch painter van Gogh chose this chair to convey how he wished to be considered. Placed in a modest setting, this rural piece of furniture helps to create the impression of a straightforward and down-to-earth character. The pipe and tobacco left on the chair act as personal attributes and suggest that the artist is present somewhere.
Vincent van Gogh, *The Chair*, 1888.

▲ **The artist**
Van Hoogstraten liked to depict objects that were of personal significance to him. Behind the ribbons are mundane items, such as his comb and glasses, as well as objects that highlight his achievements as an artist and a writer. He was the author of the two books and he received the gold medal from the Holy Roman Emperor. The handwritten poem in the top right corner celebrates his skill at creating convincing illusions.
Samuel van Hoogstraten, *Trompe l'Oeil Still Life (Pinboard)*, 1666–8.

▶ **The senses**
The French painter Baugin ingeniously uses the still life to suggest the five senses. A luminous glass of wine and the crusty bread represent taste; the carnations stand for the sense of smell; the lute and music book allude to the sense of hearing; and the purse and playing cards embody the sense of touch. Our sense of sight is satisfied by the painting itself, with its accurate rendition of textures and atmospheric representation of light.
Lubin Baugin, *The Five Senses*, 1630.

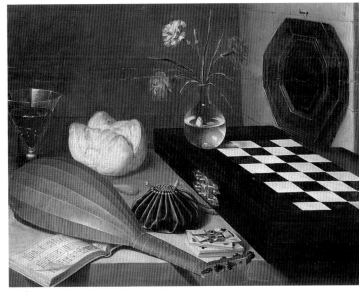

▼ **The unconscious**
René Magritte was closely associated with the Surrealists and, like them, he was fascinated by the unconscious. In this painting the Belgian artist teases our expectations by bringing together seemingly unconnected objects. A disembodied hand, an apple, and a third, unidentifiable object all occupy their own box-like spaces, like specimens in a museum display case. The fourth box is covered by a paper cut-out which conceals its contents.
René Magritte, *The One Night Museum*, 1927.

▶ **Still-life portrait**
Giuseppe Arcimboldo devised an innovative type of painting which cleverly combined the genres of portraiture and still life. The Italian painter used inanimate and usually organic objects, such as fruit and vegetables, to create illusionistic images of human faces. Some of these are portraits of his patrons, others represent concepts such as Summer. In his depiction of Summer, Arcimboldo playfully arranged vegetables into profile portraits, using a pod of peas for the teeth and a peach for the cheek; he included his name on the figure's collar.
Giuseppe Arcimboldo, *Summer*, 1563.

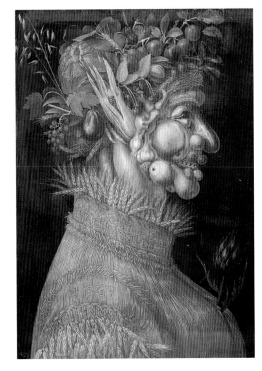

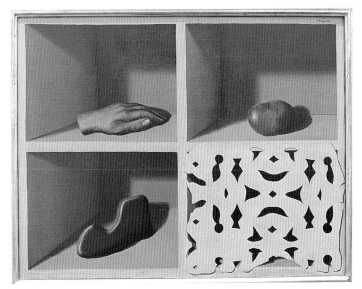

SYMBOLISM AND ALLEGORY 231

A feast for the eyes

ood has been a constant subject of still-life painting (see page 224) ever since the ancient Greek artist Zeuxis painted grapes in a realistic way. When still life emerged as a separate genre in seventeenth-century Europe, artists followed his example and sought to create images that looked so real that they appealed as much to the appetite as to the eye. This required painters to record faithfully the textures and colours of a wide variety of different foods, which demanded considerable technical skill. By the nineteenth century the goal of creating an illusion of surfaces was often replaced by other aims. The still lifes of Caillebotte and Cézanne, for example, convey little of the texture and taste of the fruit depicted. The Impressionist Caillebotte attempted to suggest glimpsed views of still-life subjects found in the everyday world. In contrast, his contemporary and fellow Frenchman Cézanne was preoccupied with the formal design of his carefully set-up still-life arrangements. In the paintings of each period, the nature of the display is of utmost importance, suggesting a context for the food, be it a banquet, a kitchen, a market, or a billboard. This changes from one century to the next, reflecting the society in which the painting was produced.

Breakfast-pieces

From the early years of the seventeenth century pictures of food laid out on tables were popular in Dutch painting. Such still lifes, which were known as *onbijtjes*, or breakfast-pieces, appeared in various forms. Some, such as *Still Life with Pie* by Clara Peeters (see page 222), depict all kinds of luxury foods, fine glasses, and intricate objects, arranged in an orderly manner on a crisp white tablecloth. The high viewpoint allows us to see as much as possible of the lavishly laid table, and there is little overlapping. These festive displays suggest a special occasion taking place in a privileged household and their plentiful nature, like paintings of precious objects ("pronk" still lifes), reflects the abundance and variety of foods in the Netherlands at this time. A less formal type of breakfast-piece, such as those painted by Pieter Claesz., also

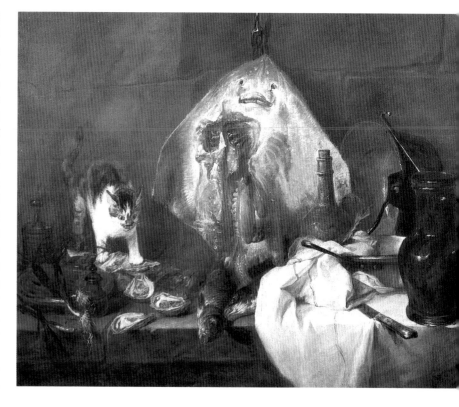

The kitchen
This painting is one of the most celebrated still lifes by the French artist Chardin. The arresting depiction of the splayed ray, its slimy belly gleaming in the light, earned the painter instant acclaim and secured him a position as a member of the French Academy. The painting's large scale and sensational subject separate it from the intimate and subdued works for which Chardin is best known. However, the deliberately casual arrangement of oysters, fish, pots, and pans is typical of his still lifes. While the red fish dominates the composition, the animated cat provides a fitting and dramatic contrast, as well as strong anecdotal interest.
Jean-Baptiste-Siméon Chardin, *Still Life with Ray Fish*, 1728.

Breakfast piece
Pieter Claesz, born in Germany, worked in Haarlem, in the Netherlands, where he specialized in a type of still life known as the breakfast-piece. His paintings, which have an intimate and understated quality, usually depict simple meals of fish and bread on pewter dishes, with a glass of beer or wine.

Claesz used a restricted palette, usually browns and greys, with which he evoked the light and atmosphere that envelop the objects. His skill at representing different textures is evident in this painting, in which the gleam of the oily herring contrasts with the crustiness of a bread roll.
Pieter Claesz., *Still Life with Fish and Bread*, 1636.

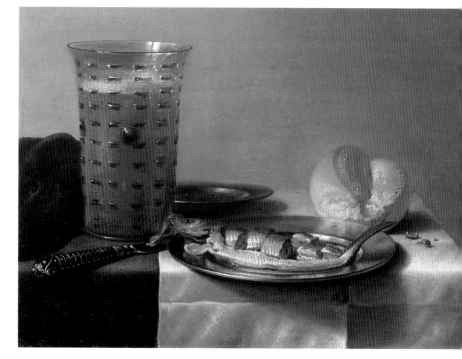

developed in the Dutch Republic. These represent simpler foods, such as bread or fish, within humbler settings, and the composition is deliberately casual, with knives lying on the table and food sliced or half-eaten, suggesting that a meal is already in progress. The viewpoint is often low and close to the table edge.

Inspired by his Dutch predecessors, Jean-Baptiste-Siméon Chardin concentrated on the still life. He specialized in intimate depictions of ordinary foods and simple vessels, arranged on bare tables or stone shelves. The food is not on display, nor being offered for consumption, as in the breakfast-pieces of the previous century, but shown in a kitchen environment, as if being prepared. Chardin's seemingly haphazard arrangements of kitchen utensils give the impression of disarray, but their casual appearance is misleading, as he organized his objects with the utmost care, balancing their shapes, colours, and textures to create compositions of exquisite harmony. The overall effect is far more important than the precise imitation of details. He developed a bold and painterly technique, through which the illusion of textures, such as those of fish entrails or shining copper, is created only when the work is seen from a distance.

Immediacy

Impressionist still lifes usually show objects and food-stuffs as they might be glimpsed in the real world. Such an approach was not surprising among a group which in general moved away from the traditional subjects of art to create pictures that represented the world in an evidently spontaneous way. Caillebotte was unusual in painting still lifes as if he were out of doors. His *Fruits Displayed on a Stand* has the candid appearance of an unplanned snapshot, with some of the fruit cut abruptly at the edge of the painting. This gives the impression that the colourful display suddenly caught the painter's eye as he strolled past. Like his colleagues, Caillebotte was interested in depicting the rapidly changing city of Paris, and he located his still life in a street market, where the fruit was arranged beautifully to attract the eye of the customer.

The way in which things were sold was also a theme explored in the 1950s and 1960s by the Pop artists, whose paintings address the consumer culture of the twentieth century. Andy Warhol's painting of Campbell's soup cans departs from the conventional still life in several ways: for example, it does not represent the food itself, but focuses on the brightly coloured modern packaging; and, unlike the carefully composed displays of earlier still lifes, his arrangement is completely flat, eliminating any sense of real space. Warhol had, in fact, adopted the language and technique of the modern media, giving his works the appearance of mass-produced images and, by mimicking the commercial, mechanical printing of product labels, diminishing the impression that the artist made the picture with his own hands.

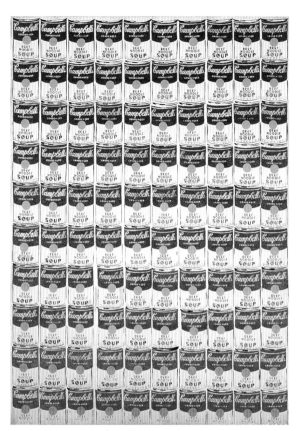

◄ **Consumerism**
The Pop artist Andy Warhol made numerous images of Campbell's soup cans in various media, including painting. While many focus on just one can, this one depicts 100 identical soup cans, all laid out in uniform rows. The repetition of the same image reminds us of the mass-produced nature of food (and other goods) in modern consumer society. Warhol also adopted the language and techniques of mass media, eliminating all trace of the artist's own skill and giving the work the polished appearance of a billboard poster or product label.
Andy Warhol, *Campbell's Soup, 100 Cans*, 1962.

▲ **Street-market scene**
Gustave Caillebotte was a member of the Impressionists and showed his work in many of their group exhibitions, held in Paris from 1874 to 1886. As well as painting scenes of the French capital, he produced numerous still lifes. In this one he used a high-keyed palette, typical of Impressionist paintings, to represent the varied, colourful display of fruit and vegetables. The colours take on a life of their own, creating a vivid pattern across the whole surface of the canvas. They convey more about the consistency of the paint itself than about the textures of the items depicted.
Gustave Caillebotte, *Fruits Displayed on a Stand*, c.1882.

A new perspective

◄**Colour and form**
Cézanne arranged his objects
into a balanced composition in
which the round form of the jar
is echoed in the fruit surrounding
it. The stability of this central
group is counterbalanced by the
plate of apples, which is set at
such an acute angle that the
fruit seems in danger of rolling
onto the floor. This detail gives
dynamism and suspense to the
otherwise stable still life.
Paul Cézanne, *Still Life with
Ginger Jar and Eggplants*,
c.1890–4.

► **Fragmented views**
Braque's still life is composed of
fragmentary details, which breaks
the illusionistic picture surface
into incoherent parts. The
disjointed parts show the objects
from a number of viewpoints,
which together create an
all-around view that would
be impossible in reality. For
example, the violin's tuning key
is shown from the side, while its
soundboard is shown from the
front. As if to draw attention to
this clever distortion of space, the
palette at the top is painted in a
conventional way, from a single
viewpoint. It hangs from a nail
that is painted to appear to be a
real nail pounded into the canvas.
It even casts a painted shadow,
providing a stark and witty
contrast with the shattered
image beneath it.
Georges Braque, *Violin and
Palette*, 1909.

With the development of Cubism during the early years of the twentieth century, still life entered an exciting new era. Since the Renaissance, artists had sought to make their pictures look like windows on the world, rendering views or subjects as if seen from the stable position of one viewer, and they used perspective and modelling to further this illusion. However, beginning in about 1907, Pablo Picasso and Georges Braque departed radically from this tradition. They abandoned conventional perspective and began to experiment with new ways of representing reality. In their still lifes they sought to challenge the belief that the eye perceives the world from a single viewpoint, as if through a camera lens, and to show how the brain accumulates visual information gradually, from different viewpoints and over a period of time.

The legacy of Cézanne

Although the revolutionary paintings of Picasso and Braque seem completely different from anything that preceded them, both painters were in fact influenced by the work of Paul Cézanne. During the 1860s and 1870s Cézanne had been associated with the Impressionists, showing work in several of their group exhibitions, but he did not share all of their artistic aims. While the Impressionists were principally concerned with representing the fleeting effects of sunlight or the constant flow of urban life, Cézanne wished to convey the more permanent aspects of the natural world. In both his landscapes and still lifes he sought to capture the stability and density of solid forms, such as rocks, trees, apples, and jugs. Traditionally painters had used light and shade to create the illusion of three-dimensionality, but Cézanne used brushstrokes of contrasting colours. In addition, where earlier painters had used a consistent perspective system to give their paintings stability and depth, Cézanne deliberately distorted his pictorial space, tilting surfaces and plates at precarious angles. Despite the appearance of imbalance that this created, he organized his compositions with meticulous care, propping up objects on piles of coins to get them into perfect positions. By subtly combining various angles and viewpoints, he aimed to give a more complete view of his arrangements of objects. He also distorted the forms of his pots and jugs for the same purpose: in his *Still Life with Ginger Jar and Eggplants*, for example, the pot is shown simultaneously from above and from the side.

In 1907, a year after Cézanne's death, a large exhibition of his work was held in Paris, enabling artists of the younger generation to see many of his paintings for the first time. These had a great impact on Picasso and Braque, who adopted and developed many

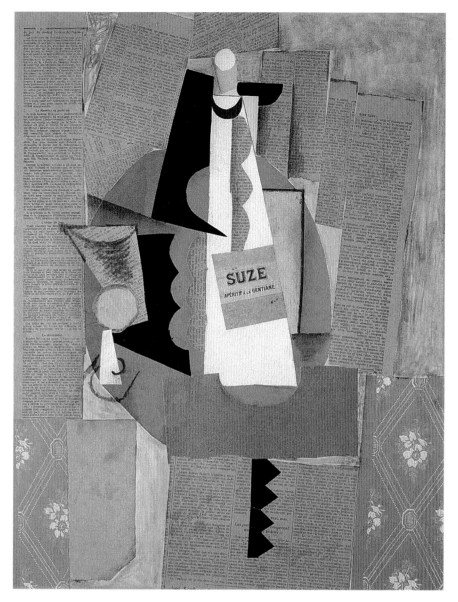

▼ **Flat colour**
Although Léger was influenced by the innovations of Picasso and Braque, he took their ideas a step further in this painting. While a Cubist still life combines numerous viewpoints of the same objects, this work brings together fragmentary views of completely different things. On the left are a vase and a platter, which bear no relation to the bowl of pears on the right. Only one stray pear bridges the abrupt division between the two halves. The flat areas of bold colours give the image the appearance of a collage and the overlapping frames draw attention to the conceits of the painting.
Fernand Léger, *Still Life (Bowl of Pears)*, 1925.

of Cézanne's ideas in their early Cubist works. Their early still lifes continued to explore the possibilities of combining simultaneous viewpoints. They distorted the forms of their objects to the point of fragmentation, creating the impression that the artist walked around his arrangement while painting, noticing different details with each step. As a result their paintings suggest a sense of movement through both time and space. A Cubist still life such as Braque's *Violin and Palette* does not depict objects in their entirety, but merely suggests them with fragmentary details. A keyboard might stand for a piano and a curving line for a violin. Cubist paintings are also filled with flat, prismatic planes, which suggest the fragmentation of three-dimensional forms. By combining disparate details and viewpoints in a single canvas, Picasso and Braque shattered the illusion of a consistent fictive space.

Exploiting the picture surface

As Cubism developed, these two artists found new ways to draw attention to the flatness of the picture surface. At times they superimposed painted letters

▲ **Illusion and reality**
Picasso's collage plays with the notion of illusionism in an unexpected way. On one level it represents a bottle and glass arranged on a table, but on another it is simply a flat arrangement of cut-out paper. The unexpected combination of real materials and illusionistic image confuses the eye, forcing it to shift from one level to the other. While some materials, such as the bottle label, are used to represent themselves, others stand for a wide range of things. The newspaper, for example, is used for the background, the glass, and part of the bottle. As well as providing forms, its text also provides a historical context for the work. The date is 18 November 1912 and the subject the conflicts of the Balkan War.
Pablo Picasso, *Glass and Bottle of Suze*, 1912.

or words on their images, or mixed their paint with glue and sand to give it greater texture. Around 1911 they began to incorporate materials from the real world, such as wallpaper and newspaper, into their still lifes. This was the first time that ordinary objects were introduced into a high-art context. While earlier still-life painters had aimed to represent objects in as illusionistic a way as possible, Picasso and Braque simply cut fragments of paper into the shapes of objects and stuck them onto their pictures. In his *Glass and Bottle of Suze*, for example, Picasso used newspaper, wallpaper, and a bottle label to create the image. The contrast between the familiar, real-life materials and the fictive arrangement of objects forces the eye to shift back and forth from the flat picture surface to the illusionistic image of objects on a table.

Picasso and Braque were the principal players in the development of Cubism, but their approach was followed by many of their contemporaries. Both Fernand Léger and Juan Gris adopted the ideas underlying Cubism, but built upon them to create works in their own distinctive and personal styles.

> "If pictorial expression has changed,
> it is because modern life has
> made it necessary."

Fernand Léger, "Contemporary Achievements in Painting," 1914

Abstract Painting

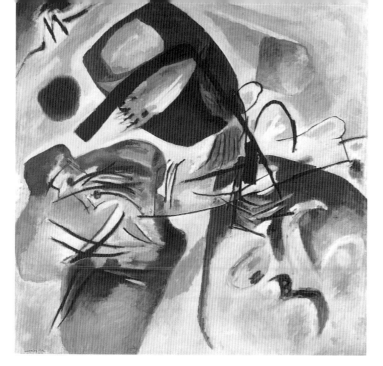

▲ Roots of abstraction
The Russian-born painter Wassily Kandinsky is often credited with creating the first abstract paintings. This work, with its rhythmic arrangement of shapes floating and colliding in space, might be described as an abstract "composition" analogous to a musical work. There also seem to be hints of a landscape here – traces of a figurative painting style that the artist was moving away from at this time.
Wassily Kandinsky, *Painting with the Black Arch*, 1912

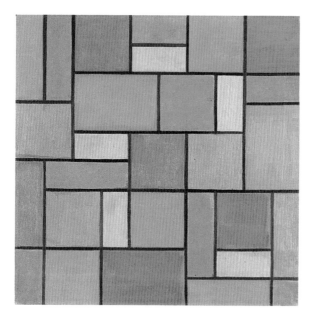

▲ Order and harmony
The reduction of painting to an irregular grid of black lines enclosing flat planes of colour is characteristic of the Dutch movement De Stijl, of which Theo van Doesburg was a leading member. These artists rejected figurative art, believing that a painting should stand on its own as a balanced composition of straight lines, rectangles, primary colours, and non-colours (black, grey, and white). They felt that this visual language had universal validity, carrying feelings of order and harmony.
Theo van Doesburg, *Composition 17*, 1919.

Elsewhere in this book we explore paintings by their subject matter, but this approach becomes difficult when discussing abstract art, which does not depict external subjects. Adopting a more traditional approach, we will look at several key movements in abstract painting in chronological order, placing each of these "isms" in its broad cultural and historical context. All of the works come from the same century, the first abstract works having been produced in the early 1910s.

Although the term "abstract" has been used to describe works of art for almost a century, it is not without its problems. "Non-figurative," "non-objective," and "non-representational" have also appeared, in different contexts, to suggest fundamental breaks with the idea of a painting as a window onto a recognizable world. To "abstract" means to withdraw something and many artists have arrived at "abstraction" by moving away from the real world, simplifying or reducing their visual language. But other artists claim that their work has no links to external reality, which suggests that an abstract work may have its own reality. For example, Theo van Doesburg insisted in 1930 that his art had "no significance other than itself" and stated that "nothing is more real than a line, a colour, a surface."

Interpretations

Van Doesburg's words might lead us to understand that abstract paintings are essentially about such formal components as colour, shape, and line, and that the viewer is to appreciate them for these stylistic qualities rather than search for subject matter. Certainly such ideas have been very influential throughout much of the late twentieth century, but they have their roots in art and thought of the late nineteenth century. Art, understood to have been freed from its traditional descriptive role by photography, and from its social requirements by the decline of institutional patronage, could now explore its own concerns. For many, these concerns were visual, and paintings which emphasized visual effects (at the expense of, say, narrative intentions) were deemed advanced. Thus a statement by the influential French painter and theorist Maurice Denis,

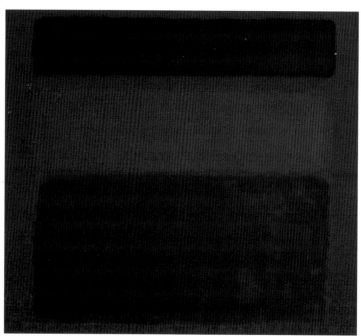

◄ Emotion
"My paintings are about tragedy, ecstasy, and doom," wrote Rothko. "If people do not burst into tears when they see my work, then they miss the point." Rothko, who was born in Russia but moved to the United States as a child, was particularly anxious to control both the interpretation and the exhibiting of his work. He hoped his huge canvases would communicate at a deep emotional level and in this painting he uses a restricted palette to convey mood.
Mark Rothko, *Untitled; Red, Brown, and Black,* 1958.

written in 1890, might seem to be laying the ground for abstraction: "A picture – before it is a war horse, a nude woman or some anecdote – is essentially a plane surface covered with colours assembled in a certain order." Art criticism developed a specialized formalist language for dealing with this new "autonomous" art, which was usually to be found in the galleries of a fast-growing and somewhat exclusive art world.

It is tempting to use this approach when looking at *all* abstract paintings, which are, after all, compositions of colour, line, form, and so on. One of the problems of this method is that it masks or ignores the often very different intentions of artists and the various contexts within which their work was produced. Abstract art is not one thing. It is not simply about styles, or different ways of applying paint, or placing colour, and it certainly has not evolved in a coherent, linear way.

Varieties of abstract art

One simple way to categorize the images shown on these two pages, for example, is to distinguish between the "geometric" works of van Doesburg and Judd, and the looser, more "organic" look of paintings by Kandinsky and de Kooning. In the first style, materials are used with restraint and the emphasis seems to be on structure, perhaps suggesting emotional detachment on the part of the artists. In the second style, gestural techniques draw attention to the surface of the paint itself, emphasizing the artist's making of the picture. Rothko's work might be seen to sit somewhere between these two tendencies.

This distinction between "geometric" and "organic" abstraction is, in fact, somewhat arbitrary and also ignores the historical context. To correct this narrow view we might note that Rothko, de Kooning, and Judd were all American artists of the period following the Second World War. How did these three male artists differ in their attitude to the social and political realities of that time? Or we might note the dates of the works by Kandinsky and van Doesburg and ponder the relevance in Europe of the intervening First World War.

We may also draw distinctions between artists' intentions. Kandinsky, like many artists of his time, sought to transcend superficial appearances and reach a deeper reality. In his highly subjective paintings he used symbolic colours and shapes to build images which he hoped would have the emotional impact of music. Very different from this world of intuitive vision and poetic metaphor is the work of Donald Judd, who insisted on the literalism of his box-like works. Here the artist is close to being an engineer.

In the following pages we encounter artists who make widely differing claims about the meaning of their work. Some of these meanings are spiritual, some political, and some relate to the idea of the unconscious mind. The questions of whether abstract paintings can "speak" universally, across time and space, and whether artists can break with representation, and existing visual languages, and communicate in genuinely new ways, have interested both artists and theorists in recent times.

▼ **Geometric art**
This cool, impersonal drawing appears to be a representation of a structure. Numbers and words are included, perhaps as notes for the construction of the object. The American artist Donald Judd was not painting in 1967–8, but produced radically simplified, three-dimensional works using industrial materials. Paradoxically, this image is one of a series of line drawings that he intended to be independent works in their own right.
Donald Judd, *Untitled*, 1967–8.

◄ **Visitation**
De Kooning's title for this painting reveals that it treads a fine line between abstraction and representation. Paint is hurled, dragged, and splashed over the canvas, but a highly distorted and sexualized figure of a woman is visible. John McMahon, the assistant of the Dutch-born American artist, documented the evolution of this painting in a series of photographs that he took over several months at the end of 1966. He also suggested the title, saying that with the evidence of a second figure, floating with eyes closed above the woman, the work reminded him of a medieval painting of a religious visitation or the Annunciation to the Virgin Mary.
Willem de Kooning, *The Visit*, 1966–7.

Shattering the image

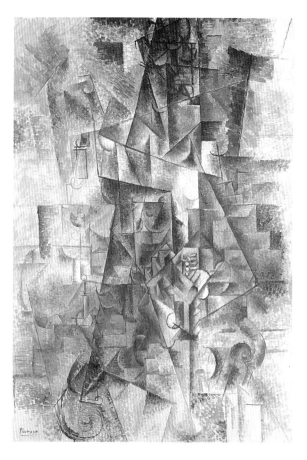

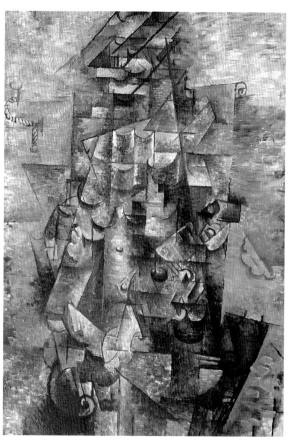

◄ Lyricism
In an interview in 1908 the French painter Georges Braque suggested that it was "necessary to draw three figures in order to portray every physical aspect of a woman, just as a house must be drawn in plan, elevation, and section." This painting is one of a series Braque made on a musical theme and the lyricism of the shapes may be related to this new approach to picture-making. **Georges Braque**, *Man with a Guitar*, 1911.

▼ Pictorial puzzle
In this canvas by the Spaniard Juan Gris the simplifications and multiple viewpoints of the "analytical" Cubism of Picasso and Braque are joined by a further, disruptive element: a fragment of printed paper collaged into the painting. The introduction of this piece of "reality" prompts speculation as to what is real and what is illusory. **Juan Gris**, *The Sunblind*, 1914.

▲ Dealer Cubism
One of Picasso's most abstract paintings, this work was made at a time when the artist and his close friend Georges Braque had the complete backing of the influential Paris art dealer Daniel-Henri Kahnweiler, who bought every work they produced and showed them at his gallery. This arrangement relieved Picasso of the need to spend time thinking about reaching a wider viewership by having his work shown at more public exhibitions. **Pablo Picasso**, *The Accordion Player*, 1911.

"Picasso took the orange, he peeled it, he cut it open, and shared what was inside. Art would never be the same again." In 1996 the British abstract sculptor Anthony Caro thus described Pablo Picasso's revolutionary approach to visual reality in his Cubist paintings of 1908–12. Although Picasso was never an abstract artist, he and some of his contemporaries were involved at this time in radical departures from Western traditions of representation. Works from this period and the ideas and debates which surrounded them have been of great significance for later exponents of abstract art.

Painting and complexity

Caro's words suggest that Picasso's innovation was somehow to do with piercing external reality, dissecting the world, even unveiling something extraordinary. The word "Cubism," coined by the French critic Louis Vauxcelles in 1908, perhaps hints at something else: a visual style which looks cubic. In any case an encounter with a work such as *The Accordion Player*, painted by Picasso in 1911, is a complex affair. Strikingly similar is a work painted by his friend Georges Braque in the same year. The two artists were working "like mountaineers roped together," as Braque later put it, in southern France when they made these paintings. The surfaces of

these works appear fragmented or organized into a series of tilting geometric planes. It is not clear what we are looking at, but a glance at the titles encourages us to search for clues. A few details begin to emerge: the scroll ends of the arms of chairs, a guitar's soundhole and fretboard. Diagonal lines which cross the grid-like structures give the paintings triangular compositions; perhaps these form the outlines of figures.

Picasso and Braque were rethinking pictorial devices that had been used since the Renaissance to create the illusion of objects and space in two-dimensional paintings. Here colour is reduced to a narrow range of greys, browns, and dull greens. There is no consistent light source and the figures merge with the space around them. Above all, these artists rejected the idea that one must look at the world from a single viewpoint – the very basis of perspective. Instead an "account" could be constructed from several different angles. This approach brought a new kind of scrutiny: a structured analysis of the world. But it also meant a kind of dispersal, so that a painting was now an amalgam of different views, combined in a shallow pictorial space.

Cubism did not occur in a vacuum. The work of Paul Cézanne, for example, was much admired by Picasso and Braque. Since the 1880s the French painter had explored new ways of representing form and space by building up the surface of his paintings with patches of colour, creating a sense of solidity and unity.

Speed

The Cubism of Picasso, Braque, and Juan Gris was exclusive in that it was exhibited in small dealers' galleries in Paris and seen by very few people. Quite different in this respect was the group of Italian artists known as the Futurists. Seeking to address a broad public directly, and to provoke questions about the relationship between art and modern life, they launched their movement with a manifesto published on the front page of the French newspaper *Le Figaro* on February 20, 1909. "The world's magnificence has been enriched by a new beauty: the beauty of speed. A racing car whose hood is adorned with great pipes, like serpents of explosive breath – a racing car that seems to ride on grapeshot is more beautiful than *The Victory of Samothrace*." This passage from the Futurists' manifesto gives a clear idea of the movement's concerns. The Classical past had been usurped by the radical and widespread transformations of the modern era. Technology was to be embraced.

The Futurists' rhetoric sits somewhat awkwardly with the sophisticated easel paintings by Balla and Severini shown here. But this visual language is a direct result of the artists' attempts to represent the fragmentation of urban life and especially the perceptual effects of speed. Cubist visual language is used and extended by pictorial disruptions and the loss of boundaries between objects and the space surrounding them is related to the movement of vehicles and/or the viewer. This subject matter seems far away from the more conventional café still lifes and figure paintings of Cubism, but all the paintings shown here are responses to a fast-changing world. Cubism not only breaks the window of painting, shattering the image, but is also an art of flux. Identities are not fixed, perception is shifting. These are works which acknowledge the uncertainty and dynamism of their time. It seems no coincidence that during this period Einstein developed his theories of relativity and Henri Bergson his ideas about the relationship between time and space.

▼ **Movement**
For the Futurists the racing car symbolized technological progress. But the car itself is not the subject in this work. In the manifesto of painting that they published in Paris in 1910 the Futurists claimed that "movement and light destroys the materiality of bodies." The sleek diagonals which dominate this image convey a sense of ideal movement.
Giacomo Balla, *Abstract Speed – the Car Has Passed*, 1913.

▼ **Dynamism**
In their 1910 manifesto of painting the Futurists stated that they wanted to "put the spectator at the centre of the picture," to involve the viewer in the shifting perspectives and disorientation that characterize the modern world. Severini's representation of urban life is certainly full of visual jolts and interruptions. He incorporates closely observed details – chimneys and advertising hoardings – into a simplified yet dynamic arrangement of shapes and forms.
Gino Severini, *Suburban Train Arriving in Paris*, 1915.

The invention of abstraction

I n the years leading up to the First World War several varieties of abstract art emerged in different contexts. Although Paris is often acknowledged as the capital of Western culture at this time, and it was here that the French painter Robert Delaunay exhibited his prismatic Cubist works, it is important to look further afield as well. In Germany and Russia artists were making paintings which varied greatly, not only in how they looked but also in the intentions which lay behind them.

Art and the transcendental

Wassily Kandinsky is one of several artists who might be seen as the originators of abstract art. His works of the early 1910s made in Munich employ an impressive range of colours and painterly techniques. In his highly influential writings of this time he makes it clear that he relinquished outer appearances in the hope that he could more directly communicate feelings to the viewer. Kandinsky believed that colours and shapes could convey deep spiritual truths that lie beyond everyday appearances and are difficult to describe in words. Seeing a similarity between painting and music, he wrote in 1912: "Colour is the keyboard. The eye is the hammer. The soul is the piano, with its many strings. The artist is the hand that purposefully sets the soul vibrating by means of this or that key." Kandinsky was a friend of the composers Schoenberg and Scriabin, and his paintings can be explored using a terminology common to both music and art: as improvisations or compositions, whose tones and rhythms give rise to harmony or dissonance.

In Russia around the same time, Kasimir Malevich was painting arrangements of abstract forms which appear to be suspended in space. But the rigid geometry of a painting such as *Suprematist Black Rectangle* contrasts sharply with the looseness of Kandinsky's works and is evidence of a faith in technological progress rather than an organic world evocative of nature. Malevich's work developed out of Cubism and Futurism, for he would have seen works by Paris-based Modernists in the collections of wealthy Moscow industrialists, but in important ways the two artists' aims were similar. In particular, both saw their turn toward abstraction as an artistic and a spiritual cleansing. Malevich, like Kandinsky, regarded colours as feelings and painted them floating across white planes which, for him, represented "the void." His squares and rectangles were new symbols, divorced from pictorial tools of the past but emblematic of a new spiritual reality.

Malevich called his kind of painting Suprematism, a word derived from the Latin *supremus*, meaning "highest or absolute ruler." He and Kandinsky shared a strong faith in the value of a new, independent art. They

Pioneer of abstraction
Many of the earliest abstract paintings by Kandinsky were executed on a small scale in the fluid medium of watercolour. Although this work is signed and dated 1910, there is consensus among art historians that the artist is unlikely to have painted it before 1912. The suspicion is that, wishing to be seen as the "inventor" of abstraction, he backdated it and gave it the title *First Abstract Watercolour* several years after its execution. Kandinsky was born in Russia but moved to Munich in 1896 at the age of thirty and there founded the group of painters known as Der Blaue Reiter (The Blue Rider). He went back to Russia during the First World War and then returned to Germany, where, from 1922 to 1933, he taught at the Bauhaus school of art and design in Weimar, Dessau, and Berlin, becoming a German citizen in 1927. **Wassily Kandinsky**, *First Abstract Watercolour*, c.1913.

The visible world
The French poet Guillaume Apollinaire coined the term "Orphism" for Delaunay's colourful brand of Cubist painting. The word derives from Orpheus, the musician of Greek mythology, and the reference emphasizes the analogy between art and music. As the title of this work suggests, Delaunay's paintings of this time maintain links with the visible world. The artist was interested in light and visual perception, but there are hints of urban architecture in the structure of this painting. **Robert Delaunay**, *Windows Open Simultaneously*, 1912.

also shared an interest in the mystical philosophies of the period and aspired to discover universal truths. In an exhibition of thirty-five of his paintings in 1915, Malevich hung them all unframed and placed one across the corner of the exhibition space, echoing the way icons were often displayed in Russian homes. The painting was of a black square on a white background.

Ends and beginnings

Malevich claimed to have painted his first "black square" as early as 1913. It is easy to see how this radical rejection of representation might be taken as an end of painting, yet for the artist it was a new beginning. Indeed his was a radical art for a time of radical change in Russia and many other painters turned to abstraction around this time. The Revolution of 1917 had dramatic consequences for most aspects of Russian society, including attitudes to culture. Art, as it was understood in Western capitalist society, was called into question and artists, traditionally seen as geniuses different from the rest of society, now realigned themselves as "workers." Art could no longer be a luxury commodity for the wealthy but had to be useful – to play an integrated role in building the new Soviet Russia.

The Russian Alexander Rodchenko would doubtless have been unhappy about his *Non Objective Painting* being called "art" at all. This work was not conceived as an object for aesthetic contemplation but as an exploration of line and space which might have other applications, for example in design or architecture. During the post-revolutionary period Rodchenko was working in areas such as model-making and poster design, and the transparent yellow planes in this image may relate to his experiments with "modern" materials such as plastic and glass.

◀ **Dynamism within order**
Malevich creates space in this work by simple means: shapes of different colours and sizes are painted on a white background, some overlapping, others separate. A sense of order is offset by diagonals, which introduce a sense of dynamism. Given Malevich's philosophical ideas on his art, it might be appropriate to describe this painting as a cosmological arrangement of forms.
Kasimir Malevich, *Suprematist Black Rectangle*, 1915.

▼ **Language of abstraction**
This painting seems more considered than Kandinsky's earlier *First Abstract Watercolour*. The restraint of the composition suggests that the artist was attempting to formulate his language of abstract art. He painted this work while teaching at the Bauhaus, in the year that the Bauhaus moved from Weimar to Dessau.
Wassily Kandinsky, *Swinging*, 1925.

▶ **Investigation**
This work has visual similarities to other paintings shown here, but it is very different in intention. Rodchenko painted it during the post-revolutionary era in Russia, when he thought of himself not as an artist but as a Constructivist, his work more akin to that of an engineer. Here he presents line and colour not to express emotion but as part of a practical investigation of structure and materials.
Alexander Rodchenko, *Non Objective Painting*, 1919.

Neo-Plasticism

◀ **Placement**
The clean, geometric planes and primary colours of this work are characteristic of Neo-Plasticism and strongly influenced much architecture and design during the twentieth century. Van Doesburg gives a sense of movement to this plane of interlocking coloured rectangles through his horizontal and vertical placement of the blocks of colour.
Theo van Doesburg, *Composition*, 1920.

▲ **Union of opposites**
Piet Mondrian aimed to achieve a feeling of equilibrium in his rigorous abstract works. For him, certain stylistic characteristics had a significance that went beyond the purely visual. The crossing of vertical and horizontal lines represented the union of opposites – for example, matter and spirit, and positive and negative. In painting works such as this Mondrian sought to make a new "universal" art for the modern age.
Piet Mondrian, *Composition with Grey, Red, Yellow, and Blue*, c.1920–6.

The term "Neo-Plasticism" was used by the Dutch painters Piet Mondrian and Theo van Doesburg to describe their austere, geometric abstract art. Its implication is that their paintings consist of purely formal, or "plastic," elements such as colours, forms, lines, and planes. All reference to the natural world are banished from canvases such as Mondrian's *Composition with Grey, Red, Yellow, and Blue* and van Doesburg's *Composition*, both of which were painted soon after the end of the First World War. These works are examples of the Dutch movement De Stijl (The Style), a loose grouping of painters founded in 1917 (along with a journal of the same name) led by van Doesburg and Mondrian. The stark visual language of these paintings has made them icons of the modern age.

The rudiments of painting

Mondrian's *Composition with Grey, Red, Yellow, and Blue* appears to be a relatively simple configuration of elements. Thin black lines run horizontally and vertically across the painting, precisely parallel to the edges of the canvas. They form an irregular grid which contains flat, rectangular areas of colour: black, several shades of grey, and red and yellow mixed with grey. The arrangement is asymmetrical but the way in which these blocks of colour are related across the painting maintains a sense of balance or visual unity.

Not long before painting this work Mondrian wrote that it would be wrong to look for references to the world in his paintings: "You must first try to see composition, colour and line and not representation *as representation*." This was art with its own reality, distinct from the rest of life. The Neo-Plasticists reduced drawing to its most basic form and used only the three primary colours (those from which all other colours can be mixed): blue, red, and yellow.

Harmony

On many occasions Mondrian stated that he sought an art of harmony and equilibrium. This was not simply a pictorial concern, for he understood the balance in his works to be the equivalent of a cosmic harmony. Like the Russian painter Kandinsky, he was an artist in search of a universal language able to communicate spiritual truths. Both painters were interested in theosophy, a blend of Eastern philosophies popular in Europe at the time, the central belief of which was that a knowledge of God could be gained by spiritual ecstasy, intuition, or direct personal communication.

Another major influence on Mondrian at this time (although he later dismissed his ideas) was the Dutch mathematician and mystic Dr Matthieu Schoenmaekers, who in 1915 had written: "The two fundamental complete contraries which shape our earth are: the *horizontal* line of power, that is, the course of the earth around

the sun, and the *vertical*, profoundly spatial movement of rays that originates in the centre of the sun."

The geometric structure of Mondrian's painting is very different from the subjective, gestural world of Kandinsky's pre-war art. The Dutchman had visited Paris in 1911 and studied Cubist paintings with their complex, faceted surfaces of shifting planes. He had also been impressed by the architecture of the modern metropolis and it is not difficult to see a connection between the grid-like armature of his paintings and the idea of an urban fabric.

In 1917 he wrote: "If art is to be a living reality for modern man, it has to be a pure expression of the new consciousness of the age." Neo-Plasticism was an idealistic art which was intended to be "timeless" but its utopian forms are nevertheless a product of a distinct era. Order and stability had great importance after the traumas of the First World War, and for Mondrian and van Doesburg art had a key role to play in restoring Western civilization. Works by these two artists may therefore be seen as an example, leading the way both

morally and aesthetically as Europe entered a new phase of history. Van Doesburg in particular exemplified these ideas. He wrote extensively of a new rational art, spreading the word through avant-garde journals, lecturing widely, and teaching at the Bauhaus school of art and design in Germany. Unlike Mondrian, who remained committed to painting, he extended his principles of abstraction into architecture, interior design, and graphic design.

A new direction

By 1942 Mondrian was living in New York. Having spent two decades exploring different combinations of his basic pictorial elements – primary colours, a black grid, and a white ground – he changed direction dramatically in late works such as *Broadway Boogie-Woogie*. As the title suggest, this painting was directly inspired by the city itself, as well as by the rhythms of jazz. Its busy visual language and openness to worldly references reveal an artist turning his back on the self-imposed restrictions of Neo-Plasticism.

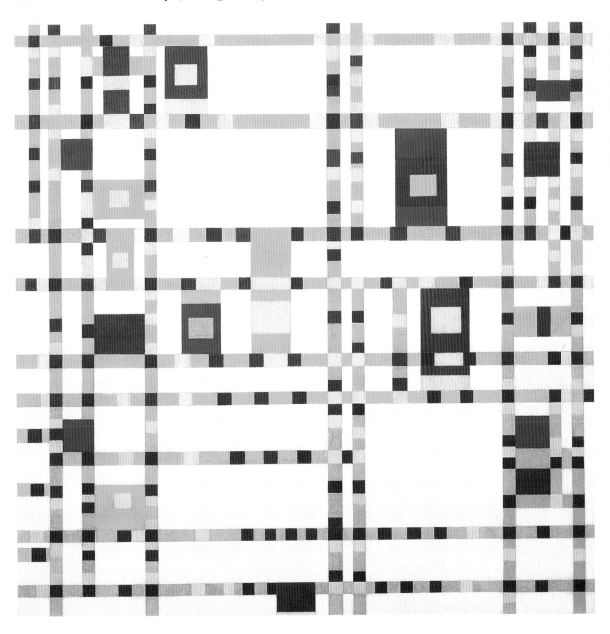

Urban rhythms
This work, painted some twenty-five years after the first examples of Neo-Plasticism, is a late mutation of the style. Mondrian evokes the rectilinear street plan of Manhattan and combines this imagery with a strong suggestion of the frenetic rhythms of the jazz that filled New York during the 1940s. This is a witty and confident painting by an artist who by now was considered one of the masters of abstract art.
Piet Mondrian, *Broadway Boogie-Woogie*, 1942–3.

Abstract Expressionism

Abstract Expressionism was an American phenomenon, the artists involved working in or around New York City. Its heyday was in the 1950s, when this new, large-scale abstraction was celebrated by the modern art establishment for making a significant departure from European artistic traditions. Extreme simplification in composition, colour, and form, along with exploration of unusual painting techniques, led to success in an art world which valued stylistic originality.

Individual artists worked in very different ways. The most rigorously "abstract" were Barnett Newman and Mark Rothko, whose enormous canvases were often saturated with one or two intense colours. Jackson Pollock, Franz Kline, and Willem de Kooning were more obviously "Expressionists," their gestural techniques emphasizing the process of painting itself and earning them the title "action painters."

One thing that united these artists was an interest in a particular kind of content. Several of them had made early works populated by archetypal figures derived from various mythological traditions. Throughout the late 1940s and the 1950s Pollock, Rothko, Newman, and others continued to see themselves as contemporary "myth makers," artists who might communicate timeless truths in a modern world.

"I'm not interested in illustrating my time," wrote Clyfford Still in 1963. "A man's time limits him, it does not truly liberate him. Our age – it is of science, of mechanism, of power and death. I see no point in adding to its mammoth arrogance the compliment of graphic homage." Like Kandinsky and Mondrian before them (see pages 242–5), the Abstract Expressionists turned away from the material world. They responded to the political and social realities of America of the 1930s and 1940s, and the Second World War, with abstract paintings about existence itself.

Automatic painting

The idea of the unconscious mind was crucial for Jackson Pollock. Undergoing Jungian analysis, he attempted to communicate directly from the depths of his psyche, developing extraordinary painterly techniques partly derived from the French Surrealists of the 1920s. In Pollock's brand of "automatism" he placed the canvas on the floor of the studio and dripped, threw, or spattered paint across it. He used sticks, crusty old brushes, or other implements to deploy the paint, which he also poured onto the canvas to build up complex webs. This "drip" technique," famously documented in film and photographs by Hans Namuth, amounted to a kind of dance. "On the floor I am more at ease," stated the artist in 1947. "I feel nearer, more a part of the painting, since this way I can walk around it, walk from the four sides and literally be in the painting." This was an art of spontaneity and of the untrammelled translation of the artist's emotions for the viewer.

Another reference point for Pollock's "drip" technique was the sand paintings of North American Indians. Several New York artists were fascinated by the rituals and living traditions of indigenous Americans since they were believed to be part of honest, authentic, and pure ways of living. Pollock identified with the role of the shaman or healer, seeing his paintings as cathartic, not only for himself but also for the world at large.

Such ambitions would seem natural to Mark Rothko. His paintings, often made on a scale which seems to envelop the viewer, are nevertheless subtle manipulations of colour and tone, as in *Light Red on Black*. With their softly brushed edges, large rectangles appear to hover in a space which is intended to invite meditative contemplation. Although the viewer seeks

▼ **Mysteries**
"The artist tries to wrest truth from the void," Newman wrote in 1945. For this artist painting was about "the mystery of life and death. It can be said that the artist like a true creator is delving into chaos." The titles Newman gave to his paintings echo this sense of profundity; "Onement" perhaps represents a mythic point of origin, the central vertical line symbolizing transcendence.
Barnett Newman, *Onement 3*, 1949.

▼ **Landscape of the spirit**
Critics have likened the jagged, craggy forms and heavily worked textures of Still's paintings to the landscapes of the American West. Although the artist acknowledged the validity of this comparison, he saw his , paintings more as metaphysical landscapes, metaphors for the unlimited expanses of the imagination. In a letter of 1959 he described his work thus:

"It was a journey that one must make, walking straight and alone . . . until one had crossed the darkened and wasted valleys and come at last into the clear air and could stand on a high and limitless plain." This dramatic imagery, evoking huge scale and grandeur, seems to be already evident in this early work.
Clyfford Still, *Painting*, 1944.

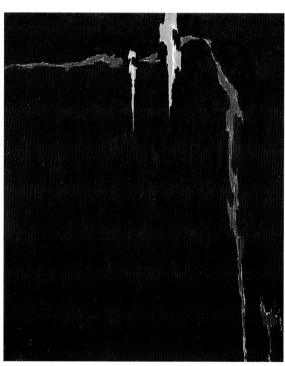

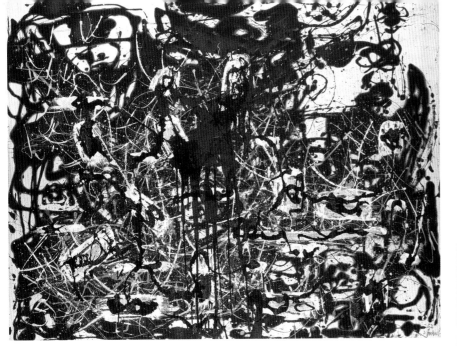

▲ **Conflict**

When he was questioned about the connection between his art and landscape painting, Pollock simply replied: "I am nature." This work was made six years after the artist began to use a technique of dripping and

pouring paint onto a canvas to give spontaneous expression to his emotions. By 1952 he was a troubled man, uncertain about the direction his form of abstraction would take. Here there is perhaps evidence of anger or frustration: drips of

coal-black paint obscure and appear to destroy the implied optimism and escapism of the brighter composition underneath.
Jackson Pollock, *Yellow Islands*, 1952.

▼ **Colour field**

In this work hazy patches of colour emerge, resolving themselves into an arrangement of hovering dark rectangular shapes. The work is an example of Rothko's large "colour field" paintings. By 1950 he had established this style and for much of the decade he used warm colours. However, by the time he made this canvas his

palette was becoming darker, perhaps mirroring the depression he was suffering. Here he seeks to maximize the emotional impact of colour, placing black at the heart of the composition. Rothko often deflected the suggestion that there were links between his paintings and the horizon and spaces of the natural landscape.
Mark Rothko, *Light Red over Black*, 1957.

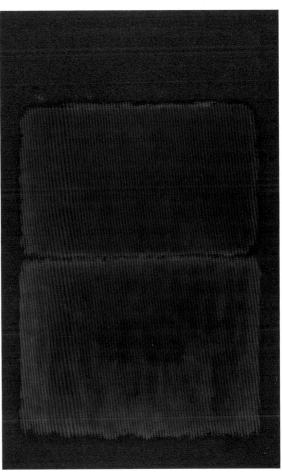

▲ **Exclusion**

Vivid oranges and greens twist and turn, battling for supremacy. The image of a mythic woman is alluded to rather than spelled out. Krasner struggled to be accepted by the Abstract Expressionists, who projected a distinctly macho image. She painted this work in the year after the car crash in which her husband and fellow artist, Jackson Pollock, was killed.
Lee Krasner, *Sun Woman II*, 1957.

to "enter" these works, lured in by contrasts of warm and cool colours and semi-transparent veils of paint, these "windows" are blocked and therefore repeatedly return him or her to the surface of the image.

The issue of interpretation is an interesting one when it comes to such paintings. Both Rothko and Newman were furious when their works were considered merely as arrangements of colour, line, and so on. This was art about deep truths, often tragic. Newman's "zip" paintings, for example, had their roots in Jewish mysticism. Pollock, interviewed in 1950, argued that any viewers of his work should "look passively and try to receive what the painting has to offer and not bring a

subject matter or preconceived idea of what they are to be looking for." In other words, "respond" – attempt to set aside one's cultural conditioning and awareness of context and see afresh.

Individual expression

Many writers have accorded Abstract Expressionist paintings mythic status. These works have been celebrated as the ultimate destiny of a modern approach to painting concerned with "purification," and as autonomous works which fully acknowledge that painting is a matter of putting pigment onto a flat canvas. They have also been heralded as masterpieces of individual expression, extraordinary feats of genius which shattered previous visual traditions of representation. Finally, they have been seen to signify freedom itself – an attitude which tied in neatly with American cultural policy during the Cold War.

Minimalism

▲ Art of the necessary
This painting was first exhibited at New York's Museum of Modern Art in 1959. In the catalogue Carl Andre wrote:"Art excludes the unnecessary. Frank Stella has found it necessary to paint stripes. There is nothing else in his painting Stella's painting is not symbolic. His stripes are the paths of brush on canvas." In Stella's paintings of this time very thick wooden stretchers, dense black paint, and lines which echo the edge of the canvas give the works an object-like quality.
Frank Stella, *The Marriage of Reason and Squalor, II*, 1959.

Minimalist art was made in New York in the 1960s in a spirit very different from that of earlier abstraction. In radically paring down elements such as colour, form, and structure – a tendency we associate with Mondrian and Rothko – the artists of the works shown here intended to raise questions about creativity and the experience of looking at art. The challenge of Minimalism lay not only in painting: artists such as Sol LeWitt, Donald Judd, and Carl Andre produced three-dimensional structures more accurately categorized as sculptures. They wanted to question not only the nature but also the place of art in American capitalist society.

Repetition

The large scale of Frank Stella's influential painting *The Marriage of Reason and Squalor* echoes that of Abstract Expressionism. Yet it has none of the flamboyance or drama of Pollock or de Kooning: there seems to be emotional detachment here. Gestural painting, with all its associations of individualism, is rejected and intuitive processes are replaced by a very different approach. Stella made a basic division of his canvas along a central vertical axis. He took a housepainter's brush, loaded with black commercial paint, on a journey from, say, the bottom left-hand corner of the painting to the top, moving along the edge of the canvas to the right and then down again on reaching the central division. This logic was then repeated within this first half of the work, leaving a thin area of bare canvas between the lines. Stella filled the other half of the canvas in the same way.

▼ Variations on black
Ad Reinhardt was a vehement critic of gestural painting. "Art is art," he wrote, as he repetitively rehearsed the end of representation. By 1960 he was working on a series of canvases which all appeared to be black. In fact, each of these large square works is itself divided into nine squares, each a slight variation on black. Reinhardt was also a witty cartoonist, often passing ironic comment on the interpretation of modern art.
Ad Reinhardt, *Abstract Painting No. 5*, 1962.

Repetitive, time-consuming, even dull, this kind of painting seemed to parody more subjective expressionist techniques. It also raised other issues. The idea of time was introduced, the finished painting being a record of a laborious serial procedure. But there were also links to more worldly labour: the industrial materials and repetition Stella used echoed the logic of the production line. Three years before Andy Warhol introduced reproductive techniques into his art and renamed his studio "The Factory," Stella laid down his own challenge to the world of aesthetic contemplation.

Minimalist works seemed difficult to "contemplate" for a number of reasons. They were starkly anti-illusionistic, having a kind of literal presence. "What you see is what you see," said Stella in 1966. Paint sits on the surface of his paintings; materials are presented in undisguised ways, an aspect of this art that links it to works such as *Non Objective Painting* (see page 243) by the Russian Constructivist Alexander Rodchenko.

Agnes Martin, Robert Ryman, and others did away with the whole idea of composition and their paintings have a strong presence as self-sufficient entities. Viewers of modern art used to appreciating

▼ Happiness

The titling of abstract paintings is often significant and many Minimalist works are referred to as "Untitled." Agnes Martin called this work *Morning* and later wrote: "When I painted 'Morning' I was painting about happiness and bliss. I had to leave out a lot of things one expects to see in a painting. Happiness and bliss are very simple states of mind I guess." Martin had been one of the few women associated with Abstract Expressionism before she turned to a more geometric art.

Agnes Martin, *Morning*, 1965.

the relationships between the elements *within* a painting – colour, shapes, line – suddenly found themselves confronted with grids, repetitive units, or completely blank surfaces. These visual devices either emphasized the factual presence of the support's surface or pushed the eye to the edge of the painting, reiterating its format time and time again. Viewers were made to feel self-conscious and were thrown back on themselves, on the here and now. The artists were interested in raising questions about the values and rituals of art. Rejecting deep meaning, symbolism, and metaphor, they shifted the emphasis to the experience of the viewer. Thus, despite obvious similarities between the appearance of their work and, say, Kasimir Malevich's black paintings of the 1910s, they were taking art into a new terrain.

Wall paintings

Sol LeWitt took some key principles of Minimalism to extremes. In 1968 he began to make "wall paintings," highly structured works which do not seem to have to be made by the artist at all. They exist in the form of sets of written instructions, allowing the same work to be made in various settings. Often the visual form of a drawing varied considerably between locations as basic divisions of the space formed the starting point for many of these works. This was an ideas-based practice and LeWitt considered himself a conceptual artist.

▼ Concept and execution

Straight lines running in four directions are the basis of this work, which is painted directly onto the wall, not necessarily by LeWitt himself. A stark structure and procedural logic link this painting to Minimalism, but LeWitt's art is essentially one of ideas. In 1967 he wrote: "In conceptual art the idea or concept is the most important aspect of the work . . . all of the planning and decisions are made beforehand and the execution is a perfunctory affair. The idea becomes the machine that makes the art."

Sol LeWitt, *Wall Drawing No. 821*, 1998.

▲ Serial production

Rejecting the idea that an artist's output has to evolve, Minimalists often build just one series of works. Robert Ryman makes paintings with white paint, which he applies in different but always highly structured ways, varying details of material, support, and wall fittings. In this work he applied a commercial "pigmented" shellac to fibreglass, both materials being notable for their transparency. A wooden stretcher and aluminium mounts are visible and are integral parts of the work. Perhaps Ryman's paintings comment ironically on the ubiquitous white walls of modern art galleries.

Robert Ryman, *Ledger*, 1983.

Op Art

It was in New York in 1965 that the Optical, or Op, Art movement began to gain international recognition with the staging of the Museum of Modern Art's exhibition "The Responsive Eye." The paintings that were exhibited had illusionistic surfaces which triggered extraordinary visual responses in the viewer. Spatial ambiguities and sensations of movement were generated by a range of devices, including the manipulation of geometric patterns and the juxtaposition of intense colours. This show, organized by William G. Seitz, did much to popularize Op Art in both the USA and Europe.

Origins of Op Art

Although the press seized on this movement as a new artistic phenomenon, much as it had done with Pop Art, the roots of Op Art go back to visual theories developed by Kandinsky and others during the 1920s. At the Bauhaus school of art and design, founded in Germany in 1919 to investigate a functional modern aesthetic, students of industrial design were taught the principles of colour and tone in a structured way. The way in which a colour is perceived depends on its context; for example, certain colours "vibrate" against one another. The German-born Josef Albers systematically studied the relativity and instability of colours, later teaching at colleges in the USA.

The Hungarian-born artist Victor Vasarely was a key figure in the history of Op Art. He attended the Budapest Bauhaus, where there was a strong faith in technological progress. In an interview in 1969 he recalled that the teachers "wanted us to become constructive human beings who are useful and beautiful at the same time and who are able to integrate into a society that will inevitably be ruled by science and progress." As the astronomical-sounding title of his painting *Supernovae* suggests, Vasarely continued to believe in a futuristic utopia, and he intended his art to be a rational, universal art for the masses. He strongly opposed the idea of the artist as egotist; as with the work of many of his younger contemporaries of the 1960s, there is no evidence of the artist in his paintings. He called his mathematically controlled works

△ Undulation
As its title suggests, this work produces subtle sensations of movement. Working with a very precise technique, Riley has produced a painting which is flat yet undulates. It can be read as black on white or white on black. Riley, who exhibited works in this style very early in her career, made an important contribution to Op Art. After the 1960s she devoted herself increasingly to making paintings in which vibrant colours are juxtaposed.
Bridget Riley, *Shiver*, 1964.

"cinetic." The term was different from "kinetic," which suggests actual movement; it described a "virtual" equivalent: the illusion of movement. Variations within the grid structure of *Supernovae* set up strange effects, pulsating and pushing and pulling the spectator.

In her black and white paintings of the mid-1960s the British artist Bridget Riley introduced slight modifications within structures that were overall geometric. Varying in shape and tone, these works triggered optical oscillations and undulations, but also extreme, almost bodily disturbances. Riley's illusionism was particularly disorientating and was too much for admirers of classic modern abstraction and Abstract Expressionism. Despite adhering to a single, "purified" pictorial space, Riley overtly manipulated the viewer. For certain American critics the much-cherished ritual of looking had been turned into an optical circus.

Commercial exploitation

Within a year of Riley's 1964 exhibition at the Richard Feigen Gallery in New York, Op Art was a household name in both Britain and America. This was due not to a sudden extraordinary rise in gallery attendance but to the artist's visual devices being taken up almost immediately by the worlds of fashion and graphic design. Suddenly Op Art patterns were everywhere, adapted for use on all kinds of products. Riley hated this, threatening one New York dress manufacturer who had translated one of her paintings into a textile design. This was "vulgarisation in the rag trade," she claimed,

cynical about the commercialization and mechanical reproduction of her singular works of art. Riley, like Vasarely, had worked in advertising and so would have been acutely aware of the fleeting nature of such a trend. Once its moment had passed, she reasoned, her works would be left dated rather than timeless.

A threat which loomed over most twentieth-century abstraction was the idea that it might be deemed "decorative," nice but essentially meaningless. Op Art ran the risk of being seen as empty for a variety of reasons. It was not an art of deep, symbolic meanings. Op artists themselves reduced abstraction to a kind of design. Everything was staked on the viewer's immediate visual experience, but the artists employed illusionism, exposing themselves to accusations of trickery. The movement has certainly received a mixed reception in recent years. According to the contemporary American painter Ross Bleckner, Op Art was "naive, superficial, and by most accounts a failure." On the other hand, because these paintings are about illusion, it could be said that they raise important questions about the idea of visual truth.

△ Diverse influences
The American Larry Poons studied composition under John Cage before becoming a painter, and his works have an affinity with Cage's "music of chance." He was also influenced by abstract painters such as Rothko. Although the subjectivity and spiritual questing of Abstract Expressionism might appear to be diametrically opposed to the supposedly impersonal approach of Op Art, Poons seems to combine the two in works such as this.
Larry Poons, *Untitled*, 1966.

ABSTRACT PAINTING

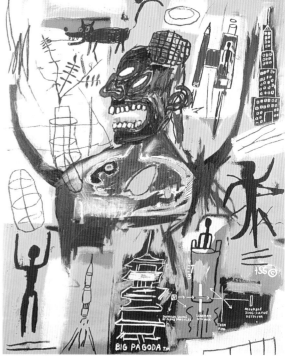

⏵ City life
Against a vivid yellow background a distorted black face bares its teeth. Other figures appear to jump and weave their way around an assortment of lines and shapes, some readable, others not. With their additions, alterations, and urban scrawls, Basquiat's paintings bring to mind the graffiti on the walls and in the subways of New York, where he began and ended his brief but highly acclaimed career. This self-taught artist died of a heroin overdose in 1988 at the age of twenty-seven.
Jean-Michel Basquiat, *Pyro*, 1984.

⏶ Painting a mood
With its broad brushstrokes, dappling, and intense colours, this painting is intended to convey a mood. "I paint representational pictures of emotional situations," Hodgkin has said, emphasizing that his works should be looked at in personal, subjective ways. The broad red bands of paint which "frame" the picture set up a window-like space, but, despite the title, this is not a literal depiction of an interior.
Howard Hodgkin, *Interior at Oakwood Court*, 1978–83.

A word often used to describe the art practice of the decades since the 1960s is "pluralistic." It suggests the coexistence of a variety of approaches. This period is indeed one during which the pre-eminence of painting has been challenged by other media and the special status of abstraction as "advanced" art called into question.

Conceptual art of the late 1960s and the 1970s was often anti-visual; it avoided the associations of painting in favour of an art of ideas. Any methods (video, performance, mixed-media installations) were appropriate in works which raised issues of context: the interpretation, exhibition, and definition of "work of art." Conceptual art challenged the values of early abstract art and the repercussions of this challenge continue to be felt by painters in a variety of ways.

Expressionism and the 1980s

One response to such questions was to ignore them. As the Minimalists rethought their abstraction in an age of mechanical reproduction, painters such as the American Joan Mitchell continued to make works which were highly subjective ciphers of emotion. Her gestural mark-making and drawing of inspiration from nature link her to Kandinsky's intuitive art. Howard Hodgkin is another artist whose sumptuous paintings explore colour. His luminous swathes of related hues are a delight for anyone versed in the language of formalist visual analysis.

Whether or not such paintings were timeless works which spoke to all, they did well in the booming art market of the 1980s. Oil on canvas and expressionist brushstrokes were seen as loaded with authenticity – a valuable commodity. During the same period there was a renewed investment in representational art, also referred to as figuration. Artists such as Lucian Freud and Francis Bacon, who had made their reputations in the 1950s, were newly acclaimed by conservative critics, who saw theirs as a proper, genuine kind of painting.

At the same time the quest for raw creativity unearthed younger talents such as Jean-Michel Basquiat. A graffiti artist on the streets of New York before making paintings, Basquiat produced works which had an impressive vitality. They incorporated imagery from the street, from black culture, and from television, building up a heady cocktail of visual layers. Although Hodgkin and Basquiat could both be seen as expressionist artists, Basquiat's worldly references and collage-like technique inhabit a different world from that of Hodgkin's work.

"Art is wretched, cynical, stupid, helpless, confusing We have lost the great ideas, the Utopias; we have lost all faith, everything that creates meaning." These are the words of the German painter Gerhard Richter, who has wrestled with many of the contradictions of painting at the end of the twentieth century. Early abstract art had

▸ **Continuing a tradition**
Throughout her long career Joan Mitchell has never deviated from her commitment to Abstract Expressionism. After moving to New York in the 1940s she was initially inspired by the gestural paintings of Willem de Kooning. The two artists shared an engagement with nature and Mitchell has spent the later part of her life living in Monet's old house at Vétheuil, in the countryside near Paris. Many of her paintings seem more joyful than the angst-ridden work of her fellow Abstract Expressionists.
Joan Mitchell, *Border*, 1989.

▴ **Cancellation and creation**
This work is one of a series of paintings Richter has made which appear to have been smeared or scraped. Using palette knives or a housepainter's trowel, he has dragged the paint in a process which is self-cancelling but which allows a composition to emerge. Rough textures and rich colours are the result of a kind of planned chance.
Gerhard Richter, *Brick Tower*, 1987.

emerged in the spirit of idealism – of optimism about the future and the role that art might play in it – but Richter's work comes out of a context of doubt.

Richter does not stick to one style or technique, but has worked at the same time on both "figurative" and abstract works. Recognized in the 1960s for hand-painted reproductions of snapshot photographs, he has also made grey monochromes, grid paintings based on commercial colour charts, and highly illusionistic paintings of candles. Richter's *Brick Tower* is one of a number of works whose surfaces are scraped or smeared. The technique the artist uses is paradoxical, both creating the painting and seeming to cancel it.

"I want painting to be very heterogeneous," Richter has written. "The contradictions have to be there, but must coexist." This attitude is also evident in the work of the British artist Fiona Rae. Emerging in London at the end of the 1980s, Rae made paintings

▴ **Quotation**
Unlike the work of Kandinsky or Pollock, who sought to create an original art of direct, unmediated expression, Rae's paintings mix visual languages which already exist. In her witty and irreverent canvases Pollock collides with Disney, geometric abstraction with heraldry and interior design. A range of quoted forms and motifs appear collaged together in compositions that are both playful and carefully controlled.
Fiona Rae, *Untitled (Blue and Purple Triptych)*, 1994.

which have little visual unity. Various techniques jostle and collide. Many of these are drawn from the art of the past: a Pollock splatter meets Kandinsky's geometry next to lashings of Ernst. But there are other, more worldly references too: wallpaper designs, technical drawing, and cartoon graphics cheekily join the fray.

Art as interpretation
Rae's witty paintings turn their back on many of the basic assumptions of classic abstract art. They are full of appropriations, mixing visual languages rather than inventing new ones. Worldly elements shatter any idea of a separate aesthetic sphere, the "low" culture of everyday life invading the space of high art. Had abstract paintings ever escaped representation? Had language ever really been suppressed? Rae's works seem to be about interpretation itself. They are complex paintings for complex times.

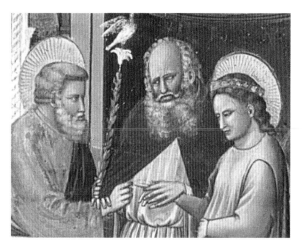

Egg tempera
This is a late and very refined example of painting with egg tempera. The lightness of touch needed when working with tempera paint seems perfectly suited to the sense of line and detail displayed by the artist. The fine touches of gold that enliven the hair and clothing of Tobias and the Angel are painted in shell gold. The two figures' left hands are identical, indicating the artist's probable reuse of a preparatory drawing.
Attributed to Andrea del Verrocchio, *Tobias and the Angel*, c.1475.

Costly materials
This work, which probably belonged to King Richard II of England, was extremely costly to produce. The finest materials of the day – ultramarine and gold – have been used in abundance and the workmanship is exquisite. The gold of the background is stippled with patterning, which is different on each panel. Mary's halo is scored with delicate lines, increasing the illusion of radiance, and the infant Jesus has a tiny circle of thorns stippled on his halo, foretelling his death. King Richard's cloak is a good example of *sgraffito*, a technique in which a layer of paint is applied over gold leaf and then scraped away to make a pattern.
English or French School, *Wilton Diptych* (details), 1395–9.

◄**Gleaming gold**
This is a detail from Duccio's enormous *Maestà* (see page 38 for the whole image), an altarpiece that he made for Siena Cathedral and executed in egg tempera paint. He used a huge amount of gold leaf for both the haloes and the background, so the altarpiece would have gleamed with great richness in the candlelit cathedral, trumpeting the wealth and piety of the citizens of Siena to all comers.
Duccio di Buoninsegna, *Maestà* (detail), 1311.

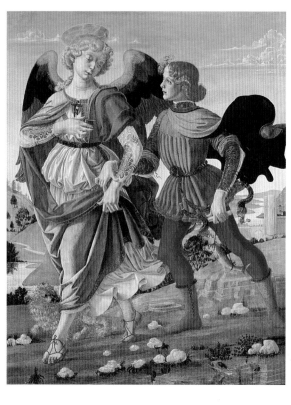

Workshops

Medieval and Renaissance master painters rarely worked alone, but were assisted in their workshops by apprentices, who were bound by contract, usually for about four years. Apprentices prepared the painting materials and learned the techniques of painting, collaborating on work for clients as they became more skilled. Finished paintings were therefore usually the work of more than one hand. Large paintings were never made speculatively, but on the commission of a wealthy patron, monastery, or civic group. Artists worked to the terms of a contract with their client and sometimes collected part of their payment before beginning work.

Supports and grounds

From the thirteenth to the early sixteenth century artists generally used wooden panels as the support for their paintings. Poplar was usually employed in Italy and oak in northern Europe. Wooden planks were glued together to make the panel and planed to a smooth, even surface. A large panel – destined to be an altarpiece, for example – would be strengthened with battens nailed across its back. Often the frame was made at this time and attached to the panel before painting began, or even carved from the same piece of wood – notice that in Deutsch's *St Luke Painting the Virgin* (see page 256) St Luke paints on a preframed panel.

An even layer of white ground prepared the surface of the panel for painting. Chalk in northern Europe, and gypsum, or gesso, in Italy were mixed with animal-skin glue and spread over the panel. Often several layers were applied and each was scoured and burnished to provide the smoothest possible surface.

Pigments

Prepared paints were not widely available to artists until the early nineteenth century. Medieval and Renaissance painters mixed their own limited range of

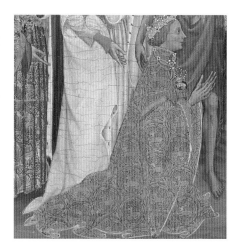

colours, using dried pigments made from ground-up organic and mineral substances. Some pigments could be collected and prepared by the artists themselves. These included iron-oxide earth pigments, which yielded ochre, sienna, and umber colours, and organic matter such as charred twigs and peach stones, which, like soot, served as black pigment.

Pigments made from rarer sources came from apothecaries and specialist suppliers – minerals such as cinnabar, for example, which made orange-red vermilion, and malachite, which made green pigment. The rarest colour of all was ultramarine. This deep blue was made from ground lapis lazuli, whose only source at this time was what is now Afghanistan, making it more valuable than gold itself. Artists' contracts with their clients often specified the exact amount of ultramarine paint to be used – and paid for – in a painting. Cheaper blue pigments were azurite, made from copper ore, and smalt, made with powdered blue glass.

Egg tempera

To make paint, artists mixed the powdered pigments with a liquid medium. Animal-skin glue was sometimes used, but until the middle of the fifteenth century the usual medium was egg. The yolk, and on occasion the whole egg, was combined with a paste made of pigment and water, to produce a creamy, opaque paint called egg tempera. Once mixed, egg tempera paint dries extremely fast, and therefore painters worked colour by colour, preparing a small amount of each one and using it before it hardened. They built up the painting in thin layers, with light, delicate brushstrokes, as thick, loaded brushstrokes are impossible with tempera, as is blending of colours on the paint surface. This technique can be seen in the tiny, separate strokes of paint forming the highlighted areas on Jesus's arms and face in the detail of the *Wilton Diptych*.

Paintbrushes for this kind of work were made from ermine tail hairs, held in a cut quill inserted into a wooden handle. In a city such as Florence, brushes could be purchased in many different sizes from brush-makers, but many artists made their own.

Gilding

Gold was widely used all over medieval Europe to add richness to paintings – particularly those with religious subjects, in which it usually denotes something spiritual or heavenly. The area to be gilded – often a halo – was moistened, and gold leaf was laid down. In Italy artists often spread a layer of bole, or red clay, on the area to be gilded. This made the next step easier – smoothing and burnishing the gold leaf with ivory or a smooth stone. Patterns were then often punched or incised into the gilding, to make it sparkle and catch the light, as in the background of the *Wilton Diptych*. Silver leaf was also used, sometimes with a yellow varnish to imitate gold. Shell gold, so called because it was kept in a mussel shell, was a paint made of powdered gold.

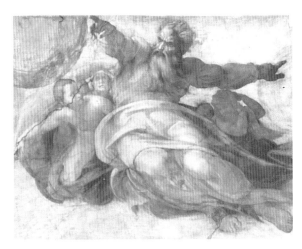

▶ Fresco

Fresco is the technique by which water-based pigments are applied directly onto a plastered wall. There are two fresco methods. In *fresco secco* (dry fresco) paint is applied to dry plaster, forming a surface that is liable to flake off. *Buon fresco* (true fresco) requires the artist to paint while the freshly laid plaster is still wet – hence the term fresco (meaning fresh in Italian). As the plaster dries, the paint fuses with it, becoming part of the wall and resulting in a much more durable surface. Michelangelo decorated the Sistine Chapel ceiling with *buon fresco*. His method for transferring his design to the plaster, which differed from the commonly used technique, is illustrated by the detail from a cherub's face. The features are sketched with swift, incised lines that acted as guidelines for painting. The thick line dates from a sixteenth-century attempt to restore a crack in the plaster. **Michelangelo**, *Sistine Chapel ceiling*, 1508–12.

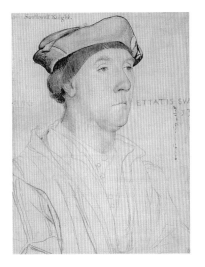

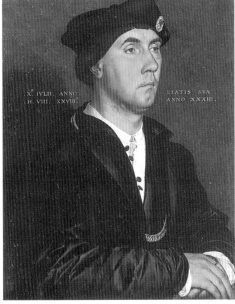

▲ Preparatory work

Medieval and early Renaissance artists devised their paintings carefully, employing compositional studies and pattern books and often reusing studio drawings. In the Renaissance, as they sought a greater degree of naturalism in their pictures, they started to make detailed preliminary drawings of the world around them. Portraits, in which a likeness to reality was particularly important, were often planned in advance in a preliminary study. For a painting there were various ways to translate these drawings onto the prepared ground. For the painting shown above right, Holbein made an extremely detailed drawing (above left) in which not only Southwell's features but also the shadows and tones of his head are fully worked out. He would then have placed a second sheet of paper, with some black chalk on the back, beneath his drawing, and traced it onto his prepared wood panel, which gave him the guidelines to begin painting.

Another method was "pouncing," or pricking tiny holes along the lines of a drawing, again with a second sheet of paper beneath the drawing. The drawing was then removed and the pierced lower sheet was placed onto the picture surface and rubbed with charcoal, which passed through the holes, leaving a dotted line to be worked from. **Hans Holbein the Younger,** *Sir Richard Southwell*, 1536.

Materials and techniques: Early oil painting

▶ An artist's workshop
Although it represents a legendary episode in Christian history – St Luke painting a portrait of Mary, the mother of Christ – this scene contains many elements typical of a medieval or Renaissance artist's workshop. The young apprentice at the back has been grinding pigments with the stone ball on the grey stone slab on the table, and mixing them with a paint medium. He arranges the resulting paints on a palette, ready for use. St Luke works from another neatly ordered palette, very similar to a modern one, and his range of differently sized brushes rests tidily with some pigment jars on the low bench at his feet.
Niklaus Manuel Deutsch,
St Luke Painting the Virgin, 1515.

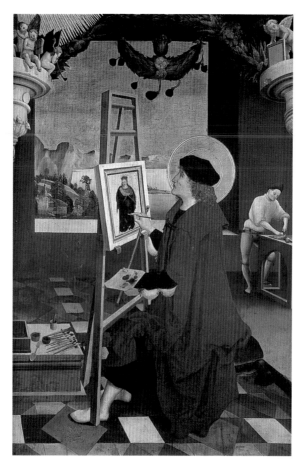

The beginnings of oil painting

"The oil technique was a most wonderful invention, and a great improvement in the art of painting This procedure enhances the colours. All it asks of the artist is care and love, for oil in itself possesses the property of making colour smoother, softer, more delicate, and more easily harmonized and shaded." So wrote Giorgio Vasari, the author of the first history of art, in 1550. He went on to credit the fifteenth-century Flemish artist Jan van Eyck with the discovery of oil painting. In fact painters had used oils since the eighth century, although for glazing and varnishing purposes rather than as the principal painting medium.

Van Eyck and his followers seem to have experimented with a variety of oil glazes, using them extensively over an underlayer of tempera paint. While tempera is opaque, paint made from pigments ground into oil is translucent. This enables the artist to build up the paint surface in many thin layers, through which light can pass, giving it a depth, luminosity, and complexity of colour and tone that are impossible to achieve with tempera paint. Two kinds of oil were used in painting. Thick oils, usually pressed from linseeds and poppy seeds, and sometimes boiled to increase their density, dried extremely slowly. Thinning oils and resins (such as turpentine) were used to dilute paint, making it easier to work with, and these dried swiftly

▶ A new medium
This work is an early example of a picture painted using mostly oil as a medium. Van Eyck used many layers of oil glazes to build up the red turban's deep, velvety shadows, rich mid-tones, and clear highlights, and expertly blended these into one another so that no visible brushstrokes destroy the illusion of reality. The sitter's face is a masterpiece of realism, from the web of wrinkles around his left eye to the stubbly hairs on his chin. It is possible that this is a self-portrait.
Jan van Eyck, *A Man in a Turban*, 1433.

▼ Light and shadow
In his paintings Leonardo da Vinci was deeply concerned with the harmonious arrangement of light and shadow, or chiaroscuro. The corners of Mona Lisa's mouth are a fine example of *sfumato* – the subtle blending of one tone into another. Leonardo built up his paintings from dark to light, in many transparent glazes, to give them depth and subtlety of tone.
Leonardo da Vinci, *Mona Lisa* (detail), c.1503–6.

by evaporation. The pigments used at the time of van Eyck were the same as those described on pages 254–5.

The development of the technique of oil painting came at a time when artists were seeking to achieve greater naturalism in their pictures. Oil paint greatly facilitated this, for not only did it allow for much more variation and depth of colour and tone, but also its slow-drying nature gave painters much more freedom of execution. They no longer had to mix a quantity of tempera colour and jump from one part of a picture to another, hurrying to use the paint before it dried, but could work in a more leisurely way, concentrating on one area if they wished. Oil paint could be blended on the surface of a painting, to make a smooth, finished surface with no visible brushstrokes. Its lengthy drying process also allowed extensive reworking.

During the fifteenth century many painters travelled widely in Europe, working at different royal and aristocratic courts. As they travelled they spread and learned new artistic practices and ideas. By the turn of the sixteenth century tempera paint had largely been superseded by the use of oil as a paint medium throughout Europe, and painters were beginning to experiment widely with the technical possibilities oil offered.

Supports

Oil paint could perfectly well be applied to a wood panel prepared with a chalk or gesso (gypsum) ground, and this kind of support continued to be used for various purposes. However, as the technique of oil painting evolved, canvas supports became increasingly popular. Canvas had been used in earlier centuries for temporary decorations such as stage scenery or festival banners, and occasionally for more permanent paintings. It had qualities that wood panels could not offer. A large canvas could be woven to order, without the joins that were unavoidable when planks of wood were used. Canvas had the further advantage that it was extremely light to mount or hang and could be rolled and transported easily. Its flexibility prevented it from warping and cracking as wood panels often did over time, which caused damage to the paint surface.

Priming

Canvas was prepared, or primed, with a coat of animal glue followed by thin layers of white lead mixed with oil. Painters started to experiment with coloured priming and grounds, which could significantly affect the final appearance of a picture. In the sixteenth century Hans Holbein, painting on oak panel, used mid-grey priming in *The Ambassadors* (see page 162), leaving it untouched to represent the greys and whites of the oriental carpet between the two men. Other artists, such as Titian, and later El Greco, Rubens, and Velázquez, tinted the white priming of their canvases with brown pigment. They left parts of this ground uncovered to provide subtle half-tones and an interesting contrast of texture with areas where the paint was thick.

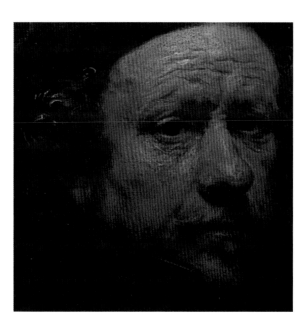

◀ ▲ **Preparatory work**
Titian began his pictures by laying down a priming layer of thin colour, often a brownish tint, which acted as the background to the features that he then built up in thicker paint. He made use of the many possibilities of oil paint, experimenting with both thin washes and thick, impasted strokes of paint. This work shows great freedom of execution. For example, the stream and Actaeon's waistband are lightning-quick dashes of pure, fluid white paint.
Titian, *The Death of Actaeon* (full image and detail), *c.*1565.

◀ **Vigorous brushwork**
Rembrandt often built up his oil paintings over dark reddish-brown grounds, so his figures seem to emerge from a sea of deep, warm tone. He applied the paint with tremendous vigour and freedom. In many of his pictures his brushstrokes are visible, adding an appearance of energy to the paint surface. Sometimes he scratched into the paint with the handle of his paintbrush to suggest details such as curling hairs.
Rembrandt, *Self-Portrait with Beret and Turned-Up Collar* (detail), 1659(?).

Materials and techniques: Modern painting

Manufactured pigments and paints

Advances in the chemical industry during the late eighteenth and early nineteenth centuries resulted in the production of many new, manufactured pigments for painters. These included zinc white and cobalt blue, artificial ultramarine to replace the still extremely expensive pigment made from lapis lazuli, and later cadmium yellow, emerald green, cadmium red, and many others.

Until this time some artists had continued to use paints that they prepared themselves, using ground pigments purchased from artists' suppliers, and mixing them in the studio with various oils and diluents. Prepared paints were also available, having first appeared in the seventeenth century, and were sold in little bags known as bladders, made of skin and tied tightly to keep the paint soft and usable. Bladders were far from ideal, however, as they often burst, or let the air in once they were punctured for use, which caused the paint to deteriorate and harden.

Several attempts to solve this problem were made in the early nineteenth century, including the use of a brass syringe lined with tin. Then, in 1841, the collapsible metal paint tube of the kind used today was invented by John G. Rand, an American portrait painter living in London. Windsor & Newton in London and other firms started to manufacture paints in tubes made of thinly rolled metal lined with membrane and equipped with

▲ Watercolour

Watercolour paint is composed of pigments ground with gum arabic and combined with water. Sable and squirrel-hair brushes are usually used with watercolour. For centuries it was used mainly to colour preparatory drawings, but it came into its own in England in the eighteenth and early nineteenth centuries, when it was used extensively, mostly for landscape. Turner made many images in watercolour, using its fluidity, transparency, and luminosity to experiment with new effects. In the late nineteenth century the Impressionists and Post-Impressionists, especially Cézanne, often worked with watercolour, and its twentieth-century adherents include Paul Klee and Raoul Dufy in Europe and John Marin and Jim Dine in the USA. **Joseph Mallord William Turner**, *The Lauerzer Sea, with the Mythens*, c.1846–50.

▶ Outdoor painting

Manet depicts Claude Monet in the small boat he used as a floating studio. Monet sits back, palette and brushes held by his knee, appraising the progress of his painting of the river scene while Camille Monet, his wife and frequent model, sits nearby. The invention in the mid-nineteenth century of commercially prepared paints in tubes made outdoor, or *plein-air*, painting possible. Easily transportable materials enabled Monet to go out and capture the effects of light and shadow on water, or of different times of day and seasons on the landscape, as in his series of paintings of wheatstacks, as he sat working before his subject. **Édouard Manet**, *Monet in his Floating Studio*, 1874.

▼ Sculptural relief

Van Gogh wrote to his brother Theo of his plans to make a painting of sunflowers "in which the raw or broken chrome yellows will blaze forth." This painting, a study in a variety of yellows, displays the painter's characteristic method of laying on oil paint – often straight from the tube and unmixed – with a thickly loaded brush. This technique, which he carried out with the dense commercial oil paints of the late nineteenth century, lends the surface of his paintings something of the quality of a sculpted low relief, as the light catches the varnished paint masses. Each brushstroke is left visible, giving us a sense of van Gogh's energy and his excitement at painting these flowers, which were for him a symbol of happiness. **Vincent van Gogh**, *Sunflowers*, 1888.

airtight stoppers. These light, easily transportable tubes made it easy, for the first time, for painters to use oil paints outdoors, and in response to this development artists' suppliers began to stock portable easels and small paintboxes with folding palettes. They also sold a wide variety of sable and hog's-hair brushes and palette knives that allowed artists to take advantage of the texture of the new paints, which were thicker and more buttery than those mixed in the studio.

Commercially prepared canvases

Nineteenth-century artists' suppliers could also provide prepared canvases, which were now made in standard sizes. Specially woven linen was stretched over wood frames and primed, ready for painting. Primed card-boards and papers were also sold. Painters of the early to mid-nineteenth century, such as Constable, Turner, Delacroix, and Daumier, continued to tint the primer or ground on which they were to paint. The Impressionists often preferred to paint directly onto a white ground, valuing the brightness it added to their work.

New materials

In the twentieth century painters experimented with a wide variety of new painting materials, as well as continuing to use traditional oil paints, and even to revive the art of egg-tempera painting. The most impor-tant innovation of recent times is acrylic paint, which appeared in the 1950s and whose colours are bright, opaque, quick-drying, and non-fading.

Synthetic paints and enamels produced for domestic and industrial use were taken up by painters such as Picasso and Jackson Pollock as well as by artists belonging to movements such as Op Art and Minimalism, for whom their reflective, smooth finish was attractive. In recent decades painting has been opened up still further by the possibilities offered by computer-generated art.

◄ **Acrylic paint**
David Hockney began using acrylic paint extensively during the 1960s and 1970s. He found its bright, clear tones and its opaque quality appropriate for his crisp, brilliantly lit Californian landscapes. In this painting the artist explores a subject that fascinated him – sunlight on a swimming pool. The flatness of the acrylic paint is perfectly suited to Hockney's division of the water's surface into pattern-like turquoise forms, contained by the sparkling lines of reflected sunlight, while depth is conveyed by the swimmer and the darker blues of the water.
David Hockney, *Portrait of an Artist (Pool with Two Figures)*, 1972.

▶ **Mixed materials**
In 1912 Pablo Picasso and Georges Braque began experimenting with collage and assemblage. Suddenly two-dimensional art was no longer limited to traditional artistic techniques, but could combine them with materials from the real world to make images that examined how we see and experience reality in an entirely new way. In this work the different kinds of paper used, which include newspaper and wallpaper, have as much presence in and importance to the composition as the areas of paint and charcoal. Picasso and Braque opened the way for artists to use any material they chose.
Pablo Picasso, *Glass and Bottle of Suze*, 1912.

▶ **Exploring paint surfaces**
For this work Robert Ryman used shellac, which is an industrial varnish made from a natural insect-derived resin in an alcohol solution, into which he mixed coloured pigments. The artist's work is primarily concerned with the texture and light-giving properties of his paint surfaces, so a varnish-based medium, which offers luminosity and also retains brushstrokes, meets his requirements well.
Robert Ryman, *Ledger*, 1983.

Glossary

Bold type indicates a reference to another entry.

ABSTRACT EXPRESSIONISM A style of painting that germinated in New York during the Second World War and emerged as the leading international avant-garde in the early 1950s. Its initiators included Arshile Gorky, Jackson Pollock, and Willem de Kooning, and its main critical voice was Clement Greenberg. Starting from a violent, Romantic Surrealism – or **Expressionism** – these artists came close to eliminating subject and motif, making the paint and frequently the large scale of the canvas convey the message.

ABSTRACTION The process of working from the real motif or subject toward an artistic mark or form that is no longer naturalistic or even recognizable. Any kind of stylized or non-naturalistic form can be called abstract, but abstraction is associated primarily with the twentieth century, when many modes of abstraction were tried, including the Expressionism of the **Blaue Reiter**, **Cubism**, and the work of individual painters such as Paul Klee. During the twentieth century a sharp distinction was often made between purely abstract or "non-figurative" art and figurative art, but this is very difficult to sustain.

ACTION PAINTING Painting as action, or pure action, without deliberation and as if in a trance or performing a dance; associated above all with the canvases which Jackson Pollock laid on the floor and painted without pause or apparent reflection.

ALTARPIECE A structure above and behind an altar in a Christian church used as a field for painting and sculpture. Also known as a reredos. A main altarpiece adorns a church's main altar.

BAROQUE A term used to describe both a style and a period. The Baroque extends from about 1600 until the late eighteenth century ("Late Baroque"). Its end is less sharply defined than its beginning, but it was certainly over by the time of the death of Giambattista Tiepolo in 1770 and the French Revolution of 1789. When applied to the styles of art prevalent during this period, the term is more problematic, because originally it characterized distortion and excess, whereas the dominant characteristic of the Baroque period is, in fact, its **Classicism**. Starting with Caravaggio, the Carracci, and Rubens, as a deliberate return to the values of the High **Renaissance** as opposed to the tired **Mannerism** of the late sixteenth century, it was a fuller, richer, usually more exuberant and more ambitious continuation of the Renaissance style.

BLAUE REITER A group of artists who exhibited together in Munich from 1911, including notably Kandinsky, Marc, Klee, and Macke. The reference is ultimately to the non-naturalistic colours of French **Fauvism**. These influential Blaue Reiter artists constituted a second wave of German **Expressionism**, following **Die Brücke**. In particular, Klee and Kandinsky contributed greatly to the evolution of twentieth-century **abstraction**.

BRIT ART British art as an international phenomenon, as it became in the 1990s. Its roots were in **Conceptual art** and it consisted mostly of graduates of Goldsmiths' College in London. Their installations and paintings successfully attracted controversy. The artists involved are also known as "YBA" (Young British Artists).

CLASSICISM The tradition of adherence to the rules and standards to be learned from Classical sculpture. The basis for later Classicism – embodying ideals of proportion, balance, and avoidance of excess – was formed during the **Renaissance** and developed in the **Baroque** period. Classicism was particularly strong in France, and Poussin was its greatest exponent.

COLOUR FIELD A painting style within **Abstract Expressionism** in which the brushwork becomes invisible and the paint is frequently stained onto the support. Rothko was its greatest exponent.

COMPLEMENTARY COLOURS Colours opposite on the colour wheel which, in combination, enhance each other – for example, red and green. The complementary to a bright colour seen by the human eye tends to remain as an after-image on the retina.

CONCEPTUAL ART Art which can be conceived, described, and recorded, but consists more in the instruction of what is to be created than in the product. More an approach than a movement, and certainly not a style, Conceptual art was initially (in the 1960s) rather theoretical and didactic, questioning what art was. It led art away from painting and sculpture into performance, events, and the creation of environments and installations. Apart from informing the work of strictly Conceptual artists such as Carl Andre and Joseph Kosuth, Conceptualism was fundamental to that of artists such as Joseph Beuys.

CONSTRUCTIVISM A development of Synthetic **Cubism** applied particularly to sculpture. From 1917 in Russia Constructivists such as Gabo and Pevsner avoided starting from nature and instead built abstract sculptural objects.

CONTRAPPOSTO The spiral rhythm running through the **Classical** Greek and Roman standing figure. In order to give life to the statue, the parts of the body are put into contrasting movement: the head turned, one shoulder forward, one back, one leg taking the weight, the other relaxed, and so on.

CUBISM A revolutionary style invented by Picasso and Braque in 1908 and developed throughout the next two decades. Deriving their inspiration mainly from Cézanne, these two painters began representing objects not naturalistically in the round but as the sum of their planar facets. This breaking down of the object into constituent marks is known as Analytical Cubism. Around 1911 Picasso and Braque evolved Synthetic Cubism, which involved using marks (or even ready-made patterns) to build up a self-sufficient composition. Strongly theoretical among its dedicated practitioners, Cubism liberated contemporary painters more generally from a dependence on naturalism.

DADAISM A movement so loud in its disruption and desecration that its serious purpose, if any, remains obscure. Dada took different manifestations in the various capital cities (the first was Zurich) in which it suddenly appeared around 1915 before disappearing altogether in the early 1920s. It was against everything and would have been against itself if it had been a philosophy.

DE STIJL A **Modernist** movement, founded in 1917 and led by Mondrian and van Doesburg. De Stijl, meaning "The Style", was also the name of their journal. Mondrian, in particular, believed that there was only one possible style, founded on functional principles. A functional painting had to be abstract and highly restricted in colouring and form, otherwise it would become decorative.

DIE BRÜCKE A group of German artists, including notably Kirchner and Nolde, who from 1906 adopted this name, meaning "The Bridge" – quite from where to where the members never explained, but they sought progress and communication. Influenced by **Fauvism**, but also deliberately medievalist in, for example, their revival of the woodcut, they arrived at an anti-**Classicist** and distorted style that is now called **Expressionism**.

DIPTYCH A work of art in two panels. The panels are often hinged, making two inner fields and two outer fields available for painting.

DRIP PAINTING Mark-making using drips rather than brushstrokes; a technique associated with **action painting**.

EXPRESSIONISM A movement in twentieth-century art emphasizing significance and feeling at the expense of naturalistic form or perspectival space. Though the term is primarily associated with German art and the groups **Die Brücke** and the **Blaue Reiter**, a similar kind of Expressionism can be seen in Gauguin and other **Symbolists** and in **Fauvism**. Many other kinds of art can be expressionistic (with a small "e") in tendency. See also **Abstract Expressionism**.

FAUVISM A movement named after a show in Paris in 1905 in which painters such as Matisse and Vlaminck shocked the public with their bright, lurid colours, and simple brushstrokes. For this **Expressionism** they were called *fauves*, or "wild beasts."

FUTURISM A **Modernist** movement originating in Italy in 1909 and also propagated through its "manifestos" in Paris and London. It prophesied a new aesthetic of the machine age, and its painters, such as Carrà and Balla, developed **Cubism** to depict the excitement of speed.

GESTURE/GESTURAL A critical term of the later twentieth century referring to the marks of the painter's hand or brush, in contrast to **Colour Field**.

GOTHIC The period in Western art extending from the mid-twelfth century to the fifteenth century, during which the readily identifiable Gothic style of architecture was dominant. The term is also used to describe the associated painting and sculpture, which was eventually rejected by the **Renaissance** because its emphasis on rhythm and linear grace did not conform with **Classical** norms and proportions.

HYPERREAL Minutely exact and particular in describing reality.

ICONOGRAPHY The subject matter of a work of art, or the study of the subject matter of art.

ILLUSIONISM Giving the illusion on a painted surface of three-dimensional depth. The term is particularly applied to the elaborate stage-management of **Baroque** wall and ceiling frescos, which create a whole architecture within a plain room.

IMPRESSIONISM Probably the best known of all art-history terms, Impressionism took its name from a painting by Monet called *Impression: Sunrise*, exhibited in 1874. As in this picture, many Impressionists sought to depict the "impression" that natural light left on the eye, in a drive toward truthfulness in painting landscape.

However, several artists in the group to which Monet belonged, though also referred to as Impressionists, did not have entirely the same aim. When painters such as Gauguin located the truthfulness they sought not in nature or in the eye but in the mind, and painters such as Cézanne became preoccupied by the pattern the motif made on the surface, Impressionism changed direction.

MANNERISM The term applied to art produced after the highpoint of the High **Renaissance** in Italy, around 1500–20, and before the initiation of the **Baroque**, around 1600. The name originated in the phrase *la maniera*, meaning the satisfactory achievement of a **Classicist** style. It took on a pejorative sense when there was a reaction against artists seen to be trying too hard in their pursuit of beauty and in their emulation of the ancients and of one another. The term is also used with a small "m" to describe affectedness or excess in style.

MINIMALISM Often summed up today in the phrase "less is more," Minimalism was originally, in the 1960s, a theortical movement devoted to taking the "art" out of art, so that it became no more than the characterless object the viewer saw. In this way it was an extreme form of **abstraction**. The term has been used more widely to summarize a whole aesthetic of absence, requiring clean lines, seamless finish, and reduction to the essential.

MODERNISM A self-conscious effort from the mid-nineteenth century until the late twentieth century to innovate and to skirt around the mainstream. It rejected nostalgia, decorativeness, respect, or imitation of the past and even art that was figurative at all. Posited on the idea of progress and achieved by successive avant-gardes displacing obsolete establishments, it became orthodoxy after the Second World War and was considered to have done its work. See also **Post-modernism**.

NABIS A group of art students who formed a secret brotherhood in 1888–9. They took the name "Nabi" from the Hebrew word for "prophet" and developed some of the implications of Gauguin's ideas. The group formed part of the **Symbolist** movement.

NAZARENES A group of early-nineteenth-century German artists with medievalist ideals who worked in Italy, mainly in Rome, and founded an artistic community. They painted meticulously in the preternaturally clear style of early Raphael and his contemporaries.

NEOCLASSICISM The Neoclassicism that became so fashionable in Europe and America at the end of the eighteenth century and into the nineteenth was underpinned by the discovery of new aspects of the **Classical** past, brought about by the excavation of Pompeii and the systematic exploration of ancient Greece. Although the tendency was rooted in an exploration of Roman and Greek themes, Neoclassicism was not a renewal of **Classicism** but a revision of it, extending its vocabulary. The delicacy of **Rococo** was not swept away but given a stricter grid. The monumentality of Late **Baroque** was not abandoned but developed still further, particularly by early Romantic artists.

PASTORAL A term which relates to the life of shepherds and to rural life in general, but which in the context of literature or art refers to the idealization of country life.

PENDANT One of a pair of paintings, intended to be seen together.

PERSPECTIVE The illusion of spatial recession in a painting. This may be rudimentary or very poor, as in much medieval art, or highly lifelike and optically exact. During the early **Renaissance** there was a vogue for geometric perspective, in which the orthogonals, or lines receding into space, were carefully calibrated to converge on a single vanishing point. This worked very well for street scenes but was too artificial for landscapes. The illusion of distance in landscapes was given by variations of colour (sometimes called aerial perspective) as well by the judicious placing of scaled markers.

POLYPTYCH A work of art in separately framed panels – two (diptych), three (triptych), or more. **Altarpieces** of the late Middle Ages and the early **Renaissance** were generally polyptychs, and might have opening and closing wings, painted on both sides with several scenes. Beneath the central main field was a **predella**.

POP ART Short for "popular" and formed by analogy with "Pop music," the term refers to a liberating and fun-loving movement of the 1960s that enabled figurative art to re-enter the avant-garde. Pop Art's entry ticket was the abandonment of "nature" and the acceptance of modern culture itself, or its reproduced artefacts, as the matter of art, whether these were soup-can boxes or pin-ups. Ranging from the highly subtle (as in the work of Jasper Johns) to the impersonal and slick or the deliberately banal, Pop Art already held the seeds of **Post-modernism**.

POST-IMPRESSIONISM The title invented by the British art critic and painter Roger Fry in 1910 for an exhibition of the latest French art in London. This exhibition "after **Impressionism**" was dominated by late works of Cézanne and paintings by Gauguin and van Gogh. In England the exhibition was the springboard for a **Modernist** emulation of the Continental avant-gardes. Fry later broadened the term to include the work of Seurat and the Pointilists. The title remains useful as a collective term for various tendencies that emerged in France between 1880 and 1900 as departures from Impressionism. Many of these resemble early-twentieth-century German **Expressionism**.

POST-MODERNISM A favourite critical label and subject of debate in the late twentieth century, describing the cultural situation in the 1980s and 1990s when **Modernism** had been assimilated and was no longer progressive. Post-modern art necessarily lacks the theoretical guidelines of a directional movement and cannot be simply itself, but tends to be ironic and self-conscious.

PREDELLA The part of a polyptych or other **altarpiece** that lies below the main image. It is usually a long, thin panel, painted with a narrative relating to the dedicatee of the main image.

PRE-RAPHAELITES A group of artists formed in 1848, dedicated to naturalism and honesty in painting. Like the **Nazarenes** before them, they rejected the lifelessness of academic imitation of Raphael and regarded earlier, "primitive" art as an example of freshness. Like their supporter the British writer, critic, and artist Ruskin, they were highly moral in their outlook, and in their search for serious subjects anticipated **Symbolism**.

REALISM A movement in nineteenth-century France, led by Courbet, who wished to substitute the present and actual as the greatest subject of painting in place of allegory and "history." When written with a small "r" the term usually means opposed to idealism, showing things as they really are, or the ugly rather than the beautiful.

RENAISSANCE This term, meaning "rebirth," refers to the period, culture, and style that succeeded the Middle Ages and developed into the **Baroque**. It takes its name from the idea that the arts had decayed since **Classical** times, during the Dark Ages and the **Gothic** period, but were then revived. It was not a new birth but depended on the rediscovery of the Classical past. In painting, it was foreshadowed by Giotto in the early fourteenth century, but did not start to become established until the fifteenth century in Italy. In the sixteenth century the Italian style of Classicism was adopted everywhere else in Europe.

ROCOCO A predominantly French style of delicacy and playfulness that came in with the eighteenth century, in a change of tone from the grandeur of **Baroque** that had prevailed at the court of the flamboyant Louis XIV. Watteau is the great painter of the Rococo, which also had manifestations particularly in the decorative arts in Germany and to a limited extent in England.

ROMANTICISM A cultural movement dominant in the first half of the nineteenth century, following on from the Enlightenment, **Neoclassicism**, and the French Revolution. It was never a style of art, nor an avant-garde, but rather a general approach which valued genius and individuality. An artist had to paint great paintings celebrating the **Sublime**, whether human or natural. For this he or she could range the whole of the past, not only the newly discovered ancient Greek past but also the Middle Ages, and even contemporary literature and events.

SUBLIME A term introduced into English art criticism by Edmund Burke, who published his *Enquiry into the Sublime and the Beautiful* in 1757. The Sublime in nature – for example, mountain landscapes or a terrible storm, or even the tragedy of a play by Shakespeare – would become a subject for art, especially **Romantic** painting.

SUPREMATISM Theory of abstract art as practised by artists such as Malevich in Russia from 1913. Like the contemporary theory of **Constructivism**, Suprematism sought to remove subject matter from art altogether.

SURREALISM A movement of the 1920s that sought to bring the unconscious mind into art, both in the making of art "automatically" – that is, without conscious manipulation and exploiting chance – and in its content, which should be the stuff of dreams. Artists such as Magritte and Dali used a highly naturalistic style to represent the objectively impossible.

SYMBOLISM A movement in art widely acclaimed as the direction forward in the late 1880s and the 1890s, but discarded soon after. Art was to be suggestive and evocative, luminous rather than clear, emotional rather than descriptive. The main practitioners were Gauguin, Puvis de Chavannes, Redon, and Moreau in France, Burne-Jones in England, and Klimt in Austria.

TROMPE-L'OEIL Meaning literally "deceive the eye," trompe-l'oeil is a kind of illusionism, usually on a small scale, which tricks the eye into believing that the painted object – for example, a fly which has apparently just alighted – is real or really occupies space.

TRIPTYCH A work of art in three panels: centre, left, and right.

VANITAS The Latin word for "vanity," in art it denotes a still life featuring symbols of transience and death, such as flowers or skulls. Such pictures, by stressing the passing of time, were meant to induce fear of eternal torment after death and thus set the viewer on the path of righteousness.

VEDUTA Italian for "view" or "vista," specifically a view of a city, a landscape or a ruined **Classical** monument.

List of paintings

Gogh, Vincent van 1853–90
Three Pairs of Shoes, 1886–7; oil on canvas; 48.3×71.1cm (19×28in); Fogg Art Museum, Harvard. **p.8**
Sunflowers, 1888; oil on canvas; 92.1×73cm (36¼×28¾in); NG London. **pp.227, 258**
The Chair, 1888; oil on canvas; 91.8×73cm (36⅛×28¾in); NG London. **p.231**
The Starry Night, 1889; oil on canvas; 73.7×92.1cm (29×36⅛in); MoMA. **p.187**
Self-Portrait with a Bandaged Ear, 1889; oil on canvas; 60.5×50cm (23⅞×19¾in); Courtauld. **pp.16, 149**

Goltzius, Hendrik, 1558–1617
Hercules and Cacus, 1613; oil on canvas; 207×142.5cm (81½×56¼in); Frans Hals Museum, Haarlem. **p.82**

Gossaert, Jan (called Mabuse), 1478–1532
Still Life with Skull, 1517; oil on panel; 42.5×27cm (16¾×10⅝in); Louvre. **p.228**

Goya, Francisco de (Francisco de Goya y Lucientes), 1746–1828
Bullfight in a Village, c.1812–19; oil on wood; 45×72cm (17¾×28⅜in); Museo de la Real Academia de Bellas Artes de San Fernando, Madrid. **p.217**
3rd May 1808, 1814; oil on canvas; 268×347cm (105½×136⅝in); Prado. **pp.16, 130**

Goyen, Jan van, 1596–1656
Summer and *Winter*, 1625; oil on panel; diam. 33.5cm (13⅛in); Rijksmuseum, Amsterdam. **p.184**

Greco, El (Domenikos Theotokopoulos), 1541–1614
The Martyrdom of St Maurice and the Theban Legion, 1582; oil on canvas; 448×301cm (176⅜×118⅜in); Monasterio de El Escorial, Madrid. **p.56**
The Purification of the Temple, c.1600; oil on canvas; 41.9×52.4cm (16½×20⅝in); Frick Collection, New York. **p.47**

Grien, Hans Baldung, c.1485–1545
The Three Ages and Death, 1509–10; oil on wood; 48.2×32.5cm (19×12⅞in); Kunst. **p.100**

Greuze, Jean-Baptiste, 1725–1805
The Broken Eggs, 1756; oil on canvas; 73×94cm (28¾×37in); Met. **p.201**

Gris, Juan, 1887–1927
The Sunblind, 1914; chalk, collage, and charcoal on canvas; 92.1×72.7cm (36¼×28⅝in); Tate Modern, London. **p.240**

Gros, Antoine-Jean, 1771–1835
Napoleon in the Plague House at Jaffa, 1804; oil on canvas; 392×496cm (154¼×195⅛in); Louvre. **p.130**

Grosz, George, 1893–1959
Circe, 1925; watercolour on paper; 61.6×48.9cm (24¼×19¼in); Hirshhorn Museum, Washington. **p.91**

Grünewald, Mathis (Mathis Neithardt Gothardt), c.1480–1528
The Crucifixion, The Resurrection, and The Temptation of St Anthony, c.1515; oil on panel; 269×307cm (105½×120⅞in); Unterlinden Museum, Colmar. **pp. 49, 52, 33**

Guercino (Giovanni Francesco Barbieri), 1591–1666
Hersilia Separating Romulus from Tacitus, 1645; oil on canvas; 253×267cm (99½×105⅛in); Louvre. **p.124**

Guérin, Pierre-Narcisse, 1774–1833
The Death of Cato, 1797; oil on canvas; 111×144cm (43¾×56½in); Ecole Nationale Supérieure des Beaux-Arts, Paris. **p.119**

H

Hackert, Jakob Philipp 1737–1807
Autumn, 1784; oil on canvas; 97×66.5cm (38¼×26¼in); Wallraf Richartz Museum, Cologne. **p.185**

Haecht, Willem van, 1593–1637
The Art Gallery of Cornelis van der Geest, 1628; oil on panel; 100×130cm; (39¼×51⅛in); Rubenshuis, Antwerp. **p.6**

Hals, Frans, c.1581/5–1666
Banquet of the Jorisdoelen Officers at Haarlem, 1616; oil on canvas; 175×324cm (69×127½in); Frans Hals Museum, Haarlem. **p.153**

Harnett, William, 1848–92
Old Models, 1892; oil on canvas; 137.2×71.1cm (54×28in); MFA. **p.224**

Heckel, Erich, 1883–1970
Landscape in Thunderstorm, 1959; oil on canvas; 146×110cm (57½×43¼in); Tel Aviv Museum. **p.183**

Heyden, Jan van der, 1634–1712
The Dam with the New Town Hall in Amsterdam, 1688; oil on canvas; 73×87cm (28¾×34¼in); Louvre. **p.176**

Höch, Hannah, 1889–1978
Glasses, 1927; oil on canvas; 77.5×77.5cm (30½×30½in); Staatliche Museen, Kassel. **p.225**

Hockney, David, 1937–
Man in Shower in Beverly Hills, 1964; acrylic on canvas; 167.3×167cm (66×65½in); Tate Britain, London. **p.113**
Portrait of an Artist (Pool with Two Figures), 1972; acrylic on canvas; 214×304.8cm (84×120in); PC. **pp.205, 259**
My Parents, 1977; oil on canvas; 182.9×182.9cm (72×72in); Tate Britain, London. **p.151**
Dog Painting 30, 1995; oil on canvas; 27.3×22.2cm (10⅝×8¾in); PC. **p.215**

Hodgkin, Howard. 1932–
Interior at Oakwood Court, 1978–83; oil on wood; 81.3×137.2cm (32×54in); Whitworth Art Gallery, Manchester. **p.252**

Hogarth, William, 1697–1764
The Graham Children, 1742; oil on canvas; 160.5×181cm (63¼×71¼in); NG London. **p.163**
Marriage à la Mode 1, The Marriage Contract, before 1743; oil on canvas; 69.9×90.8cm (27½×35¾in); NG London. **p.201**

Holbein, Hans, the Younger, 1497/8–1543
Georg Gisze a German Merchant in London, 1532; oil on wood; 96.3×85.7cm (38×33¾in); Gemäldegalerie, Staatliche Museum, Berlin. **p.147**
Allegory of the Old and New Testaments, c.1535; oil on panel; 50×60.5cm (19¾×23⅞in); National Gallery of Scotland, Edinburgh. **p.37**
Sir Richard Southwell, 1536; oil on wood; 47.5×38cm (18¾×15in); Uffizi. **p.255**
Preparatory drawing; pen and chalk on pink priming on canvas; 37×28.1cm (14½×11⅛in); Royal Collection, Windsor. **p.255**
The Ambassadors, 1533; oil on oak; 207×209.5cm (81½×82½in); NG London. **pp.5, 15, 162**

Homer, Winslow, 1836–1910
Milking Time, 1875; oil on canvas; 60.9×97.1cm (24×38½in); Delaware Art Museum. **p.207**
Right and Left, 1909; oil on canvas; 71.8×122.9cm (28¼×48¼in); NG Washington. **p.217**

Honthorst, Gerrit van, 1592–1656
Christ before the High Priest, c.1617; oil on canvas; 272×183cm (107×72in); NG London. **p.48**

Hooch, Pieter de, 1629–83
The Mother, 1661–3; oil on canvas; 95.2×102.5cm (37½×40⅜in); Gemäldegalerie, Staatliche Museum, Berlin. **p.198**

Hoogstraten, Samuel van, 1627–78
Trompe l'Oeil Still Life (Pinboard), 1666–8; oil on canvas; 63×79cm (24¾×31⅛in); Staatliche Kunstalle, Karlsruhe. **p.231**

Hopper, Edward, 1882–1967
New York Movie, 1939; oil on canvas; 81.9×101.9cm (32¼×40⅛in); MoMA. **p.209**

Hunt, William Holman, 1827–1910
The Light of the World, 1853–6; oil on canvas; 125.5×59.8cm (49¼×23½in); Keble College, Oxford. **p.41**
The Shadow of Death, 1870–3; oil on canvas; 76.4×109.5cm (30×43⅛in); City Art Gallery, Manchester. **p.37**

Huysum, Jan van, 1682–1749
Flowers in a Terracotta Vase, 1736; oil on canvas; 133.5×91.5cm (52½×36in); NG London. **p.225**

I

Ingres, Jean-Auguste-Dominique, 1780–1867
Raphael and La Fornarina, 1811–12; oil on canvas; 64.8×53.3cm (25½×21in); Fogg Art Museum, Harvard. **p.122**
Henri IV of France Playing with his Children, 1817; oil on canvas; 39.5×50cm (15½×19¾in); Musée du Petit Palais, Paris. **p.211**
Ruggiero Rescuing Angelica, 1819; oil on canvas; 147×190cm (58×75in); Musée du Petit Palais, Paris. **p.87**
Oedipus and the Sphinx, c.1820; oil on canvas; 189×144cm (75×56¾in); Louvre. **p.83**
Louis-François Bertin, 1833; oil on canvas; 118×95cm (46½×37½in); Louvre. **p.142**
Venus Anadyomène, 1848; oil on board; 163×92cm (64¼×36 ½in); Musée Condé, Chantilly. **p.110**
Madame Moitessier, 1856; oil on canvas; 120×92.1cm (47¼×36¼in); NG London. **p.163**

Inness, George, 1825–94
The Lackwanna Valley, 1856; oil on canvas; 86×127.5cm (33¾×50⅛in); NG Washington. **p.173**

J

John, Gwen, 1876–1939
Nude Girl, 1909–10; oil on canvas; 44.5×27.9cm (18×11in); Tate Britain, London. **p.115**

Judd, Donald 1928–94
Untitled, 1967–8; black felt-tip pen on yellow paper; 43.6×56cm (17×22in); Tate Collection, London. **p.239**

K

Kalf, Willem, 1618–93
Still Life with a Late Ming Ginger Jar, 1669; oil on canvas; 78.1×66cm (30¾×26in); Indianapolis Museum of Art. **p.223**

Kandinsky, Wassily, 1866–1944
Painting with the Black Arch, 1912; oil on canvas; 189×198cm (74½×78in); Musée national d'art moderne, Paris. **pp.17, 238**
First Abstract Watercolour, c.1913; pencil and Chinese ink, and watercolour on paper; 49.6×64.8cm

(19½×25½in); Musée national d'art moderne, Paris. **p.242**
Swinging, 1925; oil on board; 70.5×50.2cm (27¾×19¾in); Tate Collection, London. **p.243**

Khnopff, Fernand, 1858–1921
The Caress of the Sphinx, 1896; oil on canvas; 50×150cm (19¾×59in); Musée Royaux des Beaux Arts de Belgique, Brussels. **p.87**

Kiefer, Anselm, 1945–
The Red Sea, 1984–5; oil, woodcut, lead, photograph, and shellac on canvas; 278.8×425.1cm (109⅞×167⅜in); MoMA. **p.191**

Kielland, Kitty, 1843–1914
Summer Night, 1886; oil on canvas; 100.5×135.5cm (39½×53¼in); National Gallery, Oslo. **p.187**

Kirchner, Ernst Ludwig, 1880–1938
Bathers at Moritzburg, 1909–26; oil on canvas; 1511×1997cm (59½×78⅛in); Tate Modern, London. **p.107**
The Amselfluh, 1922; oil on canvas; 120×170.5cm (47½×67¼in); Museum of Fine Arts, Basel. **p.189**

Klimt, Gustav, 1862–1918
The Knight, from *The Beethoven Frieze*, 1902; fresco and mixed media on stucco; c.215×3414cm (93×1344in) overall; Osterreichische Galerie, Vienna. **p.89**
Adele Bloch-Bauer I, 1907; oil, silver, and gilt on canvas; 140×140cm (55½×55½); Osterreichische Galerie, Vienna. **p.160**
Danaë, c.1907–8; oil on canvas; 77×83cm (30¼×32⅛in); PC. **p.94**

Kokoschka, Oskar, 1886–1980
Joseph de Montesquiou-Fezensac, 1911; oil on canvas; 80×63cm (31½×25in); Moderna Museet, Stockholm. **p.145**

Kooning, Willem de, 1904–97
The Visit, 1966–7; oil on canvas; 152.4×121.9cm (60×48in); Tate Collection, London. **p.239**

Krasner, Lee, 1908–84
Sun Woman II, 1957; oil on canvas; 176.5×288.3cm (69½×113½in); PC. **p.247**

L

Labisse, Félix, 1905–
The Strange Leda, 1950; oil on canvas; 55×46cm (21½×18¼in); Galérie Christine et Isy Brachot, Brussels. **p.93**

Lancret, Nicolas, 1690–1743
The Breakfast of Ham, 1735; oil on canvas; 188×123cm (74×48⅛in); Musée Condé, Chantilly. **p.203**

Landseer, Edwin, 1802–73
Windsor Castle in Modern Times, 1840–5; oil on canvas; 113×143.8cm (44½×56¾in); Royal Collection, Windsor. **p.155**
Monarch of the Glen, 1851; oil on canvas; 163.8×169cm (64½×66½in); PC. **p.215**

Léger, Fernand, 1881–1955
The City, 1919; oil on canvas; 231.1×298.4cm (91×117⅜in); Museum of Art, Philadelphia. **p.177**
Still Life (Bowl of Pears), 1925; oil on canvas; 92×65cm (36⅛×25⅛in); Staatliche Kunsthalle, Karlsruhe. **p.235**

Leibl, Wilhelm, 1844–1900
Three Women in a Church, 1882; oil on mahogany; 113×77in (44½×30¼in); Kunsthalle, Hamburg. **p.207**

Leighton, Frederic, Lord, 1830–96
Perseus on Pegasus Hastening to the Rescue of Andromeda, c.1895–6; oil

on canvas; diam. 184.2cm (72½in); New Walk Museum, Leicester. **p.86**

Lely, Peter, 1618–80
Charles I with his Son James, Duke of York, c.1648; oil on canvas; 121.9×143.5cm (48×56½in); Collection of the Duke of Northumberland. **p.140**

Leonardo da Vinci, 1452–1519
Mona Lisa, c.1503–6; oil on wood; 77×53cm (30×20⅞in); Louvre. **pp.144, 256**

Lesenko, Anton, 1737–72/3
Hector Taking Leave of Andromache, 1772–3; oil on canvas; 155.8×211.5cm (61⅜×83⅛in); Tretyakov Gallery, Moscow. **p.125**

LeWitt, Sol, 1928–
Wall Drawing No. 821, 1998; acrylic installation on wall; Lisson Gallery, London. **p.249**

Lichenstein, Roy, 1923–97
In the Car, 1963; magna on canvas; 172×203.5cm (67¾×80¼in); Scottish National Gallery of Modern Art, Edinburgh. **p.195**
Whaam!, 1963; acrylic and oil on canvas; 172.7×406.4cm (68×160in); Tate Collection, London. **p.9**

Limbourg Brothers, The, active 1400–16
June and *October*, 1415–16; from the *Très Riches Heures*; manuscript; 14×22cm (5⅝×8¼in) each; Musée Condé, Chantilly. **p.184**

Loo, Carle van, 1705–65
The Rest During the Hunt, 1737; oil on canvas; 220×250cm (86⅝×98⅜in); Louvre. **p.204**

Lorenzetti, Ambrogio, c.1285–c.1348
The Effects of Peace or *Good Government in the City*, 1338–40; fresco; 296×1398cm (116⅛×550in); Palazzo Pubblico, Siena. **pp.14, 176**

Lotto, Lorenzo, c.1480–1556
Marsilio Cassotti and his Bride Faustina, 1523; oil on canvas; 71×84cm (28×33in); Prado. **p.150**
The Annunciation to Mary, c.1534–5; oil on canvas; 166×114cm (65¼×45in); Pinacoteca Communale, Recanati. **p.43**

M

Machy, Pierre-Antoine, attributed to, 1723–1807
Festival of the Supreme Being, 1794; oil on canvas; 53.5×88.5cm (21×35in); Musée Carnavalet, Paris. **p.66**

Magritte, René, 1898–1967
The One Night Museum, 1927; oil on canvas; 50×65cm (19¾×25½in); PC. **p.231**
The Betrayal of Images (This is not a Pipe), 1953; gouache on canvas; 14×16.5cm (5½×6½in); PC. **p.10**

Malevich, Kasimir, 1878–1935
Suprematist Black Rectangle, 1915; oil on canvas; 101.5×62cm (40×24¼in); Stedelijk Museum, Amsterdam. **p.243**

Manet, Édouard, 1832–83
Olympia, 1863; oil on canvas; 103.5×190cm (40¾×74¾in); Musée d'Orsay, Paris. **p.111**
The Execution of Maximilian, 1867; oil on canvas; 252×302cm (99⅛×119in); Städtische Kunsthalle, Mannheim. **p.130**
Monet in his Floating Studio, 1874; oil on canvas; 82.5×100.5cm (32½×39½in); Neue Pinakothek, Munich. **p.258**
The Bar at the Folies-Bergère, 1881–2; oil on canvas; 96×130cm (37¾×51⅛in); Courtauld. **p.203**

Mantegna, Andrea, 1431–1506
St Sebastian, c.1480; oil on canvas; 255×140cm (100½×55in); Louvre. **p.62**
The Triumphs of Caesar: Vase Bearer and Bearer of Trophies and Bullion, c.1486–94; egg tempera on canvas; c.270×280cm (106×110in); Royal Collection, Hampton Court Palace. **p.74**

Martin, Agnes, 1912–
Morning, 1965; acrylic and pencil on canvas; 182.6×181.9cm (72×71⅕); Tate Modern, London. **p.249**

Martin, John, 1789–1854
The Great Day of His Wrath, 1851–3; oil on canvas; 196.5×303.2cm (78×121in); Tate Collection, London. **p.190**

Martini, Simone, c.1280/5–1344
Altarpiece of St Louis of Toulouse, c.1317; tempera on wood; 200×138cm (78¾×54¼in); Museo di Capodimonte, Naples. **p.139**

Masaccio, Tommaso di Ser Giovanni di Mone di, 1401–28
The Expulsion of Adam and Eve from Eden, c.1427; fresco; 206×88cm (81¼×34¼in); Brancacci Chapel, Sta Maria del Carmine, Florence. **pp.14, 31**

Massys, Quentin (Matsys or Metsys), 1465/6–1530
The Ill-Matched Lovers, 1520–5; oil on panel; 43.2×63cm (17×25in); NG Washington. **p.200**

Master of St Francis, attributed to, active c.1260–72
Crucifix, 1272–85; egg on poplar; 92.1×71cm (36¼×28in); NG London. **p.106**

Master of St Giles, active c.1500
The Mass of St Giles, c.1500; oil and egg on oak; 61.6×45.7cm (24¼×18in); NG London. **p.22**

Master of St Veronica, active c.1395–1420
St Veronica with the Sudarium, c.1420; oil and gold on canvas on pine; 78×48cm (30¾×19in); Alte Pinakothek, Munich. **p.40**

Matisse, Henri, 1896–1954
Luxe, Calme et Volupté, 1904; oil on canvas; 98×118cm (38½×46¼in); Musée d'Orsay, Paris. **p.173**
The Dance (II), 1910; oil on canvas; 260×391cm (102¼×154in); Hermitage. **p.114**
Still Life, Seville II, 1910–11; oil on canvas; 90×117cm (35½×46in); Hermitage. **p.227**
The Chapel of the Rosary, 1947–51; ceramic tile; Vence. **p.22**

Memlinc, Hans (Hans Memling), c.1433–94
The Passion, c.1480; oil on wood; 55×90cm (21½×35½in); Galleria Sabauda, Turin. **p.48**
Marian Flower-Piece, c.1485 oil on oak; 299×225cm (117¾×88½in); Museo Thyssen Bornemisza, Madrid. **p.226**
The Van Nieuwenhove Diptych, 1487; oil on panel; 44×33cm (17¼×13in) each wing; Memling Museum, Sint Janshospitaal, Bruges. **p.29**

Michelangelo Buonarroti, 1475–1564
Sistine Chapel, c.1480–1541; Vatican, Rome. **p.25**
Sistine Chapel ceiling, 1508–12; fresco; Vatican, Rome. **pp.15, 30, 255**

Millais, John Everett 1829–96
Christ in the House of His Parents, 1850; oil on canvas; 86.4×139.7cm (34×55in); Tate Collection, London. **p.45**

Millet, Jean-François, 1814–75
The Sower, 1850; oil on canvas; 101.6×82.6cm (40×32¼in); MFA. **p.206**
Man with a Hoe, 1860–2; oil on canvas; 80×90cm (31½×39in); J. Paul Getty Museum, Malibu. **p.195**

Miró, Joan, 1893–1983
Dog Barking at the Moon, 1926; oil on canvas; 73×92.1cm (28¾×36¼in); Museum of Art, Philadelphia. **p.215**

Mitchell, Joan, 1926–92
Border, 1989; oil on canvas; 115.5×88.9cm (45½×35in); Robert Miller Gallery, New York. **p.253**

Modigliani, Amadeo, 1884–1920
Chaim Soutine, 1917; oil on canvas; 91.7×59.7cm (36¼×23½in); NG Washington. **p.141**

Mondrian, Piet, 1872–1944
Composition with Grey, Red, Yellow, and Blue, c.1920–6; oil on canvas; 99.7×100.3cm (39¼×39½in); Tate Modern, London. **pp.17, 244**
Broadway Boogie-Woogie, 1942–3; oil on canvas; 127×127cm (50×50in); MoMA. **p.245**

Monet, Claude, 1840–1926
The Magpie, c.1869; oil on canvas; 89×130cm (35×51½in); Musée d'Orsay, Paris. **p.183**
Boulevard des Capucines, 1873; oil on canvas; 61×80cm (24×31½in); Pushkin Museum, Moscow. **p.208**
Wheatstacks, Snow Effect, Morning, 1891; oil on canvas; 65×100cm (25½×39¼in); J. Paul Getty Museum, LA. **pp.16, 167**

Moreau, Gustave, 1826–9
Jason and Medea, 1865; oil on canvas; 204×115.5cm (80¼×45½in); Musée d'Orsay, Paris. **p.83**
The Maiden of Thrace Carrying the Head of Orpheus, 1865; oil on canvas; 147×98cm (57¾×38½in); Musée Gustave Moreau, Paris. **p.83**
The Unicorns, 1887–8; oil on canvas; 115×90cm (45¼×35¼in); Musée Gustave Moreau, Paris. **p.86**

Morisot, Berthe, 1841–95
View of Paris from the Trocadéro, 1872; oil on canvas; 46×81.3cm (18¼×32in); Museum of Art, Santa Barbara. **p.171**

Mostaert, Jan, style of, c.1475–1555/6
Christ as the Man of Sorrows, c.1520s; oil on oak; 30.5×21cm (12×8¼in); NG London. **p.29**

Munch, Edvard, 1863–1949
Evening on Karl Johan, 1892; oil on canvas; 84.5×121cm (33¼×47¾in); Kunstmuseum, Bergen. **p.209**

Murillo, Bartolomé, 1617/8–82
The Virgin of the Immaculate Conception, c.1678; oil on canvas; 222.3×118cm (87½×46½in); Prado. **p.38**

N

Nain, Louis Le, c.1593–1648
Peasant Interior with an Old Flute-Player, c.1642; oil on canvas; 54.1×62.1cm (21¼×24½in); Kimbell Art Museum, Fort Worth. **p.196**

Nash, Paul, 1889–1946
The Menin Road, 1919; oil on canvas; 182.8×317.5cm (72×125in); Imperial War Museum, London. **p.191**
Totes Meer, 1940–1; oil on canvas; 101.6×152.4cm (40×60in); Tate Britain, London. **p.133**

Newman, Barnett, 1905–70
Onement 3, 1949; oil on canvas; 182.5×84.9cm (71¾×33½in); MoMA. **p.246**

The *First Station* from *The Stations of the Cross*, 1958; magna on raw canvas; 198.1×152.4cm (78×60in); PC. **p.21**

Nolan, Sidney, 1917–92
Ned Kelly, 1946; enamel on board; 79.4×121.2cm (31¼×47¼in); National Gallery of Art, Canberra. **p.97**

Nolde, Emil, 1867–1976
The Sea I, 1912; oil on canvas; 73.5×89cm (29×35in); Norton Simon Foundation, Pasadena. **p.179**

O

O'Keeffe, Georgia, 1887–1986
Two Calla Lilies on Pink, 1928; oil on canvas; 101.6×76.2cm (40×30in); Museum of Art, Philadelphia. **p.227**

Overbeck, Johann Friedrich, 1789–1869
The Triumph of Religion in the Arts, 1831; oil on canvas; 393×392cm (154½×154½in); Städel. **p.63**

P

Pacher, Michael, c.1435–98
St Wolfgang Altarpiece, 1481; oil on lime and pine; 1110×650m (437×256in); St Wolfgang, Salzkammergut. **p.26**
The Four Doctors of the Church, c.1483; oil on cedar; 212×200cm (83½×78¾in) central panel; Alte Pinakothek, Munich. **p.54**

Parmigianino (Girolamo Francesco Mazzola), 1503–40
Self-Portrait in a Convex Mirror, 1523–4; oil on section of wood sphere; diam. 24.4cm (9½in); Kunst. **p.148**
The Conversion of St Paul, c.1527–8; oil on canvas; 117.5×128.5cm (46¼×50½in); Kunst. **p.42**

Patenier, Joachim, 1480–1524
St Jerome in the Desert, c.1525; oil on wood; 78×137cm (30½×54in); Louvre. **p.168**

Peeters, Clara, 1594–1657
Still Life with Pie, 1640; oil on panel; 55×73cm (21½×28½in); Prado. **p.222**

Piazzetta, Giovanni Battista, 1682–1754
St James Led to Martyrdom, c.1722–3; oil on canvas; 165×138cm (65×54¼in); Sant'Eustachio (St Stae), Venice. **p.57**

Picasso, Pablo, 1881–1973
Portrait of Gertrude Stein, 1906; oil on canvas; 100×81.3cm (39½×32in); Met. **p.136**
Les Demoiselles d'Avignon, 1907; oil on canvas; 243.9×223.7cm (96×88in); MoMA. **p.114**
Daniel-Henry Kahnweiler, 1910; oil on canvas; 101.1×73.3cm (39¾×28¼in); Art Institute of Chicago. **p.161**
The Accordion Player, 1911; oil on canvas; 130×89.5cm (51¼×35⅛in); Guggenheim. **p.240**
Glass and Bottle of Suze, 1912; collage of pasted paper, gouache, and charcoal; 65.4×50.2cm (25¾×19¾in); Washington University Gallery, St Louis. **pp.235, 259**
Minotaur and Dead Mare, 1936; gouache and ink; 50×65cm (19¾×25½in); Musée Picasso, Paris. **p.87**
Guernica, 1937; oil on canvas; 349.3×776.6cm (137½×305½in); Prado. **pp.17, 133**
Dora Maar Seated, 1937; oil on canvas; 92×65cm (36¼×25½in); Musée Picasso, Paris. **p.161**
Bull's Skull, Fruit, and Pitcher, 1939; oil on canvas; 65×50cm (19¼×25½in); Cleveland Museum of Art. **p.229**

Massacre in Korea, 1951; oil on plywood; 110×210cm (43¼×82½in); Musée Picasso, Paris. **p.133**
The Intervention of the Sabine Women (after David), 1963; oil on canvas; 195×130cm (76¾×51¼in); MFA. **p.94**

Piero della Francesca, c.1419/21–92
Madonna della Misericordia, 1445–62; oil and tempera on panel; 273×330cm (107½×130in); Pinacoteca Conmunale, Borgo Sansepolcro, Rome. **p.39**
The Flagellation, c.1460; tempera on panel; 59×81.3cm (23¼×32in); Galleria Nazionale delle Marche, Urbino. **p.49**

Piero di Cosimo, c.1462–after 1515
A Satyr Mourning over a Nymph, c.1495; oil on poplar; 65.4×184.2cm (25¾×72¼in); NG London. **p.86**

Pissarro, Camille, 1830–1903
Woman in an Enclosure, Spring Sun, Eragny Field, 1887; oil on canvas; 54×67cm (21½×26¼in); Musée d'Orsay, Paris. **p.185**

Pollaiuolo, Antonio del', c.1432–98, and Piero del' Pollaiuolo, c.1441–96
Apollo and Daphne, 1470s; oil on wood; 29.5×20cm (11½×7¼in); NG London. **p.80**

Pollard, James, 1792–1867
Doncaster Races, Horses Starting for the St Leger, 1831; oil on canvas; 37×45cm (14½×25¼in); Mellon Collection, Museum of Art, Virginia. **p.216**

Pollock, Jackson, 1912–56
Guardians of the Secret, 1943; oil on canvas; 122.9×191.4cm (48¾×75¾in); MoMA, San Francisco. **p.97**
Totem Lesson II, 1945; oil on canvas; 182.8×152.4cm (72×60in); National Gallery of Art, Canberra. **p.67**
Wooden Horse, 1948; collage, oil on canvas; 90×178cm (35½×70in); National Museum of Modern Art, Stockholm. **p.95**
Yellow Islands, 1952; oil on canvas; 143.5×185.4cm (56½×73in); Tate Collection, London. **pp.236, 247**

Pontormo, Jacopo, 1494–1557
Joseph with Jacob in Egypt, c.1518; oil on wood; 96.5×109.5cm (38×43⅛in); NG London. **p.7**

Poons, Larry, 1937–
Untitled, 1966; synthetic polymer on canvas; 330.2×228.6cm (130×90in); Whitney Museum of American Art, New York. **p.251**

Potter, Paulus, 1625–54
The Young Bull, 1647; oil on canvas; 233.5×339cm (92×133½in); Mauritshuis, Hague. **p.214**

Poussin, Nicolas, 1594–1665
The Martyrdom of St Erasmus, 1628–9; oil on canvas; 320×186cm (129×73¼in); Pinacoteca, Vatican, Rome. **p.57**
The Adoration of the Golden Calf, c.1634–5; oil on canvas on board; 154.3×214cm (60½×83¼in); NG London. **p20**
Et in Arcadia Ego, 1636–9; oil on canvas; 85×121cm (33½×47¼in); Louvre. **pp.15, 121**
The Continence of Scipio, 1640; oil on canvas; 114.5×163.5cm (45×64¼in); Pushkin Museum, Moscow. **p.125**
The Sacrament of the Holy Eucharist, 1647; oil on canvas; 117×178cm (46×70in); National Gallery of Scotland, Edinburgh. **p.63**

Landscape with the Ashes of Phocion, 1648; oil on canvas; 116.5×178.5cm (45¼×70¼in); Walker Art Gallery, Liverpool. **p.174**
Spring or *The Earthly Paradise*, 1660–4; oil on canvas; 118×160cm (46½×63in); Louvre. **p.169**

Pozzo, Andrea, 1642–1709
The Glory of St Ignatius Loyola, 1691–4; fresco; St Ignazio, Rome. **pp.65, 103**

Prud'hon, Pierre-Paul, 1758–1823
Justice and Divine Vengeance Pursuing Crime, 1808; oil on canvas; 244×294cm (96×115⅞in); Louvre. **p.99**

Q

Quarton, Enguerrand, c.1410–66
The Avignon Pietà, c.1455; oil on panel; 163×218.5cm (64⅛×86in); Louvre. **p.39**
The Coronation of the Virgin, 1449; oil on panel; 183×220cm (72×86½in); Musée Municipal, Villeneuve-lès-Avignon. **p.53**

R

Rae, Fiona, 1963–
Untitled (Blue and Purple Triptych), 1994; acrylic and mixed media on canvas; 183×502.9cm (72×198in); Saatchi Gallery, London. **p.253**

Raphael (Raffaello Sanzio), 1483–1520
Galatea, c 1506; fresco; 300×220cm (118¼×86¼in); Villa Farnesina, Rome. **p.72**
The Entombment, 1507; oil on wood; 184×176cm (72¼×69¼in); Borghese Gallery, Rome. **p.51**
The Cardinal and Theological Virtues (Prudence, Fortitude, and Temperence), 1508–11; fresco; base 770cm (303⅛in); Stanza della Segnatura, Vatican, Rome. **p.98**
The School of Athens, 1508–11; fresco; base 770cm (303⅛in); Stanza della Segnatura, Vatican, Rome. **p.75**
Portrait of Baldassare Castiglione, 1514–15; oil on canvas; 82×66cm (32¼×26in); Louvre. **p.142**
The Burning of the Borgo, 1514–17; fresco; base 670cm (263⅛in); Sala dell'Incendio, Stanza dell'Incendio, Vatican, Rome. **p.121**
The Sacrifice at Lystra, 1515–16; bodycolour on paper mounted on canvas; 350×560cm (137⅞×220½in); Victoria and Albert Museum, London. **p.62**
The Vision of Ezekiel, c.1518; oil on canvas; 40×30cm (15⅞×12in); Uffizi. **p.54**

Reinhardt, Ad, 1913–67
Abstract Painting No. 5, 1962; oil on canvas; 152.4×152.4cm (60×60in); Tate Collection, London. **p.248**

Rembrandt Harmensz. van Rijn, 1606–69
A Man in Oriental Dress: "The Noble Slav," 1632; oil on canvas; 152.7×111.1cm (60½×43¼in); Met. **p.137**
The Blinding of Samson, 1636; oil on canvas; 206×276cm (81¼×108½in); Städel. **p.34**
The Nightwatch, 1642; oil on canvas; 363×437cm (143×172in); Rijksmuseum, Amsterdam. **p.152**
Bathsheba, 1654; oil on canvas; 142×142cm (56×56in); Louvre. **p.109**
Portrait of Titus at his desk, 1655; oil on canvas; 77×63cm (30¼×25in); Museum Boijmans-van Beuningen, Rotterdam. **p.158**

Self-Portrait with Beret and Turned-Up Collar, 1659(?); oil on canvas; 52.2×43cm (20½×17in); National Gallery of Scotland, Edinburgh. **pp.15, 148, 257**

Reni, Guido, 1575–1642
Atalanta and Hippomenes, 1612; oil on canvas; 206×297cm (81⅛×117in); Museo Nazionale di Capodimonte, Naples. **p.72**
Deianira Abducted by the Centaur Nessus, 1620; oil on canvas; 239×193cm (94×76in); Louvre. **p.86**

Renoir, Pierre-Auguste, 1841–1919
The Bathers, 1918–19; oil on canvas; 110×160cm (43¼×63in); Musée d'Orsay, Paris. **p.111**

Reynolds, Joshua, 1732–92
The Infant Hercules Strangling the Serpents, 1786–8; oil on canvas; 303×297cm (119¼×117in); Hermitage. **p.82**

Ribera, Jusepe de, 1591–1652
The Sense of Taste, c.1614–15; oil on canvas; 113.7×87.6cm (44¾×34½in); Wadsworth Atheneum, Hartford. **p.203**

Richter, Gerhard, 1932–
Brick Tower, 1987; oil on canvas; 200×140cm (78¾×55in); Anthony d'Offay Gallery, London. **p.253**

Rigaud, Hyacinthe, 1659–1743
Louis XIV in Royal Costume, 1701; oil on canvas; 277×194cm (109⅛×76⅜in); Louvre. **p.156**

Riley, Bridget, 1931–
Shiver, 1964; emulsuion on hardboard; 68.5×68.5cm (27×27in); Mayor Gallery, London. **p.251**

Rivera, Diego, 1886–1957
La Civilisation Zapothèque, 1929–35; mural painting; National Palace, Mexico City. **p.211**

Robert, Hubert, 1733–1808
Young Girls Dancing Around an Obelisk, 1798; oil on canvas; 119.7×99cm (47⅛×39in); Museum of Fine Arts, Montreal. **p.180**

Robert, Leopold, 1794–1835
Harvesters Arriving in the Pontine Marshes, 1830; oil on canvas; 141×212cm (55½×83⅜in); Louvre. **p.206**

Rodchenko, Alexander, 1891–1956
Non Objective Painting, 1919; oil on canvas; 84.5×71.1cm (33¼×28in); MoMA. **p.243**

Romano, Giulio, 1492–1546
Jupiter with Thunderbolt, 1526–35; fresco; Palazzo del Tè, Mantua. **p.76**
Olympia Seduced by Jupiter, 1528; fresco; Sala di Amore, Palazzo del Tè, Mantua. **p.78**

Rosa, Salvator, 1615–73
The Broken Bridge, c.1640; oil on canvas; 160×127cm (41⅜×50in); Palazzo Pitti, Florence. **p.188**
L'umana fragilità, c.1656; oil on canvas; 197.4×131.5cm (77⅝×51¾in); Fitzwilliam Museum, Cambridge. **p.100**

Rossetti, Dante Gabriel, 1828–82
Pandora, 1869; red and blue chalk on paper; 100.6×72.7cm (39⅝×28¾in); Faringdon Collection, Buscot Park, Oxfordshire. **p.90**

Rosso Fiorentino (Giovanni Battista Rosso), 1494–1540
Moses and the Daughters of Jethro, c.1523; oil on canvas; 160×117cm (63×46in); Uffizi. **p.35**

Rothko, Mark, 1903–70
Light Red over Black, 1957; oil on canvas; 232.7×152.7cm (91⅝×60⅛in); Tate Modern, London. **pp.17, 247**

Untitled; Red, Brown, and Black, 1958; oil on canvas; 270.8×297.8cm (106×117⅛in); MoMA. **p.238**
Rothko Chapel, 1971; oil on canvas; Houston, Texas. **p.25**

Rousseau, Henri, 1844–1910
Tiger in a Tropical Storm (Surprised!), 1891; oil on canvas; 129.8×161.9cm (51⅛×63¾in); NG London. **p.189**

Rubens, Peter Paul, 1577–1640
Cain Slaying Abel, c.1608–9; oil on panel; 131.2×94.2cm (51⅝×37in); Courtauld. **p.34**
Self-Portrait with Isabella Brandt, 1609; oil on canvas mounted on oak; 178×136.5cm (70×53¾in); Alte Pinakothek, Munich. **p.145**
Roman Charity, 1612; oil on canvas transferred from panel; 140.5×180.3cm (55¼×71in); Hermitage. **p.125**
The Miracles of St Ignatius Loyola, 1619; oil on canvas; 535×395cm (210⅝×155⅝in); Kunst. **p.59**
Henry IV Receives the Portrait of Marie, 1621–5; oil on canvas; 204×115.5cm (80¼×45½in); Louvre. **p.103**
War and Peace, 1629–30; oil on canvas; 203.5×298cm (80⅛×117⅛in); NG, London. **p.102**
The Judgement of Paris, 1632–5; oil on oak; 144.8×193.7cm (57×76¼in); NG London. **pp.15, 76, 107**
Landscape with a Rainbow, 1636–7; oil on oak panel; 135.6×235cm (53⅜×92½in); Wallace Collection, London. **p.172**
The Consequences of War, c.1638; oil on canvas; 206×345cm (81⅛×135⅞in); Palazzo Pitti, Florence. **p.7**

Ruisdael, Jacob van, 1628–82
The Jewish Cemetery, c.1655–60; oil on canvas; 142.2×189.2cm (56×74½in); Detroit Institute of Arts. **p.180**
View of Haarlem from the North-west with the Bleaching Fields in the Foreground, c.1670; oil on canvas; 43×38cm (17×15in); Rijksmuseum, Amsterdam. **p.166**

Runge, Philipp Otto, 1777–1810
The Rest on the Flight into Egypt, 1805–6; oil on canvas; 96.5×129.5cm (38×51in); Kunsthalle, Hamburg. **p.45**
Spring Morning, 1808; oil on canvas; 109×85.5cm (50×33¼in); Kunsthalle, Hamburg. **p.66**

Ryman, Robert, 1930–
Ledger, 1983; shellac on composition panel; 152.4×152.4cm (60×60in); Tate Collection, London. **pp.249, 259**

S

Saenredam, Pieter, 1597–1665
The Interior of the Grote Kerk, Haarlem, 1636–7; oil on oak; 59.5×81.7cm (23½×32¼in); NG London. **p.64**

Samokhvalov, Alexandr Nikolaiewitsch, 1894–1971
Kirov at the Sports Day Parade, 1935; oil on canvas; 305×372.5cm (120×146⅝in); Russian State Museum, St Petersburg. **p.131**

Sano di Pietro, 1406–81
St Bernardino of Siena Preaching, 1445; tempera on panel; Chapter House, Capitolo del Duomo, Siena. **p.23**

Sargent, John Singer, 1856–1946
The Daughters of Edward Darley Boit, 1882; oil on canvas; 221×221cm (87⅛×87in); MFA. **p.153**
Madame X, 1883–4; oil on canvas; 208.6×109.9cm (82⅛×43⅛in); Met **p.143**

Gassed, 1918; oil on canvas; 231×611.1cm (91×240⅞in); Imperial War Museum. **p.132**

Saville, Jenny, 1970–
Propped, 1992; oil on canvas; 213.5×183cm (84×72in); Saatchi Gallery, London. **p.115**

Savoldo, Gian Girolamo, active c.1480/5–1508/48
St Jerome in the Desert, c.1530; oil on canvas; 120.4×158.8cm (47½×62½in); NG London. **p.61**

Schiele, Egon, 1890–1918
Double Portrait of Heinrich and Otto Benesch, 1913; oil on canvas; 121×130cm (47⅝×51¼in); Neue Galerie der Stadt Linz, Wolfgang Gurlitt Museum, Linz. **p.151**

Schnorr von Carolsfeld, Julius, 1794–1874
Kriemhild being Killed by Hildebrand, 1849; fresco; 475×529cm (187×208¼in); Royal Palace, Munich. **p.88**

Serov, Valentin Alexandrovich, 1865–1911
The Rape of Europa, 1910; tempera on canvas; 138×178cm (54⅜×70in); Serov Collection, Moscow. **p.73**

Seurat, Georges, 1859–91
La Grande Jatte, 1884–6; oil on canvas; 207.6×308cm 81⅞×121⅜in); Art Institute of Chicago. **p.204**

Severini, Gino, 1883–1966
Suburban Train Arriving in Paris, 1915; oil on canvas; 88.6×115.6cm (35×45½in); Tate Collection, London. **p.241**

Shannon, Joe, 1933–
Pink Minotaur Monitor: Night Guests, 1982; oil on canvas; 185.4×129.5cm (73×51in); PC. **p.95**

Signorelli, Luca, c.1450–1523
The Saved and The Damned, from The Apocalypse, 1500–4; fresco; Cappella Nuova Chapel of San Brizio, Orvieto Cathedral. **p.69**

Sisley, Alfred, 1839–99
The Fog, Voisins, 1874; oil on canvas; 50.5×65cm (20×25½in); Musée d'Orsay, Paris. **p.183**

Spelt, Adriaen van der, 1630–73 and Frans van Mieris, 1635–81
Trompe l'Oeil Still Life with a Flower Garland and a Curtain, 1658; oil on panel; 190×271cm (74¾×106⅞in); Art Institute of Chicago. **p.224**

Spencer, Stanley, 1891–1959
The Resurrection, Cookham, 1924–7; oil on canvas; 274.3×548.6cm (108×216in); Tate Collection, London. **p.69**
Self-Portrait with Patricia Preece, 1937; oil on canvas; 61×91.2cm (24×36in); Fitzwilliam Museum, Cambridge. **p.112**

Spranger, Bartholomeus, 1546–1611
Vulcan and Maia, c.1585; oil on copper; 23×18cm (9×7in); Kunst. **p.84**
Minerva Victorious over Ignorance: Allegory on Rudolf II, c.1591; oil on canvas; 163×117cm (64¼×46in); Kunst. **p.102**

Steen, Jan, 1625/6–79
The Dissolute Household, c.1660; oil on canvas; 80.5×89cm (31¾×35in); Apsley House, Trustees of the Victoria and Albert Museum, London. **p.194**
Grace before Meat, 1660; oil on panel; 51.1×44.5cm (20⅛×17½in); Sudeley Castle, Gloucestershire. **p.203**
The Effects of Intemperance, 1663; oil on wood; 76×106.5cm (30×42in); NG London. **p.200**

The Life of Man, 1665–7; oil on canvas; 68.2×82cm (26⅛×32¼in); Mauritshuis, Hague. **p.192**

Steenwyck, Harmen (Harmen Evertsz), 1612–after 1655
Still Life: An Allegory of the Vanities of Human Life, c.1640; oil on oak; 39.2×50.7cm (15½×20in); NG London. **p.228**

Stella, Frank, 1936–
The Marriage of Reason and Squalor, II, 1959; enamel on canvas; 230.5×337.2cm (90¾×132⅛in); MoMA. **p.248**

Still, Clyfford, 1904–80
Painting, 1944; oil on unprimed canvas; 264.5×221.4cm (104¼×87⅛in); MoMA. **p.246**

Stuart, Gilbert, 1755–1828
The Skater, Portrait of William Grant, 1782; oil on canvas; 245.5×147.4cm (96¼×58in); NG Washington. **p.157**
George Washington (the "Athenaeum Washington Original"), 1796; oil on canvas; 121.9×94cm (48×37in); National Portrait Gallery, Washington DC. **pp.16, 155**

Stubbs, George, 1724–1806
Whistlejacket, 1762; oil on canvas; 292×246.4cm (115×97in); NG London. **p.214**

Surikov, Vasily, 1848–1916
The Execution of Boyarina Pajaritar Morozova, 1887; oil on canvas; 304×587.5cm (119⅝×231⅜in); Tretyakov Gallery, Moscow. **p.123**

Sweerts, Michiel, 1624–64
Feeding the Hungry, 1645–50; oil on canvas; 75×99cm (29½×39in); Rijksmuseum, Amsterdam. **p.196**

T

Tiepolo, Giambattista, 1696–1770
The Virgin Mary Presents the Scapular to St Simon Stock, 1749; oil on canvas; 533×342cm (209⅞×134¾in); Scuola dei Carmini, Venice. **p.38**

Tintoretto, Jacopo, 1518–94
The Miracle of the Slave, 1548; oil on canvas; 415×541cm (163⅜×213in); Accademia. **p.59**
The Presentation of the Virgin, 1556; oil on canvas; 429×480cm (169×189in); Madonna dell'Orto, Venice. **p.42**
The Crucifixion, 1565; oil on canvas; 536×1224cm (211×482in); Scuola Grande di San Rocco, Venice. **pp.15, 49**
Origin of the Milky Way, c.1575–80; oil on canvas; 148×165.1cm (58×65in); NG London. **p.79**

Titian (Tiziano Vecellio), c.1488/9–1576
Concert Champêtre, 1508 see **Giorgione**
Noli Me Tangere, c.1510; oil on canvas; 108.6×90.8cm (42¾×35⅛in); NG London. **p.52**
The Assumption, 1518; oil on board; 690×360cm (271⅝×141⅛in); Sta Maria Gloriosa dei Frari, Venice. **pp.18, 53**
Bacchus and Ariadne, 1522–3; oil on canvas; 175.2×190.5cm (69×75in); NG London. **pp.11, 80**
Portrait of a Noblewoman (La Bella), 1537; oil on canvas; 89×75cm (35×29⅛in); Galleria Palatina, Palazzo Pitti, Florence. **p.137**
Venus of Urbino, 1538; oil on canvas; 119×165cm (46⅛×65in); Ufizzi. **pp.15, 108**

The Emperor Charles V on Horseback at Mühlberg, 1548; oil on canvas; 323×279cm (127⅛×109⅞in); Prado. **p.154**
Danaë Receiving the Shower of Gold, before 1553; oil on canvas; 129×180cm (50⅞×70⅞in); Prado. **p.79**
The Rape of Europa, 1559–62; oil on canvas; 178.7×205.5cm (70⅛×81in); Isabella Stewart Gardner Museum, Boston. **p.78**
The Death of Actaeon, c.1565; oil on canvas; 178.4×198.1cm (70⅛×78in); NG London. **p.257**

Tour, Georges de la, 1593–1652
The Penitent Magdalene, 1638–43; oil on canvas; 133.4×102.2cm (52½×40¼in); Met. **p.61**

Trumbell, John, 1756–1843
The Battle of Bunker Hill, 1786; oil on canvas; 63.5×86.4cm (25×34in); Yale University Art Gallery, New Haven. **p.118**

Turner, Joseph Mallord William, 1775–1851
Snow Storm: Hannibal and his Army Crossing the Alps, 1812; oil on canvas; 146×237.5cm (57½×93½in); Tate Britain, London. **p.121**
The Fighting "Téméraire" Tugged to her Last Berth to be Broken Up, 1839; oil on canvas; 90.8×121.9cm (35⅞×48in); NG London. **p.178**
The Lauerzer Sea with the Mythens, c.1846–50; watercolour on paper; 36.8×54cm (14½×21¼in); Victoria and Albert Museum, London. **p.258**

U

Uccello, Paolo (Paolo di Dono), 1397–1475
Hunt in the Forest, c.1460; oil on canvas; 73×117cm (28¾×46in); Ashmolean Museum, Oxford. **p.216**
St George and the Dragon, c.1460; oil on canvas; 56.5×74cm (22⅛×29⅛in); NG London. **p.87**

V

Valenciennes, Pierre-Henri de, 1750–1819
View of the Ancient Town of Agrigento, 1787; oil on canvas; 110×164cm (43⅜×64⅛in); Louvre. **p.175**

Vallayer-Coster, Anne, 1744–1818
Still Life with Ham, Bottles, and Radishes, 1767; oil on canvas; 45×55cm 17⅞×21⅝in); Gemäldegalerie, Staatliche Museum, Berlin. **p.221**

Vanderlyn, John 1775–1852
The Murder of Jane McCrea, 1803–4; oil on canvas; 81.3×67.3cm (32×26⅛in); Wadsworth Atheneum, Hartford. **p.123**

Vasarely, Victor 1908–97
Supernovae, 1959; oil on canvas; 241.9×152.4cm (95¼×60in); Tate Collection, London. **p.250**

Velásquez, Diego (Diego Rodriguez de Silva y Velásquez), 1599–1660
The Waterseller of Seville, 1623; oil on canvas; 106.7×81cm (42×31¼in); Apsley House, London. **p.202**
Philip IV in Armour, 1624; oil on canvas; 57×44cm (22⅜×17¼in); Prado. **p.163**
Philip IV as a Hunter, 1632–3; oil on canvas; 191×126cm (75¼×49⅝in); Prado. **p.163**
The Toilet of Venus ("The Rokeby Venus"), 1647–51; oil on canvas; 122.5×177cm (48¼×69⅝in); NG London. **pp.104, 108**

Portrait of Pope Innocent X, 1650; oil on canvas; 141×119cm (55⁴/×46⁴/in); Galleria Doria Pamphili, Rome. **pp.13, 145**
Philip IV, 1652–5; oil on canvas; 69×56cm (27⁴/×22in); Prado. **p.163**
Las Meninas, 1656; oil on canvas; 332×279cm (130⁴/×109⁴/in); Prado. **pp.15, 152**
Veneziano, Domenico, 1410–61
St John the Baptist in the Desert, c.1445; tempera on panel; 28.3×32.4cm (11⁴/×12⁴/in); NG Washington. **p.60**
Venne, Adriaen Pietersz van de, 1589–1662
Fishing for Souls, 1614; oil on panel; 98×189cm (38⁴/×74⁴/in); Rijksmuseum, Amsterdam. **p.64**
Jan Vermeer, 1632–75
The Lacemaker, c.1669–70; oil on canvas transferred to panel; 24×31cm (9⁴/×12⁴/in); Louvre. **p.198**
A Young Woman Seated at a Virginal, c.1670; oil on canvas; 51.5×45.5cm (20⁴/×18in); NG London. **pp.15, 212**
Vernet, Claude-Joseph, 1714–89
View of Naples with Vesuvius, 1748; oil on canvas; 99×197cm (39×77⁴/in); Louvre. **p.170**
A Storm with a Shipwreck, 1754; oil on canvas; 87×137cm (34⁴/×54in); Wallace Collection, London. **p.182**
Veronese, Paolo (Paolo Caliari), 1528–88
The Marriage at Cana, 1562–3; oil on canvas; 666×990cm (262⁴/×389⁴/in); Louvre. **p.47**

The Family of Darius before Alexander, c.1565–70; oil on canvas; 236.2×474.9cm (93×187in); NG London. **p.120**
Venus and Adonis, c.1580; oil on canvas; 212×191cm (83⁴/×75⁴/in); Prado. **p.81**
Verrocchio, Andrea del (Andrea di Cioni), 1435–88, and Leonardo da Vinci, 1452–1519
The Baptism of Christ, 1470–5; oil on panel; 177×151cm (69⁴/×59⁴/in); Uffizi. **p.46**
Verrocchio, Andrea del, attributed to, c.1435–88
Tobias and the Angel, c.1475; tempera on poplar; 83.6×66cm (33×26in); NG London. **pp.55, 254**
Vigée-Lebrun, Elisabeth Louise, 1755–1842
Self-Portrait in a Straw Hat, c.1782–3; oil on canvas; 97.8×70.5cm (38⁴/×27⁴/in); NG London. **p.149**
Viola, Bill, 1951–
Room for St John of the Cross, 1983; video installation; The Museum of Contemporary Art, LA. **p.61**
Volpedo, Giuseppe Pellizza da, 1868–1907
The Fourth Estate, 1898–1901; oil on canvas; 293×545cm (115⁴/×214⁴/in); Civica Galleria d'Arte Moderna, Pinacoteca Brera, Milan. **p.132**
Vroom, Hendrik, 1566–1640
Dutch Man-of-War and Fishing Boat in a Breeze, c.1590; oil on copper; 16.5×25cm (6⁴/×9⁴/in); National Maritime Museum, London. **p.178**

W
Wall, Jeff, 1946–
A Sudden Gust of Wind (after Hokusai), 1993; transparency and illuminated display case; 250×397cm (98⁴/×156⁴/in); Tate Collection, London. **p.167**
Warhol, Andy, 1930–87
Campbell's Soup, 100 Cans, 1962; oil on canvas; 183×132cm (72×52in); Albright-Knox Art Gallery, Buffalo. **p.233**
Self Portrait, 1967; acrylic silkscreen print; PC. **Jacket**
Mao, 1972; silkscreen ink and polymer paint on canvas; 108×157cm (82×62in); Thomas Ammann Fine Art Gallery, Zurich. **pp.17, 134**
Watteau, Jean-Antoine, 1684–1721
The Pleasures of the Ball, c.1714; oil on canvas; 52.6×65.4cm (20⁴/×25⁴/in); Dulwich College Picture Gallery, London. **p.213**
Waterhouse, John William, 1849–1917
Ulysees and the Sirens, 1891; oil on canvas; 182.8×152.4cm (72×60in); National Gallery of Victoria, Melbourne. **p.83**
West, Benjamin, 1738–1820
The Death of General Wolfe, 1770; oil on canvas; 152.6×214.5cm (60×84⁴/in); National Gallery of Canada, Ottawa. **p.116**
Weyden, Rogier van der, 1399–1464
The Descent from the Cross, c.1435; oil on panel; 220×262cm (86⁴/×103⁴/in); Prado. **p.50**

St Luke Painting the Virgin Mary, c.1435–40; oil and tempera on panel; 135×108.2cm (53⁴/×42⁴/in); MFA. **p.20**
Last Judgement, 1443–51; oil on panel; 215×560cm (84⁴/×2209⁴/in); Musée de l'Hotel Dieu, Beaune. **p.68**
Whistler, James Abbott McNeill, 1834–1903
Arrangement in Grey and Black: Portrait of the Painter's Mother, 1871; oil on canvas; 144.3×162.5cm (56⁴/×64in); Musée d'Orsay, Paris. **p.160**
Wright, Joseph, of Derby, 1734–97
An Academy by Lamplight, c.1768–9; oil on canvas; 127×101cm (50×39⁴/in); Paul Mellon Collection, Yale Centre for British Art, New Haven. **p.125**
Witz, Konrad c.1400–45
The Miraculous Draught of Fishes, 1444; oil on wood; 132×154cm (52×60⁴/in); Musée d'Art et d'Histoire, Geneva. **p.46**

Z
Zoffany, Johann, 1733–1810
The Bradshaw Family, 1769; oil on canvas; 133.9×176.3cm (52⁴/×69⁴/in); Tate Collection, London. **p.159**
Zurbarán, Francisco de, 1598–1664
Still Life with Lemons, Oranges, and a Rose, 1633; oil on canvas; 62.2×109.5cm (24⁴/×43⁴/in); The Norton Simon Institute, Pasadena. **p.230**

UNKNOWN ARTSISTS
English or French School
The Wilton Diptych, 1395–9; egg on oak; 53×37cm (21×14⁴/in) each panel; NG London. **pp.14, 28, 214, 254**
School of Tours
The Emperor Lothair, 849–51; manuscript; Bibliothèque Nationale, Paris. **p.138**
Unknown artist
Portrait of John II "the Good King" of France, c.1360; oil on panel; 60×44.5cm (23⁴/×17⁴/in); Louvre. **p.138**
Unknown artist
Still Life with Books and an Hourglass, c.1630–40; oil on canvas; 34.9×56.8cm (13⁴/×22⁴/in); Staatliche Museum, Berlin. **p.229**
Unknown artist
Still Life with Marine Creatures, before 79 AD; fresco; Pompeii. **p.220**
Unknown English School
Richard II, c.1395; Westminster Abbey, London. **p.154**
Unkown Spanish artist
A Moor and a Christian Playing Lutes, 1221–84; manuscript; Monasterio de El Escorial, Madrid. **p.212**

OTHER WORKS
Workshop of Hegesandrus, Athenodorus, and Polydorus of Rhodes
The Laocoön, third century BC–first century AD; marble; Pio Clementine Museum, Vatican, Rome. **pp.11, 106**
Dome of the Mirhab at the Great Mosque, 961; mosaic; Córdoba. **p.24**
Christ Pantokrator, c.1148; mosaic; Cefalù Cathedral. **p.40**

Bibliography

GENERAL
Gombrich, Ernst Hans, *The Story of Art*, Phaidon Press, London, and Prentice Hall, New York, 1995.
Hall, James (ed.), *Dictionary of Subjects and Symbols in Art*, HarperCollins Publishers, New York, 1979, and John Murray, London, 1984.
Janson, H. W. and Antony F., *History of Art*, Thames and Hudson, London, and Abrams, New York, 1999.
Kemp, Martin (ed.), *Oxford History of Western Art*, Oxford University Press, Oxford and New York, 2000.
Thomas, A., *An Illustrated Dictionary of Narrative Painting*, John Murray, London, 1994.

ORIGINAL SOURCES
Alberti, Leon Battista, *On Painting*, Penguin Books, Harmondsworth, and Viking Penguin, New York, 1991.
Chipp, Herschel B., *Theories of Modern Art: A Source Book by Artists and Critics*, University of California Press, Berkeley, 1970.
Gilmore Holt, Elizabeth (ed.), *A Documentary History of Art*, Princeton University Press, New Jersey, 2 vols, 1981 and 1983.
Reynolds, Sir Joshua, *Discourses on Art*, Yale University Press, New Haven and London, 1997.
Vasari, Giorgio, *Lives of the Artists*, Bull, George (trans.), Penguin Books, Harmondsworth, 1987, and Viking Penguin, New York, 1988.

RELIGIOUS PAINTING
Belting, Hans, *Likeness and Presence: A History of the Image before the Era of Art*, University of Chicago Press, Chicago, 1993.
Finaldi, Gabriele (ed.), *Image of Christ: Catalogue of the Exhibition "Seeing Salvation,"* National Gallery Publications, London, 2000.
Murray, Peter and Linda, *The Oxford Companion to Christian Art and Architecture*, Oxford University Press, Oxford and New York, 1996.

MYTH AND ALLEGORY
Ovid, *Metamorphoses*, Golding, Arthur (trans.), Penguin Books, Harmondsworth, 2001.
Gombrich, Ernst Hans, *Symbolic Images: Studies in the Art of the Renaissance*, Phaidon Press, London, 1985, and New York, 1994.
Grimal, Pierre (ed.) and Maxwell-Hyslop, A.R. (trans.), *The Concise Dictionary of Classical Mythology*, Viking Penguin, New York, 1991, and Blackwell Publishers, Oxford, 1996.

THE NUDE
Clark, Sir Kenneth, *The Nude*, Penguin, Harmondsworth, 1993, and Fine Communications, New York, 1996.
Elkins, James, *Pictures of the Body*, Stanford University Press, Stanford, 2000.
Nead, Linda, *The Female Nude: Art, Obscenity and Sexuality*, Routledge, London and New York, 1992.

HISTORY PAINTING
Boardman, John etc, (ed.), *Oxford History of the Classical World*, Oxford University Press, Oxford, 1986, and New York, 1988.
Gerdts, William H. and Thistlethwaite, Mark, *Grand Illusions: History Painting in America*, exhibition catalogue, Amon Carter Museum, Fort Worth, 1988.
Wright, Beth S., *Painting and History during the French Restoration: Abandoned by the Past*, Cambridge University, Press Cambridge and New York, 1997.

PORTRAITURE
Brilliant, Richard, *Portraiture*, Reaktion Books, London, 1991, and Harvard University Press, Cambridge, 1992.
Campbell, Lorne, *Renaissance Portraits: European Portrait Painting in the 14th, 15th, and 16th centuries*, Yale University Press, New Haven and London, 1990.
Pointon, Marcia, *Hanging the Head: Portraiture and Social Formation in Eighteenth Century England*, Yale University Press, New Haven and London, 1993.

LANDSCAPE
Andrews, Malcolm, *Landscape and Western Art*, Oxford University Press, Oxford, 1999, and New York, 2000.
Clark, Sir Kenneth, *Landscape into Art*, John Murray, London, 1997.

Warnke, Martin, *Political Landscape: Art History of Nature*, Reaktion Books, London, 1994, and Harvard University Press, Cambridge, 1995.

GENRE
Baudelaire, Charles, *The Painter of Modern Life and Other Essays*, Mayne, Jonathan (ed.), Phaidon Press, London, and Chronicle Books, San Francisco, 1995.
Clark, T.J., *The Painting of Modern Life: Paris in the Art of Manet and his Followers*, Princeton University Press, New Jersey, 1999, and Thames and Hudson, London, 2000.
Johns, Elizabeth, *American Genre Painting: The Politics of Everyday Life*, Yale University Press, New Haven and London, 1992.
Schama, Simon, *The Embarrassment of Riches: An Interpretation of Dutch Culture in the Golden Age*, Fontana, London, 1988, and Vintage Books, New York, 1997.

STILL LIFE
Bryson, N., *Looking at the Overlooked: Four Essays on Still Life Painting*, Reaktion Books, London, and Harvard University Press, Cambridge, 1990.
Chong, A., and Kloek, W., *Still-Life Paintings from the Netherlands 1550–1720*, exhibition calalogue, Waanders, Zwolle, 2000.
Jordan, W., *Spanish Still Life from Velásquez to Goya*, National Gallery Publications, London, 1995.

Rowell, M., *Objects of Desire: The Modern Still Life*, exhibition catalogue, The Museum of Modern Art, New York, 1997.

ABSTRACT PAINTING
Dawtrey, M., etc., *Investigating Modern Art*, Yale University Press, New Haven and London, 1996.
Hughes, Robert, *The Shock of the New: Art and the Century of Change*, McGraw-Hill, New York, 1990, and Thames and Hudson, London, 1991.
Moszynska, A., *Abstract Art*, Thames and Hudson, London and New York, 1990.
Taylor, B., *The Art of Today*, Weidenfeld & Nicolson, London, 1995.

MATERIALS AND TECHNIQUES
Bomford, D., etc., *Art in the Making: Italian Painting Before 1400*, exhibition catalogue, National Gallery Publications and Yale University Press, London and New Haven, 1989.
Bomford, D., etc., *Art in the Making: Impressionism*, exhibition catalogue, National Gallery Publications and Yale University Press, London and New Haven, 1990.
Kirsh, Andrea and Levenson, Rustin S., *Seeing Through Paintings: Physical Examination in Art Historical Studies*, Yale University Press, New Haven and London, 2000.

Index

General Editor's acknowledgments

A book such as this is a group endeavour and I would like to thank all those who have worked towards its production: firstly the contributors, but also Richard Dawes, Paul Holberton, Michael Ricketts, Tim Brown, Jenny Faithfull, John Jervis, and Oliver Roberts. I would also particularly like to thank Hollis Clayson and Anthea Snow for their care, consideration, and humanity during our almost exclusively electronic collaboration. Finally I must thank Anna Benn without whom very little would be possible.

Picture acknowledgments

KEY

fc front cover; **bc** back cover; **b** bottom; **c** centre; **l** left; **r** right; **t** top; **A** Artothek, Peissenburg, Germany; **AKG** AKG London; **AP** AP; **AV** Accademia, Venice; **BAL** Bridgeman Art Library; **BN** The Barnett Newman Foundation; **C** Corbis UK Ltd; **CG** Courtauld Gallery, London; **CMA** The Cleveland Museum of Art; **EL** Erich Lessing; **FAM** Fogg Art Museum, Harvard University Art Museums, USA; **FC** The Frick Collection, New York; **G** Photographie Giraudon; **GAV** Galleria dell'Accademia, Venice; **GB** Groenigemuseum, Bruges; **IWM** Imperial War Museum, London; **JPGM** The J. Paul Getty Museum, Los Angeles; **KH** Kunsthalle, Hamburg; **KM** Kunsthistorisches Museum, Vienna; **L** Louvre, Paris; **MCAG** Manchester City Art Galleries; **MET** The Metropolitan Museum of Art, New York; **MFAB** Courtesy Museum of Fine Arts, Boston; **MM** Memling Museum, Bruges; **MNAM** Collections du Centre Georges Pompidou, Musée national d'art moderne, Paris; **MOD** Museo dell'Opera del Duomo, Siena; **MOMA** The Museum of Modern Art, New York; **MOP** Musée d'Orsay, Paris; **MRBAB** Musées Royaux des Beaux-Arts de Belgique, Brussels; **MU** Musée Unterlinden, Colmar; **NGA** National Gallery of Art, Washington, DC; **NGL** National Gallery, London; **NGS** National Gallery of Scotland, Edinburgh; **NSF** The Norton Simon Foundation, Pasadena, CA; **P** Museo del Prado, Madrid; **PBM** Pinacoteca di Brera, Milan; **PC** Private Collection; **PMM** Pushkin Museum, Moscow; **PP** Palazzo Pitti, Florence; **PPS** Palazzo Pubblico, Siena; **PV** Pinacoteca Vaticana; **PW** Peter Willi; **RA** Rijksmuseum, Amsterdam; **RHPL** Robert Harding Picture Library; **S** Scala; **SGSR** Scuola Grande di San Rocco, Venice; **SHM** The State Hermitage Museum, St Petersburg; **SMBPK** Staatliche Museen zu Berlin – Preussischer Kulturbesitz; **SS** SuperStock/The Huntingdon Library, Art Collections and Botanical Gardens, San Marino, CA; **SU** Duke of Sutherland Collection; **TG** © Tate Gallery, London 2000; **U** Galleria degli Uffizi, Florence; **VAM** The Victoria & Albert Museum, London; **VMG** Vatican Museums and Galleries, Vatican City; **WA** Wadsworth Atheneum, Hartford; **WC** The Wallace Collection, London.

UK jacket: fctl © NGL; **fctcl** BAL/CG; **fctcr** CMA/© Succession Picasso/DACS 2000; **fctr** NSF; **fccl** BAL/NGL; **fcccl** AKG/AP; **fcccr** NGA/Chester Dale Collection; **fccr** BAL/PC; **fcbl** © 1999 The Board of Trustees, NGA/ Widener Collection; **fcbcl** BAL/KM; **fcbcr** BAL/NGL; **fcbr** BAL/IMW; **bctl** S/P; **bctr** AKG/L; **bcbl** S/L; **bcbr** BAL/P/ Succession Picasso/DACS 2000. **US jacket: fc** SMBPK/Jörg P Anders. **5** BAL/NGL; **6** BAL/Rubenshuis, Antwerp; **7t** BAL/PP; **7b** © NGL; **8t** BAL/FAM; **8b** TG/© ADAGP, Paris and DACS, London 2000; **9** TG/© The Estate of Roy Lichtenstein/ DACS 2000; **10t** G/PC/© ADAGP, Paris and DACS, London 2000; **10c** TG/© DACS 2000; **11l** © NGL; **11r** AKG/VMG; **12l** © NGL; **12r** © NGL; **13t** AKG/Galleria Doria Pamphilj, Rome; **13b** BAL/Aberdeen Art Gallery and Museum, Scotland/© Estate of Francis

Bacon/ARS, NY and DACS, London 2000; **14tl** S; **14tcl** BAL/PPS; **14tcr** BAL/NGL; **14tr** NGA/Samuel H Kress Collection; **14cl** AKG/Chiesa del Carmine, Capella Brancacci/San Dominigie; **14c** AKG/U; **14bl** AKG/NGL; **14br** S/U; **15tl** BAL/NGL; **15tcr** BAL/U; **15tr** BAL/VMG; **15cr** BAL/ NGL; **15ctl** BAL/SGSR; **15bl** AKG/P; **15bcl** AKG/EL/L; **15bcr** BAL/SU/NGS; **15br** © NGL; **16tl** NSF; **16tcl** AKG/L; **16tcr** MFAB/William Francis Warden Fund, John H and Ernestine A Payne Fund, Commonwealth Cultural Preservation Trust. Jointly owned by the Museum of Fine Arts Boston and the National Portrait Gallery, Washington, DC; **16tr** SS; **16c** AKG/L; **16cr** S/P; **16cbr** JPGM; **16bl** BAL/Museo de Arte, Ponce, Puerto Rico; **16bcl** S/L; **16br** BAL/CG; **17t** MNAM/Philippe Migeat; **17c1** TG; **17c2** BAL/P; **17c3** TG; **17c4** BAL/ The Daros Collection; **17b** BAL/James Goodman Gallery, New York; **18** BAL/Santa Maria Gloriosa dei Frari, Venice/Francesco Turio Bohm; **20t** BAL/NGL; **20b** MFAB/Gift of Mr and Mrs Henry Lee Higginson; **21tl** AKG/KM; **21tr** BAL/Santa Maria del Popolo, Rome; **21b** BN/© ARS, NY and DACS, London 2000; **22t** BAL/NGL; **22b** BAL/Chapelle du Rosaire, Venice/ © Succession H Matisse/DACS 2000; **23l** S/Capitolo del Duomo, Siena; **23tr** S/L; **23br** BAL/GB; **24l** RHPL/P Koch; **24r** S; **25l** S; **25r** The Rothko Collection/Hickey-Robertson; **26l&26r** AKG/EL/St Wolfgang Salzkammergut; **27l** S/AV; **27r** S/PV; **28** BAL/ NGL; **29l** S/MM; **29c** S/MM; **29r** BAL/NGL; **30t** BAL/KM; **30b** BAL/VMG; **31tl** TG; **31tr** AKG/Chiesa del Carmine, Cappella Brancacci/San Dominigie; **31bl** AKG/P; **32l** © NGL; **32r** BAL/MRBAB; **33l** S/MU; **33tr** BAL/Wilhelm Lehmbruck Museum, Duisberg/© ADAGP, Paris and DACS, London 2000; **33br** TG; **34l** BAL/CG; **34r** A/ Joachim Blaeu/Städelsches Kunstinstitut Frankfurt; **35l** NGA/Richard Carafelli; **35r** BAL/U; **35b** BAL/U; **36** AKG/EL/St Peter, Leuven; **37t** BAL/NGS; **37b** BAL/MCAG; **38t** BAL/MOD; **38bl** BAL/Scuola Grande dei Carmini, Venice; **38br** BAL/P; **39tl** BAL/ Pinacoteca, San Sepolcro; **39tr** BAL/L; **39cl** AKG/Städelsches Kunstinstitut, Frankfurt; **39bl** AKG/National Gallery, Prague; **39br** BAL/Ludwig Museum, Cologne; **40tl** BAL/Cathedral, Cefalù, Sicily/G; **40tr** BAL/AP; **40bl** NGS; **40br** S/Pinacoteca Nazionale, Siena; **41** BAL/NGL; **41r** Albright-Knox Art Gallery, Buffalo, New York/General Purchase Fund, 1946; **41t** BAL/St Bavo Cathedral, Ghent/G; **41c** BAL/Keble College, Oxford; **42l** A/Joachim Blauel/AP; **42r** S/S Maria dell'Orto, Venice; **43l** BAL/Scrovegni Chapel, Padua; **43r** AKG/Pinacoteca Civica, Recanati; **44l** © NGL; **44t** S/U; **45r** AKG/KH; **45tl** AKG/U; **45bl** © S; **46t** S/U; **46b** AKG/ Musée d'Art et d'Histoire, Geneva; **47t** BAL/ PW/L; **47b** © FC; **48l** S/Galleria Sabauda, Turin; **48t** © NGL; **49t** S/Palazzo Ducale, Urbino; **49c** S/MU; **49b** BAL/SGSR; **50l** S/P; **50r** S/Museo Poldi Pezzoli, Milan; **51tl** BAL/ Galleria Borghese, Rome; **51tr** BAL/PBM; **51b** BAL/NGA; **52l** © NGL; **52r** AKG/MU; **53l** BAL/Santa Maria Gloriosa dei Frari, Venice/Francesco Turio Bohm; **53r** BAL/ Musée Municipal, Villeneuve-lès-Avignon,

France/PW; **54l** BAL/KM; **54r** BAL/PP; **54b** S/AP; **55t** AKG/EL/L; **55cl** AKG/ Kunstgalerie, Gera/© DACS 2000; **55cr** © NGL; **55b** BAL/Santa Maria della Passione, Milan; **56l** AKG/L; **56r** S/Monasterio de El Escorial, Spain; **57r** BAL/San Stae (Sant' Eustachio), Venice; **57tl** S/Oratory of St John the Baptist, La Valletta; **57b** S/Pinacoteca Vaticano; **58t** S/Pinacoteca Vaticano; **58b** AKG/GAV; **59l** AKG/GAV; **59r** AKG/KM; **60l** BAL/Samuel H Kress Collection, Washington, DC; **60r** © FC; **61l** MET/Gift of Mr and Mrs Charles Wrightsman, 1978; **61tr** © NGL; **61br** The Museum of Contemporary Art, Los Angeles/The El Paso Natural Gas Company Fund for California Art/Photo: Kira Perov/SQUIDDS & NUNNS; **62t** S/L; **62b** BAL/VAM; **63t** Städelsches Kunstinstitut Frankfurt am Main/© Ursula Edelmann, Frankfurt am Main; **63b** BAL/SU/NGS; **64t** © NGL; **64b** RA; **65** BAL/Church of St Ignatius, Rome; **66l** AKG/Musée Carnavalet, Paris; **66r** AKG/KH; **67t** BAL/MFAB; **67b** National Gallery of Australia, Canberra/ © ARS, NY and DACS, London 2000; **68** BAL/Hôtel Dieu, Beaune; **69tl** S/Orvieto Cathedral; **69tr** S/Orvieto Cathedral; **69b** TG; **70** S/U; **72t** S/U; **72c** S/Palazzo della Farnesina, Rome; **72b** BAL/P; **73t** BAL/ Nationalmuseum, Stockholm; **73c** BAL/ Museo de Arte, Ponce, Puerto Rico; **73b** AKG/Serov Collection, Moscow; **74r** The Royal Collection © 2000, Her Majesty Queen Elizabeth II; **74t** BAL/NGL; **75** S/Stanze di Raffaello, Vatican; **76l** BAL/ NGL; **76r** AKG/EL/Palazzo del Tè, Sala dei Giganti, Mantua; **77tl** S/U; **77tr** AKG/L; **77bl** AKG/Bayerischen Staatsgemälde-sammlungen, Munich; **78tl** BAL/Palazzo del Tè, Mantua; **78tr** SMBP/Photo: Jörg P Anders; **78b** Isabella Stewart Gardner Museum, Boston; **79tl** BAL/P; **79tr** BAL/KM; **79cl** BAL/NGL; **79bl** BAL/WC; **80l** BAL/ NGL; **80r** © NGL; **81l** S/P; **81r** TG; **82t** © NGL; **82bl** BAL/SHM; **82br** Frans Halsmuseum, Haarlem; **83t** National Gallery of Victoria, Melbourne; **83cl** S/MOP; **83cr** BAL/PW/MOP; **83b** S/L; **84l** © NGL; **84r** AKG/EL/MM; **85** S/Palazzo Schifanoia, Ferrara; **86tl** BAL/New Walk Museum, Leicester City Museum Service; **86tr** AKG/ EL/L; **86bl** BAL/Musée Gustave Moreau, Paris; **86br** BAL/NGL; **87t** AKG/Musées Royaux d'Art et d'Histoire, Brussels; **87c** BAL/Musée Picasso, Paris/© Succession Picasso/DACS 2000; **87bl** © NGL; **87br** BAL/ PW/L; **88l** AKG/Royal Academy of Fine Arts, London; **88r** AKG/Residenz (Königsbau, Niebelungensaal, Saal der Rache), Munich; **89l** BAL/Lady Lever Art Gallery, Port Sunlight, Merseyside. Board of Trustees: National Museums & Galleries on Merseyside; **89r** BAL/Österreichische Galerie, Vienna; **90l** BAL/Faringdon Collection, Buscot, Oxon; **90r** Reproduced by kind permission of Sefton MBC Leisure Services Department, Arts and Cultural Services, Atkinson Art Gallery; **91** Hirshhorn Museum and Sculpture Garden, Smithsonian Institution/Gift of Joseph H Hirshhorn, 1966/Photo by Lee Stalsworth/© DACS 2000; **92l** TG/© Salvador Dali–Foundation Gala-Salvador Dali/DACS 2000; **92r** TG/ © Foundation P. Delvaux-St Idesbald/

Belgium/DACS, London 2000; **93r** BAL/PW/ PC/© DACS 2000; **93tl** TG/© Foundation P.Delvaux-St Idesbald/Belgium/DACS, London 2000; **93bl** Courtesy Galerie Christine et Isy Brachot, Bruxelles/ © ADAGP, Paris and DACS, London 2000; **94l** BAL/PC; **94r** MFAB/Juliana Cheney Edwards Collection, Tompkins Collection, and Fanny P Mason Fund in Memory of Alice Thevin/© Succession Picasso/DACS 2000; **95t** NGA/Gift of Mrs Max Beckmann/ © DACS 2000; **95c** The Poindexter Collection; **95b** AKG/Moderna Museet, Stockholm/ © ARS, NY and DACS, London 2000; **96l** BAL/G/Château de Malmaison, Paris; **96r** BAL/CG; **97t** San Francisco Museum of Modern Art/Albert M Bender Collection, Albert M Bender Bequest Fund Purchase/ © ARS, NY and DACS, London 2000; **97b** National Gallery of Australia, Canberra/ Gift of Sunday Reed 1977; **98t** Ikona/ P Zigrossi/Stanze di Raffaello Stanza della Segnatura Raffaello, Vatican; **98b** AKG/ EL/U; **99l** BAL/NGL; **99r** S/L; **100l** AKG/KM; **100r** BAL/Fitzwilliam Museum, University of Cambridge; **101** © NGL; **102t** AKG/EL/KM; **102b** © NGL; **103l** S/L; **103tr** BAL/Royal Society of Arts, London; **103br** BAL/Church of St Ignatius, Rome; **104** © NGL; **106t** AKG/ VMG; **106c** © NGL; **106b** BAL/U; **107t** BAL/ NGL; **107c** AKG/AP; **107b** TG; **108l** BAL/U; **108r** © NGL; **109r** BAL/WC; **109tl** BAL/L; **109bl** BAL/G /L; **110l** RMN, Paris/Musée Thomas Henry, Cherbourg; **110r** Lauros-Giraudon/Musée Condé, Chantilly; **111l** BAL/Visual Arts Library, London/MOP; **111tr** TG; **111br** BAL/MOP; **112t** BAL/ Fitzwilliam Museum, University of Cambridge/© Estate of Stanley Spencer 2000. All Rights Reserved, DACS; **112b** TG/ © Estate of Francis Bacon/ARS, NY and DACS, London 2000; **113t** TG; **113b** PC; **114l** MOMA/Acquired through the Lillie P Bliss Bequest/© Succession Picasso/DACS 2000; **114r** BAL/SHM/© Succession H Matisse/DACS 2000; **115r** TG/© Estate of Gwen John 2000. All Rights Reserved, DACS; **115tl** Acquavella Galleries, Inc, New York; **115bl** The Saatchi Gallery, London; **116** National Gallery of Canada, Ottawa/ Transfer from the Canadian War Memorials, 1921 (Gift of the 2nd Duke of Westminster, Eaton Hall, Cheshire, 1918); **118t** S/L; **118b** BAL/PC; **119t** École Nationale Supérieure des Beaux-Arts, Paris; **119c** S/L; **119b** AKG/L; **120** BAL/NGL; **121l** Ikona/ VMG/Photo P. Zigrossi, 1986; **121tr** AKG/ EL/L; **121br** TG; **122l** © NGL; **122r** BAL/ Fogg Art Museum, Harvard University, Cambridge, Massachusetts/Bequest of Grenville L. Winthrop; **123tl** BAL/NGL; **123cl** WA/Purchased by the Wadsworth Atheneum; **123b** BAL/Tretyakov Gallery, Moscow; **124tl** AKG/L; **124tr** RA; **124b** AKG/L; **125tl** SHM; **125tr** BAL/Yale Centre for British Art, Paul Mellon Collection, USA; **125c** AKG; **125b** BAL/ PMM; **126** AKG/EL/L ; **127t** S/L; **127b** RMN, Paris/Arnaudaet; **128** TG; **129l** S/Musées Royaux des Beaux-Arts, Brussels; **129r** BAL/Château de Malmaison, Paris/G; **130tl** S/L; **130tr** BAL/Städtische Kunsthalle, Mannheim; **130br** S/P; **131t** NGA/Ferdinand Lammot Belin Fund; **131b** AKG/State

Russian Museum, St Petersburg/© DACS 2000; **132t** BAL/PBM; **132b** IWM; **133tl** BAL/P/© Succession Picasso/DACS 2000; **133cl** TG; **133cr** BAL/PW/Musée Picasso, Paris/© Succession Picasso/DACS 2000; **134** BAL/The Daros Collection; **136t** C/Francis G Mayer/© Succession Picasso/DACS 2000; **136b** AKG/U; **137t** SHM; **137c** BAL/PP; **137b** MET/Bequest of William K Vanderbilt, 1920 (20.155.2); **138l** AKG/Bibliothèque Nationale de France/VISIOARS; **138r** AKG/EL/L; **139tc** © NGL; **139tr** © NGL; **139b** S/Museo di Capodimonte, Naples; **140r** The Collection of the Duke of Northumberland; **140tl** The Royal Collection © 2000, Her Majesty Queen Elizabeth II; **140bl** © NGL; **141t** NGA/Chester Dale Collection; **141b** Sainsbury Centre for Visual Arts, University of East Anglia/© Estate of Francis Bacon/ARS, NY and DACS, London 2000; **142l** AKG/EL/L; **142bl** AKG/EL/L; **143tl** The Phillips Collection, Washington, DC; **143tr** BAL/Musée National d'art Moderne, Paris/© DACS 2000; **143bl** C/Francis G Mayer; **144t** Lauros-Giraudon/Musée Mandralisca, Cefalù; **144b** AKG/EL/L; **145t** AKG/Galleria Doria Pamphilj, Rome; **145b** Moderna Museet/© DACS 2000; **146** AKG/EL/NGL; **147tl** AKG/Berlin, SMPK, Gemäldegalerie; **147tr** BAL/NGL; **147b** Courtesy of the Maryland Commission on Artistic Property of the Maryland State Archives; **148tl** AKG/KM; **148tr** AKG/AP; **148bl** AKG/EL/AP; **148br** BAL/SU/NGS; **149tl** © NGL; **149tr** AKG/Busch-Reisinger Museum, Cambridge, Massachusetts/© DACS 2000; **149bl** BAL/CG; **149br** Pace Wildenstein, New York; **150t** The Royal Collection © 2000, Her Majesty Queen Elizabeth II; **150b** AKG/P; **151t** TG; **151b** BAL/Neue Galerie, Linz; **152l** AKG/EL/P; **152r** AKG; **153t** AKG/Frans Hals Museum, Haarlem; **153b** MFAB/Gift of Mary Louisa Boit, Julia Overing Boit, Jane Hubbard Boit and Florence D Boit in memory of their father, Edward Darley Boit; **154t** AKG/P; **154b** © Dean and Chapter of Westminster, London; **155tl** AKG/Schloss Charlottenburg, Berlin; **155tr** MFAB/William Francis Warden Fund, John H and Ernestine A Payne Fund, Commonwealth Cultural Preservation Trust. Jointly owned by the MFAB and the National Portrait Gallery, Washington, DC; **155br** The Royal Collection © 2000, Her Majesty Queen Elizabeth II; **156l** NGA/Samuel H Kress Collection/Photo by Lyle Peterzell; **156r** AKG/EL/L; **157l** NGA/Andrew W Mellon Collection/Photo by Bob Grove; **157r** SuperStock/The Huntingdon Library, Art Collections, and Botanical Gardens, San Marino, California; **158t** NGA/Andrew W Mellon Fund, Photo by Richard Carafelli; **158b** Museum Boijmans-van Beuningen, Rotterdam; **159t** TG; **159b** BAL/PC; **160t** AKG/Österreichische Galerie im Belvedere, Vienna; **160b** BAL/PW/MOP; **161t** photograph © 2000 Art institute of Chicago/Gift of Mrs Gilbert W Chapman in memory of Charles B Goodspeed/© Succession Picasso/DACS 2000; **161b** BAL/Musée Picasso, Paris/© Succession Picasso/DACS 2000; **162r** BAL/L; **162tl** BAL/NGL; **162bl** AKG/Stedelijk Museum "De Lakenhal", Leiden; **163tl** BAL/NGL; **163tr** Oroñoz/P; **163cr** AKG/P; **163bl** BAL/NGL; **163br** Oroñoz/P; **164** JPGM; **166t** NGA/Samuel H Kress Collection; **166c** RMN, Paris/Michèle Bellot/L; **166b** RA; **167l** © NGL; **167tr** JPGM; **167br** TG; **168l** Groeningemuseum, Bruges; **168r** BAL/PW/L; **169r** BAL/Gemäldegalerie, Dresden, Germany; **169tl** BAL/G/L; **169bl** MET, Gift of Mrs Russell Sage, 1908 (08.228); **170t** Ville de Dijon, Musée des Beaux-Arts; **170b** BAL/G/L; **171tl** © 1999 The Board of Trustees,

NGA, Washington/Widener Collection; **171cr** BAL/PW/L; **171br** Santa Barbara Museum of Art/Gift of Mrs Hugh N Kirkland; **172t** BAL/PW/L; **172b** BAL/WC; **173t** © NGL; **173bl** BAL/Roger-Viollet, Paris/MOP/© Succession H Matisse/DACS 2000; **173br** NGA/Gift of Mrs Huttleston Rogers. Photo by Lyle Peterzell; **174** BAL/Walker Art Gallery, Liverpool, Board of Trustees: National Museums & Galleries on Merseyside; **175t** MET/H O Havemeyer Collection, Bequest of Mrs H O Havemeyer, 1929; **175b** AKG/L; **176tl** BAL/PPS; **176tr** BAL/PPS; **176b** AKG/L; **177t** Philadelphia Museum of Art/A.E. Galatin Collection/© ADAGP, Paris and DACS,London 2000; **177b** NSF; **178t** National Maritime Museum, London; **178b** BAL/NGL; **179l** NGA, Ailsa Mellon Bruce Collection/Photo by Richard Carafelli; **179tr** AKG/SMPK, Nationalgalerie Berlin; **179br** NSF; **180l** © 1996 The Detroit Institute of Arts/Gift of Julius H Haass in memory of his brother Dr Ernest W. Haass; **180r** The Montreal Museum of Fine Arts Collection/Photo Bernard Brien; **181r** CMA/Hinman B Hurlbut Collection, 1335.1917; **181t** JPGM; **182t** BAL/GAV; **182b** WC; **183r** Collection of the Tel Aviv Museum of Art/Gift of the American Fund for Israeli Institutions; **183tl** BAL/PW/MOP; **183bl** BAL/MOP; **184tl** AKG; **184tr** AKG/Musée Condé, Chantilly; **184bl** RA; **184br** RA; **185tl** RMN, Paris/Hervé Lewandowski/L; **185tr** Wallraf-Richartz-Museum, Cologne; **185cl** © FC; **185b** BAL/KM; **186t** BAL/NGL; **186b** BAL/L; **187r** MOMA/Acquired through the Lillie P Bliss Bequest; **187t** BAL/Nasjonalgalleriet, Oslo; **188l** SMBPK/Photo: Jörg P Anders; **188r** BAL/PP; **189tl** © 1985 The Detroit Institute of Arts/Founders Society Purchase, Robert H Tannahill Foundation Fund, Gibbs-Williams Fund, Dexter M Ferry Jr, Merrill Fund, Beatrice W Rogers Fund, & Richard A Manoogian Fund; **189tr** BAL/NGL; **189b** Kunstmuseum Basel/© by Dr Wolfgang & Ingeborg Henze-Ketterer, Wichtrach/Bern; **190t** TG; **190b** BAL/P; **191t** WA/The Ella Gallup Sumner and Mary Catlin Sumner Collection Fund/© ADAGP, Paris and DACS, London 2000; **191c** BAL/IWM; **191b** MOMA/Enid A Haupt Fund; **192** Mauritshuis, The Hague; **194t** AKG/Palazzo Schiffanoia, Ferrara; **194c** AKG; **194b** VAM; **195tl** JPGM; **195tr** BAL/Niedersächsische Landesmuseum, Hanover; **195b** BAL/Scottish National Gallery of Modern Art, Edinburgh/© The Estate of Roy Lichtenstein/DACS 2000; **196tl** MET/Rogers Fund, 1919 (19.164); **196tr** RA; **196bl** C/O Kimbell Art Museum, Fort Worth, Texas; **197t** MFAB/Ernest Wadsworth Longfellow Fund; **197b** BAL/Royal Holloway and Bedford New College, Surrey; **198l** SMBPK/Photo: Jörg P Anders; **198r** BAL/L; **199l** © NGL; **199r** BAL/MCAG; **200l** NGA/Ailsa Mellon Bruce Fund; **200r** © NGL; **201tl** C/Francis G Mayer; **201tr** TG; **201b** BAL/NGL; **202t** The Governing Body, Christ Church, Oxford; **202tl** AKG/KM; **202tr** AKG/EL/Wellington Museum, Apsley House, London; **203tl** WA/Ella Gallup Sumner and Mary Catlin Summner Collection; **203cl** BAL/Sudeley Castle, Winchcombe, Gloucestershire; **203cr** BAL/Musée Condé, Chantilly, France; **203b** BAL/CG; **204t** BAL/G/L; **204b** BAL/Art Institute of Chicago, Illinois; **205l** © David Hockney; **205tr** Solomon R Guggenheim Museum, New York/Photo by © The Solomon R Guggenhim Foundation, New York/© DACS 2000; **206t** BAL/PMM; **206b** BAL/MFAB; **207r** AKG/KH; **207tl** Musée des Beaux-Arts Besançon/Charles Choffet; **207bl** Delaware Art Museum, Wilmington; **208t** BAL/Royal Holloway and Bedford New College, Surrey;

208b AKG/PMM; **209tl** BAL/Rasmus Meyers Samlinger, Bergen; **209bl** AKG/MOP; **209r** MOMA. Given anonymously; **210l** AKG/EL/L; **210t** The Art Archive/Royal Academy, London; **211l** BAL/G/National Palace, Mexico City/Reproduced by permission of the Instituto Nacional de Bellas Artes, Mexico; **211tr** G/Musée du Petit Palais, Paris; **212l** BAL/Monasterio de El Escorial, Spain/Index; **212r** © NGL; **213t** BAL/Dulwich Picture Gallery, London; **213c** BAL/PC/© ADAGP, Paris and DACS, London 2000; **213b** PC/Photograph © 1987 The Metropolitan Museum of Art, New York; **214tl** © NGL; **214tr** BAL/NGL; **214b** BAL/Mauritshuis, The Hague; **215t** BAL/United Distillers and Vintners; **215c** RMN, Paris/Gérard Blot/MOP; **215bl** Philadelphia Museum of Art/A E Gallatin Collection; **215br** © David Hockney/Photo: Steve Oliver; **216t** BAL/Ashmolean Museum, Oxford; **216b** BAL/PC; **217tl** NGA/Gift of the Avalon Foundation; **217tr** BAL/Academia de San Fernando, Madrid; **217b** BAL/The Barber Institute of Fine Arts, University of Birmingham; **218** BAL/Ambrosiana, Milan; **220t** AKG/EL/National Museum of Archaeology; **220b** © NGL; **221tl** BAL/KM; **221tr** BAL/CG; **221c** SMBPK Gemäldegalerie/Photo: Jörg P Anders; **221b** Louis K Meisel Gallery, New York/Incorporating A Portion Of The Margaret Bourke-White Photograph 'Buchenwald, April 1945' © Time Inc./Photo: Bruce C Jones; **222t** Oroñoz/P; **222b** BAL/Ambrosiana, Milan; **223l** San Diego Museum of Art/Gift of Anne R and Amy Putnam; **223r** Indianapolis Museum of Art/Gift of Mrs James W Fesler in memory of Daniel W. and Elizabeth C. Marmon; **224r** MFAB/The Hayden Collection; **224tl** AKG/L; **224bl** Art Institute of Chicago/Wirt D Walker Fund, 1949.585; **225tl** BAL/NGL; **225tc** BAL/NGL; **225tr** Statens Konstmuseer, Stockholm; **225bl** Staatliche Museen Kassel; **225br** AKG/Germanisches Nationalmuseum, Nürnberg; **226l** AKG/Mauritshuis, The Hague; **226r** Museo Thyssen-Bornemisza, Madrid; **227tl** AKG/SHM/© Succession H Matisse/DACS 2000; **227tr** © NGL; **227br** Philadelphia Museum of Art/Bequest of Georgia O'Keeffe for the Alfred Stieglitz Collection; **228t** © NGL; **228b** RMN, Paris/Jean Schormans/L; **229r** CMA/© Succession Picasso/DACS 2000; **229tl** SMBPK Gemäldegalerie/Jörg P Anders; **229bl** Statens Konstmuseer/Photo: SKM; **230t** NSF; **230b** AKG/SHM; **231tl** Staatliche Kunsthalle Karlsruhe; **231tr** BAL/NGL; **231c** RMN, Paris/Gérard Blot/L; **231bl** AKG/KM; **231br** BAL/PC/© ADAGP, Paris and DACS, London 2000; **232t** BAL/L; **232b** Museum Boijmans-van Beuningen, Rotterdam; **233t** Collection Albright-Knox Art Gallery/Gift of Seymour H Knox, 1963/© Licensed by the Andy Warhol Foundation for the Visual Arts, Inc/DACS London 2000. Trademarks Licensed by Campbell Soup Company. All Rights Reserved.; **233b** MFAB/Fanny P Mason Fund in Memory of Alice Thevin; **234t** MET/Bequest of Stephen C Clark, 1960 (61.101.4); **234b** Solomon R Guggenheim Museum/Photograph by Lee B Ewing © The Solomon R Guggenheim Foundation, New York (FN 54.1412)/© ADAGP, Paris and DACS, London 2000; **235l** Washington University Gallery of Art, St Louis/University purchase, Kende Sale Fund, 1946/© Succession Picasso/DACS 2000; **235r** Staatliche Kunsthalle Karlsruhe/© ADAGP, Paris and DACS, London 2000; **236** TG/© ARS, NY and DACS, London 2000; **238t** Collections du Centre Georges Pompidou, Musée national d'art moderne, Paris/Philippe Migeat/© ADAGP, Paris and DACS, London 2000; **238c** Haags Gemeentemuseum/© DACS 2000;

238b MOMA/Mrs Simon Guggenheim Fund/© Kate Rothko Prizel and Christher Rothko/ARS, NY and DACS, London 2000; **239t** TG; **239b** TG/© Willem de Kooning/ARS, NY and DACS, London 2000; **240tl** Solomon R Guggenheim Museum/Gift, Solomon R Guggenheim, 1937/© Succession Picasso/DACS 2000; **240tr** MOMA/Acquired through the Lillie P Bliss Bequest/© ADAGP, Paris and DACS, London 2000; **240b** TG; **241l** TG/© DACS 2000; **241r** TG/© ADAGP, Paris and DACS, London 2000; **242t** Collections du Centre Georges Pompidou, Musée national d'art moderne, Paris/Jacques Faujour/© ADAGP, Paris and DACS, London 2000; **242b** Peggy Guggenheim Collection, Venice/© The Solomon R Guggenheim Foundation; **243tr** BAL/Stedelijk Museum, Amsterdam; **243bl** MOMA/Gift of the artist, through Jay Leyda/© DACS 2000; **243br** TG/© ADAGP, Paris and DACS, London 2000; **244l** MNAM/Jean-Claude Planchet/© DACS 2000; **244r** TG/© 2000 Mondrian/Holtzman Trust c/o Beeldrecht, Amsterdam, Holland & DACS London; **245** MOMA/Given anonymously/© 2000 Mondrian/Holtzman Trust c/o Beeldrecht, Amsterdam, Holland & DACS London; **246l** MOMA/The Sidney and Harriet Janis Collection; **246r** MOMA/Gift of Mr and Mrs Joseph Slifka/© ARS, NY and DACS, London 2000; **247r** TG/© Kate Rothko Prizel and Christher Rothko/DACS 2000; **247tl** TG/© ARS, NY and DACS, London 2000; **247bl** Robert Miller Gallery, New York; **248l** MOMA/Larry Aldrich Foundation Fund/© ARS, NY and DACS, London 2000; **248r** TG/© ARS, NY and DACS, London 2000; **249r** Lisson Gallery London/Photo: Steve White, London; **249tl** TG; **249bl** TG; **250** TG; **251l** PC – photo: courtesy Bridget Riley/© Bridget Riley; **251r** Whitney Museum of American Art, New York/Photo by Geoffrey Clements; **252l** The Whitworth Art Gallery, The University of Manchester; **252r** BAL/PC/James Goodman Gallery, New York; **253tl** © Courtesy Anthony d'Offay Gallery, London; **253tr** Robert Miller Gallery, New York; **253b** The Saatchi Gallery, London; **254t** BAL/MOD; **254c** © NGL; **254bl** BAL/NGL; **254bc** BAL/NGL; **254br** BAL/NGL; **255t** National Geographic Society Image Collection, Washington, DC/Victor Boswell; **255c** BAL/Vatican Library, Rome; **255bl** BAL/U; **255br** The Royal Collection © 2000, Her Majesty Queen Elizabeth II; **256t** Kunstmuseum Bern/Peter Lauri, Bern 1992; **256bl** BAL/NGL; **256br** AKG/EL/L; **257tl** BAL/NGL; **257c** BAL/NGL; **257bl** BAL/SU/NGS; **258t** VAM; **258c** AKG/Neue Pinakothek, Munich; **258bl** © NGL; **258br** © NGL; **259l** © David Hockney; **259tr** Washington University Gallery of Art/University purchase Kende Sale Fund, 1946/© Succession Picasso/DACS 2000; **259br** TG.